PHOTO-REALISM

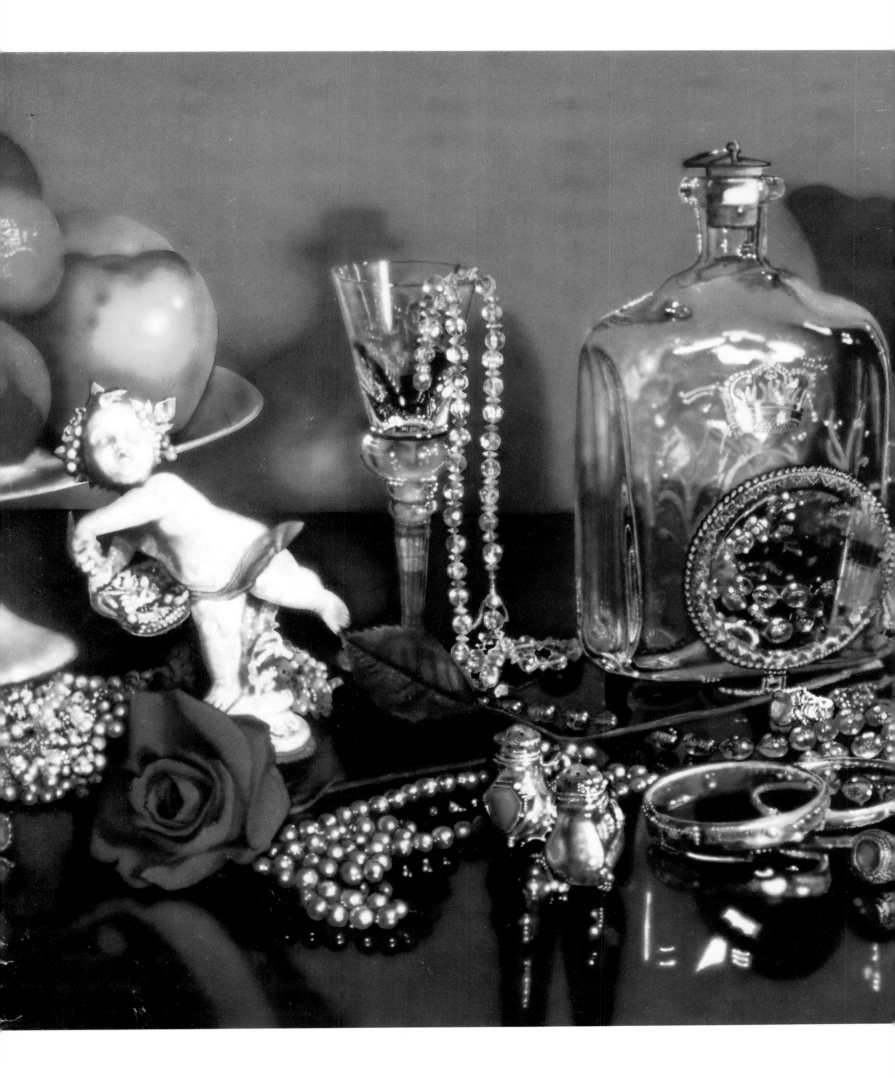

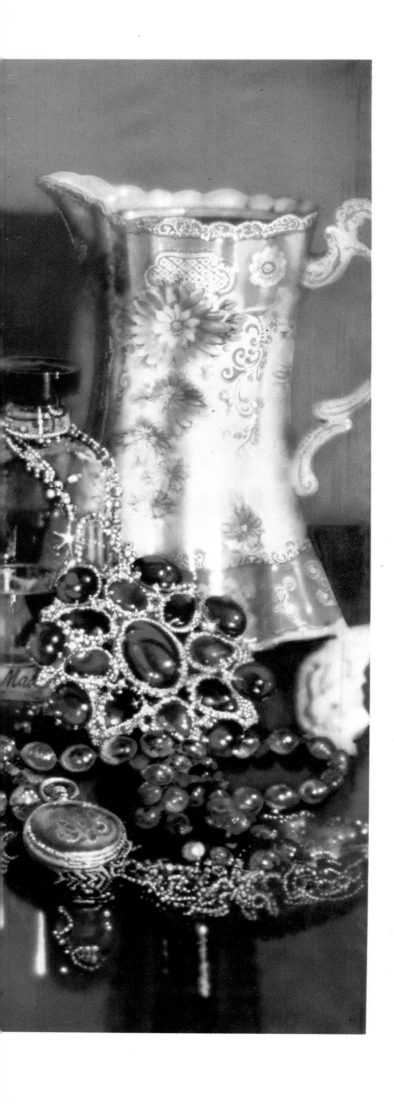

PHOTO-REALISM

by Louis K. Meisel

Foreword by Gregory Battcock

Research and Documentation
by Helene Zucker Seeman

ABRADALE PRESS
HARRY N. ABRAMS, INC., PUBLISHERS,
NEW YORK

Project Manager: Margaret L. Kaplan
Editor: Margaret Donovan
Designer: Dirk Luykx

Frontispiece: Audrey Flack. *Jolie Madame.* 1972
Oil on canvas, 71 x 96". Australian National Gallery, Canberra

Library of Congress Cataloging-in-Publication Data
Photo-Realism / by Louis K. Meisel; foreword by Gregory Battcock;
 research and documentation by Helene Zucker Seeman.
 p. cm.
 Bibliography: p. 433
 Includes index.
 ISBN 0–8109–8092–4
 1. Photo-realism. 2. Painting, Modern—20th Century. I. Meisel,
Louis K. II. Seeman, Helene Zucker, 1950–
ND196.P42P45 1989
759.13—dc 19 89–44

CONTENTS

PREFACE

The purpose of this volume is to provide as complete a reference work as possible on the art of the Photo-Realists. The original intention was to illustrate every painting done by the major Photo-Realists from 1967 to 1977, the first decade of the movement. We have come very close to doing this and have also been able to include most works done through 1979. In the few instances where we were unable to acquire a photograph of a work or have chosen not to illustrate one, we have listed the title of the missing work with pertinent information. In the introductions to the chapters on the thirteen major artists, notice is taken of any significant missing works or relevant information. We have also attempted to list as thoroughly as possible all biographical and bibliographical material. Some minor and obscure entries may be missing from these bibliographies, which have been compiled from the files of the artists and those of their dealers. The research for this book has taken about ten years, during which time I have seen about ninety percent of the paintings illustrated herein.

Beginning in 1973 my wife, Susan Pear Meisel, transformed our loft into the "salon" of the Photo-Realists. In that year, they all met one another there, most for the first time, at the first of the now annual Fall parties and since then there have been over one hundred gatherings. The discussions, arguments, and mutual criticisms as well as the personal relationships in which I have participated over these years form the basis of the text of this book.

The book is divided into three sections. The first is an introduction to Photo-Realism, including a definition and a brief history. Following the introduction is a section containing extensive coverage of the thirteen artists who, in my opinion, are at present most clearly identified as the central, most significant Photo-Realists. Finally, there is a selected list of exhibitions and bibliography containing detailed information on the Photo-Realist movement during the years covered by the book.

I have relied totally on Helene Zucker Seeman, librarian, for bibliographical and biographical research, at which she is expert. Her work is precise and accurate, and the value of this book as a reference would be diminished by half without her contribution. Grace Meisel was in charge of coordinating the information gathered from three sources: the artists, the dealers, and owners of the works. In many cases, we received three different answers to the same question, such as the size, date, or title. In almost all cases we used the information from the artist, and if we were totally unable to be sure of accuracy it is so indicated. This is the first volume of what we expect to be a thorough survey of Photo-Realism; a succeeding volume on work done through the end of 1990 will be issued shortly.

L.K.M.

FOREWORD

By the late nineteen sixties, it had become apparent that a new type of art was emerging from the abstraction-dominated art centers of New York and Western Europe. The new art was startling and confusing because it seemed to repudiate the hard-won gains of Abstract Expressionist and Minimalist art. After many years of struggle, nonobjective and abstract art had finally come to be recognized as permanent and positive aesthetic developments, only to be threatened by the appearance of a new art style that emphasized the image in all its objective clarity.

For some observers, the new realism represented something of an aesthetic backlash. The new art was thought to be a conservative, almost reactionary, phenomenon that would crush the formalist inventions of nonobjectivism in much the same way that, it is popularly assumed, Social Realist art sprang up for the explicit purpose of destroying the autonomous explorations of the Constructivists in Russia in the twenties.

The comparison, however, is not valid. For in some ways the new, "photo" realism can be seen as an affirmation rather than a repudiation of mainstream modernist art. Many of the problems and aesthetic challenges that motivated the Conceptualist and Minimalist artists have been considered by the Photo-Realists in their work. In the early years, this was not generally recognized, and, in fact, back in the sixties most people ridiculed Photo-Realist art. If the style was not reactionary, at most it was merely a fad. Or perhaps simply a way to gain attention. For some observers it was a put-on and for others it was a joke.

Though many critics, dealers, and publishers refused to take the style seriously, a few pioneers offered it support. Sporadic exhibitions were mounted and reviewed from 1965 to 1968, thus bringing the work of such artists as Robert Bechtle, John Clem Clarke, Chuck Close, Audrey Flack, and Malcolm Morley to public attention. Nevertheless it seemed that no single individual, with the exception of Ivan Karp, was willing, capable, or adventurous enough to concentrate on developing the potential of the Photo-Realist mode. None, that is, until Louis Meisel opened his second gallery on Prince Street in Soho in 1973. Photo-Realism thus came of age and was assured the constant and thorough attention it had been waiting for.

This opportunity for consistent and sustained appreciation of Photo-Realist art helped pave the way for a better understanding of what the style was all about. With the chance to examine the heritage, or context, on the one hand, and the new, emerging artists and their works, on the other, several important characteristics of the new art revealed themselves. It became clear that a style that had once been regarded as anti-

intellectual and faddish was, in fact, a logical and necessary extension of aesthetic principles developed throughout a half century of abstract and nonobjective art.

Throughout twentieth-century art history, the realism label has appeared over and over. The mid-nineteenth century produced its own school of realism, represented by the art of such figures as Jean-Baptiste Camille Corot and Gustave Courbet. At one time criticized for its "extreme" realism, their work is regarded today in a very different way. The realism does not seem quite so startling, and the modern viewer finds the naturalness and freshness of the paintings refined, sensual, and pleasing.

In the critical response they elicited, today's realists are quite close to their nineteenth-century predecessors. Additionally, the tradition of realism in Western art allows for a very broad interpretation of the concept of realism itself, thus recognizing relationships between the new realism and past realisms. The modern concern for realism and the contemporary need to redefine the term have even led to new approaches to the entire history of art. It is perhaps with this fact in mind that Louis Meisel devoted his energies, over an extensive period of time, to organizing and consolidating the efforts of the various realist artists who combined to make up the new style.

Because our ideas about realism in art are constantly changing, the realism of one art-historical period can be far removed from that advocated by another. Although it is probably safe to say that the kind of realism practiced by many artists today is linked to the realist art created in the seventeenth century by Caravaggio and Georges de La Tour, there are equally important connections to be revealed with recent Minimalist and Nonobjectivist art.

If Meisel—who began working with this art in 1967 and coined the term in 1968—is the single individual to significantly recognize and help formulate the movement into a cohesive reality at an early stage, it is worth asking how he came to appreciate an art style that was rejected, at least initially, by so many others. Meisel's extensive experience in printing might serve as a clue. The experience of designing and printing brochures for artists and galleries no doubt sensitized Meisel to the subtle and detailed problems that interested Minimalists, Conceptualists, and Abstract Expressionists. As president of Eminent Publications, Inc., Meisel found himself in a position to deal directly and closely with artists and writers in a unique way. Most important, working in printing in the nineteen sixties, Meisel viewed all art as reproduction. The artworks, as he saw them at the presses, were actually pictures.

In this sense, no matter how abstract, or conceptual, or nonobjective the image, it was nevertheless an image. It was a reproduction of reality, even though the reality may have been nonobjective. As a result, Meisel was able to see that so-called "realist" works were in fact no more or no less "real" than the most nonreferential works. He was, at an early stage, in a position to recognize that all works possessed realistic, as opposed to illusionistic, properties. It was but a small step, then, from nonobjective to realist. In fact, in the closest analysis, for Meisel the more "realistic" the work, the more nonobjective in terms of the reproduction; for, as a reproduction, even the most realistic work becomes an abstraction.

Terms such as "realism" and "abstraction" can become blurred, as they have today. The old meanings and the antagonisms associated with them cease to be as important as they were once thought to be. It is Meisel's appreciation of the changing emphasis at an early point that is remarkable.

There is yet another concept in art that seems to be changing and that is particularly pertinent to the Photo-Realist style. It has to do with critical interpretation of a work of art. Photo-Realism is unique in modern art because it allows, for the first time in a long while, an opportunity for interpretive criticism. For most of the twentieth century, a type of critical approach labeled "formalism" dominated art thought. Artworks were to be judged solely on their own verifiable content, that is, on their shape, color, material, proportion, and the like. The work did not "represent" anything other than what it was itself. For example, Minimal Art, the literal style that immediately preceded Photo-Realist art, offers no possibility for figurative interpretation. Such art, in fact, seemed almost designed to preclude any kind of interpretive critical analysis. Thus, one critical process—description and identification of the art object itself—became the major critical preoccupation. This idea originated during the Constructivist period and continued to be a major critical concept unifying most modern art.

The emergence of the New Realism has challenged the dominance of this approach. For one thing, it has already raised the possibility of art appreciation on the basis of subject matter. In 1973, Louis Meisel organized an exhibition of Photo-Realist art utilizing the theme of aviation. It was a radical and daring exhibition because such frank appreciation of the theme of the art in question seemed to suggest that the important thing about the works was their subject matter. This view contradicted some seventy years of modernist critical methodology. At the same time, it opened up the possibility of actually enriching a critical approach that was relatively limited.

The new Photo-Realist style will not automatically result in a return to a criticism of interpretation, although such a step within the field of criticism and aesthetics seems inevitable. Neither criticism nor art remains static.

A survey of the history of modernist art reveals that the immediate ancestry of today's conceptual, realist, and process art lies in Abstract Expressionism, wherein serious efforts were made to achieve the improbable and ultimately unattainable goal of subordinating social and iconographic content to the visualization of purely aesthetic functions. Artistic process became the legitimate subject matter for frank, direct, and rich aesthetic maneuvering. Within today's new realism, the subject of process remains a source for considerable aesthetic exploration. Reflective surfaces, illusory paint surfaces, and distorted, exaggerated perspectives all contribute to the continual re-evaluation of the process of making art, of painting a painting. In this sense, the new realism may be more closely related to Abstract Expressionist art than, say, to the obvious similarities within the Pop Art morphology.

Although Pop Art and Photo-Realist art both emphasize the priority of the image in their subject matter, some major distinctions are apparent. For example, rarely were the Pop Art painters and sculptors offering direct representations of everyday environments; in brief, Pop Art offered views of popular icons, rather than realism as such. Familiar images need not be related to realism. Also, in terms of process, the Pop school will be remembered because of the efforts of its artists to deny the illustration of process in their art, rather than to illuminate it.

It has been pointed out that the flatness of a painting became a characteristic that was emphasized by the modernist artists. The flatness should not be challenged; it

was a fact of art that could not be changed and it should be respected. Curiously, the Photo-Realist artists seem to recognize the importance of flatness, and many realists take steps to insure the principle of flatness, sometimes in rather surprising ways.

Despite all its pretensions to depth illusion, Photo-Realist painting is actually quite flat. The recurrent emphasis on reflective surfaces reveals a desire to make paintings so flat that they are, in a way, inside out. Today's realism, it appears, is flatter than flat. It goes deeper into flatness than was heretofore thought possible. Through the device of reflective surfaces, the greatest depth appears in the foreground of many Photo-Realist paintings, and not in the background where it might be expected to be found. The vast panes of glass, mirrors, shiny metal, and other reflective surfaces that make up the foregrounds of paintings by Richard Estes, Don Eddy, Tom Blackwell, and Charles Bell, to name only a few, serve to obscure the background while, at the same time, reflecting what is in front of the foreground. Thus what is *not* in the picture (according to usual perspective) is what we see in the picture. In order to identify the dislocation, the new realist artist may provide "frames" in the form of a low wall, a curb, or a bit of sidewalk. These serve to enclose the reflective surface, which reveals the information before, or in front of, the foreground.

From the time Louis Meisel opened his first gallery in New York in 1966, he emphasized the work of the realist artists who today form the basis for the new realist style. As a result of his early involvement, this book is a unique survey in its astonishing thoroughness. Within the scope of modernist art, there has probably not been any single movement or style that has been so dependent upon the enthusiasm, administration, and support of two people—Meisel and Karp—as has been the contemporary Photo-Realist style. It is a chapter in the history of art without parallel.

It may be premature to imply that Photo-Realist art has run its course. There are numerous newer artists who have become involved in the style and seem deeply committed to it. The range of subject matter available has only begun to be explored. The implications for art criticism remain unexamined, as does the potential of Photo-Realism to change the conventional approaches to art and its subject.

It is safe to say that the full implications of Photo-Realism have not yet been felt. There is great potential for exploration and experimentation within the confines of the style and, with the support of receptive, generous connoisseurs such as Meisel, aided by a group of new, interested patrons, one can expect the very definition of art as it exists today to be enriched, challenged, and expanded. After all, the early years of Abstract Expressionism, while exciting and wondrous, were followed by several decades of continual activity in which a broad variety of concerns were revealed and a great many aesthetic provocations were introduced. Working out the full implications of the realist discoveries will demand the energy and dedication of many more artists, dealers, critics, and thinkers. This is only the beginning.

Gregory Battcock
New York City
November, 1979

INTRODUCTION

In the early nineteen sixties, when Pop Art was just beginning to come to the attention of the international art world, a great many artists, widely dispersed geographically and of varied backgrounds, were already at work advancing on the newly legitimatized return of imagery to mainstream, avant-garde American art. These artists, whose philosophical and artistic foundations were extremely diverse, were eventually grouped together as the "New Realists." In fact, the Pop artists were also included under this catchall phrase. At that time, any artist using recognizable imagery was called a New Realist simply because it was the post-Abstract period and the term differentiated these artists from those in previous realist movements. In short order, numerous other words began to appear to describe the different branches of the realist tree. Among these were Super-Real, Magic Real, Sharp Focus, Radical Real, Hyperreal, and Romantic Real. All these names were ambiguous and essentially interchangeable. Some are meaningless; none is really descriptive. The term Magic Realism was first used by Alfred Barr in 1942 to describe an American form of Surrealism. Hyperrealism is the word that the French use to describe the work of the artists in this book. Sharp Focus Realism, the title of an exhibition at the Janis Gallery in 1972, alluded to the use of photography but was simply a catchy title not defined by the exhibition.

In 1968, after having seen the work of Richard Estes and Chuck Close, I realized that it was a photographic realism in both appearance and method. I then began calling their work and that of several others Photo-Realism. Two years later, in January, 1970, the word appeared in print for the first time in the introduction to the catalogue for the Whitney Museum show entitled "Twenty-two Realists." This exhibition, the first to open in the new decade, was also the first major effort on the part of a New York museum toward showing the New Realism. Although about one-third of the artists exhibited were Photo-Realists, they were not specifically listed as such, and the word went undefined. I had been using the term for a couple of years by then, and many times I was asked what I meant by Photo-Realist or Photo-Realism. My reply then was simply that a Photo-Realist was an artist who used a camera instead of a sketch pad, transferred images to the painting surface by means of a grid or projector, and had the technical ability to make a painting look photographic. This early definition was a bit vague and could by its terms include some artists who were not truly Photo-Realists.

In 1972, I developed a five-point definition at the request of Stuart M. Speiser, who later asked me to commission a collection for him. In the fall of 1972 I discussed our plans with the artists and began to publicize the word, the artists, and the collection, called "Photo-Realism 1973: The Stuart M. Speiser Collection," which was eventual-

ly to travel to more than twenty museums. In 1978, Speiser donated the collection to the Smithsonian Institution, to be exhibited in one or more of the museums of the Institution. My definition of the characteristics that qualify an artist as a full-fledged contributor to the Photo-Realist movement is as follows:

1. The Photo-Realist uses the camera and photograph to gather information.

2. The Photo-Realist uses a mechanical or semimechanical means to transfer the information to the canvas.

3. The Photo-Realist must have the technical ability to make the finished work appear photographic.

4. The artist must have exhibited work as a Photo-Realist by 1972 to be considered one of the central Photo-Realists.

5. The artist must have devoted at least five years to the development and exhibition of Photo-Realist work.

1. The Photo-Realist uses the camera and photograph to gather information. In the past, realist artists worked from life, drawings, studies, imagination, and, in many cases, from photographs. When photographs were used, however, they were incidental and their use was subverted by the artist. There were, in fact, vehement arguments between those artists who supported the use of photographs and others who considered their use absolutely outside the realm of fine art. In the early sixties, a communal drawing group that included Audrey Flack and a number of other noted realists ultimately broke up as a result of arguments concerning Flack's use of the camera. While the others were drawing from models, Flack would take a Polaroid photograph and go off by herself to work from it.

Photo-Realist painting cannot exist without the photograph. If Richard Estes attempted to sit in front of a building and simply draw or paint what he saw, his work would look like any other academic realist work. It would lose the clarity, accuracy, and immediacy of detail for which it is known and admired. As he sat there working, the traffic would move, the light would change; if the artist were to move a microfraction of an inch, all reflections would change radically. Over a longer period, as he tried to record every detail, the window display would change, as would the weather and the seasons. For the Photo-Realist, change and movement must be frozen to one second in time, which must be totally and accurately represented. Only a photo can do that.

Another example is Don Eddy's series of show windows displaying silverware. Silver and chrome exist as instantaneously changing reflective surfaces. No eye sees the same image from one blink to the next, and the attempt to paint a silver or chrome object from life would produce an Impressionistic work. In fact, all realism prior to Photo-Realism is to some degree Impressionistic, or at least an impression.

If Chuck Close were to have a model pose for him for a year, it would still be impossible to work from life and achieve the result he wants. A face changes constantly: eyes blink, hair grows, complexions alter, and wrinkles come and go. Since it is not possible for a person to remain perfectly still, lighting and shadows also continue to vary. Many portrait artists have used, and many still use, photographs which they then interpret loosely. Close's work has nothing to do with any type of

portrait we have ever seen. His paintings do not look like any portrait ever done. They look like their subject matter—a photograph.

Still-life painters such as Flack, Bell, and Schonzeit, while able to refer to their subjects directly during painting, must also use the photograph to freeze the objects, which do move, if only slightly. They also need the camera to pursue their interest in working with focus, depth of field, and perspective.

2. The Photo-Realist uses a mechanical or semimechanical means to transfer the information to the canvas. Many mechanical ways of transferring an image from photograph to painting surface have been devised, used, and legitimatized by the Photo-Realists. The most common method is simply to project a slide or transparency from a projector, or a photograph from an opaque projector. The artist then carefully draws all the details and information he needs over the projected image. This method—used by Bechtle, Bell, Blackwell, Cottingham, Flack, Goings, Kleemann, McLean, Salt, and Schonzeit—may take many days, but any other way would be more time-consuming and less accurate.

The second major method, used by Chuck Close and Don Eddy is the grid system. Known and used by artists long before Photo-Realism, the grid was generally used for enlarging or transferring images from drawings to paintings or from one painting to another. Using this method, a Photo-Realist superimposes a graph over the chosen photograph, most commonly by drawing lines vertically and horizontally across the photo anywhere from an eighth of an inch to an inch or more apart. The canvas is then correspondingly graphed. If the photograph is 8 by 10 inches and the painting is to be 8 by 10 feet, and if the grid squares on the photo are a quarter of an inch apart, then the squares on the painting will be twelve times that size, or three inches square. The closer the photo and painting are in size, and the smaller the grid squares, the greater the detail that can be transferred. Referring to each grid square on the photo, the artist finds the corresponding square on the painting and transfers the information from one to the other.

This method can be even more exact and impersonal than the projection method. If, for example, an 8-by-10-inch color photo were to be gridded into 10,000 tiny squares, each the size of a pencil point, and a canvas of equal size were gridded the same way, then theoretically the first 10,000 people on line waiting to buy tickets to the Super Bowl could be enlisted to create a Photo-Realist work of art. Each one, presented with the photo, the canvas, and a set of colored pencils, could select the pencil corresponding to the dominant color in his or her assigned square on the photo and mark the corresponding square on the canvas. (On both the photo and the canvas, all but the assigned squares would be masked from view.) The result would be an exact and impersonal visual duplication of the photo.

In the early sixties, Malcolm Morley did a great deal of work and experimentation with the grid. Although Morley has been called one of the first Photo-Realists, I consider him a late Pop artist who, through the use of the grid method, painted extremely photographic images from postcards of ocean liners. These works are, however, more akin to Warhol's soup cans and Lichtenstein's cartoons than to the Photo-Realist work that was to come.

A still more impersonal method which does not even require any initial drawing is a procedure used by Guy Johnson and, more recently, by Paul Staiger. It involves

developing the image on a photo-sensitized canvas or paper. Both these painters use a black-and-white image which they then paint over. There are several other artists, most notably Lynton Wells and John Murray, using this technique who are not Photo-Realists, but whose work is related.

3. The Photo-Realist must have the technical ability to make the finished work appear photographic. While all the Photo-Realists employ techniques directed toward the production of paintings that imitate photographs, none of them allows technique to interfere with making art. There are as many techniques as there are Photo-Realists. The slightly practiced eye can identify each of these artists by the way they put paint on canvas—sometimes by studying no more than a three-inch square of any work, as shown by the discussion and illustrations on the following pages. I must emphasize here that, whichever technique the artist employs, it will remain uniform throughout the canvas since the surface of any photograph, whether matte, glossy, stippled, or otherwise, is uniform throughout.

In Photo-Realist painting there is rarely any thick paint; in the case of airbrush painters, there never is. Each area is painted in the same way as every other area. If there were a way to bleach all color from a painting by Close, Flack, Schonzeit, Salt, or Eddy, we would be left with a perfectly smooth white canvas with no indication of what the image had been. If, on the other hand, one were to eliminate all color from a painting by Vermeer, Eakins, Harnett, Homer, Hopper, Cézanne, Dali, or Wyeth, the image and shapes would still be visible, determined by paint thickness and brushstroke. A blind person with a highly developed sense of touch can feel the outlines of a bowl and each apple and orange on the surface of a Cézanne still life, but would discern nothing on the surface of a Close. While Wyeth uses different paint, brushes, and techniques to paint grass, faces, and wood, McLean treats grass, horsehair, faces, metal trophies, and leather identically. Evenness of surface is one of the universal characteristics of Photo-Realist technique.

There are basically two tools that the Photo-Realists use to put paint on canvas: the traditional bristle brush and the more recent airbrush. The airbrush is a very refined and controllable spray gun which looks like and is held like a pen, but which never touches the canvas. It is not difficult to differentiate airbrush painting from bristle painting when either is used exclusively. The airbrush uses a very small amount of paint and leaves a smoothly blended surface without the visible brush marks we are used to seeing. Chuck Close states that for each of his 9-feet-high black-and-white paintings he used, in total, about two tablespoons of black pigment.

It is interesting to note at this point that the airbrush painters—and especially Chuck Close—have chosen the airbrush for reasons that involve their philosophical and conceptual approaches to painting. These ideas concern impersonality, system, surface, and more, and will be discussed in succeeding chapters. Other exclusively airbrushed works are by Flack, Schonzeit, and Eddy.

Painters who use only a bristle brush include Estes, Bell, Goings, McLean, Bechtle, and Cottingham, while Blackwell and Kleemann are bristle painters who use the airbrush as a final touch in finishing their work. Goings and McLean have developed such exquisite technique with bristles that, except upon very close inspection, it appears that they use an airbrush. The opposite is true of Bell, Kleemann, and Estes, who make no effort to disguise their technique. Charles Bell, who has done extensive

From a distance of several feet, all Photo-Realist works look clear and photographic; up close, however, a personality is evident for each artist. From only a three-inch square of canvas, one can recognize individual artists from their technique. Note, for instance, the headlights painted by Salt, Bechtle, Kleemann, and Blackwell. The Salt is done with an airbrush and appears very thinly painted. There are some sharp edges, caused by spraying through stencils, as well as the typical smooth airbrush blending. The Bechtle shows hints of brushstrokes but is also thinly painted; it is fairly well blended. Kleemann utilizes much thicker paint and hardly blends at all. His brushwork is quite abstract, free, and "loose," yet from the proper viewing distance, it is the most detailed. His is the most painterly and beautiful brushwork upon close inspection. Blackwell's technique is similar to Kleemann's, but involves more layers of paint and glazing, sometimes as many as eight.

Flack and Schonzeit are two airbrush painters closely related in technique and sometimes in subject. Schonzeit's work, however, displays a more slick and finished surface, one that is as precise and perfect as a photograph. Flack, on the other hand, leaves a personal touch of slight and insignificant imperfections.

Comparing Estes to Cottingham or Goings, we clearly see the major differences between East Coast and West Coast Photo-Realists. The former are blenders, the latter painterly. Note the neon painted by Cottingham in contrast to Estes's neon. Cottingham's is smooth, blended, and finished; Estes's is ragged and coarse, yet more inspired and less tedious in feeling.

1. Estes's brushwork is sure, precise, and quick in appearance. Generally, when a stroke is made it stands, since he doesn't feel he must obliterate its beginning and end with blending.

2. Blackwell is more painterly than most. His brushwork is evident, and his colors, applied in numerous layers, are bright and alive. His surfaces are glossy, transparent, and deep.

3. Cottingham's paintings show few brushstrokes and little blending of colors. His tonal gradations are almost hard-edged. His method, akin to some illustration techniques, requires that the blending be done in the eye of the viewer.

4. Schonzeit is a supreme technician with an airbrush and in his masking. His edges are razor sharp, with no "feathers," spatters, or uncontrolled marks. His finish is between matte and semigloss.

5. Bechtle, like Estes, is concerned less with meticulous technique than with overall image and mood. His brushwork combines the painterliness of Kleemann with the polished blending of McLean.

6. McLean has the smoothest technique of the major Photo-Realists. No brushstrokes remain visible after his careful blending. His surfaces are generally thinly painted and semigloss.

7. Goings's brushwork and technique fall somewhere between those of Bechtle and McLean. While his brushwork is very smooth, there is more evidence of the bristles than in McLean's work but not quite as much as in Bechtle's.

8. Eddy's airbrush work is almost pointillist, marked by a thin application of paint in very small areas of color. Eddy's primary colors are thalo green, burnt sienna, and dioxazine purple.

9. Flack's work has a smooth, matte surface. Painting more thickly than most airbrushers, she leaves any spits or marks of imprecise masking, being less concerned with perfect execution than with content.

10. Salt's pigment is muted in tone, very thin, and generally sprayed on, with stencils imparting sharp edges. His whites come from the primed canvas. The surface is unvarnished and of a matte finish.

11. Bell uses extremely high chroma, bright color, glazes, and much blending (but not enough to eliminate visible brushstrokes). His glossy surfaces glow and reflect light.

12. Kleemann's work is the most painterly and brushy, made up of many abstract areas of color with almost no blending. The paint is thick, the whites the thickest and last to be applied.

research on the techniques of the masters from Vermeer and Rembrandt to Dali, has rediscovered and reinvented a great many of their forgotten techniques. Although he remains an absolutely contemporary Photo-Realist, he has introduced these techniques into his work to a greater extent than any other avant-garde painter I know. Ron Kleemann utilizes a smooth, painterly quality akin to that of an abstract painter, and while "painterly" is not a word often used to describe a Photo-Realist, it seems appropriate to Kleemann.

The outstanding quality in the work of Richard Estes is a supreme confidence. His brushstrokes are sure and obvious, strong and accurate. He does not attempt to "clean up" the ends of a stroke where some bristles have left the canvas before others. He does not try to obliterate the presence of brush marks, and he does not spend a great amount of time blending colors. He knows how to place color next to color for the desired visual effect, and, once a mark is made, it stands. The same confidence is evident in the airbrush work of Audrey Flack. She does not find it necessary to tediously touch up edges and "splits" that happen. In masking an area, she is more concerned with visual effect than with absolute perfection, and this comes across as strong confidence and lack of self-consciousness.

4. The artist must have exhibited work as a Photo-Realist by 1972 to be considered one of the central Photo-Realists. By 1972, Photo-Realism was a well-founded and

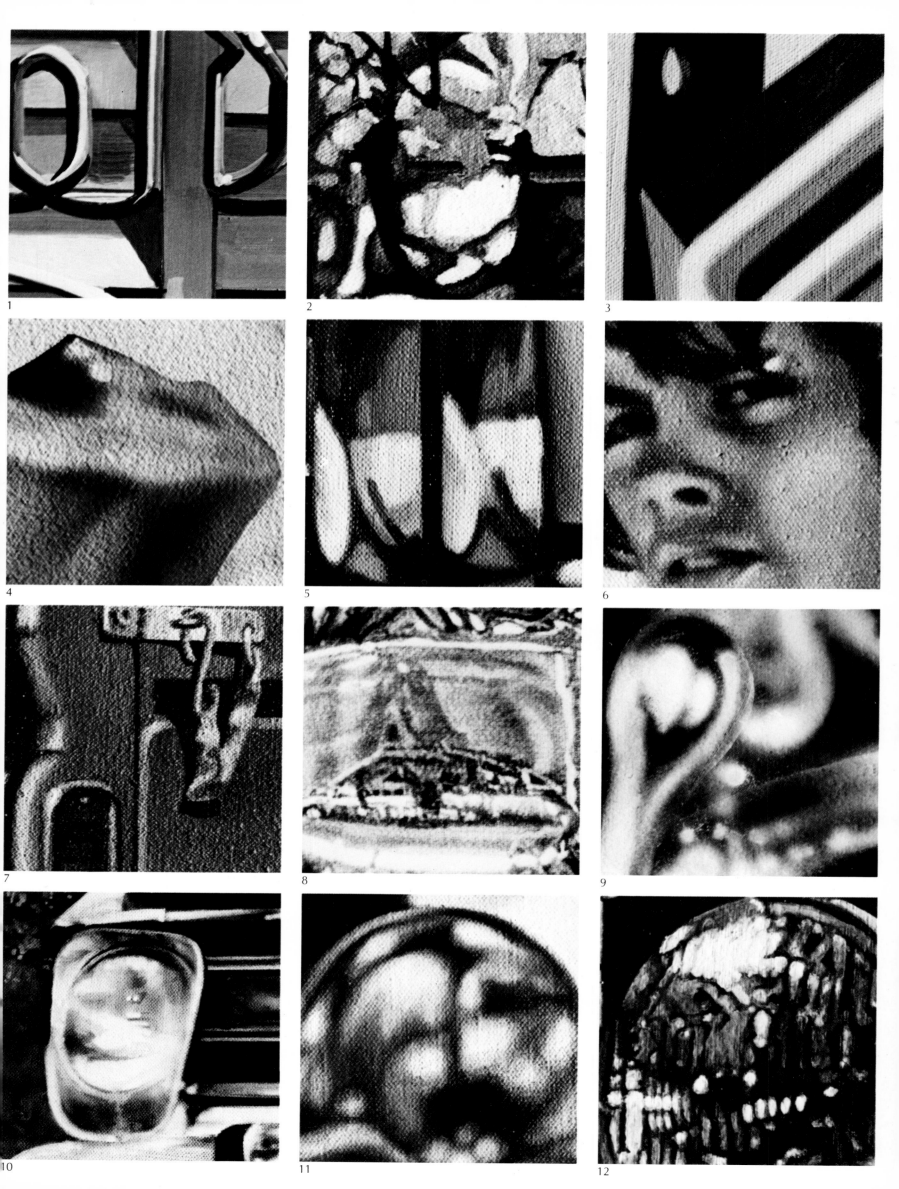

1

2

3

4

5

6

7

8

9

10

11

12

developed style. Considering the time-consuming nature of this type of painting, an artist must have been working in this direction prior to 1970 in order to have exhibited developed work by 1972. Since there was little or no dissemination of information or illustration of this kind of realism before that time, it may be assumed that each of these painters developed independently in the direction of Photo-Realism from historical foundations in other areas. For one reason or another, they all, on the basis of their own personal logic, moved in the late sixties toward the work for which they are now known. Since I know each personally and closely, I can attest to the truth of this pattern, and will elaborate on each background in the chapters on the individual artists. Flack's first Photo-Realist work was *Kennedy Motorcade,* which she painted in 1964. Bechtle's was his *'56 Chrysler* in 1964. Both Close and Estes executed Photo-Realist paintings in 1967. In 1969 we first saw the work of Bell, Blackwell, Kleemann, Salt, Eddy, Goings, and McLean. Although there had been solo exhibitions and even some museum group shows, there was little media attention until the Whitney Museum opened the decade with "Twenty-two Realists" in January, 1970. Even then, there were only seven true Photo-Realists included.

By 1972, however, there had been several other important exhibitions of Photo-Realist work, including Documenta 5 in Kassel, West Germany. By this time, there were many realists whose work began to resemble that of the Photo-Realists, and whose work was, indeed, founded on Photo-Realism. These artists may be called second-generation Photo-Realists. Some second-generation artists, such as Hilo Chen, Jack Mendenhall, and Jerry Ott, have added significantly to the movement. Both Chen and Ott are involved with the human figure in a way not previously explored by the earlier Photo-Realists. The figure does appear in the works of Bechtle, Goings, McLean, and Estes, but not as the central reason for the painting. John Kacere uses the figure from the thigh to midtorso as a sort of landscape or still life, but Chen and Ott use it as a primary subject, greatly advancing figure painting. Unlike any of the others, Mendenhall concerns himself with the interior spaces of Middle American homes. He has set up problems of painting rugs, fabrics, and objects in artificially lit settings. Today there are third- and fourth-generation painters in this style who are students of the students of the original Photo-Realists.

5. The artist must have devoted at least five years to the development and exhibition of Photo-Realist work. There are many painters who have executed several Photo-Real canvases. Some were experimenting and rapidly moved in other directions. Others were students of the Photo-Realists and were influenced by the style for a short period. Still others were "band wagoners" who did not find the hoped-for immediate success and promptly tried something else. Any artist today can paint Photo-Realism, just as any artist can paint Abstract Expressionism, Op, Minimal, or any other style, once having been shown the way. The work thus produced is of little consequence if it does not add to what we already know in a clear, well-founded, and developed manner.

I must emphasize at this point that, in reality, there are as many definitions of art and styles as there are artists. It is always a bit unfair and inaccurate to group artists together under a title or category. It is always convenient, however, for historical and academic ends, as well as for commercial purposes, to establish and define groups or

movements, even though some individual artists may not personally identify with the perceived ideas and intents of the others. This independence is particularly true of the Pop Artists and the Photo-Realists.

In the days of the Impressionists, the Cubists, the Surrealists, the Ash Can School, and the Abstract Expressionists, the art world was extremely small, elitist, and closed. The art media was minimal compared to today's, and small groups of artists gathered in a single location (first Paris and later New York). Artists searched out others who were developing ideas similar to their own; they influenced one another and created very definite movements and doctrines. They arranged their own exhibitions and eventually joined with one or two dealers whom they felt understood them. After each movement came second and third generations and "schools of." For these artists there was strength in unity, both intellectually and commercially. Each of these schools or movements included poets and writers who attempted to explain and criticize what the artists were doing.

Late in the nineteenth century, young artists arrived in Paris to study and work with the Impressionists and, after learning the "lessons and doctrines," they began to look for ways to advance and build upon what they had seen and learned. Picasso, Léger, and Braque, with their dealer, Kahnweiler, influenced each other and gave birth to Cubism. In Europe, this process of mutual interaction and stimulation continued in one form or another until the late nineteen thirties. In America, however, there has been only one true movement, the "Great American Movement," Abstract Expressionism. The days of Abstract Expressionism were so exciting and intense that they created not only a doctrine upon which all contemporary art draws, but also a life style and a commercialism that have spawned tens of thousands of "artists," millions of "art" buyers, thousands of galleries, hundreds of contemporary museums and alternate spaces, and dozens of art magazines and art columns in almost every newspaper extant.

In an attempt to recapture and continue the stimulating atmosphere that the Abstract Expressionists provided, we are now continually seeking the next "exciting" movement and, when it is not easily found, we create it. Pop Art was created when Leo Castelli brought together such artists as Warhol, Lichtenstein, Johns, Rauschenberg, Ramos, and Rosenquist. These artists were christened "Pop" by Lawrence Alloway, and the second American movement was established, though not by the artists. Johns, Rivers, and Rauschenberg were grouped with Warhol and Lichtenstein in shows, books, and articles, although they had very little in common philosophically. The art world rejoiced, and the art boom of the sixties began. Immediately, the search began for the next movement; we saw Op, Minimal, Conceptual, Environmental, Nihilist, Happenings and Performance, Earth Art, Video and Kinetic, and more. It is unlikely that Vasarely in France, Riley in England, and Anuskiewicz in New York knew each other or had anything in common; nevertheless, Op Art was called a movement.

It is to avoid this facile categorizing that none of the Photo-Realists really wants to be identified by a title. With the notable exception of Goings, McLean, and Bechtle, none of the Photo-Realist artists had even heard of the others during the years when they were formulating their ideas and working toward the use of the camera and photograph in their work. And all of them arrived at their conclusions by different processes, even if they all started with the same premises. The attempt to create

parallels between the development of Estes, Flack, Close, and Bechtle—in my opinion, the leading exponents of what we call Photo-Realism—is impossible. To suggest that they had any influence on each other would be totally false. Each one of them gives different artists as earlier influences. Each developed independently, geographically as well as philosophically. With the advent of instantaneous coverage in the art press and with many more artists traveling to colleges and universities for lectures and Visiting Artist programs, it has become unnecessary for artists to congregate in one place to be in touch with what is happening in avant-garde art.

Flack graduated from Yale in 1951, a totally different Yale than the one Chuck Close graduated from in 1964. Bechtle developed his art in California, which is as far from New York in both distance and influence as is Paris. Estes grew up in Chicago and was more or less self-taught and, in a way, oblivious to almost all contemporary art. In 1970, these four appeared among others in the Whitney show and were thereafter continually shown, contrasted, and compared on common grounds.

What I am saying is that there is no such thing as a movement, in the old sense of the term, called Photo-Realism. There is only Photo-Realist painting, loosely defined by the previously discussed five points. There is no doctrine, set of rules, or manifesto set forth by any of these artists. One of the reasons there has been no outstanding critic championing Photo-Realism is that there is really very little to interpret or explain; the paintings speak for themselves. Where there is more to know and understand, the artists themselves have been vociferous and coherent. Close, Flack, and Bechtle have lectured and taught extensively. All the artists have been interviewed; many have written about their work. What they say is what there is; there are no mysteries or secrets. Grounded in paint rather than theory, Photo-Realism does not need the intellectualizing, speculating, and interpreting required by Minimal, Conceptual, Environmental, and Performance art. This does not make Photo-Realism any better or worse, any more or less important than any other type of art.

Since all art is a product of its times and historical context, however, it is useful to review the general background of Photo-Realism and cover the few points that the artists do have in common.

During the nineteenth century, the camera was invented and developed, and the world had a new way of recording itself. At the same time, the "academies" and "art schools" had become extremely efficient in training artists in realist painting and sculpture. The American realists of the time were among the finest realist painters in art history, and this tradition in American painting has continued undaunted to the present.

The move away from the rules and restrictions of realist art began in Europe with Cézanne and the French Impressionists, from whose era we date modern art. In the one hundred years that followed, many new ideas, artists, and movements pushed the boundaries farther and farther away from realism until in the sixties, with the advent of Minimal, Conceptual, and Environmental art, it was proclaimed that easel painting was dead. Artists had seemingly cast off one of the final rules of such painting—that one had to put paint on canvas. Although one no longer had to, it is frequently overlooked that today's artists may do just about anything and call it art, including putting paint on canvas. Further, they can do this in any way they can conceive, using any tool.

The Photo-Realists have grown from and added to this legacy of freedom in several important ways, the most notable being in the use of the photograph. Even in the extremely liberal atmosphere of the sixties, it was still regarded as cheating or "against the rules" to paint from or use the photograph. This prejudice can be easily dispelled if one accepts the concept that the subject matter of a Photo-Realist painting is in fact a photograph. If it is acceptable to paint a picture of any object, it is also acceptable to paint a picture of a photograph. The Impressionists executed many of their paintings from drawings, using them as a means to gather information and work out ideas, composition, color, and form. The Photo-Realists accomplish the same thing with the camera rather than the drawing pad, not because they cannot draw, but because they would have to spend years trying to gather the necessary information. In many cases, it would be impossible to draw the image needed because of movement of either the artist or the object, changing light, and other factors. While another type of realist may make hundreds of drawings for a painting, Photo-Realists may take hundreds of photos. They can use the one that is just right, or they may combine more than one for a painting.

There are philosophical reasons for the use of the photograph as well. Many of the Photo-Realists claim that they want almost all of the decisions to be made when they begin to paint. They can then concentrate on the technical problems of painting without spending time on composition, color, and imagery. An interesting side effect is that a Photo-Realist rarely, if ever, "loses" a painting. While an abstract painter may make fifty paintings and then discard and dispose of the forty that do not satisfy him, the Photo-Realist knows exactly what the completed painting will look like and continues to work at it until it attains that look. If an Abstract Expressionist, while painting, made a decision as to where to make a mark and it was wrong, the painting was "lost." The Photo-Realists do not have this concern.

The photograph also makes possible effects that could never be acquired in any other way. Masking tape was a tool legitimatized by the hard-edge painters in the sixties. Some said it was "against the rules" to use tape; the real artist would paint the straight line by hand. Not only would it take time to paint by hand, but there is something desirable that happens to the edge of a taped and painted area, such as the buildup of paint imparting a raised appearance to primed canvas, or the slight feathering where the paint bleeds under the tape on an unprimed canvas. Tape thus provides a new quality. In a similar manner, the photo and camera provide a quality which cannot be obtained otherwise. The camera sees with one eye, not two. This is of utmost importance when one realizes how much a Photo-Realist painting looks like a photograph, even if not painted in a technique that aims to simulate a photograph exactly. It is not immediately apparent that, if painted from life, the work would look more like what we see when we view something in person. Also, we are so steeped in the new "reality" of the media—newspapers, books, television, movies—that we now perceive through the one eye of the lens all things which we have not experienced firsthand, thus enhancing our perception of reality in photo-derived paintings. The camera also makes it possible to deal with focus in a way that is not possible otherwise, a quality much in evidence in the work of some Photo-Realists, particularly Close, Flack, Bell, and Schonzeit. This focal quality gives these paintings a look which we immediately sense but do not immediately identify as new. Much has been said about Photo-Realist subject matter and much more will be

said in this book, but the primary subject matter of all the Photo-Realists is a photograph. All else discussed will be pertaining to the subject matter of the photograph and how and why it was chosen.

One of the major contributions of Photo-Realism is the return of craftsmanship and draftsmanship to contemporary art. Most Photo-Realist artists say that while they were growing up and studying art, there was no school teaching the techniques and methods that they were to require as mature Photo-Realist painters. Abstract theory and ways of putting paint on canvas were all there were at the time. Most of the realists learned and became well versed in the theory and methods then current, but when they began to move in their own directions, they had to reinvent, or rediscover, the painting techniques they now employ. At one point or another each turned to the camera as an aid. If they had studied academic rather than abstract painting, they might have been so restricted and satisfied by academic technique that they might not have turned to the photograph. This is exactly the case with Arne Besser who, after studying with a greatgrandson of Audubon, became a truly fine realist painter. In 1973 he began using slides and did several Photo-Realist paintings. He was, however, so well trained as an academician that he did not feel comfortable and has returned to his previous methods.

All the Photo-Realists have at one time or another mentioned the names of earlier artists whose work has interested and influenced them. Names most often mentioned are Vermeer, Ingres, Homer, Hopper, Sheeler, Avery, Thiebaud, Diebenkorn, and Artschwager. It is interesting to note that none mentions Pearlstein or Morley, who were among the earliest of the New Realists to gain public attention and who were shown just before the Photo-Realists began to appear. It is sometimes difficult to determine how these earlier realists affected the Photo-Realists. While Estes has said he admires the works of Homer and Eakins, this is not really evident in his work. On the other hand, Homer and Eakins are the stated favorites of Andrew Wyeth, a totally different kind of realist, in whose work the influence is clear. Wyeth almost single-handedly "carried the ball" of realism from the early forties into the sixties. There is an entire school of academic and traditional realism that has benefited from this link with pre-forties American realism. I mention this influence to emphasize that Photo-Realism is not founded in the tradition of academic realism, but in the tradition of modernism and more specifically in Abstract Expressionism and Pop.

Whether or not we can immediately see the lines of influence, we must accept that they exist if the artists say so. In cases where the influences of other artists are not as clear—as in the Vanitas influence on Flack—I will discuss them in the chapters on the individual Photo-Realists.

Returning to craftsmanship and draftsmanship, we come to the mediums of drawing and watercolor. Until 1973, almost the entire output of the Photo-Realists was in acrylic or oil on canvas, with little attention to other mediums. For the traditional artist, watercolors and drawings were generally used as studies for paintings, and not usually considered important as finished works in themselves. Since the Photo-Realists did not need or use drawings and watercolors as preliminaries to their paintings, they did not think about working in these areas.

It was once said that the Photo-Realists could not draw and had to project or grid photographs to copy images. In 1974, Susan Pear Meisel assembled an exhibition that helped to dispel this misconception. Many artists were represented by their first

work in the medium in this show. The exhibition contained watercolors and drawings by all the Photo-Realists as well as by many earlier American realists dating back to the nineteenth century. Watercolors and drawings rely almost purely on the artist's ability rather than on the use of mechanical aids. The Photo-Realists proved to be among the finest artists in these mediums in history.

Not only have Photo-Realist artists reinvented and rediscovered techniques, but they have also added to our knowledge of drawing. The definition of drawing itself has been expanded. Close has added several new ways of drawing to his repertoire, among them his sprayed-dot series, his methods of using pastels, and even his new fingerprint works. Flack has done a number of freehand airbrush drawings. Kleemann, while involved in lithography and screenprinting, has made some very new kinds of drawings and has also called his Spinoffs series his drawings. In his most recent show, Schonzeit exhibited more than a dozen new works of the same image, each in a different technique. Don Eddy's drawings of silver show windows are as exquisite and new as any pencil works I have ever seen.

Since 1972 or 1973, all of these artists have produced extremely sensitive and technically outstanding watercolors. The finest in this medium are Goings, McLean, Blackwell, Close, and Salt. While an error in oil or acrylic can be overpainted and corrected, a watercolor must be right from the beginning. It is very hard to correct a mistake in watercolor because of the sensitivity and transparency of the paint. The initial drawing must be minimal and light so as not to show through the paint, and this decreases the amount of aid available from the projector and photograph. Watercolor, which began to interest the Photo-Realists as an aftereffect of their paintings, has now become a major aspect of their work, and some of the painters are doing more watercolors than oils. Chuck Close, as mentioned previously, has developed several new methods and has concentrated heavily on this medium.

It was also about 1972 or 1973 that the Photo-Realists began turning to printmaking as a medium of expression, and, in the years since, they have done many highly innovative prints. Photo-Realist printmaking involves numerous problems, which the artists have solved with the aid of expert technicians. The leading publishers of Photo-Realist prints today are Parasol Press, under the guidance of Robert Feldman, and Editions Lassiter-Meisel, operated by master printers Norman Lassiter and Susan Pear Meisel. Parasol has published seventeen editions by Richard Estes, and three editions by Chuck Close, while Lassiter-Meisel is working with Bell, Blackwell, Kleemann, Goings, McLean, Estes, and Flack, and plans to work with most of the others. In 1972, Shorewood Atelier produced a portfolio of ten prints by the Photo-Realists for Documenta 5. This was a rather hurried affair with purely commercial intentions, but it did whet appetites for future and more successful attempts at printmaking. Also, Landfall Press in Chicago has done some very fine prints with Cottingham.

The making of a Photo-Realist print is extremely time-consuming, demanding, and costly if it is to communicate in the same way as the painting. One large print by Estes took two years and about two hundred colors (impressions) to complete. Flack's *Royal Flush* and Kleemann's *Mustang* each took as long, but the prints were done with fewer than fifty impressions thanks to more extensive camera work coupled with the methodology developed by Norman Lassiter. The artists are experimenting with lithography, screenprinting, and etching—and Close has used mezzotint—but the dominant method at present is screenprinting, with lithography second.

Some of the innovations developed in printmaking by the Photo-Realists have yet to be generally accepted, including, once again, photography. In December, 1978, a retrospective exhibition of every print produced by the Photo-Realists was assembled by Susan Pear Meisel and shown at Louis K. Meisel Gallery. A complete reference book on these prints was published in conjunction with the show.

It has now been more than ten years since Photo-Realism began to appear in galleries in New York. Since then, hundreds of these works have been seen in museums throughout the world. About a dozen books and numerous major catalogues have been published which devote much attention to these artists. Most of the art magazines have done major articles on or devoted issues to Photo-Realism. At present, eleven Photo-Realists are represented in the permanent collections of the four major art museums in New York: the Metropolitan, the Museum of Modern Art, the Guggenheim, and the Whitney (Flack in all four, Bechtle, Blackwell, Close, Estes, Kleemann, and McLean in two, and Bell, Chen, Cottingham, and Goings in one each). Museums throughout the country and the world are collecting the works of the Photo-Realists.

The breakthrough years of struggle have come to an end. These artists are no longer the controversial "enfants terribles" of the seventies. Major group shows presenting "samplings" of the style are becoming more infrequent. The artists are all settling down to making mature and outstanding paintings. Many of them are still aspiring toward work that is innovative, both technically and visually. The eighties will bring an increased interest in their work from collectors and museums as well as a great deal of literature and in-depth analysis, especially when these artists begin having retrospective exhibitions. An Estes retrospective has already taken place, and retrospectives for Close and Flack are in the planning stages.

Almost all of the leading Photo-Realists are making changes of imagery, and some—notably Flack, Close, Schonzeit, and, to some extent, Kleemann—are experimenting with different styles and techniques. Almost all have put a great distance between themselves and the Pop Art heritage.

There are fewer artists painting in the Photo-Realist genre at present, and all seem to be producing fewer works. I plan to continue documenting and analyzing this group of artists as they advance in their work, and will attempt to illustrate all work at five-year intervals in succeeding volumes, for I believe the Photo-Realists have an exciting, if somewhat unpredictable, future.

L.K.M.

Note: The captions in the following chapters on the major Photo-Realists contain a number in parentheses after the year of the work's completion. This number is intended to indicate, as accurately as possible, the chronological order of the work in the artist's total Photo-Realist oeuvre. For example, in plate 21, the "(33)" after the year 1971 denotes that the painting is the thirty-third Photo-Realist work completed by Robert Bechtle. These numbers have also been supplied for the unillustrated works listed at the end of each chapter. No chronological numbers have been assigned for the works of Richard Estes since the records of his works are so fragmentary.

13. Robert Bechtle in his studio

ROBERT BECHTLE

Robert Bechtle is one of three artists I sometimes call the "West Coast Photo-Realist Triumvirate." California plays some part in the backgrounds of many of the Photo-Realists (Blackwell, Bell, Estes, Eddy, and Cottingham), but Bechtle, Goings, and McLean are most closely identified with the banal, Pop-related form of Photo-Realism that developed on the West Coast. Bechtle was the first of the West Coast painters to execute a true Photo-Realist work, '56 Chrysler (pl.15), in 1964. According to Bechtle, his '61 Pontiac (pl. 47), completed a year earlier, was painted from life, through his studio window without photographic aids.

Bechtle, Goings, and McLean were students together at the California College of Arts and Crafts. Not close friends at the time, they were to be drawn together in the coming years by their art form. Bechtle and McLean eventually shared a studio. It is difficult to determine exactly who exerted the greatest influence, but it is obvious, in the similarity of vision, composition, and technique, that influence existed. It is likely that Bechtle, the earliest of the three to paint a Photo-Realist painting, can be credited with the role of leader and innovator.

Bechtle indicates that Richard Diebenkorn was the artist who most influenced his own move to figurative painting and realism, but he also acknowledges an interest in earlier realists. He has expressed liking for the works of Vermeer, Homer, Eakins, and Hopper.

Bechtle began using the camera in the mid-sixties for much the same reason as the other Photo-Realists: the range of subject matter. In fact, the photograph made it possible to paint just about anything that could be seen, from microscopic to telescopic images. The important question here is why it was not until 1964 that he decided to use the previously frowned-upon camera as a tool in making fine art. Bechtle has said, "Pop Art led to an awareness of commercial art techniques . . .

which is where the license for use of photographs and projectors came from for me."

We know that many fine painters have used photographs as aids since the camera was invented, including many of the most respected realists, but none was open about this use and some even denied it. Bechtle and the other Photo-Realists proclaim the camera an integral part of their art, and have indeed made it an acceptable tool for future artists to use as they see fit.

Bechtle's subject matter deals in part with the middle class, which he tried at one point to reject, but later accepted as his own, and which he documents in his paintings of suburban houses with automobiles. Some artists have found it more interesting to paint emotionally and politically charged pictures of the very poor and the struggling lower classes, while others have painted the yachts, airplanes, and mansions of the rich and the elite. Bechtle has filled a void by painting the average, commonplace middle class. Yet somehow the subject matter becomes compelling in a Bechtle painting, as we come to recognize and think about aspects of our environment we have previously ignored. Two outstanding paintings of this type are '60 Chevies (pl. 44) and '61 Pontiac (pl. 29).

Bechtle says his compositions are "dumb." His family self-portrait in '61 Pontiac is so typical of the snapshot one expects to find in any family album that it is "dumb" to paint it, and yet the painting forces us to confront our values. The '60 Chevies is also a very "dumb" image because it is so familiar a scene that no one would even think of photographing it. In a sense, it is unnecessary for Bechtle to paint these countless banal images, because, after seeing just a few of his paintings, we begin to view our environment—our relatives, streets, buildings, shopping malls—in a new way, as a sort of Bechtle painting in the mind.

Although Bechtle relates to the things he paints, he maintains a neutral point of view, refraining from making value judgments concerning good or bad, right or wrong. This is left to the viewer. Unlike the East Coast painters, many of whom tend toward the dramatic, Bechtle avoids drama and romanticism. He usually takes what he calls "lousy" photographs so as to leave decisions for improvement and completion to the painting process. His objects are in the middle ground, he uses frontal, even light and bland drab colors, and he does not get into extremes of focus. "Exciting" is not a word used to describe his images.

Following is a statement by the artist written for inclusion in this book:

I was not originally interested in "realism" as such. Painting things as they looked —as accurately as I could and without the pretense of a painterly style—was a way of rejecting the attitudes and appearances of painting that I had learned in school. I was trying to avoid the look of the expressive marks and the kinds of decisions one was expected to make. I think, though, that I have always been interested in how things looked rather than in the uses of materials or a search for form. I suppose it entails a feeling that something of substance is to be found in the details of appearance. At any rate, when my painting began to divorce itself from the influence of the Bay Area Figurative style in the early sixties, it seemed logical and felt natural to move in the direction of observation and "objectivity."

I had people pose for me (I did a lot of self-portraits) or I painted objects around the house. I began to use photographs as a way of getting my models to sit still longer,

but soon became aware of their potential for expanding the range of things I could paint. I had begun to be interested in automobiles as subjects and found the photograph the only way I could get the authenticity I felt I needed. (I did do one painting of my own car through the window while it was parked in front.)

Photographs allow me to paint with enough accuracy that the reference to the "real thing" is direct and not distracted by the inevitable distortions of drawing from the actual object. I am not particularly interested in those subtle differences between the way we perceive a three-dimensional object and the way we might translate it into two-dimensional marks, but rather in having those marks make up as convincing a reminder of that object as possible. (Even if the finished painting reminds us of the photograph, that is close enough, since we tend to believe in the veracity of the camera.)

I try for a kind of neutrality or transparency of style that minimizes the artfulness that might prevent the viewer from responding directly to the subject matter. I would like someone looking at the picture to have to deal with the subject without any clues as to just what his reaction should be. I want him to relate to it much as he would to the real thing, perhaps to wonder why anyone should bother to paint it in the first place.

I think of the photograph, in addition to its being a reference source, as a kind of structure or system for the painting which limits the choices of color and placement. It allows me to keep some of the traditional concerns of the painter—drawing, composition, color relationships—from assuming too important a role, for they are not what the painting is about. Most of the choices are made when the photograph is taken. I try to avoid composing too obviously, aiming for an offhand and casual look. But something about the situation had to attract me to it in the first place, something that suggested that there might be a painting in it. Perhaps whatever "art" the painting might have is given to it at that moment of initial choice. On the other hand, the rather subtle choices that are made as the painting progresses, as I try to re-invent the information in the photograph and make it convincing as painting, may be what gives it its "art." Whatever the reason, the painting ends up being different from the photograph and certainly different from the "real thing." When it is successful the picture is evocative in a way that has nothing to do with the processes of making it nor with the subject matter as such.

My subject matter comes from my own background and surroundings. I paint them because they are a part of what I know and as such I have affection for them. I see them as particular embodiments of a general American experience. My interest has nothing to do with satire or social comment though I am aware of the interpretations others might give. I am interested in their ordinariness—their invisibility through familiarity—and in the challenge of trying to make art from such commonplace fare.

Robert Bechtle
September, 1973

Robert Bechtle executed 51 Photo-Realist paintings between 1963 and 1979, and 43 watercolors between 1970 and June of 1978. All of the works are illustrated herein.

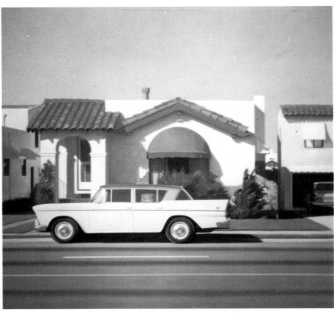

14. *'58 Rambler.* 1967 (14). Oil on canvas, 30 x 32".
Sloan Galleries of American Paintings, Valparaiso University, Ind.

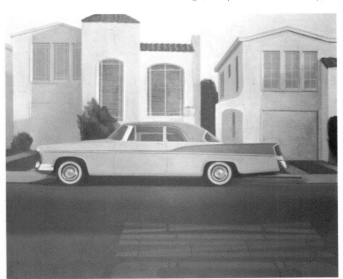

15. *'56 Chrysler.* 1964 (3). Oil on canvas, 36 x 40".
Collection Herbert D. Kosovitz, Calif.

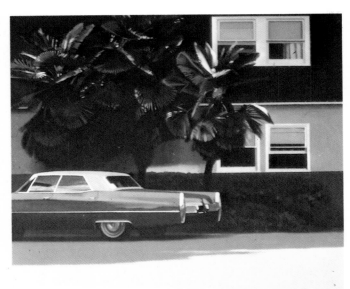

16. *'67 Cadillac.* 1968 (19). Acrylic on canvas, 22 x 24".
Collection Dr. and Mrs. H. J. Joseph, Mo.

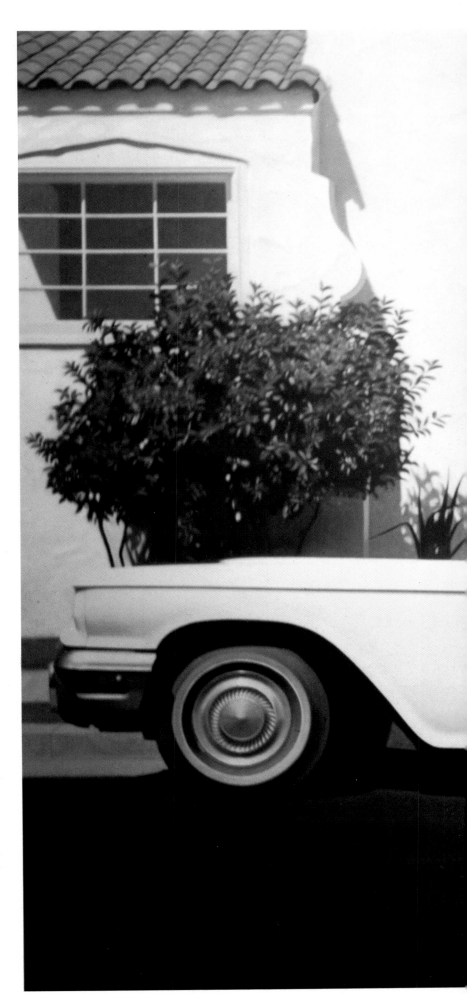

17. *'60 T-Bird.* 1967–68 (22). Oil on canvas, 72 x 98".
Collection University Art Museum, University of California, Berkeley

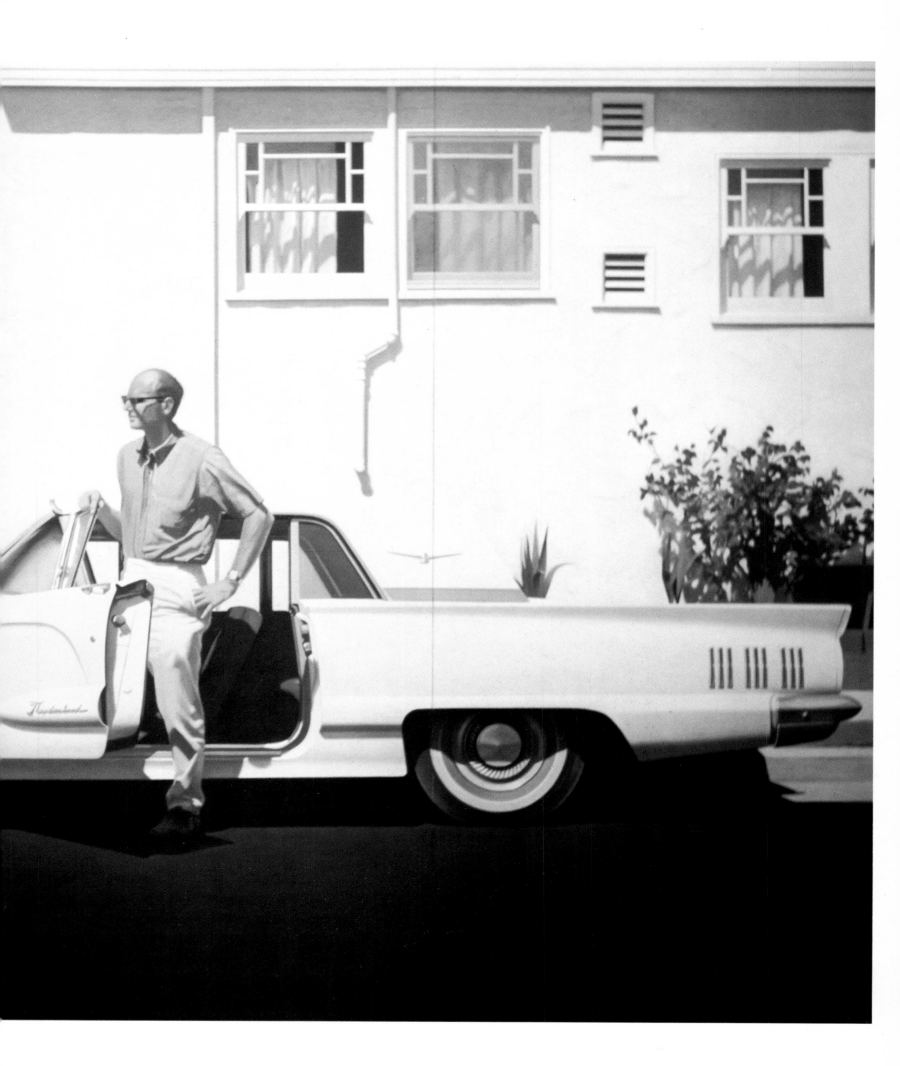

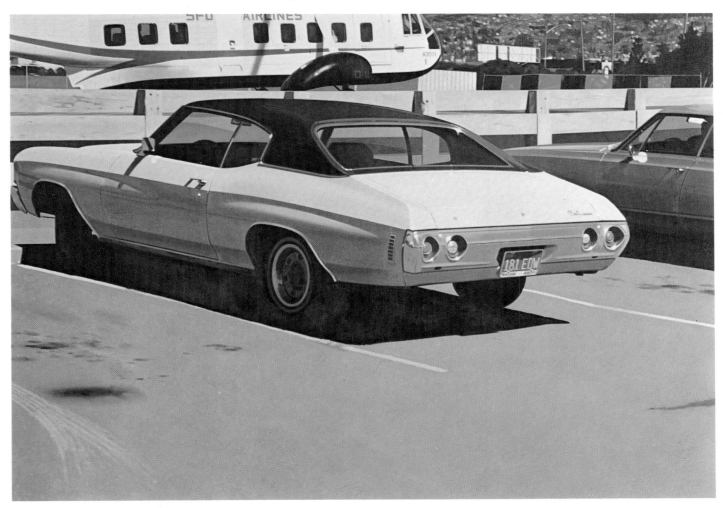

18. *S F O Malibu*. 1973 (44). Oil on canvas, 36 x 50". Stuart M. Speiser Collection, Smithsonian Institution, Washington, D.C.

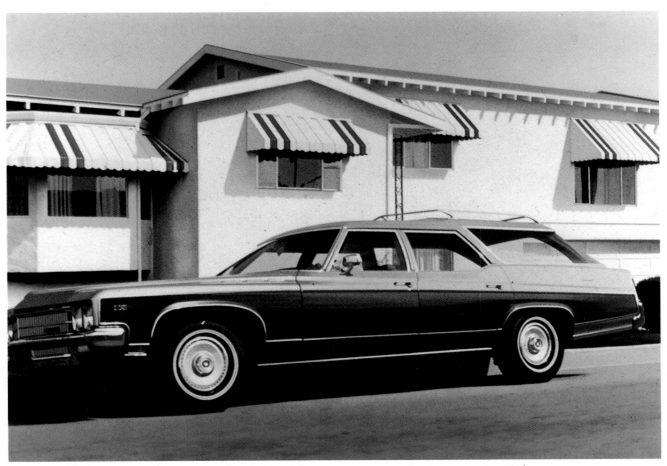

19. *'71 Buick*. 1972 (36). Oil on canvas, 47⅞ x 68". Solomon R. Guggenheim Museum, New York.
Purchased with funds contributed by Mr. and Mrs. Barrie M. Damson

20. *Date Palms.* 1971 (32). Oil on canvas, 60 x 84". Neue Galerie der Stadt Aachen. Ludwig Collection

21. *'64 Valiant.* 1971 (33). Oil on canvas, 48 x 69". Richard Brown Baker Collection, New York

22. *Roses*. 1973 (42).
Oil on canvas, 60 x 84".
Collection Mr. and Mrs.
Morton G. Neumann, Ill.

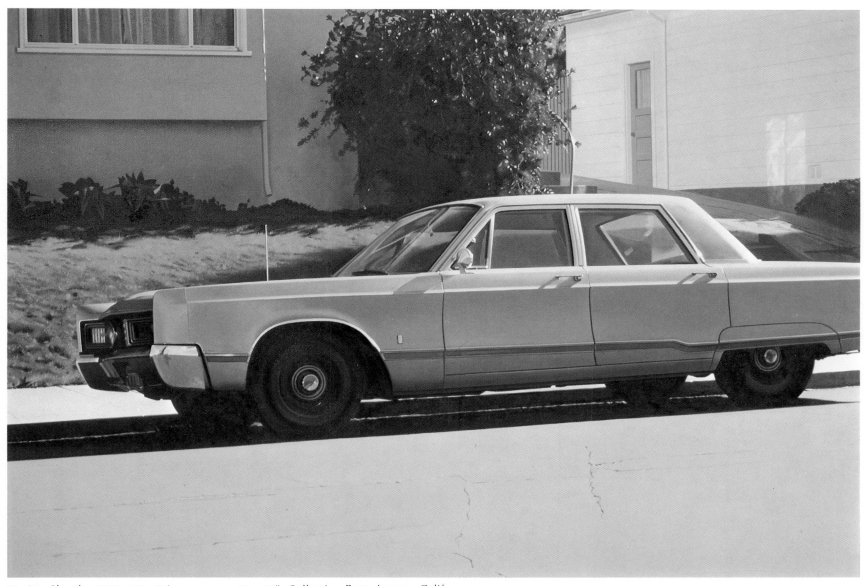

23. *'67 Chrysler.* 1973 (43). Oil on canvas, 48 x 69". Collection Barry Lowen, Calif.

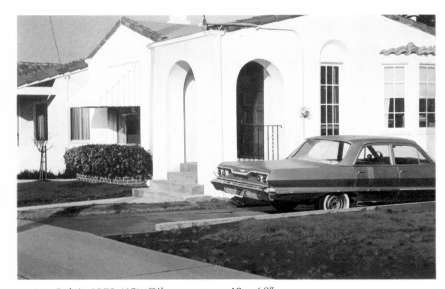

24. *'63 Belair.* 1973 (45). Oil on canvas, 48 x 69".
Collection Edmund P. Pillsbury, Conn.

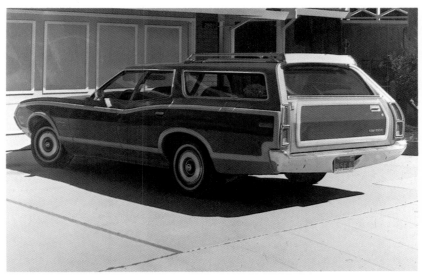

25. *Alameda Gran Torino.* 1974 (53). Oil on canvas, 48 x 69". San Francisco Museum of Art. T. B. Walker Foundation Fund.
Purchase in honor of John Humphry

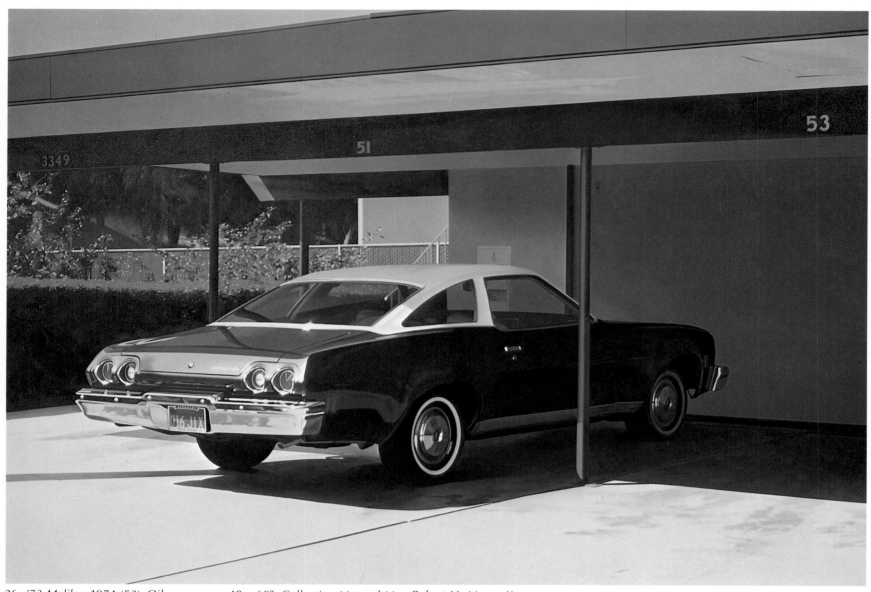

26. *'73 Malibu*. 1974 (52). Oil on canvas, 48 x 69". Collection Mr. and Mrs. Robert H. Mann, Kans.

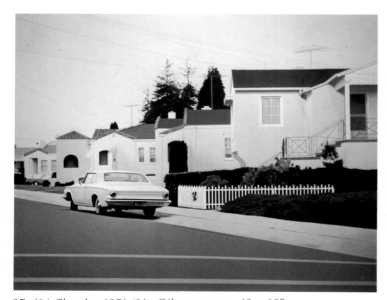

27. *'64 Chrysler*. 1971 (31). Oil on canvas, 48 x 60".
Private collection, Calif.

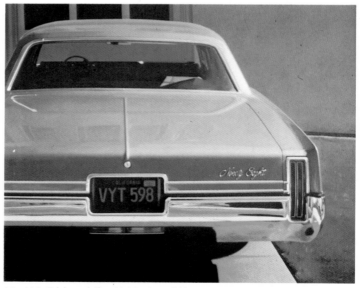

28. *'68 Oldsmobile*. 1969 (24). Oil on canvas, 45 x 52".
Collection Indiana National Bank

28a. *'68 Cadillac*. 1970 (25a). Oil on canvas.
Collection Louis and Susan Meisel, New York

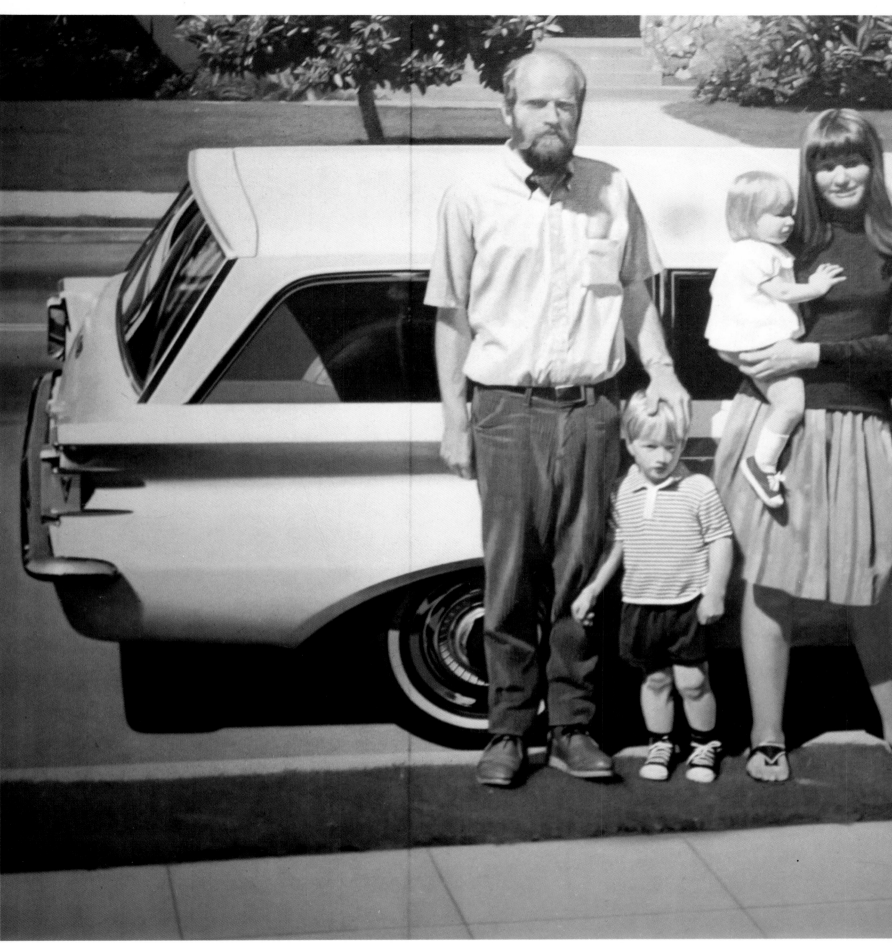

29. *'61 Pontiac*. 1969 (23). Oil on canvas, 60 x 84". Whitney Museum of American Art, New York.
Gift of Richard and Dorothy Rodgers Fund

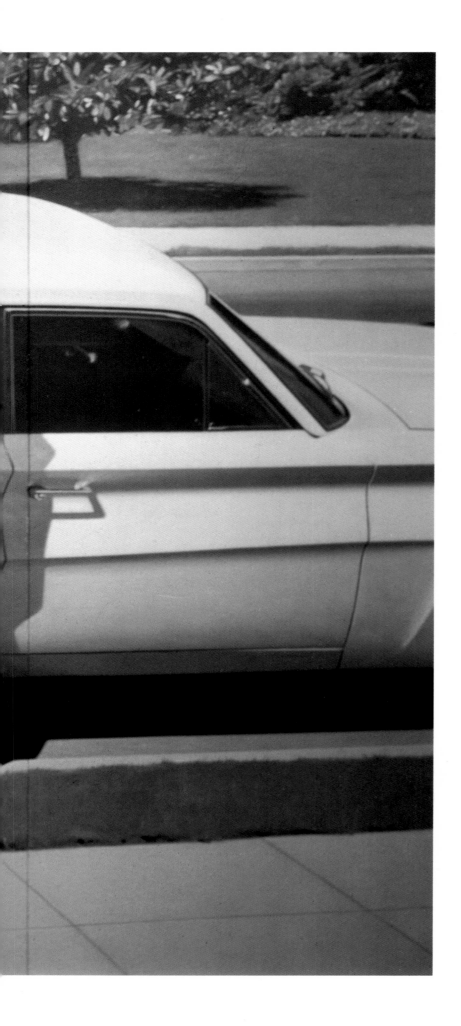

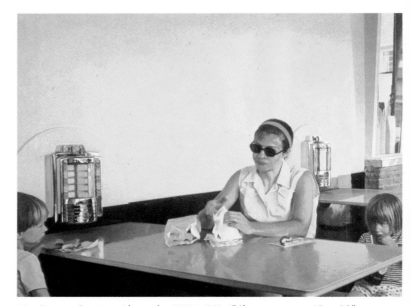

30. *Fosters Freeze, Alameda.* 1970 (27). Oil on canvas, 48 x 60".
Collection Mrs. Beatrice C. Mayer, Ill.

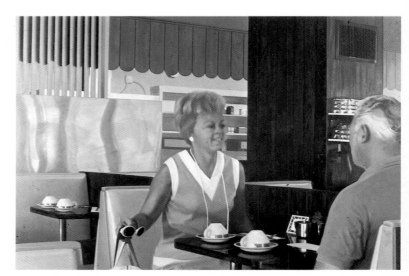

31. *At the Golden Nugget.* 1972 (37). Oil on canvas, 45 x 65".
Private collection, Ill.

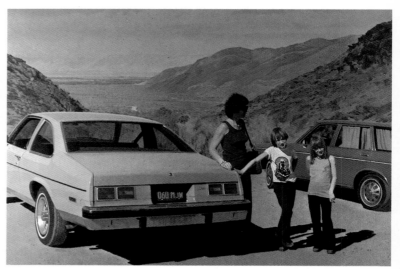

32. *Agua Caliente Nova.* 1975 (65). Oil on canvas, 48 x 69".
High Museum of Art, Atlanta, Ga.

33. *Berkeley Pinto*. 1976 (78).
Oil on canvas, 48 x 69".
Neue Galerie der Stadt Aachen.
Ludwig Collection

34. *Max Piggyback*. 1967 (17).
Oil on canvas, 36 x 40".
Collection Mrs. Beatrice C. Mayer, Ill.

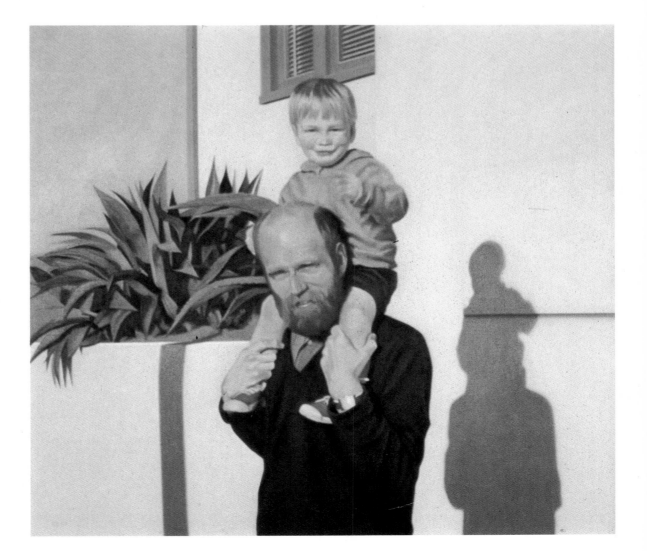

38

35. *Xmas at Gilroy.* 1971 (34).
Oil on canvas, 48 x 69".
Collection Mrs. Sonny Gurman, Mich.

36. *Watsonville Olympia.* 1977 (84).
Oil on canvas, 48 x 69".
Collection the artist

37. *Santa Barbara Motel.* 1977 (85).
Oil on canvas, 48 x 69".
Private collection

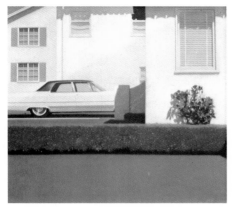

38. *'66 Cadillac*. 1968 (18).
Oil on canvas, 22 x 24".
Collection Doane College, Nebr.

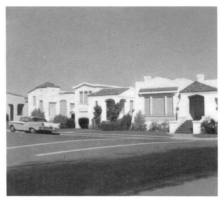

39. *'57 Ford*. 1967 (13).
Oil on canvas, 30 x 32".
Private collection

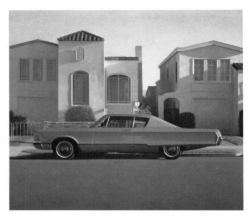

40. *'67 Chrysler*. 1967 (16).
Oil on canvas, 36 x 40".
Private collection, Calif.

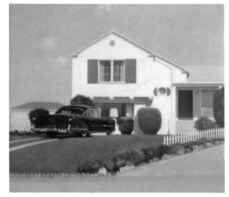

41. *'56 Cadillac*. 1966 (8).
Oil on canvas, 22 x 24".
Private collection, Europe

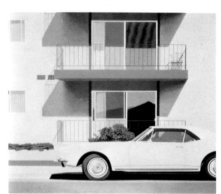

42. *'67 Camaro*. 1968 (20).
Acrylic on canvas, 22 x 24".
Collection Galerie Isy Brachot, Brussels

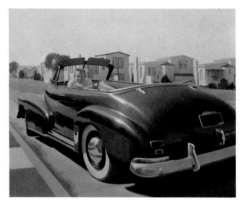

43. *'46 Chevy*. 1965 (5).
Oil on canvas, 45 x 53".
Collection Mr. and Mrs. Jerome Fox, Calif.

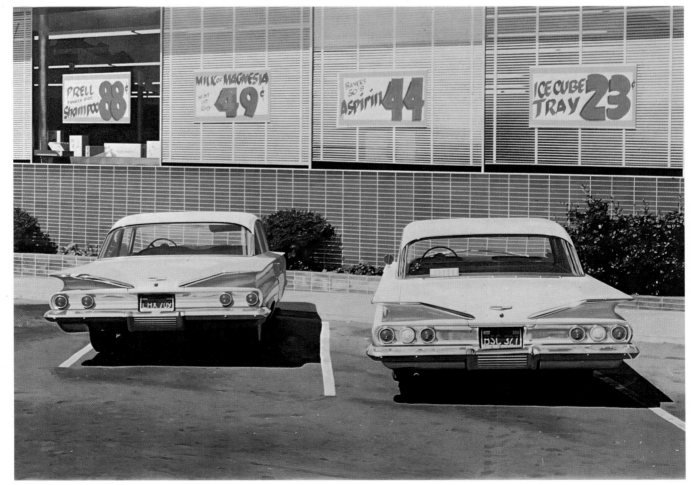

44. *'60 Chevies*. 1971 (35). Oil on canvas, 48 x 69".
Private collection

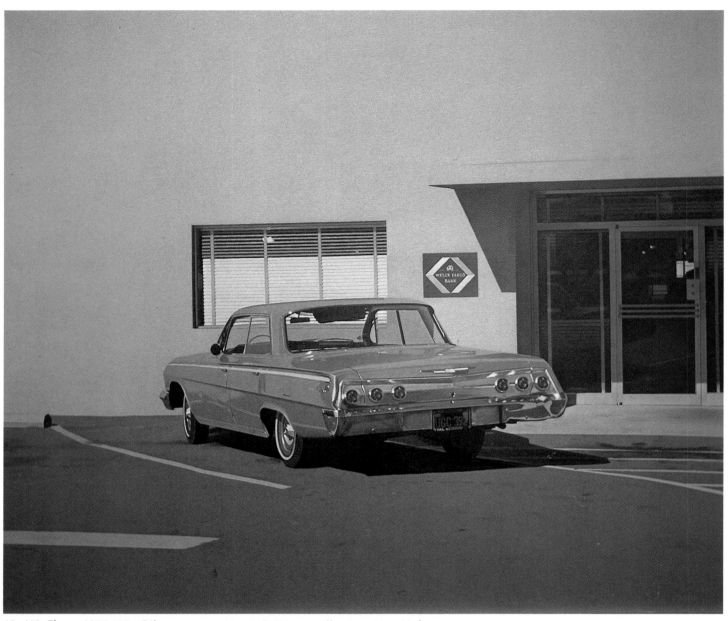

45. *'62 Chevy*. 1970 (28). Oil on canvas, 46 x 52". Private collection, New York

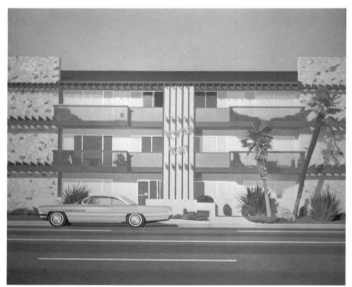

46. *Kona Kai*. 1967 (15). Oil on canvas, 45 x 52".
Carolina Art Association, Gibbes Art Gallery, Charleston, S.C.

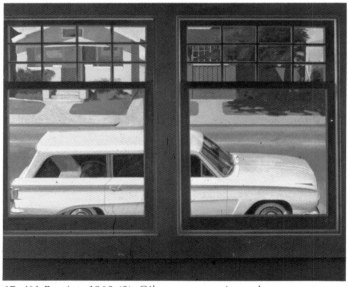

47. *'61 Pontiac*. 1963 (2). Oil on canvas, size unknown.
Private collection

48. *Berkeley Stucco*. 1977 (86). Oil on canvas, 48 x 69". Sydney and Frances Lewis Foundation, Va.

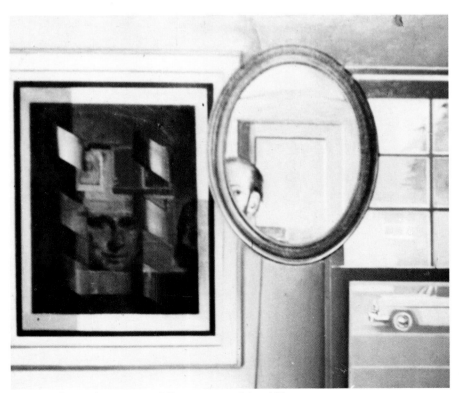

49. *'56 Plymouth*. 1963 (1). Oil on canvas, 36 x 40".
Private collection

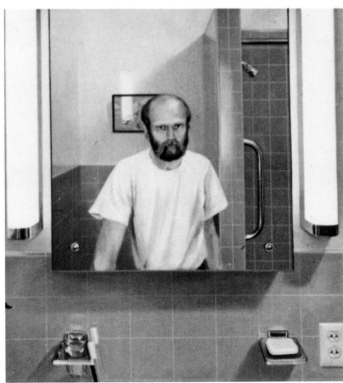

50. *Pink Toothbrush*. 1966 (10). Oil on canvas, 36 x 32".
Private collection, New York

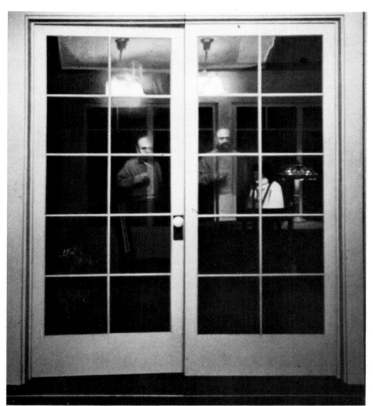

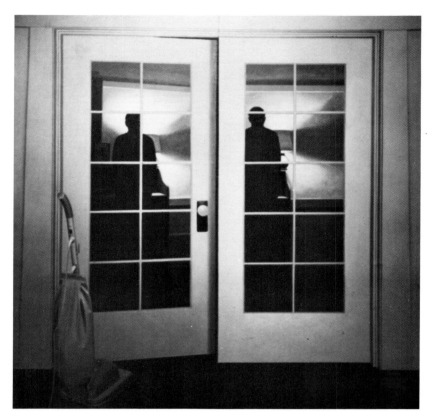

51. *French Doors II.* 1966 (9). Oil on canvas, 72 x 72".
E. B. Crocker Art Gallery, Calif.

52. *French Doors I.* 1965 (6). Oil on canvas, 72 x 72".
Collection Mr. and Mrs. Alan S. Weller, Ill.

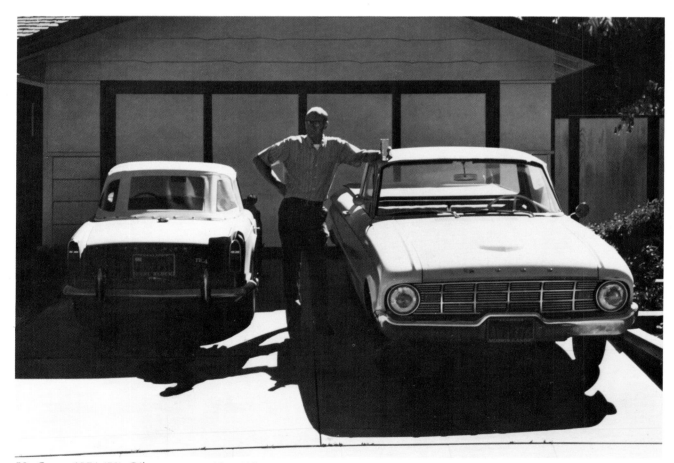

53. *Coors.* 1974 (51). Oil on canvas, 48 x 69".
Sydney and Frances Lewis Foundation, Va.

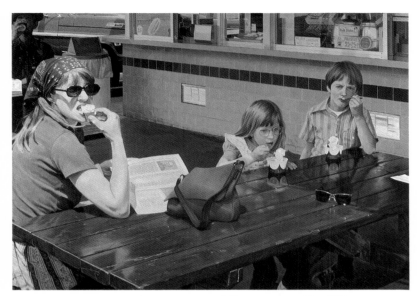

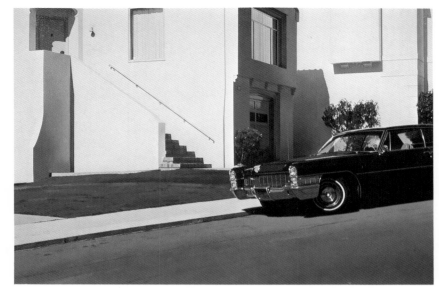

54. *Fosters Freeze, Escalon.* 1975 (64). Oil on canvas, 40 x 58".
Private collection, Calif.

55. *San Francisco Cadillac.* 1975 (66). Oil on canvas, 40 x 58".
Private collection

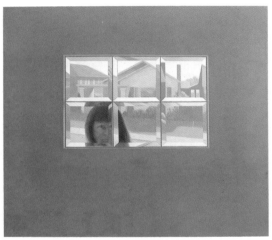

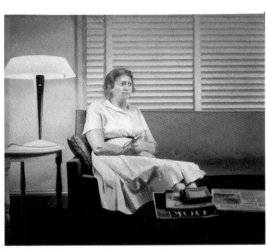

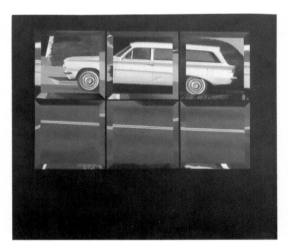

56. *Grove Street.* 1965 (7).
Oil on canvas, 36 x 40".
Collection Mr. and Mrs. Hewitt Crane, Calif.

57. *Thelma.* 1965 (4).
Oil on canvas, 46 x 52".
Collection Monte Vista High School, Calif.

58. *'61 Pontiac.* 1967 (11).
Oil on canvas, 36 x 40".
Collection Mr. and Mrs. Douglas Engelbart, Calif.

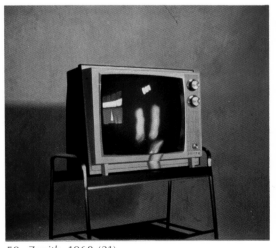

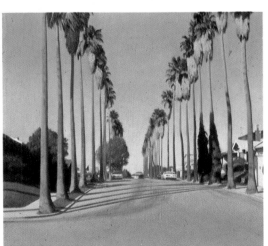

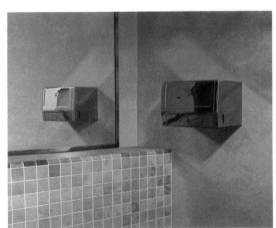

59. *Zenith.* 1968 (21).
Oil on canvas, 36 x 40".
Private collection, Ill.

60. *Burbank Street.* 1967 (12).
Oil on canvas, 30 x 32".
Private collection, Calif.

61. *Towel Dispenser.* 1970 (26).
Oil on canvas, 48 x 60".
Lowe Art Museum, Fla.

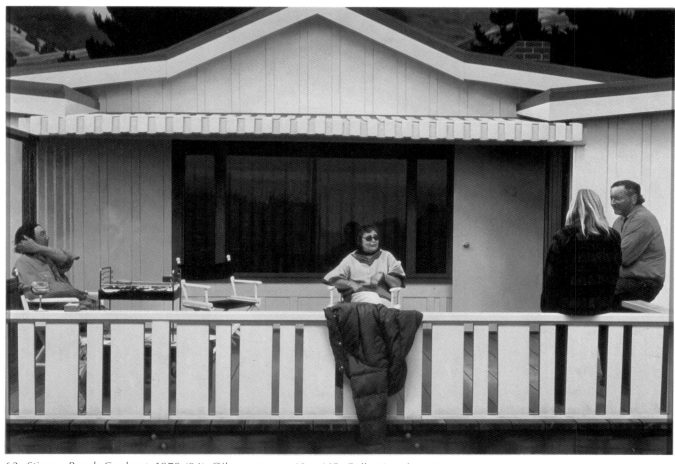

62. *Stinson Beach Cookout*. 1979 (94). Oil on canvas, 48 x 69". Collection the artist

62a. *Stinson Beach Cookout*. 1978 (92a). Watercolor. Private collection

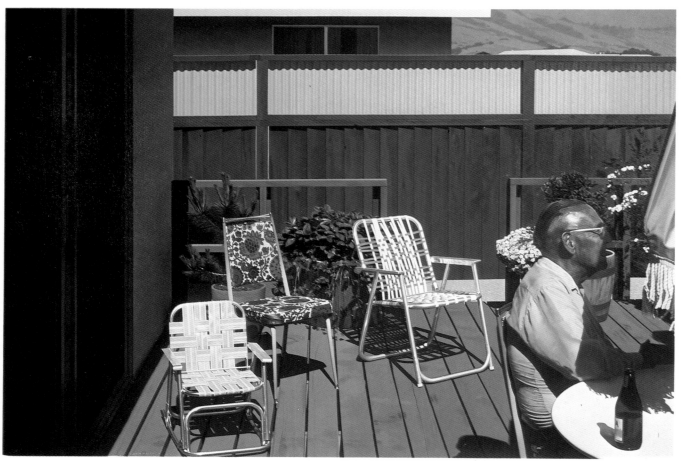

63. *Watsonville Chairs*. 1976 (77). Oil on canvas, 48 x 69". Private collection, Tenn.

64. *Four Palm Trees.* 1969 (25).
Oil on canvas, 45 x 52".
Collection Jan van der Marck, Wash.

65. *Watsonville Olympia.* 1976 (82).
Watercolor on paper, 10 x 16".
Collection Barbara Toll, New York

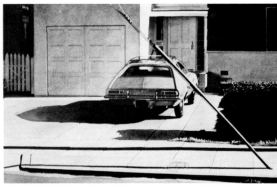

66. *Albany Pinto.* 1973 (50).
Watercolor, 10 x 16".
Collection Louis and Susan Meisel, New York

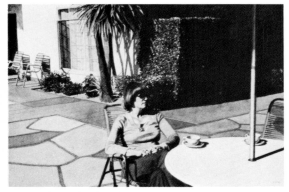

67. *Ambassador-by-the-Sea.* 1976 (83).
Watercolor, 10 x 16".
Private collection, New York

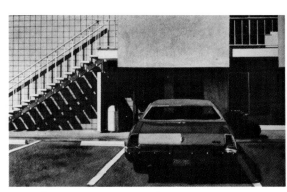

68. *Palm Springs Monte Carlo.* 1976 (79).
Watercolor on paper, 10 x 15".
Private collection

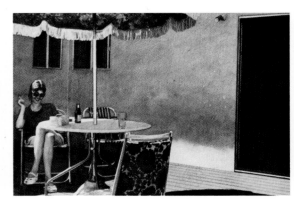

69. *Watsonville Patio.* 1977 (87).
Watercolor on paper, 10 x 16".
John Berggruen Gallery, Calif.

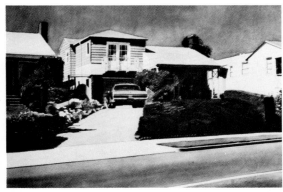

70. *'67 Polara.* 1972 (40).
Watercolor, 11½ x 16".
Collection Mr. and Mrs. Robert H. Mann, Kans.

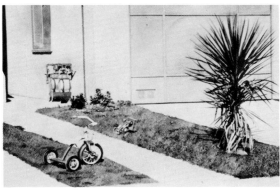

71. *Murray and Tonka.* 1970 (30).
Watercolor, 10 x 14".
Collection Bo Alvaryd, Sweden

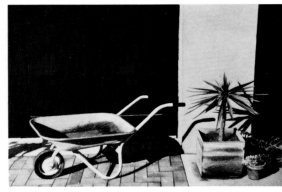

72. *Berkeley Wheelbarrow.* 1978 (93).
Watercolor on paper, 10 x 15".
Collection Alameda County, Calif.

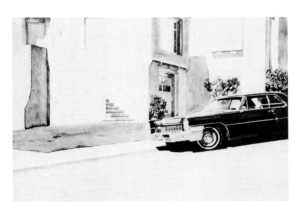

73. *'66 Cadillac.* 1972 (38).
Watercolor on paper, 10 x 14".
Collection Mr. and Mrs. Stephen Paine, Mass.

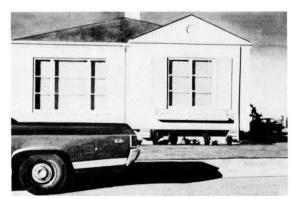

74. *El Camino.* 1972 (39).
Watercolor on paper, 10 x 14".
Collection Mr. and Mrs. Stephen Paine, Mass.

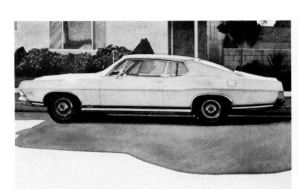

75. *'69 Ford.* 1973 (46).
Watercolor on paper, 10 x 16".
Collection Edmund P. Pillsbury, Conn.

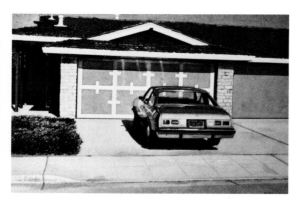

76. *Alameda Nova.* 1978 (91).
Watercolor on paper, 10 x 15".
John Berggruen Gallery, Calif.

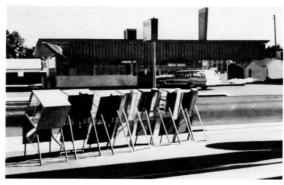

77. *Newsstands, Los Banos.* 1973 (49).
Watercolor on paper, 10 x 16".
Collection Mr. and Mrs. Robert Bechtle, Calif.

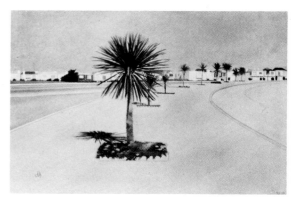

78. *Yucca.* 1973 (48). Watercolor on paper, 10 x 15".
San Francisco Museum of Art, Civic
Center. Gift of Byron Meyer, Calif.

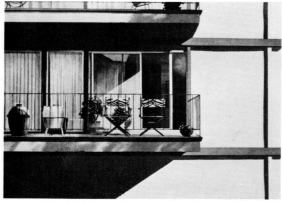

79. *Oakland Chairs.* 1974 (54).
Watercolor on paper, 10 x 13".
Private collection

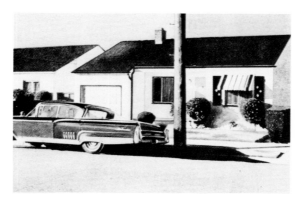

80. *'62 Mercury.* 1974 (55).
Watercolor on paper, 10 x 13¾".
Collection Norman Dubrow, New York

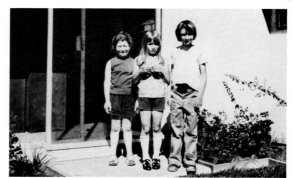

81. *Dublin Kids.* 1974 (56).
Watercolor on paper, 10 x 16".
Collection Mr. and Mrs. Robert Bechtle, Calif.

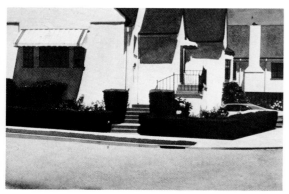

82. *California Garden II.* 1974 (57).
Watercolor, 10 x 15".
Private collection

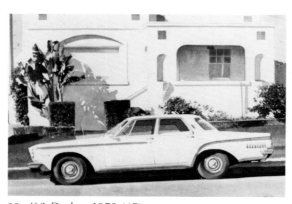

83. *'63 Dodge.* 1973 (47).
Watercolor, 10 x 14".
Collection Louis and Susan Meisel, New York

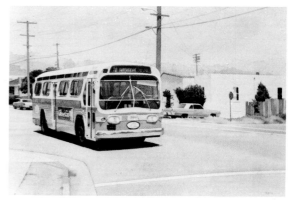

84. *A. C. Transit.* 1974 (58).
Watercolor on paper, 10 x 16".
Private collection, New York

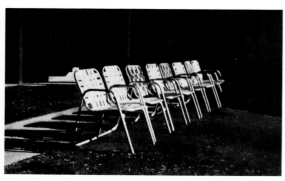

85. *La Jolla Chairs.* 1974 (59).
Watercolor, 10 x 16".
Private collection, Paris

86. *'64 Valiant.* 1974 (60).
Watercolor, 10 x 16".
Collection Bill Bass, Ill.

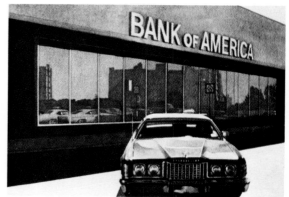

87. *B. of A. T-Bird.* 1974 (61).
Watercolor on paper, 10 x 15".
Richard Brown Baker Collection, New York

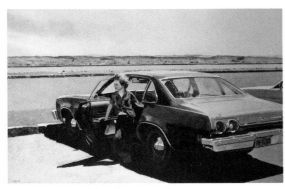

88. *Hawaii Malibu: Max at Kilauea.* 1974 (62).
Watercolor on paper, 10 x 15½".
Collection Edmund P. Pillsbury, Conn.

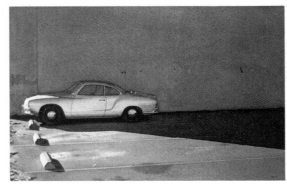

89. *Oakland Ghia.* 1974 (63).
Watercolor on paper, 10 x 15½".
Collection Edmund P. Pillsbury, Conn.

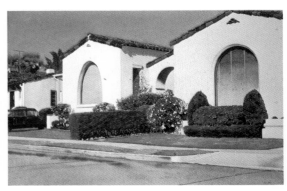

90. *Oakland Houses.* 1975 (67).
Watercolor on paper, 10 x 15".
Private collection, New York

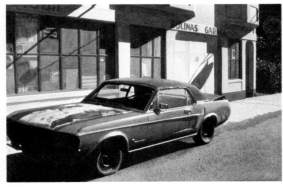

91. *Bolinas Mustang.* 1975 (68).
Watercolor, 10 x 15". Collection
Mr. and Mrs. Martin Schmukler, New York

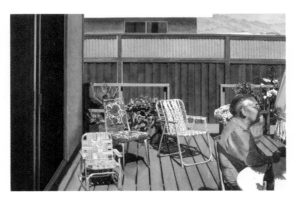

92. *Watsonville Chairs.* 1975 (69).
Watercolor on paper, 10 x 15".
Collection Mr. and Mrs. Robert Bechtle, Calif.

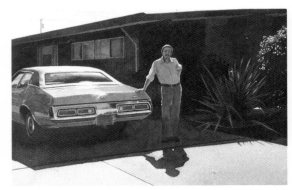

93. *Sacramento Montego.* 1975 (70).
Watercolor on paper, 10 x 15".
Collection Mr. and Mrs. Leonard Hantover

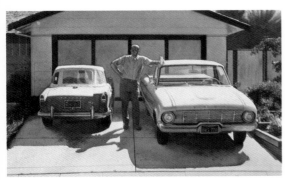

94. *Coors.* 1975 (71).
Watercolor on paper, 10 x 16".
Private collection, Iran

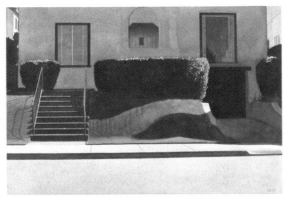

95. *Ingleside House.* 1975 (72).
Watercolor on paper, 8 x 11".
Oakland Museum, Calif.

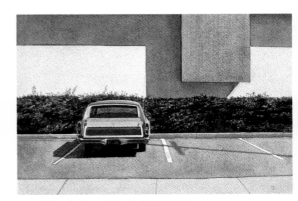

96. *Palm Springs Ford.* 1975 (73).
Watercolor, 8 x 11".
Private collection

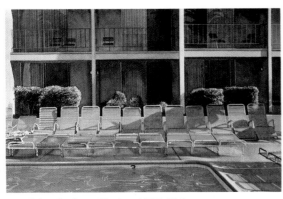

97. *Palm Springs Chairs.* 1975 (74).
Watercolor on paper, 10 x 14".
Georgia Museum of Art, Athens

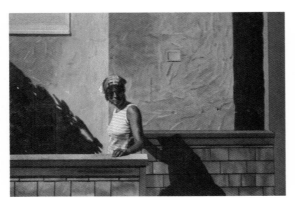

98. *Berkeley Stucco.* 1975 (75).
Watercolor on paper, 10 x 14".
Private collection, Calif.

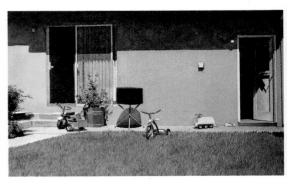

99. *Chico Tricycles.* 1975 (76).
Watercolor on paper, 10 x 16".
Collection Dr. and Mrs. Barry J. Paley, New York

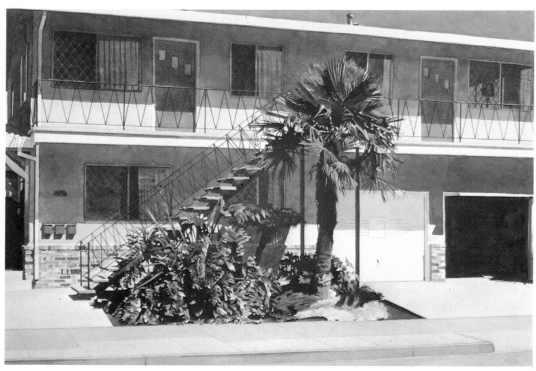

100. *California Garden I.* 1972 (41). Watercolor on paper, 10 x 15".
Private collection

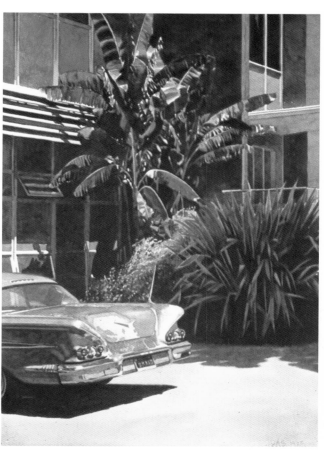

101. *'58 Chevy.* 1970 (29). Watercolor on paper, 15¼ x 11¼".
Private collection

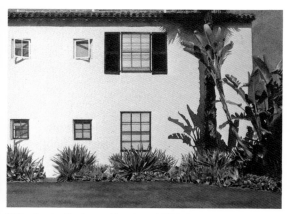

102. *Santa Barbara Garden.* 1976 (81).
Watercolor on paper, 10 x 15".
Private collection

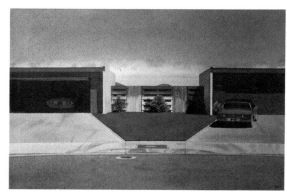

103. *Palm Springs Porsche.* 1976 (80).
Watercolor on paper, 10 x 16".
Private collection

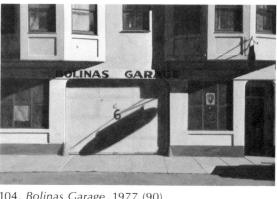

104. *Bolinas Garage.* 1977 (90).
Watercolor on paper, 10 x 15".
Collection the artist

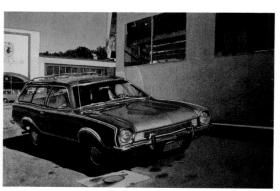

105. *Solano Avenue Pinto.* 1977 (88).
Watercolor, 10 x 16".
Collection Louis and Susan Meisel, New York

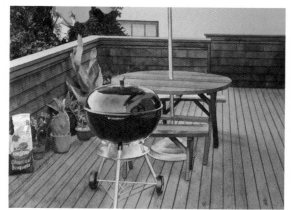

106. *Weber Kettle.* 1978 (92).
Watercolor on paper, 10 x 13".
Collection the artist

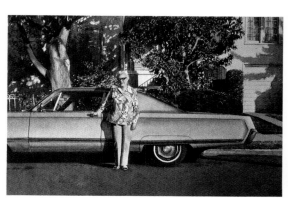

107. *Alameda Chrysler.* 1977 (89).
Watercolor, 10 x 16".
Collection Harvey Schulman, New York

49

BIOGRAPHY

1932 Born: San Francisco

EDUCATION
1954 B.A., California College of Arts and Crafts, Oakland
1958 M.F.A., California College of Arts and Crafts, Oakland
 University of California, Berkeley

TEACHING
1957– California College of Arts and Crafts, Oakland
1965 University of California, Berkeley
1967 University of California, Davis
1968– San Francisco State University

SOLO EXHIBITIONS
1959 San Francisco Museum of Modern Art
1964 San Francisco Museum of Modern Art
1965 Berkeley Gallery, Berkeley, Calif.
 Richmond Art Center, Richmond, Calif.
1966 E. B. Crocker Art Gallery, Sacramento, Calif.
1967 Berkeley Center, San Francisco
 San Francisco Museum of Modern Art
 University of California, Davis
1969 Achenbach Foundation for Graphic Arts, California Palace of the
 Legion of Honor, San Francisco
1971 O. K. Harris Gallery, New York
1973 E. B. Crocker Gallery, Sacramento, Calif.
 Fine Arts Gallery of San Diego, Calif.
 Jack Glenn Gallery, San Diego, Calif.
 John Berggruen Gallery, San Francisco
1974 O. K. Harris Gallery, New York
1977 O. K. Harris Gallery, New York

SELECTED GROUP EXHIBITIONS
1957 California State Fair, Sacramento
 Oakland Art Museum, Calif.
 Richmond Art Center, Richmond, Calif.
 San Francisco Art Institute
1958 Boston Museum of Fine Arts
 Oakland Art Museum, Calif.
 Provincetown Arts Festival, Mass.
 Richmond Art Center, Richmond, Calif.
 San Francisco Art Institute
1959 Bradley University, Peoria, Ill.
 California State Fair, Sacramento
 Oakland Art Museum, Calif.
 Richmond Art Center, Richmond, Calif.
1960 "American Graphic Art," USIA–SAGA Overseas Exhibition
 Brooklyn Museum, New York
 California Society of Etchers, San Francisco
 Library of Congress, Washington, D.C.
 "Lithography: Ingres to Picasso," Achenbach Foundation for Graphic
 Arts, California Palace of the Legion of Honor, San Francisco
 Oakland Art Museum, Calif.
 Richmond Art Center, Richmond, Calif.
 San Francisco Art Institute
 "Winter Invitational," California Palace of the Legion of Honor, San
 Francisco
1961 California Society of Etchers, San Francisco
 California State Fair, Sacramento
 Oakland Art Museum, Calif.
 Richmond Art Center, Richmond, Calif.
 San Francisco Art Institute
 Wichita Art Association, Kans.
 "Winter Invitational," California Palace of the Legion of Honor, San
 Francisco
1964 Brooklyn Museum, New York
 California Society of Etchers, San Francisco
 Richmond Art Center, Richmond, Calif.
 "Winter Invitational," California Palace of the Legion of Honor, San
 Francisco

1965 "California Printmakers," San Francisco Art Institute
 "Contemporary American Lithographers," USIA Overseas Exhibition
 "Recent California Painting," Witte Memorial Museum, San Antonio,
 Tex.
1966 "East Bay Realists," San Francisco Art Institute
1967 "The Artist as His Subject," Museum of Modern Art, New York
 California Palace of the Legion of Honor, San Francisco
 "Contemporary Western Painting," University of Arizona, Tucson
 "1967 Biennial Exhibition of American Art," Krannert Art Museum,
 University of Illinois, Champaign-Urbana
 "Painters Behind Painters," California Palace of the Legion of Honor,
 San Francisco
1967–68 "Annual Exhibition of Contemporary American Painting," Whitney
 Museum of American Art, New York
1968 "Realism Now," Vassar College Art Gallery, Poughkeepsie, N.Y.
 "West Coast Now," Portland Art Museum, Oreg.; Seattle Art Museum,
 Wash.; M. H. de Young Museum, San Francisco; Los Angeles
 Municipal Art Gallery
1969 "The American Realist Tradition," Philbrook Art Center, Tulsa, Okla.;
 Oklahoma Art Center, University of Oklahoma, Norman
 "American Report on the '60s," Denver Art Museum
 "Contemporary American Painting and Sculpture," Krannert Art
 Museum, University of Illinois, Champaign-Urbana
 "Directions 2: Aspects of a New Realism," Akron Art Institute, Ohio;
 Milwaukee Art Center; Contemporary Arts Museum, Houston
 "Direct Representation," Fischbach Gallery, New York; Phyllis Kind
 Gallery, Chicago; London Arts Gallery, Detroit
 Indiana State University, Terre Haute
 "Painting and Sculpture Today, 1969," Indianapolis Museum of Art
 University of Oklahoma, Tulsa
1970 "American Painting 1970," Virginia Museum of Fine Arts, Richmond
 "American Report—The 1960s," Denver Art Museum
 "The American Scene: The 20th Century," Indiana University Art
 Museum, Bloomington
 "Beyond the Actual—Contemporary California Realist Painting,"
 Pioneer Museum and Haggin Galleries, Stockton, Calif.
 "Christmas at Christie's," City Art Museum of St. Louis
 "Cool Realism," Everson Museum of Art, Syracuse, N.Y.
 "The Cool Realists," Jack Glenn Gallery, Corona del Mar, Calif.
 "Directions 1970," Virginia Museum of Fine Arts, Richmond
 "Directly Seen—New Realism in California," Newport Harbor Art
 Museum, Balboa, Calif.
 "Graphics '71," University of Kentucky at Lexington
 Jerrold Morris Gallery, Toronto
 "Looking West, 1970," Jocelyn Art Museum, Omaha, Nebr.
 "Painting and Sculpture Today, 1970," Indianapolis Museum of Art
 "Twenty-two Realists," Whitney Museum of American Art, New York
 "West Coast '70," E. B. Crocker Art Gallery, Sacramento, Calif.
 "Younger Artists from O. K. Harris," Dayton Art Institute, Ohio
1971 "Arts Festival, 1971," Dowling College, Oakdale, N.Y.
 "New Realism," Brainerd Hall Art Gallery, State University College,
 Potsdam, N.Y.
 Purdue University, Lafayette, Ind.
 "Radical Realism," Museum of Contemporary Art, Chicago
 "The Shape of Realism," Deson-Zaks Gallery, Chicago
1972 "Art Around 1970," Neue Galerie der Stadt Aachen, West Germany
 "California Painting," Albright-Knox Art Gallery, Buffalo, N.Y.
 "California Prints," Museum of Modern Art, New York
 "California Representation: Eight Painters in Documenta 5," Santa
 Barbara Museum of Art, Calif.
 "Documenta 5," Kassel, West Germany
 "Phases of the New Realism," Lowe Art Museum, University of Miami,
 Coral Gables, Fla.
 "The Realist Revival," New York Cultural Center, New York
 "Sharp-Focus Realism," Sidney Janis Gallery, New York
 "The State of California Painting," Govett-Brewster Art Gallery, New
 Plymouth, New Zealand
 "Works on Paper," John Berggruen Gallery, San Francisco
1972–73 "Amerikanischer Fotorealismus," Württembergischer Kunstverein,

50

Stuttgart; Frankfurter Kunstverein, Frankfurt; Kunst und
Museumsverein, Wuppertal, West Germany
1973 "American Art—Third Quarter Century," Seattle Art Museum, Wash.
"Biennial," Whitney Museum of American Art, New York
"East Coast/West Coast/New Realism," San Jose State University, Calif.
"Ekstrem realisme," Louisiana Museum, Humlebaek, Denmark
"Grands maîtres hyperréalistes américains," Galerie des Quatre
Mouvements, Paris
"Hyperréalistes américains," Galerie Arditti, Paris
"Image, Reality, and Superreality," Arts Council of Great Britain,
traveling exhibition
"Mit Kamera, Pinsel und Spritzpistole," Ruhrfestspiele Recklinghausen,
Städtische Kunsthalle, Recklinghausen, West Germany
"Photo Realism," Serpentine Gallery, London
"Quatrième salon international d'art," Basel
"Separate Realities," Los Angeles Municipal Art Center
1973–74 "Hyperréalisme," Galerie Isy Brachot, Brussels
1973–78 "Photo-Realism 1973: The Stuart M. Speiser Collection," traveling
exhibition: Louis K. Meisel Gallery, New York; Herbert F. Johnson
Museum of Art, Ithaca, N.Y.; Memorial Art Gallery of the University
of Rochester, N.Y.; Addison Gallery of American Art, Andover,
Mass.; Allentown Art Museum, Pa.; University of Colorado
Museum, Boulder; University Art Museum, University of Texas,
Austin; Witte Memorial Museum, San Antonio, Tex.; Gibbes Art
Gallery, Charleston,S.C.; Brooks Memorial Art Gallery, Memphis,
Tenn.; Krannert Art Museum, University of Illinois, Champaign-
Urbana; Helen Foresman Spencer Museum of Art, University of
Kansas, Lawrence; Paine Art Center and Arboretum, Oshkosh, Wis.;
Edwin A. Ulrich Museum, Wichita State University, Kans.; Tampa
Bay Art Center, Tampa, Fla.; Rice University, Sewall Art Gallery,
Houston; Tulane University Art Gallery, New Orleans; Smithsonian
Institution, Washington, D.C.
1974 "Amerikaans fotorealisme grafiek," Hedendaagse Kunst, Utrecht; Palais
des Beaux-Arts, Brussels
"Art 5 '74," Basel
"Contemporary American Paintings from the Lewis Collection,"
Delaware Art Museum, Wilmington
"Living American Artists and the Figure," Pennsylvania State
University, University Park
"New Photo-Realism," Wadsworth Atheneum, Hartford, Conn.
"Tokyo Biennale, '74," Toyko Metropolitan Museum of Art; Kyoto
Municipal Museum; Aichi Prefectural Art Museum, Nagoya
"Works on Paper," Virginia Museum of Fine Arts, Richmond
1975 Carlin Station, Syracuse University, N.Y.
"A Change of View," Aldrich Museum of Contemporary Art, Ridgefield,
Conn.
"Image, Color and Form—Recent Paintings by Eleven Americans,"
Toledo Museum of Art, Ohio
Lafayette Natural History Museum and Planetarium, Lafayette, La.
"The New Realism: Rip-Off or Reality?," Edwin A. Ulrich Museum of
Art, Wichita State University, Kans.
"Richard Brown Baker Collects," Yale University Art Gallery, New
Haven, Conn.
"Signs of Life: Symbols in the City," Renwick Gallery, Smithsonian
Institution, Washington, D.C.
"Watercolors and Drawings—American Realists," Louis K. Meisel

Gallery, New York
1975–76 "Photo-Realism, American Painting and Prints," New Zealand traveling
exhibition: Barrington Gallery, Auckland; Robert McDougall Art
Gallery, Christchurch; Academy of Fine Arts, National Art Gallery,
Wellington; Dunedin Public Art Gallery, Dunedin; Govett-Brewster
Art Gallery, New Plymouth; Waikato Art Museum, Hamilton
"Super Realism," Baltimore Museum of Art
1976 "America as Art," National Collection of Fine Arts, Smithsonian
Institution, Washington, D.C.
"Art 7 '76," Basel
"Contemporary Images in Watercolor," Akron Art Institute, Ohio;
Indianapolis Museum of Art; Memorial Art Gallery of the University
of Rochester, N.Y.
Lowe Art Center, Syracuse University, N.Y.
"Today/Tomorrow," Lowe Art Museum, University of Miami, Coral
Gables, Fla.
"Works on Paper," Galerie de Gestlo, Hamburg
1976–78 "America 1976," Corcoran Gallery of Art, Washington, D.C.;
Wadsworth Atheneum, Hartford, Conn.; Fogg Art Museum,
Cambridge, Mass., and Institute of Contemporary Art, Boston;
Minneapolis Institute of Arts; Milwaukee Art Center; Fort Worth Art
Museum; San Francisco Museum of Modern Art; High Museum of
Art, Atlanta; Brooklyn Museum, New York
"Aspects of Realism," traveling exhibition sponsored by Rothman's of
Pall Mall Canada, Ltd.: Stratford, Ont.; Centennial Museum,
Vancouver, B.C.; Glenbow-Alberta Institute, Calgary, Alta.; Mendel
Art Gallery, Saskatoon, Sask.; Winnipeg Art Gallery, Man.;
Edmonton Art Gallery, Alta.; Art Gallery, Memorial University of
Newfoundland, St. John's; Confederation Art Gallery and Museum,
Charlottetown, P.E.I.; Musée d'Art Contemporain, Montreal, Que.;
Dalhousie University Museum and Gallery, Halifax, N.S.; Windsor
Art Gallery, Ont.; London Public Library and Art Museum and
McIntosh Memorial Art Gallery, University of Western Ontario; Art
Gallery of Hamilton, Ont.
1977 "New Realism: Modern Art Form," Boise Gallery of Art, Idaho
"A View of a Decade," Museum of Contemporary Art, Chicago
"Works on Paper II," Louis K. Meisel Gallery, New York
1977–78 "Illusion and Reality," Australian touring exhibition: Australian
National Gallery, Canberra; Western Australian Art Gallery, Perth;
Queensland Art Gallery, Brisbane; Art Gallery of New South Wales,
Sydney; Art Gallery of South Australia, Adelaide; National Gallery
of Victoria, Melbourne; Tasmanian Museum and Art Gallery, Hobart
1978 Albert Contreras Gallery, Los Angeles
"Art and the Automobile," Flint Institute of Arts, Mich.
"California: Three by Eight Twice," Honolulu Academy of Arts
"Photo-Realist Printmaking," Louis K. Meisel Gallery, New York
Tolarno Galleries, Melbourne, Australia
1979 "America in the 70s As Depicted by Artists in the Richard Brown
Baker Collection," Meadowbrook Art Gallery, Oakland
University, Rochester, Mich.
1979–80 "Late Twentieth Century Art from the Sidney and Frances Lewis
Foundation," Institute of Contemporary Art of the University of
Pennsylvania, Philadelphia; Dayton Art Institute, Ohio; Brooks
Memorial Art Gallery, Memphis; Dupont Gallery, Washington and
Lee University, Lexington, Va.
"Reflections of Realism," Museum of Albuquerque

SELECTED BIBLIOGRAPHY

CATALOGUES
Recent California Painting. Witte Memorial Museum, San Antonio, Tex., 1965.
Biennial Exhibition of American Art. Krannert Art Museum, University of
Illinois, Champaign-Urbana, 1967.
Painters Behind Painters. California Palace of the Legion of Honor, San
Francisco, 1967.

Annual Exhibition of Contemporary Painting. Whitney Museum of American
Art, New York, Dec. 13, 1967–Feb. 4, 1968.
Nochlin, Linda. "The New Realists." In *Realism Now.* Vassar College Art
Gallery, Poughkeepsie, N.Y., May 8–June 21, 1968.
West Coast Now. Portland Art Museum, Oreg.; Seattle Art Museum, Wash.;
M. H. de Young Museum, San Francisco; Los Angeles Municipal Art Gallery, 1968.

Burton, Scott. *Direct Representation.* Fischbach Gallery, New York; Phyllis Kind Gallery, Chicago; London Arts Gallery, Detroit, 1969.

Shipley, James R., and Weller, Allen S. Introduction to *Contemporary American Painting and Sculpture 1969.* Krannert Art Museum, University of Illinois, Champaign-Urbana, Mar. 2–Apr. 6, 1969.

Taylor, John Lloyd, and Atkinson, Tracy. Introduction to *Directions 2: Aspects of a New Realism.* Milwaukee Art Center, June 28–Aug. 10, 1969; Contemporary Arts Museum, Houston, Sept. 17–Oct. 19, 1969; Akron Art Center, Ohio, Nov. 9–Dec. 14, 1969.

Warrum, Richard L. Introduction to *Painting and Sculpture Today, 1969.* Foreword by Robert J. Rohn. Indianapolis Museum of Art, May, 1969.

Brewer, Donald. Introduction to *Beyond the Actual—Contemporary California Realist Painting.* Pioneer Museum and Haggin Galleries, Stockton, Calif., Nov. 6–Dec. 6, 1970.

Brown, Denise Scott, and Venturi, Robert. Introduction to *The Highway.* Institute of Contemporary Art, University of Pennsylvania, Philadelphia, Jan. 14–Feb. 25, 1970; Institute for the Arts, Rice University, Houston, Mar. 12–May 18, 1970; Akron Art Institute, Ohio, June 5–July 16, 1970.

Directly Seen: New Realism in California. Newport Harbor Art Museum, Balboa, Calif., 1970.

Graphics 71. University of Kentucky, Lexington (circulated by the Smithsonian Institution), 1971.

Monte, James. Introduction to *Twenty-two Realists.* Whitney Museum of American Art, New York, Feb., 1970.

Selz, Peter. Introduction to *American Painting 1970.* Foreword by James M. Brown. Virginia Museum of Fine Arts, Richmond, May 4–June 7, 1970.

Warrum, Richard L. Introduction to *Painting and Sculpture Today, 1970.* Foreword by Robert J. Rohn. Indianapolis Museum of Art, May, 1970.

West Coast 70: Crocker Biennial. E. B. Crocker Art Gallery, Sacramento, Calif., 1970.

Goldsmith, Benedict. *New Realism.* Brainerd Hall Art Gallery, State University College, Potsdam, N.Y., Nov. 5–Dec. 12, 1971.

Karp, Ivan C. Introduction to *Radical Realism.* Museum of Contemporary Art, Chicago, May 22–June 4, 1971.

Amman, Jean Christophe. Introduction to *Documenta 5.* Neue Galerie and Museum Fridericianum, Kassel, West Germany, June 30–Oct. 8, 1972.

Art Around 1970. Neue Galerie der Stadt Aachen, West Germany, 1972.

Baratte, John J., and Thompson, Paul E. *Phases of the New Realism.* Lowe Art Museum, University of Miami, Coral Gables, Fla., Jan. 20–Feb. 20, 1972.

Janis, Sidney. Introduction to *Sharp-Focus Realism.* Sidney Janis Gallery, New York, Jan. 6–Feb. 4, 1972.

Walls, Michael. *California Republic.* Foreword by Robert Ballard. Govett–Brewster Art Gallery, New Plymouth, New Zealand, 1972.

Baur, John I. H. Foreword to *1973 Whitney Biennial.* Whitney Museum of American Art, New York, Jan. 10–Mar. 18, 1973.

Burton, Scott. *The Realist Revival.* New York Cultural Center, New York, Dec. 6, 1972–Jan. 7, 1973.

Schneede, Uwe, and Hoffman, Heinz. Introduction to *Amerikanischer Fotorealismus.* Württembergischer Kunstverein, Stuttgart, Nov. 16–Dec. 26, 1972; Frankfurter Kunstverein, Frankfurt, Jan. 6–Feb. 18, 1973; Kunst und Museumsverein Wuppertal, West Germany, Feb. 25–Apr. 8, 1973.

Alloway, Lawrence. Introduction to *Photo-Realism.* Serpentine Gallery, London, Apr. 4–May 6, 1973.

American Art. Seattle Art Museum, Wash., 1973.

Robert Bechtle. John Berggruen Gallery, San Francisco, Oct. 22–Nov. 24, 1973.

Becker, Wolfgang. Introduction to *Mit Kamera, Pinsel und Spritzpistole.* Ruhrfestspiele Recklinghausen, Städtische Kunsthalle, Recklinghausen, West Germany, May 4–June 17, 1973.

Dali, Salvador. Introduction to *Grands maîtres hyperréalistes américains.* Galerie des.Quatre Mouvements, Paris, May 23–June 25, 1973.

Dreiband, Laurence. Notes to *Separate Realities.* Foreword by Curt Opliger. Los Angeles Municipal Art Gallery, Sept. 19–Oct. 21, 1973.

Ekstrem realisme. Louisiana Museum, Humlebaek, Denmark, 1973.

Hogan, Carroll Edwards. Introduction to *Hyperréalistes américains.* Galerie Arditti, Paris, Oct. 16–Nov. 30, 1973.

Lucie-Smith, Edward. Introduction to *Image, Reality, and Superreality.* Arts Council of Great Britain traveling exhibition, 1973.

Meisel, Louis K. *Photo-Realism 1973: The Stuart M. Speiser Collection.* New York, 1973.

Radde, Bruce. Introduction to *East Coast/West Coast/New Realism.* University Art Gallery, San Jose State University, Calif., Apr. 24–May 18, 1973.

Van der Marck, Jan. Text to *American Art Third Quarter Century.* Foreword by Thomas N. Maytham and Robert B. Dootson. Seattle Art Museum, Wash., Aug. 22–Oct. 14, 1973.

Karp, Ivan C., and McKillop, Susan. *Robert Bechtle: A Retrospective Exhibition.* E. B. Crocker Art Gallery, Sacramento, Calif., Sept. 15–Oct. 14, 1973; Fine Arts Gallery of San Diego, Calif., Dec. 8, 1973–Jan. 20, 1974.

Amerikaans fotorealisme grafiek. Hedendaagse Kunst, Utrecht, Aug., 1974; Palais des Beaux-Arts, Brussels, Sept.–Oct., 1974.

Chase, Linda. "Photo-Realism." In *Tokyo Biennale 1974.* Tokyo Metropolitan Museum of Art; Kyoto Municipal Museum; Aichi Prefectural Art Museum, Nagoya, 1974.

Davis, William. *Living American Artists and the Figure.* Foreword by William Hull. Pennsylvania State University, University Park, Nov. 2–Dec. 22, 1974.

Walthard, Dr. Frederic P. Foreword to *Art 5 '74.* Basel, Switzerland, June 19–24, 1974.

Wyrick, Charles, Jr. Introduction to *Contemporary American Paintings from the Lewis Collection.* Delaware Art Museum, Wilmington, Sept. 13–Oct. 17, 1974.

Dyer, Carlos. Introduction to *A Change of View.* Foreword by Larry Aldrich. Aldrich Museum, Ridgefield, Conn., Fall, 1975.

Meisel, Susan Pear. *Watercolors and Drawings—American Realists.* Louis K. Meisel Gallery, New York, Jan., 1975.

Phillips, Robert F. Introduction to *Image, Color and Form: Recent Paintings by Eleven Americans.* Toledo Museum of Art, Ohio, Jan. 12–Feb. 9, 1975.

Stebbins, Theodore E., Jr. Introduction to *Richard Brown Baker Collects.* Yale University Art Gallery, New Haven, Conn., Apr. 24–May 22, 1975.

Richardson, Brenda. Introduction to *Super Realism.* Baltimore Museum of Art, Nov. 18, 1975–Jan. 11, 1976.

Doty, Robert. *Contemporary Images in Watercolor.* Akron Art Institute, Ohio, Mar. 14–Apr. 25, 1976; Indianapolis Museum of Art, June 29–Aug. 8, 1976; Memorial Art Gallery, Rochester, N.Y., Oct. 1–Nov. 11, 1976.

Taylor, Joshua C. Introduction to *America as Art.* National Collection of Fine Arts, Washington, D.C., 1976.

Walthard, Dr. Frederic P. Introduction to *Art 7 '76.* Basel, Switzerland, June 16–21, 1976.

Chase, Linda. "U.S.A." In *Aspects of Realism.* Rothman's of Pall Mall Canada, Ltd., June, 1976–Jan., 1978.

Kleppe, Thomas S.; Rosenblum, Robert; and Welliver, Neil. *America 1976.* Corcoran Gallery of Art, Washington, D.C., Apr. 27–June 6, 1976; Wadsworth Atheneum, Hartford, Conn., July 4–Sept. 12, 1976; Fogg Art Museum, Cambridge, Mass., and Institute of Contemporary Art, Boston, Oct. 19–Dec. 7, 1976; Minneapolis Institute of Arts, Jan. 16–Feb. 27, 1977; Milwaukee Art Center, Mar. 19–May 15, 1977; Fort Worth Art Museum, June 18–Aug. 14, 1977; San Francisco Museum of Modern Art, Sept. 10–Nov. 13, 1977; High Museum of Art, Atlanta, Dec. 10, 1977–Feb. 5, 1978; Brooklyn Museum, New York, Mar. 11–May 21, 1978.

Friedman, Martin; Pincus-Witten, Robert; and Gay, Peter. *A View of a Decade.* Museum of Contemporary Art, Chicago, 1977.

Karp, Ivan. Introduction to *New Realism: Modern Art Form.* Boise Gallery of Art, Idaho, Apr. 14–May 29, 1977.

Stringer, John. Introduction to *Illusion and Reality.* Australian Gallery Directors' Council, North Sydney, N.S.W., 1977–78.

Hodge, G. Stuart. Foreword to *Art and the Automobile.* Flint Institute of Arts, Mich., Jan. 12–Mar. 12, 1978.

Meisel, Susan Pear. Introduction to *The Complete Guide to Photo-Realist Printmaking.* Louis K. Meisel Gallery, New York, Dec., 1978.

Stokes, Charlotte. "As Artists See It: America in the 70s." In *America in the 70s As Depicted by Artists in the Richard Brown Baker Collection.* Meadowbrook Art Gallery, Oakland University, Rochester, Mich., Nov. 18–Dec. 16, 1979.

Butler, Susan L. Introduction to *Late Twentieth Century Art from the Sidney and Frances Lewis Foundation.* Institute of Contemporary Art of the University of Pennsylvania, Mar. 22–May 2, 1979; Dayton Art Institute, Ohio, Sept. 13–Nov. 4, 1979; Brooks Memorial Art Gallery, Memphis, Dec. 2, 1979–Jan. 27, 1980; Dupont Gallery, Washington and Lee University, Lexington, Va., Feb. 18–Mar. 21, 1980.

Landis, Ellen. Introduction to *Reflections of Realism.* Museum of Albuquerque, Sept. 1, 1979–Jan. 30, 1980.

ARTICLES

"Exhibition: Artists' Gallery," *Art Digest 28,* Dec. 1, 1953, p. 22.

Nordland, Gerald. "Art: John Altoon," *Frontier Magazine,* Oct., 1958.

———. "Altoon, A Scrupulous Draftsman," *Los Angeles Mirror,* Jan. 23, 1961.

Magloff, Joanna. "Art News from San Francisco," *ARTnews,* Apr., 1964, p. 20.

Reuschel, John. "John Altoon: Four Drawings," *Artforum 2,* Feb., 1964, p. 30.

Seldis, Henry J. "In the Galleries: Altoon Expands Pop Art Horizons," *Los Angeles Times,* May 18, 1964.

Ventura, Anita. "Pop, Photo and Paint," *Arts,* Apr., 1964, pp. 50–54.

Perkins, Constance. "In the Galleries: Altoon Provides Window on Subconscious," *Los Angeles Times,* Feb. 5, 1965.

Metcalf, Katherine. "Reviews: San Francisco," *ARTnews,* Feb., 1966.

Monte, James. "San Francisco," *Artforum,* Oct., 1966.

Seldis, Henry J. "In the Galleries: John Altoon Satirizes Man at Stuart Galleries," *Los Angeles Times,* Dec. 16, 1966.

Frankenstein, Alfred. "Realism Brought Down to Date," *San Francisco Chronicle,* Feb. 2, 1967.

French, Palmer. "San Francisco," *Artforum,* Oct., 1967.

Fried, Alexander. "Review," *San Francisco Examiner,* Aug. 11, 1967.

Gruen, John. "The Shape of Things," *New York Magazine,* Sept. 8, 1969.

Nilson, Karl-Gustav. "Realism U.S.A.," *Konstrevy* (Stockholm), no. 2 (Nov. 2, 1969), pp. 68–71.

Pincus-Witten, Robert. "Direct Representation at the Fischbach Gallery," *Artforum,* Nov., 1969.

Schjeldahl, Peter. "Exhibition at Fischbach Gallery," *Art International,* Nov., 1969.

Alloway, Lawrence. "Notes on Realism, Exhibition at Whitney Museum," *Arts Magazine,* Apr., 1970.

Atkinson, Tracy, and Taylor, John Lloyd. "Likenesses, Aspects of a New Realism at Milwaukee Art Center," *Art and Artist,* Feb., 1970.

Davis, Douglas. "Return of the Real: Twenty-two Realists on View at New York's Whitney," *Newsweek,* Feb. 23, 1970, p. 105.

Genauer, Emily. "On the Arts," *Newsday,* Feb. 21, 1970.

Lord, Barry. "The Eleven O'Clock News in Colour," *Arts Canada,* June, 1970.

Marandel, J. Patrice. "Review," *Art International,* May, 1970.

Pincus-Witten, Robert. "Twenty-two Realists, Whitney Museum," *Artforum,* Apr., 1970.

Ratcliff, Carter. "Twenty-two Realists Exhibit at the Whitney," *Art International,* Apr., 1970, p. 105.

Marandel, J. Patrice. "The Deductive Image: Notes on Some Figurative Painters," *Art International,* Sept., 1971, pp. 58–61.

Sager, Peter. "Neue Formen des Realismus," *Magazin Kunst,* 4th Quarter, 1971, pp. 2512–16.

Amman, Jean Christophe. "Realismus," *Flash Art,* May–July, 1972, pp. 50–52.

Chase, Linda; Foote, Nancy; and McBurnett, Ted. "The Photo-Realists: 12 Interviews," *Art in America,* vol. 60, no. 6 (Nov.–Dec., 1972), pp. 73–89.

"Les hommes et les oeuvres," *La Galerie,* no. 120 (Oct., 1972), pp. 16–17.

Karp, Ivan. "Rent Is the Only Reality, or the Hotel Instead of the Hymn," *Arts Magazine,* Dec., 1972, pp. 47–51.

Kurtz, Bruce. "Documenta 5: A Critical Preview," *Arts Magazine,* Summer, 1972, pp. 34–41.

Levequi, J. J. "Les hommes et les oeuvres," *Argus de la Presse,* Oct., 1972.

Muller, W. K. "Prints and Multiples," *Arts Magazine,* Apr., 1972, p. 28.

Naimer, Lucille. "In the Galleries," *Arts Magazine,* Feb., 1972.

O'Doherty, Brian. "Robert Bechtle," *Art in America,* Nov.–Dec., 1972, pp. 73–74.

Pozzi, Lucio. "Super Realisti U.S.A.," *Bolaffiarte,* no. 18 (Mar., 1972), pp. 54–63.

Ratcliff, Carter. "New York Letter," *Art International,* Feb., 1972, pp. 54–55.

Rosenberg, Harold. "The Art World," *The New Yorker,* Feb. 5, 1972, pp. 88–93.

Schulze, Franz. "It's Big, and It's Superreal," *Chicago Daily News,* Feb. 12–13, 1972, p. 6.

Seitz, William C. "The Real and the Artificial: Painting of the New Environment," *Art in America,* Nov.–Dec., 1972, pp. 58–72.

Wasmuth, E. "La révolte des réalistes," *Connaissance des Arts,* June, 1972, pp. 118–23.

Wolmer, Bruce. "Reviews and Previews," *ARTnews,* Feb., 1972.

Albright, Thomas. "An Artist with Vision," *San Francisco Chronicle,* Oct. 26, 1973.

Bell, Jane. "Stuart M. Speiser Collection," *Arts Magazine,* Dec., 1973, p. 57.

Chase, Linda. "Recycling Reality," *Art Gallery Magazine,* Oct., 1973, pp. 75–82.

Chase, Linda, and McBurnett, Ted. "Interviews with Robert Bechtle, Tom Blackwell, Chuck Close, Richard Estes, and John Salt," *Opus International,* no. 44–45 (June, 1973), pp. 38–50.

Dunham, Judith. "Robert Bechtle Print Retrospective," *Art Week,* Nov. 10, 1973.

Frankenstein, Alfred. "A Cool Retrospective of a Master New Realist," *San Francisco Chronicle,* Oct. 7, 1973.

Fried, Alexander. "Turning Photos into Subtle Art," *San Francisco Examiner,* Nov. 6, 1973.

Geeting, Corinne. "Today's Pilgrims," *Christian Science Monitor,* Nov. 21, 1973.

Guercio, Antonio del. "Iperrealismo tra 'pop' e informale," *Rinascita,* no. 8 (Feb. 23, 1973), p. 34.

Hjort, Oysten. "Kunstmiljoeti Rhinlandet," *Louisiana Revy,* vol. 13, no. 3 (Feb., 1973).

"L'Hyperréalisme américain," *Le Monde des Grandes Musiques,* no. 2 (Mar.–Apr., 1973), pp. 4, 56–57.

Johnson, Charles. "A New Realist Takes a Look at Parked Cars," *Sacramento Bee,* Sept. 16, 1973.

Markell, John. "Robert Bechtle's Photo Realism," *Daily Californian Arts Magazine* (Berkeley), Nov. 2, 1973.

Michael, Jacques. "Le super-réalisme," *Le Monde,* Feb. 6, 1973, p. 23.

Mizue (Tokyo), vol. 8, no. 821 (1973).

Nochlin, Linda. "The Realist Criminal and the Abstract Law," *Art in America,* Nov.–Dec., 1973, p. 102.

Seldis, Henry J. "New Realism; Crisp Focus on the American Scene," *Los Angeles Times,* Jan. 21, 1973, p. 54.

"Stuart Speiser Collection," *Art International,* Nov., 1973.

Chase, Linda. "The Connotation of Denotation," *Arts Magazine,* Feb., 1974, pp. 38–41.

Davis, Douglas. "Summing Up the Season," *Newsweek,* July 1, 1974, p. 73.

Frank, Peter. "On Art," *Soho Weekly News,* Apr. 18, 1974, p. 14.

———. "On Art," *Soho Weekly News,* May 16, 1974, pp. 19, 22.

"Flowers, Planes and Landscapes in New Art Exhibits," *Saturday Times-Union* (Rochester, N.Y.), Jan. 5, 1974.

"Gallery Notes," *Memorial Art Gallery of the University of Rochester Bulletin,* vol. 39, no. 5 (Jan., 1974).

Hughes, Robert. "An Omnivorous and Literal Dependence," *Arts Magazine,* June, 1974, pp. 25–29.

Levin, Kim. "Audrey Flack at Meisel," *Art in America,* May–June, 1974, p. 106.

Loring, John. "Photographic Illusionist Prints," *Arts Magazine,* Feb., 1974, pp. 42–43.

Schjeldahl, Peter. "Too Easy To Be Art?," *New York Times,* May 12, 1974, p. 23.

Slipek, Edwin J., Jr. "Multi-Dimensional Works on Paper," *Richmond* (Va.) *Mercury,* Oct. 23, 1974, p. 19.

Virginia Museum Bulletin, vol. XXXV, no. 1 (Sept., 1974).

Albright, Thomas. "A Wide View of the New Realists," *San Francisco Chronicle,* Feb. 6, 1975, p. 38.

Bruner, Louise. "Brash Paintings Stimulate Thinking Rather than Passive Thoughts," *Toledo Blade,* Jan. 12, 1975, p. 4.

Fagan, Beth. "Coast Artists Credited with Realism's Growth," *Portland Oregonian,* Sept. 21, 1975.

Hull, Roger. "Realism in Art Returns with Camera's Clarity," *Portland Oregonian,* Sept. 14, 1975.

Lucie-Smith, Edward. "The Neutral Style," *Art and Artists,* vol. 10, no. 5 (Aug., 1975), pp. 6–15.

"Photo-Realism Exhibit Is Opening at Paine Sunday," *Oshkosh Daily Northwestern,* Apr. 17, 1975.

"Photo-Realism Flies High at Paine," *Milwaukee Journal,* May, 1975.

"Photo-Realists at Paine," *View Magazine,* Apr. 27, 1975.

Sutinen, Paul. "American Realism at Reed," *Willamette Week,* Sept. 12, 1975.

Wolfe, Tom. "The Painted Word," *Harper's,* Apr., 1975, pp. 91–92.

Borlase, Nancy. "Art," *Sydney Morning Herald,* Dec. 30, 1976.

Chase, Linda. "Photo-Realism: Post Modernist Illusionism," *Art International,* vol. XX, no. 3–4 (Mar.–Apr., 1976), pp. 14–27.

Forgey, Benjamin. "The New Realism, Paintings Worth 1,000 Words," *Washington Star,* Nov. 30, 1976, p. G 24.

Fox, Mary. "Aspects of Realism," *Vancouver Sun,* Sept. 21, 1976.

K. M. "Realism," *New Art Examiner,* Nov., 1976.

Larson, Kay. "Painting the Public Lands," *ARTnews,* Jan., 1976.

McDonald, Robert. "Richard McLean and Robert Cottingham," *Artweek,* Oct. 16, 1976, pp. 3–4.

Perreault, John. "Getting Flack," *Soho Weekly News,* Apr. 22, 1976, p. 19.

Rosenblum, Robert. "Painting America First," *Art in America,* Jan.–Feb., 1976, pp. 82–85.

Greenwood, Mark. "Toward a Definition of Realism: Reflections on the Rothman's Exhibition," *Arts/Canada,* vol. XXIV, no. 210–11 (Dec., 1976–Jan., 1977), pp. 6–23.

Borlase, Nancy. "In Selecting a Common Domestic Object," *Sydney Morning Herald,* July 30, 1977.

"Illusion and Reality," *This Week in Brisbane,* June, 1977.

Makin, Jeffrey. "Realism from the Squad," *Melbourne Sun,* Oct. 19, 1977, p. 43.

Perreault, John. "Four Artists," *Soho Weekly News,* Dec. 29, 1977.

Phillips, Ralph. "Just Like the Real Thing," *Sunday Mail* (Brisbane), Sept. 11, 1977.

Pidgeon, W. E. "In Search of Reality," *Sunday Telegraph* (New South Wales), July 31, 1977.

Raynor, Vivian. "Art: While Waiting for Tomorrow," *New York Times,* Dec. 29, 1977.

Bongard, Willie. *Art Aktuell* (Cologne), Apr., 1978.

Harris, Helen. "Art and Antiques: The New Realists," *Town and Country,* Oct., 1978, pp. 242, 244, 246–47.

Karlstrom, Paul. "San Francisco," *Archives of American Art Journal,* vol. 18, no. 3 (1978), p. 30.

Mackie, Alwynne. "New Realism and the Photographic Look," *American Art Review,* Nov., 1978, pp. 72–79, 132–34.

Harshman, Barbara. "Photo-Realist Printmaking," *Arts Magazine,* Feb., 1979, p. 17.

Richard, Paul. "New Smithsonian Art: From 'The Sublime' to Photo Realism," *Washington Post,* Nov. 30, 1978, p. G21.

BOOKS

Kultermann, Udo. *New Realism.* New York: New York Graphic Society, 1972.

Brachot, Isy, ed. *Hyperréalisme.* Brussels: Imprimeries F. Van Buggenhoudt, 1973.

Sager, Peter. *Neue Formen des Realismus.* Cologne: Verlag M. DuMont Schauberg, 1973.

Who's Who in American Art. New York: R. R. Bowker, 1973.

L'Iperrealismo italo Medusa. Rome: Romana Libri Alfabeto, 1974.

Plagens, Peter. *Sunshine Muse: Contemporary Art on the West Coast.* New York: Praeger, 1974.

Battcock, Gregory, ed. *Super Realism, A Critical Anthology.* New York: E. P. Dutton, 1975.

Chase, Linda. *Hyperréalisme.* New York: Rizzoli, 1975.

Kultermann, Udo. *Neue Formen des Bildes.* Tübingen, West Germany: Verlag Ernst Wasmuth, 1975.

Lucie-Smith, Edward. *Late Modern—The Visual Arts Since 1945.* 2d ed. New York: Praeger, 1975.

Rose, Barbara, ed. *Readings in American Art, 1900–1975.* New York: Praeger, 1975.

Honisch, Dieter, and Jensen, Jens Christian. *Amerikanische Kunst von 1945 bis Heute.* Cologne: DuMont Buchverlag, 1976.

Who's Who in American Art. New York: R. R. Bowker, 1976.

Wilmerding, John. *American Art.* Harmondsworth, England: Penguin, 1976.

Cummings, Paul. *Dictionary of Contemporary American Artists.* 3d ed. New York: St. Martin's Press, 1977.

Rose, Barbara (with Jules D. Brown). *American Painting.* New York: Skira, Rizzoli, 1977.

Lucie-Smith, Edward. *Super Realism.* Oxford: Phaidon, 1979.

Seeman, Helene Zucker, and Siegfried, Alanna. *SoHo.* New York: Neal-Schuman, 1979.

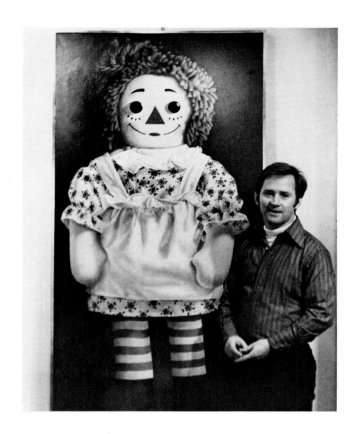

108. Charles Bell with *Raggedy Ann No. 1*

CHARLES BELL

Although Charles Bell had been painting and drawing all his life, his decision to seriously pursue a career as a fine artist came only in the early sixties, in California, after finishing a tour of duty in the navy. He took a job to support himself and began the final development of the Photo-Realist style for which he is known today. Speaking of his California experience, Bell says, ''In the early sixties in California when I decided to become a painter I was strongly influenced by Diebenkorn and Thiebaud, who were showing out there. And of course there was Pop. It was so refreshing to see subject matter reintroduced into painting. The more research I did the further I got into realism and eventually did a lot of experimentation with trompe-l'oeil. You had to be something of a renegade to be a realist back then. What I try to do is create a very 'today' image but by using techniques which are really quite traditional. I find the camera ideal for my work not only because it allows a complexity in subject matter which would be otherwise virtually impossible, but the lens eye view gives a special 'today' quality to visual experience, thanks to our daily media bombardment.'' Subsequently, in 1967, Bell came east to New York, and set up his first studio.

While almost all the West Coast Photo-Realists can be called landscape painters in a loose sense, Bell turned to still life, which was more in evidence in the works of the New York painters (Flack, Schonzeit, Kacere, and, to some extent, Kleemann and Blackwell). The West Coasters were painting horses, trucks, houses, and cars as part of an overall landscape in a scale much smaller than lifesize, but Bell's vision was almost diametrically opposed—to him the subject was all that counted and he painted it five to ten times lifesize.

Bell's choice of the still-life format developed from his research into classicism and his concern for controlling compositional elements. His choice of subjects is determined by their presentation as ''blow-ups.'' (It is interesting to note that artists such as Close, Flack, Kacere, and Schonzeit also use blow-ups, though for different reasons.) Bell says, ''For myself, choosing subjects is definitely an emotional process rather

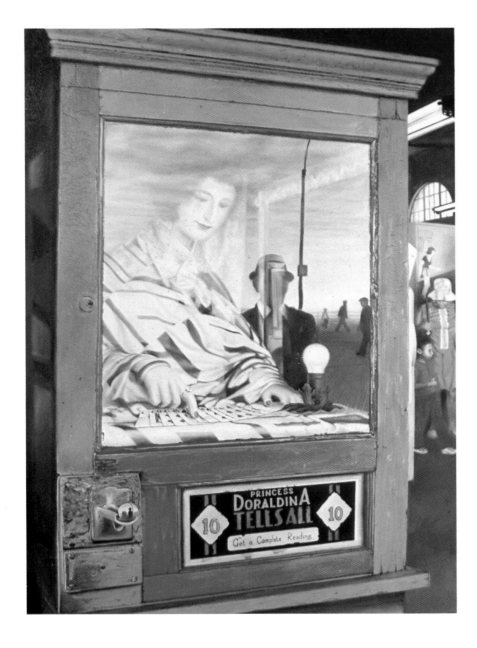

109. *Fortune Teller.* 1974 (18).
Oil on canvas, 80 x 50".
Private collection

than an intellectual exercise. A large part of the process is dispassionately putting things together with disregard for what the objects are except as tools for composition; yet part of it is very much concerned with the subject. By radically changing the size of everyday objects we can get into them and more easily explore their surfaces and construction—their reality. I am also concerned with the feelings we share about familiar objects, but not in a nostalgic way. Rather, it's like the feeling you get when you discover that a place you have seen in a hundred postcards really is beautiful. I'm saying, 'Hey, look, these everyday things really are terrific.' '' Much of the impact of Bell's work comes from scale, composition, and a strong palette, but it is an interest in the use of light that uniquely characterizes his work. Light plays an active part in all his paintings.

There have been three distinct periods, or series, in Bell's work, and each of them began with a specific challenge posed by light. Subject matter was then chosen that would best present the particular technical challenge Bell wanted to overcome.

In his first series, Bell wanted to explore the problems of how light, reflected from all types of surfaces, can be convincingly painted. More specifically, he wished to portray reflected light coming from outside the picture space. On the basis of previous decisions concerning the need for an object that was small enough to be painted much larger than lifesize, one that was strongly and brightly colored, and one that evoked something of a nostalgic sense, Bell selected small toys made of wood, plastic, metal, and other materials for this series. He acquired the toys and set up his still lifes with exactly the lighting situations he wanted. Because light, shadows, and

reflections change with the movement of the viewer, it was necessary to photograph the setup and work from the slide, which remained constant during the three to six months of painting. The first painting in this series was the standing Raggedy Ann (pl. 144); the series ended with one of Bell's best-known works, *Seaplane in Bathtub* (pl. 117). This final painting was commissioned in 1972 by Stuart M. Speiser and became a crucial work since it led to Bell's most famous series, the Gumball Machine paintings.

While setting up the seaplane painting and then in executing it, Bell became interested in how light was reflected, refracted, diffused, and distorted in water. His second series concerned how to work with refracted and reflected light. Although the gumball machines were not very different from the toys as objects, the glass globes with their different thicknesses and shapes, and their imperfections, affected light in just the way Bell wanted. For the next four years, Bell concentrated on this series until, in 1977, he felt that he had accomplished what he had set out to do.

As a side effect of this series, Bell began photographing with a very narrow field of focus, as is evident in the blurred, out-of-focus areas in the backgrounds or foregrounds of the paintings. This concern with focus has become a very important aspect of Bell's Photo-Realist philosophy, and can also be seen in the paintings of Close, Flack, and Schonzeit. It is not a part of West Coast work nor can it be found in Estes's work. In fact, Estes will take three focus settings of the same image so as to paint the foreground, middle range, and background all in clear and sharp focus. Bechtle, McLean, and Goings shoot with a wide field of focus for the same reason.

In 1977, seeking a subject that would really confront the focus problem as well as a new challenge relating to light, Bell hit on the Pinball Machine. In his third series, Bell was to work with the light source coming from within or projecting from the subject itself. *Double Advance* (pl.151), a late painting in this series, embodies solutions to the most difficult problems in Photo-Realist painting and is one of the most complex works I know of in the movement. When part of a picture is as far out of focus as the foreground is in this painting, it becomes almost impossible for the artist to determine what is happening in the photo. Deciding how to paint such an area requires hours of studying, overpainting, and glazing. To make the light appear to be coming from the painted surface without using dayglo paints or other tricks demands an enormous knowledge of how paint and color interact.

Bell has studied and researched paint and technique for twenty years, and has delved into the works of every important realist painter from Vermeer to Dali. At one point, Dali asked Bell to work with him on one of his projects. Dali was impressed that Bell had independently discovered and developed most of Dali's "fifty magic secrets." Although the project was never realized, Bell learned from Dali. Dali and his wife, Gala, however, could not understand why Bell wanted to paint out of focus.

Bell knows more about paints, glazes, and technique than any other contemporary painter I know. Much of his knowledge—considered unimportant by the major movements of the fifties and sixties—gives his Photo-Realist paintings their special depth and glorious, glowing color.

As of the end of 1979, Charles Bell had painted 38 oils and done five watercolors, one pastel, and one drawing. Of these, 44 are illustrated herein. The remaining work is a second, similar version of plate 144; its whereabouts is unknown.

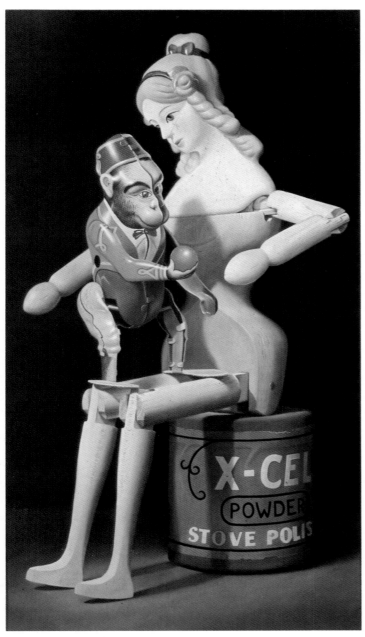

110. *Manikin Monkey*. 1972 (11). Oil on canvas, 72 x 40".
Collection Richard Clair, New York

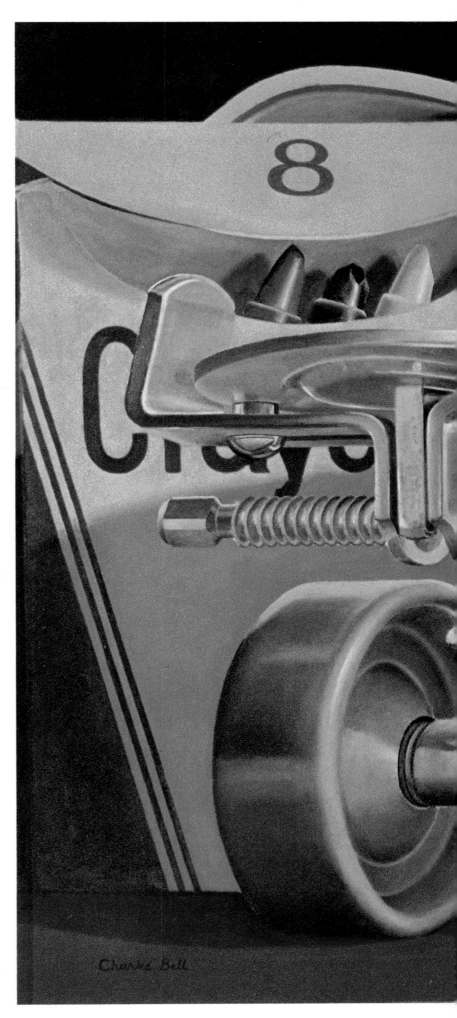

111. *Skate*. 1971 (2).
Oil on canvas, 36 x 48".
Private collection

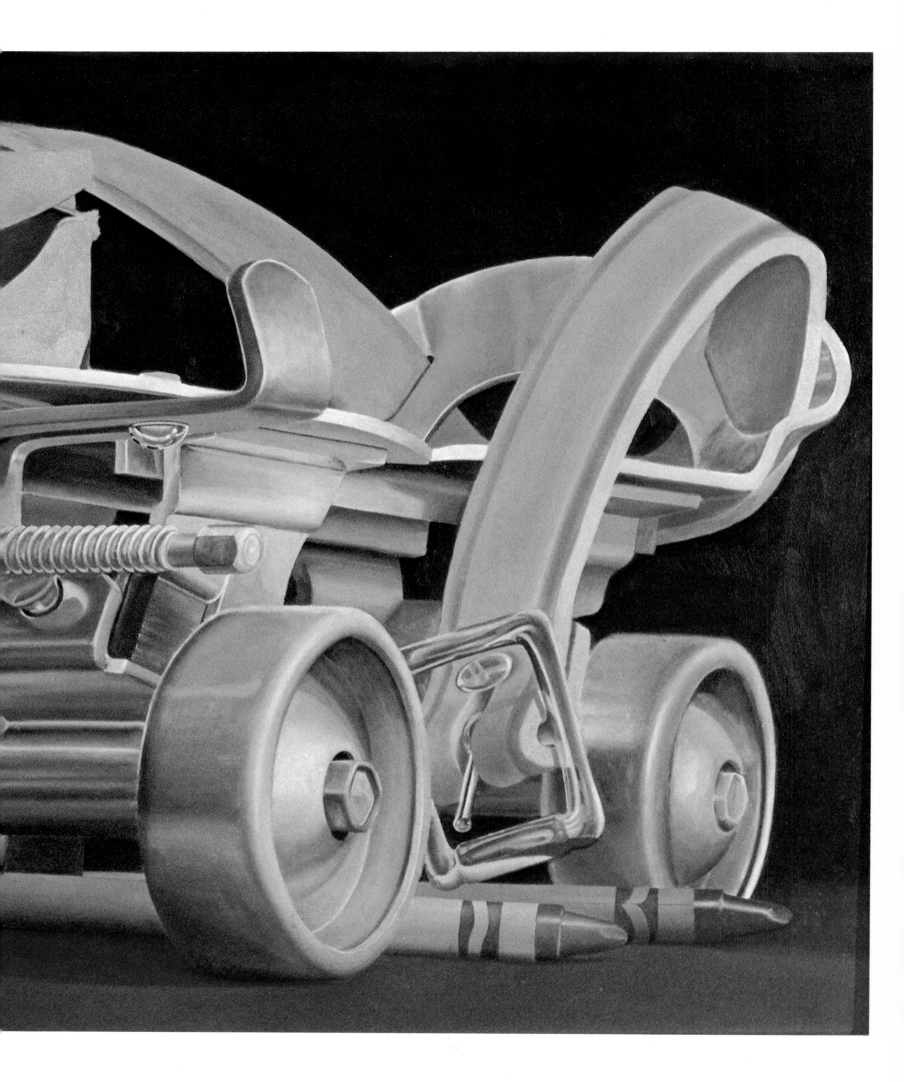

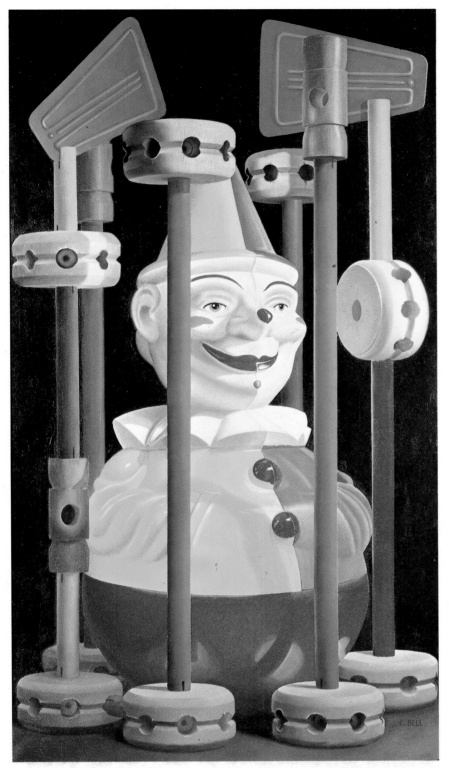

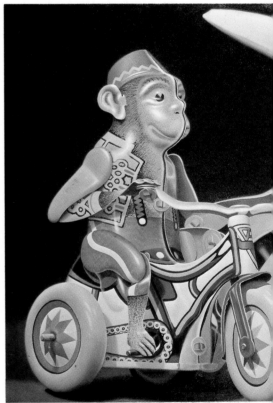

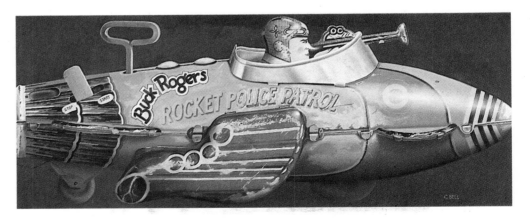

112. *Tinker Toy.* 1972 (5). Oil on canvas, 72 x 40".
Collection Mr. Herbert Allen, New York

113. *Bunny Cycle.* 1972 (12). Oil on
canvas, c. 48 x 60". Collection
Mr. and Mrs. Morton G. Neumann, Ill.

114. *Buck Rogers.* c. 1972 (7).
Oil on canvas, 24 x 60".
Collection Patricia Field and
Jo-Ann Salvucci, New York

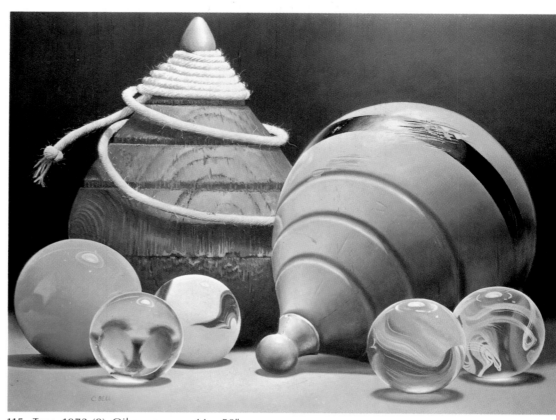

115. *Tops*. 1972 (9). Oil on canvas, 44 x 58".
Collection Ms. Carmel Roth, New York

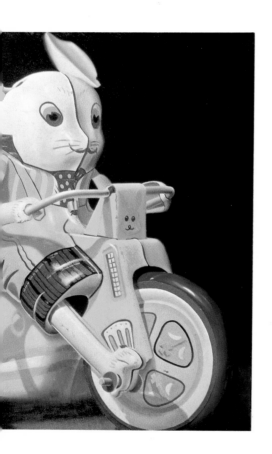

116. *Donald Duck*. 1972 (6).
Oil on canvas, 54 x 40".
Collection Mr. Herbert Allen, New York

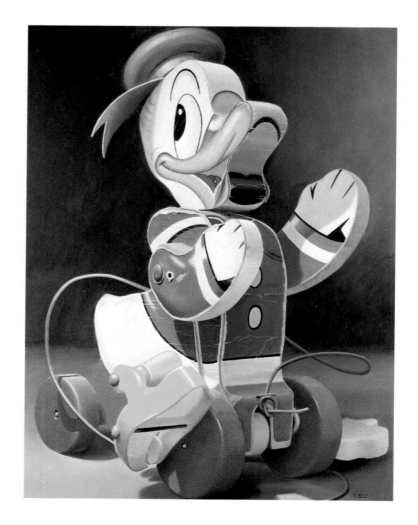

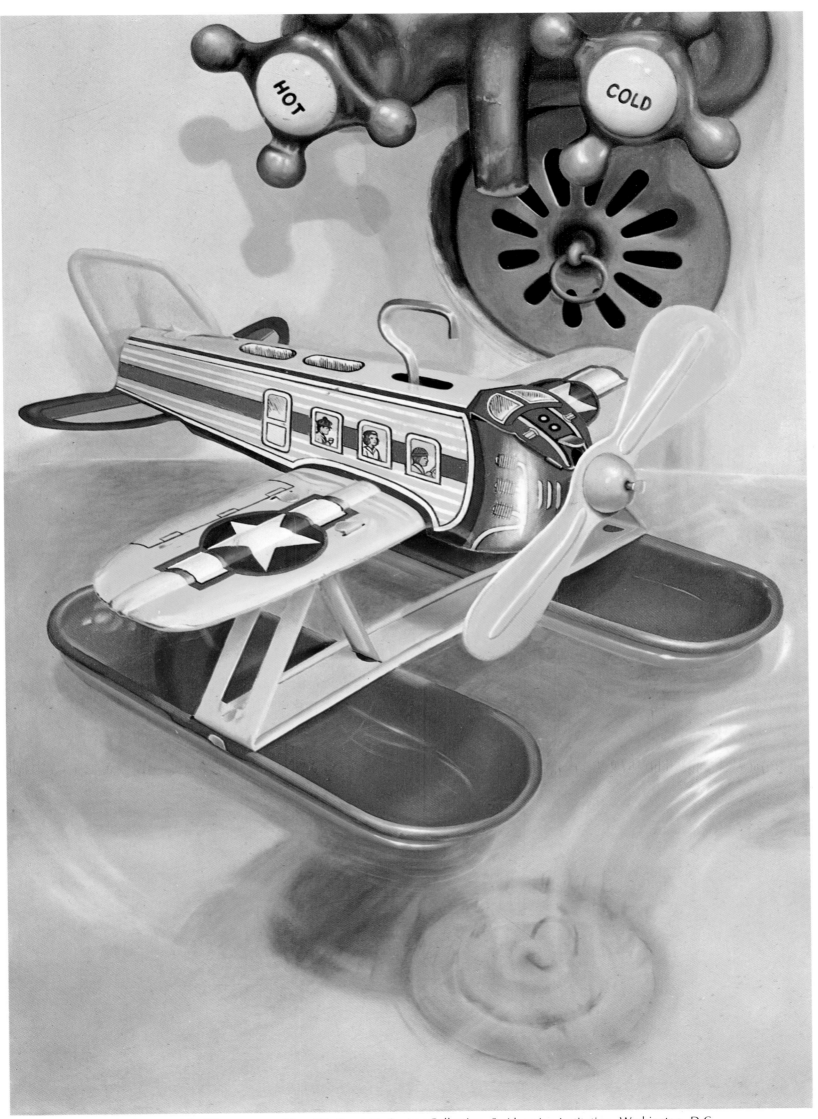

117. *Seaplane in Bathtub.* 1973 (14). Oil on canvas, 68 x 48″. Stuart M. Speiser Collection, Smithsonian Institution, Washington, D.C.

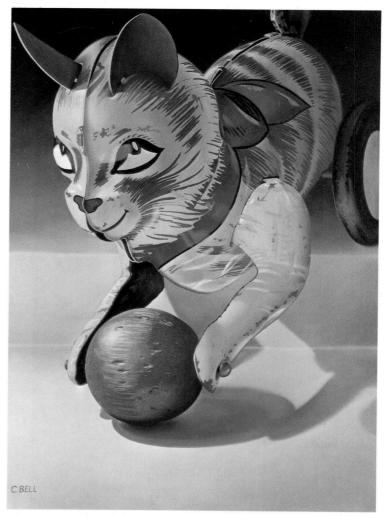

118. *Cat.* 1973 (10). Oil on canvas, 45 x 37".
Collection Miriam Groman, Calif.

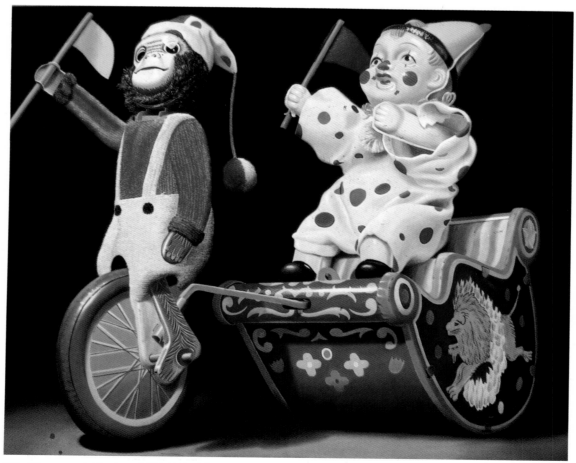

119. *Clown and Monkey*. 1972 (13). Oil on canvas, 50 x 62". Collection Richard Chestnov and
Harvey Gold, New York

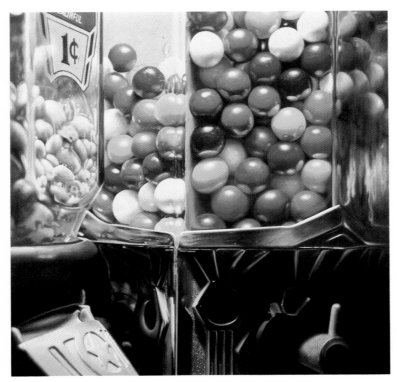

120. *Gum Ball No. 8.* 1975 (25). Oil on canvas, 48 x 48".
Collection Richard Chestnov and Harvey Gold, New York

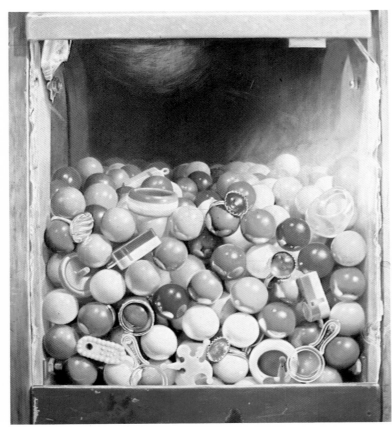

121. *Gum Ball No. 6.* 1974 (21). Oil on canvas, 54 x 50".
Collection Richard Belger, Mo.

122. *Gum Ball No. 5* "Thank You." 1974 (20). Oil on canvas, 72 x 90".
Collection Jim and Myra Morgan, Kans.

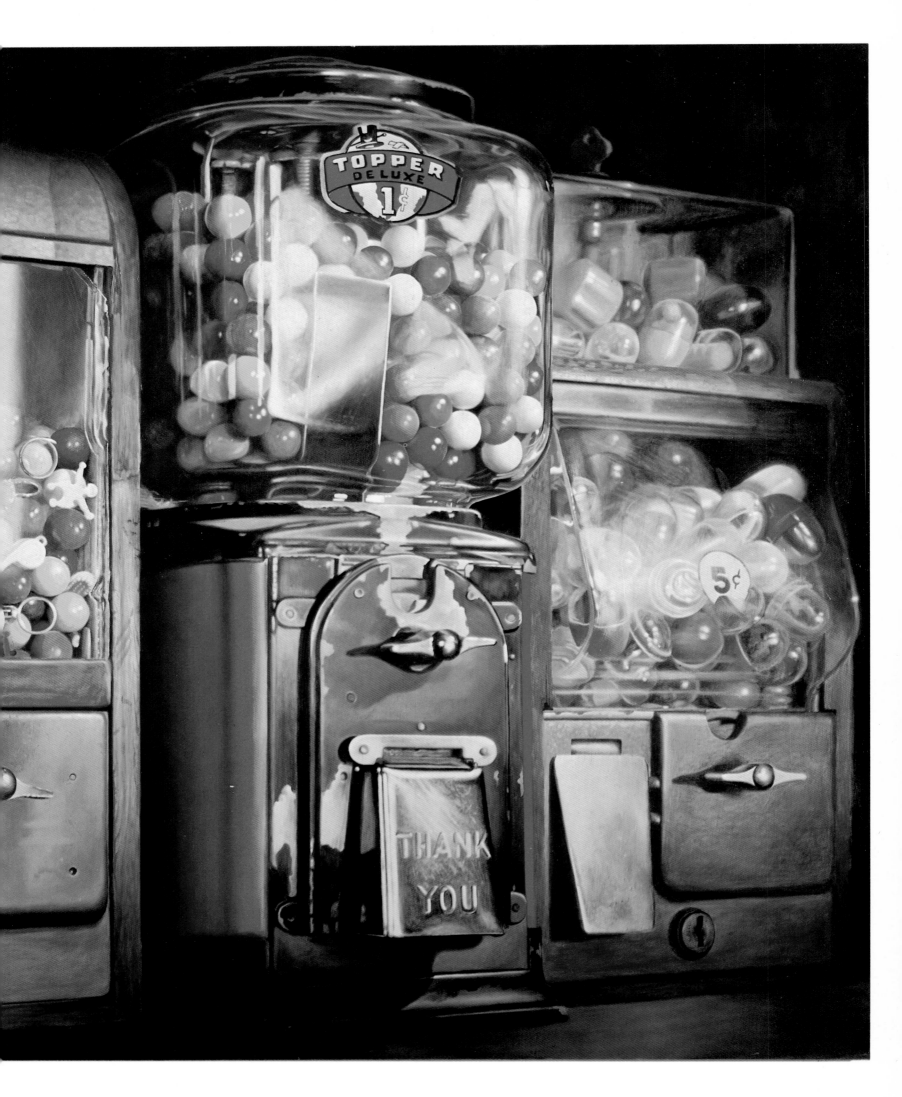

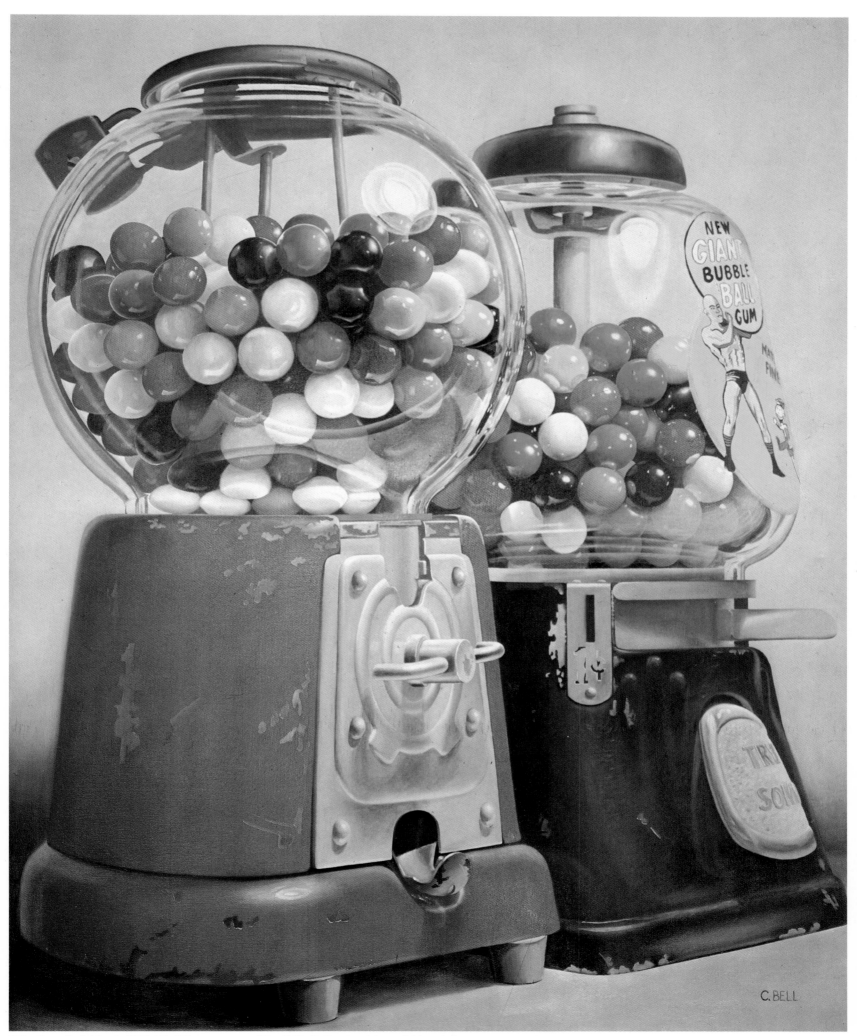

123. *Gum Ball No. 1.* 1971 (4). Oil on canvas, 72 x 54". Collection Mr. and Mrs. Arthur H. Morowitz, N.J.

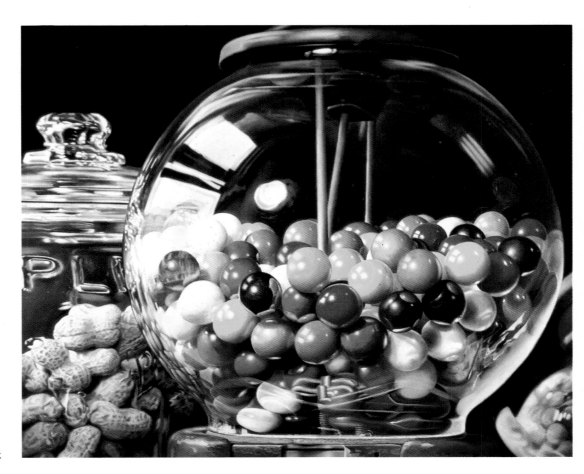

124. *Gum Ball No. 9.* 1975 (26).
Oil on canvas, 54 x 66".
Collection Mr. and Mrs. W. Jaeger, New York

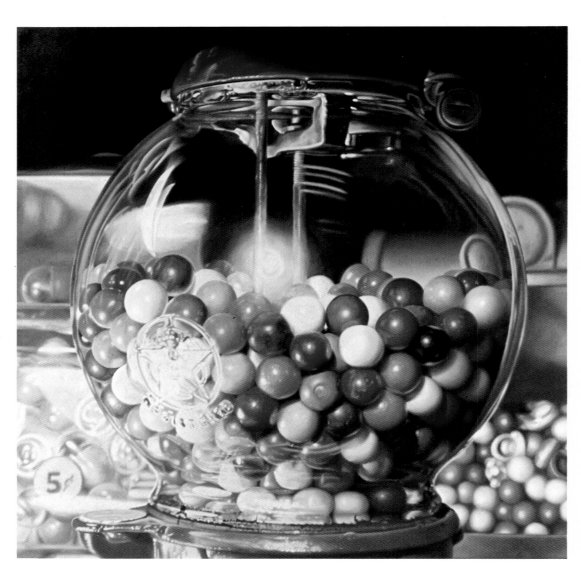

125. *Gum Ball No. 12 "5¢ Special."* 1976 (30).
Oil on canvas, 72 x 72".
Private collection

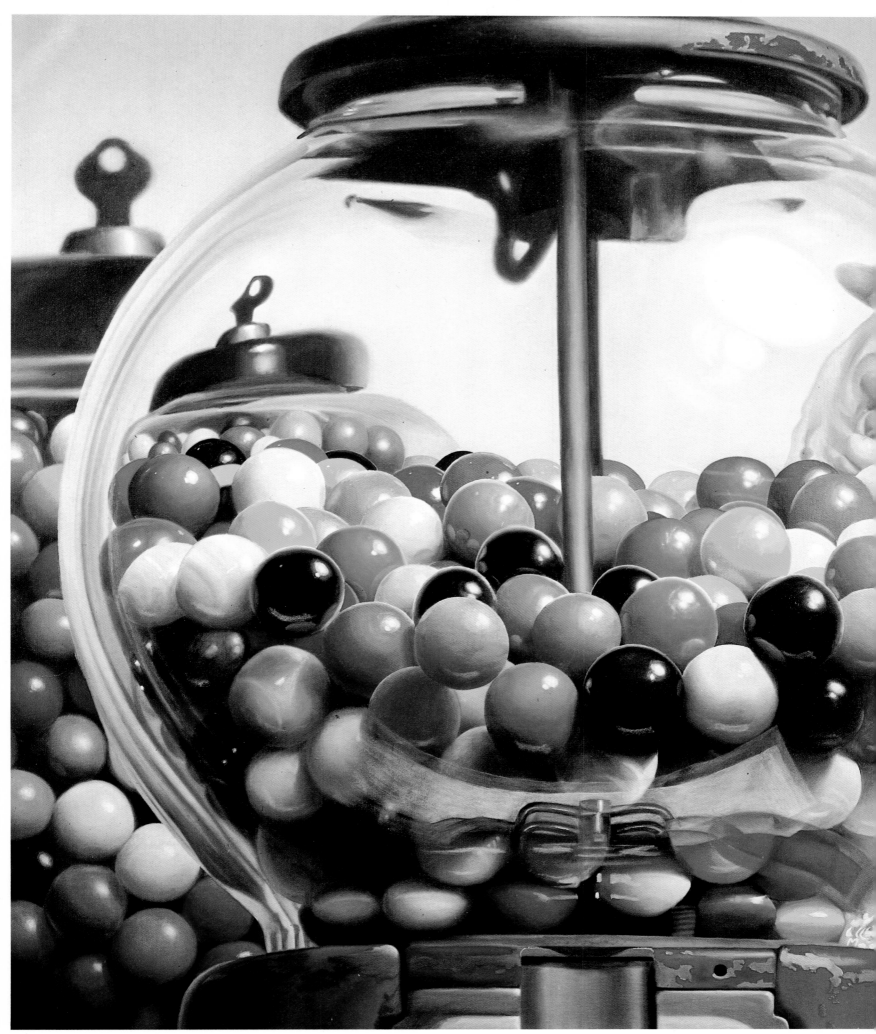

126. *Gum Ball No. 2*. 1973 (15). Oil on canvas, 60 x 78½".
Collection Louis and Susan Meisel, New York

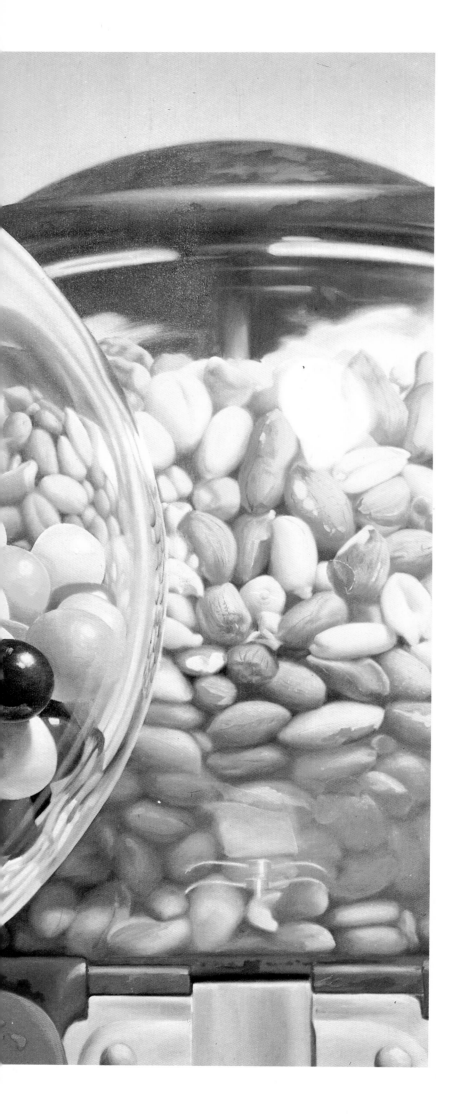

127. *Gum Ball Fragment No. 3 "One Cent."* 1976 (34). Oil on canvas, 34 x 40". Collection Ms. Carmel Roth, New York

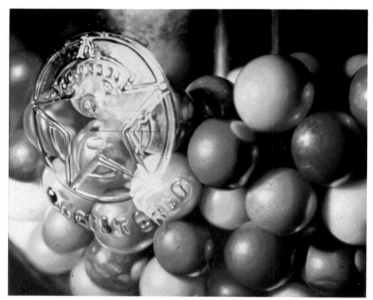

128. *Gum Ball Fragment No. 2.* 1976 (33). Oil on canvas, 30 x 36". Private collection

129. *Gum Ball Fragment No. 1.* 1976 (32). Oil on canvas, 34 x 40". Collection Stanton Rosenberg, M.D., Kans.

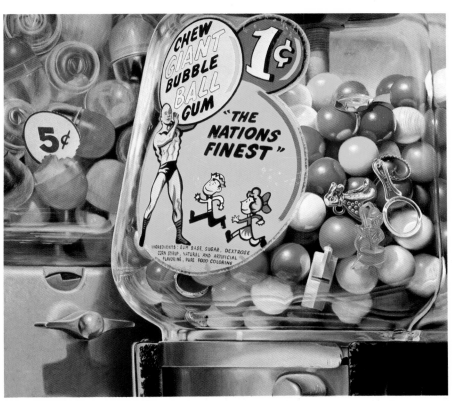

130. *Gum Ball No. 4 "Nation's Finest."* 1974 (17). Oil on canvas, 54 x 60".
Collection Jay P. and Meryle Samuels, New York

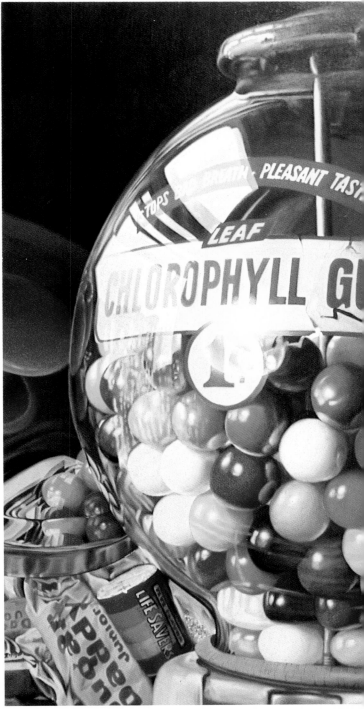

131. *Gum Ball No. 10 "Sugar Daddy."* 1975 (27).
Oil on canvas, 66 x 66".
Solomon R. Guggenheim Museum, New York

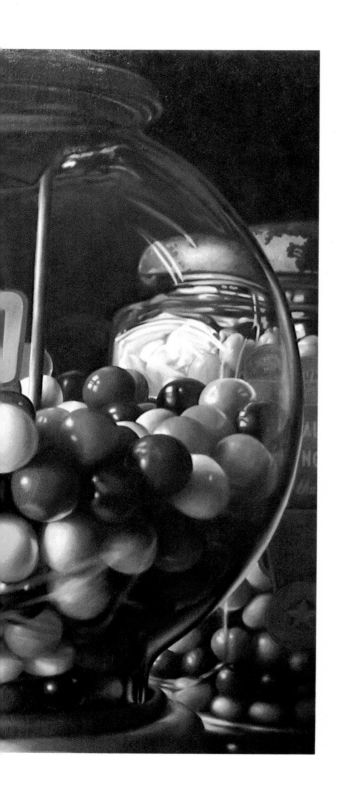

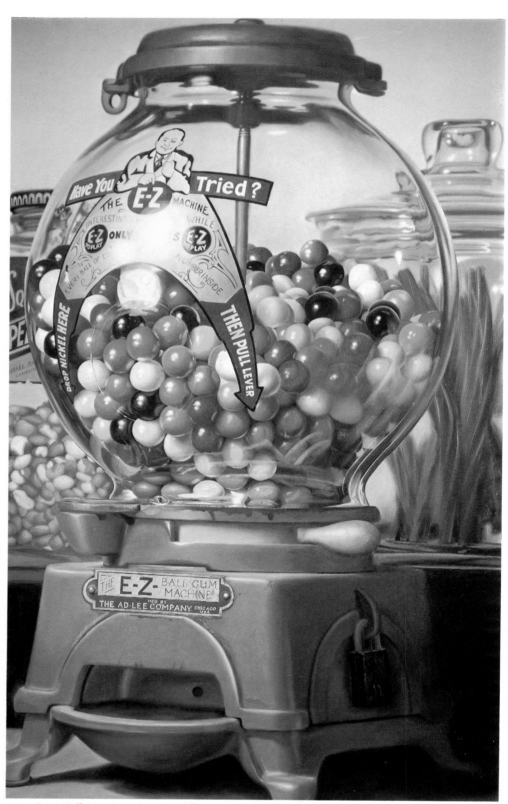

132. *Gum Ball No. 3.* 1973 (16). Oil on canvas, 84 x 52". Private collection, Paris

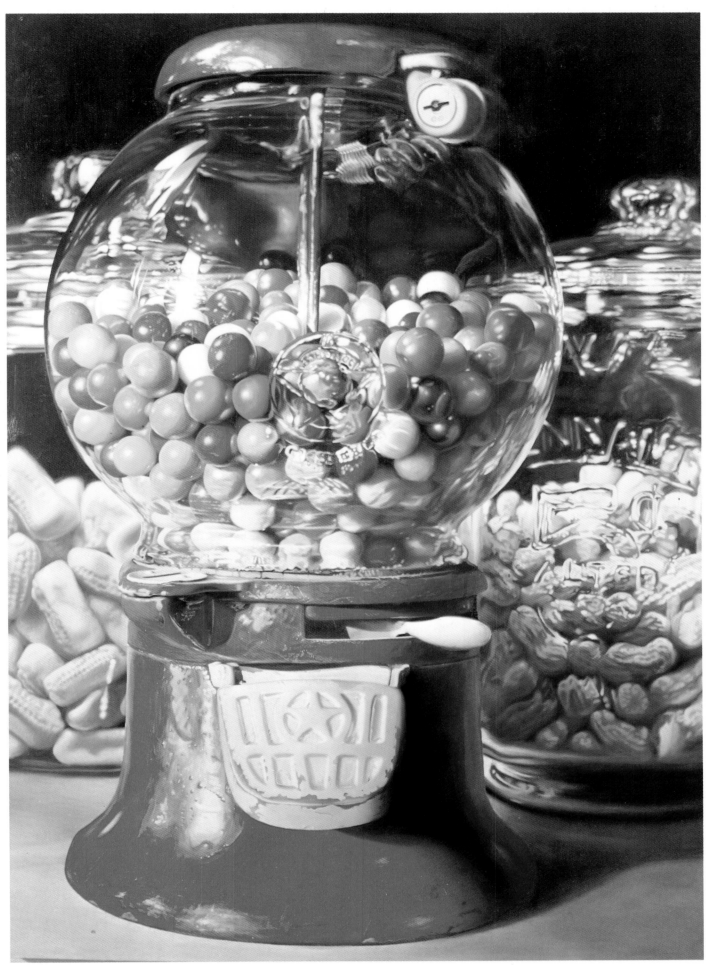

133. *Gum Ball No. 11.* 1976 (29). Oil on canvas, 84 x 60". Cooper Family Collection, New York

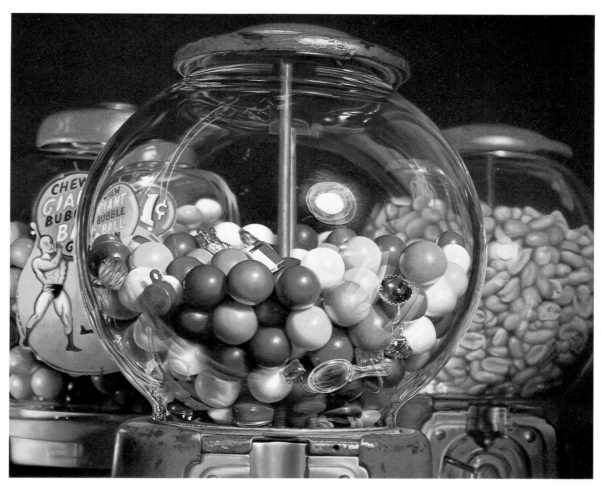

134. *The Ultimate Gum Ball*. 1978 (42). Oil on canvas, 54¼ x 66". Collection Joan and Barrie Damson, Conn.

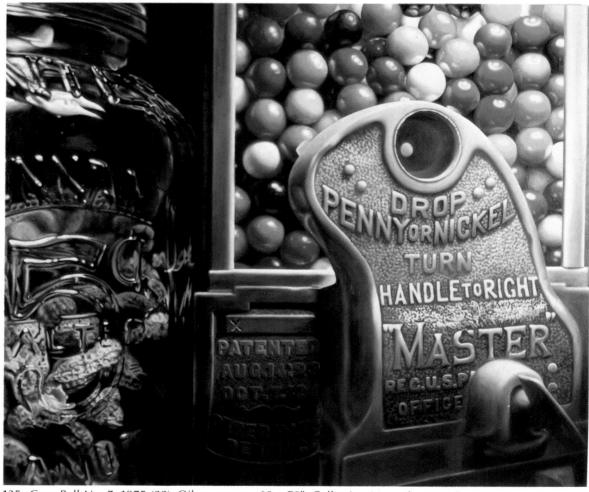

135. *Gum Ball No. 7*. 1975 (22). Oil on canvas, 60 x 70". Collection Mr. and Mrs. Robert H. Mann, Kans.

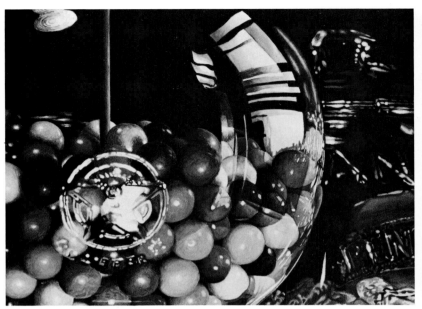

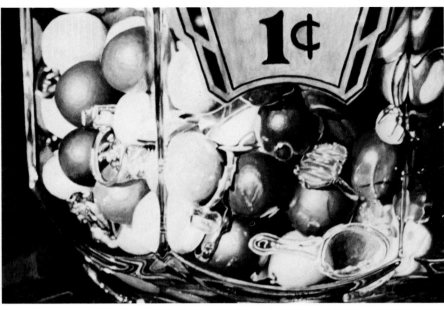

136. *Gum Ball Watercolor No. 1.* 1975 (28). Watercolor, 12 x 15".
Collection Louis and Susan Meisel, New York

137. *Gum Ball Watercolor No. 2.* 1976 (31). Watercolor, 16 x 22½".
Private collection

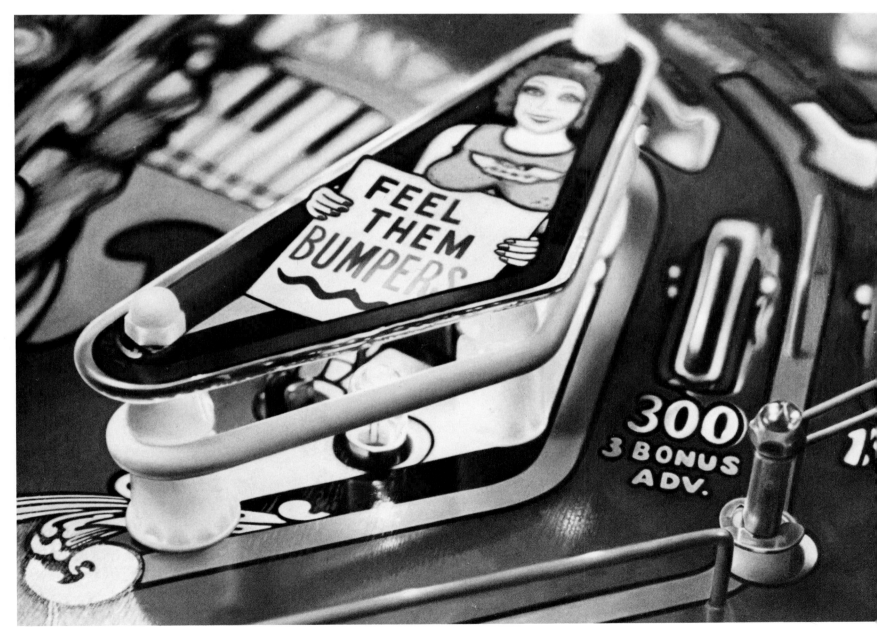

138. *Feel Them Bumpers.* 1977 (40). Oil on canvas, 42 x 54". Collection the artist

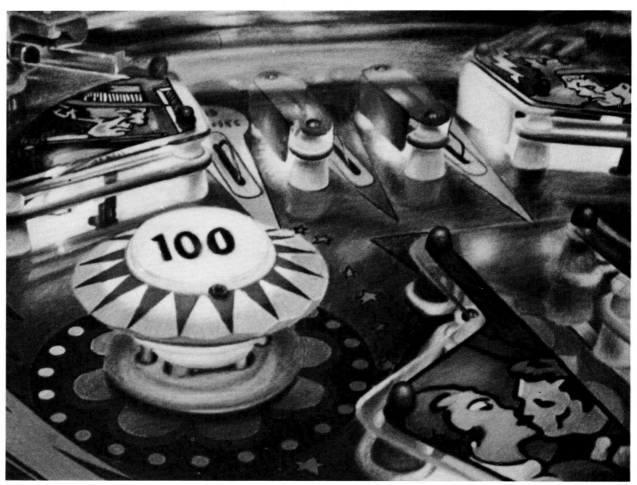

139. *Pinball No. 1.* 1976 (36). Pastel on paper, 19 x 24". Collection Joel Bogart, New York

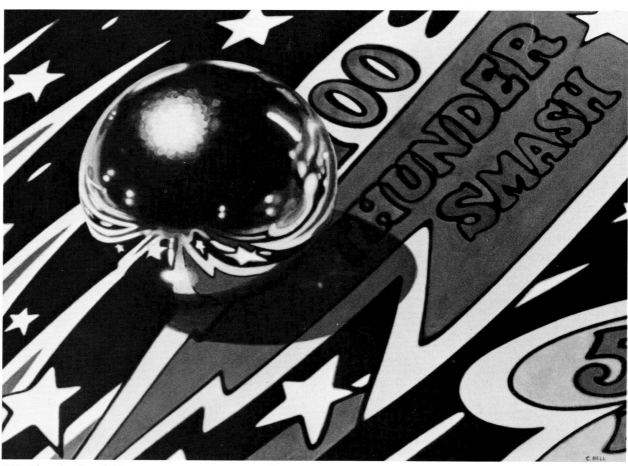

140. *Thunder Smash Fragment.* 1978 (43). Watercolor, 16 x 20". Collection Louis and Susan Meisel, New York

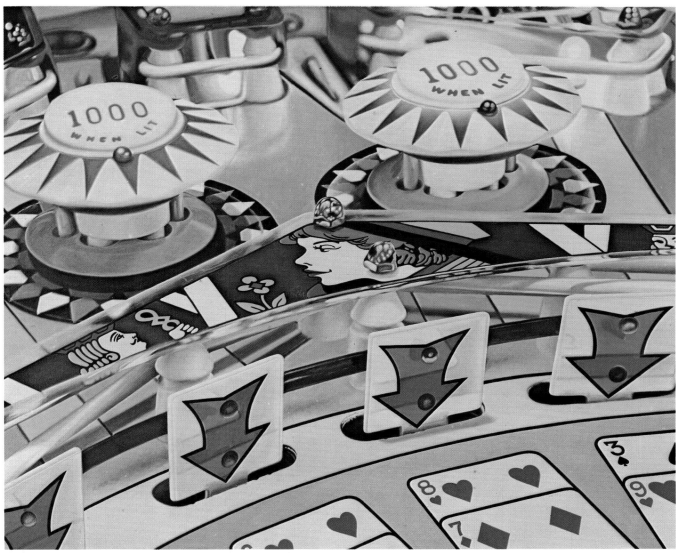

141. *Gin*. 1977 (38). Oil on canvas, 60 x 72". Private collection

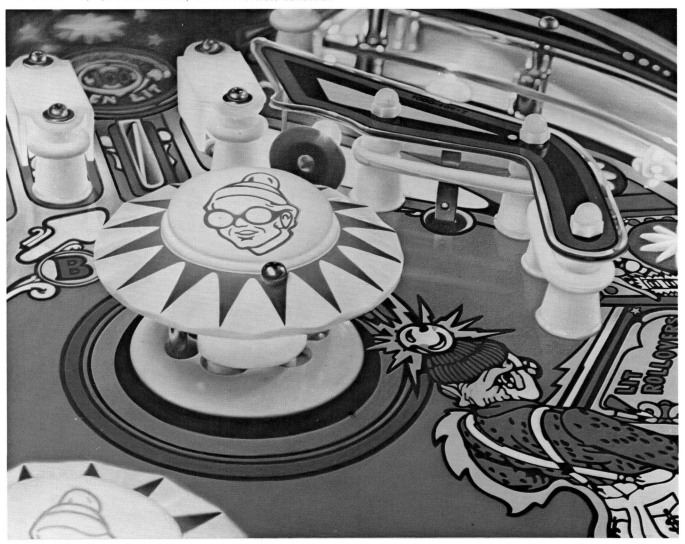

142. *The Wizard*. 1977 (37). Oil on canvas, 54 x 66". Collection Mr. and Mrs. Barry Hirschfeld, Colo.

143. *Fire Ball 500 No. 1*. 1977 (39). Oil on canvas, 54 x 66". Private collection

144. *Raggedy Ann No. 1.* 1969 (1). Oil on canvas, 72 x 36".
Collection Priscilla Kidder, Mass.

145. *Raggedy Ann with Baseball.* 1971 (3). Oil on canvas, 48 x 36".
Collection Dr. and Mrs. Jack Levine, Fla.

146. *Horn & Hardart.* 1974 (19).
Oil on canvas, 52 x 72".
Private collection

78

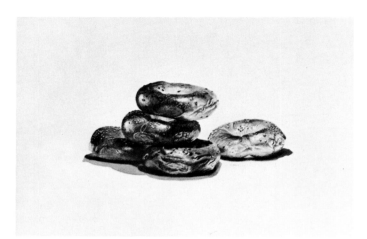

147. *Bagels.* 1974 (23). Watercolor on paper, 12 x 17".
Collection Martin I. Harman, New York

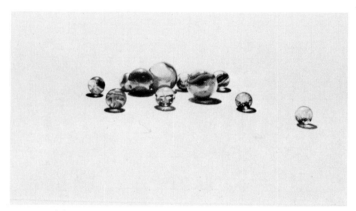

148. *Marbles.* 1974 (24). Watercolor on paper, 7½ x 9½".
Collection Frank Sierra, New York

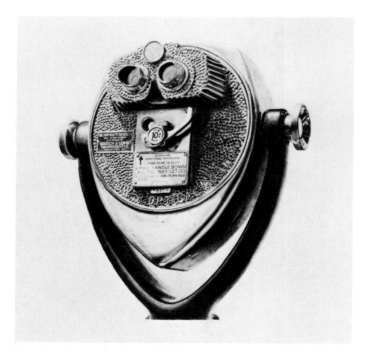

149. *Scenic Overlook.* 1976 (35).
Pencil on paper, 17 x 17".
Private collection

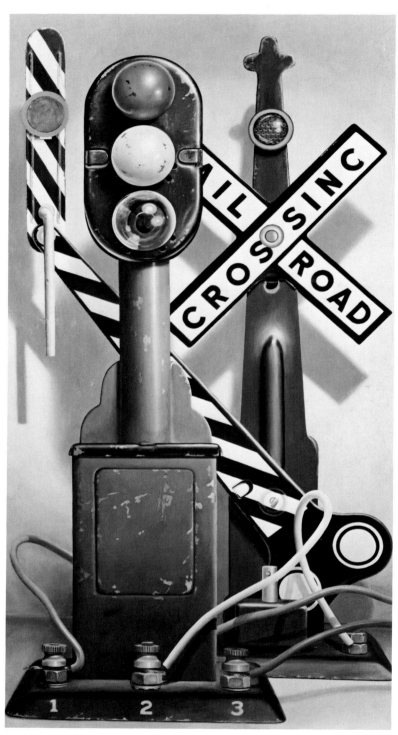

150. *Lionel.* 1972 (8). Oil on canvas, 84 x 48". Private collection, Paris

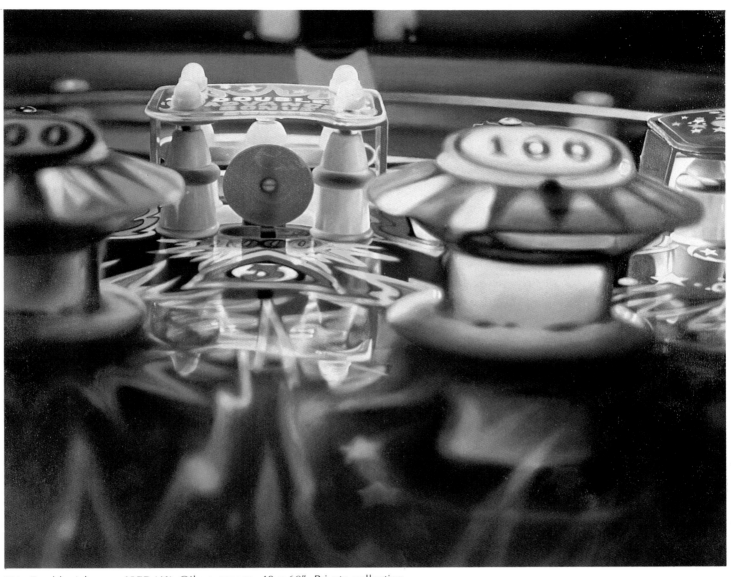

151. *Double Advance.* 1977 (41). Oil on canvas, 48 x 60". Private collection

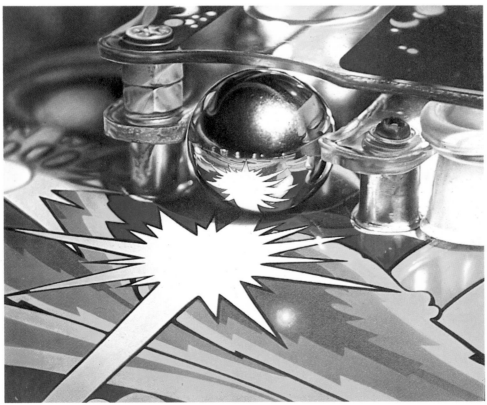

152. *Captive Messenger.* 1979 (44). Oil on canvas, 36 x 42". Private collection

BIOGRAPHY

1935 Born: Tulsa, Okla.

EDUCATION
1957 B.B.A., University of Oklahoma, Norman

SOLO EXHIBITIONS
1972 Meisel Gallery, New York
1974 Louis K. Meisel Gallery, New York
1976 Morgan Gallery, Shawnee Mission, Kans.
1977 Louis K. Meisel Gallery, New York

SELECTED GROUP EXHIBITIONS
1968 M. H. de Young Memorial Museum, San Francisco
 Setay Gallery, Beverly Hills, Calif.
1969 Greenwich Gallery, New York
 Meisel Gallery, New York
1973 "East Coast/West Coast/New Realism," San Jose State University, Calif.
1973–78 "Photo-Realism 1973: The Stuart M. Speiser Collection," traveling
 exhibition: Louis K. Meisel Gallery, New York; Herbert F. Johnson
 Museum of Art, Ithaca, N.Y.; Memorial Art Gallery of the University
 of Rochester, N.Y.; Addison Gallery of American Art, Andover,
 Mass.; Allentown Art Museum, Pa.; University of Colorado
 Museum, Boulder; University Art Museum, University of Texas,
 Austin; Witte Memorial Museum, San Antonio, Tex.; Gibbes Art
 Gallery, Charleston, S.C.; Brooks Memorial Art Gallery, Memphis,
 Tenn.; Krannert Art Museum, University of Illinois, Champaign-
 Urbana; Helen Foresman Spencer Museum of Art, University of
 Kansas, Lawrence; Paine Art Center and Arboretum, Oshkosh, Wis.;
 Edwin A. Ulrich Museum, Wichita State University, Kans.; Tampa
 Bay Art Center, Tampa, Fla.; Rice University, Sewall Art Gallery,
 Houston; Tulane University Art Gallery, New Orleans; Smithsonian
 Institution, Washington, D.C.
1974 "New Photo-Realism," Wadsworth Atheneum, Hartford, Conn.
 "Tokyo Biennale, '74," Tokyo Metropolitan Museum of Art; Kyoto
 Municipal Museum; Aichi Prefectural Art Museum, Nagoya
1975 "The New Realism: Rip-Off or Reality?," Edwin A. Ulrich Museum,
 Wichita State University, Kans.
 "Photo–Realists," Louis K. Meisel Gallery, New York
 "Thirty-ninth Annual Midyear Show," Butler Institute of American Art,
 Youngstown, Ohio
 "Watercolors and Drawings—American Realists," Louis K. Meisel
 Gallery, New York
1975–76 "Photo-Realism, American Painting and Prints," New Zealand traveling
 exhibition: Barrington Gallery, Auckland; Robert McDougall Art

Gallery, Christchurch; Academy of Fine Arts, National Art Gallery,
 Wellington; Dunedin Public Art Gallery, Dunedin; Govett-Brewster
 Art Gallery, New Plymouth; Waikato Art Museum, Hamilton
1976 "Troisième foire internationale d'art contemporain," Grand Palais,
 Paris
 "Washington International Art Fair," Washington, D.C.
1976–78 "Aspects of Realism," traveling exhibition sponsored by Rothman's
 of Pall Mall Canada, Ltd.: Stratford, Ont.; Centennial Museum,
 Vancouver, B.C.; Glenbow-Alberta Institute, Calgary, Alta.;
 Mendel Art Gallery, Saskatoon, Sask.; Winnipeg Art Gallery, Man.;
 Edmonton Art Gallery, Alta.; Art Gallery, Memorial University of
 Newfoundland, St. John's; Confederation Art Gallery and Museum,
 Charlottetown, P.E.I.; Musée d'Art Contemporain, Montreal, Que.;
 Dalhousie University Museum and Gallery, Halifax, N.S.; Windsor
 Art Gallery, Ont.; London Public Library and Art Museum and
 McIntosh Memorial Art Gallery, University of Western Ontario; Art
 Gallery of Hamilton, Ont.
1977 "New Realism," Jacksonville Art Museum, Fla.
 "Washington International Art Fair," Washington, D.C.
 "Works on Paper II," Louis K. Meisel Gallery, New York
1978 "Drawings Since 1960," University Art Gallery, Creighton
 University, Omaha, Nebr.
 "Landscape-Cityscape," Brainerd Hall Art Gallery, State University
 College, Potsdam, N.Y.
 "Painting and Sculpture Today, 1978," Indianapolis Museum of Art
 "Photo-Realism and Abstract Illusionism," Arts and Crafts Center of
 Pittsburgh
 "Photo-Realist Printmaking," Louis K. Meisel Gallery,
 New York
 Solomon R. Guggenheim Museum, New York
 Tolarno Galleries, Melbourne, Australia
 "Washington International Art Fair," Washington, D.C.
1979 "Brooklyn '79," Community Gallery, Brooklyn Museum,
 New York
 Middendorf Gallery, Washington, D.C.
 "New York Now," Phoenix Art Museum
 "Photo-Realism: Some Points of View," Jorgensen Gallery,
 University of Connecticut, Storrs
 "Prospectus: Art in the Seventies," Aldrich Museum of
 Contemporary Art, Ridgefield, Conn.
 "Selections of Photo-Realist Paintings from N.Y.C. Galleries,"
 Southern Alleghenies Museum of Art, St. Francis College,
 Loretto, Pa.
 Washington International Art Fair, Washington, D.C.

SELECTED BIBLIOGRAPHY

CATALOGUES
Hogan, Carroll Edwards. Introduction to *Hyperréalistes américains*. Galerie
 Arditti, Paris, Oct. 16–Nov. 30, 1973.
Meisel, Louis K. *Photo-Realism 1973: The Stuart M. Speiser Collection*. New
 York, 1973.
Radde, Bruce. Introduction to *East Coast/West Coast/New Realism*. University
 Art Gallery, San Jose State University, Calif., Apr. 24–May 18, 1973.
Chase, Linda. "Photo-Realism." In *Tokyo Biennale 1974*. Tokyo Metropolitan
 Museum of Art; Kyoto Municipal Museum; Aichi Prefectural Art Museum,
 Nagoya, 1974.
Cowart, Jack. *New Photo-Realism*. Wadsworth Atheneum, Hartford, Conn.,
 Apr. 10–May 19 ,1974.
Meisel, Susan Pear. *Watercolors and Drawings—American Realists*. Louis K.
 Meisel Gallery, New York, Jan., 1975.

Thirty-ninth Annual Midyear Show. Butler Institute of American Art,
 Youngstown, Ohio, June 29–Aug. 31, 1975.
Felluss, Elias A. Foreword to *Washington International Art Fair*. Washington,
 D.C., 1976.
Gervais, Daniel. Introduction to *Troisième foire internationale d'art
 contemporain*. Grand Palais, Paris, Oct. 16–24, 1976.
Chase, Linda. "U.S.A.," In *Aspects of Realism*. Rothman's of Pall Mall Canada,
 Ltd., June, 1976–Jan., 1978.
Dempsey, Bruce. *New Realism*. Jacksonville Art Museum, Fla., 1977.
Felluss, Elias A. Foreword to *Washington International Art Fair*. Washington,
 D.C., 1977.
Meisel, Louis K. Introduction to *Charles Bell*. Louis K. Meisel Gallery,
 New York, Nov. 5–26, 1977.
Garfield, Alan. Introduction to *Drawings Since 1960*. University Art Gallery,

Creighton University, Omaha, Nebr., Sept. 30–Oct. 28, 1978.

Meisel, Louis K. Introduction to *Landscape/Cityscape.* Brainerd Hall Art Gallery, State University College, Potsdam, N.Y., Sept. 22–Oct. 22, 1978.

Meisel, Susan Pear. Introduction to *The Complete Guide to Photo-Realist Printmaking.* Louis K. Meisel Gallery, New York, Dec., 1978.

Yassin, Robert. Introduction to *Painting and Sculpture Today, 1978.* Indianapolis Museum of Art, June 15–July 30, 1978.

Felluss, Elias A. Introduction to *Washington International Art Fair '79.* Washington, D.C., May 2–7, 1979.

Frankel, Robert. Introduction to *New York Now.* Phoenix Art Museum, Apr. 20–May 27, 1979.

Gerling, Steve. Introduction to *Photo-Realism: Some Points of View.* Jorgensen Gallery, University of Connecticut, Storrs, Mar. 19–Apr. 10, 1979.

Streuber, Michael. Introduction to *Selections of Photo-Realist Paintings from N.Y.C. Galleries.* Southern Alleghenies Museum of Art, St. Francis College, Loretto, Pa., May 12–July 8, 1979.

ARTICLES

Allen, Barbara. "In and Around," *Interview Magazine,* Nov., 1973, p. 36.

Beardsall, Judy. "Stuart M. Speiser Photorealist Collection," *Art Gallery Magazine,* vol. XVII, no. 1 (Oct., 1973), pp. 5, 29–34.

Sherman, Jack. "Art Review: Photo-Realism, Johnson Museum," *Ithaca Journal,* Nov. 13, 1973.

"The Speiser Collection of Photo-Realism 1973," *Village Voice,* Sept. 20, 1973, p. 29.

Art Gallery Scene, Oct., 1974, p. 8.

"Collection of Aviation Paintings at Gallery," *Andover* (Mass.) *Townsman,* Feb. 28, 1974.

Frank, Peter. "Charles Bell," *ARTnews,* Dec., 1974, p. 100.

Gruen, John. "Charles Bell," *Soho Weekly News,* Oct. 31, 1974, p. 16.

Marticelli, Joseph. "Our Books and Yours," *Case and Comment,* vol. 79, no. 4 (July–Aug., 1974), p. 11 and cover illustration.

Walsh, Sally. "Paintings that Look Like Photos," *Rochester Democrat and Chronicle,* Jan. 17, 1974.

Frackman, Noel. "Charles Bell," *Arts Magazine,* Jan., 1975, p. 11.

Lucie-Smith, Edward. "Contemporary Art in America," *Illustrated London News,* Jan., 1975.

McNamara, T. J. "Photo-Realist Exhibition Makes Impact," *New Zealand Herald* (Auckland), July 23, 1975.

"Photo-Realism Exhibit Is Opening at Paine Sunday," *Oshkosh Daily Northwestern,* Apr. 17, 1975.

"Photo-Realism Flies High at Paine," *Milwaukee Journal,* May, 1975.

"Photo-Realists at Paine," *View Magazine,* Apr. 27, 1975.

Artner, Alan. "Mirroring the Merits of a Showing of Photo-Realism," *Chicago Tribune,* Oct. 24, 1976.

Better Homes and Gardens, Aug., 1976, p. 35.

Brown, Gordon. "Group Show," *Arts Magazine,* Sept., 1976.

Fox, Mary. "Aspects of Realism," *Vancouver Sun,* Sept. 21, 1976.

Hoffman, Donald. *Kansas City Star,* May, 1976.

K. M. "Realism," *New Art Examiner,* Nov., 1976.

Greenwood, Mark. "Toward a Definition of Realism: Reflections on the Rothman's Exhibition," *Arts/Canada,* vol. XXIV, no. 210–11 (Dec., 1976–Jan., 1977), pp. 6–23.

Battcock, Gregory. "Dinner for Eighty," *Soho Weekly News,* Nov. 10, 1977.

Beardsall, Judy. "Charles Bell," *Arts Magazine,* Nov., 1977, p. 14.

Crossley, Mimi. "Review: Photo-Realism," *Houston Post,* Dec. 9, 1977, p. 10E.

Edelson, Elihu. "New Realism at Museum Arouses Mixed Feelings," *Jacksonville* (Fla.) *Journal,* Feb., 1977.

Perreault, John. "Pin Ball Wizard," *Soho Weekly News,* Nov. 14, 1977, p. 26.

Bongard, Willie. *Art Aktuell* (Cologne), Apr., 1978.

Harris, Helen. "Art and Antiques: The New Realists," *Town and Country,* Oct., 1978, pp. 242, 244, 246–47.

Mackie, Alwynne. "New Realism and the Photographic Look," *American Art Review,* Nov., 1978, pp. 72–79, 132–34.

Richard, Paul. "New Smithsonian Art: From 'The Sublime' to Photo Realism," *Washington Post,* Nov. 30, 1978, p. G21.

Soho Weekly News, Apr. 1978, centerfold.

Veehoff, Cary. "Show Capsulizes Two Decades of Art," *Creighton* (Ohio), vol. LVI, Sept. 22, 1978.

Zimmer, William. "Charles Bell," *Arts Magazine,* Jan., 1978, pp. 24–25.

"Brooklyn Museum Showcases Borough Artists," *New York Daily News,* Jan. 31, 1979, p. 3.

Louie, Elaine. "For Passionate Collectors," *House Beautiful,* Feb., 1979, pp. 56–57.

BOOKS

Battcock, Gregory, ed. *Super Realism, A Critical Anthology.* New York: E. P. Dutton, 1975.

Kultermann, Udo. *Neue Formen des Bildes.* Tübingen, West Germany: Verlag Ernst Wasmuth, 1975.

Who's Who in American Art. New York: R. R. Bowker, 1976.

Seeman, Helene Zucker, and Siegfried, Alanna. *SoHo.* New York: Neal-Schuman, 1979.

153. Tom Blackwell at work

TOM BLACKWELL

Although he is not one of the earliest Photo-Realists, Tom Blackwell is one of the artists most closely identified with this style of painting. Automotive subject matter —the car, the truck, and the motorcycle—has become synonymous with Photo-Realism, and Blackwell has produced a most significant body of work based on the motorcycle. When the Stuart M. Speiser Collection was first exhibited, in 1973, the airplane became a subject of interest, and here, too, Blackwell created the most sizable body of work devoted to this subject. For Blackwell, the airplane was very similar to the motorcycle, both being motorized forms reflecting light from metal surfaces. It was also important as his transition from the "machine" indoors to the "machine" outdoors. The sequence was: motorcycles indoors, airplanes outdoors, motorcycles outdoors—often including cars and some storefronts—and, most recently, storefronts with highly complex reflections and angles.

Blackwell very adequately outlines his career and artistic development in the following statement:

We were all brought up to believe that copying is cheating. There is an irony in the fact that all my time now is spent in such copying. Far from cheating, I have discovered that copying requires the most intense discipline and that limiting the arena of self-expression also refines it. Working from the photograph requires a new kind of invention—an invention of means rather than of forms. It also makes one, in a sense, a voyeur. The photograph is a tool which enables me to freeze the "ordinariness" I am after, one which helps me to achieve the veracity that makes it possible to capture the ineffable in the commonplace.

Nailing down that precise moment, the optimum moment that best sums up a visual event—which I try to do when photographing something—is what painting

these images is all about for me. I shoot my pictures with high-speed film, mostly out of doors in real-life situations. People are often disconcerted by someone who goes about photographing ordinary things with such intensity when there is apparently nothing worthy of being photographed. It makes them suspicious. But to me, the modern world, vulgar, impersonal and machine-made, is a sort of virgin territory, and the camera and high-speed film make it accessible.

My first Photo-Realist paintings were of highly customized bikes from motorcycle magazine photographs. At that point, after a good many years as an abstract painter, I was doing Pop-influenced work juxtaposing photographic images in irrational and poetic ways. It was a hit-and-miss situation. Sometimes it worked surprisingly well and other times a painting would end up as the visual equivalent of a bad pun.

One of these paintings had an image of a section of a motorcycle engine. As I worked on the painting it came to me that I could just paint that, large scale, and throw out all the other imagery—the juxtapositions, associations, and allegorical elements. The image could speak for itself without my manipulation. It seemed that my painting was failing by trying to do too much, to encompass too many things. I could do more by doing just one thing really well.

I realized that the motorcycle forms in the painting were so compelling that they became the real issue of the painting and that all the rest of it was extraneous. The various pipes, sprockets, bars, etc., were so complex that it was almost like looking at an abstract painting. I was fascinated by the play of light on the chrome surfaces and by the way the light modified the shapes and your perception of the metal. I promptly went out and bought a bunch of motorcycle magazines, mostly depicting the more exotic customized bikes.

As the work evolved, these initial efforts, which were still directly related to abstract painting, gave way to a more honest approach to representationalism, in some ways more traditional, in other ways more radical. But that came about as a result of using the camera myself.

It became apparent to me almost immediately that the magazine photographs were not adequate to my needs. They didn't allow me enough choice: my purposes were different. A lot of detail was lost in the cheap half-tone reproductions; there was no subtlety. I wanted to see some real chrome. I went to a Rod and Cycle Show at the New York Coliseum where they had hundreds of bikes and cars on display, and I shot pictures for hours. My work for the next couple of years came from that day.

These motorcycles and cars were show vehicles in artificial situations, up on revolving pedestals, cosmetically lighted—all of which suited my purposes then. At first, I used the camera in much the same way as it had been used by the magazines; the bikes were idealized objects. I was painting sections of them, large scale, divorced from their real function as vehicles, as chunks of machinery, close-up and abstract.

Eventually I moved outside and began photographing bikes, and then planes, as part of their natural environment, and then store windows and other everyday scenes. I was turning away from the deliberate use of close-ups to create overall composition, and became involved in creating the illusion of deep space. I was more willing to accept the use of illusionism with no apologies to modernist tenets. One of the exciting aspects of painting the store windows is the tension between the overall composition and flatness of the picture plane created by the plate glass and the

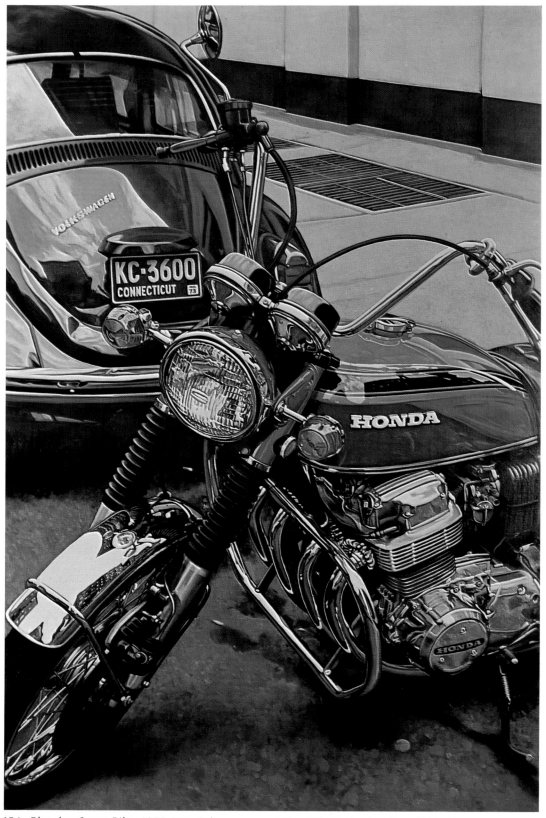

154. *Bleecker Street Bike.* 1973 (13). Oil on canvas, 72 x 48". Collection Carroll N. Abrams, Kans.

spaces inside the window and behind the viewer reflected on the window. The real space and the illusion of space caught by the glass tend to contradict each other and therefore flatten each other out. So you have the illusion of flatness and space at once.

A painting based on a photograph, while it may be antimodernist, is intrinsically "modern." I realized that it isn't just the world we live in that I was interested in depicting, but also our method of recording and perceiving it—the photograph itself.

More than just a means of capturing the image, the photograph is part of the subject of the painting.

We are so inundated with photographs in one form or another—movies, TV, newspapers, etc.—that what a camera does to reality has become a kind of reality itself. This photographic vocabulary is very much a part of my painting.

The camera enables me to confront freshly, as if seen for the first time, not only particular scenes, but also views and viewpoints we take for granted. Several of my paintings, for example, are based on photos taken out of car windows, through the windshield or out the side window. These compositions are determined by the way both the film and the vehicle frame reality. The illusion in these paintings is made up of shapes and forms which are cropped in ways that would be "unreadable" except that our eyes have been educated by the media to instantly grasp this kind of cropping. This is also true of the vast differences in focus between background and foreground.

A common element in all my painting is the reflective surface. Each type of hard or shiny surface—chrome, stainless steel, plastic, plate glass—reflects light differently. These differences are multiplied by variations in color and value and by the environment and the type of light which is reflected. The camera records these reflections at a moment frozen in time, transcribing and interpreting it according to its own laws. In my painting I am dealing with a twofold reality: light and its translation on film.

Certain photographic peculiarities are particularly noticeable in large-scale projected slides. One reason I employ large scale is that it affords me the space to really get in and paint the specific ways in which light breaks across a surface. The smaller the scale, the less specific those transitions. In areas of great contrast there is a kind of "buffer zone" and the film will handle this by showing a slight edge of spectrum color before making the transition from dark to light. By using this in my painting I am making a direct reference to the photograph because the eye will perceive this only under extreme circumstances. Ironically, the more photographic the painting becomes the more "real" it seems, even though the photograph itself is unreal.

Another important aspect of reflective surfaces is that they expand the space depicted to include things actually outside the scene encompassed by the canvas. A tail pipe, or a car mirror, for example, will reflect things in front of them which are behind (or, depending on the angle, to the side of) the person taking the picture. A fascinating aspect of this is that the shape of the reflective object will distort whatever is reflected at the same time that this distortion will describe the shape of the reflective surface.

Many of my recent paintings incorporate plate glass windows. The spatial complexities of plate glass when captured by the camera are infinite. The reflections that appear on the glass war with its transparency so that things in the window display often fuse and seem to melt into the objects outside being reflected. At the same time you are aware of the depth of the space both in front of and behind you. When interior light predominates the reflections recede; when there is less interior light the reflections become more evident. As cars go by and people move everything shifts. The effect is like counterpoint in music, and when choosing a slide to paint I look for the richest example of this.

A great range of possibilities exists in paint handling when working from a photo-

graphic source, all the way from a completely airbrushed treatment on a highly polished surface (total photographic mimesis) to the impasto affectations of someone like Malcolm Morley in his later work, who is obviously mocking the photograph. I don't try to hide brushstrokes and gestures, although I don't want the viewer to be particularly aware of them either. Up close I want my work to have a painterly integrity; each area must be brought to the same degree of realization. You are aware of the fact that the image just consists of areas of paint of various hues and values and intensities put down in a particular manner. Up close there is no illusion, just good solid painting. The illusion is actually "put together" in the eyes of the viewer and this occurs at some distance from the canvas. That's another reason why scale is so important. The visual response of the viewer completes the equation.

In painterly realism, great importance is attached to the artist's personal "handwriting," the personal and individual gesture captured in the paint. Thick paint is best for preserving such marks: gesture is given substance. Photo-Realism, however, emulates its photographic source, which is flat and without surface incident, more precise and thus less suitable for the exercise of personal and idiosyncratic gestures. The "soul" or sensibility of the artist is often thought to reside in such gestures and, when they are missing or minimalized, people tend to assume that the painter is lacking these characteristics also.

In my painting I build the image using primarily thin washes of transparent paint. I make as much use of transparent colors as possible to attain the greatest luminosity. For me, the richest possibilities exist in a dialogue between opaque and translucent areas.

Painting a Photo-Realist painting is a humbling and self-limiting experience: instead of personal angst you have patient observation. You are detached from the connotations of the particular object in a painting, but passionately involved in the painting of that object.

Yet clearly no image is without meaning. The motorcycle is fascinating not only visually but also as a highly anthropomorphic piece of machinery. A painting of a motorcycle, a store window, a parked car, or an airplane is, in one sense, highly impersonal, but in another the humanity which created these things is always present.

It seems absurd to painstakingly reproduce by hand the information gained in a photograph with the click of a shutter, but although the photographic sensibility is part of the subject of the painting, a painting is not a photograph. As you paint each area you make it your own. You may record the photographic information precisely, but you add to it your knowledge of how things look and are. Painting is a way of appropriating reality.

If, as Susan Sontag suggests, a photograph is a kind of assassination, the painting is an act of love. It creates intimacy for the artist and the viewer.

Tom Blackwell
1978

Tom Blackwell had executed 55 paintings and watercolors as a Photo-Realist through December 31, 1979. Illustrated herein are 48; the remainder are listed.

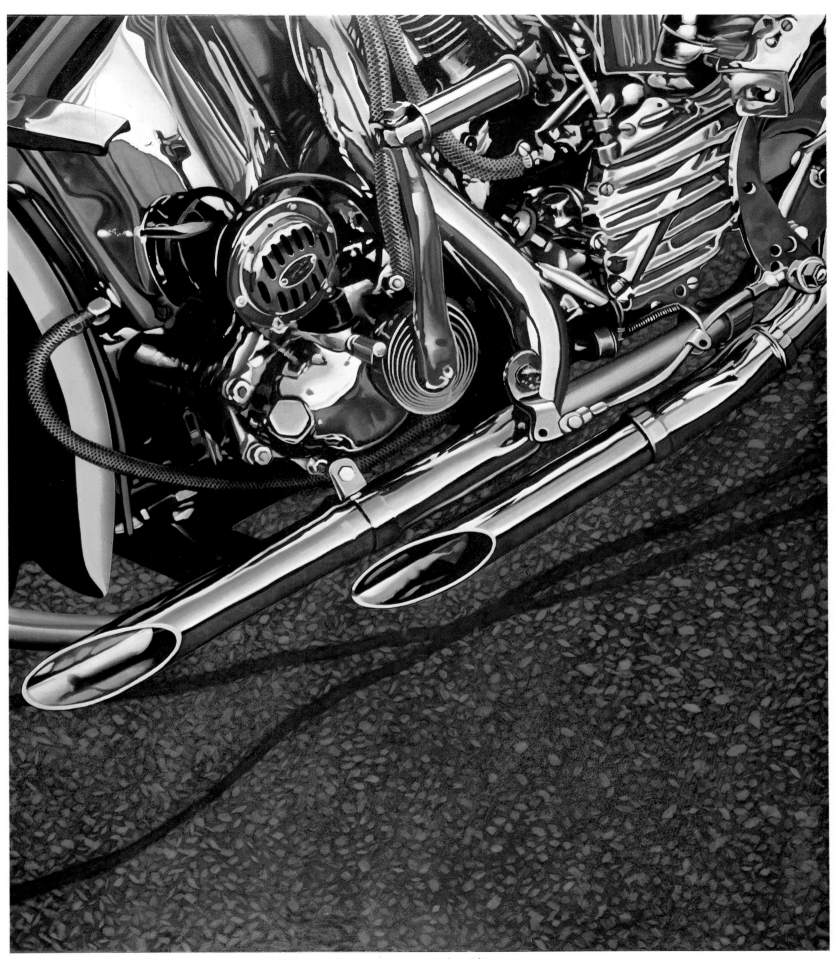

155. *Baffled Extensions*. 1971 (4). Oil on canvas, 84 x 72". Collection Don M. Hisaka, Ohio

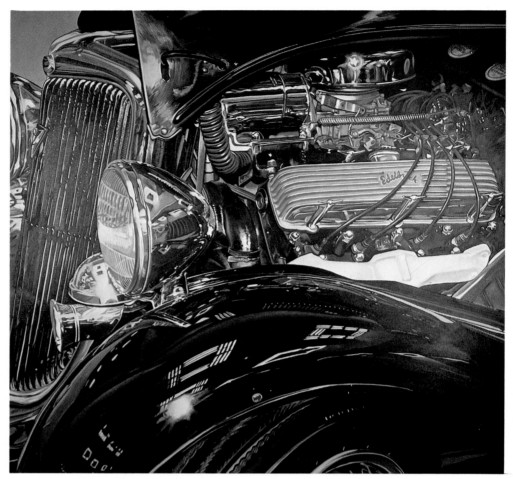

156. *'34 Ford Tudor Sedan*. 1971 (7). Oil on canvas, 54 x 56". Private collection, Calif.

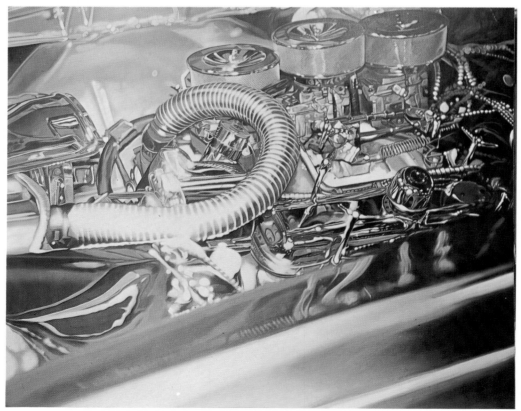

157. *Triple Carburetor GTO*. 1971 (6). Oil on canvas, 78 x 96". Richard Brown Baker
Collection, New York

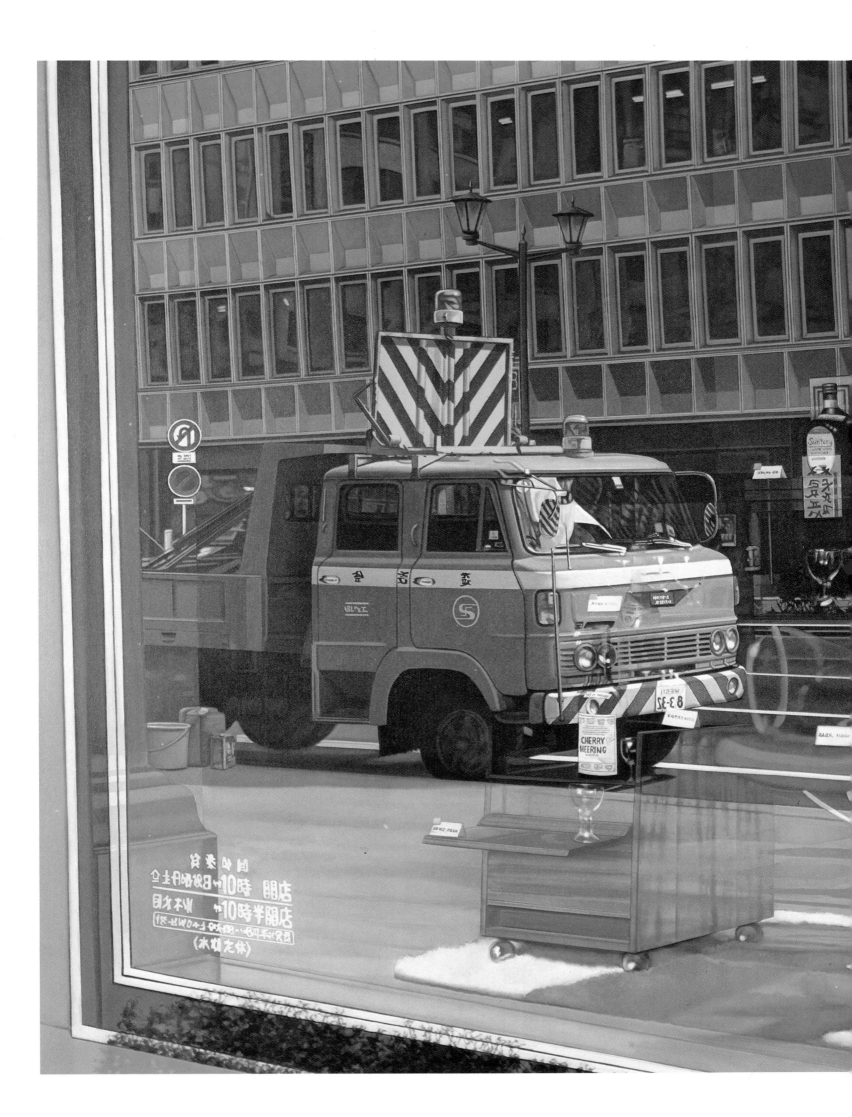

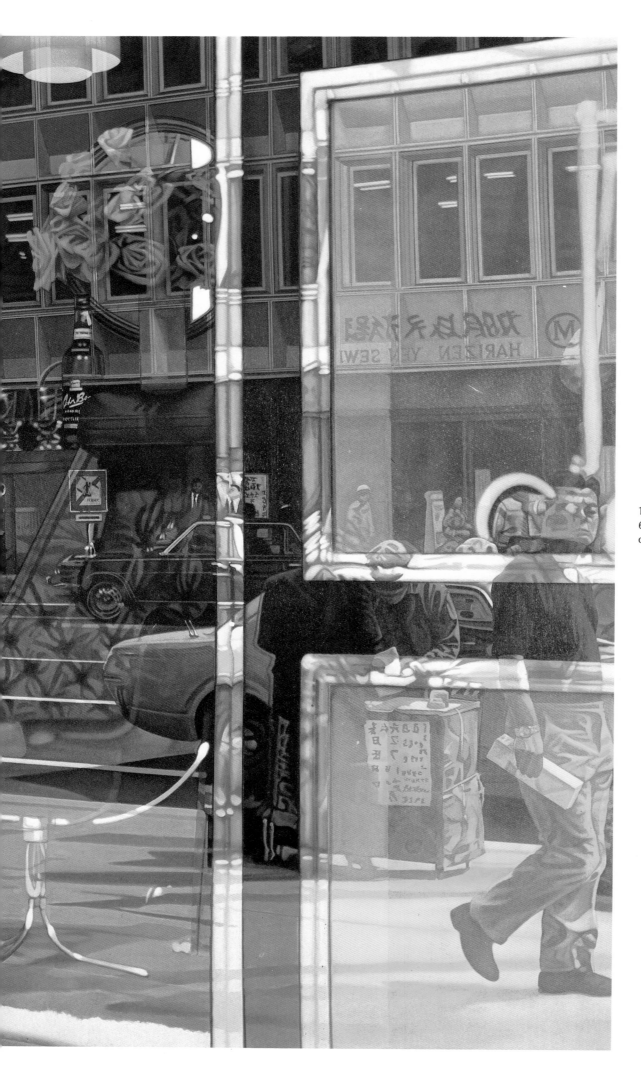

158. *Takashimaya*. 1974 (22). Oil on canvas, 68 x 96". Elvehjem Art Center, University of Wisconsin, Madison

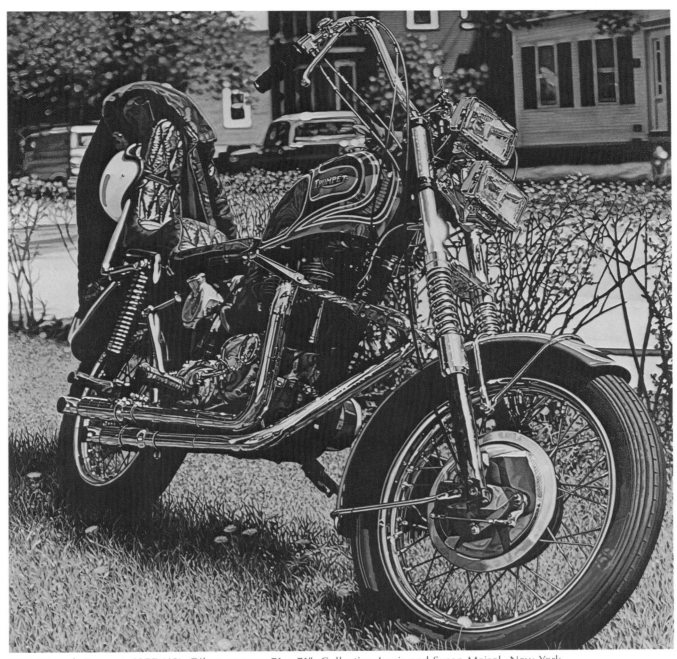

159. *Triumph Trumpet.* 1977 (42). Oil on canvas, 71 x 71". Collection Louis and Susan Meisel, New York

160. *Orphan Annie.* 1971 (5).
Oil on canvas, 72 x 86".
Private collection

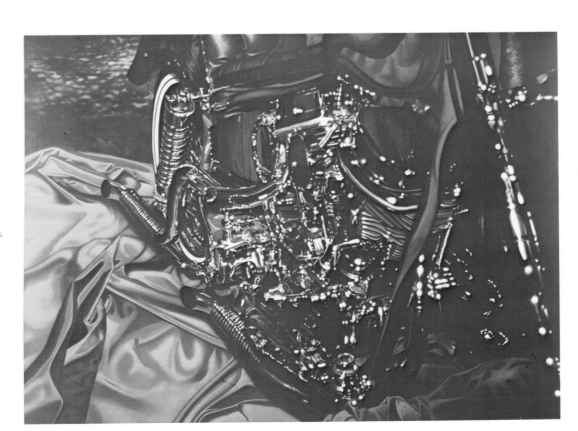

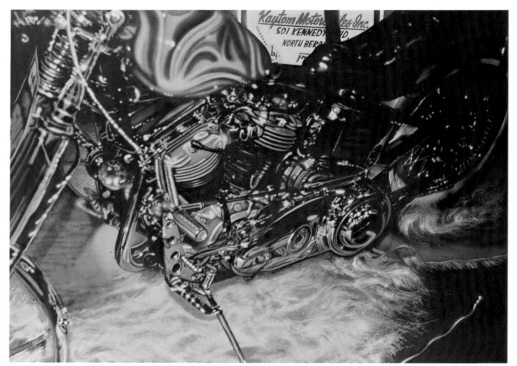

161. *Kaytom Cycle Display*. 1972 (11). Oil on canvas, 72 x 96". Private collection

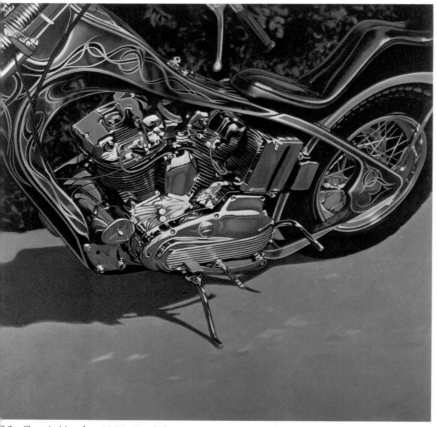

162. *Gary's Hustler*. 1971 (8). Oil on canvas, 56 x 64".
ollection Daniel Filipacchi, New York

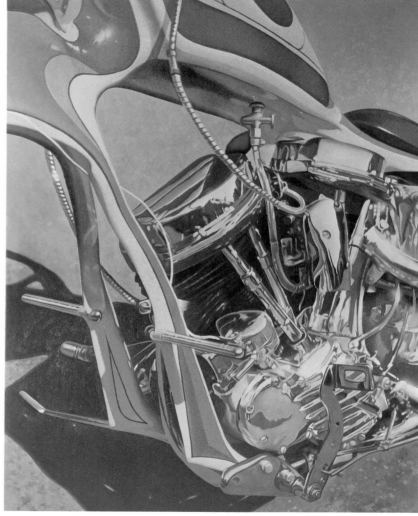

163. *Rainbow '74*. 1970 (1). Oil on canvas, 96 x 72". Private collection

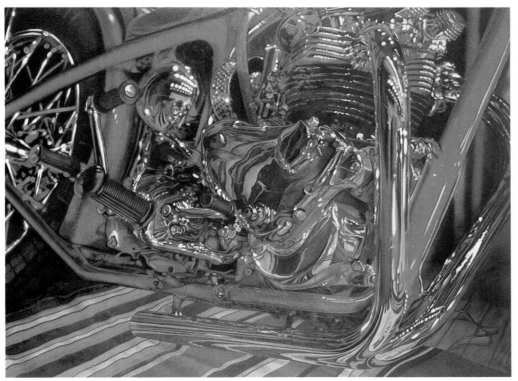

164. *Art's Red Triumph*. 1973 (12). Oil on canvas, 78 x 96". Private collection

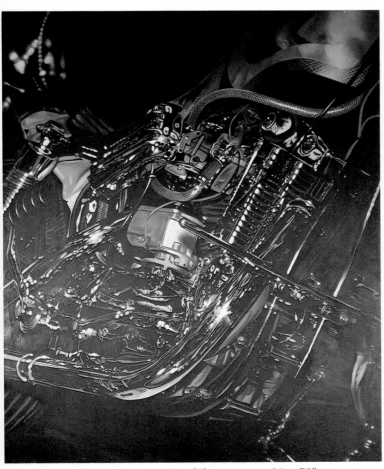

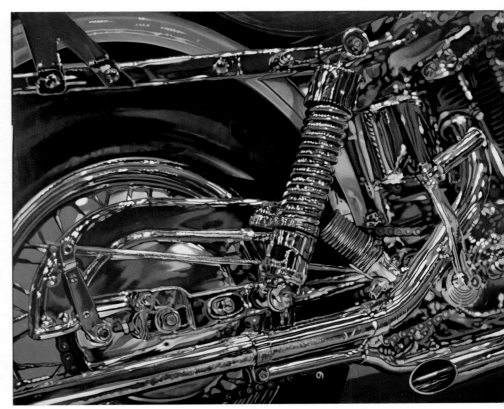

166. *Jack Armstrong Tail Section*. 1972 (9). Oil on canvas, 50 x 62".
Collection Michael K. Lenihan, New York

165. *Indian's Chopper II*. 1971 (3). Oil on canvas, 96 x 78".
Collection First National Bank of Boston

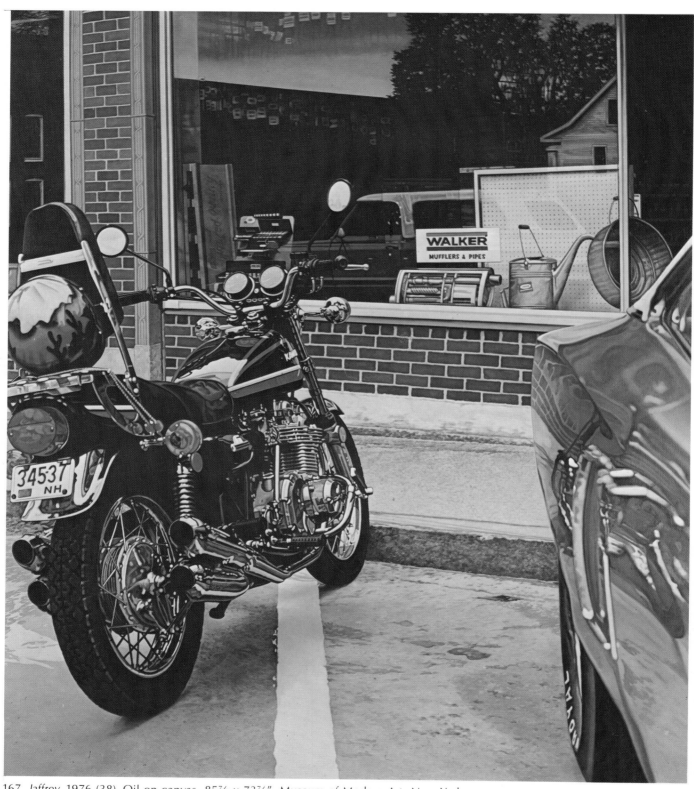

167. *Jaffrey*. 1976 (38). Oil on canvas, 85⅞ x 73⅞". Museum of Modern Art, New York.
Mr. and Mrs. Stuart M. Speiser Fund, 1976

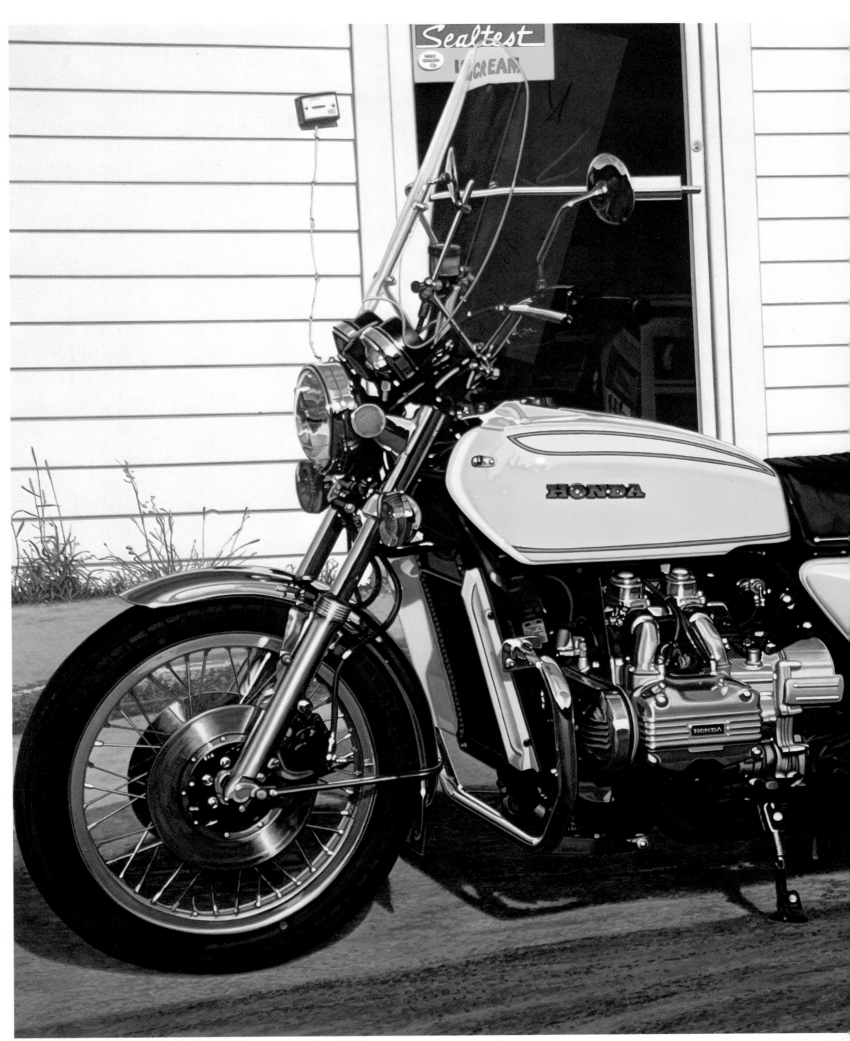

168. *Little Roy's Gold Wing*. 1977 (43). Oil on canvas, 67⅝ x 83¼".
Solomon R. Guggenheim Museum, New York

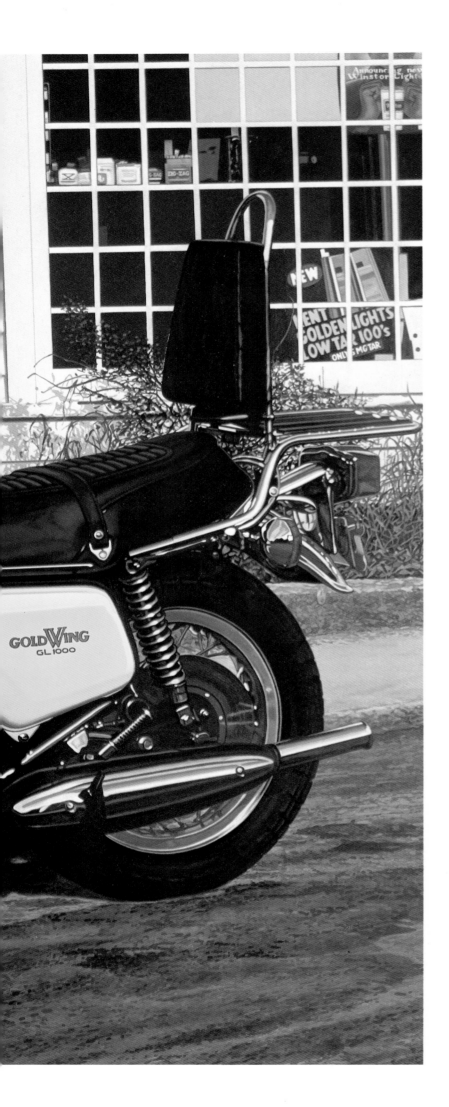

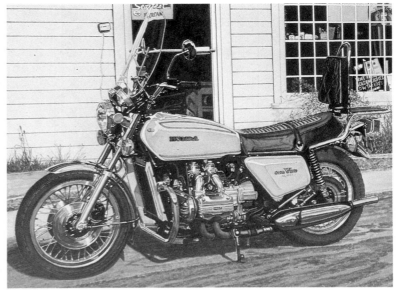

169. *Little Roy's Gold Wing.* 1977 (47). Watercolor on paper, 12½ x 16".
Collection Mr. and Mrs. W. Jaeger, New York

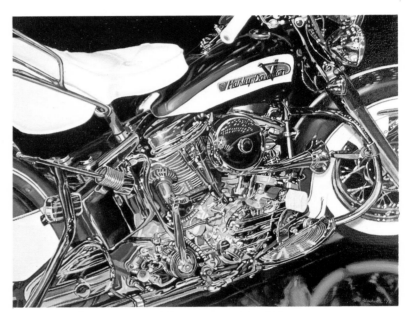

170. *'56 Harley.* 1974 (24). Oil on canvas, 16 x 20".
Collection Louis and Susan Meisel, New York

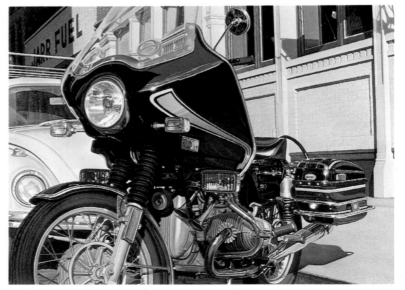

171. *Wooster Street Saturday.* 1976 (36). Oil on canvas, 36 x 48".
Private collection, New York

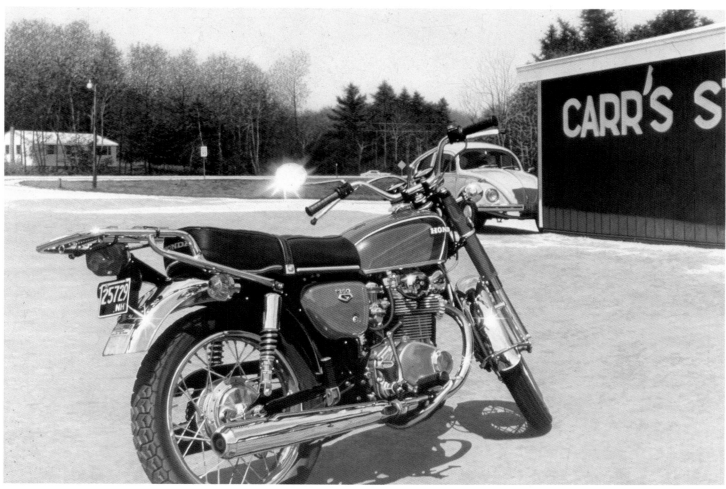

172. *Bond's Corner, Spring.* 1975 (31). Oil on canvas, 50 x 74". Collection Stanton Rosenberg, M.D., Kans.

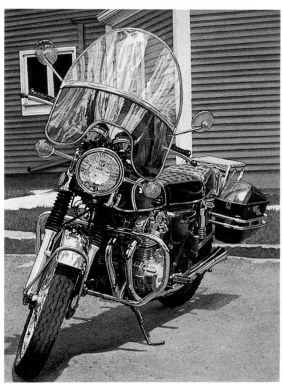

173. *Austin's Honda.* 1976 (39).
Watercolor on paper, 15 x 11".
Collection Richard Clair, New York

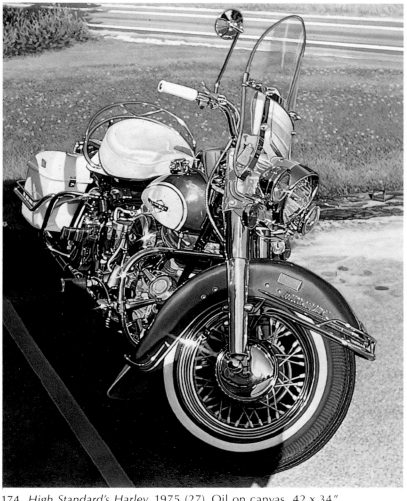

174. *High Standard's Harley.* 1975 (27). Oil on canvas, 42 x 34".
Collection Irene and Marcus Kutter, Switzerland

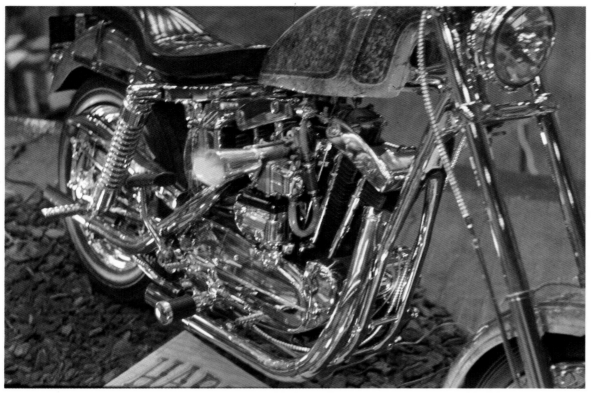

175. *Blue Harley*. 1972 (10). Oil on canvas, 36 x 48". Private collection, France (working photograph)

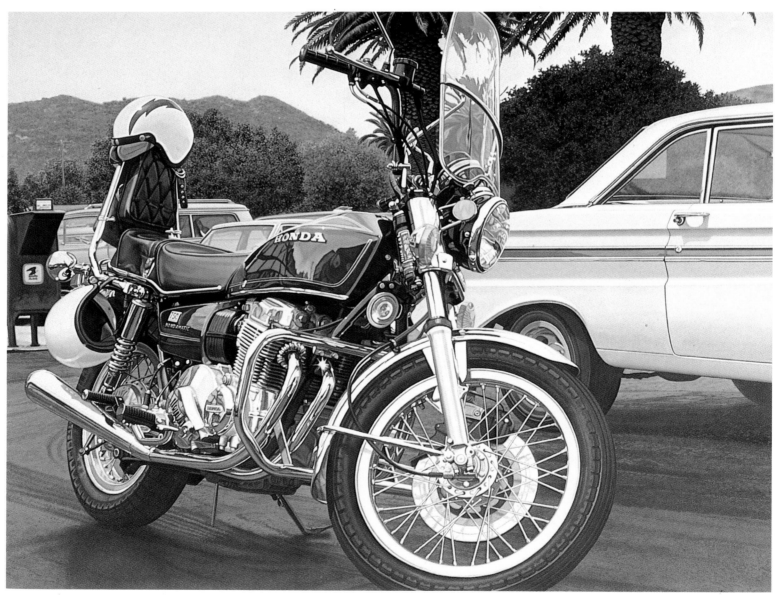

176. *Honda 750*. 1978 (50). Oil on canvas, 66 x 84".
Collection Joan and Barrie Damson, Conn.

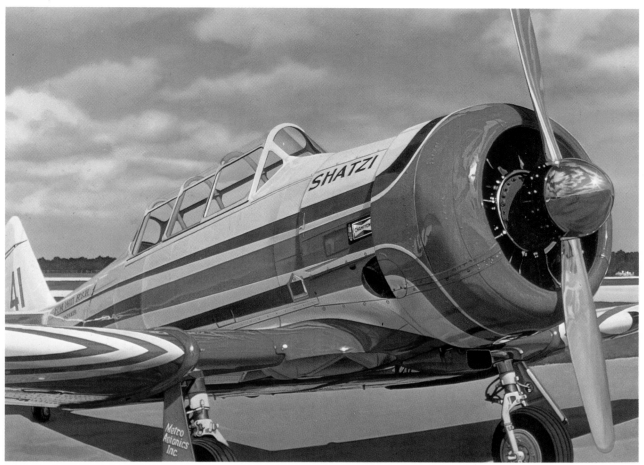

177. *Shatzi*. 1975 (26). Oil on canvas. 50 x 68". Collection Louis and Susan Meisel, New York

177a. *Shatzi, Small Version*. 1978 (49a). Oil on Masonite, 17 x 22". Collection Louis and Susan Meisel, New York

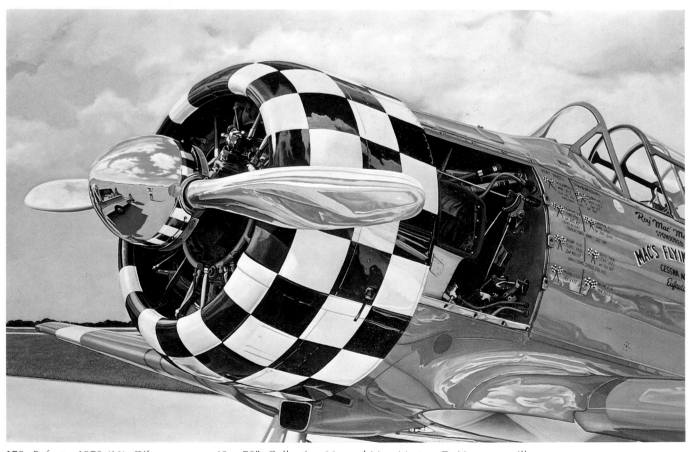

178. *Enfanta*. 1973 (16). Oil on canvas, 48 x 72". Collection Mr. and Mrs. Morton G. Neumann, Ill.

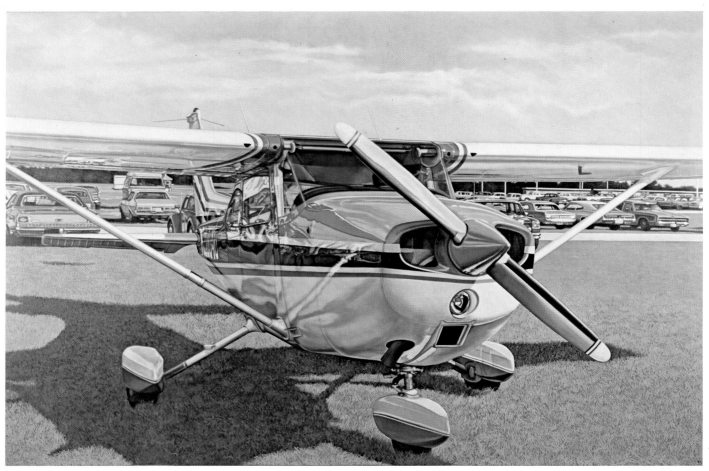

179. *Skyhawk Parked*. 1973 (17). Oil on canvas, 48 x 72". Collection Edmund P. Pillsbury, Conn.

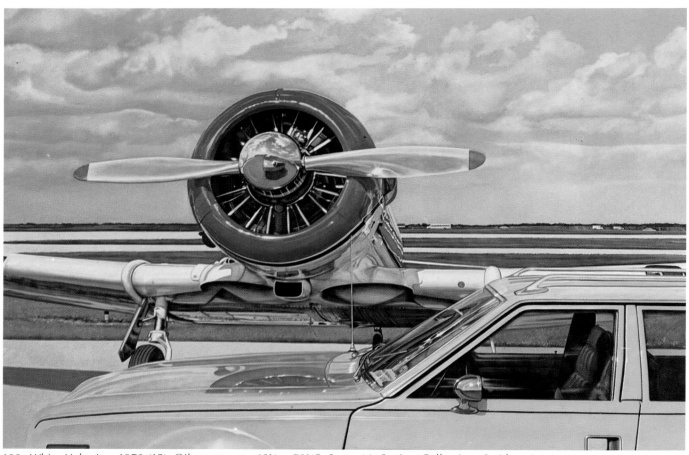

180. *White Lightning*. 1973 (15). Oil on canvas, 48¼ x 72¼". Stuart M. Speiser Collection, Smithsonian Institution, Washington, D.C.

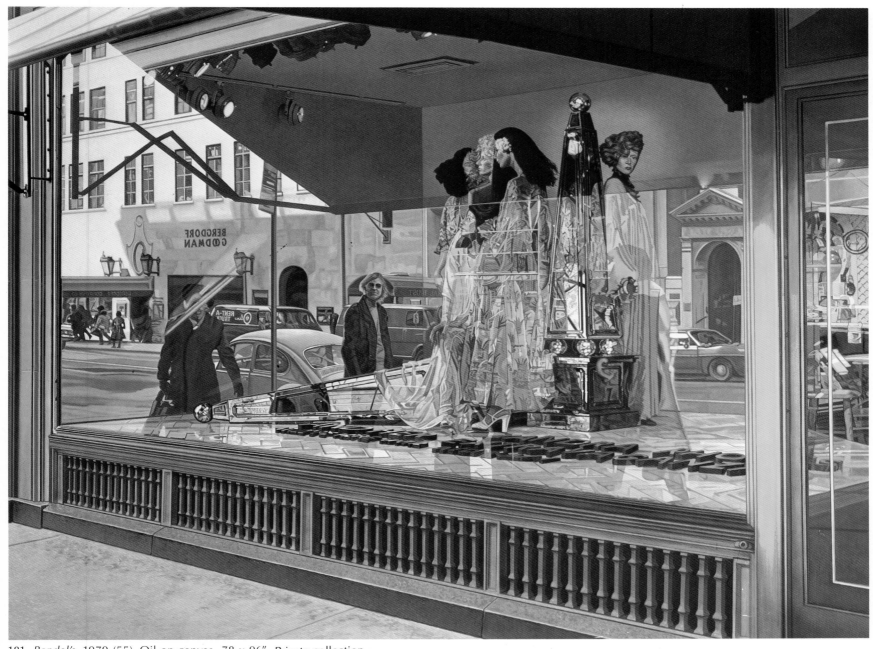

181. *Bendel's*. 1979 (55). Oil on canvas, 78 x 96". Private collection

182. *Bendel's*. 1979 (53).
Watercolor on paper, 14½ x 21".
Private collection, New York

183. *Untitled*. 1979 (54).
Watercolor on paper, 22 x 30".
Collection the artist

184. *GM Showroom*. 1977 (41).
Watercolor on paper, 15 x 22".
Collection Louis and Susan Meisel, New York

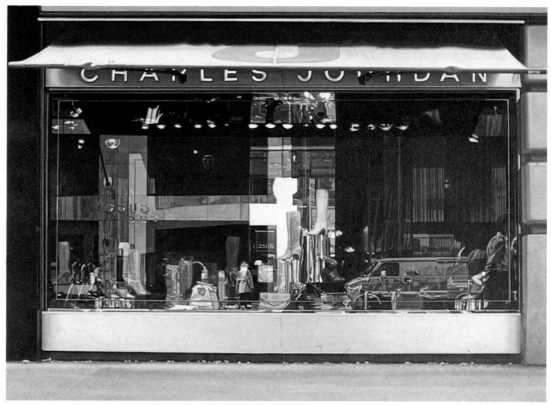

185. *Charles Jourdan.* 1979 (52). Oil on canvas, 36 x 48". Private collection, New York

185a. *Charles Jourdan.* 1979 (51a). Watercolor, 22 x 30". Collection Arlene Cohen

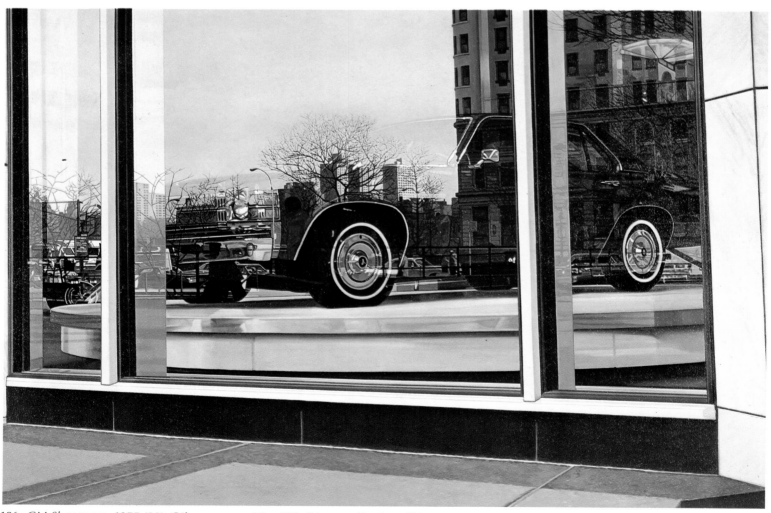

186. *GM Showroom.* 1975 (32). Oil on canvas, 50 x 72". Private collection, Chicago

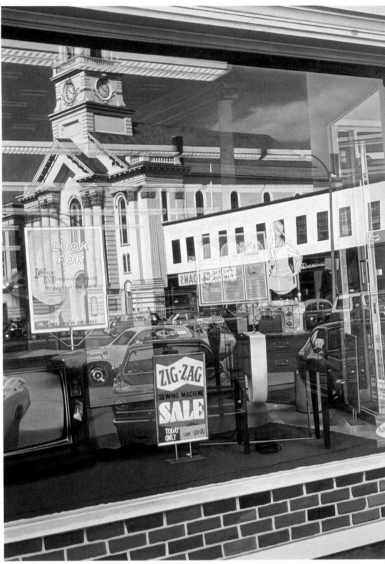

187. *Estelle Powledge No. 1, Grimes County, Texas.* 1978 (49). Oil on canvas, 70 x 50". Private collection, New York

188. *Main Street (Keene, N.H.).* 1973–74 (19). Oil on canvas, 96 x 60". Private collection

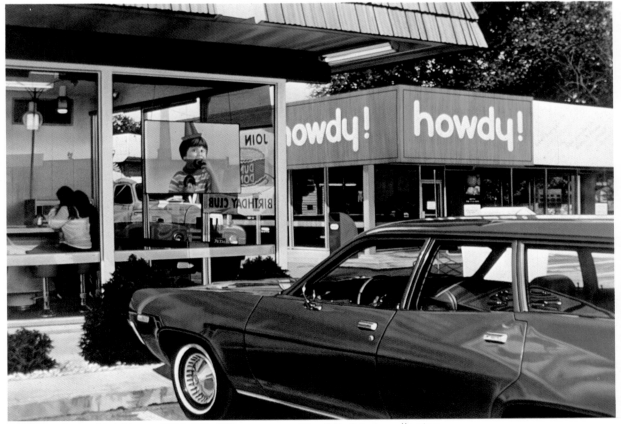

189. *Howdy Beef 'n' Burger.* 1974 (20). Oil on canvas, 60 x 84". Private collection

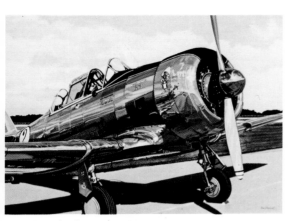

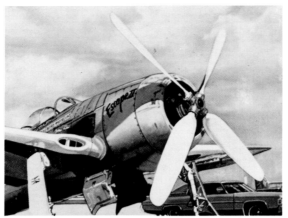

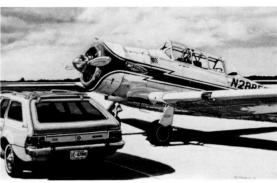

190. *Speedy Gonzales*. 1975 (35).
Oil on canvas, 16 x 20".
Collection Mr. and Mrs. Pat Blackwell, Calif.

191. *Escape II*. 1973–75 (30).
Oil on canvas, 15½ x 19".
Collection Richard Belger, Mo.

192. *White Lightning*. 1975 (40).
Acrylic on board, 10¼ x 15⅛".
Collection Elliott Meisel, New York

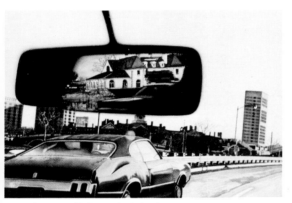

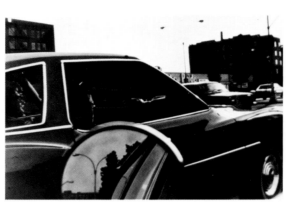

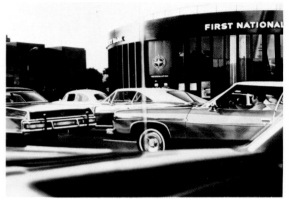

193. *Storrow Drive*. 1977 (44).
Watercolor on paper, 18 x 27".
Private collection, London

194. *Red Light*. 1975 (28).
Oil on canvas, 42 x 62".
Collection the artist

195. *Queens Boulevard*. 1974 (21).
Oil on canvas, 62 x 84".
Collection Paul and Camille Hoffman, Ill.

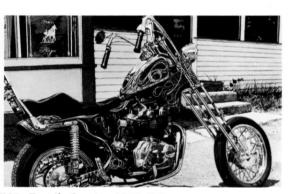

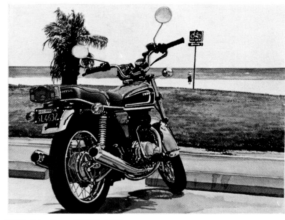

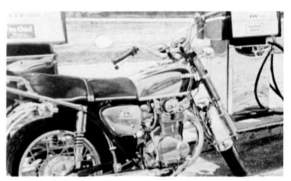

196. *Tequila Sunrise*. 1976 (37).
Oil on panel, 9¼ x 13¾".
Private collection

197. *Venice*. 1977 (48).
Watercolor on paper, 15 x 17".
Collection Linda Chase, N.H.

198. *Fire Chief*. 1975 (34).
Acrylic on board, 10¼ x 16".
Collection Myra and Jim Morgan, Kans.

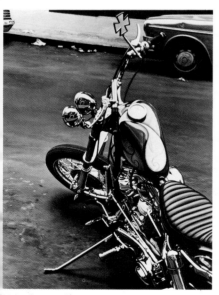

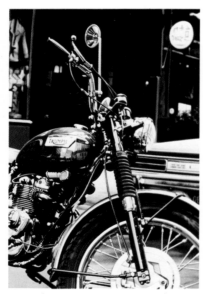

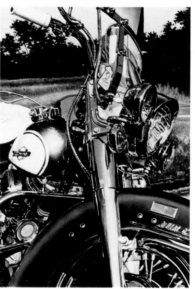

199. *Street Chopper*. 1974 (23).
Oil on canvas, 72 x 54".
Collection the artist

200. *Thompson Street Triumph*.
1975 (29). Oil on canvas, 48 x 33".
Private collection, New York

201. *High Standard's Harley*.
1975 (25). Acrylic on paper, 22 x 15".
Collection Louis and Susan
Meisel, New York

NOT ILLUSTRATED
Indian's Chopper I. 1970 (2).
Oil on canvas, 96 x 78".
Private collection, New York

Motorcycle Watercolor. 1973 (18).
Watercolor on paper, c. 9 x 12".
Collection Carroll Janis, New York

Honda. 1973 (14).
Oil on canvas, 36 x 48".
Private collection

Triumph Trumpet. 1977 (45).
Watercolor on paper, 15½ x 15½".
Private collection

Shatzi. 1977 (46).
Watercolor on paper, 15½ x 22".
Private collection

Jaffrey. 1978 (51).
Watercolor on paper, 17 x 14¾".
Collection Louis and
Susan Meisel, New York

BIOGRAPHY

1938 Born: Chicago

SOLO EXHIBITIONS
1961 Roy Parsons Gallery, Los Angeles
1962 Rex Evans Gallery, Los Angeles
1964 Orange Coast College Museum, Santa Ana, Calif.
1975 Morgan Gallery, Shawnee Mission, Kans.
 Sidney Janis Gallery, New York
1976 Galerie Le Portail, Heidelberg
1977 Louis K. Meisel Gallery, New York
1980 Louis K. Meisel Gallery, New York

SELECTED GROUP EXHIBITIONS
1966 "Psychedelic Art," Riverside Museum, New York
1968 "The Visionaries," East Hampton Gallery, N.Y.
1969 "Human Concern/Personal Torment," Whitney Museum of American
 Art, New York
1970 Molly Barnes Gallery, Los Angeles
1971 "All California Show," Laguna Beach Art Association Museum, Calif.
 "New Realism/Old Realism," Bernard Danenberg Gallery, New York
 O. K. Harris Gallery, New York
 "Projected Artists/Artists at Work," Finch College Museum, New York
1972 "L'Hyperréalistes américains," Galerie des Quatre Mouvements, Paris
 "Painting and Sculpture Today, 1972," Indianapolis Museum of Art
 "Phases of the New Realism," Lowe Art Museum, University of Miami,
 Coral Gables, Fla.
 "Realism Now," New York Cultural Center, New York
 "Sharp-Focus Realism," Sidney Janis Gallery, New York
 "Whitney Annual," Whitney Museum of American Art, New York
1972–73 "Amerikanischer Fotorealismus," Württembergischer Kunstverein,
 Stuttgart; Frankfurter Kunstverein, Frankfurt; Kunst und
 Museumsverein, Wuppertal, West Germany
1973 "American Realism, Post-Pop," Meadowbrook Art Gallery, Oakland
 University, Detroit
 "Realism Now," Katonah Gallery, Katonah, N.Y.
 "Richard Brown Baker Collection," San Francisco Museum of Art
 "The Super-Realist Vision," DeCordova and Dana Museum, Lincoln,
 Mass.
1973–74 "Hyperréalisme," Galerie Isy Brachot, Brussels
1973–78 "Photo-Realism 1973: The Stuart M. Speiser Collection," traveling
 exhibition: Louis K. Meisel Gallery, New York; Herbert F. Johnson
 Museum of Art, Ithaca, N.Y.; Memorial Art Gallery of the University
 of Rochester, N.Y.; Addison Gallery of American Art, Andover,
 Mass.; Allentown Art Museum, Pa.; University of Colorado
 Museum, Boulder; University Art Museum, University of Texas,
 Austin; Witte Memorial Museum, San Antonio, Tex.; Gibbes Art
 Gallery, Charleston, S.C.; Brooks Memorial Art Gallery, Memphis,
 Tenn.; Krannert Art Musum, University of Illinois, Champaign-
 Urbana; Helen Foresman Spencer Museum of Art, University of
 Kansas, Lawrence; Paine Art Center and Arboretum, Oshkosh, Wis.;
 Edwin A. Ulrich Museum, Wichita State University, Kans.; Tampa
 Bay Art Center, Tampa, Fla.; Rice University, Sewall Art Gallery,
 Houston; Tulane University Art Gallery, New Orleans; Smithsonian
 Institution, Washington, D.C.
1974 "Amerikaans fotorealisme grafiek," Hedendaagse Kunst, Utrecht; Palais
 des Beaux-Arts, Brussels
 "Ars '74 Ateneum," Fine Arts Academy of Finland, Helsinki
 "Art 5 '74," Basel, Switzerland
 "Corporations Collect," DeCordova and Dana Museum, Lincoln, Mass.
 Institute of Contemporary Art, University of Pennsylvania, Philadelphia
 "New Photo-Realism," Wadsworth Atheneum, Hartford, Conn.
 "Tokyo Biennale, '74," Tokyo Metropolitan Museum of Art; Kyoto
 Municipal Museum; Aichi Prefectural Art Museum, Nagoya
 "Twenty-five Years of Janis: Part II," Sidney Janis Gallery, New York
1975 "The New Realism: Rip-Off or Reality?," Edwin A. Ulrich Museum,
 Wichita State University, Kans.

"Photo-Realists," Louis K. Meisel Gallery, New York
"Realismus und Realität," Kunsthalle, Darmstadt, West Germany
"Watercolors and Drawings—American Realists," Louis K. Meisel
 Gallery, New York
1975–76 "Photo-Realism, American Painting and Prints," New Zealand traveling
 exhibition: Barrington Gallery, Auckland; Robert McDougall Art
 Gallery, Christchurch; Academy of Fine Arts, National Art Gallery,
 Wellington; Dunedin Public Art Gallery, Dunedin; Govett-Brewster
 Art Gallery, New Plymouth; Waikato Art Museum, Hamilton
 "Super Realism," Baltimore Museum of Art
1976 Galerie Le Portail, Heidelberg
 "Herbert Distel's Museum of Drawers," Museum der Stadt Solothurn,
 Switzerland
 "Realism (Paintings and Drawings)," Young Hoffman Gallery, Chicago
 "Troisième foire internationale d'art contemporain," Grand Palais,
 Paris
 "Washington International Art Fair," Washington, D.C.
1976–78 "Aspects of Realism," traveling exhibition sponsored by Rothman's
 of Pall Mall Canada, Ltd.: Stratford, Ont.; Centennial Museum,
 Vancouver, B.C.; Glenbow-Alberta Institute, Calgary, Alta.;
 Mendel Art Gallery, Saskatoon, Sask.; Winnipeg Art Gallery, Man.;
 Edmonton Art Gallery, Alta.; Art Gallery, Memorial University of
 Newfoundland, St. John's; Confederation Art Gallery and Museum,
 Charlottetown, P.E.I.; Musée d'Art Contemporain, Montreal, Que.;
 Dalhousie University Museum and Gallery, Halifax, N.S.; Windsor
 Art Gallery, Ont.; London Public Library and Art Museum and
 McIntosh Memorial Art Gallery, University of Western Ontario; Art
 Gallery of Hamilton, Ont.
1976–79 National Air and Space Museum, Smithsonian Institution, Washington,
 D.C.
1977 "Breaking the Picture Plane," Tomasulo Gallery, Union College,
 Cranford, N.J.
 "Fliegen—Ein Traum," Museum der Stadt Recklinghausen, West
 Germany
 "New Realism," Jacksonville Art Museum, Fla.
 "Photo-Realists," Shore Gallery, Boston
 "Washington International Art Fair," Washington, D.C.
 "Works on Paper II," Louis K. Meisel Gallery, New York
1977–78 "Illusion and Reality," Australian touring exhibition: Australian
 National Gallery, Canberra; Western Australian Art Gallery, Perth;
 Queensland Art Gallery, Brisbane; Art Gallery of New South Wales,
 Sydney; Art Gallery of South Australia, Adelaide; National Gallery
 of Victoria, Melbourne; Tasmanian Museum and Art Gallery, Hobart
1978 "Art and the Automobile," Flint Institute of Arts, Mich.
 "Landscape/Cityscape," Brainerd Hall Art Gallery, State University
 College, Potsdam, N.Y.
 Monmouth Museum, Lincroft, N.J.
 Palm Springs Art Fair, Calif.
 "Photo-Realism and Abstract Illusionism," Arts and Crafts Center of
 Pittsburgh
 Thomas Segal Gallery, Boston
 Tolarno Galleries, Melbourne, Australia
 "Washington International Art Fair," Washington, D.C.
1979 Middendorf Gallery, Washington, D.C.
 "Photo-Realist Printmaking," Louis K. Meisel Gallery,
 New York
 "Prospectus: Art in the Seventies," Aldrich Museum of
 Contemporary Art, Ridgefield, Conn.
 "Realist Space," C. W. Post Art Gallery, Long Island University,
 Brookville, N.Y.
 "Selections from the Collection of Richard Brown Baker," Squibb
 Gallery, Princeton, N.J.
 "Selections of Photo-Realist Paintings from N.Y.C. Galleries,"
 Southern Alleghenies Museum of Art, St. Francis College,
 Loretto, Pa.
 Washington International Art Fair, Washington, D.C.

SELECTED BIBLIOGRAPHY

CATALOGUES

Abadie, Daniel. Introduction to *Hyperréalistes américains*. Galerie des Quatre Mouvements, Paris, Oct. 25–Nov. 25, 1972.

Baratte, John J., and Thompson, Paul E. *Phases of the New Realism*. Lowe Art Museum, University of Miami, Coral Gables, Fla., Jan. 20–Feb. 20, 1972.

Baur, I. H. Foreword to *1972 Annual Exhibition*. Whitney Museum of American Art, New York, Jan. 25–Mar. 19, 1972.

Janis, Sidney. Introduction to *Sharp-Focus Realism*. Sidney Janis Gallery, New York, Jan. 6–Feb. 4, 1972.

Warrum, Richard L. Introduction to *Painting and Sculpture Today, 1972*. Indianapolis Museum of Art, Apr. 26–June 4, 1972.

Amaya, Mario. Introduction to *Realism Now*. New York Cultural Center, New York, Dec. 6, 1972–Jan. 7, 1973.

Schneede, Uwe, and Hoffman, Heinz. Introduction to *Amerikanischer Fotorealismus*. Württembergischer Kunstverein, Stuttgart, Nov. 16–Dec. 26, 1972; Frankfurter Kunstverein, Frankfurt, Jan. 6–Feb. 18, 1973; Kunst und Museumsverein, Wuppertal, West Germany, Feb. 25–Apr. 8, 1973.

Lamagna, Carlo. Foreword to *The Super-Realist Vision*. DeCordova and Dana Museum, Lincoln, Mass., Oct. 7–Dec. 9, 1973.

Meisel, Louis K. *Photo-Realism 1973: The Stuart M. Speiser Collection*. New York, 1973.

Radde, Bruce. Introduction to *East Coast/West Coast/New Realism*. University Art Gallery, San Jose State University, Calif., Apr. 24–May 18, 1973.

Hyperréalisme. Galerie Isy Brachot, Brussels, Dec. 14, 1973–Feb. 9, 1974.

Amerikaans fotorealisme grafiek. Hedendaagse Kunst, Utrecht, Aug., 1974; Palais des Beaux-Arts, Brussels, Sept.–Oct., 1974.

Chase, Linda. "Photo-Realism." In *Tokyo Biennale 1974*. Tokyo Metropolitan Museum of Art; Kyoto Municipal Museum; Aichi Prefectural Art Museum, Nagoya, 1974.

Cowart, Jack. *New Photo-Realism*. Wadsworth Atheneum, Hartford, Conn., Apr. 10–May 19, 1974.

Sarajas-Korte, Salme. Introduction to *Ars '74 Ateneum*. Fine Arts Academy of Finland, Helsinki, Feb. 15–Mar. 31, 1974.

Twenty-five Years of Janis: Part II from Pollack to Pop, Op and Sharp Focus Realism. Sidney Janis Gallery, New York, Mar. 13–Apr. 13, 1974.

Walthard, Dr. Frederic P. Foreword to *Art 5 '74*. Basel, Switzerland, June 19–24, 1974.

Krimmel, Bernd. Introduction to *Realismus und Realität*. Foreword by H.W. Sabais. Kunsthalle, Darmstadt, West Germany, May 24–July 6, 1975.

Meisel, Susan Pear. *Watercolors and Drawings—American Realists*. Louis K. Meisel Gallery, New York, Jan., 1975.

Thirty-ninth Annual Midyear Show. Butler Institute of American Art, Youngstown, Ohio, June 29–Aug. 31, 1975.

Tom Blackwell. Sidney Janis Gallery, New York, Feb. 5–Mar. 1, 1975.

Richardson, Brenda. Introduction to *Super Realism*. Baltimore Museum of Art, Nov. 18, 1975–Jan. 11, 1976.

Felluss, Elias A. Foreword to *Washington International Art Fair*. Washington, D.C., 1976.

Gervais, Daniel. Introduction to *Troisième foire internationale d'art contemporain*. Grand Palais, Paris, Oct. 16–24, 1976.

Chase, Linda. "U.S.A." In *Aspects of Realism*. Rothman's of Pall Mall Canada, Ltd., June, 1976–Jan., 1978.

Dempsey, Bruce. *New Realism*. Jacksonville Art Museum, Fla., 1977.

Felluss, Elias A. Foreword to *Washington International Art Fair*. Washington, D.C., 1977.

Meisel, Louis K. Introduction to *Tom Blackwell*. Louis K. Meisel Gallery, New York, Oct. 8–29, 1977.

Stringer, John. Introduction to *Illusion and Reality*. Australian Gallery Directors' Council, North Sydney, N.S.W., 1977–78.

Hodge, G. Stuart. Foreword to *Art and the Automobile*. Flint Institute of Arts, Mich., Jan. 12–Mar. 12, 1978.

Meisel, Louis K. Introduction to *Landscape/Cityscape*. Brainerd Hall Art Gallery, State University College, Potsdam, N.Y., Sept. 22–Oct. 22, 1978.

Meisel, Susan Pear. Introduction to *The Complete Guide to Photo-Realist Printmaking*. Louis K. Meisel Gallery, New York, Dec., 1978.

Baker, Richard Brown. Introduction to *Selections from the Collection of Richard Brown Baker*. Squibb Gallery, Princeton, N.J., Oct. 4–Nov. 4, 1979.

Felluss, Elias A. Introduction to *Washington International Art Fair '79*, Washington, D.C., May 2–7, 1979.

Miller, Wayne. Introduction to *Realist Space*. Foreword by Joan Vita Miller. C. W. Post Art Gallery, Long Island University, Brookville, N.Y., Oct. 19–Dec. 14, 1979.

Streuber, Michael. Introduction to *Selections of Photo-Realist Paintings from N.Y.C. Galleries*. Southern Alleghenies Museum of Art, St. Francis College, Loretto, Pa., May 12–July 8, 1979.

ARTICLES

"Reviews," *Artforum*, Apr. 16, 1964, p. 18.

Glueck, Grace. "Reviews," *New York Times*, Apr. 1, 1967, p. 26.

"Living Big in a Loft," *Life*, 1970.

Chase, Linda; Foote, Nancy; and McBurnett, Ted. "The Photo-Realists: 12 Interviews," *Art in America*, vol. 60, no. 6 (Nov.–Dec., 1972), pp. 73–89.

Hickey, David. "Sharp Focus Realism," *Art in America*, Mar.–Apr., 1972, pp. 116–18.

Hughes, Robert. "The Realist as Corn God," *Time*, Jan. 31, 1972, pp. 50–55.

"Hyperréalistes américains," *Argus de la Presse*, Nov. 16, 1972.

Kramer, Hilton. "And Now, Pop Art: Phase II," *New York Times*, Jan. 16, 1972.

Lerman, Leo. "Sharp Focus Realism," *Mademoiselle*, Mar., 1972, pp. 170–73.

Lista, Giovanni. "Iperrealisti americani," *NAC* (Milan), no. 12 (Dec., 1972), pp. 24–25.

Marmori, Giancarlo di. "Piú vero del vero," *L'Espresso*, no. 29 (June 16, 1972), pp. 4–15.

Marvel, Bill. "Saggy Nudes? Giant Heads? Make Way for 'Superrealism,'" *National Observer*, Jan. 29, 1972, p. 22.

Rosenberg, Harold. "The Art World," *The New Yorker*, Feb. 5, 1972, pp. 88–93.

Seitz, William C. "The Real and the Artificial: Painting of the New Environment," *Art in America*, vol. 60, no. 6 (Nov.–Dec., 1972), pp. 58–72.

Thornton, Gene. "These Must Have Been a Labor of Love," *New York Times*, Jan. 23, 1972.

Warnod, Jeanine. "Le réalisme et son oeuvre," *Le Figaro* (Paris), 1972.

Art Now Gallery Guide, Sept., 1973, pp. 1–3.

Bell, Jane. "Stuart M. Speiser Collection," *Arts Magazine*, Dec., 1973, p. 57.

Borgeaud, Bernard. "Hyperréalisme américain," *Pariscope*, Oct., 1973, p. 73.

Chase, Linda. "Recycling Reality," *Art Gallery Magazine*, Oct., 1973, pp. 75–82.

Chase, Linda, and McBurnett, Ted. "Interviews with Robert Bechtle, Tom Blackwell, Chuck Close, Richard Estes and John Salt," *Opus International*, no. 44–45 (June, 1973), pp. 38–50.

Derfner, Phyllis. "New York Letter," *Art International/The Lugano Review*, 1973.

Hakanson, Joy. "Post-Pop Realists Break Rules—Beautifully," *Detroit Sunday News*, Feb., 1973.

"L'hyperréalisme américain," *Le Monde des Grandes Musiques*, no. 2 (Mar.–Apr., 1973), pp. 4, 56–57.

Levin, Kim. "The New Realism: A Synthetic Slice of Life," *Opus International*, no. 44–45 (June, 1973), pp. 28–37.

Moulin, Raoul-Jean. "Hyperréalistes américains," *L'Humanité*, Jan. 16, 1973.

Piradel, Jean-Louis. "Paris I: hyperréalistes américains," *Opus International*, no. 39 (1973), pp. 51–52.

Tall, Bill. "The World of Post-Pop: Scintillating New Wave," *Detroit News*, Feb., 1973.

Chase, Linda. "The Connotation of Denotation," *Arts Magazine*, Feb., 1974, pp. 38–41.

Hartford Magazine, Apr., 1974, p. 14.

Hughes, Robert. "An Omnivorous and Literal Dependence," *Arts Magazine*, June, 1974, pp. 25–29.

Spector, Stephen. "The Super Realists," *Architectural Digest*, Nov.–Dec., 1974, p. 85.

"Tom Blackwell," *Goya*, no. 119 (Mar.–Apr., 1974).

University of Kansas Museum of Art Calendar, Dec., 1974–Jan., 1975.

Auckland Star, June 25, 1975, p. 1.

Battcock, Gregory. "Art in New York," *Domus*, June, 1975, pp. 54–55.

Bromhead, Peter. "Going Back in Time," *Auckland Star*, 1975.

———. "When Is Copying Not Cheating?," *Auckland Star*, 1975.

Curnow, Wynston. "The Imagery of Now," *New Zealand Listener*, Sept., 1975.

Ellenzweig, Allen. "Reviews," *Arts Magazine*, Apr., 1975, p. 14.

"First Exhibition of Photo-Realist Art in Auckland," *Auckland Tourist Times,* 1975.

"Goings On About Town," *The New Yorker,* Feb. 24, 1975, p. 8.

"Local Art Exhibition," *South Auckland Courier,* July, 1975.

McNamara, T. J. "Photo-Realist Exhibition Makes Impact," *New Zealand Herald* (Auckland), July 23, 1975.

"Photo-Realism," *New Zealand Herald* (Auckland), July, 1975.

"Photo-Realism," *Northern Advocate* (New Zealand), Aug., 1975.

"Photo-Realism at Best," *Christchurch Star* (New Zealand), Aug., 1975.

"Photo-Realism Exhibit Is Opening at Paine Sunday," *Oshkosh Daily Northwestern,* Apr. 17, 1975.

"Photo-Realism Flies High at Paine," *Milwaukee Journal,* May, 1975.

"Photo-Realism on the Way," *Western Leader* (New Zealand), July, 1975.

"Photo-Realism Tours Our Big Centers," *Manawato Evening Standard* (New Zealand), July, 1975.

"Photo-Realist Art," *Auckland Tourist Times,* Aug., 1975.

"Photo-Realist Art to Be Shown in Dunedin," *Evening Star* (New Zealand), July, 1975.

"Photo-Realists at Paine," *View Magazine,* Apr. 27, 1975.

Ratcliff, Carter. "Tom Blackwell at Sidney Janis," *Art International,* vol. XIX, no. 14 (Apr. 20, 1975), pp. 56–57.

Ray, Steve. "Photo/Art: Real or Reel," *Oshkosh Advance-Titan,* May 1, 1975.

Richard, Paul. "Whatever You Call It, Super Realism Comes On with a Flash," *Washington Post,* Nov. 25, 1975, p. B1.

Russell, John. "Tom Blackwell," *New York Times,* Feb. 8, 1975, p. 21.

"Unique Art Exhibition," *City News* (New Zealand), July, 1975.

Artner, Alan. "Mirroring the Merits of a Showing of Photo-Realism," *Chicago Tribune,* Oct. 24, 1976.

Chase, Linda. "How Much Is a Painting Worth?," *The New Englander,* vol. 23, no. 8 (Dec., 1976), pp. 54–62.

Chase, Linda. "Photo-Realism: Post Modernist Illusionism," *Art International,* vol. XX, no. 3–4 (Mar.–Apr., 1976), pp. 14–27.

"Exhibition Displays Aspects of Realism," *New Westminster* (B.C.) *Columbian,* Oct. 9, 1976.

Glasser, Penelope. "Aspects of Realism at Stratford," *Art Magazine* (Toronto), vol. 7, no. 28 (Summer, 1976), pp. 22–29.

Hoffman, Donald. *Kansas City Star,* May, 1976.

K. M. "Realism," *New Art Examiner,* Nov., 1976.

Lamagna, Carlo. "Tom Blackwell's New Paintings," *Art International,* vol. XX, no. 10 (Dec., 1976), pp. 22–26.

Owen, Barbara. "For the First Time...I Like What I Am Doing," *Stars and Stripes* (Heidelberg), Dec. 17, 1976.

Parker, William. "Perspectives," *Monadnock* (N.H.) *Ledger,* July, 1976, p. 5.

Schneider, Helmut. "Heidelberg: Photo Realismus," *Die Zeit* (Heidelberg), Dec. 17, 1976, p. 38.

Yankee Magazine, vol. 40, no. 5 (May, 1976), pp. 104–5.

Greenwood, Mark. "Toward a Definition of Realism: Reflections on the Rothman's Exhibition," *Arts/Canada,* vol. XXIV, no. 210–11 (Dec., 1976–Jan., 1977), pp. 6–23.

Battcock, Gregory. "Dinner for Eighty," *Soho Weekly News,* Nov. 10, 1977.

Borlase, Nancy. "In Selecting a Common Domestic Object," *Sydney Morning Herald,* July 30, 1977.

Edelson, Elihu. "New Realism at Museum Arouses Mixed Feelings," *Jacksonville* (Fla.) *Journal,* Feb., 1977.

"Fleigen–Ein Traum," *Ruhrfestspiele,* Kunsthalle, Recklinghausen, West Germany, 1977.

"A Gallery of Aviation," *Pilot Magazine,* Dec., 1977, p. 66.

McGrath, Sandra. "I Am Almost a Camera," *The Australian* (Brisbane), July 27, 1977.

Phillips, Ralph. "Just Like the Real Thing," *Sunday Mail* (Brisbane), Sept. 11, 1977.

R. S. "The Museum of Modern Art," *Art in America,* Sept., 1977, pp. 93–96.

Ratcliff, Carter. "Remarks on the Nude," *Art International,* vol. XXI, no. 2 (Mar. 4, 1977), pp. 60–65.

Zimmer, William. "Works on Paper," *Arts Magazine,* Mar., 1977, p. 38.

"Acquisitions," *1978 Annual Report,* The Solomon R. Guggenheim Museum, New York.

Bongard, Willie, *Art Aktuell* (Cologne), Apr., 1978.

"For the Record," *The Art Gallery,* vol. XXI, no. 6 (Aug.–Sept., 1978), p. 16.

Harris, Helen. "Art and Antiques: The New Realists," *Town and Country,* Oct., 1978, pp. 242, 244, 246–47.

Mackie, Alwynne. "New Realism and the Photographic Look," *American Art Review,* Nov., 1978, pp. 72–79, 132–34.

"New Acquisitions," *Elvehjem Museum of Art Calendar* (Madison, Wis.), Sept., Oct., Nov., 1978.

Perreault, John. "Art Picks: Photo-Realist Prints," *Soho Weekly News,* Dec. 14, 1978, p. 54.

"Photo Journalism and Photo Realism," *Milwaukee Journal,* Dec. 10, 1978.

Zimmer, William. "Tom Blackwell," *Arts Magazine,* Jan., 1978, pp. 24–25.

Loge, Qystein. "Et Nytt Salongmaleri er pa vei," *Bergens Tidende* (Norway), Aug. 10, 1979, p. 4.

Reif, Rita. "Auctions: Orientalia Leads the Way," *New York Times,* Nov. 16, 1979.

BOOKS

Houston, Jean, and Masters, Robert. *Psychedelic Art.* New York: Grove Press, 1968.

Brachot, Isy, ed. *Hyperréalisme.* Brussels: Imprimeries F. Van Buggenhoudt, 1973.

Sager, Peter. *Neue Formen des Realismus.* Cologne: Verlag M. DuMont Schauberg, 1973.

Who's Who in American Art. New York: R. R. Bowker, 1973.

Calamandrei, Mauro, and Gorgoni, Gianfranco. *Art USA.* Milan: Fratelli Fabbri Editori, 1974.

Battcock, Gregory, ed. *Super Realism, A Critical Anthology.* New York: E. P. Dutton, 1975.

Chase, Linda. *Hyperréalisme.* New York: Rizzoli, 1975.

Kultermann, Udo. *Neue Formen des Bildes.* Tübingen, West Germany: Verlag Ernst Wasmuth, 1975.

Rose, Barbara, ed. *Readings in American Art, 1900–1975.* New York: Praeger, 1975.

Who's Who in American Art. New York: R. R. Bowker, 1976.

Battcock, Gregory. *Why Art.* New York: E. P. Dutton, 1977.

Lucie-Smith, Edward. *Super Realism.* Oxford: Phaidon, 1979.

Seeman, Helene Zucker, and Siegfried, Alanna. *SoHo.* New York: Neal-Schuman, 1979.

202. *Self-Portrait.* 1976 (72).
Watercolor on paper mounted on canvas, 81 x 58¾".
Neue Galerie der Stadt Aachen. Ludwig Collection

CHUCK CLOSE

Chuck Close is the paradox of this movement. He is at once a leading exponent of
Photo-Realism, one of its best-known and widely recognized painters, and yet
not a Photo-Realist at all. Although his work shares an appearance with that of the
other Photo-Realists, he has nothing more in common with them. To be sure, he and
his work do meet all the points of my definition, but his interests, concerns, and
self-imposed challenges are from a different part of the galaxy.

The other artists called Photo-Realists spend a good deal of time choosing subject
matter and determining composition. These are concerns which Close has not con-
sidered since he initially approached the problem in 1967 (one hundred works ago).
The others have spent the last ten years getting better and better and more proficient
in their singular painting method and technique. As Close became proficient in one
technique, he started over on a new one, and it is this aspect of his work that
distinguishes him not only from the other Photo-Realists but from almost all other
artists. It is his quest for "new ways to make marks which make art," rather than his
use of the photograph and camera, for which he will be known and remembered. In
the early seventies a graduate seminar at a California university had as its topic for
discussion, "What will Chuck Close paint next?" A pertinent response to that ques-
tion would be, "Ask not *what* Chuck Close will paint next, but *how* will Chuck Close
paint next."

In 1966 Close reached a personal turning point in his work and, therefore, in his
life. He had spent most of his life making art. He had gone through an entire formal
education as an artist, had received his degrees, and was teaching. He enjoyed
making art but no longer liked what he was making. He says, "I couldn't stand what
I was doing." What Close was doing was abstract painting with very thick, colorful
paints, following habitual and "pat" styles using other people's "artmarks." He
decided to repudiate everything he had been doing and establish totally new systems

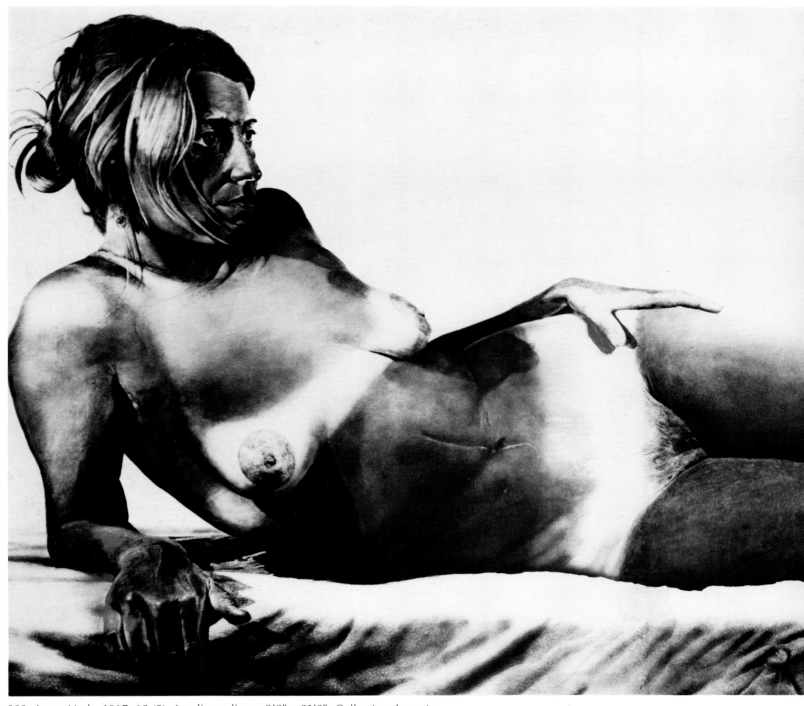

203. *Large Nude*. 1967–68 (3). Acrylic on linen, 9'9" x 21'2". Collection the artist

and guidelines for his art. He eliminated color and allowed himself only black. He got rid of all the thick, luxurious paint and limited himself to just a few tablespoons of pigment for an enormous canvas. He threw out brushes and knives and opted for the airbrush, so that he no longer even felt the paint and the response of the canvas.

Since all these technical changes were diametrically opposed to what he had been doing, the same had to be true of imagery. From abstract it had to become realist. Close decided to use the camera and photograph in order that almost all decisions about what a painting would look like would be made before starting to paint. A photograph also adds a certain discipline, because it becomes more difficult to make changes toward easier work if the photo image is the master. The photo, however, is just one element in Close's entire system. The method he decided upon for transferral of information from the photo to the canvas was the grid. (This factor alone, com-

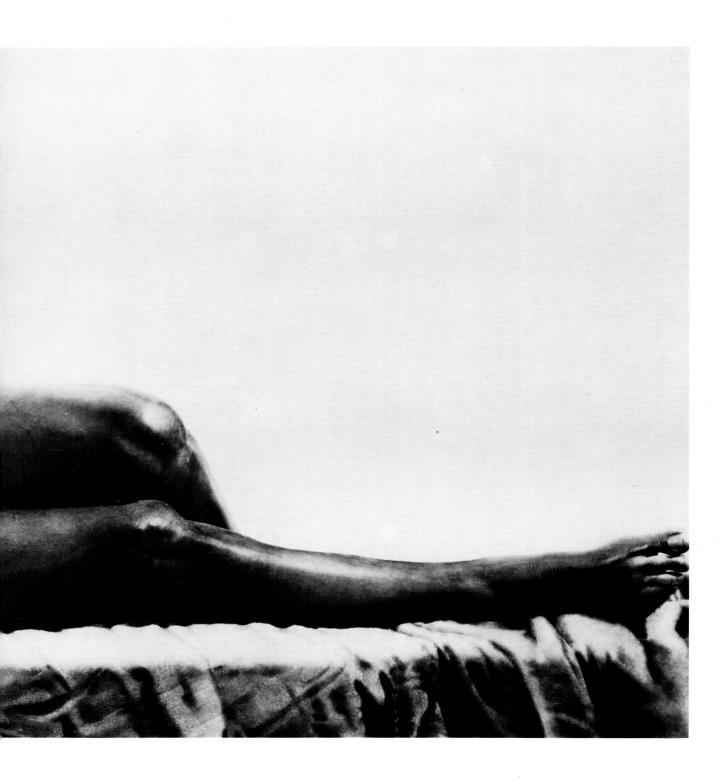

bined with his other choices, draws him nearer to the Minimalists of the sixties than to the Photo-Realists.) For Morley, Ott, and Eddy the grid was simply a transfer method; for Close it was the basic foundation for all systems to come.

In speaking with Chuck and his wife Leslie, I have heard the preceding story numerous times. Chuck seems to downgrade the whole process of his change to an almost accidental, random sort of happening. I see it as one of the most self-aware and calculated breakthroughs ever made by an artist, somewhat akin to Pollock's development of his first Drip works.

The first painting created under Close's freshly evolved system was a reclining nude (pl. 203). As large as the painting is, it still didn't have the scale he was looking for. While photographing it one day, Close got in front of the camera and at arm's length snapped a photo of his own face. The painting made from this photograph (pl. 204) is

the first of all Chuck Close heads and the first of the now well-known series of eight black-and-white portraits (pls. 204 to 211).

By the time he reached the second painting in the series, Close had made certain decisions concerning subject matter and composition which have remained constant to the present and may continue throughout his career. (In this respect he has something in common with Albers, an influence at Yale when Close studied there.) The decisions were: that he would paint the faces of close friends; they would pose in a set position, with predetermined borders at the top right and left and just below the collar bone on the bottom; the face would be as expressionless as possible; the lighting would remain constant; and there would be a shallow depth of field. As stated previously, the tool would be airbrush, the pigment thin and black only.

In 1970, after the initial eight black-and-whites were done, I feel that Close began to realize where his career and challenges were to lead. While adhering to his earlier choices about subject and composition, he decided to go to color, but only very slightly, doing three fragmented pencil studies using only red, yellow, and blue. These colors were then painted one over the other from color separations, still with the airbrush and minuscule amounts of pigment. The only other change at this point was that the color works were smaller than the first eight identical-sized black-and-whites. With this turning toward color, I believe that Chuck Close discovered for himself that it was going to be new methods, and not new images, for which he would be searching in the future. As he put it, different ways of making artmarks. His present vocabulary of marks is the most varied and extensive of any artist I know, and it is still growing.

In the six color works of the early seventies (pls. 212, 219 to 221, 223, and 227) and in *Linda* (pl. 228), Close limited himself to three colors from which, with extraordinary accuracy, he mixed all the others directly on the working surface. In the color works of the late seventies—mostly pastels—he has almost abandoned mixing (something he was no longer challenged by), in favor of choosing, from among the approximately one thousand different colors in his pastel collection, just the right color for each grid square.

The size of the works has gone from a minuscule couple of inches to nine feet high. The size of the grid squares in proportion to the overall picture has changed drastically, from as much as ten percent to as little as one tenth of one percent, with a corresponding difference in clarity and detail. The pigment, however, has always been applied thinly so far, but recently, by returning to a bristle brush for some of his watercolors, Close has made it possible for some thickness to edge back into his work.

Chuck Close has chosen or invented numerous ways to make the marks called art. He has made art in black and white and in color, in pastel, oil, and watercolor. He has printed in mezzotint, lithograph, and etching. He has used his fingerprints. He can execute a color painting with three colors or with three thousand colors. He is adept at continuous tone, dot, spraying, cross-hatching. He can use a brush, an airbrush, a pen, a pencil, a stylus, a stamp pad, a crayon, a piece of chalk, or the tip of his finger to make a face. How *will* he work next?

Chuck Close had executed 100 works as of the end of 1979. Of these, 76 are illustrated in the following pages; the remainder are listed.

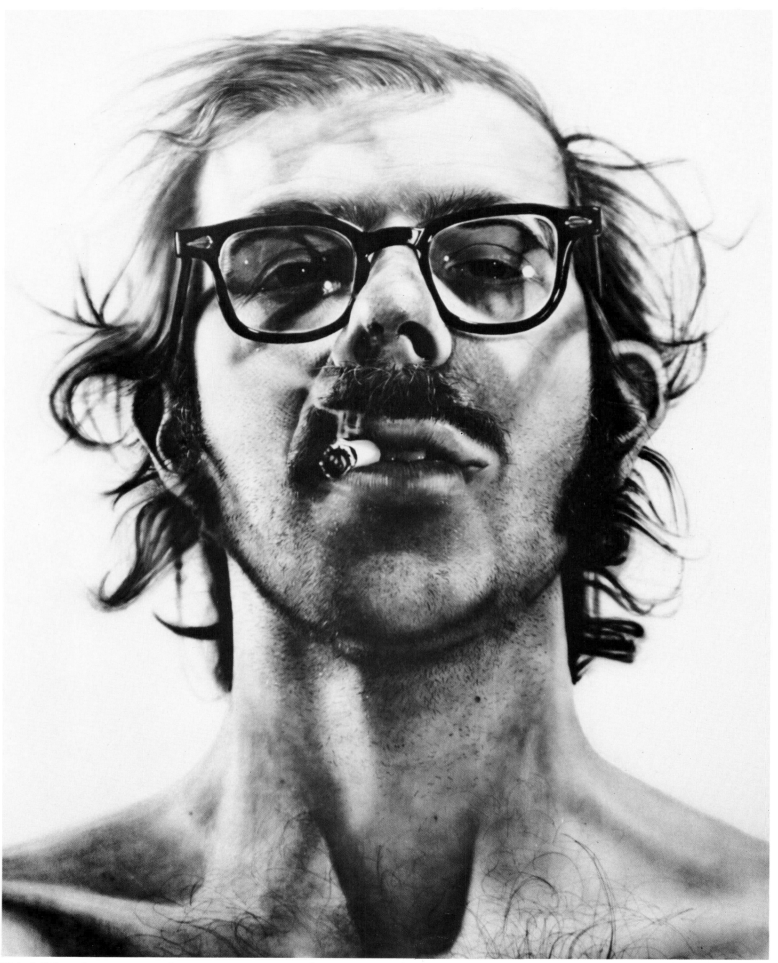

204. *Self-Portrait*. 1968 (4). Acrylic on canvas, 9' x 7'. Walker Art Center, Minn.

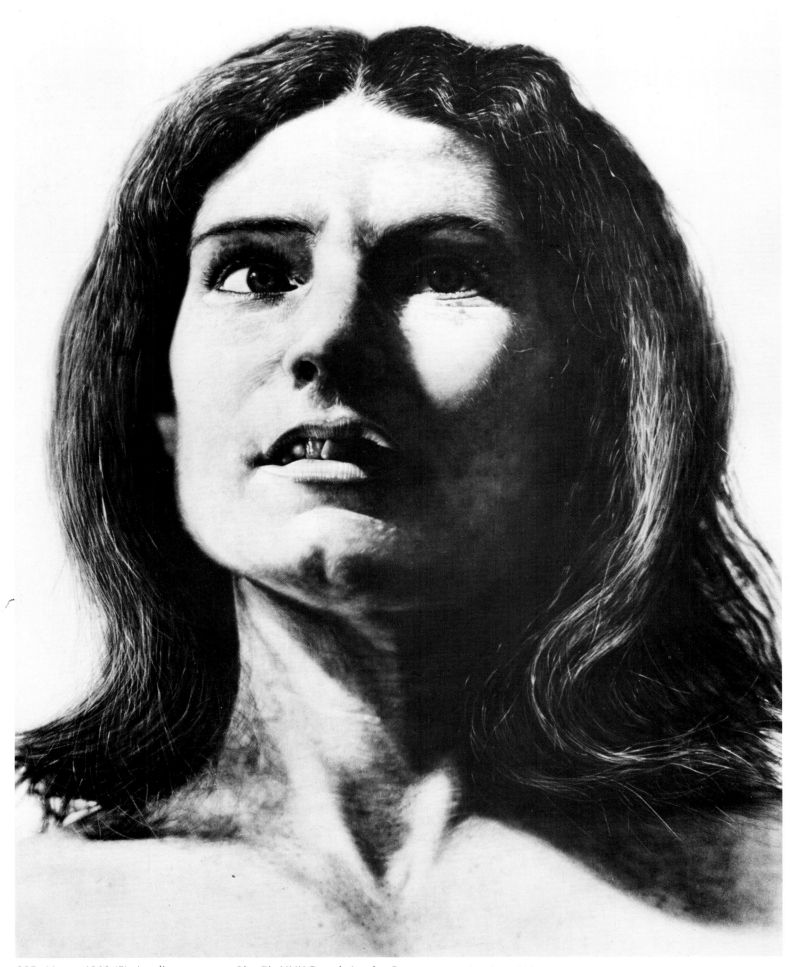

205. *Nancy*. 1968 (5). Acrylic on canvas, 9' x 7'. HHK Foundation for Contemporary Art, Inc., Wisc.

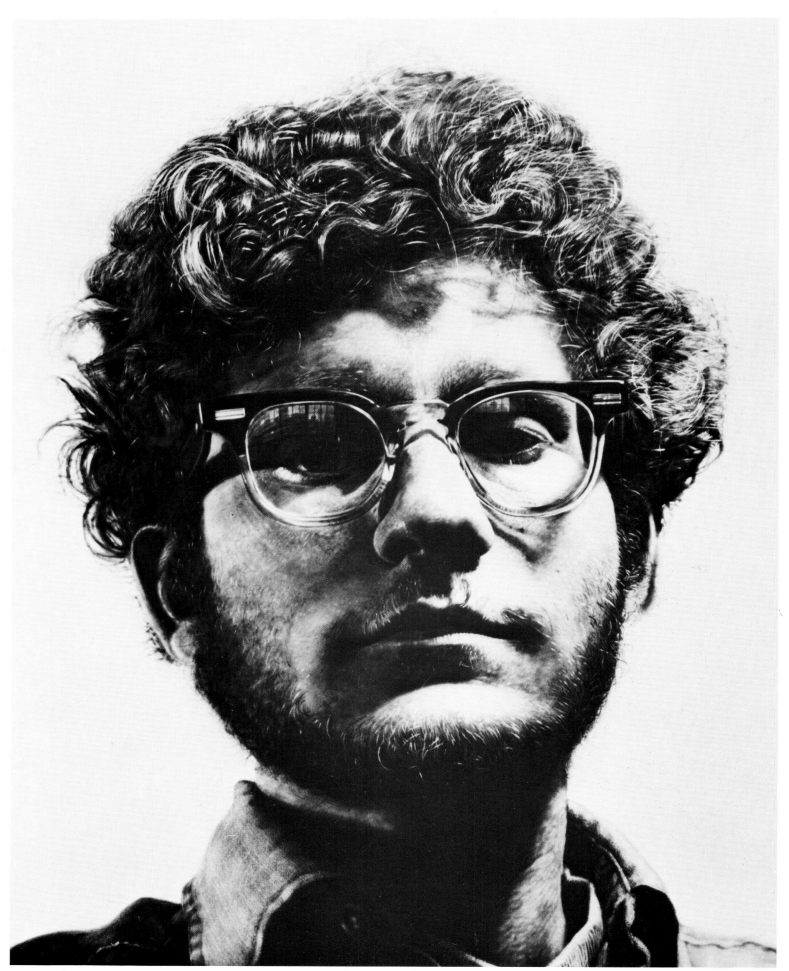

206. *Frank*. 1969 (6). Acrylic on canvas, 9' x 7'. Minneapolis Institute of Arts, Minn.

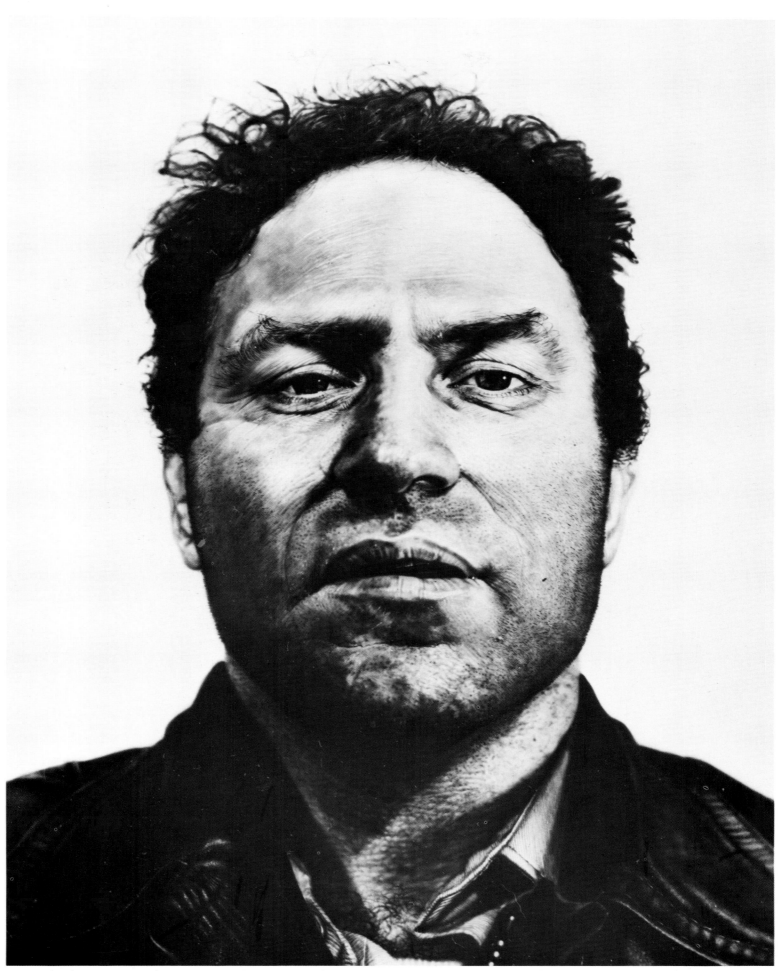

207. *Richard.* 1969 (7). Acrylic on canvas, 9' x 7'. Neue Galerie der Stadt Aachen. Ludwig Collection

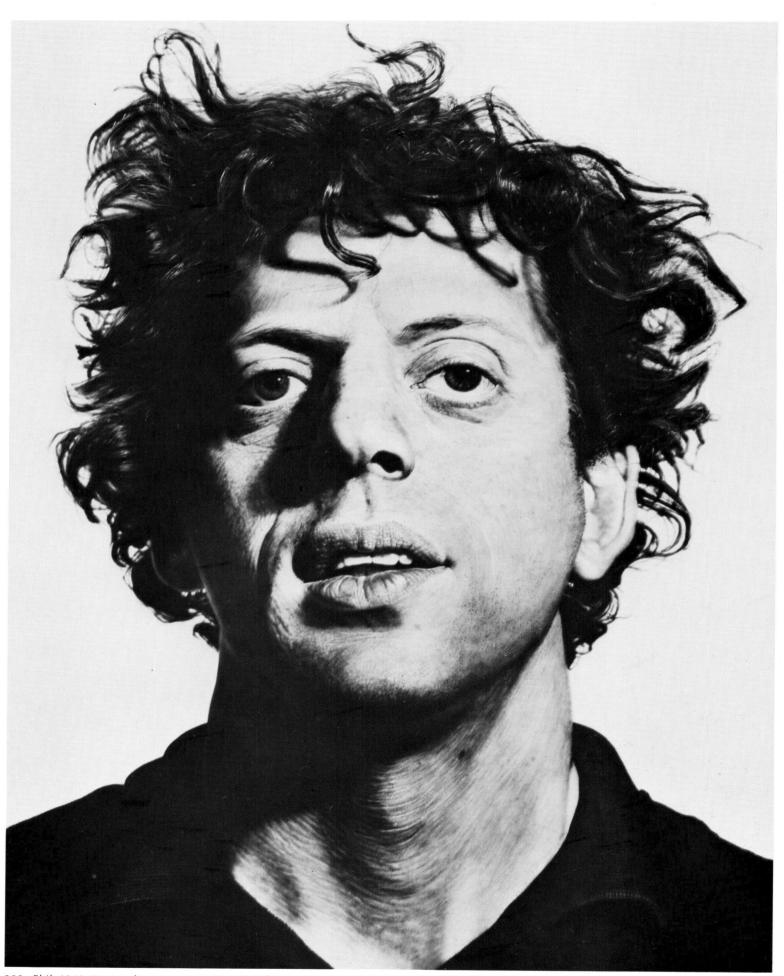

208. *Phil.* 1969 (8). Acrylic on canvas, 9' x 7'. Whitney Museum of American Art, New York. Gift of Mrs. Robert A. Benjamin

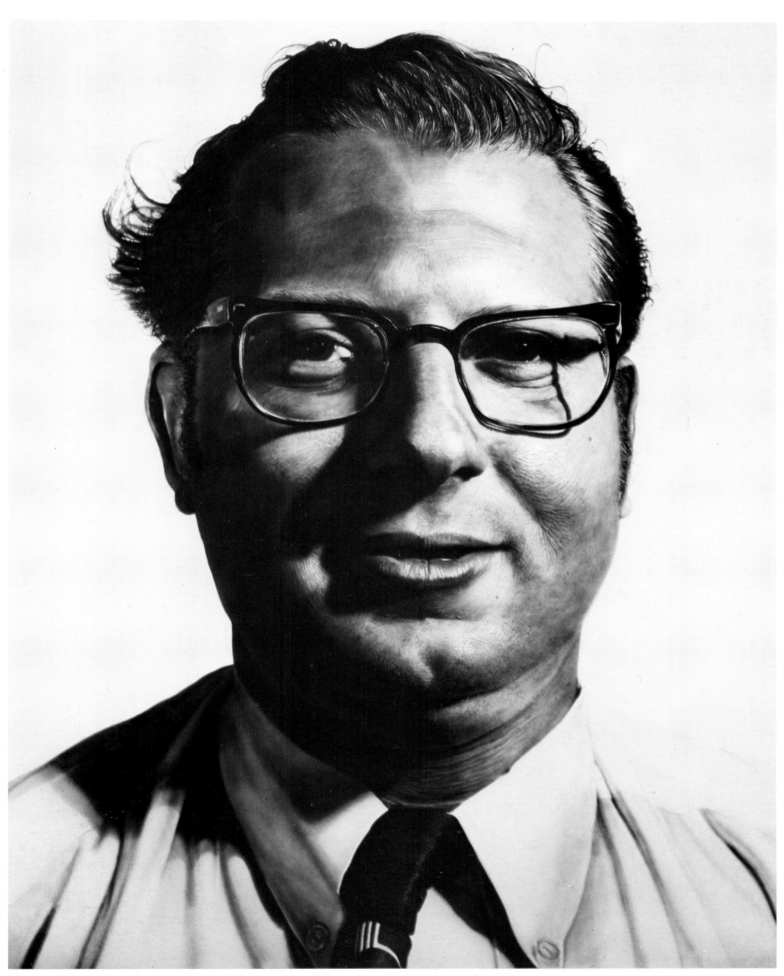

209. *Joe*. 1969 (9). Acrylic on canvas, 9' x 7'. Collection Doris and Charles Saatchi, London

118

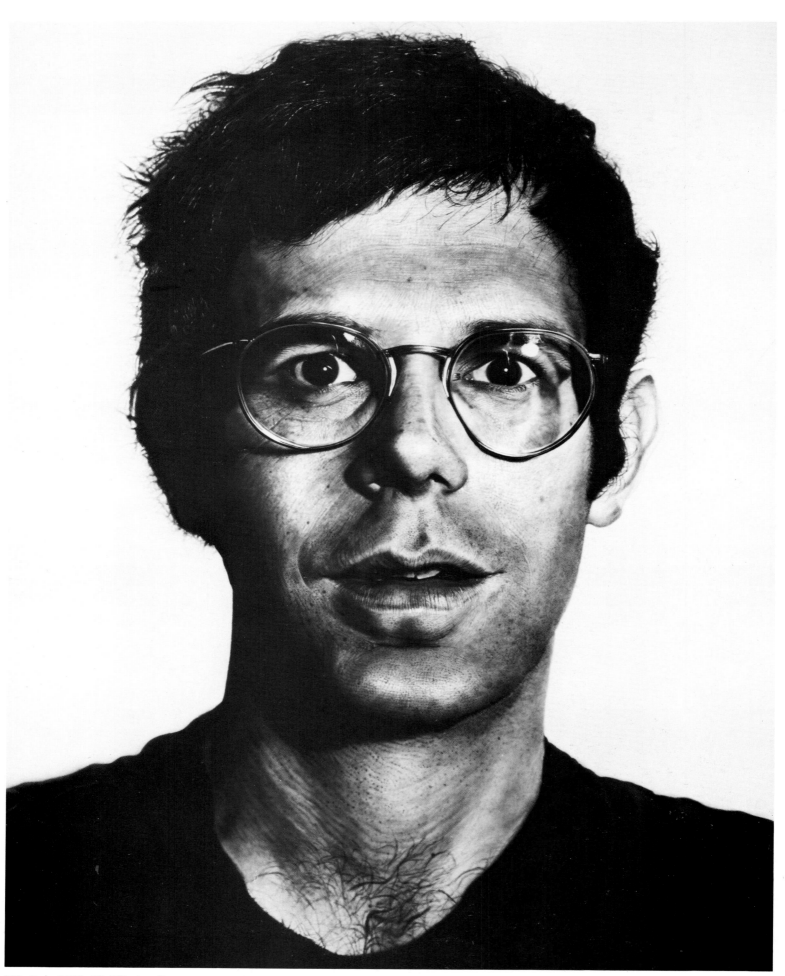

210. *Bob*. 1969–70 (10). Acrylic on canvas, 9' x 7'. Australian National Gallery, Canberra

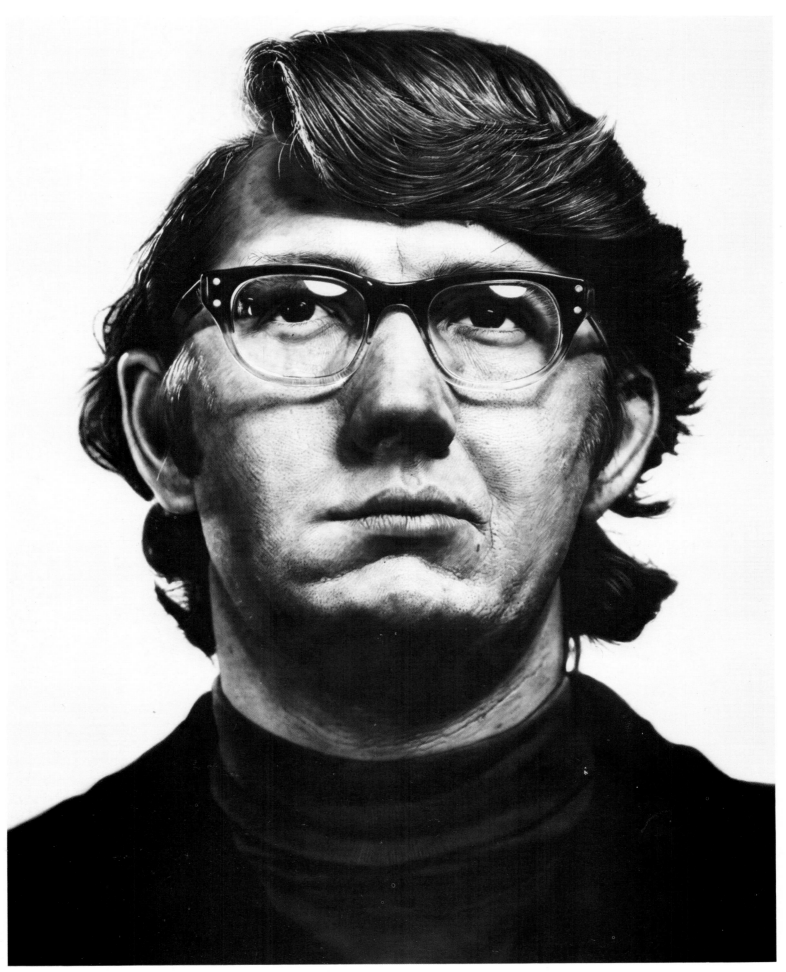

211. *Keith*. 1970 (11). Acrylic on canvas, 9' x 7'. Collection the artist

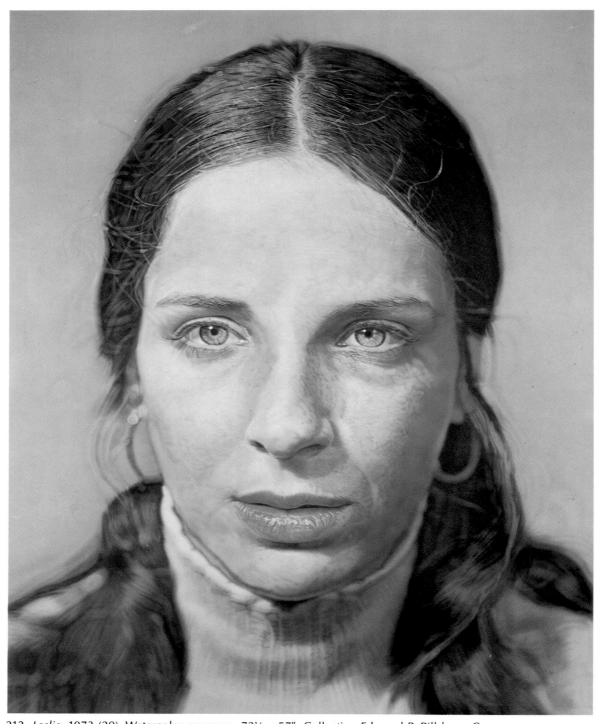

212. *Leslie*. 1973 (20). Watercolor on paper, 72½ x 57". Collection Edmund P. Pillsbury, Conn.

213. *Leslie/1,140.* 1973 (21).
Watercolor on paper, 22 x 17".
Whereabouts unknown

214. *Leslie/4,560 Unfinished.* 1973 (22).
Watercolor on paper, 30 x 22½".
Collection Robert Feldman, New York

215. *Leslie/Pastel.* 1977 (86).
Pastel on watercolor paper, 30½ x 22".
Private collection

216. *Small Kent.* 1970 (12).
Colored pencil on paper, 24½ x 21½".
Collection Louis and Susan Meisel, New York

217. *Kent.* c. 1970–71 (14). Watercolor on
paper, 30 x 22½". Allen Memorial Art
Museum, Oberlin College, Ohio

218. *Large Kent.* 1970 (13). Colored pencil on illustration board, 35½ x 33½".
Private collection, Oreg.

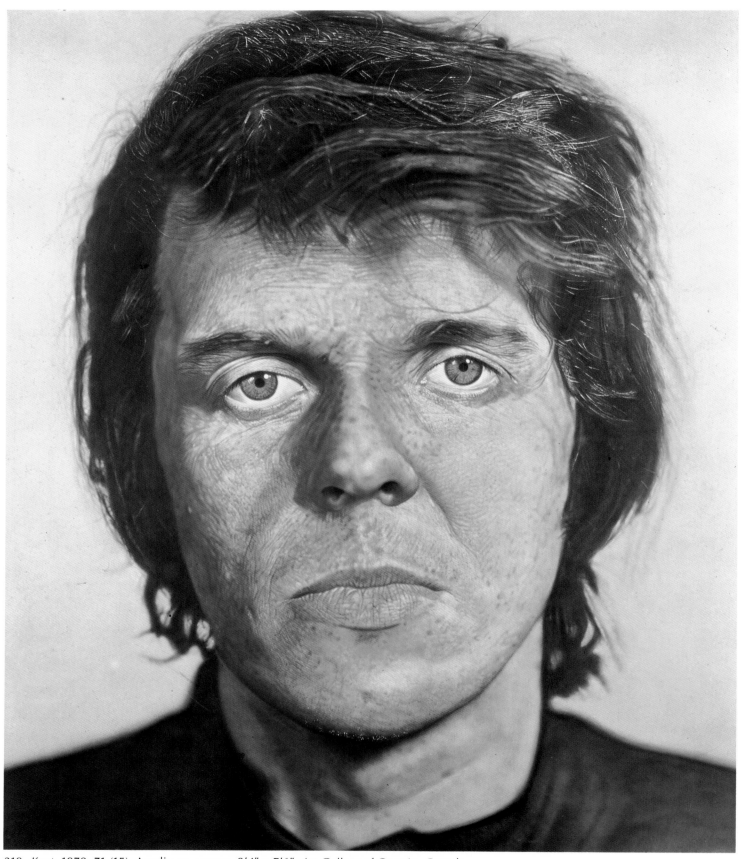

219. *Kent.* 1970–71 (15). Acrylic on canvas, 8'4" x 7'6". Art Gallery of Ontario, Canada

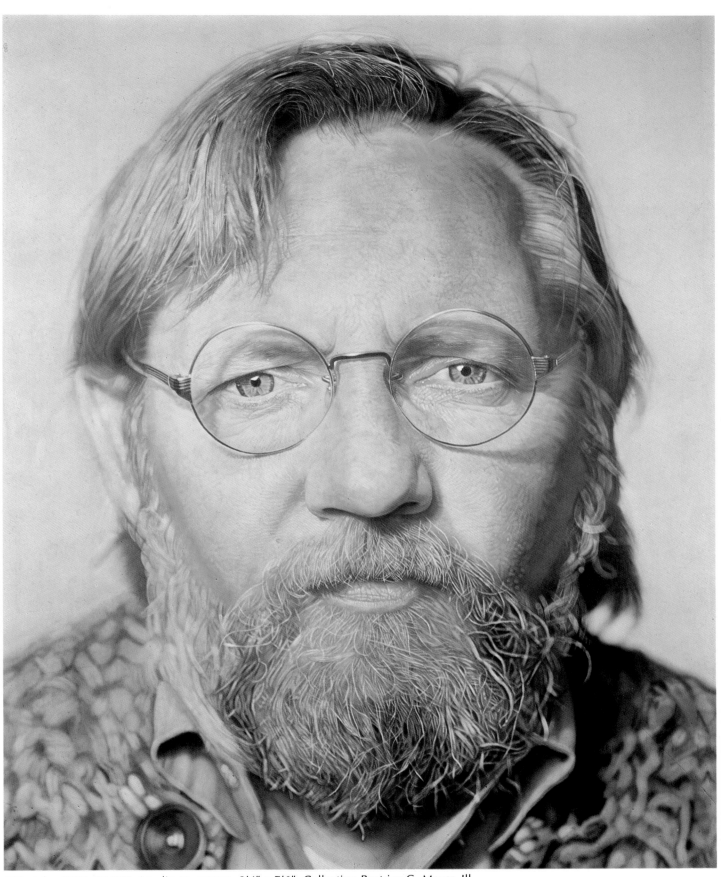

220. *John*. 1971–72 (18). Acrylic on canvas, 8'4" x 7'6". Collection Beatrice C. Mayer, Ill.

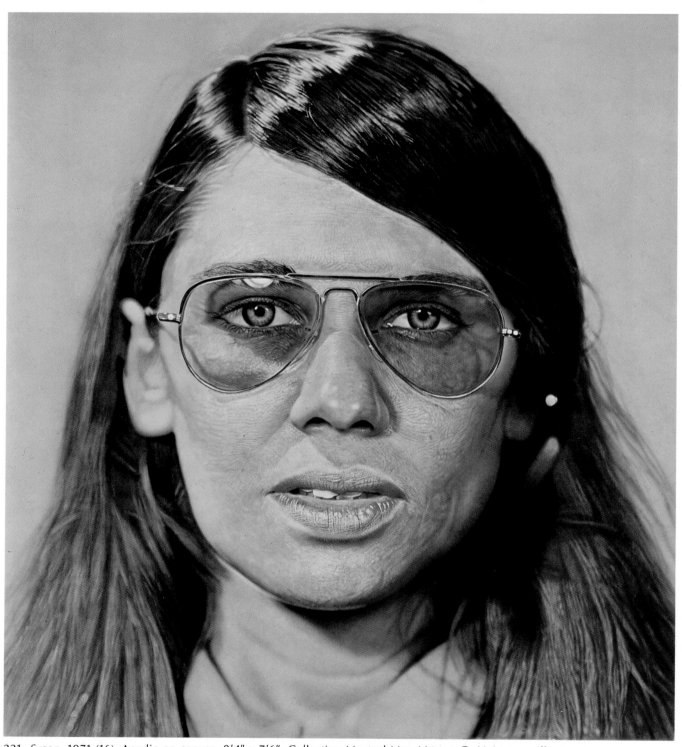

221. *Susan*. 1971 (16). Acrylic on canvas, 8'4" x 7'6". Collection Mr. and Mrs. Morton G. Neumann, Ill.

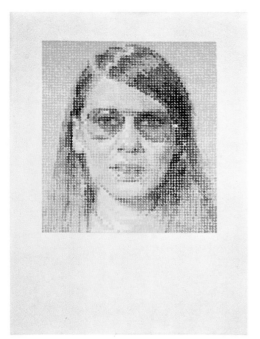

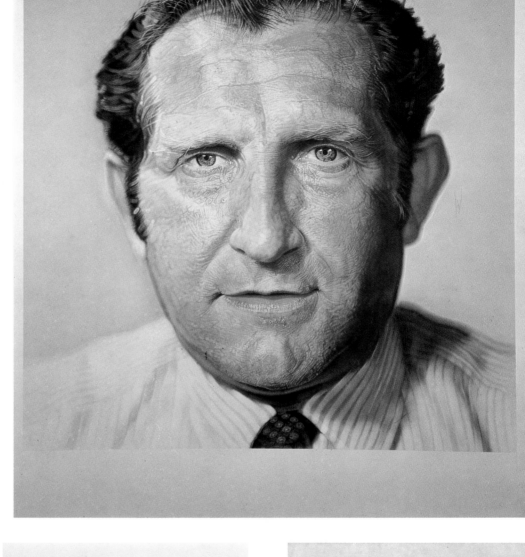

222. *Susan Z./Pastel*. 1977 (85).
Pastel on watercolor paper, 30½ x 22".
Private collection

223. *Nat*. 1972 (19).
Watercolor on paper, 67 x 57".
Neue Galerie der Stadt Aachen.
Ludwig Collection

224. *Nat/Horizontal, Vertical, Diagonal*.
1973 (34). Watercolor on paper, 30 x 22½".
Collection Edmund P. Pillsbury, Conn.

225. *Nat/Colored Pencil Version*. 1973 (35).
Colored pencil on paper, 30 x 22½".
John Berggruen Gallery, Calif.

226. *Nat/Pastel*. 1978 (91).
Pastel on watercolor-washed paper, 30½ x 22".
Collection the artist

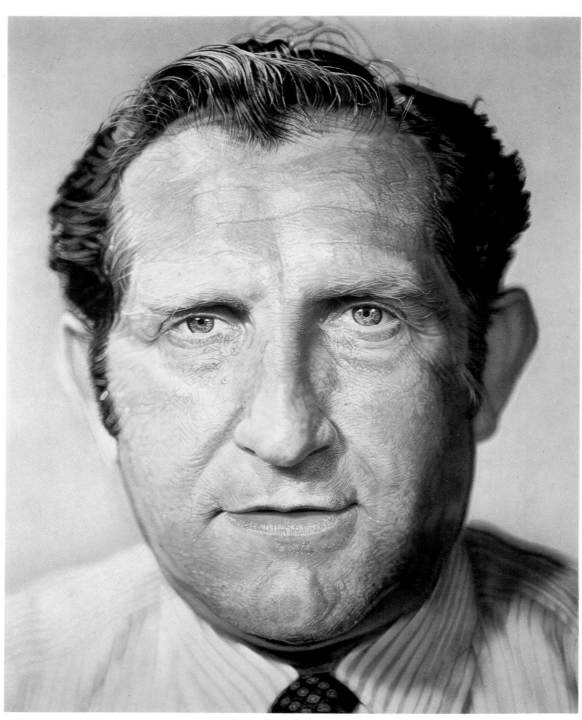

227. *Nat.* 1971 (17). Acrylic on canvas, 8'4" x 7'6". Collection Anita and Burton Reiner, Md.

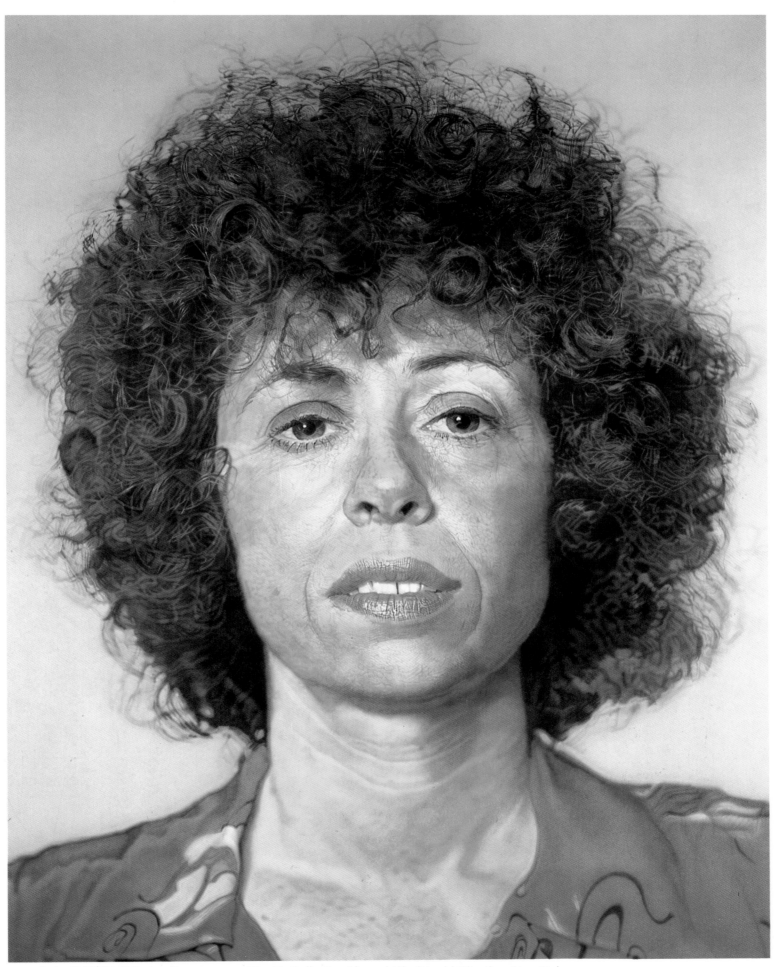

228. *Linda*. 1975–76 (68). Acrylic on canvas, 9' x 7'. Collection Mr. and Mrs. Arnold Glimcher, New York

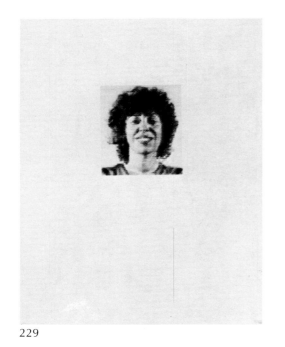

229

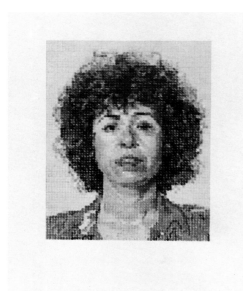

230

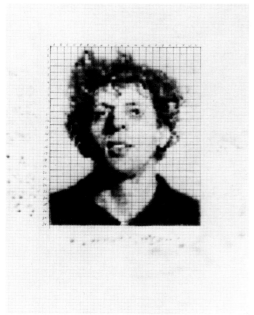

231

229. *Linda*. 1974 (52). Ink and graphite on paper, 30 x 22".
Collection Linda Rosenkranz Finch, New York

230. *Linda/Pastel*. 1977 (78). Pastel and graphite on paper, 29¾ x 22⅛".
Collection the artist

231. *Phil/2,464*. 1973 (23). Ink and graphite on paper, 22 x 17".
Whitney Museum of American Art, New York. Gift of Lily
Auchincloss in honor of John I. H. Baur

232. *Phil/Watercolor*. 1977 (88). Watercolor and graphite on paper, 56 x 40".
Private collection

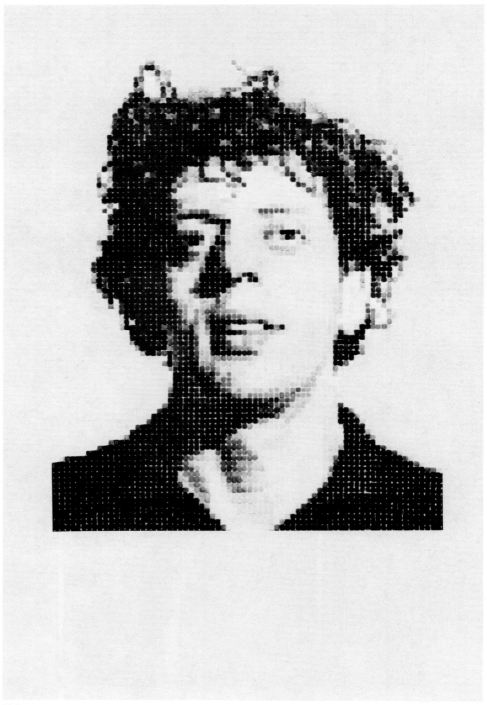

232

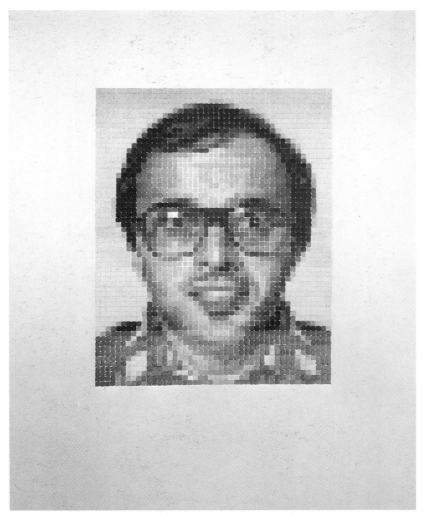

233. *Mark/Watercolor Unfinished.* 1978 (90). Watercolor on paper, 53½ x 40″. Collection the artist

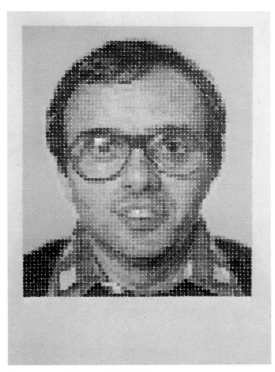

234. *Mark/Pastel.* 1978 (89).
Pastel on watercolor-washed paper, 30½ x 22″.
Private collection

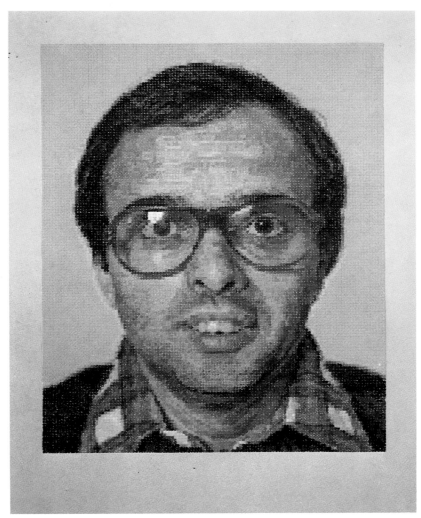

235. *Large Mark Pastel.* 1978 (92). Pastel on watercolor-washed paper, 56 x 43″. Private collection, New York

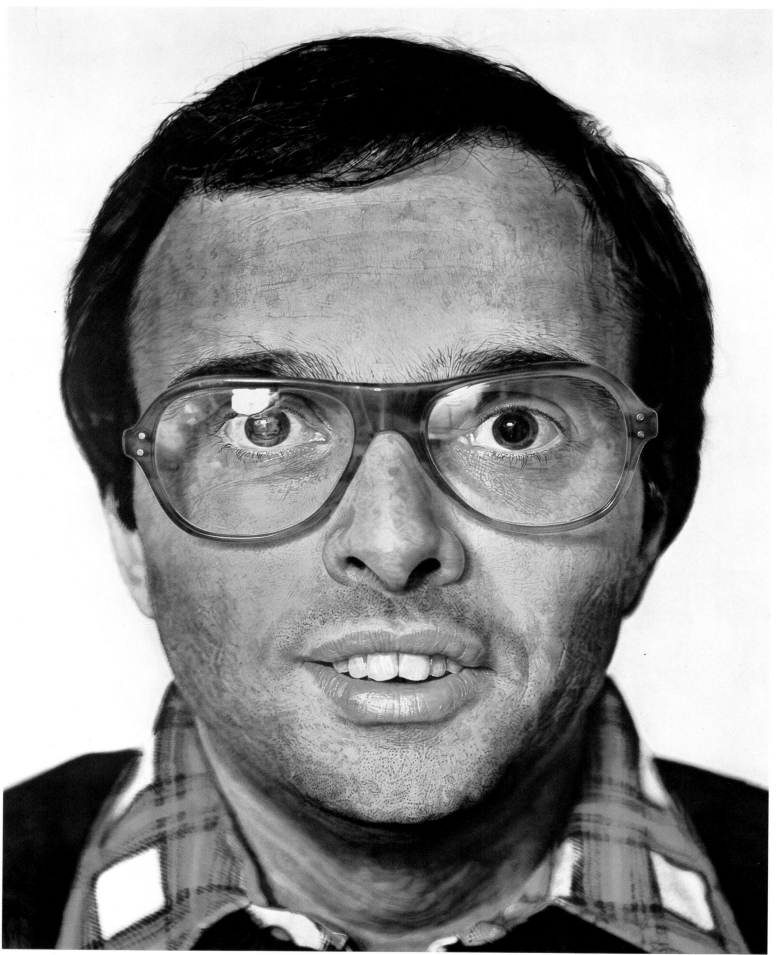

236. *Mark*. 1978–79 (100). Acrylic on canvas, 9′ x 6′8″. Collection the artist

237. *Self-Portrait.* 1975 (66).
Ink and graphite on paper, 30 x 22½".
Collection the artist

238. *Self-Portrait/White Dot Version.*
1976 (67). White ink and graphite on
black Arches paper, 30 x 22½".
Collection M. de Jong, Holland

239. *Self-Portrait/8 x 1.* 1977 (82).
Ink and graphite on paper, 29¾ x 22⅛".
Collection Mr. and Mrs. Martin
Schmukler, New York

240. *Self-Portrait/6 x 1.* 1977 (83).
Ink and graphite on paper, 29⅞ x 22¼
Private collection

241. *Self-Portrait/Spray Dot Version.*
1977 (84). Ink and graphite on paper,
30 x 22½". Collection Louis and
Susan Meisel, New York

242. *Self-Portrait/Pastel.* 1977 (87).
Pastel on ink-washed paper, 30½ x 22".
Private collection

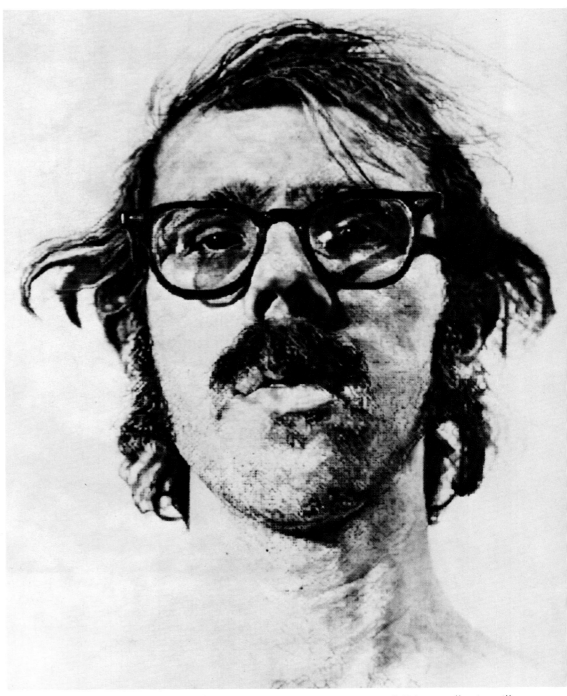

132

243. *Self Portrait/58,424.* 1973 (36). Ink and graphite on paper, 70½ x 58". Private collection, Ill.

244. *Twelve Heads x 154 Dots.* 1977 (80). Ink and graphite on paper, 30 x 80". Private collection

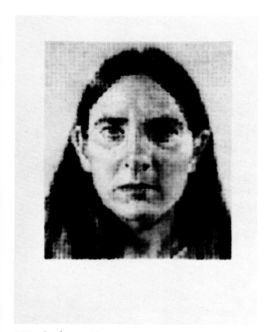

245. *Barbara.* 1974 (39).
Ink and graphite on paper, 30 x 22".
Private collection, New York

246. *Richard A.* 1974 (40).
Ink and graphite on paper, 30 x 22".
Collection Richard Artschwager, New York

247. *Cathy A.* 1974 (41).
Ink and graphite on paper, 30 x 22".
Private collection, Paris

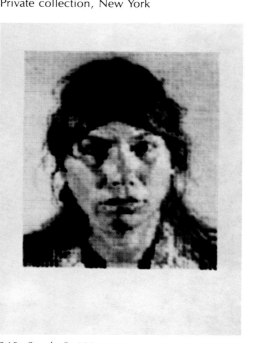

248. *Sandy B.* 1974 (42).
Ink and graphite on paper, 30 x 22½".
Private collection

249. *Leslie C.* 1974 (44).
Ink and graphite on paper, 30 x 22".
Sydney and Frances Lewis Foundation, Va.

250. *Mark/I.* 1974 (45).
Ink and graphite on paper, 30 x 20½".
Collection Ellen Cohen, New York

251. *Robert/104,072*. 1973–74 (38). Ink and graphite on canvas, 9' x 7'. Museum of Modern Art, New York. Gift of J. Frederick Byers & promised gift of an anonymous donor

252. *Robert I/154*. 1974 (54). Ink and graphite on paper, 30 x 22½". Collection Robert Feldman, New York

253. *Keith/1,280*. 1973 (24). Ink and graphite on paper, 22 x 17". Collection Robert Feldman, New York

254. *Bob I/154*. 1973 (29). Ink and graphite on paper, 30 x 22½". Private collection

255. *Robert II/616*. 1974 (55).
Ink and graphite on paper, 30 x 22".
Collection Robert Feldman, New York

256. *Robert III/2,464*. 1974 (56).
Ink and graphite on paper, 30 x 22".
Collection Robert Feldman, New York

257. *Robert IV/9,856*. 1974 (57).
Ink and graphite on paper, 30 x 22".
Collection Robert Feldman, New York

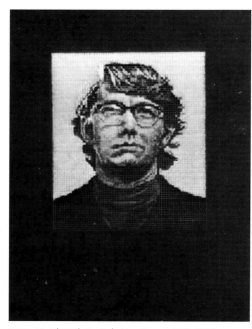

258. *Keith/Large Version*. 1973 (25).
Ink and graphite on paper, 30 x 22½".
Private collection

259. *Keith/White Ink Version*. 1973 (26).
Graphite and white ink on black paper,
30 x 22½". Private collection, New York

260. *Keith/Ink on Graphite Version*. 1973 (28).
Ink on graphite ground on paper, 30 x 22½".
Private collection, New York

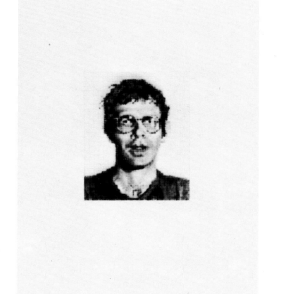

261. *Bob II/616*. 1973 (30).
Ink and graphite on paper, 30 x 22½".
Private collection

262. *Bob III/2,464*. 1973 (31).
Ink and graphite on paper, 30 x 22½".
Private collection

263. *Bob IV/9,856*. 1973 (32).
Ink and graphite on paper, 30 x 22½".
Private collection

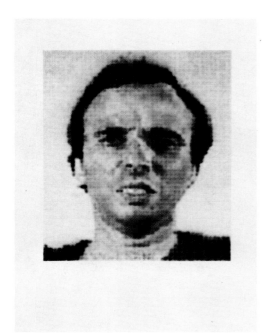

264. *Mark.* 1974 (46).
Ink and graphite on paper, 30 x 22".
Private collection, Calif.

265. *Bob F.* 1974 (47).
Ink and graphite on paper, 30 x 22".
Collection Myra and Jim Morgan, Kans.

266. *Lisa P.* 1974 (48).
Ink and graphite on paper, 30 x 22".
Collection Edmund P. Pillsbury, Conn.

267. *Kerry P.* 1974 (49).
Ink and graphite on paper, 30 x 22".
Private collection, New York

268. *Jack B.* 1974 (50).
Ink and graphite on paper, 30 x 22".
Private collection

269. *Chris.* 1974 (51).
Ink and graphite on paper, 30 x 22".
Collection Dr. Jack E. Chachkes, New York

270. *Fanny.* 1974 (58).
Ink and graphite on paper, 30 x 22".
Collection the artist

271. *Marge R.* 1974 (59).
Ink and graphite on paper, 30 x 22".
Collection Dr. and Mrs. Donald Dennis, Ala.

272. *Don N.* 1975 (61).
Ink and graphite on paper, 30 x 22".
Gilman Paper Company Collection, New York

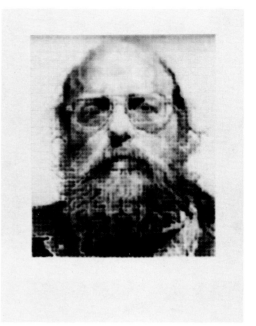

273. *Leslie N.* 1975 (62).
Ink and graphite on paper, 30 x 22".
Gilman Paper Company Collection, New York

274. *Julie P.* 1975 (63).
Ink and graphite on paper, 30 x 22".
Private collection

275. *Joe A.* 1975 (64).
Ink and graphite on paper, 30 x 22".
Private collection, New York

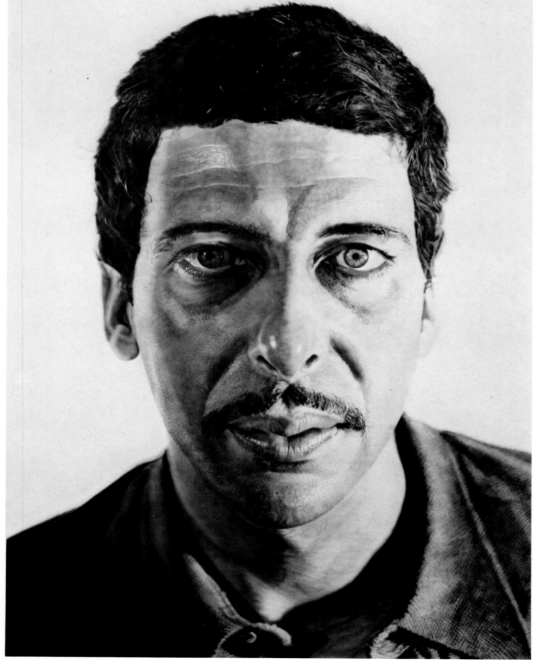

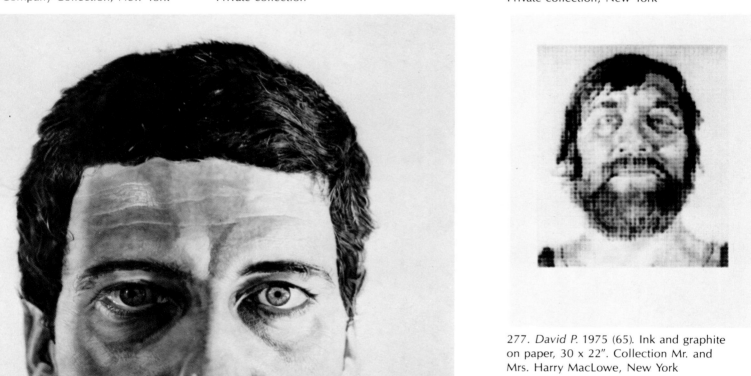

277. *David P.* 1975 (65). Ink and graphite
on paper, 30 x 22". Collection Mr. and
Mrs. Harry MacLowe, New York

NOT ILLUSTRATED
Leslie. 1967 (1).
Pencil on paper, 9½ x 7½".
Collection Nat and Shirley Rose, N. J. ·

Self-Portrait. 1967 (2).
Graphite on paper, 29⅛ x 23".
Private collection, Mass.

Keith/Ink on White Paper Version. 1973 (27).
Ink and graphite on paper, 30 x 22½".
Private collection, New York

Phil. 1973 (33).
Ink and graphite on paper, 30 x 22½".
Private collection

Mark I. 1973 (37).
Ink and graphite on paper, 30 x 22½".
Private collection

Keith/Backwards for Print. 1974 (43).
Pencil on paper, 6 x 7".
Collection Joe Zucker, New York

276. *Klaus.* 1976 (71). Watercolor on paper, 80 x 58".
Sydney and Frances Lewis Foundation, Va.

137

Bob F./Graph Paper Version. 1974 (53).
Ink and graphite on graph paper, 22 x 17".
Collection Robert Feldman, New York

John R. 1974 (60).
Ink and graphite on paper, 30 x 22".
Collection Richard Belger, Mo.

Bill Feltzin. 1976 (69).
Ink and graphite on paper, 30 x 22½".
Collection William Feltzin, New York

Robert. 1976 (70).
Ink and graphite on paper, 30 x 22½".
Private collection, N. J.

Linda/Eye I—Magenta. 1977 (73).
Watercolor on paper, 30 x 22½".
Collection Paul and Camille Hoffman, Ill.

Linda/Eye II—Cyanne. 1977 (74).
Watercolor on paper, 30 x 22½".
Collection Paul and Camille Hoffman, Ill.

Linda/Eye III—Magenta and Cyanne. 1977 (75).
Watercolor on paper, 30 x 22½".
Collection Paul and Camille Hoffman, Ill.

Linda/Eye IV—Yellow. 1977 (76).
Watercolor on paper, 30 x 22½".
Collection Paul and Camille Hoffman, Ill.

Linda/Eye V—Magenta, Cyanne and Yellow. 1977
(77). Watercolor on paper, 30 x 22½".
Collection Paul and Camille Hoffman, Ill.

Linda/Magenta Nose. 1977 (79).
Watercolor on paper, 31½ x 24".
Private collection

Klaus/8 x 1. 1977 (81).
Ink and graphite on paper, 29¾ x 22⅛".
Private collection, New York

Robert/Square Fingerprint II. 1978 (93).
Black stamp-pad ink transferred to
paper by fingerprint, 30 x 22½".
Collection the artist

Robert/Square Fingerprint I. 1978 (94).
Black stamp-pad ink transferred to
paper by fingerprint, 30 x 22½".
Collection the artist

Robert/Fingerprint. 1978 (95).
Black stamp-pad ink transferred to
paper by fingerprint, 30 x 22½".
Collection the artist

Phil/Fingerprint II. 1978 (96).
Black stamp-pad ink transferred to
paper by fingerprint, 30 x 22½".
Collection the artist

Phil/Fingerprint. 1978 (97).
Black stamp-pad ink transferred to
paper by fingerprint, 30 x 22½".
Collection the artist

Self-Portrait/Conte Crayon. 1979 (98).
Conte crayon and graphite on Moulin
de Verge paper, 29½ x 22".
Private collection, New York

Arnold/Conte Crayon. 1979 (99).
Conte crayon and graphite on Moulin
de Verge paper, 29½ x 22".
Collection Arnold Glimcher, New York

BIOGRAPHY

1940 Born: Monroe, Wash.

EDUCATION
1961 Yale Summer School of Music and Art, Norfolk, Conn.
1962 B.A., University of Washington, Seattle
1963 B.F.A., Yale University, New Haven, Conn.
1964 M.F.A., Yale University, New Haven, Conn.
1964–65 Fulbright grant to Vienna, Austria; studied at Akademie der Bildenden
 Kunste, Vienna

TEACHING
1965–67 University of Massachusetts, Amherst
1967–71 School of Visual Arts, New York
1970 University of Washington, Seattle
1970–73 New York University
1971–72 Yale Summer School of Music and Art, Norfolk, Conn.

SOLO EXHIBITIONS
1967 Art Gallery, University of Massachusetts, Amherst
1970 Bykert Gallery, New York
1971 Bykert Gallery, New York
 Los Angeles County Museum of Art
1972 Museum of Contemporary Art, Chicago
1973 Akron Art Institute, Ohio
 Bykert Gallery, New York
 Museum of Modern Art, Projects Gallery, New York
1975 Bykert Gallery, New York
 "Chuck Close Prints," Edwin A. Ulrich Museum, Wichita State
 University, Kans; Mint Museum of Art, Charlotte, N.C.; Ball State
 University Art Gallery, Muncie, Ind.; Phoenix Art Museum, Ariz.;
 Minneapolis Institute of Art
1975–76 "Chuck Close: Dot Drawings 1973–1975," Laguna Gloria Art Museum,
 Austin, Tex.; Art Museum of South Texas, Corpus Christi; Texas

Gallery, Houston; Portland Center for the Visual Arts, Oreg.; San
Francisco Museum of Modern Art; Contemporary Arts Center,
Cincinnati; Baltimore Museum of Art
1977 Pace Gallery, New York
1977–78 "Matrix 35," Wadsworth Atheneum, Hartford, Conn.
1979 Georges Pompidou Centre/Musée National d'Art Moderne, Paris
 Kunstraum München, Munich
 Pace Gallery, New York

SELECTED GROUP EXHIBITIONS
1969 Bykert Gallery, New York
 "Contemporary American Painting," biennial exhibition, Whitney
 Museum of American Art, New York
1970 "Three Young Americans," Allen Memorial Art Museum, Oberlin
 College, Oberlin, Ohio
 "Twenty-two Realists," Whitney Museum of American Art, New York
1971 "Prospect '71," Städtische Kunsthalle, Düsseldorf
 "Whitney Annual," Whitney Museum of American Art, New York
1972 "Art Around 1970," Neue Galerie der Stadt Aachen, West Germany
 "Colossal Scale," Sidney Janis Gallery, New York
 "Crown Point Press at the San Francisco Art Institute," Emanuel Walker
 Gallery, San Francisco Art Institute
 "Documenta 5," Kassel, West Germany
 "Eight New York Painters," University Art Museum, University of
 California, Berkeley
 "L'Hyperréalistes américains," Galerie des Quatre Mouvements, Paris
 "Realism Now," New York Cultural Center, New York
 "Whitney Annual," Whitney Museum of American Art, New York
1972–73 "Amerikanischer Fotorealismus," Württembergischer Kunstverein,
 Stuttgart; Frankfurter Kunstverein, Frankfurt; Kunst und
 Museumsverein, Wuppertal, West Germany
 "Eighteenth National Print Exhibition," Brooklyn Museum, New York;
 California Palace of the Legion of Honor, San Francisco

Brookville, N.Y.
"Selections of Photo-Realist Paintings from N.Y.C. Galleries,"
Southern Alleghenies Museum of Art, St. Francis College,
Loretto, Pa.
"20 x 24," Light Gallery, New York
"Whitney Biennial," Whitney Museum of American Art, New York

1979–80 "Late Twentieth Century Art from the Sidney and Frances Lewis
Foundation," Institute of Contemporary Art of the University of
Pennsylvania, Philadelphia; Dayton Art Institute, Ohio; Brooks
Memorial Art Gallery, Memphis; Dupont Gallery, Washington and
Lee University, Lexington, Va.

SELECTED BIBLIOGRAPHY

CATALOGUES

"Contemporary American Painting," 1969 Biennial Exhibition. Whitney
Museum of American Art, New York, Dec., 1969.

Monte, James. Introduction to Twenty-two Realists. Whitney Museum of
American Art, New York, Feb., 1970.

Baur, I. H. Foreword to 1971 Annual Exhibition. Whitney Museum of American
Art, New York, Feb., 1971.

Fischer, Konrad; Harten, Jurgen; and Strelow, Hans. "Projection," Prospect 71:
Projection. Städtische Kunsthalle, Düsseldorf, 1971.

Scott, Gail R. "Chuck Close: Recent Work," Los Angeles County Museum of
Art, Sept. 21–Nov. 14, 1971.

Abadie, Daniel. Introduction to Hyperréalistes américains. Galerie des Quatre
Mouvements, Paris, Oct. 25–Nov. 25, 1972.

Adrian, Dennis. Chuck Close. Museum of Contemporary Art, Chicago,
Feb. 5–Mar. 19, 1972.

Amman, Jean Christophe. Introduction to Documenta 5. Neue Galerie and
Museum Fridericianum, Kassel, West Germany, June 30–Oct. 8, 1972.

Art Around 1970, Neue Galerie der Stadt Aachen, West Germany, 1972.

Baur, I. H. Foreword to 1972 Annual Exhibition. Whitney Museum of American
Art, New York, Jan. 25–Mar. 19, 1972.

Colossal Scale. Sidney Janis Gallery, New York, Mar., 1972.

Crown Point Press. San Francisco Art Institute, Sept. 1–Oct. 1, 1972.

"19th and 20th Century Prints, Photographs, Drawings," Graphics
International. Washington, D.C., Catalogue no. 2 (Oct., 1972).

Warrum, Richard L. Introduction to Painting and Sculpture Today, 1972.
Indianapolis Museum of Art, Apr. 26–June 4, 1972.

Amaya, Mario. Introduction to REALISM Now. New York Cultural Center,
Dec. 6, 1972–Jan. 7, 1973.

Eighteenth National Print Exhibition. Brooklyn Museum, New York, Nov. 22,
1972–Feb. 4, 1973; California Palace of the Legion of Honor, San Francisco,
Mar. 24–June 17, 1973.

Schneede, Uwe, and Hoffman, Heinz. Introduction to Amerikanischer
Fotorealismus. Württembergischer Kunstverein, Stuttgart, Nov. 16–Dec. 26,
1972; Frankfurter Kunstverein, Frankfurt, Jan. 6–Feb. 18, 1973; Kunst und
Museumsverein, Wuppertal, West Germany, Feb. 25–Apr. 8, 1973.

Alloway, Lawrence. Introduction to Photo-Realism. Serpentine Gallery,
London, Apr. 4–May 6, 1973.

Becker, Wolfgang. Introduction to Mit Kamera, Pinsel und Spritzpistole.
Ruhrfestspiele Recklinghausen, Städtische Kunsthalle, Recklinghausen,
West Germany, May 4–June 17, 1973.

Combattimento per un'immagine. Galleria Civica d'Arte Moderna, Turin,
Mar. 4, 1973.

Dali, Salvador. Introduction to Grands maîtres hyperréalistes américains.
Galerie des Quatre Mouvements, Paris, May 23–June 25, 1973.

Ekstrem realisme. Louisiana Museum of Modern Art, Humlebaek, Denmark,
1973.

Lamagna, Carlo. Foreword to The Super Realist Vision. DeCordova and Dana
Museum, Lincoln, Mass., Oct. 7–Dec. 9, 1973.

Laursen, Steigrim. Introduction to Young American Artists. Radhus (City Hall),
Gentofte, Denmark, 1973.

Solomon, Elke M. American Drawings, 1963–1973. Whitney Museum of
American Art, New York, 1973.

Van der Marck, Jan. American Art: Third Quarter Century. Foreword by
Thomas N. Maytham and Robert B. Dootson. Seattle Art Museum, Wash.,
Aug. 22–Oct. 14, 1973.

Becker, Wolfgang. Introduction to Kunst nach Wirklichkeit. Kunstverein
Hannover, West Germany, Dec. 9, 1973–Jan. 27, 1974.

Hyperréalisme. Galerie Isy Brachot, Brussels, Dec. 14, 1973–Feb. 9, 1974.

Amerikaans fotorealisme grafiek. Hedendaagse Kunst, Utrecht, Aug., 1974;
Palais des Beaux-Arts, Brussels, Sept.–Oct., 1974.

Chase, Linda. "Photo-Realism." In Tokyo Biennale 1974. Tokyo Metropolitan
Museum of Art; Kyoto Municipal Museum; Aichi Prefectural Art Museum,
Nagoya, 1974.

Clair, Jean; Abadie, Daniel; Becker, Wolfgang; and Restany, Pierre.
Introductions to Hyperréalistes américains—réalistes européens. Centre
National d'Art Contemporain, Paris, Archives 11/12, Feb. 15–Mar. 31,
1974.

Kijken naar de Werkelijkheid. Museum Boymans–van Beuningen, Rotterdam,
June 1–Aug. 18, 1974.

Ronte, Dieter. Introduction to Kunst bleibt Kunst. Projekt '74, Wallraf-Richartz
Museum, Cologne, 1974.

Sarajas-Korte, Salme. Introduction to Ars '74 Ateneum. Fine Arts Academy of
Finland, Helsinki, Feb. 15–Mar. 31, 1974.

Shulman, Leon. Three Realists: Close, Estes, Raffael. Worcester Art Museum,
Mass., Feb. 27–Apr. 7, 1974.

Walthard, Dr. Frederic P. Foreword to Art 5 '74. Basel, Switzerland, June 19–
24, 1974.

Meisel, Susan Pear. Watercolors and Drawings—American Realists. Louis K.
Meisel Gallery, New York, Jan., 1975.

Portrait Painting 1970–1975. Allan Frumkin Gallery, New York, 1975.

Slade, Roy. Thirty-fourth Biennial Exhibition of Contemporary American
Painting. Corcoran Gallery of Art, Washington, D.C., 1975.

Chuck Close Dot Drawings 1973–1975. Laguna Gloria Art Museum, Austin,
Tex.; Art Museum of South Texas, Corpus Christi; Texas Gallery, Houston;
Portland Center for the Visual Arts, Oreg.; San Francisco Museum of Modern
Art; Contemporary Arts Center, Cincinnati; Baltimore Museum of Art,
1975–76.

Delahunty, Suzanne. Foreword to Painting, Drawing and Sculpture of the 60's
and 70's from the Dorothy and Herbert Vogel Collection. Institute of
Contemporary Art, University of Pennsylvania, Philadelphia, Oct. 7–Nov.
18, 1975; Contemporary Arts Center, Cincinnati, Dec. 17, 1975–Feb. 15,
1976.

Field, Richard S. Introduction to Recent American Etching. Davison Art Center,
Wesleyan University, Middletown, Conn., Oct. 10–Nov. 23, 1975; National
Collection of Fine Arts, Smithsonian Institution, Washington, D.C., Jan.
21–Mar. 27, 1976.

Armstrong, Thomas N., III. Three Decades of American Art. Seibu Museum of
Art, Tokyo, June 18–July 20, 1976.

Haskell, Barbara. American Artists: A New Decade. Fort Worth Art Museum,
Tex.; Detroit Institute of Arts, 1976.

Paschke, Anne, and Varnedoe, J. Kirk T. Modern Portraits: The Self and Others.
Wildenstein Gallery, New York, 1976.

The Photographer and the Artist. Sidney Janis Gallery, New York, 1976.

Rorimer, Ann. Seventy-second American Exhibition. Art Institute of Chicago,
1976.

Walthard, Dr. Frederic P. Introduction to Art 7 '76. Basel, Switzerland, June
16–21, 1976.

Kord, Catherine. Richard Artschwager, Chuck Close, Joe Zucker. Daniel
Weinberg Gallery, San Francisco, Sept. 14–Oct. 22, 1976; La Jolla Museum
of Contemporary Art, Nov. 5–Dec. 5, 1976; Memorial Union Art Gallery,
University of California, Davis, Jan. 5–28, 1977.

Rose, Bernice. Drawing Now. Museum of Modern Art, New York; Edinburgh
College of Art, Scotland; Kunsthaus, Zurich; Staatliche Kunsthalle,
Baden-Baden; Sonja Henie–Neils Onstad Museum, Oslo; Tel Aviv

Museum, 1976–77.

Chase, Linda. "U.S.A." In *Aspects of Realism*. Rothman's of Pall Mall Canada, Ltd., June, 1976–Jan., 1978.

Chuck Close/Matrix 35. Matrix Gallery, Wadsworth Atheneum, Hartford, Conn., 1977.

Chuck Close: Recent Work. Pace Gallery, New York, Apr. 30–June 4, 1977.

Cummings, Paul. Introduction to *American Drawing 1927–1977*. Minnesota Museum of Art, St. Paul, Sept. 6–Oct. 29, 1977.

Documenta 6. Kassel, West Germany, 1977.

Friedman, Martin; Pincus-Witten, Robert; and Gay, Peter. *A View of a Decade*. Museum of Contemporary Art, Chicago, 1977.

Haskell, Barbara, and Tucker, Marcia. Introduction to *1977 Biennial Exhibition*. Whitney Museum of American Art, New York, Feb. 19–Apr. 3, 1977.

Karp, Ivan. Introduction to *New Realism: Modern Art Form*. Boise Gallery of Art, Idaho, Apr. 14–May 29, 1977.

A. B. W. Introduction to *Works from the Collection of Dorothy and Herbert Vogel*. University of Michigan Museum of Art, Ann Arbor, Nov. 11, 1977–Jan. 1, 1978.

Hess, Thomas. Foreword to *Critics' Choice*. Lowe Art Gallery, Syracuse University, N.Y., 1977; Munson-Williams-Proctor Institute, Utica, N.Y., 1978.

Kirshner, Judith Russi. Foreword to *Land Fall Press*. Museum of Contemporary Art, Chicago, Nov. 18, 1977–Jan. 8, 1978.

Stringer, John. Introduction to *Illusion and Reality*. Australian Gallery Directors' Council, North Sydney, N.S.W., 1977–78.

Cummings, Paul. *20th Century American Drawings: Five Years of Acquisitions*. Whitney Museum of American Art, New York, July, 1978.

D'Harnoncourt, Anne. *Eight Artists*. Philadelphia Museum of Art, Apr. 29–June 25, 1978.

Gilmour, Pat. *The Mechanized Image: An Historical Perspective on Twentieth-Century Prints*. Arts Council of Great Britain, 1978.

Kardon, Janet. Introduction to *Point*. Philadelphia College of Art, Nov. 18–Dec. 15, 1978.

Meisel, Susan Pear. Introduction to *The Complete Guide to Photo-Realist Printmaking*. Louis K. Meisel Gallery, New York, Dec., 1978.

Plous, Phyllis. *Contemporary Drawing/New York*. Art Museum, University of California, Santa Barbara, 1978.

Young, Mahonri Sharp. Foreword to *Aspects of Realism*. Guild Hall, East Hampton, N.Y., July 22–Aug. 13, 1978.

Krauss, Rosalind. *Grids: Format and Image in 20th-Century Art*. Pace Gallery, New York, Dec. 16, 1978–Jan. 20, 1979; Akron Art Institute, Ohio, Mar. 24–May 6, 1979.

Cathcart, Linda L. *American Painting of the 70s*. Albright-Knox Art Gallery, Buffalo, Dec. 8, 1978–Jan. 14, 1979; Newport Harbor Art Museum, Balboa, Calif., Feb. 3–Mar. 18, 1979; Oakland Museum, Calif., Apr. 10–May 20, 1979; Cincinnati Art Museum, July 6–Aug. 26, 1979; Art Museum of South Texas, Corpus Christi, Sept. 9–Oct. 21, 1979; Krannert Art Museum, University of Illinois, Champaign-Urbana, Nov. 11, 1979–Jan. 2, 1980.

Abrahams, R. "Chuck Close," *Imports*, Murray State University, Murray, Ky., 1979.

Armstrong, Tom. Introduction to *1979 Biennial Exhibition*. Whitney Museum of American Art, New York, Feb. 6–Apr. 1, 1979.

Butler, Hiram Carruthers. "California and Others: The Seventies." In *Documents, Drawings and Collages: Fifty American Works on Paper from the Collection of Mr. and Mrs. Stephen D. Paine*, Williams College, Williamstown, Mass., 1979.

Callner, Richard. *Faculty Choice*. State University of New York, Albany, 1979.

Hulten, Pontus. *Copie/Conforme?* Centre Georges Pompidou, Musée Nationale d'Art Moderne, Paris, 1979.

Kern, Hermann. *Chuck Close*. Kunstraum München, Munich, 1979.

Lochridge, Katherine. "Faces of Self-Portraiture." In *As We See Ourselves: Artists' Self-Portraits*. Heckscher Museum, Huntington, N.Y., 1979.

Miller, Wayne. Introduction to *Realist Space*. Foreword by Joan Vita Miller. C. W. Post Art Gallery, Long Island University, Brookville, N.Y., Oct. 19–Dec. 14, 1979.

Rubin, David S. *Black and White Are Colors: Paintings of the 1950s–1970s*. Galleries of the Claremont Colleges, Claremont, Calif., 1979.

Shoemaker, Innis H. *Drawings About Drawings Today*. Ackland Art Museum, University of North Carolina, Chapel Hill, 1979.

Sims, Patterson. *The Decade in Review: Selections from the 1970s*. Whitney Museum of American Art, New York, 1979.

Streuber, Michael. Introduction to *Selections of Photo-Realist Paintings from*

N.Y.C. Galleries. Southern Alleghenies Museum of Art, St. Francis College, Loretto, Pa., May 12–July 8, 1979.

Yard, Sally. *Images of the Self*. Hampshire College Art Gallery, Hampshire, Mass., 1979.

Butler, Susan L. Introduction to *Late Twentieth Century Art from the Sidney and Frances Lewis Foundation*. Institute of Contemporary Art of the University of Pennsylvania, Philadelphia, Mar. 22–May 2, 1979; Dayton Art Institute, Ohio, Sept. 13–Nov. 4, 1979; Brooks Memorial Art Gallery, Memphis, Dec. 2, 1979–Jan. 27, 1980; Dupont Gallery, Washington and Lee University, Lexington, Va., Feb. 18–Mar. 21, 1980.

ARTICLES

Kurtz, S. A. "Reviews and Previews," *ARTnews*, Summer, 1969, p. 12.

"The Muted Moments of Hockey," *Sports Illustrated*, Nov. 3, 1969, pp. 28–33.

Nemser, Cindy. "Reviews at the Galleries," *Arts Magazine*, Summer, 1969, p. 58.

Ryan, David. "Two Contemporary Acquisitions for Minneapolis," *Minneapolis Institute of Arts Bulletin*, vol. LVIII (1969), pp. 82–83.

Wasserman, Emily. "Group Show/Bykert Gallery," *Artforum*, Sept., 1969, p. 61.

Berenson, Ruth. "Plight of Realism Today: Exhibition at the Whitney Museum," *National Review*, May 5, 1970, pp. 474–75.

Bremer, Nina. "The New York Art Scene: Realism Today," *Rivista d'Arte*, Sept., 1970, pp. 3–7.

Davis, Douglas. "Return of the Real: Twenty-two Realists on View at New York's Whitney," *Newsweek*, Feb. 23, 1970, p. 105.

Glueck, Grace. "Drawing Show All-Star Cast," *New York Times*, March 23, 1970, p. 50.

Goya, no. 96 (May, 1970), p. 368.

Gruen, John. "Museums and Galleries: It's Done with Mirrors," *New York Magazine*, March 23, 1970, p. 50.

Hughes, Robert. "An Omnivorous and Literal Dependence," *Arts Magazine*, vol. 44, no. 7 (May, 1970), p. 86.

Lord, B. "Whitney Museum's Twenty-two Realists Exhibition," *Arts/Canada*, June, 1970, p. 11.

Marandel, J. Patrice. "Expositions à la Bykert Galerie," *Art International*, May, 1970, p. 86.

Nemser, Cindy. "An Interview with Chuck Close," *Artforum*, Jan., 1970, pp. 51–55.

———. "In the Museums," *Arts Magazine*, Feb., 1970, p. 54.

———. "Presenting Charles Close," *Art in America*, Jan., 1970, pp. 98–101.

Perreault, John. "Art—Chuck Close," *Village Voice*, Mar. 12, 1970, pp. 15–16.

———. "Art—Get Back," *Village Voice*, Feb. 19, 1970, pp. 14–15, 17–18.

———. "Return of the Real," *Village Voice*, Feb. 23, 1970, p. 105.

Ratcliff, Carter. "Reviews and Previews," *ARTnews*, Apr., 1970, p. 16.

———. "Twenty-two Realists Exhibit at the Whitney," *Art International*, Apr., 1970, p. 105.

Spear, Athena. "Reflections on Close, Cooper and Jenny: Three Young Americans at Oberlin," *Arts Magazine*, May, 1970, pp. 44–47.

———. "Reflections on the Work of Charles Close, Rose Cooper, Neil Jenny, and Other Contemporary Artists," *Allen Memorial Art Museum Bulletin* (Oberlin College, Ohio), vol. XXVIII, no. 3 (Spring, 1970), pp. 108–34.

———. "Three Young Americans—A Biennial," *Allen Memorial Art Museum Quarterly* (Oberlin College, Ohio), May, 1970, pp. 27–38.

Steele, Mike. "Realism Is Simply Super," *Minneapolis Tribune*, Feb. 1, 1970.

"Chuck Close," *Art Now: New York*, vol. III, no. 4 (Dec., 1971).

Genauer, Emily. "Art '72: The Picture Is Brighter," *New York Post*, Dec. 31, 1971.

Kramer, Hilton. "Art Season: A New Realism Emerges," *New York Times*, Dec. 21, 1971, p. 50.

———. "Stealing the Modernist Fire," *New York Times*, Dec. 26, 1971, p. D5.

Los Angeles County Museum of Art Members' Calendar, Oct., 1971.

Marandel, J. Patrice. "The Deductive Image: Notes on Some Figurative Painters," *Art International*, Sept., 1971, pp. 58–61.

Sager, Peter. "Neue Formen des Realismus," *Magazin Kunst*, 4th Quarter, 1971, pp. 2512–16.

Seldis, Henry J. "Art Review: Chuck Close Work Shown," *Los Angeles Times*, Oct. 4, 1971, part IV, p. 4.

Szeemann, Harold. "Documenta 5," *L'Art Vivant*, no. 25 (Nov., 1971), pp. 4–7.

Young, Dennis. *Recent Vanguard Acquisitions*, Art Gallery of Ontario, 1971.

Amman, Jean Christophe. "Realismus," *Flash Art*, May–July, 1972, pp. 50–52.

Bannard, Walter Darby. "New York Commentary," *Studio International*, May, 1972, p. 225.

Beaucamp, E. "Wie realistisch sind die Realisten?," *Frankfurter Allgemeine*

Zeitung, no. 178 (Aug. 4, 1972), p. 11.

Borden, Lizzie. "Cosmologies," *Artforum,* Oct., 1972, pp. 45–50.

Chase, Linda; Foote, Nancy; and McBurnett, Ted. "The Photo-Realists: 12 Interviews," *Art in America,* vol. 60, no. 6 (Nov.–Dec., 1972), pp. 73–89.

"Chuck Close: Asket mit Pistole," *Der Spiegel,* no. 50 (Dec. 4, 1972), pp. 662–63.

Collins, Nancy. "Eye View," *Women's Wear Daily,* Sept. 22, 1972, p. 14.

Davis, Douglas. "Art Is Unnecessary. Or Is It?," *Newsweek,* July 17, 1972, pp. 68–69.

———. "Nosing Out Reality," *Newsweek,* Aug. 14, 1972, p. 58.

Derfner, Phyllis. "Reviews and Previews," *ARTnews,* Jan. 1972, p. 12.

"Documenta 5," *Frankfurter Allgemeine Zeitung,* no. 155 (July 8, 1972).

"Documenta Issue," *Zeit Magazin,* no. 31/4 (Aug., 1972), pp. 4–15.

Elderfeld, John. "Whitney Annual," *Art in America,* May, 1972, p. 29.

"Flashback zu Kassel," *Flash Art,* no. 35/6 (Sept.–Oct., 1972), p. 16.

Gassiot-Talabot, Gerald. "Documenta V: une imposture sur l'image?," *XXe Siècle,* vol. XXXIV, no. 39 (Dec., 1972), pp. 125–29.

Glauber, Robert H. "Museum of Contemporary Art Exhibit: Too Much of a Good Thing," *Skyline,* Mar. 1, 1972, sec. 1, p. 4.

Haydon, Harold. "An Exhibit of Realism and Its Amazing Forms," *Chicago Sun-Times,* Feb. 13, 1972.

Henry, Gerrit. "The Real Thing," *Art International,* Summer, 1972, pp. 87–91.

Hughes, Robert. "The Realist as Corn God," *Time,* Jan. 31, 1972, pp. 50–55.

"L'Hyperréalisme ou le retour aux origines," *Nouvelles Littéraires,* Oct. 6, 1972.

Jappe, Georg. "Documenta 5," *Frankfurter Allgemeine Zeitung,* no. 155 (July 8, 1972).

Karp, Ivan. "Rent Is the Only Reality, or the Hotel Instead of the Hymn," *Arts Magazine,* Dec., 1972, pp. 47–51.

"Die Kasseler Seh-Schule," *Stern Magazin,* no. 36 (Aug., 1972), pp. 20–23.

Kurtz, Bruce. "Documenta 5: A Critical Preview," *Arts Magazine,* Summer, 1972, pp. 34–41.

Lista, Giovanni. "Iperrealisti americani," *NAC* (Milan), no. 12 (Dec., 1972), pp. 24–25.

"Les malheurs de l'Amérique," *Nouvel Observateur,* Nov. 6, 1972.

Marvel, Bill. "Saggy Nudes? Giant Heads? Make Way for 'Superrealism'," *National Observer,* Jan. 29, 1972, p. 22.

"Die Nabelschau von Kassel," *Wirtschaft Feuilleton,* no. 31 (Aug. 8, 1972), p. 9.

Naimer, Lucille. "The Whitney Annual," *Arts Magazine,* Mar., 1972, p. 54.

Nakov, Andrei B. "Sharp Focus Realism: le retour de l'image," *XXe Siècle,* vol. XXXIV, no. 38 (June, 1972), pp. 166–68.

Nemser, Cindy. "Close-Up Vision: Representational Art," *Arts Magazine,* May, 1972, pp. 44–48.

"La nouvelle coqueluche: l'hyperréalisme," *L'Express,* Oct. 30, 1972.

Perreault, John. "Art: A Lollapalooza of a Mishmash," *Village Voice,* Feb. 10, 1972, p. 23.

———. "The Hand Was Colossal but Small," *Village Voice,* Mar. 23, 1972, p. 72.

———. "Realistically Speaking," *Village Voice,* Dec. 14, 1972, pp. 36–38.

———. "Reports, Forecasts, Surprises and Prizes," *Village Voice,* Jan. 6, 1972, pp. 21–24.

Pozzi, Lucio. "Super realisti U.S.A.," *Bolaffiarte,* no. 18 (Mar., 1972), pp. 54–63.

Ratcliff, Carter. "New York Letter," *Art International,* Feb., 1972, p. 54–55.

Rose, Barbara. "Real, Realer, Realist," *New York Magazine,* vol. 5, no. 5 (Jan. 31, 1972), p. 50.

Rosenberg, Harold. "Inquiry '72: On the Edge, Documenta 5," *The New Yorker,* Sept. 9, 1972, p. 75.

Schulze, Franz. "It's Big, and It's Superreal," *Chicago Daily News,* Feb. 12–13, 1972, p. 6.

Seitz, William C. "The Real and the Artificial: Painting of the New Environment," *Art in America,* Nov.–Dec., 1972, pp. 58–72.

Seldis, Henry J. "Documenta: Art Is Whatever Goes On in Artist's Head," *Los Angeles Times Calendar,* July 9, 1972.

Wasmuth, E. "La révolte des réalistes," *Connaissance des Arts,* June, 1972, pp. 118–23.

Wolmer, Denise. "In the Galleries," *Arts Magazine,* Feb., 1972, p. 58.

"Arts, musique et danse: maîtres de hyperréalisme," *Pariscope,* May 24, 1973, p. 79.

Baldwin, Carl. "Le penchant des peintres américains pour le réalisme," *Connaissance des Arts,* Apr., 1973, pp. 112–20.

———. "Realism: The American Mainstream," *Réalités,* Nov., 1973, pp. 42–51.

Berkman, Florence. " 'Big City' Art Jurors Took Hartford Too Lightly," *Hartford Times,* June 17, 1973.

Borden, Lizzie. "Reviews," *Artforum,* Oct., 1973.

Brunelle, Al. "Reviews: Chuck Close," *ARTnews,* April, 1973, p. 73.

Canaday, John. "Art: Chuck Close," *New York Times,* Oct. 1973.

Chase, Linda. "Recycling Reality," *Art Gallery Magazine,* Oct., 1973, pp. 75–82.

Chase, Linda, and McBurnett, Ted. "Interviews with Robert Bechtle, Tom Blackwell, Chuck Close, Richard Estes and John Salt," *Opus International,* no. 44–45 (June, 1973), pp. 38–50.

Davis, Douglas. "Art Without Limits," *Newsweek,* Dec. 24, 1973, pp. 68–74.

Dyckes, William. "A One-Man Print Show by Chuck Close at MOMA," *Arts Magazine,* Dec., 1972, p. 73.

"Foto Realismus," *IZW Illustrierte Wochenzeitung,* no. 14 (June, 1973), pp. 8–10.

Gilmour, Pat. "Photo-Realism," *Arts Review,* vol. 25 (Apr. 21, 1973), p. 249.

Guercio, Antonio del. "Iperrealismo tra 'pop' e informale," *Rinascita,* no. 8 (Feb. 23, 1973), p. 34.

Henry, Gerrit. "A Realist Twin Bill," *ARTnews,* Jan., 1973, pp. 26–28.

Hughes, Robert. "Last Salon: Biannual Exhibition at New York's Whitney Museum," *Time,* Feb. 12, 1973, p. 46.

"L'Hyperréalisme américain," *Le Monde des Grandes Musiques,* no. 2 (Mar.–Apr., 1973), pp. 4, 56–57.

Kipphoff, Petra. "Recovering from Documenta," *ARTnews,* Apr., 1973, pp. 43–44.

Levin, Kim. "The New Realism: A Synthetic Slice of Life," *Opus International,* no. 44–45 (June, 1973), pp. 28–37.

Mellow, James. "Largest Mezzotint by Close Shown," *New York Times,* Jan. 13, 1973, p. 25.

Melville, Robert. "The Photograph as Subject," *Architectural Review,* vol. CLIII, no. 915 (May, 1973), pp. 329–33.

Michael, Jacques. "Le super-réalisme," *Le Monde,* Feb. 6, 1973, p. 23.

"Minnesota: A State that Works," *Time,* Aug. 13, 1973, p. 28.

Mizue (Tokyo), vol. 8, no. 821 (1973).

Moulin, Raoul-Jean. "Hyperréalistes américains," *L'Humanité,* Jan. 16, 1973.

Nemser, Cindy. "Fotografiet som sandhed," *Louisiana Revy,* vol. 13, no. 3 (Feb., 1973), pp. 30–33.

"Neue Sachlichkeit—Neuer Realismus," *Kunstforum International,* Mar. 4, 1973, pp. 114–19.

Nochlin, Linda. "The Realist Criminal and the Abstract Law," *Art in America,* Sept.–Oct., 1973, pp. 54–61.

"Painting Realistic Images," *Professional Photographer,* vol. 100, no. 1,939 (Dec., 1973), p. 56.

Perreault, John. "Art: A New Turn of the Screw/Chuck Close," *Village Voice,* Nov. 1, 1973, p. 34.

Restany, Pierre. "Sharp Focus: La continuité réaliste d'une vision américaine," *Domus,* Aug., 1973.

Rose, Barbara. "Two Women: Real and More Real," *Vogue,* May, 1973, p. 82.

Selby, Roger L. "Arts Festival Spokesman Rebuts 'Misleading Article'," *Hartford Times,* July 1, 1973, p. 15A.

"Specialize and Buy the Best," *Business Week,* Oct. 27, 1973, p. 107.

"ARS '74/Helsinki," *Art International,* May, 1974, pp. 38–39.

Berkman, Florence. "Three Realists: A Cold, Plastic World," *Hartford Times,* Mar. 10, 1974.

Chase, Linda. "The Connotation of Denotation," *Arts Magazine,* Feb., 1974, pp. 38–41.

Clair, Jean. "Situation des réalismes," *Argus de la Presse,* April, 1974.

Coleman, A. D. "From Today Painting Is Dead," *Camera 35,* July, 1974, pp. 34, 36–37, 78.

Deroudille, René. "Réalistes et hyperréalistes," *Derrière Heure Lyonnaise,* Mar. 31, 1974.

Dyckes, William. "The Photo as Subject: The Paintings of Chuck Close," *Arts Magazine,* Feb., 1974, pp. 28–33.

Gassiot-Talabor, Gerald. "Le choc des 'réalismes,' " *XXe Siècle,* no. 42 (June, 1974), pp. 25–32.

Hill, Richard. "The Technologies of Vision," *Art Magazine* (Toronto), vol. 6, no. 19 (Fall, 1974), p. 10.

Hughes, Robert. "An Omnivorous and Literal Dependence," *Arts Magazine,* June, 1974, pp. 25–29.

Kelley, Mary Lou. "Pop-Art Inspired Objective Realism," *Christian Science Monitor,* Mar. 1, 1974.

Lascault, Gilbert. "Autour de ce qui se nomme hyperréalisme," *Paris-Normandie,* Mar. 31, 1974.

Loring, John. "Photographic Illusionist Prints," *Arts Magazine,* Feb., 1974, pp. 42–43.

Michael, Jacques. "La 'mondialisation' de l'hyperréalisme," *Le Monde,*

Feb. 24, 1974.

Moulin, Raoul-Jean. "Les hyperréalistes américains et la neutralisation du réel," *L'Humanité,* Mar. 21, 1974.

Peppiatt, Michael. "Paris," *Art International,* Apr. 20, 1974, pp. 52, 74–75.

Progresso fotografico, Dec., 1974, pp. 61–62.

Russell, John. "Portrait Show at Whitney Downtown," *New York Times,* Nov. 30, 1974.

Spear, Marilyn W. "An Art Show That Is for Real," *Worcester* (Mass.) *Sunday Telegram,* Feb. 24, 1974, sec. E, pp. 1, 4.

———. "Three Realists Showing at Museum," *Worcester* (Mass.) *Telegram,* Feb. 27, 1974, p. 12.

Spector, Stephen. "The Super Realists," *Architectural Digest,* Nov.–Dec., 1974, p. 85.

Stubbs, Ann. "Audrey Flack," *Soho Weekly News,* Apr. 4, 1974.

Teyssedre, Bernard. "Plus vrai que nature," *Le Nouvel Observateur,* Feb. 25–Mar. 3, 1974, p. 59.

"Three Realists: Close, Estes, Raffael," *Connoisseur,* June, 1974, pp. 142–43.

"Worcester Art Museum Hosts Major Painting Exhibition," *Hudson-Sun/Enterprise-Sun* (Worcester, Mass.), Feb. 26, 1974.

Bourdon, David. "Art: American Painting Regains its Vital Signs," *Village Voice,* Mar. 17, 1975, p. 88.

———. "Art: Tetrahedrons in the Sky," *Village Voice,* Jan. 27, 1975, pp. 98, 102.

Crossley, Mimi. "Art: The Face of Reality," *Houston Post,* Aug. 14, 1975, p. 8BB.

Derfner, Phyllis. "New York Reviews," *Art International,* June, 1975, p. 67.

Ellenzweig, Allen. "Portrait Painting 1970–1975," *Arts Magazine,* Mar., 1975, pp. 13–14.

Fagan, Beth. "Dot Clusters Add Up to 'Real' Experience for New Yorker," *Portland Sunday Oregonian,* Oct. 5, 1975, p. 14.

Forgey, Benjamin. "Corcoran Show Is Mostly Big," *Washington Star,* Feb. 21, 1975, pp. B1–2.

———. "The Thirty-fourth Corcoran Biennial," *ARTnews,* May, 1975.

Henry, Gerritt. "Artists and the Face: A Modern American Sampling," *Art in America,* Jan., 1975, p. 41.

Hudson, Andrew. "Washington Letter," *Art International,* vol. XIX, no. 6 (June 15, 1975), p. 94.

Johnson, Lincoln. "Corcoran Biennial Is 'Spare, Cerebral and Flamboyant,' " *Baltimore Sun,* Mar. 13, 1975, pp. B1–B2.

Kramer, Hilton. "Reviews: Chuck Close," *New York Times,* Apr. 26, 1975, p. 20.

Lascault, Gilbert. "Autour de quelques portraits," *XXe Siècle,* no. 44 (June, 1975), pp. 123–31.

Lucie-Smith, Edward. "The Neutral Style," *Art and Artists,* vol. 10, no. 5 (Aug., 1975), pp. 6–15.

Moser, Charlotte. "Bigger Art Has Never Meant Better Art," *Houston Chronicle,* Aug. 3, 1975, p. 12.

"Photographic Realism," *Art-Rite,* no. 9 (Spring, 1975), p. 15.

"Realism," *Oregon Journal* (Portland), Oct. 3, 1975.

"Realismus, konkrete Kunst und der intermediare Aktionismus: Chuck Close," *Der Lowe,* no. 531 (July, 1975), pp. 2–6.

Richard, Paul. "Whatever You Call It, Super Realism Comes On with a Flash," *Washington Post,* Nov. 25, 1975, p. B1.

Robbins, Daniel. "Daniel Robbins on Art," *The New Republic,* May, 1975.

Russell, John. "Art: Portraiture by Thirty-one Painters," *New York Times,* Jan. 25, 1975.

Smith, Roberta. "Thirty-fourth Biennial of Contemporary Painting," *Artforum,* May, 1975, p. 73.

Sutinen, Paul. "American Realism at Reed," *Willamette Week,* Sept. 12, 1975.

———. "A Close Look at Painting," *Willamette Week,* Oct. 13, 1975, p. 14.

Wallach, Amei. "Portrait Painting Is Alive and Well," *Newsday* (Long Island, N.Y.), Jan. 26, 1975, part 11, pp. 16–18.

Walsh, Mike E. "Chuck Close: Realist or Minimalist?," *Artweek,* vol. 6, no. 32 (Oct. 18, 1975), p. 13.

Witt, Linda. "The Lemons of Land Fall Press," *People Magazine,* Oct. 27, 1975, pp. 67–69.

Zimmer, William. "Art Reviews," *Arts Magazine,* June, 1975, pp. 8–9.

Adrian, Dennis. "Art Imitating Life in a Great Big Way," *Chicago Daily News,* Oct. 16–17, 1976.

Alloway, Lawrence. "Art," *The Nation,* vol. 222, no. 17 (May 1, 1976).

Artner, Alan. "Mirroring the Merits of a Showing of Photo-Realism," *Chicago Tribune,* Oct. 24, 1976.

Beamguard, Bud. "Close, Zucker and Artschwager," *Artweek,* vol. 7, no. 33, (Oct. 2, 1976), pp. 1, 23–24.

Borlase, Nancy. "Art," *Sydney Morning Herald,* Dec. 30, 1976.

Bourdon, David. "Bueys Will Be Bueys, Beckmann Is Beckmann," *Village Voice,* Apr. 28, 1976, pp. 98–99.

Chase, Linda. "Photo-Realism: Post Modernist Illusionism," *Art International,* vol. XX, no. 3–4 (Mar.–Apr., 1976), pp. 14–27.

Close, Chuck. "The Art of Portraiture in the Words of Four New York Artists" (with Neel, Pearlstein, and Samaras), *New York Times,* Oct. 31, 1976, pp. 26–32.

Gold, Barbara. "Art Notes: New Technique Enough," *Baltimore Sun,* Apr. 11, 1976.

Hoelterhoff, Manuela. "Strawberry Tarts Three Feet High," *Wall Street Journal,* Apr. 21, 1976.

Johnson, Lincoln F. "Artist Is Surrogate for the Machine," *Baltimore Sun,* Apr. 15, 1976, pp. B1, B14.

K. M. "Realism," *New Art Examiner,* Nov., 1976.

Kramer, Hilton. "Art: The Fascination of Portraits," *New York Times,* Oct. 22, 1976, p. C15.

Kutner, Janet. "The Visceral Aesthetic of a New Decade's Art," *Arts Magazine,* Dec., 1976, pp. 100–103.

Miotke, Anne E. "Close Dot Drawings," *Mid West Art,* Mar. 3, 1976, pp. 11, 20.

Morawski, Stefon. *Sztuka* (Warsaw, Poland), Apr. 3, 1976, p. 32.

Patton, Phil. "Books, Super-Realism: A Critical Anthology," *Artforum,* vol. XIV, no. 5 (Jan., 1976), pp. 52–54.

Russell, John. "Gallery View: The Artist Before the Camera," *New York Times,* Mar., 1976.

Seldis, Henry J. "Art Review: Appearance and Beyond," *Los Angeles Times,* Jan. 12, 1976, part IV, pp. 1, 9.

Smith, Roberta. "Drawing Now (and Then)," *Artforum,* vol. XIV, no. 8 (Apr., 1976), pp. 52–59.

Greenwood, Mark. "Toward a Definition of Realism: Reflections on the Rothman's Exhibition," *Arts/Canada,* vol. XXIV, no. 210–11 (Dec., 1976–Jan., 1977), pp. 6–23.

Marioni, Tom, ed. *Vision* (New York issue), Winter, 1976–77.

Borlase, Nancy. "In Selecting a Common Domestic Object," *Sydney Morning Herald,* July 30, 1977.

Bourdon, David. "Redrawing the Lines of Drawing," *Village Voice,* vol. XXI, no. 3 (Jan. 17, 1977), p. 77.

———. "Time Means Nothing to a Realist," *Village Voice,* May 16, 1977, p. 19.

Cavaliere, Barbara. "Arts Reviews—Chuck Close," *Arts Magazine,* Sept., 1977, p. 22.

Crossley, Mimi. "Review: Photo-Realism," *Houston Post,* Dec. 9, 1977.

Eagle, Mary. "Cool Proof That Realism Survives in Oil and Stone," *Melbourne Age,* Oct. 22, 1977.

French-Frazier, Nina. "New York Reviews—Chuck Close," *ARTnews,* Oct., 1977, p. 130.

Flash Art (Documenta issue), no. 76–77 (July–Aug., 1977).

Glueck, Grace. "The 20th Century Artists Most Admired by Other Artists," *ARTnews,* Nov., 1977.

Goldenthal, Jolene. "Art: Close's Purged Portraits," *Hartford Courant,* Nov. 20, 1977, p. 2G.

Hanson, Bernard. "Chuck Close: The Artist for People Who Are Tired of Everything Else," *Hartford News,* Dec. 29, 1977, p. G7.

Hess, Thomas B. "Art: Americans in Paris," *New York Magazine,* July 18, 1977, pp. 50–52.

———. "Art: Up Close with Richard, Phillip, Nancy and Klaus," *New York Magazine,* May 30, 1977, pp. 95–97.

Hughes, Robert. "Blowing Up the Closeup," *Time,* May 23, 1977, p. 92.

———. "The Botch of an Epic Theme," *Time,* July 11, 1977, pp. 74–75.

Langer, Gertrude. "Realising Our Limitations in Grasping Reality," *Brisbane Courier Mail,* May 28, 1977.

Makin, Jeffrey. "Realism from the Squad," *Melbourne Sun,* Oct. 19, 1977, p. 43.

McCracken, Peg. "The Illusion and Reality Show," *6 A.M. Arts Melbourne and Art Almanac,* Dec., 1977.

Perreault, John. "Abstract Heads," *Soho Weekly News,* May 19, 1977, p. 18.

Ratcliff, Carter. "New York Letter," *Art International,* vol. XXI, no. 4 (July–Aug., 1977), pp. 78–79.

Richard, Paul. "Big Name Artists and 'New Etchers,' " *Washington Post,* Feb. 2, 1977, p. C9.

Russell, John. "Art: Big Heads That Satisfy," *New York Times,* May 6, 1977, p. C19.

Sondheim, Alan. "Dots, Brackets, Salt and Other Questions," *Hartford Advocate,* Dec. 14, 1977, p. 50.

Steinbach, Alice. "A Clean, Well-Lighted Space," *Cultural Post,* July–Aug., 1977, pp. 6–7.

Stevens, Mark. "Close Up Close," *Newsweek,* May 23, 1977, p. 68.

Thomas, Daniel. "The Way We See Now," *The Bulletin,* Sept. 10, 1977.

Wilson, William. " 'Documenta 6' More Moving Than Good," *Los Angeles Times,* July 3, 1977, pp. C1, 72.

Bongard, Willie. *Art Aktuell* (Cologne), Apr., 1978.

Braff, Phyllis. "From the Studio," *East Hampton* (N.Y.) *Star,* Aug. 3, 1978, sec. II, p. 9.

Harnett, Lila. "Photo-Realist Prints: 1968–1978," *Cue,* Dec. 22, 1978, p. 23.

Harris, Helen. "Art and Antiques: The New Realists," *Town and Country,* Oct., 1978, pp. 242, 244, 246–47.

Harshman, Barbara. "An Interview with Chuck Close," *Arts Magazine,* June, 1978, pp. 142–45.

Heinrichs, Paul. "Genesis of a Great Ambition," *The Age* (Melbourne, Australia), July 19, 1978, p. 2.

"It's Art's New Face," *The Sun* (Melbourne, Australia), July 21, 1978, p. 15.

Jacobson, Carol. "Two Exhibits of Major Interest at Lincroft Sites," *Shrewsbury* (N.J.) *Daily Register,* Feb., 1978.

Kramer, Hilton. "A Brave Attempt to Encapsulate a Decade," *New York Times,* Dec. 17, 1978, p. 39.

Levin, Kim. "Chuck Close: Decoding the Image," *Arts Magazine,* June, 1978, pp. 146–49, cover.

Lifson, Ben. "Approaching Avedon," *Village Voice,* Oct. 16, 1978, p. 127.

Mackie, Alwynne. "New Realism and the Photographic Look," *American Art Review,* Nov., 1978, pp. 72–79, 132–34.

O'Conor, Mary. "Eight Artists," *East Hampton* (N.Y.) *Star,* July 17, 1978, p. 14.

Perreault, John. "Photo Realist Principles," *American Art Review,* Nov., 1978, pp. 108–11, 141.

Ratcliff, Carter. "Making It in the Art World: A Climber's Guide," *New York Magazine,* Nov. 27, 1978, p. 67.

The Sciences, Dec., 1978, cover.

Shapiro, Michael. "Changing Variables: Chuck Close and His Prints," *Print Collector's Newsletter,* vol. IX, no. 3 (July–Aug., 1978), pp. 69–73, cover.

Shirey, David L. "More Real Than Real," *New York Times,* Aug. 6, 1978, sec. LI, p. 14.

"Special from Broadway," *East Hampton* (N.Y.) *Star,* July 20, 1978, p. 13.

"Style Hampton-Style," *East Hampton* (N.Y.) *Summer Sun,* July 27, 1978, p. 11.

Wilson, Bruce. "Memo Mr. Mollison," *The Sun* (Melbourne, Australia), July 22, 1978, p. 35.

"American Painting of the Seventies," *Bulletin* of the Krannert Art Museum, University of Illinois, vol. 5, no. 1 (1979), pp. 2–3, 5.

Carr, Carolyn. "Grids: Format and Image in 20th-Century Art," *Dialogue/Akron Art Institute,* Mar./Apr., 1979, pp. 45–46.

Cummings, Paul. "Stephen D. Paine Talks to Paul Cummings," *Drawing,* vol. I, no. 2 (July/Aug., 1979), pp. 32–36.

DeKay, Ormonde, Jr. "Portraits the Hard Way, Shikler, Grausman, Close," *Art/World* (Oct. 20–Nov. 17, 1979), p. 4.

Gliewe, Gert. "Münchner Kunst Sommer Ist Besser Als Sein Ruf: Zwei Ausstellungreigenisse: Chuck Close und Jasper Johns," *TZ* (Munich), sec. 6, July 2, 1979.

G. R. "Heir Wirddas Auge Uberfuttert: Chuck Close Stellt im Kunstraum aus," *Münchner Merkur* (Munich), July 23, 1979.

Harshman, Barbara. "Grids," *Arts Magazine,* Feb., 1979, p. 4.

————. "Photo-Realist Printmaking," *Arts Magazine,* Feb., 1979, p. 17.

Jadwin, Diane Levine. "Painting from the Photograph: A Modern American Realism," *Barat Review* (Barat College Press), vol. 7, no. 1 (1979), pp. 39–45.

Kramer, Hilton. "Back to Beaubourg: A Modern Exposition Palace," *New York Times,* July 1, 1979, sec. 2, pp. 1, 25.

Martin, J. "Kinds of Realism," *Newsletter,* Allan Frumkin Gallery, New York, no. 7, Special issue, Winter, 1979.

Paris Review, no. 75 (Spring, 1979), Portfolio Section.

Rice, Shelley. "Image Making," *Soho Weekly News,* May 24, 1979, p. 50.

Russell, John. "Gallery View," *New York Times,* June 3, 1979, pp. D 27, 30.

Schmidt, Doris. "Malerei-wie Gedruckt/Zur ersten Europäischen Ausstellung von Chuck Close un Kunstraum in München," *Suddeutsche Zeitung* (Munich), no. 157, July 11, 1979.

Shirey, David L. "Looking Back at the Future," *New York Times,* Nov. 11, 1979, p. LI 25.

Whelan, Richard. "The 1979 Biennials: Discerning Trends at the Whitney," *ARTnews,* vol. 78, no. 4 (Apr., 1979), pp. 84–87.

Zimmer, William. "Everything You Always Wanted to Know About Grids," *Soho Weekly News,* Jan. 28, 1979.

BOOKS

Kline, Katherine, and Dempsey, Michael, eds. *The Year's Art 1969–1970.* New York: G. P. Putnam's Sons, 1971.

Thomas, Karin. *Bis Heute: Stilgeschichte der Bildenden Kunste in 20 Jahrhundert.* Cologne: Verlag M. DuMont Schauberg, 1971.

Coke, Van Deren. *The Painter and the Photograph.* Albuquerque: University of New Mexico Press, 1972.

Hunter, Sam. *American Art of the Twentieth Century.* New York: Harry N. Abrams, 1972.

Kultermann, Udo. *New Realism.* New York: New York Graphic Society, 1972.

Thomas, Karin. *Bis Heute.* Cologne: Verlag M. DuMont Schauberg, 1972.

Ashton, Dore, and Wilmerding, John, eds. *The Genius of American Painting.* New York: William Morrow, 1973.

Brachot, Isy, ed. *Hyperréalisme.* Brussels: Imprimeries F. Van Buggenhoudt, 1973.

Robinson, Franklin W. *One Hundred Master Drawings from New England Private Collections.* Hanover, N.H.: University Press of New England, 1973.

Sager, Peter. *Neue Formen des Realismus.* Cologne: Verlag M. DuMont Schauberg, 1973.

Who's Who in American Art. New York: R. R. Bowker, 1973.

Wilmerding, John, ed. *The Genius of American Painting.* New York: William Morrow, 1973.

Calamandrei, Mauro, and Gorgoni, Gianfranco. *Art USA.* Milan: Fratelli Fabbri Editori, 1974.

Crispolti, De Sanna, and Miotto, Restany. *Ipotesi per una casa esistenziale.* Rome: Benjamino Carucci, 1974.

L'Iperrealismo italo Medusa. Rome: Romana Libri Alfabeto, 1974.

Thornton, Gene. *Photography Year.* New York: Time-Life Books, 1974.

Battcock, Gregory, ed. *Super Realism, A Critical Anthology.* New York: E. P. Dutton, 1975.

Chase, Linda. *Hyperréalisme.* New York: Rizzoli, 1975.

Daval, Jean Luc. *Art Actuel—Skira Annuel.* Geneva: Editions Skira et Cosmopress, 1975.

Hobbs, Jack. *Art in Context.* New York: Harcourt Brace Jovanovich, 1975.

Kultermann, Udo. *Neue Formen des Bildes.* Tübingen, West Germany: Verlag Ernst Wasmuth, 1975.

Lucie-Smith, Edward. *Late Modern—The Visual Arts Since 1945.* 2d ed. New York: Praeger, 1975.

Popper, Frank. *Art—Action and Participation.* New York: New York University Press, 1975.

Rose, Barbara. *American Art Since 1900.* New York: Praeger, 1975.

————, ed. *Readings in American Art, 1900–1975.* New York: Praeger, 1975.

Walker, John A. *Art Since Pop.* London: Thames and Hudson, 1975.

Castleman, Riva. *Prints of the Twentieth Century: A History.* New York: Museum of Modern Art, 1976.

Honisch, Dieter, and Jensen, Jens Christian. *Amerikanische Kunst von 1945 bis Heute.* Cologne: DuMont Buchverlag, 1976.

Johnson, Ellen H. *Modern Art and the Object.* New York: Harper & Row, 1976.

Lipman, Jean, and Franc, Helen M. *Bright Stars: American Painting and Sculpture Since 1776.* New York: E. P. Dutton, 1976.

Stebbins, Theodore E., Jr. *American Master Drawings and Watercolors.* New York: Harper & Row, 1976.

Who's Who in American Art. New York: R. R. Bowker, 1976.

Wilmerding, John. *American Art.* Harmondsworth, England: Penguin, 1976.

Arneson, H. H. *History of Modern Art.* New York: Harry N. Abrams, 1977.

Bevlin, Marjorie E. *Design Through Discovery.* New York: Holt, Rinehart and Winston, 1977.

Billeter, Erika. *Malerei und Photographie im Dialog.* Zurich: Benteli, 1977.

Cummings, Paul. *Dictionary of Contemporary American Artists.* 3d ed. New York: St. Martin's Press, 1977.

Donson, Theodore B. *Prints and the Print Market.* New York: Thomas Y. Crowell, 1977.

Lucie-Smith, Edward. *Art Now: From Abstract Expressionism to Super-realism.* New York: William Morrow, 1977.

Rattemeyer, Volker. *Kunst und Medien: Materialien zur Documenta 6.* Kassel, West Germany: Stadtzeitung & Verlag, 1977.

Rose, Barbara (with Jules D. Brown). *American Painting.* New York: Skira, Rizzoli, 1977.

Saff, Don, and Scilotto, Deli. *Printmaking: History and Process.* New York: Holt, Rinehart and Winston, 1977.

Selleck, Jack. *Looking at Faces.* Worcester, Mass.: Davis Publications, 1977.

Distel, Henry. *The Museum of Drawers.* Zurich: Kunsthaus Zürich, 1978.

Mathey, François. *American Realism.* Geneva: Editions d'Albert Skira, 1978.

Skira Annuel No. 4/Actual Art '78. Geneva: Editions d'Albert Skira, 1978.

Vyverberg, Henry. *The Living Tradition: Art, Music and Ideas in the Modern Western World.* New York: Harcourt Brace Jovanovich, 1978.

Brown, Milton W.; Hunter, Sam; Jacobus, John; Rosenblum, Naomi; and Sokol, David M. *American Art.* New York: Harry N. Abrams; Englewood Cliffs, N.J.: Prentice-Hall, 1979.

Lucie-Smith, Edward. *Super Realism.* Oxford: Phaidon, 1979.

278. Robert Cottingham and daughters

ROBERT COTTINGHAM

"I would like my paintings to radiate tension" was Cottingham's answer to my request for a written statement concerning his art. When, at a later date, I asked him to use just one word to describe his work, the word was "facade." He says he does not like to intellectualize about his work and prefers to let the paintings speak for themselves. Cottingham's Photo-Realist works depict the facades of buildings, generally the section which starts about ten feet above the ground and extends to thirty feet above it. The angles at which these photos are taken and the placement of hard-edge areas of color next to each other do cause the paintings to generate tension. Most of Cottingham's works are either very large (six or seven feet square) or very small (nine, ten, or eleven inches square). Many images have been painted both small, in acrylic, and large, in oil.

Cottingham's first endeavors as a professional artist were as the art director of an advertising agency in the sixties. Although many people have tried to relate Photo-Realism to advertising and illustration, only Cottingham—and, to a lesser extent, Estes—were ever involved in this aspect of commercial art. Obviously, this earlier period influenced the way Cottingham sees and composes his work and his choice of subject matter. Very specifically, at this point he became extremely involved with and interested in typography and letters. Today, his home in Connecticut is filled with all sorts of advertising signs, which he and his wife Jane collect. In all of them, lettering is the dominant feature, as it is in his paintings.

Cottingham says he always liked the downtown areas of cities, particularly because they contain advertising signs from the thirties, forties, and fifties, a time when signs were more elaborate and inventive than they are today. He has always been aware of the areas above the ground floors of buildings, areas that people generally do not look at seriously. Like most of the Photo-Realists, Cottingham has

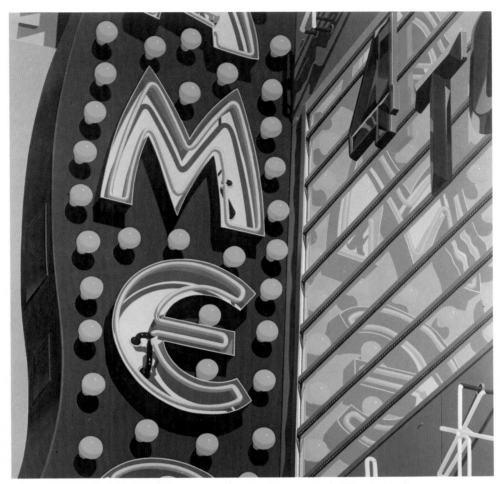

279. *Me.* 1973 (99). Oil on canvas, 78 x 78". Collection Carlo Bilotti, London

made us freshly aware of the things that he emphasizes in his paintings; after seeing them in his work we are more inclined to pay attention to them in real life.

With the exception of Salt, who is English, Cottingham is the only Photo-Realist to have spent a great deal of time in another country. He and his family lived in London from about 1972 until 1977, when he returned to the United States and settled in Connecticut. While in London, Cottingham continued to paint from slides he had taken in America. He even made periodic trips back home for new photographs, since Photo-Realism is a totally American art, dependent on America for its inspiration and subject matter.

Cottingham says that, although he is not trying to be nostalgic, his choice of subject matter does elicit nostalgia. On the other hand, he admits to a sense of humor, expressed by the way he crops a sign to get words like "Art," "Ha," or "Oh."

Cottingham is one of the most prolific of the Photo-Realists, and, in many cases, one of his images will exist in drawing, acrylic, oil, and print form. He utilizes lithography, etching, and screen printing for his editions.

Robert Cottingham had painted 192 works through December 31, 1979. Of these, 63 are illustrated herein, including almost all of his mature Photo-Realist paintings, and the rest are listed.

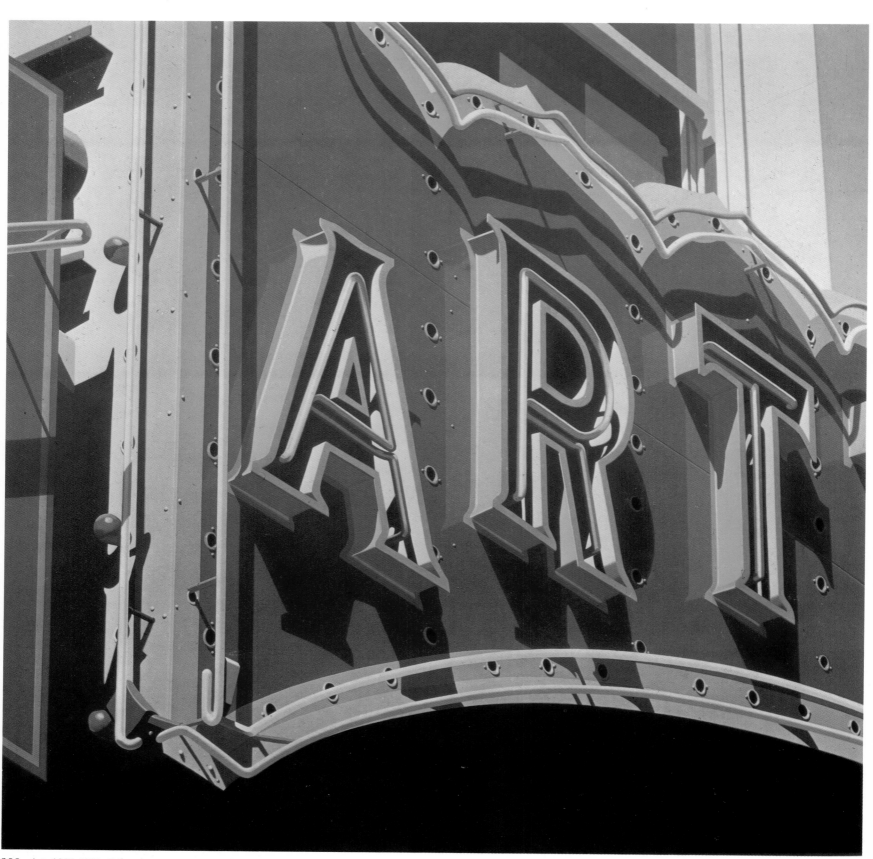

280. *Art.* 1971 (60). Oil on canvas, 78 x 78". Private collection, New York

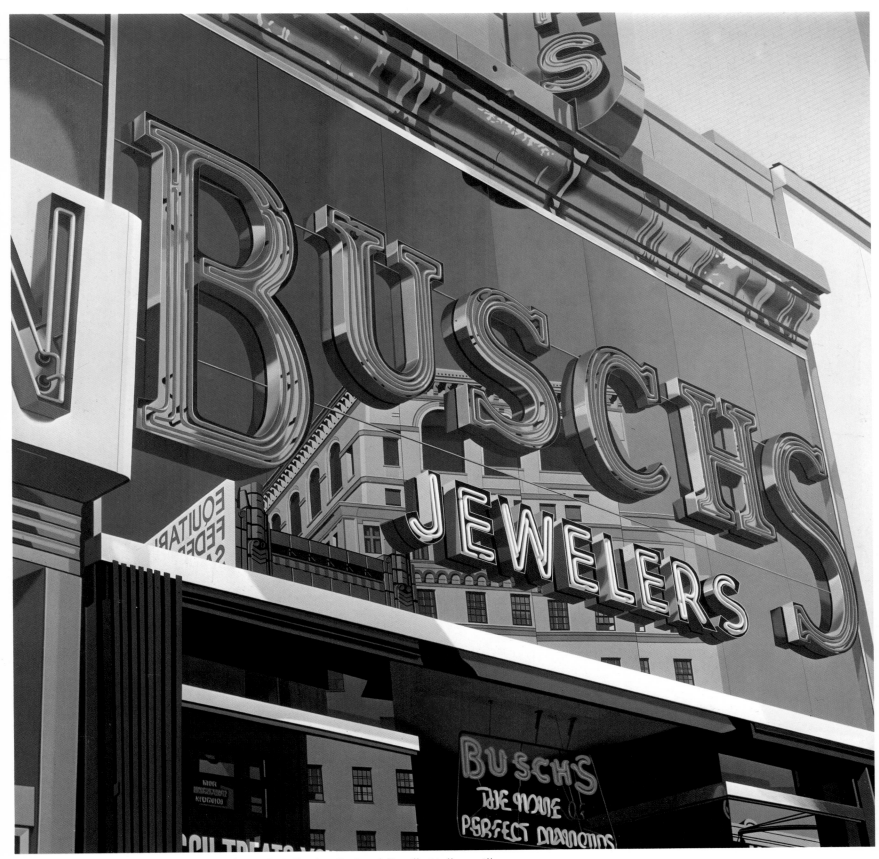

281. *Buschs*. 1974 (122). Oil on canvas, 78 x 78". Collection Paul and Camille Hoffman, Ill.

148

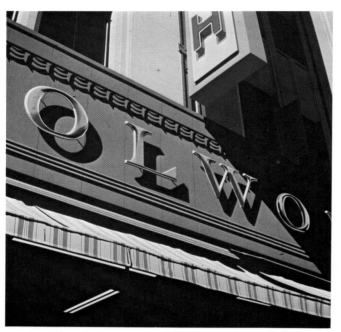

282. *Woolworth's*. 1970 (48). Oil on canvas, 78 x 78".
Collection Edward Bianchi, New York

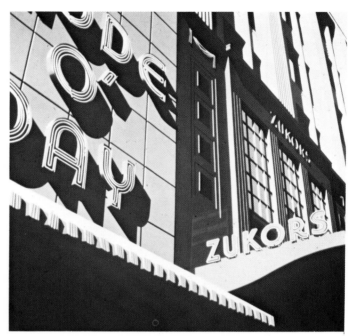

283. *Mode O' Day*. 1970 (49). Oil on canvas, 78 x 78".
Private collection

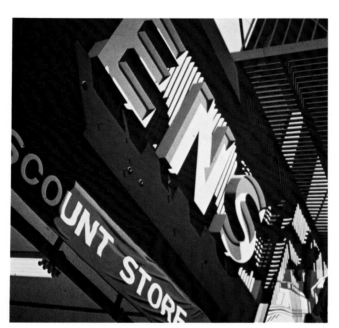

284. *Discount Store*. 1970 (50). Oil on canvas, 78 x 78".
Private collection

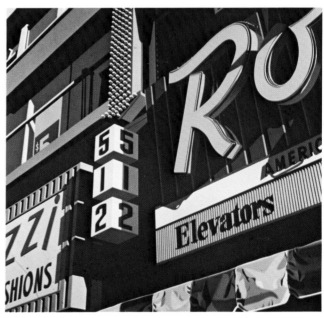

285. *"512"*. 1970 (54). Oil on canvas, 78 x 78".
Richard Brown Baker Collection, New York

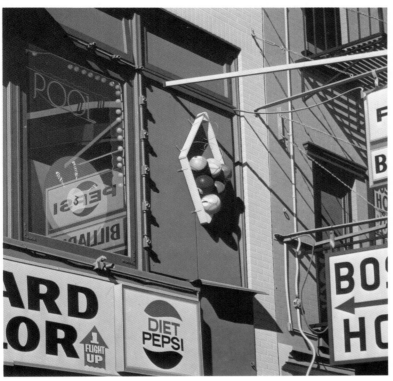

286. *Pool.* 1973 (101). Oil on canvas, 78 x 78".
Sydney and Frances Lewis Foundation, Va.

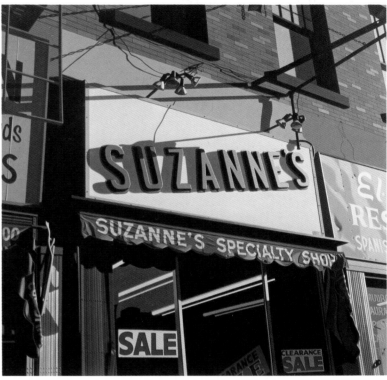

287. *Suzanne's.* 1974 (120). Oil on canvas, 78 x 78".
Collection Mr. and Mrs. Morton G. Neumann, Ill.

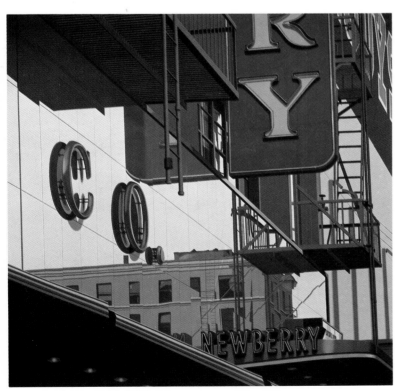

288. *Newberry.* 1974 (121). Oil on canvas, 78 x 78".
Collection Edmund P. Pillsbury, Conn.

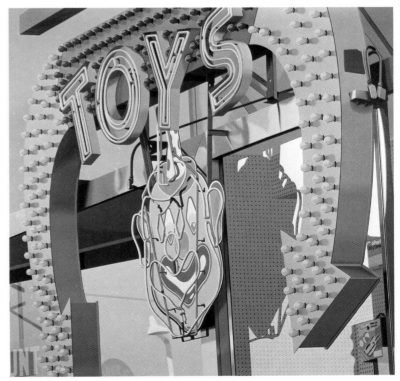

289. *Toys.* 1974 (123). Oil on canvas, 78 x 78".
Collection the artist

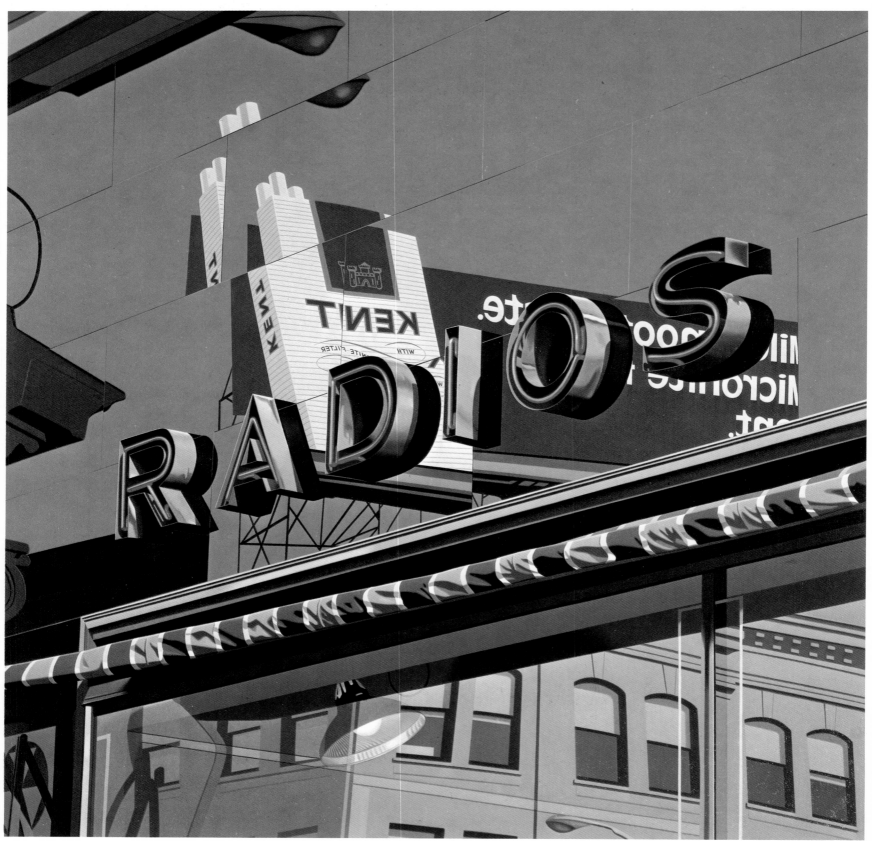

290. *Radios*. 1977 (171). Oil on canvas, 78 x 78". Whitney Museum of American Art, New York.
Gift of Sydney and Frances Lewis Foundation

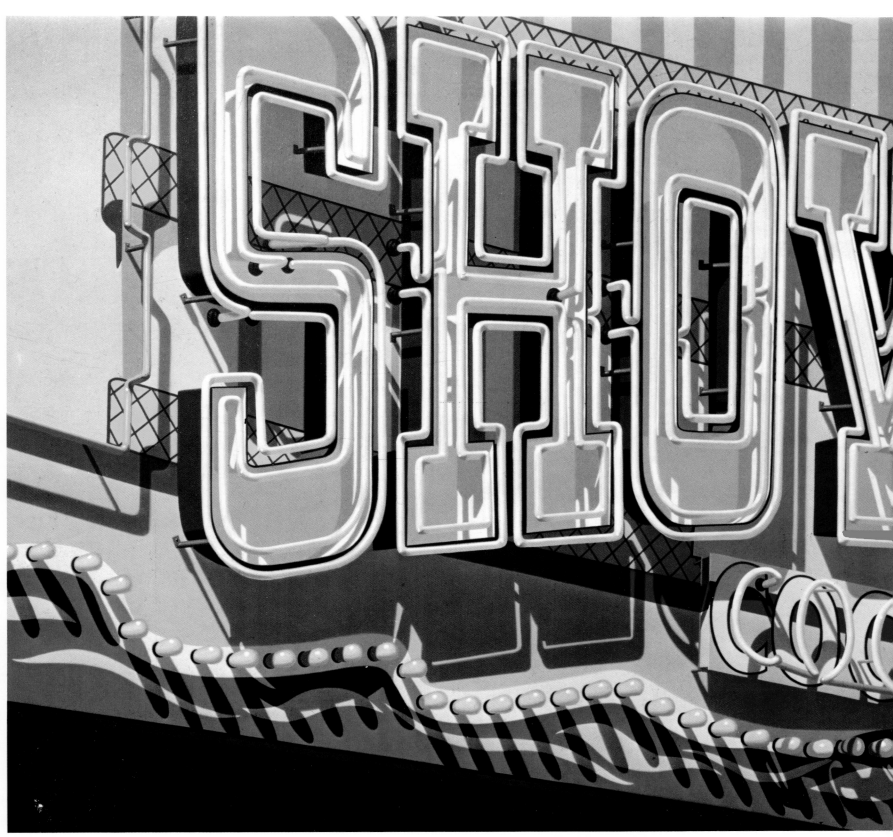

291. *Showboat*. 1972 (72). Oil on canvas, 5' x 10'8". Helen Foresman Spencer Museum of Art, University of Kansas, Lawrence

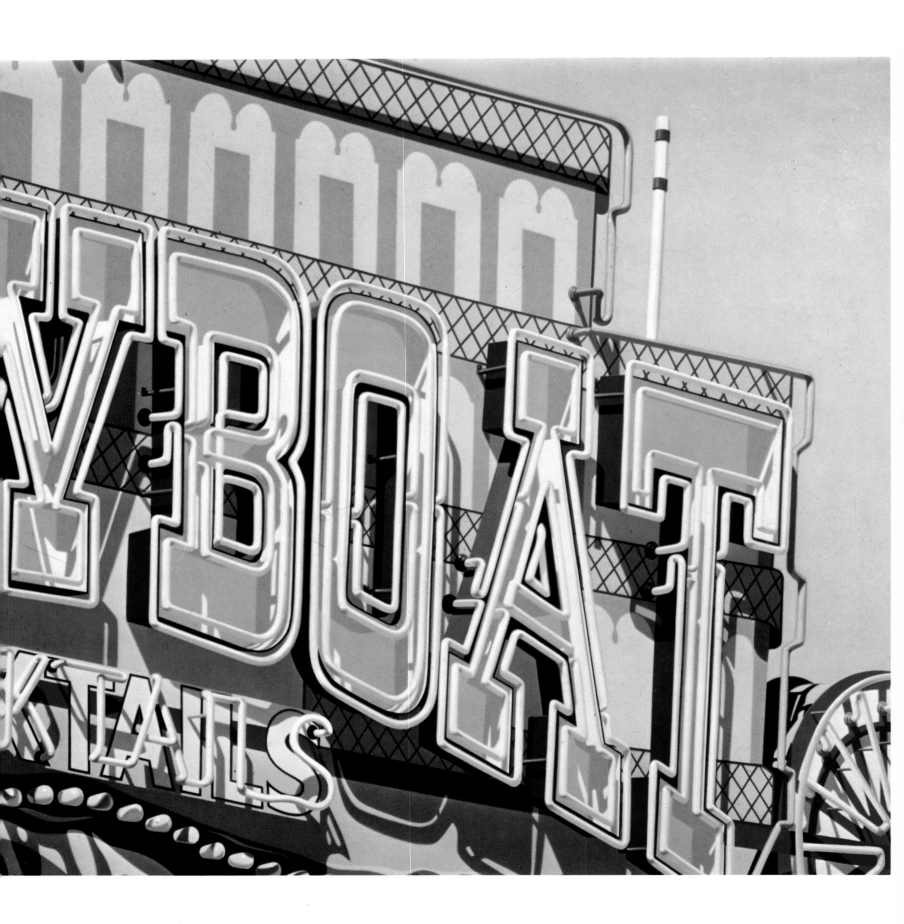

153

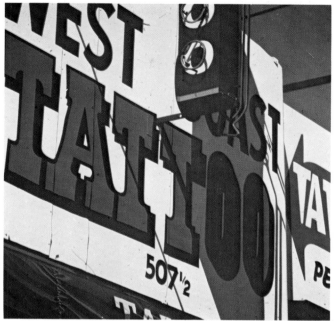

292. *Tattoo*. 1971 (58). Oil on canvas, 78 x 78".
Private collection, New York

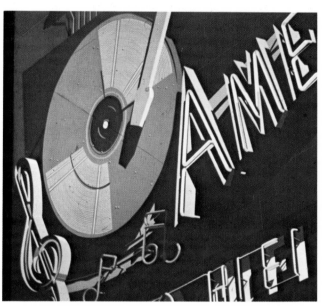

293. *American Hi-Fi*. 1971 (59). Oil on canvas, 78 x 78".
Syracuse University Art Collection, N.Y.

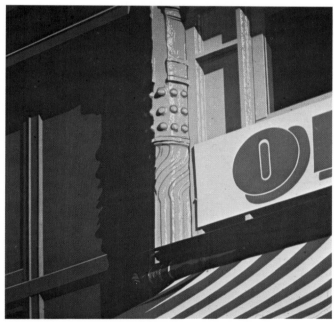

294. *"O"*. 1971 (57). Oil on canvas, 78 x 78".
Private collection

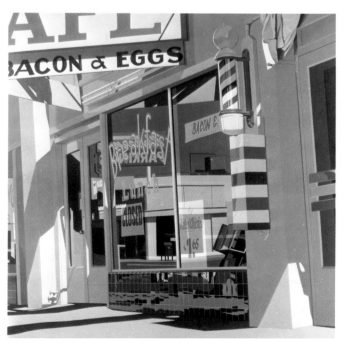

295. *Bacon & Eggs*. 1972 (73). Oil on canvas, 78 x 78".
Collection Beatrice C. Mayer, Ill.

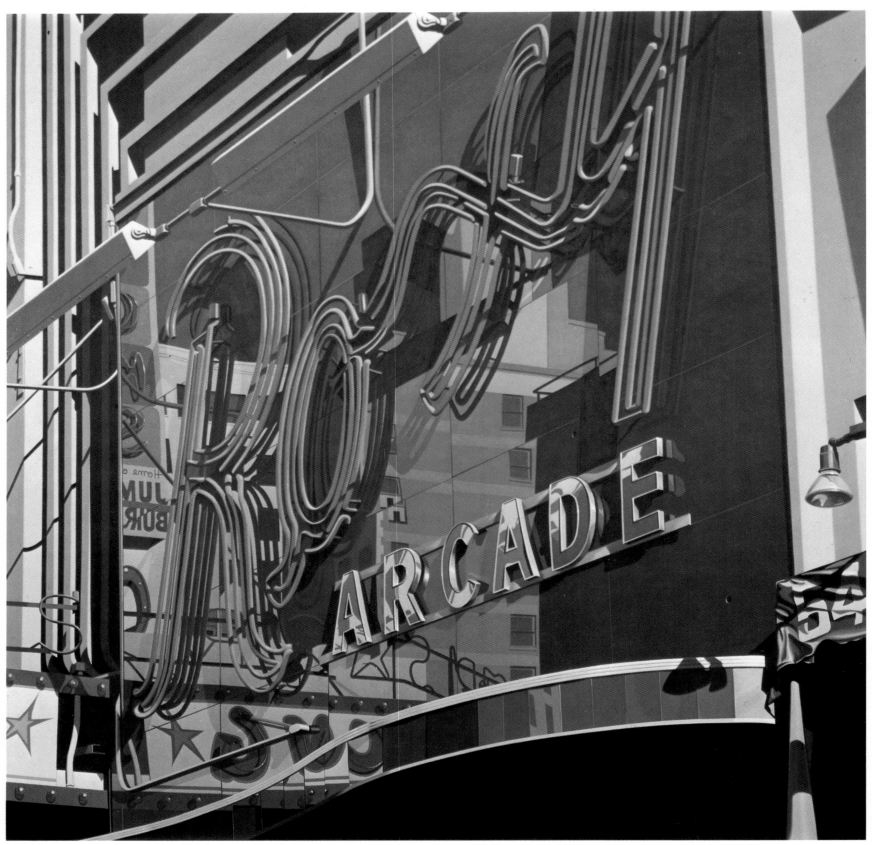

296. *Roxy*. 1972 (70). Oil on canvas, 78 x 78". Collection Charles and Doris Saatchi, London

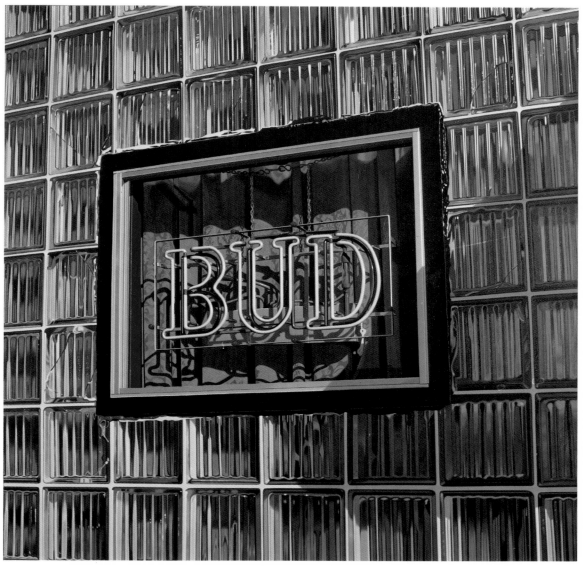

297. *Bud*. 1975 (144). Oil on canvas, 78 x 78". Collection Jane Cottingham, Conn.

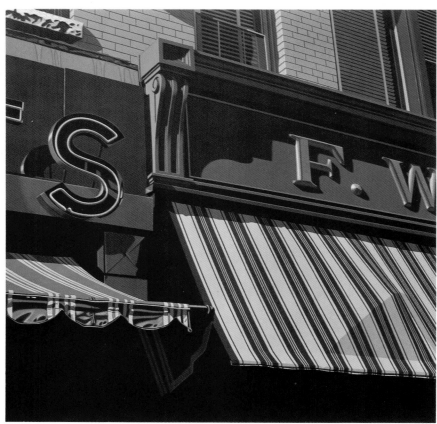

298. *F.W.* 1975 (142). Oil on canvas, 78 x 78".
Museum Boymans–van Beuningen, Rotterdam

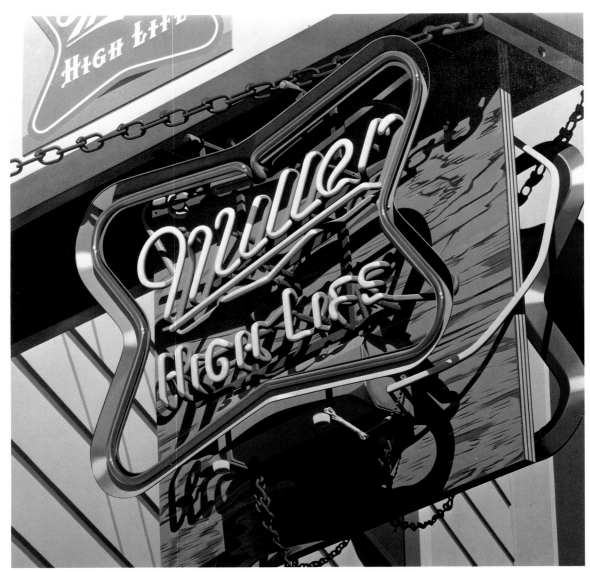

299. *Miller High Life*. 1977 (173). Oil on canvas, 78 x 78". Collection the artist

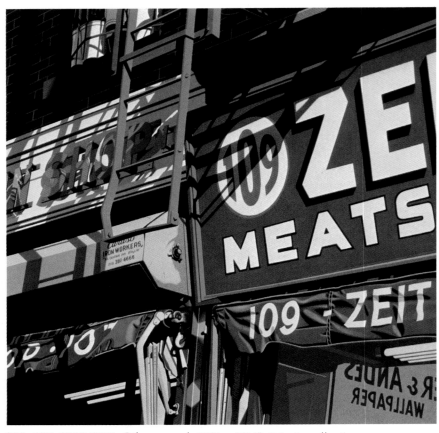

300. *109*. 1978 (186). Oil on wood, 31¾ x 31¾". Private collection

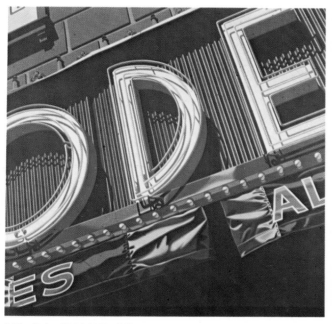

301. *Ode*. 1971 (61). Oil on canvas, 78 x 78".
Private collection

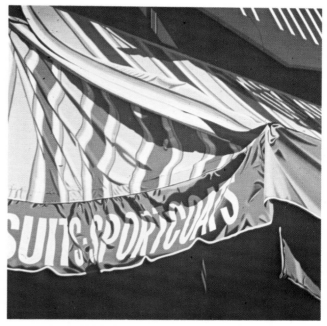

302. *Suits-Sportscoats*. 1971 (62). Oil on canvas, 78 x 78".
Indianapolis Museum of Art. Gift of Contemporary
Art Society

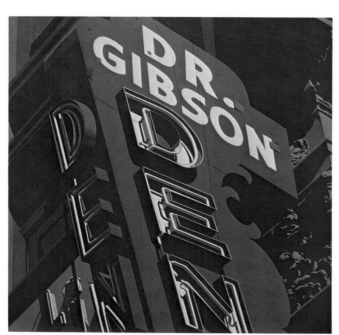

303. *Dr. Gibson*. 1971 (63). Oil on canvas, 78 x 78".
Morgan Gallery, Kans.

304. *Ha*. 1971 (64). Oil on canvas, 78 x 78".
Private collection, N.J.

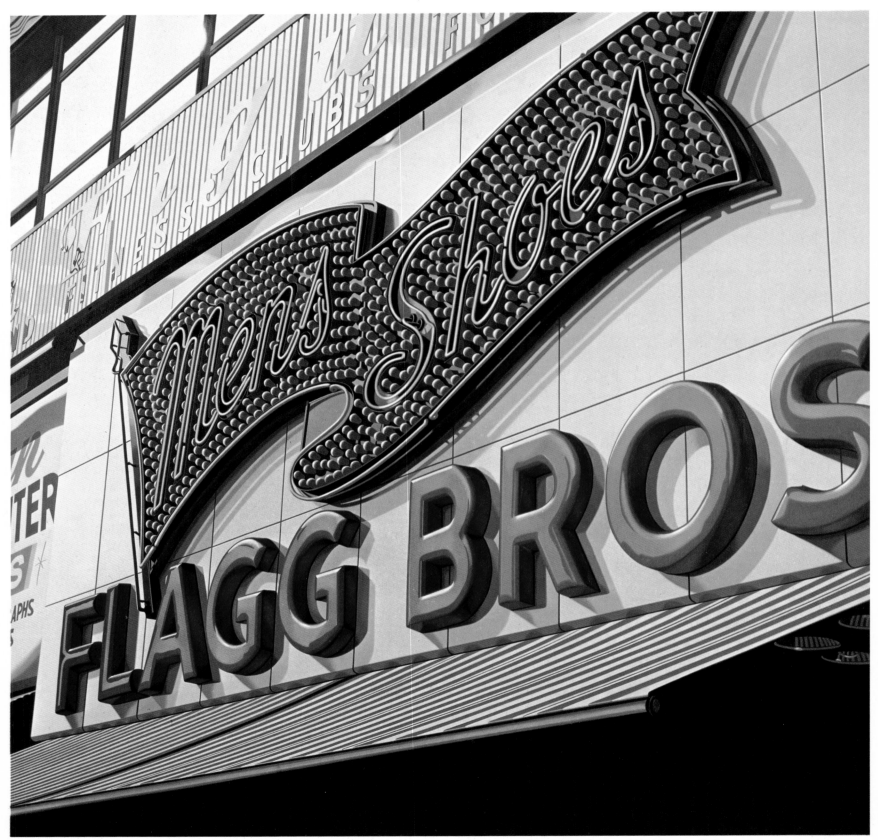

305. *Flagg Bros.* 1975 (141). Oil on canvas, 78 x 78". Hirshhorn Museum and Sculpture Garden, Smithsonian Institution, Washington, D.C.

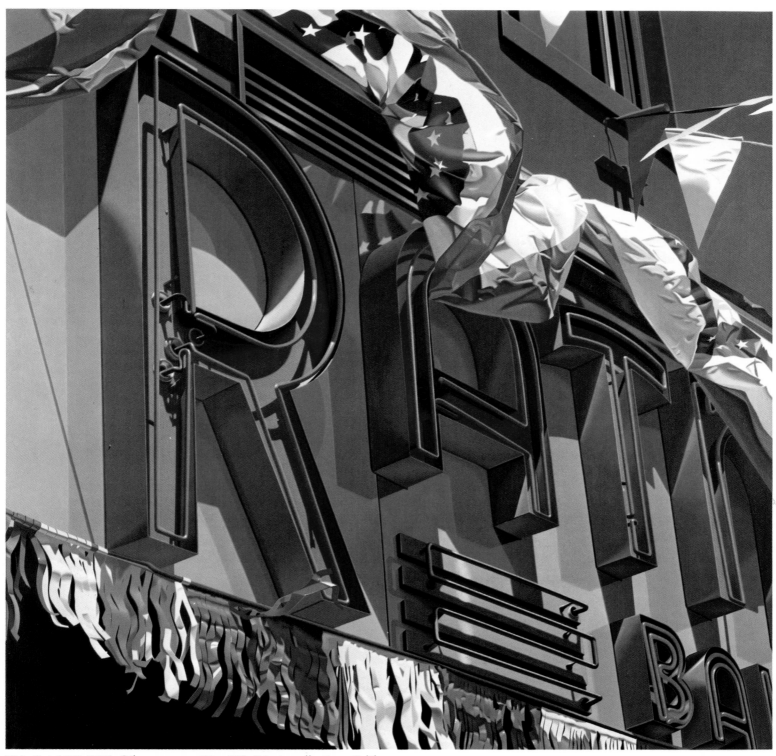

306. *Rat.* 1978 (185). Oil on canvas, 78 x 78". Private collection, Calif.

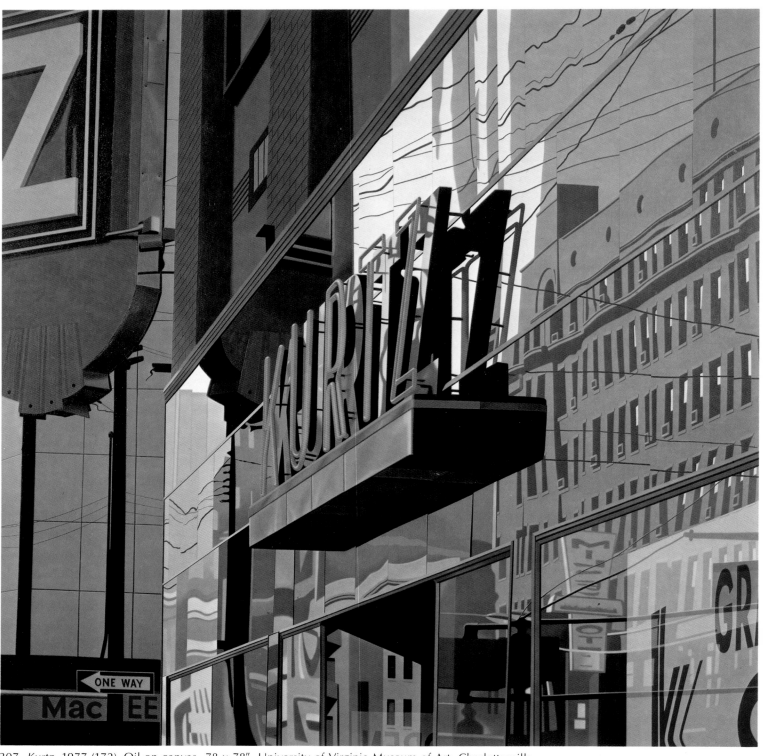

307. *Kurtz*. 1977 (172). Oil on canvas, 78 x 78". University of Virginia Museum of Art, Charlottesville

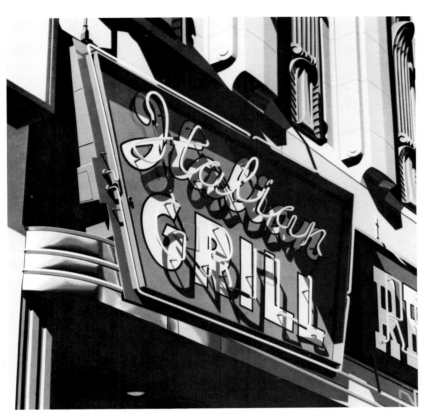

308. *Italian Grill*. 1972 (71). Oil on canvas, 78 x 78".
Collection Richard Belger, Mo.

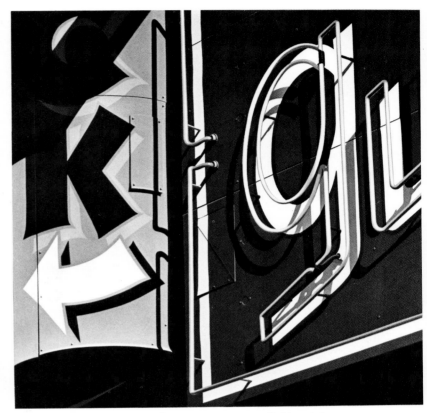

309. *G-Arrow*. 1971 (65). Oil on canvas, 78 x 78". Honolulu
Academy of Arts. National Endowment for the Arts, Grant and
Matching Funds from Academy Friends

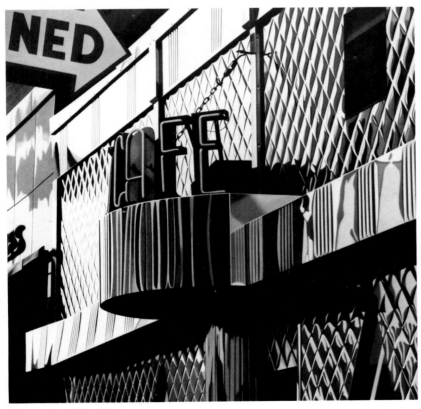

310. *Cafe*. 1976 (154).
Oil on canvas, 78 x 78".
Collection the artist

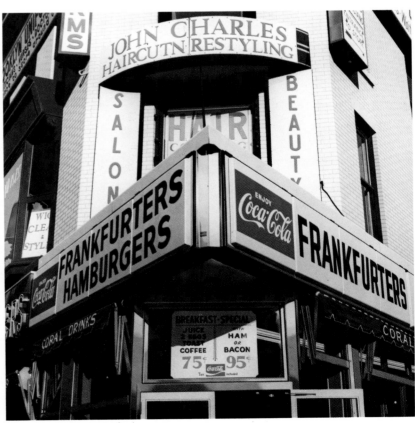

311. *Frankfurters-Hamburgers*. 1977 (174).
Oil on canvas, 78 x 78".
Collection Sandra and Joe Rotman, Canada

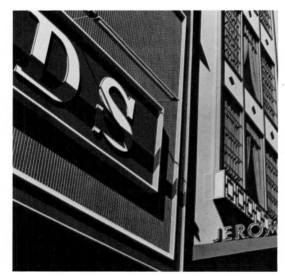

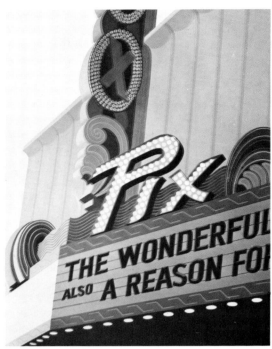

312. *Hi.* 1973 (100).
Oil on canvas, 78 x 78".
Collection Carlo Bilotti, London

313. *Carl's.* 1975 (143). Oil on canvas, 78 x 78".
Neue Galerie der Stadt Aachen.
Ludwig Collection

314. *Pix.* 1966 (23).
Oil on canvas, 78 x 58".
Collection Mr. and Mrs. Robert M. Talcott, Calif.

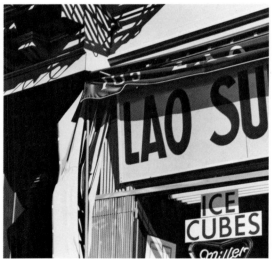

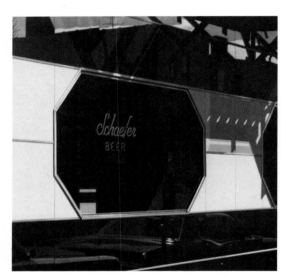

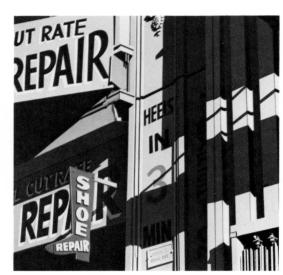

315. *Lao.* 1978 (187).
Oil on canvas, 30 x 30".
Private collection

316. *Schaefer Beer.* 1976 (153).
Oil on canvas, 78 x 78".
Collection the artist

317. *Shoe Repair.* 1971 (66).
Oil on canvas, 78 x 78".
Private collection

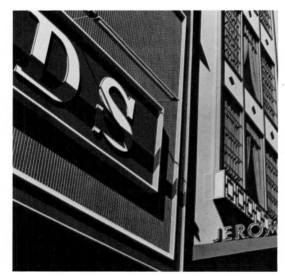

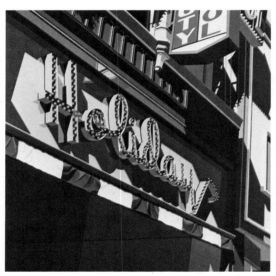

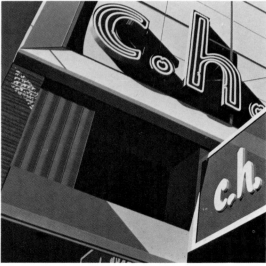

318. *D. S. (Jeromes).* 1970 (52).
Oil on canvas, 78 x 78".
Private collection

319. *Holidays.* 1970 (51).
Oil on canvas, 78 x 78".
Collection Home Savings & Loan, Calif.

320. *C.H.* 1970 (53).
Oil on canvas, 78 x 78".
Collection Mr. and Mrs. Robert M. Talcott, Calif.

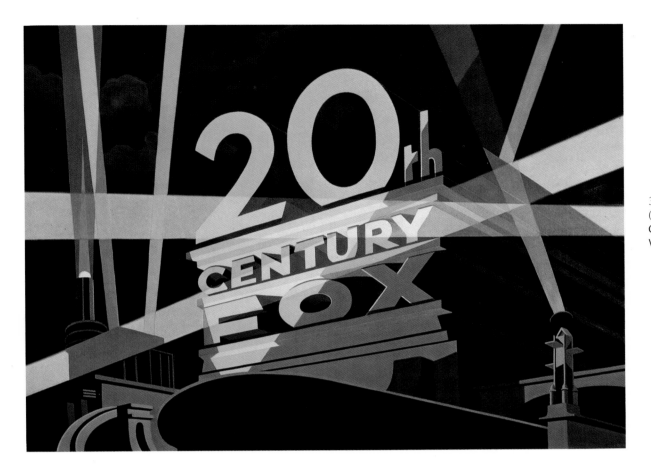

321. *20th Century Fox*. 1969 (46). Oil on canvas, 52 x 60" Collection Kent and Cara Wilson, Calif.

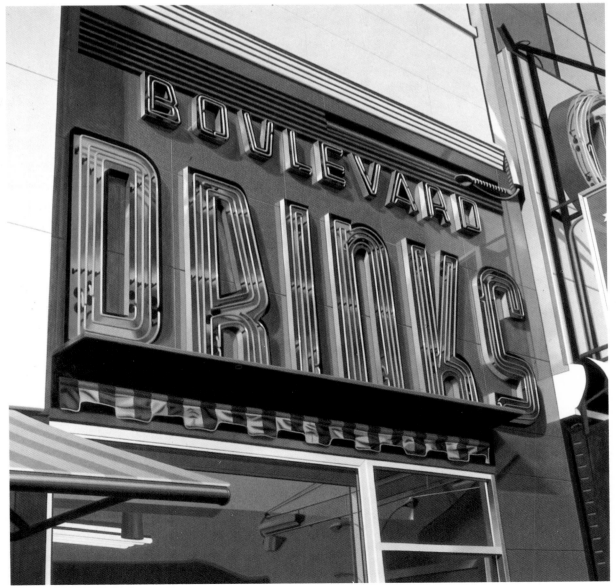

322. *Boulevard Drinks*. 1976 (155). Oil on canvas, 78 x 78 Kunsthalle, Hamburg

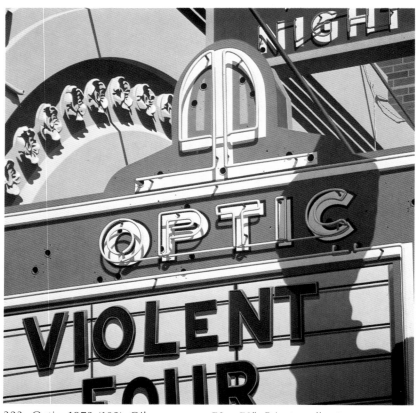

323. *Optic*. 1973 (102). Oil on canvas, 78 x 78". Private collection

324. *House on St. Andrews (Pink)*. 1969 (43).
Oil on canvas, 38 x 62½".
Private collection

325. *House on Berendo*. 1969 (40).
Oil on canvas, 48 x 70".
Private collection

326. *Pool (Swimming)*. 1969 (45).
Oil on canvas, 49½ x 72".
Private collection

327. *House on Windsor*. 1969 (44).
Oil on canvas, 51 x 72".
Private collection

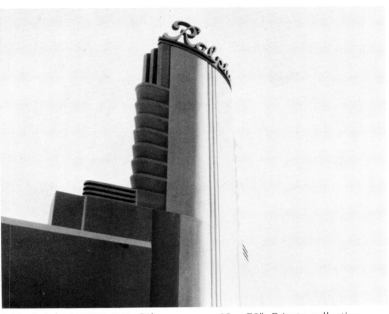

328. *Ralphs I*. 1968 (35). Oil on canvas, 63 x 78". Private collection

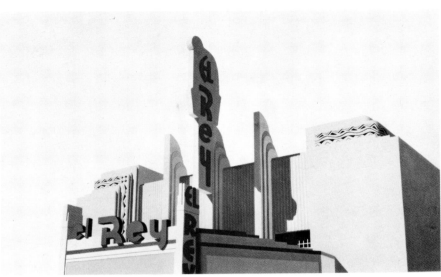

329. *El Rey*. 1968 (34). Oil on canvas, 5'6" x 9'. Private collection, Oreg.

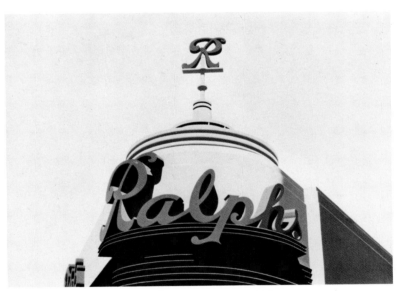

330. *Ralphs II*. 1968 (36). Oil on canvas, 60 x 82".
Private collection

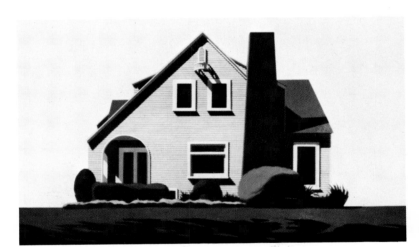

331. *House on Victoria*. 1969 (41). Oil on canvas, 48 x 81".
Long Beach Museum of Art, Calif.

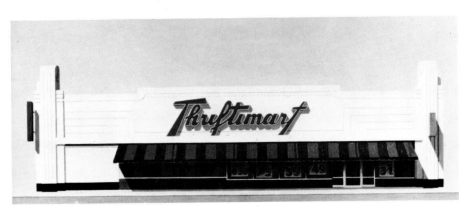

332. *Thriftimart*. 1965 (17). Oil on canvas, 33 x 78".
Collection the artist

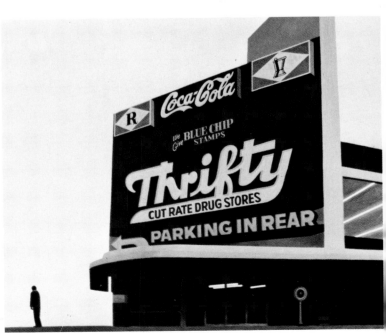

333. *Thrifty (Drug Store)*. 1965 (15). Oil on canvas, 60 x 72".
Collection Home Savings & Loan, Calif.

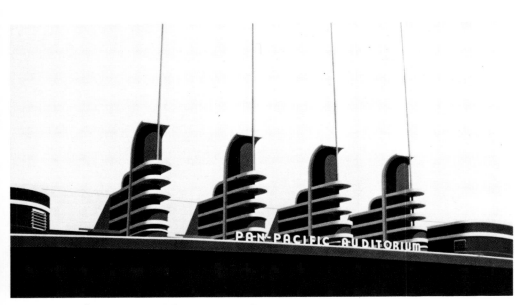

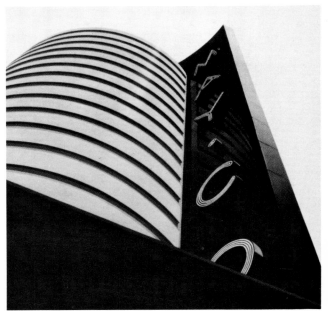

334. *Pan Pacific*. 1968 (32). Oil on canvas, 5' x 9'.
La Jolla Museum of Contemporary Art, Calif.

335. *May Co*. 1968 (33). Oil on canvas, 57 x 57".
Collection Steve Martin, Calif.

336. *House on St. Andrews (Green)*. 1969 (42).
Oil on canvas, 36 x 62½".
Collection Jane Cottingham, Conn.

337. *House with Awnings*. 1968 (39).
Oil on canvas, 59 x 59".
Private collection

338. *House on 18th Street*. 1968 (37).
Oil on canvas, 59 x 59".
Private collection

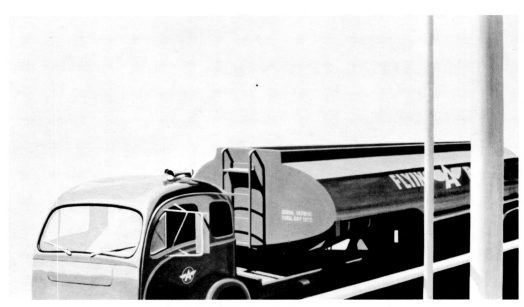

339. *Army Truck*. 1967 (30). Oil on canvas, 60 x 60".
Collection the artist

340. *Flying "A"*. 1967 (27). Oil on canvas, 44 x 78".
Collection Mr. and Mrs. Dennis Horlick, Calif.

NOT ILLUSTRATED

Still Life. 1963 (1).
Oil on canvas, 16 x 12".
Collection Jane Cottingham, Conn.

Brownstone. 1963 (2).
Oil on canvas, size unknown.
Collection Mr. and Mrs. Thomas Murray, Calif.

Nedick's. 1964 (3).
Oil on canvas, 23 x 38".
Private collection

Dollar Bill. 1964 (4).
Oil on Masonite, 13¼ x 24".
Collection Kyle Anne Cottingham, Conn.

Sink. 1964 (5).
Oil on canvas, 32 x 28".
Private collection

Alley. 1964 (6).
Oil on canvas, 36 x 26".
Private collection

Southland Hotel I. 1964 (7).
Oil on canvas, 23 x 28".
Private collection

Bus I (Side View). 1964 (8).
Oil on canvas, 24 x 40".
Collection Mr. and Mrs. Yale M. Udoff, Calif.

Buildings Behind Hayworth. 1964 (9).
Oil on canvas, 25 x 25".
Collection Mrs. James G. Cottingham, New York

Quiet Street. 1965 (10).
Oil on canvas, size unknown.
Private collection

Freeway. 1965 (11).
Oil on canvas, 40 x 50".
Collection the artist

Luggage. 1965 (12).
Oil on canvas, 46 x 63".
Collection Molly Jane Cottingham, Conn.

Telephone Booths. 1965 (13).
Oil on canvas, 41 x 35".
Private collection

Southland Hotel II. 1965 (14).
Oil on canvas, 40 x 48".
Collection Reid Ann Cottingham, Conn.

Bus II. 1965 (16).
Oil on canvas, 39 x 52".
Private collection

Bunker Hill House. 1965 (18).
Oil on Masonite, 48 x 48".
Private collection

Quiet Street. 1965 (19).
Watercolor on paper, c. 19 x 24".
Private collection

Luggage. 1965 (20).
Oil on board, 46 x 63".
Private collection

Meat Counter. 1966 (21).
Oil on canvas, 40 x 60".
Private collection

Bathtub. 1966 (22).
Oil on canvas, 41 x 60".
Collection the artist

Parking Lot. 1966 (24).
Oil on canvas, 44 x 75".
Private collection

Meat Counter. 1966 (25).
Oil on paper, 18¾ x 24".
Collection the artist

White Oil Truck. 1967 (26).
Oil on canvas, 35 x 54".
Collection Armyn and Michael Green, New York

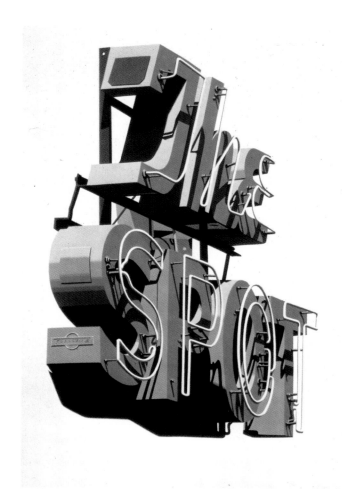

341. *The Spot.* 1978 (188).
Acrylic on paper, 23¼ x 15½".
Private collection

Shell Truck. 1967 (28).
Oil on canvas, 49 x 78".
Collection Tracy Quinn, Calif.

Gulf Truck. 1967 (29).
Oil on canvas, 72 x 53".
Private collection

Shell Truck. 1967 (31).
Oil on board, 49 x 78".
Collection the artist

House on Norton Ave. 1968 (38).
Oil on canvas, 59 x 59".
Collection Paul Rubinstein, Calif.

House on Nancy Blvd. 1970 (47).
Acrylic on canvas, 16 x 20". Collection
Mr. and Mrs. W. A. Weismann, New York

Jane's Bag. 1971 (55).
Oil on canvas, 28¼ x 42".
Collection Jane Cottingham, Conn.

"D". 1971 (56).
Oil on canvas, 78 x 78".
Private collection

Art. 1971 (67).
Watercolor on paper, 10½ x 10½".
Private collection

Dr. Gibson. 1971 (68).
Watercolor on paper, 10½ x 10½".
Private collection

El. 1971 (69).
Acrylic on paper, 10½ x 10½".
Private collection

In God We Trust. 1972 (74).
Acrylic on paper, 10½ x 10½".
Private collection

Fire Alarm. 1972 (75).
Acrylic on paper, 10½ x 10½".
Collection Barbara Toll, New York

"D". 1972 (76).
Acrylic on paper, 10½ x 10½".
Private collection

PH. 1972 (77).
Acrylic on paper, 10½ x 10½".
Private collection

Wear. 1972 (78).
Acrylic on paper, 10½ x 10½".
Private collection

Photos. 1972 (79).
Acrylic on paper, 10½ x 10½".
Private collection

402. 1972 (80).
Acrylic on paper, 10½ x 10½".
Collection Myra and Jim Morgan, Kans.

Linens. 1972 (81).
Acrylic on paper, 10½ x 10½".
Private collection

Mike's. 1972 (82).
Acrylic on paper, 10½ x 10½".
Private collection

Money. 1972 (83).
Acrylic on paper, 10½ x 10½".
Collection Norman Dubrow, New York

Hud. 1972 (84).
Acrylic on paper, 10½ x 10½".
Private collection

Ice. 1972 (85).
Acrylic on paper, 10½ x 10½".
Private collection, New York

Hi Ho. 1972 (86).
Acrylic on paper, 10½ x 10½".
Sydney and Frances Lewis Foundation, Va.

Lil' Tim Tam Cafe. 1972 (87).
Acrylic on paper, 17¼ x 13¼".
Morgan Gallery, Kans.

Bacon & Eggs. 1972 (88).
Acrylic on paper, 10½ x 10½".
Collection Paul and Camille Hoffman, Ill.

Jewelers. 1972 (89).
Acrylic on paper, 10½ x 10½".
Collection M. T. Cohen/S. J. Gallé, New York

Everybody's Bookshop, Everybody's Books.
1972 (90). Acrylic on paper, 10½ x 10½".
Private collection

Famous. 1972 (91).
Acrylic on paper, 10½ x 10½".
Private collection

Chops—Seafood. 1972 (92).
Acrylic on paper, 10½ x 10½".
Permanent Art Collection, Grinnell College, Iowa

Fast Laundry. 1972 (93).
Acrylic on paper, 10½ x 10½".
Private collection

Lone Star. 1972 (94).
Acrylic on paper, 10½ x 10½".
Private collection

Go. 1972 (95).
Acrylic on paper, 10½ x 10½".
Private collection

Optic. 1972 (96).
Acrylic on paper, 10½ x 10½".
Private collection

Wo. c. 1972 (97).
Acrylic on paper, 10½ x 10½".
Young and Hoffman Gallery, Ill.

Bullock's Snack Bar. c. 1972 (98).
Acrylic on paper, 10½ x 10½".
Private collection

Vision. 1973 (103).
Oil on canvas, 78 x 78".
Utrecht Museum of Contemporary Art

Fox. 1973 (104).
Acrylic on paper, 10½ x 10½".
Richard Brown Baker Collection, New York

Lynn's. 1973 (105).
Watercolor on paper, 13¾ x 13¾".
Collection Mr. and Mrs. Lynn St. John, New York

Oasis. 1973 (106).
Acrylic on paper, 10½ x 10½".
Private collection, Mo.

Keegan. 1973 (107).
Acrylic on paper, 10½ x 10½".
Ball State University Art Gallery, Ind.

Taft. 1973 (108).
Acrylic on paper, 10½ x 10½".
Private collection

Her. 1973 (109).
Acrylic on paper, 10½ x 10½".
Collection Mr. and Mrs. Jim Jacobs, New York

New Jersey Central. 1973 (110).
Acrylic on paper, 10½ x 10½".
Collection Benno Friedman, New York

Jack and Hy. 1973 (111).
Acrylic on paper, 10½ x 10½".
Private collection

Club. 1973 (112).
Acrylic on paper, 10½ x 10½".
Private collection

Clancy's. 1973 (113).
Acrylic on paper, 10½ x 10½".
Private collection

G & S Auto Stores. 1973 (114).
Watercolor on paper, 18 x 18".
Collection Carlo Bilotti, London

Me. 1973 (115).
Watercolor on paper, 15 x 15".
Private collection

The Pantry. 1973 (116).
Watercolor on paper, 18 x 18".
Collection Carlo Bilotti, London

Field. 1973 (117).
Watercolor on paper, 15 x 15".
Collection Carlo Bilotti, London

Liss Drugs. 1973 (118).
Watercolor on paper, 18 x 18".
Collection Carlo Bilotti, London

Rialto. 1973 (119).
Watercolor on paper, 15 x 15".
Private collection

5-10-25. 1974 (124).
Acrylic on paper, 10½ x 10½".
Private collection

Red Cross Shoes. 1974 (125).
Acrylic on paper, 10½ x 10½".
Private collection

Shell. 1974 (126).
Acrylic on paper, 10½ x 10½".
Collection Mr. and Mrs. Sam Perkins, Kans.

A & P. 1974 (127).
Acrylic on paper, 10½ x 10½".
Private collection

El Paso. 1974 (128).
Acrylic on paper, 10½ x 10½".
Collection Mr. and Mrs. Leonard Hantover

Champagne. 1974 (129).
Acrylic on paper, 10½ x 10½".
Private collection

Champagne. 1974 (130).
Acrylic on paper, c. 8 x 8".
Private collection, New York

Shine. 1974 (131).
Acrylic on paper, 10½ x 10½".
Private collection

El Toro. 1974 (132).
Acrylic on paper, 10½ x 10½".
Private collection

Kress. 1974 (133).
Acrylic on paper, 10½ x 10½".
Private collection

Moose. 1974 (134).
Acrylic on paper, 10½ x 10½".
Private collection

Avenue Fish Market. 1974 (135).
Acrylic on paper, 10½ x 10½".
Private collection

Carl's. 1974 (136).
Acrylic on paper, 10½ x 10½".
Collection the artist

F. W. 1974 (137).
Acrylic on paper, 10½ x 10½".
Collection Reid Ann Cottingham, Conn.

Frankfurters—Hamburgers. 1974 (138).
Acrylic on paper, 10½ x 10½".
Private collection

113. 1974 (139).
Acrylic on paper, 10½ x 10½".
Private collection

Black Girl. 1974 (140).
Acrylic on paper, 10½ x 10½".
Collection the artist

Abelson's Jewelers. 1975 (145).
Acrylic on paper, 10½ x 10½".
Private collection, New York

Galway. 1975 (146).
Acrylic on paper, 10½ x 10½".
Private collection

Miller High Life. 1975 (147).
Acrylic on paper, 10½ x 10½".
Private collection

43 Felden St. 1975 (148).
Watercolor on paper, c. 18 x 13".
Private collection

Yankee Burger. 1975 (149).
Watercolor on paper, 16 x 16". Collection
Mr. and Mrs. Martin Schmukler, New York

Sunoco. 1975 (150).
Acrylic on paper, 10½ x 10½".
Collection Molly Jane Cottingham, Conn.

Pershing. 1975 (151).
Acrylic on paper, 10½ x 10½".
Private collection

Kiss a Camera. 1975 (152).
Acrylic on paper, 10½ x 10½".
Collection Dr. and Mrs. Barry J. Paley, New York

Hotel Grant. 1976 (156).
Acrylic on paper, 10½ x 10½".
Collection John C. Davis, Ky.

Radios. 1976 (157).
Acrylic on paper, 10½ x 10½".
Collection Louis and Susan Meisel, New York

Frozen Custard. 1976 (158).
Acrylic on paper, 10½ x 10½". Collection
Mr. and Mrs. Nathan Gelfman, New York

Hudson Canadian. 1976 (159).
Acrylic on paper, 10½ x 10½".
Morgan Gallery, Kans.

Schaefer Beer. 1976 (160).
Acrylic on paper, 10½ x 10½".
Collection Mr. and Mrs. Allan Cramer, Conn.

Griddle. 1976 (161).
Acrylic on paper, 10½ x 10½".
Private collection

Cafe. 1976 (162).
Acrylic on paper, 10½ x 10½".
Collection Charles and Ellen Gold, New York

No. 1976 (163). Acrylic on paper, 10½ x 10½".
Utah Museum of Fine Arts, University of
Utah, Salt Lake City

Western Wear. 1976 (164).
Acrylic on paper, 10½ x 10½".
Private collection

Boulevard Drinks. 1976 (165).
Acrylic on paper, 10½ x 10½".
Collection Mr. and Mrs. W. Jaeger, New York

Plant. 1976 (166).
Pen, ink, and acrylic, 18 x 14".
Collection Mrs. F. E. Latus, New York

Brooklyn Aquarium. 1976 (167).
Acrylic on paper, 10½ x 10½".
Private collection

The Spot. 1976 (168).
Acrylic on paper, 10½ x 10½".
Collection Bruce and Barbara Berger, New York

Keystone Photo. 1976 (169).
Acrylic on paper, 10½ x 10½".
Collection Kyle Anne Cottingham, Conn.

Kurtz. 1976 (170).
Acrylic on paper, 10½ x 10½". Collection
Sydney and Frances Lewis Foundation, Va.
Bond. 1977 (175).
Acrylic on paper, 10½ x 10½".
Private collection
Star. 1977 (176).
Acrylic on paper, 10½ x 10½".
Private collection, New York
Jane. 1977 (177).
Acrylic on paper, 10½ x 10½".
Collection Jane Cottingham, Conn.
Simmons & Clark. 1977 (178).
Acrylic on paper, 10½ x 10½".
Collection Bruce and Barbara Berger, New York

3 Hr. 1977 (179).
Acrylic on paper, 10½ x 10½".
Sydney and Frances Lewis Foundation, Va.
Rat. 1977 (180).
Acrylic on paper, 10½ x 10½".
Collection Dr. and Mrs. Barry J. Paley, New York
Jumbo. 1977 (181).
Acrylic on paper, 10½ x 10½".
Private collection
Lao. 1977 (182).
Acrylic on paper, 10½ x 10½".
Collection Paul Waner, N.J.
Kitty s. 1977 (183).
Acrylic on paper, 10½ x 10½".
Collection Larry Gutsch, Ill.

Ed's. 1977 (184).
Acrylic on paper, 10½ x 10½".
Private collection
Ti. 1978 (189).
Acrylic on paper, 10½ x 10½".
Collection Peter C. Barnes, Mo.
Liquors (Blue Cross). 1978 (190).
Acrylic on paper, 10½ x 10½".
Collection the artist
Latina. 1978 (191).
Acrylic on paper, 10½ x 10½".
Private collection
Burgie! 1978 (192).
Acrylic on paper, 10½ x 10½".
Morgan Gallery, Kans.

BIOGRAPHY

1935 Born: Brooklyn, N.Y.

EDUCATION
1959–63 Pratt Institute, Brooklyn, N.Y.

TEACHING
1969–70 Art Center College of Design, Los Angeles

SOLO EXHIBITIONS
1968 Molly Barnes Gallery, Los Angeles
1969 Molly Barnes Gallery, Los Angeles
1970 Molly Barnes Gallery, Los Angeles
1971 O. K. Harris Gallery, New York
1974 O. K. Harris Gallery, New York
1975 DM Gallery, London
 Galerie de Gestlo, Hamburg
1976 John Berggruen Gallery, San Francisco
 O. K. Harris Gallery, New York
1978 Bethel Gallery, Bethel, Conn.
 "Jurors' Exhibit," Ohio State Fair, Columbus
 Morgan Gallery, Shawnee Mission, Kans.
 O. K. Harris Gallery, New York
1979 Aldrich Museum of Contemporary Art, Ridgefield, Conn.
 Beaver College, Glenside, Pa.
 Landfall Press Gallery, Chicago, Ill.
 Galerie de Gestlo, Cologne
 Delta Gallery, Rotterdam
 Getler-Pall Gallery, New York
 Dean Junior College, Franklin, Mass.
1980 Thomas Segal Gallery, Boston

SELECTED GROUP EXHIBITIONS
1966 "Newport Harbor Annual," Newport Beach, Calif.
1968 "The California Landscape," Lytton Savings & Loan, Los Angeles
1969 "The Film and Modern Art," Los Angeles Municipal Art Gallery
 "The Persistent Image," Fresno State College, Calif.
 "Seventh Annual Southern California Exhibition," Long Beach Museum
 of Art, Calif.
 "A Visit to Gallery Row," Fullerton Junior College, Calif.
1970 "Beyond the Actual—Contemporary California Realist Painting,"
 Pioneer Museum and Haggin Galleries, Stockton, Calif.
 "The Cool Realists," Jack Glenn Gallery, Corona del Mar, Calif.
 "Eighth Annual Southern California Exhibition," Long Beach Museum
 of Art, Calif.

"The Highway," Institute of Contemporary Art, University of
 Pennsylvania, Philadelphia; Institute for the Arts, Rice University,
 Houston; Akron Art Institute, Ohio
1971 "California Artists," Long Beach Museum of Art, Calif.
 "Contemporary American Art from Orange County Collections,"
 Newport Harbor Art Museum, Balboa, Calif.
 "New Realism," Brainerd Hall Art Gallery, State University College,
 Potsdam, N.Y.
 "Radical Realism," Museum of Contemporary Art Chicago
1972 "Documenta and No-Documenta Realists," Galerie de Gestlo,
 Hamburg
 "Documenta 5," Kassel, West Germany
 "L.A.—14 Painters," University of California, Santa Barbara
 "Looking West," A.C.A. Galleries, New York
 "Painting & Sculpture Today, 1972," Indianapolis Museum of Art
 "Sharp-Focus Realism," Sidney Janis Gallery, New York
 "The State of California Painting," Govett-Brewster Art Gallery, New
 Plymouth, New Zealand
1972–73 "Amerikanischer Fotorealismus," Württembergischer Kunstverein,
 Stuttgart; Frankfurter Kunstverein, Frankfurt; Kunst und
 Museumsverein, Wuppertal, West Germany
 "Realism Now," New York Cultural Center, New York
1973 "Amerikanske realister," Randers Kunstmuseum, Randers, Denmark;
 Lunds Konsthall, Lund, Sweden
 "Art in Evolution," Xerox Square Exhibit Center, Xerox Corporation,
 Rochester, N.Y.
 "California Representation: Eight Painters in Documenta 5," Santa
 Barbara Museum of Art, Calif.
 "Grands maîtres hyperréalistes américains," Galerie des Quatre
 Mouvements, Paris
 "Hyperréalistes américains," Galerie Arditti, Paris
 "Image, Reality, and Superreality," Arts Council of Great Britain
 traveling exhibition
 "Mit Kamera, Pinsel und Spritzpistole," Ruhrfestspiele Recklinghausen,
 Städtische Kunsthalle, Recklinghausen, West Germany
 "Options 73/30," Contemporary Arts Center, Cincinnati
 "Photo-Realism," Serpentine Gallery, London
 "Realism Now," Katonah Gallery, Katonah, N.Y.
 "Separate Realities," Los Angeles Municipal Art Center
 "The Super-Realist Vision," DeCordova and Dana Museum, Lincoln, Mass.
1973–74 "Hyperréalisme," Galerie Isy Brachot, Brussels
 "Kunst nach Wirklichkeit," Kunstverein Hannover, West Germany
1974 "Amerikaans fotorealisme grafiek," Hedendaagse Kunst, Utrecht; Palais
 des Beaux-Arts, Brussels

"Ars '74 Ateneum," Fine Arts Academy of Finland, Helsinki
"Art 5 '74," Basel, Switzerland
"Choice Dealers/Dealers' Choice," New York Cultural Center, New York
"Contemporary American Paintings from the Lewis Collection," Delaware Art Museum, Wilmington
"Hyperréalistes américains—réalistes européens," Centre National d'Art Contemporain, Paris
"Kijken naar de werkelijkheid," Museum Boymans–van Beuningen, Rotterdam
"New Photo-Realism," Wadsworth Atheneum, Hartford, Conn.
"Tokyo Biennale, '74," Tokyo Metropolitan Museum of Art; Kyoto Municipal Museum; Aichi Prefectural Art Museum, Nagoya
Twenty-five Years of Janis: Part II," Sidney Janis Gallery, New York

1975 "American Realism," Reed College, Portland, Oreg.
"Image, Color and Form—Recent Paintings by Eleven Americans," Toledo Museum of Art, Ohio
Lafayette Natural History Museum and Planetarium, Lafayette, La.
"The Long Island Art Collectors Exhibition," C. W. Post Art Gallery, Long Island University, Greenvale, N.Y.
"The New Realism: Rip-Off or Reality?," Edwin A. Ulrich Museum, Wichita State University, Kans.
"Realismus und Realität," Kunsthalle, Darmstadt, West Germany
"Realist Painting in California," John Berggruen Gallery, San Francisco
"Recent American Etching," Davison Art Center, Wesleyan University, Middletown, Conn.; National Collection of Fine Arts, Smithsonian Institution, Washington, D.C.; traveling to the Orient, 1976
"Richard Brown Baker Collects," Yale University Art Gallery, New Haven, Conn.
"Signs of Life: Symbols in the City," Renwick Gallery, Smithsonian Institution, Washington, D.C.
"Tendenser i moderne kunst," Nordjyllands Kunstmuseum, Aalborg, Denmark
"Watercolors and Drawings—American Realists," Louis K. Meisel Gallery, New York

1975–76 "Photo-Realism, American Painting and Prints," New Zealand traveling exhibition: Barrington Gallery, Auckland; Robert McDougall Art Gallery, Christchurch; Academy of Fine Arts, National Art Gallery, Wellington; Dunedin Public Art Gallery, Dunedin; Govett-Brewster Art Gallery, New Plymouth; Waikato Art Museum, Hamilton
"Super Realism," Baltimore Museum of Art

1976 "America as Art," National Collection of Fine Arts, Smithsonian Institution, Washington, D.C.
"American Paintings and Drawings," John Berggruen Gallery, San Francisco
"Art 7 '76," Basel, Switzerland
"Eight Realists," Dwight Boehm Gallery, Palomar College, San Marcos, Calif.
"Paintings, Drawings and Prints from the John L. Paxton Collection," University of Texas, Austin
"Photo-Realist Watercolors," Neuberger Museum, State University College, Purchase, N.Y.
"Realism (Paintings and Drawings)," Young Hoffman Gallery, Chicago
"Works on Paper," Galerie de Gestlo, Hamburg

1976–77 "Photo-Realism in Painting," Art and Culture Center, Hollywood, Fla.; Museum of Fine Arts, St. Petersburg, Fla.
"Thirty Years of American Printmaking," Brooklyn Museum, New York

1976–78 "Aspects of Realism," traveling exhibition sponsored by Rothman's of Pall Mall Canada, Ltd.: Stratford, Ont.; Centennial Museum, Vancouver, B.C.; Glenbow-Alberta Institute, Calgary, Alta.; Mendel Art Gallery, Saskatoon, Sask.; Winnipeg Art Gallery, Man.; Edmonton Art Gallery, Alta.; Art Gallery, Memorial University of Newfoundland, St. John's; Confederation Art Gallery and Museum, Charlottetown, P. E.I.,; Musée d'Art Contemporain, Montreal, Que.; Dalhousie University Museum and Gallery, Halifax, N.S.; Windsor Art Gallery, Ont.; London Public Library and Art Museum and McIntosh Memorial Art Gallery, University of Western Ontario; Art Gallery of Hamilton, Ont.

1977 "American Prints of the Twentieth Century," Philadelphia Museum of Art
"Land Fall Press—Survey of Prints 1970–1977," Museum of Contemporary Art, Chicago
"Masters of Watercolor," O.K. Harris Gallery, New York
"New in the '70s," University Art Museum, Archer M. Huntington Gallery, University of Texas, Austin
"New Realism: Modern Art Form," Boise Gallery of Art, Idaho
"Photo-Realists," Shore Gallery, Boston
"Recent Acquisitions," Hirshhorn Museum and Sculpture Garden, Smithsonian Institution, Washington, D.C.
"Recent Acquisitions," Rhode Island School of Design, Providence
"Sharp-Focus Realism," Teheran Museum of Contemporary Art
"Whitney Biennial Exhibition," Whitney Museum of American Art, New York
"Works on Paper II," Louis K. Meisel Gallery, New York

1977–78 "Illusion and Reality," Australian touring exhibition: Australian National Gallery, Canberra; Western Australian Art Gallery, Perth; Queensland Art Gallery, Brisbane; Art Gallery of New South Wales, Sydney; Art Gallery of South Australia, Adelaide; National Gallery of Victoria, Melbourne; Tasmanian Museum and Art Gallery, Hobart
"Photo-Realism in Painting," Art and Culture Center, Hollywood, Fla.; Museum of Fine Arts, St. Petersburg, Fla.

1978 "Art About Art," Whitney Museum of American Art, New York; North Carolina Museum of Art, Raleigh; Frederick S. Wight Art Gallery, University of California, Los Angeles; Portland Art Museum, Oreg.
"Artists Look at Art," Helen Foresman Spencer Museum of Art, University of Kansas, Lawrence
"Current Work from New York," Slippery Rock State College, Slippery Rock, Pa.
Herbert Distel Museum of Drawers, Switzerland, traveling exhibition
"Landfall Press," Museum of Contemporary Art, Chicago
Monmouth Museum, Lincroft, N.J.
"New Acquisitions," Whitney Museum of American Art, New York
"New Editions from Landfall Press," G. W. Einstein Gallery, New York
"Photo-Realist Printmaking," Louis K. Meisel Gallery, New York
"Super-Realism," Concordia Teachers College, Seward, Nebr.
"Washington International Art Fair," Washington, D.C.
"Watercolors," Thomas Segal Gallery, Boston
"Watercolor U.S.A.," Springfield Art Museum, Springfield, Mo.

1979 "America in the 70s As Depicted by Artists in the Richard Brown Baker Collection," Meadowbrook Art Gallery, Oakland University, Rochester, Mich.
"Prospectus—Art in the Seventies," Aldrich Museum of Contemporary Art, Ridgefield, Conn.
"Recent Acquisitions," John Berggruen Gallery, San Francisco

1979–80 "Late Twentieth Century Art from the Sidney and Frances Lewis Foundation," Institute of Contemporary Art of the University of Pennsylvania, Philadelphia; Dayton Art Institute, Ohio; Brooks Memorial Art Gallery, Memphis; Dupont Gallery, Washington and Lee University, Lexington, Va.

SELECTED BIBLIOGRAPHY

CATALOGUES
All California Art Exhibit. National Date Festival, Riverside County, Indio, Calif., Feb. 18–27, 1966.
Palmer, Herbert B. Introduction to The Film and Modern Art. Municipal Art Gallery, Los Angeles, Oct. 8–26, 1969.

Shipley, James R., and Weller, Allen S. Introduction to Contemporary American Painting and Sculpture 1969. Krannert Art Museum, University of Illinois, Champaign-Urbana, Mar. 2–Apr. 6, 1969.
Brewer, Donald. Introduction to Beyond the Actual—Contemporary California Realist Painting. Pioneer Museum and Haggin Galleries, Stockton, Calif.,

Nov. 6–Dec. 6, 1970.

Brown, Denise Scott, and Venturi, Robert. Introduction to *The Highway.* Institute of Contemporary Art, University of Pennsylvania, Philadelphia, Jan. 14–Feb. 25, 1970; Institute for the Arts, Rice University, Houston, Mar. 12–May 18, 1970; Akron Art Institute, Ohio, June 5–July 16, 1970.

Wong, James D. Introduction to *Eighth Annual Southern California Exhibition.* Long Beach Museum of Art, Calif., Apr. 19–May 17, 1970.

Garver, Thomas H. Introduction to *Contemporary American Art from Orange County Collections.* Newport Harbor Art Museum, Balboa, Calif., Oct. 23–Nov. 14, 1971.

Goldsmith, Benedict. *New Realism.* Brainerd Hall Art Gallery, State University College, Potsdam, N.Y., Nov. 5–Dec. 12, 1971.

Karp, Ivan C. Introduction to *Radical Realism.* Museum of Contemporary Art, Chicago, May 22–June 4, 1971.

Amman, Jean Christophe. Introduction to *Documenta 5.* Neue Galerie and Museum Fridericianum, Kassel, West Germany, June 30–Oct. 8, 1972.

Crispo, Andrew. Foreword to *Looking West.* A.C.A. Galleries, New York, Sept. 19–Oct. 14, 1972.

Janis, Sidney. Introduction to *Sharp-Focus Realism.* Sidney Janis Gallery, New York, Jan. 6–Feb. 4, 1972.

Walls, Michael. *California Republic.* Foreword by Robert Ballard. Govett-Brewster Art Gallery, New Plymouth, New Zealand, 1972.

Warrum, Richard L. Introduction to *Painting & Sculpture Today, 1972.* Indianapolis Museum of Art, Apr. 26–June 4, 1972.

Amaya, Mario. Introduction to *Realism Now.* New York Cultural Center, New York, Dec. 6, 1972–Jan. 7, 1973.

Schneede, Uwe, and Hoffman, Heinz. Introduction to *Amerikanischer Fotorealismus.* Württembergischer Kunstverein, Stuttgart, Nov. 16–Dec. 26, 1972; Frankfurter Kunstverein, Frankfurt, Jan. 6–Feb. 18, 1973; Kunst und Museumsverein, Wuppertal, West Germany, Feb. 25–Apr. 8, 1973.

Alloway, Lawrence. Introduction to *Photo-Realism.* Serpentine Gallery, London, Apr. 4–May 6, 1973.

Becker, Wolfgang. Introduction to *Mit Kamera, Pinsel und Spritzpistole.* Ruhrfestspiele Recklinghausen, Städtische Kunsthalle, Recklinghausen, West Germany, May 4–June 17, 1973.

Boulton, Jack. Introduction to *Options 73/30.* Contemporary Arts Center, Cincinnati, Sept. 25–Nov. 11, 1973.

Dali, Salvador. Introduction to *Grands maîtres hyperréalistes américains,* Galerie des Quatre Mouvements, Paris, May 23–June 25, 1973.

Dreiband, Laurence. Notes to *Separate Realities.* Foreword by Curt Opliger. Los Angeles Municipal Art Gallery, Sept. 19–Oct. 21, 1973.

Hogan, Carroll Edwards. Introduction to *Hyperréalistes américains.* Galerie Arditti, Paris, Oct. 16–Nov. 30, 1973.

Lamagna, Carlo. Foreword to *The Super-Realist Vision.* DeCordova and Dana Museum, Lincoln, Mass., Oct. 7–Dec. 9, 1973.

Lucie-Smith, Edward. Introduction to *Image, Reality, and Superreality.* Arts Council of Great Britain traveling exhibition, 1973.

Sims, Patterson. Introduction to *Realism Now.* Katonah Gallery, Katonah, N.Y., May 20–June 24, 1973.

Sorce, Anthony John. Introduction to *Art in Evolution.* Xerox Corporation, Rochester, N.Y., 1973.

Becker, Wolfgang. Introduction to *Kunst nach Wirklichkeit.* Kunstverein Hannover, West Germany, Dec. 9, 1973–Jan. 27, 1974.

Hyperréalisme. Galerie Isy Brachot, Brussels, Dec. 14, 1973–Feb. 9, 1974.

Amerikaans fotorealisme grafiek. Hedendaagse Kunst, Utrecht, Aug., 1974; Palais des Beaux-Arts, Brussels, Sept.–Oct., 1974.

Chase, Linda. "Photo-Realism." In *Tokyo Biennale 1974.* Tokyo Metropolitan Museum of Art; Kyoto Municipal Museum; Aichi Prefectural Art Museum, Nagoya, 1974.

Clair, Jean; Abadie, Daniel; Becker, Wolfgang; and Restany, Pierre. Introduction to *Hyperréalistes américains—réalistes européens.* Centre National d'Art Contemporain, Paris, Archives 11/12, Feb. 15–Mar. 31, 1974.

Cowart, Jack. *New Photo-Realism.* Wadsworth Atheneum, Hartford, Conn., Apr. 10–May 19, 1974.

Kijken naar de werkelijkheid. Museum Boymans–van Beuningen, Rotterdam, June 1–Aug. 18, 1974.

Sarajas-Korte, Salme. Introduction to *Ars '74 Ateneum.* Fine Arts Academy of Finland, Helsinki, Feb. 15–Mar. 31, 1974.

25 Years of Janis: Part II from Pollack to Pop, Op and Sharp Focus Realism. Sidney Janis Gallery, New York, Mar. 13–Apr. 13, 1974.

Walthard, Dr. Frederic P. Foreword to *Art 5 '74.* Basel, Switzerland, June 19–24, 1974.

Wyrick, Charles, Jr. Introduction to *Contemporary American Paintings from the Lewis Collection.* Delaware Art Museum, Wilmington, Sept. 13–Oct. 17, 1974.

Krimmel, Bernd. Introduction to *Realismus und Realität.* Foreword by H. W. Sabais. Kunsthalle, Darmstadt, West Germany, May 24–July 6, 1975.

Meisel, Susan Pear. *Watercolors and Drawings—American Realists.* Louis K. Meisel Gallery, New York, Jan., 1975.

Miller, Joan Vita. Foreword to *The Long Island Art Collectors Exhibition.* C. W. Post College, Greenvale, N.Y., Oct. 24–Nov. 23, 1975.

Phillips, Robert F. Introduction to *Image, Color and Form—Recent Paintings by Eleven Americans.* Toledo Museum of Art, Ohio, Jan. 12–Feb. 9, 1975.

Stebbins, Theodore E., Jr. Introduction to *Richard Brown Baker Collects.* Yale University Art Gallery, New Haven, Conn., Apr. 24–May 22, 1975.

Field, Richard S. Introduction to *Recent American Etching.* Davison Art Center, Wesleyan University, Middletown, Conn., Oct. 10–Nov. 23, 1975; National Collection of Fine Arts, Smithsonian Institution, Washington, D.C., Jan. 21–Mar. 27, 1976.

Richardson, Brenda. Introduction to *Super Realism.* Baltimore Museum of Art, Nov. 18, 1975–Jan. 11, 1976.

Baldwin, Russell W. Foreword to *Douglas Bond—Robert Cottingham—Dan Douke—D. J. Hall—Victor Lance Henderson—Shirley Pettibone—Gene Studebaker—Michael Wasp.* Dwight Boehm Gallery, Palomar College, San Marcos, Calif., Nov. 4–Nov. 30, 1976.

Goodall, Donald. Foreword to *Paintings, Drawings, and Prints from the John L. Paxton Collection.* University of Texas, Austin, 1976.

Taylor, Joshua C. Introduction to *America as Art.* National Collection of Fine Arts, Smithsonian Institution, Washington, D.C., 1976.

Walthard, Dr. Frederic P. Introduction to *Art 7 '76.* Basel, Switzerland, June 16–21, 1976.

Baro, Gene. Introduction to *30 Years of American Printmaking.* Brooklyn Museum, New York, Nov. 20, 1976–Jan. 30, 1977.

Hicken, Russell Bradford. Introduction to *Photo-Realism in Painting.* Art and Culture Center, Hollywood, Fla., Dec. 3, 1976–Jan. 10, 1977; Museum of Fine Arts, St. Petersburg, Fla., Jan 21–Feb. 25, 1977.

Chase, Linda. "U.S.A." In *Aspects of Realism.* Rothman's of Pall Mall Canada, Ltd., June, 1976–Jan., 1978.

Haskell, Barbara, and Tucker, Marcia. Introduction to *1977 Biennial Exhibition.* Whitney Museum of American Art, New York, Feb. 19–Apr. 3, 1977.

Karp, Ivan. Introduction to *New Realism: Modern Art Form.* Boise Gallery of Art, Idaho, Apr. 14–May 29, 1977.

Seabolt, Fred. Introduction to *New in the '70s.* Foreword by Donald Goodall. University Art Museum, Archer M. Huntington Gallery, University of Texas, Austin, Aug. 21–Sept. 25, 1977.

Sharp-Focus Realism. Teheran Museum of Contemporary Art, 1977.

Kirshner, Judith Russi. Foreword to *Landfall Press.* Museum of Contemporary Art, Chicago, Nov. 18, 1977–Jan. 8, 1978.

Stringer, John. Introduction to *Illusion and Reality.* Australian Gallery Directors' Council, North Sydney, N.S.W., 1977–78.

Hennessey, William. *Artists Look at Art.* Foreword by Charles Eldredge. Helen Foreman Spencer Museum of Art, University of Kansas, Lawrence, Jan. 15–Mar. 12, 1978.

Landwehr, William C. Introduction to *Watercolor U.S.A.* Springfield Art Museum, Springfield, Mo., May 21–July 16, 1978.

Meisel, Susan Pear. Introduction to *The Complete Guide to Photo-Realist Printmaking.* Louis K. Meisel Gallery, New York, Dec., 1978.

Stokes, Charlotte. "As Artists See It: America in the 70s." In *America in the 70s As Depicted by Artists in the Richard Brown Baker Collection.* Meadowbrook Art Gallery, Oakland University, Rochester, Mich., Nov. 18–Dec. 16, 1979.

Butler, Susan L. Introduction to *Late Twentieth Century Art from the Sidney and Frances Lewis Foundation.* Institute of Contemporary Art of the University of Pennsylvania, Philadelphia, Mar. 22–May 2, 1979; Dayton Art Institute, Ohio, Sept. 13–Nov. 4, 1979; Brooks Memorial Art Gallery, Memphis, Dec. 2, 1979–Jan. 27, 1980; Dupont Gallery, Washington and Lee University, Lexington, Va., Feb. 18–Mar. 21, 1980.

ARTICLES

Miller, Arthur. "2,700-Man Exhibit," *Los Angeles Herald Examiner,* July 18, 1965, p. B-2.

Wilson, William. "Potpourri of Work in City's Art Festival," *Los Angeles Times,* July 18, 1965.

"Leonardo da Vinci Symposium Slated," *Los Angeles Times,* Apr. 10, 1966.

"Vasarely Exhibit in Channel City," *Los Angeles Times,* June 11, 1967.

Wilson, William. "All City Art Show: Great as All Outdoors," *Los Angeles*

Times, Aug. 7, 1967.

Good, Jeanne. "Paintings Show Real America," *Hollywood Citizen News,* May 10, 1968.

Los Angeles Times Calendar, May 26, 1968.

"Mary Cassatt Exhibition at UCLA," *Los Angeles Times,* Nov. 17, 1968.

Miller, Arthur. "Exhibit . . . The California Landscape," *Los Angeles Times,* Aug. 5, 1968.

San Francisco Examiner and Chronicle, Oct. 20, 1968.

Seldes, Henry J. "Landscapes at Lytton Center," *Los Angeles Times,* Aug. 5, 1968, p. 6.

Wilson, William. "Artists Do Their Own Thing at Barnsall Exhibition," *Los Angeles Times,* June 30, 1968.

————. "Cottingham Show Indecisive," *Los Angeles Times,* May 10, 1968.

Christy, George. "Are You with It?," *Town and Country,* May, 1969, p. 81.

D. H. "College Exhibit: Persistent Image," *Fresno Bee,* July 27, 1969.

Good, Jeanne. "Cottingham Reflects America," *Hollywood Citizen News,* Feb. 14, 1969.

Los Angeles Times Calendar, Feb. 9, 1969.

M. T. "Robert Cottingham," *Arts Magazine,* Mar. 1969, pp. 66, 67.

"Pictures and Photos of L.A. Landmarks," *Los Angeles Times,* Sept. 21, 1969.

"Robert Cottingham," *ARTnews,* Apr., 1969, p. 60.

"Robert Cottingham," *Time,* West Coast edition, Feb. 21, 1969, p. E-4.

Seldis, Henry, and Wilson, William. "Art Walk," *Los Angeles Times,* Feb. 14, 1969.

"Who's Who in California Pop," *Los Angeles Times West Magazine,* Dec. 7, 1969, p. 29.

"City Festival Winners Announced," *Los Angeles Times,* June 21, 1970.

"$4,600 Awarded in Prizes," *Los Angeles Times,* Nov. 19, 1970.

Frankenstein, Alfred. "Beyond the Actual Exhibition," *San Francisco Chronicle,* Nov. 30, 1970, p. 43.

Good, Jeanne. "Two Exhibitions Complement," *Hollywood Citizen News,* June 11, 1970.

Madden, Donald. "Barbara's Bag Is Non-Affluence," *Long Island Press,* Aug. 17, 1970, p. 19.

Plagens, Peter. "Cottingham," *Artforum,* Sept., 1970, p. 83.

Ratcliff, Carter. "22 Realists Exhibit at the Whitney," *Art International,* Apr., 1970, p. 105.

"Robert Cottingham," *Art International,* Oct., 1970, p. 73.

"Robert Cottingham," *Hollywood Citizen News,* June 11, 1970.

Seldis, Henry J. "Adventurous Juried Exhibit at Long Beach Museum of Art," *Los Angeles Times,* May 11, 1970.

Seldis, Henry J., and Wilson, William. "Art Walk," *Los Angeles Times,* June 12, 1970.

Smith, Jack. "Street Scene Is Anything but Pedestrian," *Los Angeles Times,* June 25, 1970.

Wilson, William. "Why Do Colonies—of All Places—Have So Little of It?," *Los Angeles Times,* Aug. 2, 1970.

Art Now: New York, vol. III, no. 4 (Dec., 1971).

Baker, Kenneth. "The Home Forum," *Christian Science Monitor,* Nov. 16, 1971.

Domingo, Willis. "Review," *Arts Magazine,* Sept.–Oct., 1971, pp. 58, 60.

Henry, Gerrit. "New York Letter," *Art International,* Nov. 20, 1971, pp. 61–62.

Long Beach Museum of Art Bulletin, Fall, 1971.

Los Angeles Times Calendar, Oct. 31, 1971.

"Painting, Sculpture Auction Set," *Los Angeles Times,* May 9, 1971.

"Reviews," *Art in America,* Sept.–Oct., 1971, pp. 121, 123.

"Robert Cottingham," *ARTnews,* Nov., 1971, p. 18.

Sager, Peter. "Neue Formen des Realismus," *Magazin Kunst,* 4th Quarter, 1971, pp. 2512–16.

"Three Exhibits at Long Beach," *Los Angeles Times,* July 18, 1971.

"Timely Show of Portraits," *Los Angeles Times Calendar,* Sept. 19, 1971.

Borden, Lizzie. "Cosmologies," *Artforum,* Oct., 1972, pp. 45–50.

Chase, Linda; Foote, Nancy; and McBurnett, Ted. "The Photo-Realists: 12 Interviews," *Art in America,* vol. 60, no. 6 (Nov.–Dec., 1972), pp. 73–89.

"Die Documenta bestätigte sein Programm," *Hansestadt Hamburg die Welt,* no. 180 (Aug. 5, 1972).

Hickey, David. "Previews," *Art in America,* Jan.–Feb., 1972, pp. 37–38.

————. "Sharp Focus Realism," *Art in America,* Mar.–Apr. 1972, pp. 116–18.

"Les hommes et les oeuvres," *La Galerie,* no. 120 (Oct., 1972), pp. 16–17.

Karp, Ivan. "Rent Is the Only Reality, or the Hotel Instead of the Hymn," *Arts Magazine,* Dec., 1972, pp. 47–51.

Kurtz, Bruce. "Documenta 5: A Critical Preview," *Arts Magazine,* Summer, 1972, pp. 34–41.

Lerman, Leo. "Sharp-Focus Realism," *Mademoiselle,* Mar., 1972, pp. 170–73.

Levequi, J. J. "Les hommes et les oeuvres," *Argus de la Presse,* Oct., 1972.

"Living with the Space You Love," *House and Garden,* July, 1972.

Muller, W. K. "Prints and Multiples," *Arts Magazine,* Apr., 1972, p. 28.

Nemser, Cindy. "New Realism," *Arts Magazine,* Nov., 1972, p. 85.

Pozzi, Lucio. "Super Realisti U.S.A.," *Bolaffiarte,* no. 18 (Mar., 1972), pp. 54–63.

"Radical Realism," *Kansas City* (Mo.) *Star,* Dec. 24, 1972, p. 2-E.

Ratcliff, Carter. "New York Letter," *Art International,* vol. XVI, no. 3 (Mar., 1972), pp. 28–29.

Rosenberg, Harold. "The Art World," *The New Yorker,* Feb. 5, 1972, pp. 88–93.

Seldis, Henry J. "Documenta: Art Is Whatever Goes On in Artist's Head," *Los Angeles Times Calendar,* July 9, 1972.

Thornton, Gene. "These Must Have Been a Labor of Love," *New York Times,* Jan. 23, 1972.

Wasmuth, E. "La révolte des réalistes," *Connaissance des Arts,* June, 1972, pp. 118–23.

"Wish You Were Here," *New York Magazine,* Sept. 25, 1972.

Wolmer, Denise. "In the Galleries," *Arts Magazine,* Mar., 1972, p. 57.

"Arts: les expositions à New York," *Argus de la Presse,* Jan. 4, 1973.

Borden, Lizzie. "Reviews," *Artforum,* Oct., 1973.

Chase, Linda. "Recycling Reality," *Art Gallery Magazine,* Oct., 1973, pp. 75–82.

"Foto Realismus," *IZW Illustrierte Wochenzeitung,* no. 14 (June, 1973), pp. 8–10.

Gilmour, Pat. "Photo-Realism," *Arts Review,* vol. 25 (Apr. 21, 1973), p. 249.

Gosling, Nigel. "The Photo Finish," *Observer Review* (London), Apr. 8, 1973.

Guercio, Antonio del. "Iperrealismo tra 'pop' e informale," *Rinascita,* no. 8 (Feb. 23, 1973), p. 34.

"L'hyperréalisme américain," *Le Monde des Grandes Musiques,* no. 2 (Mar.–Apr., 1973), pp. 4, 56–57.

Levin, Kim. "The New Realism: A Synthetic Slice of Life," *Opus International,* no. 44–45 (June, 1973), pp. 28–37.

Lucie-Smith, Edward. "Super Realism from America," *Illustrated London News,* Mar., 1973.

Melville, Robert. "New Brotherhood," *New Statesman,* Apr. 13, 1973.

————. "The Photograph as Subject," *Architectural Review,* vol. CLIII, no. 915 (May, 1973), pp. 329–33.

Mizue (Tokyo), vol. 8, no. 821 (1973).

"Neue Sachlichkeit—Neuer Realismus," *Kunstforum International,* Mar. 4, 1973, pp. 114–19.

"Realism Now," *Patent Trader,* May 26, 1973, p. 7A.

Seldis, Henry J. "New Realism: Crisp Focus on the American Scene," *Los Angeles Times,* Jan. 21, 1973, p. 54.

Clair, Jean. "Situation des réalismes," *Argus de la Presse,* Apr., 1974.

Davis, Douglas. "Summing Up the Season," *Newsweek,* July 1, 1974, p. 73.

Deroudille, René. "Réalistes et hyperréalistes," *Derrière Heure Lyonnaise,* Mar. 31, 1974.

Frank, Peter. "On Art," *Soho Weekly News,* May 16, 1974, pp. 19, 22.

Horizon, Spring, 1974, p. 65.

Hughes, Robert. "An Omnivorous and Literal Dependence," *Arts Magazine,* June, 1974, pp. 25–29.

Lascault, Gilbert. "Autour de ce qui se nomme hyperréalisme," *Paris-Normandie,* Mar. 31, 1974.

Loring, John. "Photographic Illusionist Prints," *Arts Magazine,* Feb., 1974, pp. 42–43.

Moulin, Raoul-Jean. "Les hyperréalistes américains et la neutralisation du réel," *L'Humanité,* Mar. 21, 1974.

"The Objects of the Exercise," *Arts Guardian,* Apr. 29, 1974.

Picard, Lil. "In . . . Out . . . und In Again," *Kunstforum International,* Jan. 2, 1974.

Progresso fotografico, Dec., 1974, pp. 61–62.

Schjeldahl, Peter. "Too Easy to Be Art?," *New York Times,* May 12, 1974, p. 23.

Spector, Stephen. "The Super Realists," *Architectural Digest,* Nov.–Dec., 1974, p. 85.

Teyssedre, Bernard. "Plus vrai que nature," *Le Nouvel Observateur,* Feb. 25–Mar. 3, 1974, p. 59.

W. K. "Bohemia Reborn," *Horizon,* vol. XVI, no. 2 (1974).

Albright, Thomas. "A Wide View of the New Realists," *San Francisco Chronicle,* Feb. 6, 1975, p. 38.

Art Press (France), Feb., 1975, p. 37.

"Baltimore Show," *Washington Post,* Nov. 25, 1975, p. B-1.

Bruner, Louise. "Brash Paintings Stimulate Thinking Rather than Passive Thoughts," *Toledo Blade,* Jan. 12, 1975, p. 4.

D. M. "Robert Cottingham," *Art International,* Apr., 1975, pp. 37–38.

D. M. "Robert Cottingham," *ARTnews,* Apr., 1975, p. 82.

Del Renzio, Toni. "Robert Cottingham—The Capers of the Signscape," *Art and Artists,* Feb., 1975, pp. 5–13.

Ford, Michael. "Robert Cottingham," *Arts Review* (London), Feb. 16, 1975.

Gosling, Nigel. "U.S. Varieties," *Observer Review* (London), Feb. 16, 1975.

Hull, Roger. "Realism in Art Returns with Camera's Clarity," *Portland Oregonian,* Sept. 14, 1975.

Kent, Sarah. "Robert Cottingham," *Studio International,* Mar.–Apr. 1975, p. 150.

Lucie-Smith, Edward. "The Neutral Style," *Art and Artists,* vol. 10, no. 5 (Aug., 1975), pp. 6–15.

Nordjyllands Kunst Museum, No. 3, Sept., 1975.

Richard, Paul. "Whatever You Call It, Super Realism Comes On with a Flash," *Washington Post,* Nov. 25, 1975, p. B1.

Sutinen, Paul. "American Realism at Reed," *Willamette Week,* Sept. 12, 1975.

Vaizey, Marina. "Inspiration of Genius," *London Sunday Times,* Feb. 2, 1975.

Winter, Peter. "Die gegenwärtigen Tendenzen biespielhaft verdeutlicht," *Frankfurter Allgemeine Zeitung,* Nov. 10, 1975, p. 21.

Wykes-Joyce, Max. "Around European Museums and Galleries," *International Herald Tribune,* Feb. 22–23, 1975, p. 6.

Albright, Thomas. "Wanted: A Figurative Study," *San Francisco Chronicle,* Oct. 5, 1976.

Artweek, Oct. 16, 1976, p. 3.

Battcock, Gregory. "Good Taste, Bad Taste," *Domus 555,* Feb., 1976, p. 47.

"Buschs," *Art International,* Mar.–Apr., 1976, p. 25.

Chase, Linda. "Photo-Realism: Post Modernist Illusionism," *Art International,* vol. XX, no. 3–4 (Mar.–Apr., 1976), pp. 14–27.

Forgey, Benjamin. "The New Realism, Paintings Worth 1,000 Words," *Washington Star,* Nov. 30, 1976, p. G24.

Fried, Alexander. "Three Artists Trying to Be Different," *San Francisco Examiner,* Oct. 1, 1976, p. 32.

Hoelterhoff, Manuela. "Strawberry Tarts Three Feet High," *Wall Street Journal,* Apr. 21, 1976.

McDonald, Robert. "Richard McLean and Robert Cottingham," *Artweek,* Oct. 16, 1976, pp. 3–4.

Raymond, Jim. "Super Realism on Display," *Columbia* (Md.) *Times,* Jan., 1976.

Russell, John. "Robert Cottingham's Photorealist Paintings," *New York Times,* Mar. 6, 1976.

Schulze, Franz. "Landfall Press: 'Making Marks' in Chicago," *ARTnews,* Sept., 1976.

Borlase, Nancy. "In Selecting a Common Domestic Object," *Sydney Morning Herald,* July 30, 1977.

Eagle, Mary. "Cool Proof That Realism Survives in Oil and Stone," *Melbourne Age,* Oct. 22, 1977.

Groom, Gloria. "Modern Art Exhibit Gives a Nice Surprise," *The Citizen* (Austin, Tex.), Aug., 1977.

Langer, Gertrude. "Realising Our Limitations in Grasping Reality," *Brisbane Courier Mail,* May 28, 1977.

Lynn, Elwyn. "The New Realism," *Quadrant,* Sept., 1977.

Makin, Jeffrey. "Realism from the Squad," *Melbourne Sun,* Oct. 19, 1977, p. 43.

McCulloch. "Illusion or Reality," *Melbourne Herald,* Oct. 20, 1977.

McGrath, Sandra. "I Am Almost a Camera," *The Australian* (Brisbane), July 27, 1977.

"Photo-Realism and Related Trends," *New York Times,* Feb. 4, 1977.

Richard, Paul. "Big Name Artists and 'New Etchers,' " *Washington Post,* Feb. 2, 1977.

Schwartz, Estelle. "Art and the Passionate Collector," *Cue,* Dec. 9, 1977, pp. 7–11.

Wilson, William. "Patronage and the Corporate Patriarchy," *Los Angeles Times,* Mar. 20, 1977, p. 70.

" 'Art About Art' Show Features Area Artist," *Danbury News-Times,* July 23, 1978, p. E7.

Bongard, Willie. *Art Aktuell* (Cologne), Apr., 1978.

Harris, Helen. "Art and Antiques: The New Realists," *Town and Country,* Oct., 1978, pp. 242, 244, 246–47.

"Photo-Realism Joins Wood Sculpture," *Bridgeport* (Conn.) *Post,* May 7, 1978.

Rodriguez, Joanne Milani. "Art Show Accents the Eccentricities of Camera's Vision," *Tampa Tribune-Times,* Feb. 5, 1978, pp. 1–2.

Sanger, Elizabeth. "If Your Taste in Art Runs to the Bizarre, O.K. Harris Is O.K.," *Wall Street Journal,* Aug. 18, 1978, pp. 1, 29.

Smith, Betty. "Cottingham Is Dazzled by Signs of the Times," *Danbury News-Times,* Sept. 19, 1978, p. F7.

"This Week with the Arts," *Bridgeport* (Conn.) *Sunday Post,* July 23, 1978, p. F6.

Doherty, Stephen M. "Robert Cottingham: An Unabashed Realist," *American Artist,* July, 1979, pp. 48–53, 110.

Dudeney, Peter. "Best of Both Worlds," *Fair Fields* (Fairfield, Conn.), Aug., 1979, pp. 24–27, 38, cover.

Harshman, Barbara. "Photo-Realist Printmaking," *Arts Magazine,* Feb., 1979, p. 17.

Smith, Betty. "His Art Speaks of the City, the Store Fronts, Deli Signs," *Sunday Post* (Bridgeport, Conn.), Sept. 23, 1979, p. F7.

Cottingham, Jane. "Techniques of Three Photo-Realists," *American Artist,* Feb., 1980.

BOOKS

Hunter, Sam. *American Art of the Twentieth Century.* New York: Harry N. Abrams, 1972.

Kultermann, Udo. *New Realism.* New York: New York Graphic Society, 1972.

Brachot, Isy, ed. *Hyperréalisme.* Brussels: Imprimeries F. Van Buggenhoudt, 1973.

Sager, Peter. *Neue Formen des Realismus.* Cologne: Verlag M. DuMont Schauberg, 1973.

L'Iperrealismo italo Medusa. Rome: Romana Libri Alfabeto, 1974.

Battcock, Gregory, ed. *Super Realism, A Critical Anthology.* New York: E. P. Dutton, 1975.

Calkins, Carroll, ed. *The Story of America.* New York: Readers Digest, 1975.

Chase, Linda. *Hyperréalisme.* New York: Rizzoli, 1975.

Kultermann, Udo. *Neue Formen des Bildes.* Tübingen, West Germany: Verlag Ernst Wasmuth, 1975.

Rose, Barbara. *American Art Since 1900.* New York: Praeger, 1975.

Walker, John A. *Art Since Pop.* London: Thames and Hudson, 1975.

Honisch, Dieter, and Jensen, Jens Christian. *Amerikanische Kunst von 1945 bis Heute.* Cologne: DuMont Buchverlag, 1976.

Battcock, Gregory. *Why Art.* New York: E. P. Dutton, 1977.

Lucie-Smith, Edward. *Art Now: From Abstract Expressionism to Superrealism.* New York: William Morrow, 1977.

Pierre, Jose. *An Illustrated Dictionary of Pop Art.* London: Eyre Methuen, 1977.

Rose, Barbara (with Jules D. Brown). *American Painting.* New York: Skira, Rizzoli, 1977.

Tighe, Mary Ann, and Lang, Elizabeth Ewing. *Art America.* New York: McGraw-Hill, 1977.

Lipman, Jean, and Marshall, Richard. *Art About Art.* New York: E. P. Dutton, 1978.

Lucie-Smith, Edward. *Super Realism.* Oxford: Phaidon, 1979.

Seeman, Helene Zucker, and Siegfried, Alanna. *SoHo.* New York: Neal-Schuman, 1979.

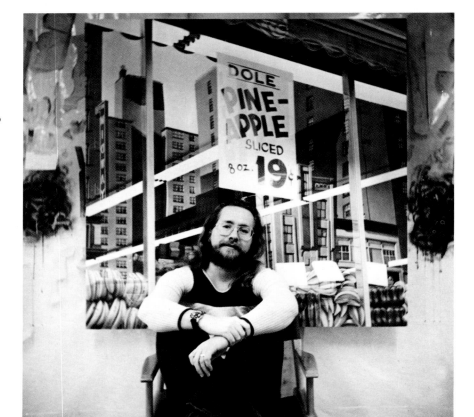

342. Don Eddy in his studio

DON EDDY

Don Eddy, the youngest of the Photo-Realists, was just twenty-seven when he had his first exhibition as a Photo-Realist in New York. Despite his youth, his work then and now displays maturity and technical accomplishment.

Eddy was born in Southern California and lived there until going to college in Hawaii. He returned to the area after college. Although he is from the same state as Goings, McLean, and Bechtle, and his early work has something of the "California look," Eddy was geographically removed during his formative years from these artists and the San Francisco art scene, and he has developed on his own with very little influence from his contemporaries. One of the more formalist Photo-Realist painters, Eddy refers to Ingres and Hans Hofmann as influences on his thinking. He mentions the challenge of spatial tensions and color systems as being derivative of Hofmann.

The artist's father was the owner of Eddy's Garage, a car-customizing shop, where at an early age Eddy became familiar with the airbrush as a painting tool. His Photo-Realist paintings are totally airbrushed, and his method of information transferral is the grid system. A master of the airbrush, Eddy paints very differently from the other airbrush painters, Close, Ott, Flack, and Schonzeit, especially in his almost pointillist way of spraying small dots of color, particularly evident in the series depicting showcases of silverware.

At one time Eddy was the most prolific of the Photo-Realists. In 1970 and 1971, while others were averaging five or six works a year, Eddy completed almost seventy paintings. As the years advanced, however, and easier problems were resolved, newer and far more difficult ones presented themselves. Subject matter became far more complex and ambitious. In 1976 and 1977 he produced only three paintings a year; now he considers the possibility of spending from two to four years on a single painting.

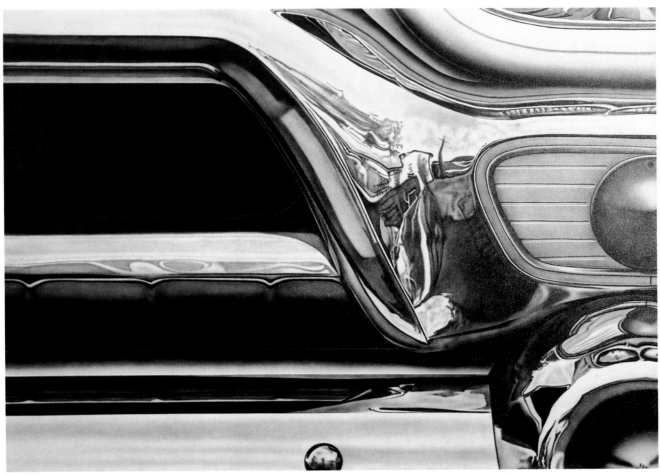

343. *Bumper Section XI: Isla Vista.* 1970 (17). Acrylic on canvas, 48 x 66". Private collection, Atlanta

The earlier paintings, especially the bumper sections, were deeply involved with abstract composition. If some of the detail were removed or blurred, the result would be truly abstract painting, concerned with color and spatial relationships, although derived from real subjects. The wire fences and the windows that appeared later were intended to define the picture plane and are analogous to a "field" in abstract terminology. In the pictures with a fence in the foreground, a sort of double painting exists, with a tension created between both elements on the canvas. The illusion of space and the realist composition are blocked and confined by the formalist, abstract surface structure of the fence, which becomes a hard-edge abstract pattern. The windows serve a different purpose. A window creates a triple situation: it has a surface, its transparency allows the appearance of a second image, and it reflects a third vision. Because of the way the eye functions, we never, in reality, see all three as separate images at the same time. By incorporating information gathered from several photographs and forcing it all onto the single focused surface of his painting, Eddy makes the physiologically impossible seem logical. A camera cannot achieve the same result because, like the eye, it focuses on either foreground or background.

In dealing with color, Eddy does not strive for reality, preferring to paint from black-and-white photographs and to create color systems that are more concerned with formalist considerations. An orange Volkswagen situated behind a red one may be reality, but a white car situated behind a blue one may work better as a painting.

Eddy's works satisfy at two levels—they please the casual viewer and they chal-lenge the art scholar to analyze the intellectual impetus behind the paintings. The following is Don Eddy's response to my request for a statement.

176

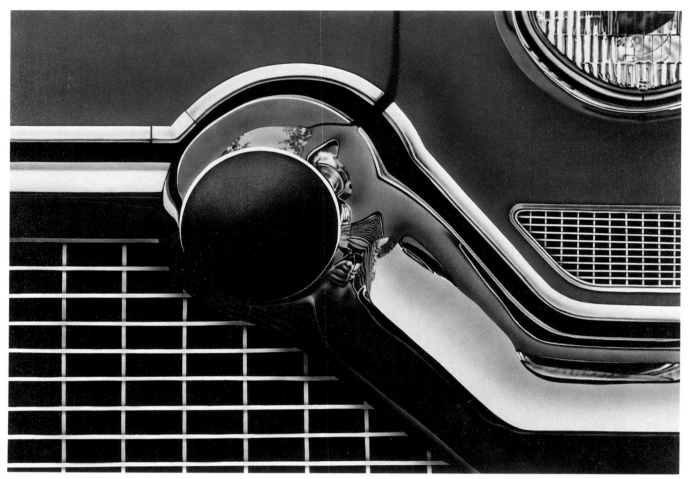

344. *Bumper Section XXI: Isla Vista.* 1970 (28). Acrylic on canvas, 34 x 48". Private collection

A general observation will do. Rather than pontificate at length about my "work, concepts, or philosophy, about new realism, or any part of it, about the state of art today," or whatever, I think it's more to the point to simply pass on something David Smith said:

Question: Does innovation play an important role in your work?
Smith: We are all subject to our own time and our own history. The best artists are probably innovators and children of their parents. My parents were every artist before me whose work I knew. There are first your immediate parents, your blood family who directly influence you, then there are relatives you adopt and feel close to. Even the artists you don't like influence you. But you can't leave your own world; you're born into it. You're always stretching to reach beyond yourself—you make a little stretch each time, but you always remain yourself. Art is made by people.... There are no rules or principles. [From Katharine Kuh, The Artist's Voice. New York and Evanston, Ill.: Harper and Row, 1962.]

Don Eddy
September, 1973

As of the end of 1979, Don Eddy had painted more than 125 Photo-Realist works. We have illustrated 93 of these on the following pages, and have listed an additional 14.

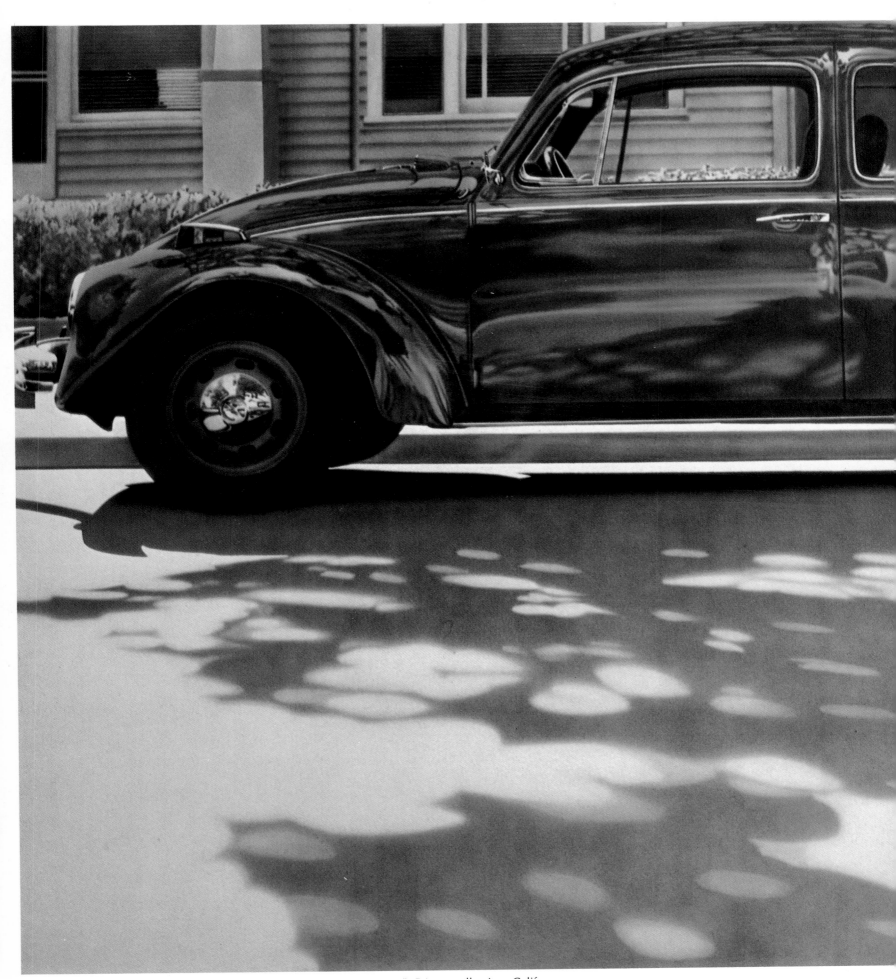

345. *Untitled (Green Volkswagen)*. 1971 (42). Acrylic on canvas, 66 x 95". Private collection, Calif.

346. *Untitled (T & M)*. 1971 (48). Acrylic on canvas, 95 x 66". Musée d'Art et d'Industrie, Saint-Etienne, France

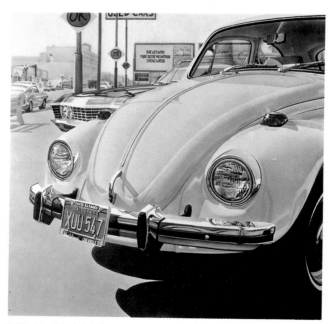

347. *Untitled (Volkswagen and OK Used Cars)*. 1971 (54). Acrylic on canvas, 48 x 48". Private collection, Paris

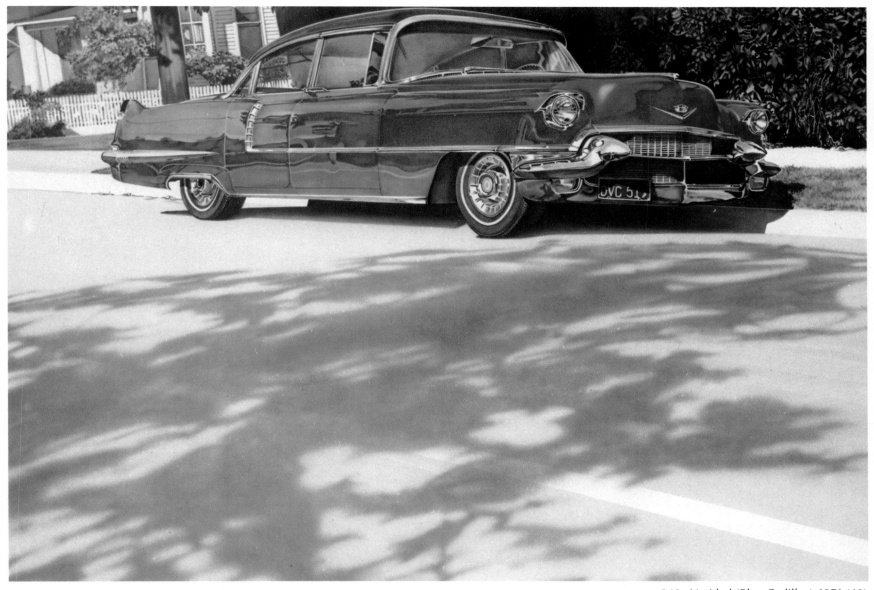

348. *Untitled (Blue Cadillac).* 1971 (46).
Acrylic on canvas, 66 x 95".
Utrecht Museum of Contemporary Art

349. *Harley Wheel Hub.* 1970 (34). Acrylic on canvas, 28 x 28".
Private collection

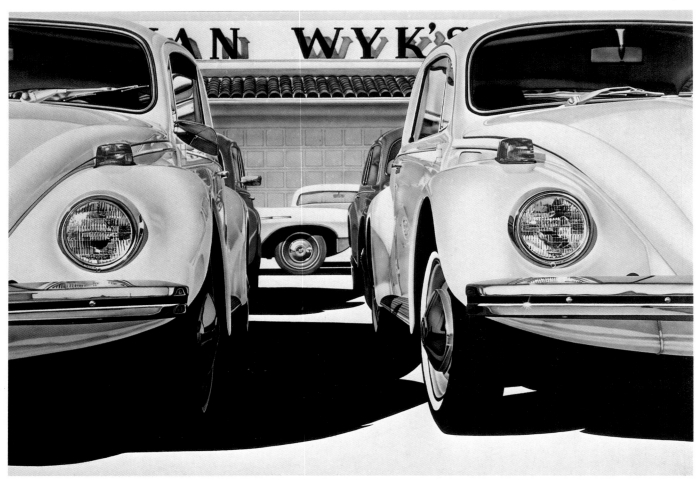

350. *Untitled (Four Volkswagens)*. 1971 (49). Acrylic on canvas, 66 x 95". Private collection, New York

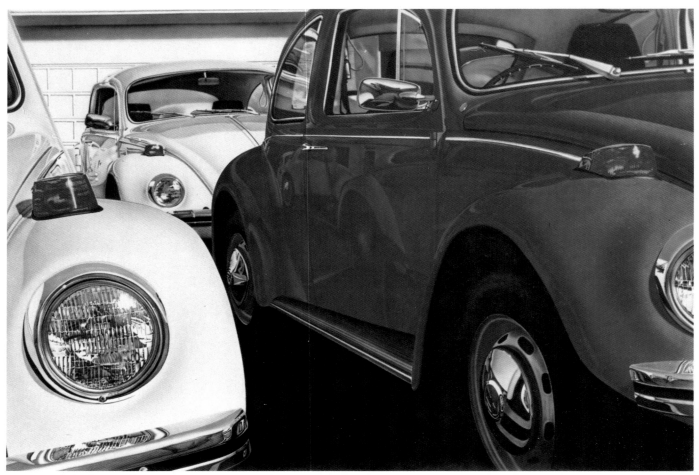

351. *Untitled (Three Volkswagens)*. 1971 (50). Acrylic on canvas, 66 x 95".
Private collection, New York

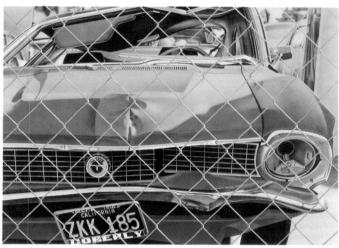

352. *Wrecking Yard III*. 1971 (60). Acrylic on canvas, 48 x 66".
Collection Edmund P. Pillsbury, Conn.

355. *Private Parking X*. 1971 (73).
Acrylic on canvas, 66 x 95".
Collection Monroe Meyerson, New York

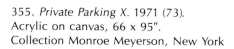

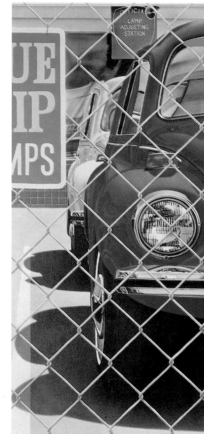

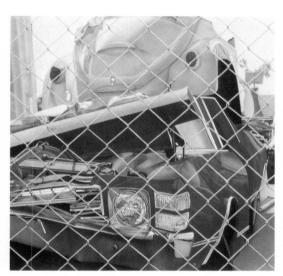

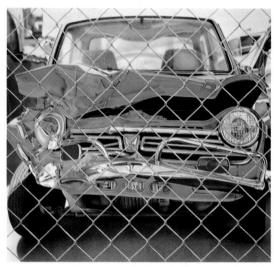

353. *Wrecking Yard I*. 1971 (58). Acrylic on canvas, 66 x 66". Private collection, New York

354. *Wrecking Yard V*. 1971 (62). Acrylic on canvas, 66 x 66". Private collection

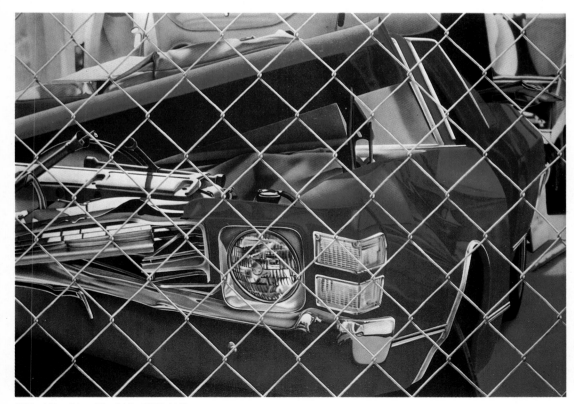

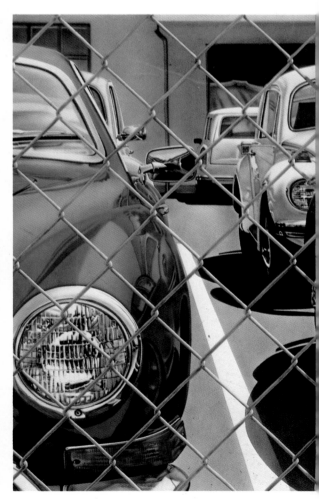

356. *Wrecking Yard VI*. 1971 (63).
Acrylic on canvas, 48 x 66".
Collection Ethel Kraushar, New York

357. *Private Parking I*. 1971 (64).
Acrylic on canvas, 48 x 66". Collection
Doris and Charles Saatchi, London

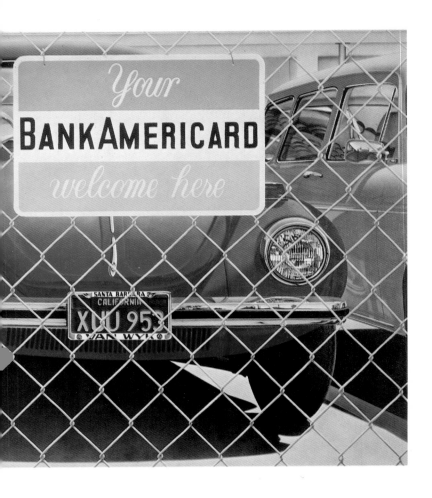

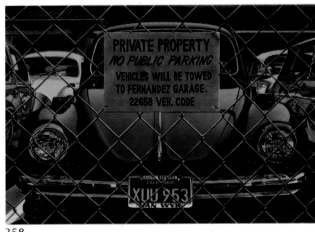

358

359

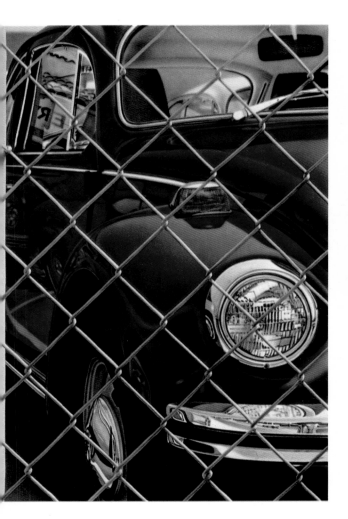

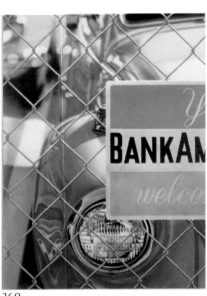

360

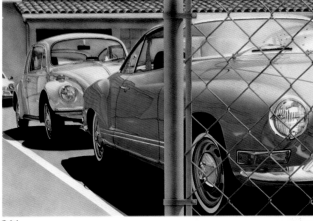

361

358. *Private Parking II*. 1971 (65).
Acrylic on canvas, 48 x 66". Collection
Mr. and Mrs. W. Jaeger, New York

359. *Private Parking VI*. 1971 (69).
Acrylic on canvas, 48 x 66".
Collection Barry Lowen, Los Angeles

360. *Private Parking VIII*. 1971 (71).
Acrylic on canvas, 48 x 34".
Private collection

361. *Private Parking III*. 1971 (66).
Acrylic on canvas, 48 x 66".
Private collection, Chicago

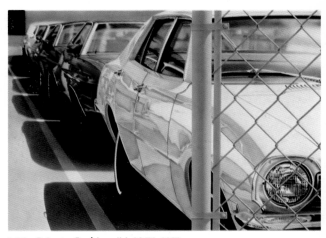

362. *Private Parking IV*. 1971 (67).
Acrylic on canvas, 48 x 66".
Private collection, New York

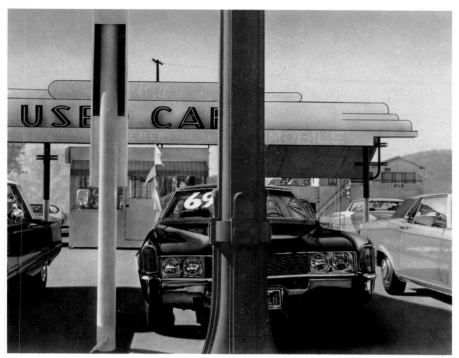

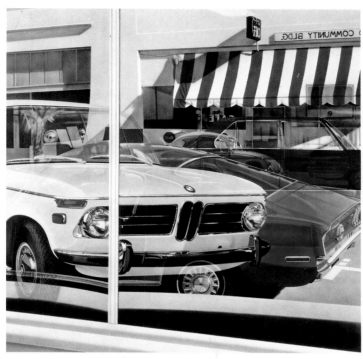

363. *Tom Williams Used Cars*. 1971 (56). Acrylic on canvas, 66 x 80".
Collection Paul and Camille Hoffman, Ill.

364. *BMW Showroom Window I*. 1971 (74). Acrylic on canvas,
66 x 66". Collection Beatrice C. Mayer, Ill.

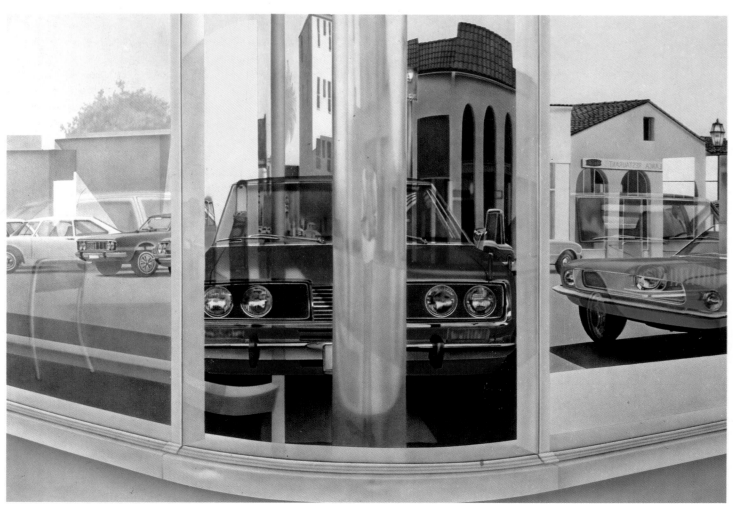

365. Toyota *Showroom Window*. 1972 (79). Acrylic on canvas, 48 x 68½". Private collection

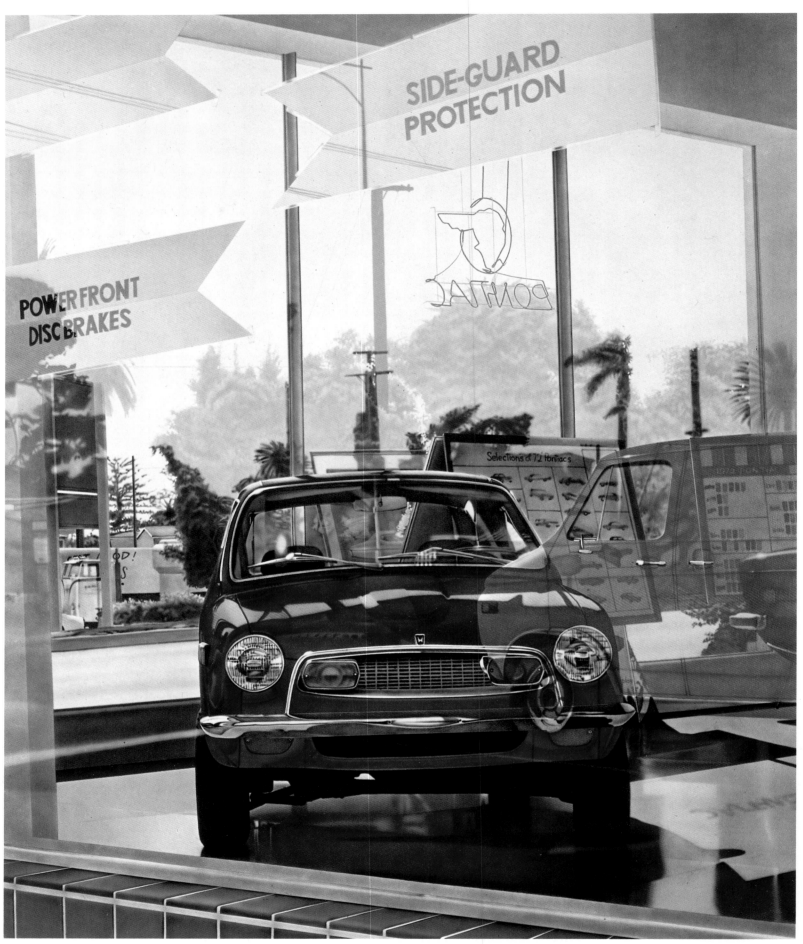

366. *Pontiac Showroom Window I*. 1972 (76). Acrylic on canvas, 80 x 66". Collection Beatrice C. Mayer, Ill.

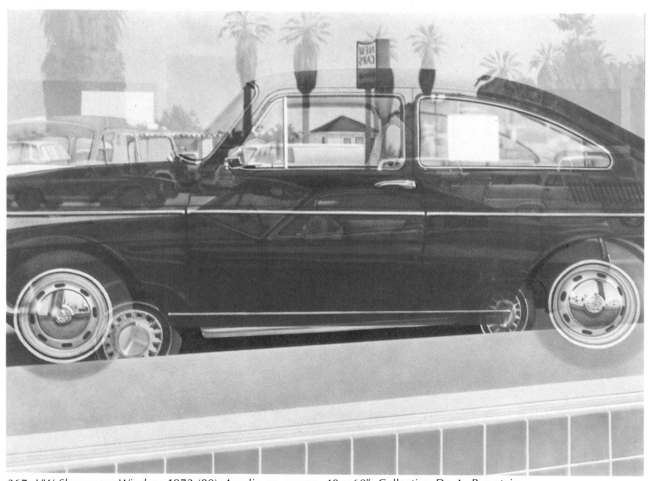

367. *VW Showroom Window.* 1972 (80). Acrylic on canvas, 48 x 60". Collection Dr. A. Burgstein

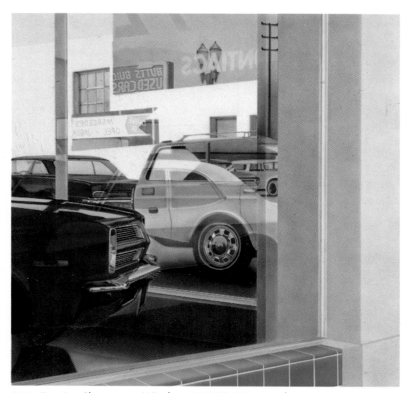

368. *Pontiac Showroom Window II.* 1972 (77). Acrylic on canvas, 48 x 48". Collection Armand Ornstein, Paris

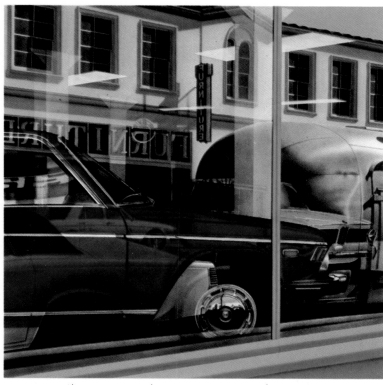

369. *BMW Showroom Window II.* 1971 (75). Acrylic on canvas, 66 x 66". Private collection

186

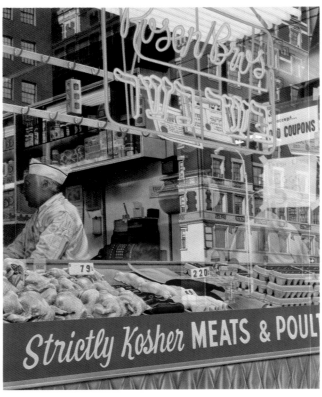

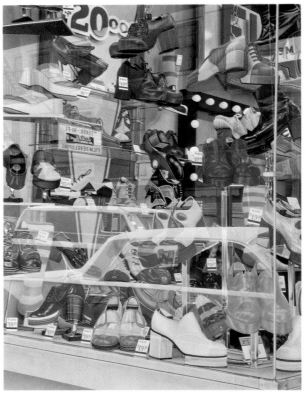

370. *Rosen Bros. Kosher Meats.* 1973 (88).
Acrylic on canvas, 59 x 48".
Private collection

371. *New Shoes.* 1973 (89).
Acrylic on canvas, 64 x 48".
Williams College Museum of Art, Mass.

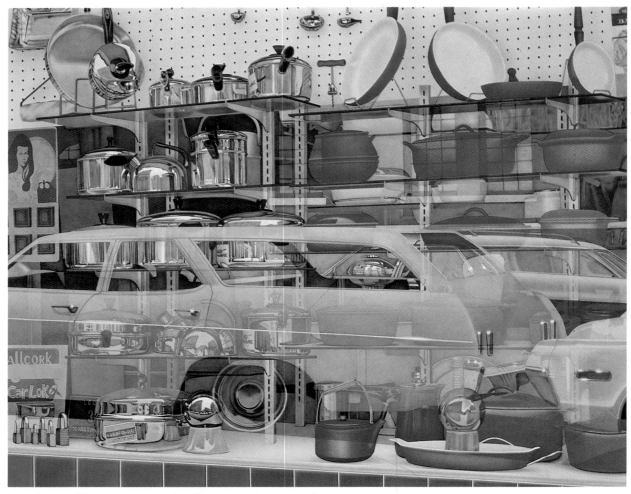

372. *Pots and Pans.* 1972 (83). Acrylic on canvas, 48 x 58".
Private collection

373. *Silverware for M.* 1975 (96).
Acrylic on canvas, 40 x 55".
Private collection

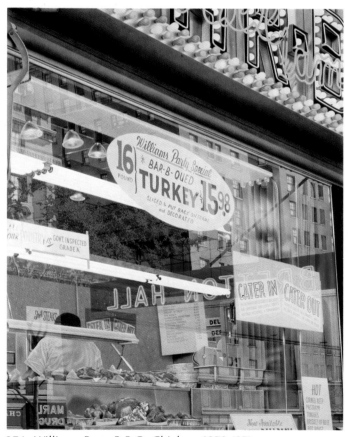

374. *Williams Bros. B.B.Q. Chicken.* 1973 (87).
Acrylic on canvas, 63 x 48".
Private collection

375. *New Shoes for H.* 1973 (91). Acrylic on canvas, 44 x 48".
Cleveland Museum of Art, Ohio. Purchased with a grant from the
NEA and matched by gifts from members of the Cleveland Society
for Contemporary Art

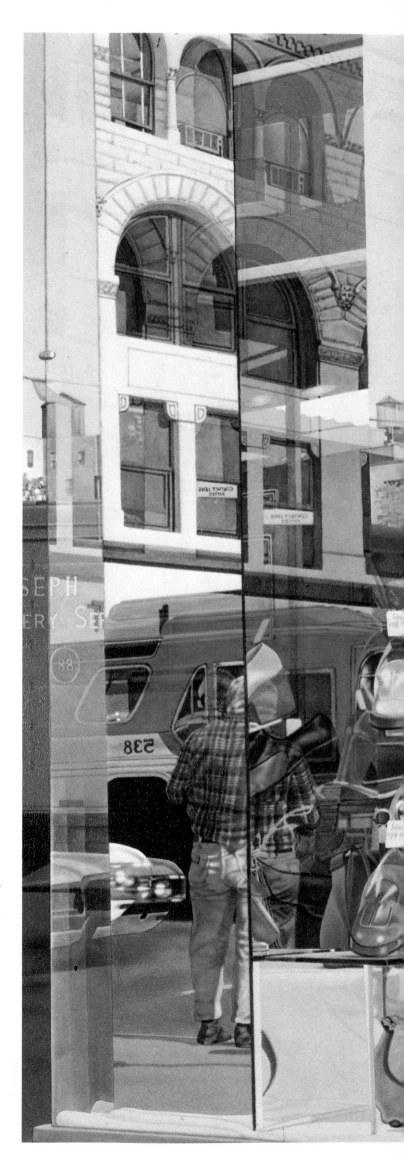

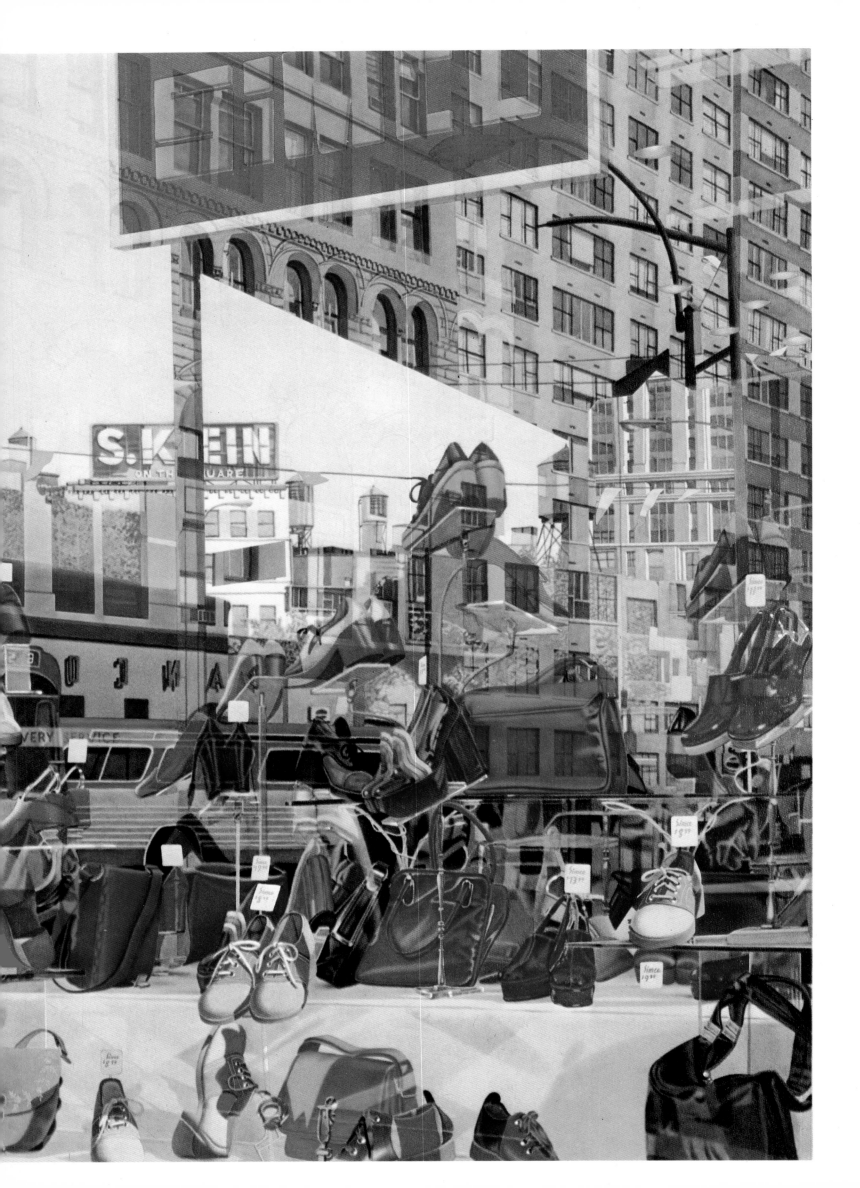

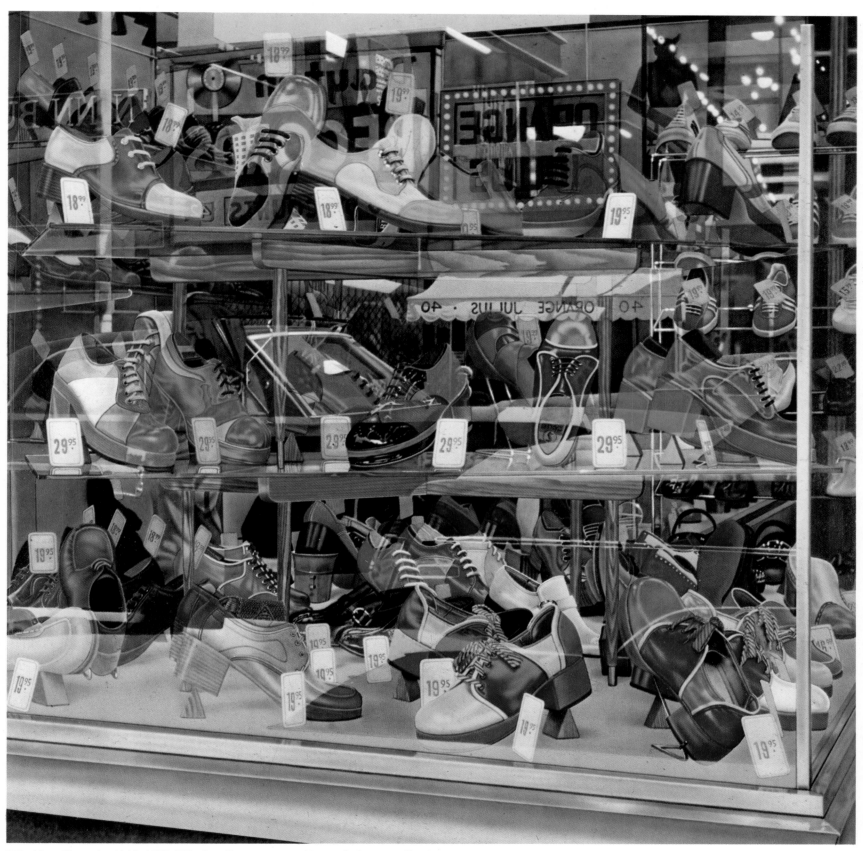

376. *New Shoes for H.M.* 1973 (90). Acrylic on canvas, 48 x 48". Private collection

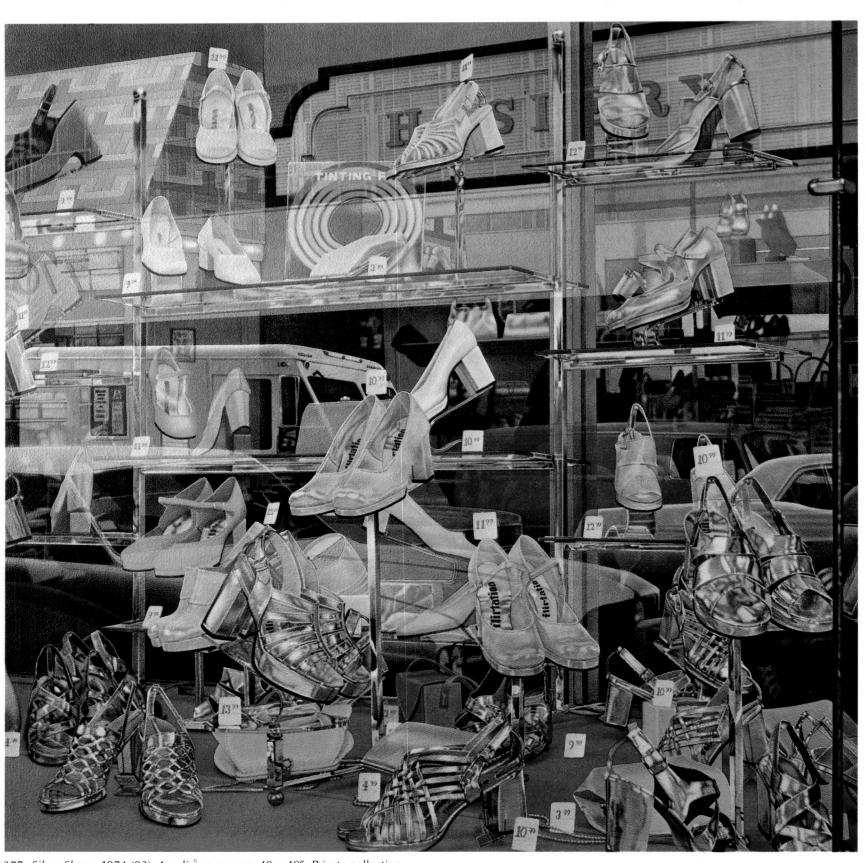

377. *Silver Shoes.* 1974 (93). Acrylic on canvas, 40 x 40". Private collection

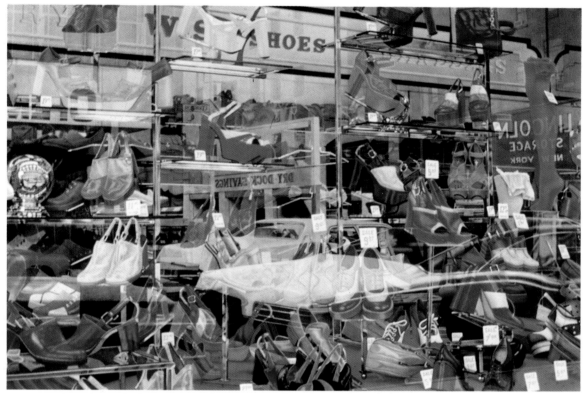

378. *Hosiery, Handbags and Shoes.* 1974 (92). Acrylic on canvas, 40 x 57".
Neue Galerie der Stadt Aachen. Ludwig Collection

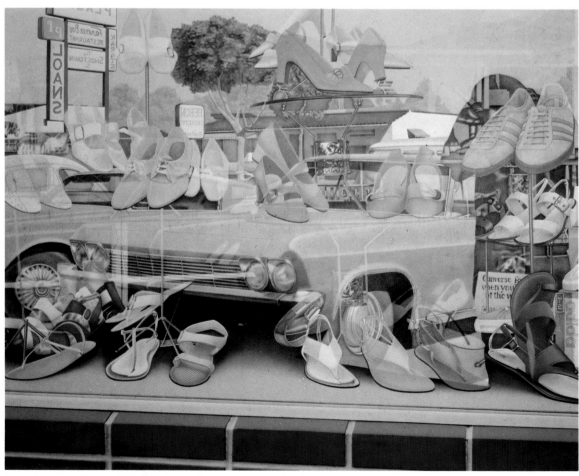

379. *Summer Shoes.* 1972 (82). Acrylic on canvas, 48 x 58".
Private collection

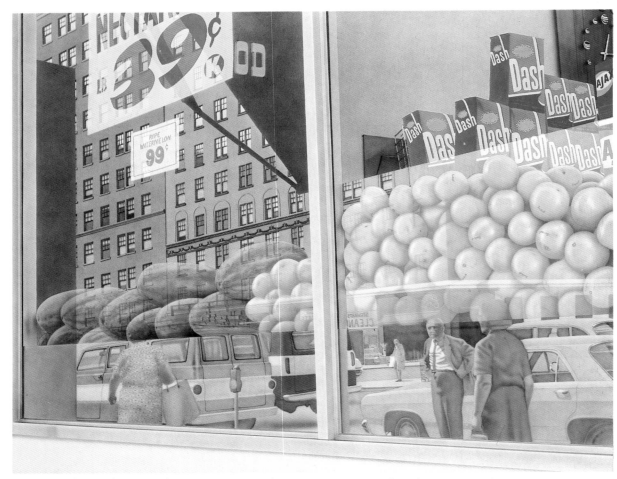

380. *Grapefruit and Watermelon.* 1972 (85). Acrylic on canvas, 48 x 58". Galerie Petit, Paris

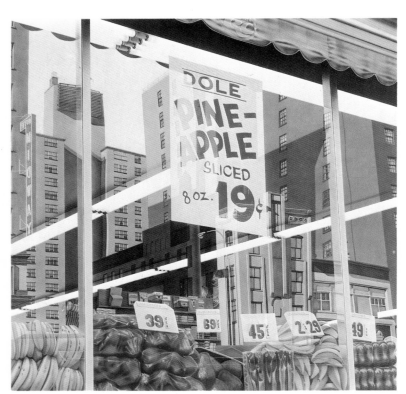

381. *Bananas, Apples, Avocados, Tomatoes.* 1973 (86).
Acrylic on canvas, 50 x 50".
Private collection

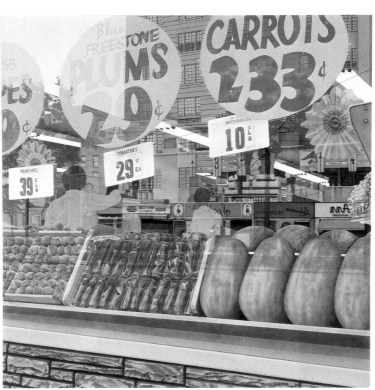

382. *Peaches, Tomatoes and Watermelons.* 1972 (84). Acrylic on canvas, 60 x 60". Museum of Art, Rhode Island School of Design, Providence. Albert Pilavin Memorial Collection of Twentieth-Century Art, June 26, 1973

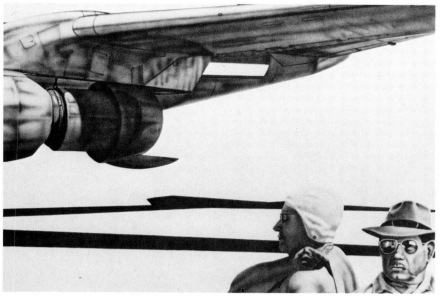

383. *Harold's Folks Took a Trip.* 1969 (2). Acrylic on canvas, 48 x 66".
Collection Fugate Carty, M.D., Hawaii

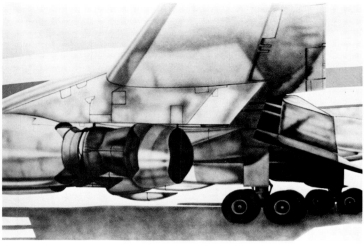

384. *Departure: DC 8 I.* 1969 (3). Acrylic on canvas, 48 x 66".
Private collection

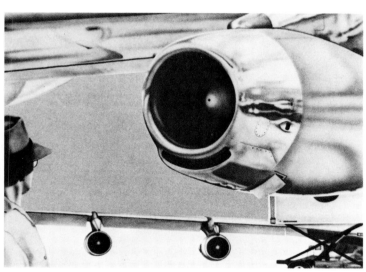

385. *Departure: DC 8 II.* 1969 (4). Acrylic on canvas, 48 x 66".
Private collection

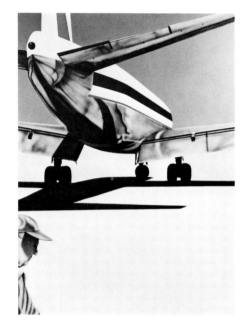

386. *Departure: DC 8 III.* 1969 (5). Acrylic on
canvas, 66 x 48". Baum Collection, Wuppertal,
West Germany

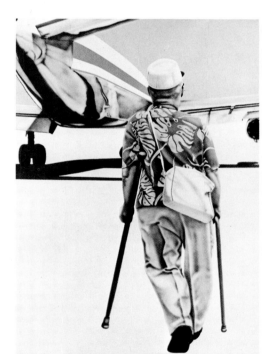

387. *Departure: DC 8 IV.* 1969 (6).
Acrylic on canvas, 66 x 48".
Private collection

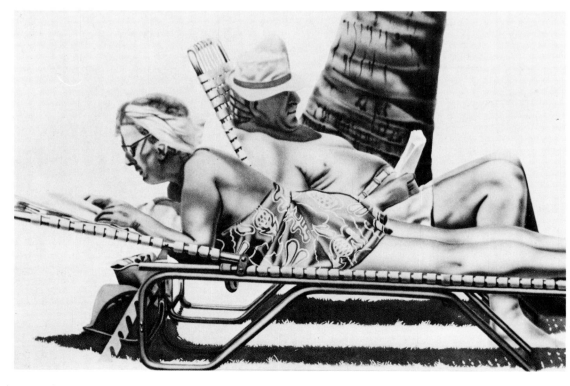

388. *Leonard's `Folks in Waikiki.* 1969 (1).
Acrylic on canvas, 44 x 66".
Collection Irene and Marcus Kutter, Switzerland

389. *Volkswagen R.R.O.* 1970 (39).
Acrylic on canvas, 66 x 48".
Private collection, Chicago

390. *Bus Stop.* 1971 (57).
Acrylic on canvas, 66 x 80".
Galerie Petit, Paris

391. *One Hour Martinizing.* 1972 (81).
Acrylic on canvas, 58 x 48".
Private collection

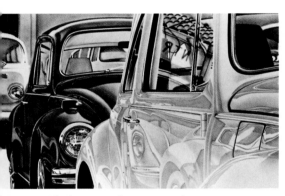

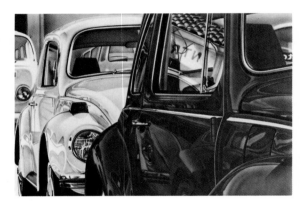

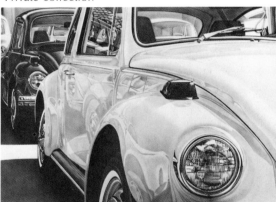

392. *Untitled (Two Volkswagens Close-up).*
1971 (52). Acrylic on canvas, 30 x 44".
Private collection

393. *Untitled (Two Volkswagens: Close-up Reverse).*
1971 (53). Acrylic on canvas, 30 x 44".
Private collection

394. *Untitled (Two Volkswagens).* 1971 (51).
Acrylic on canvas, 48 x 66".
Private collection, New York

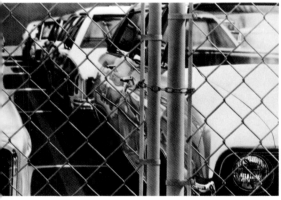

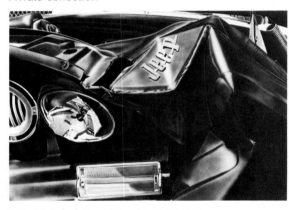

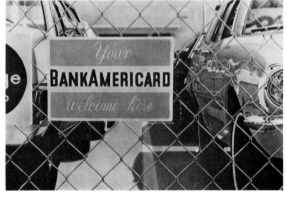

395. *Private Parking V.* 1971 (68).
Acrylic on canvas, 48 x 66".
Oklahoma Art Center, Oklahoma City

396. *Untitled (Jeep Wreck).* 1970 (38).
Acrylic on canvas, 48 x 66".
Collection Amy Yasuna, Mass.

397. *Private Parking VII.* 1971 (70).
Acrylic on canvas, 48 x 66".
Private collection, Paris

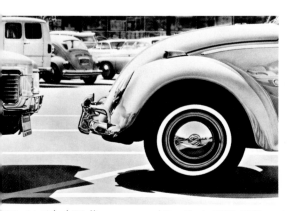

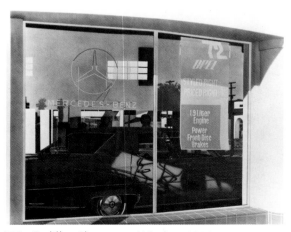

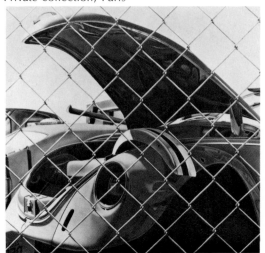

398. *Untitled (Volkswagen and Pontiac).* 1971 (55).
Acrylic on canvas, 48 x 66". Neue Galerie der
Stadt Aachen. Ludwig Collection

399. *Cadillac Showroom Window.* 1972 (78).
Acrylic on canvas, 48 x 60".
Private collection

400. *Wrecking Yard IV.* 1971 (61).
Acrylic on canvas, 48 x 48". Collection
Mr. and Mrs. Jerome Westheimer, Okla.

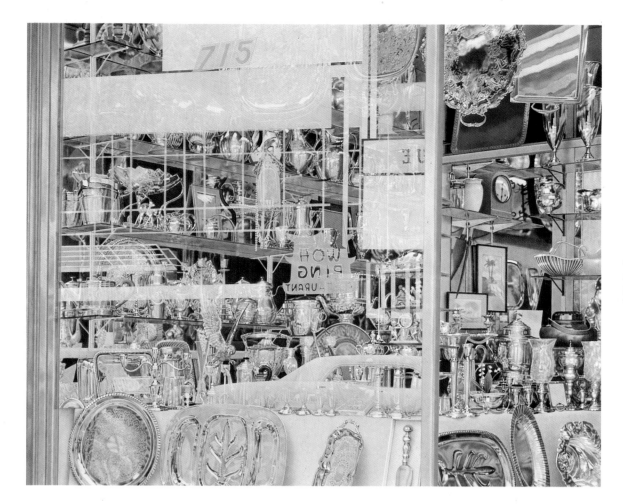

401. *715 Lexington Avenue.* 1974 (95).
Acrylic on canvas, 40 x 48".
Nebraska Art Association.
Thomas C. Woods Collection

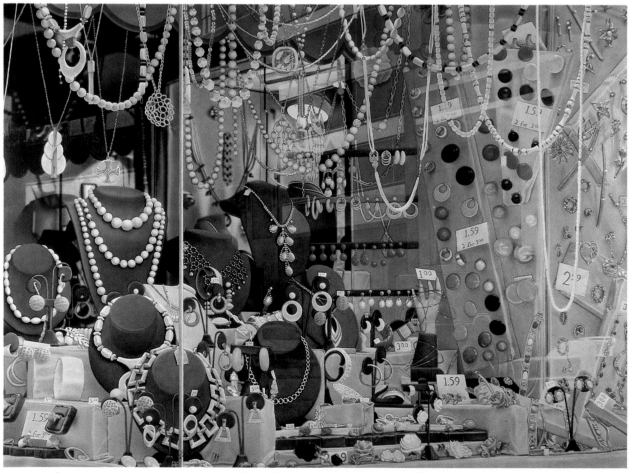

402. *Jewelry.* 1974 (94). Acrylic on canvas, 40 x 52". Toledo Museum of Art, Ohio

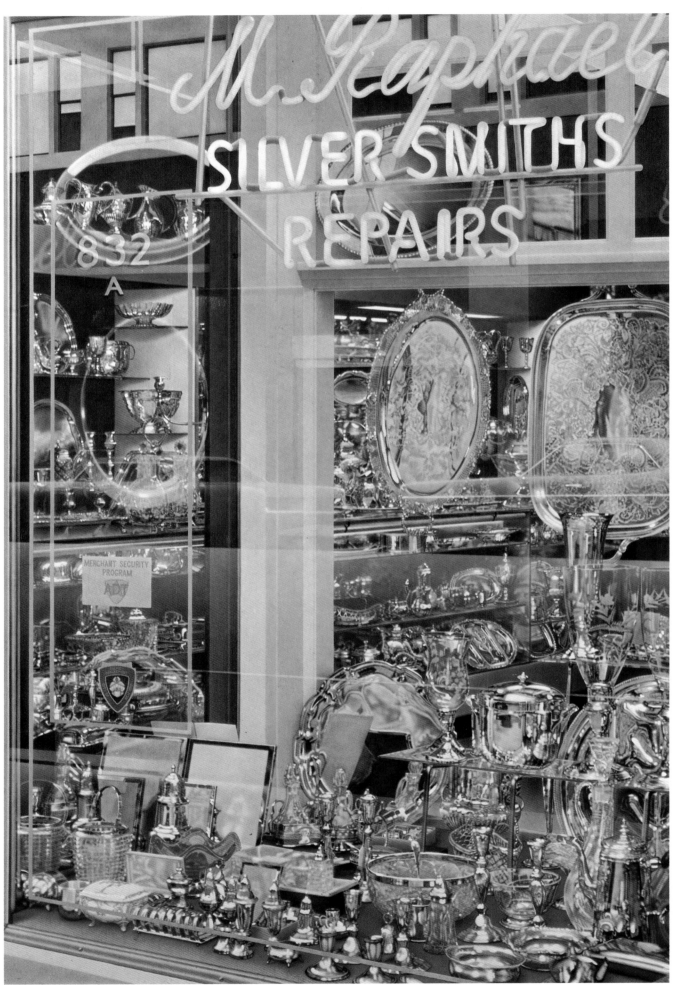

403. *M. Raphael Silverware*. 1975 (97). Acrylic on canvas, 60 x 40". Private collection

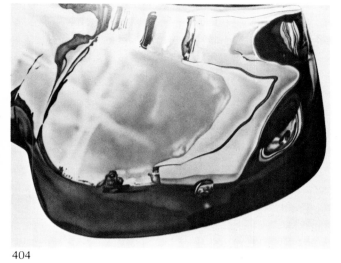
404

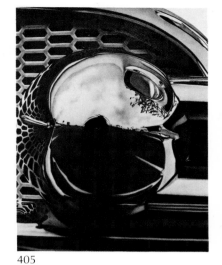
405

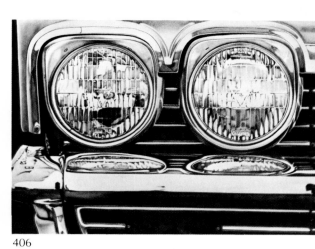
406

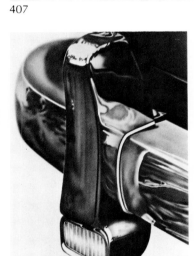
407

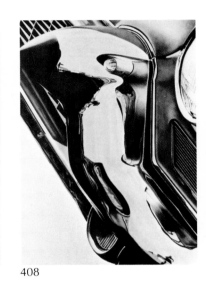
408

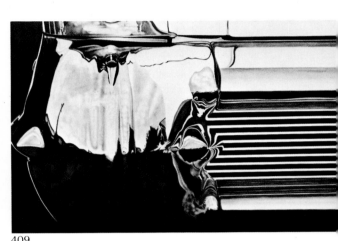
409

410

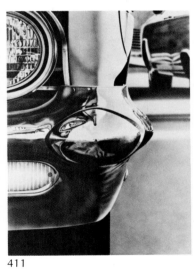
411

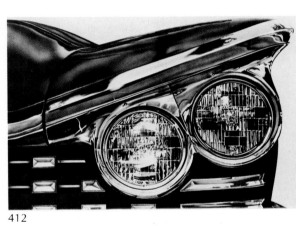
412

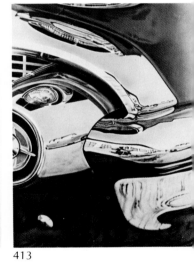
413

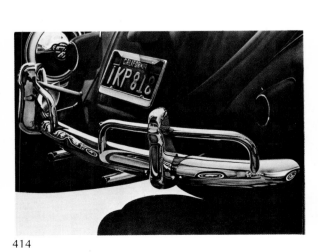
414

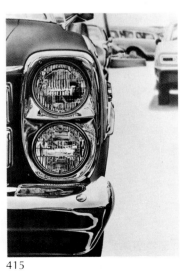
415

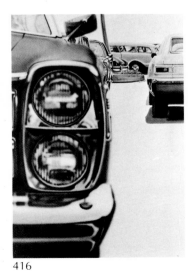
416

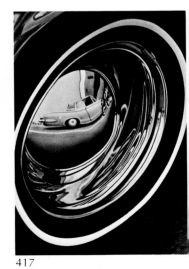
417

198

418

419

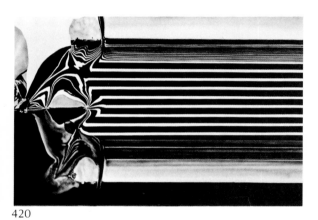

420

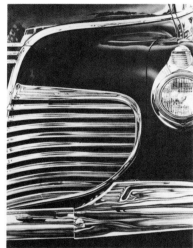

421

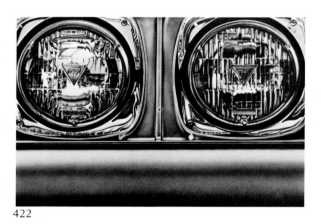

422

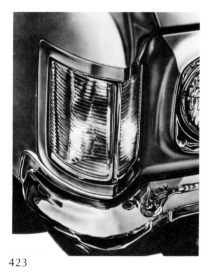

423

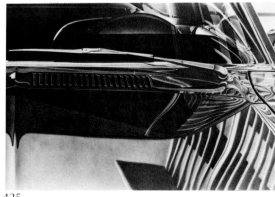

424 425

404. *Bumper Section I*. 1969 (7).
Acrylic on canvas, 36 x 46".
Collection Kenneth Trevey, Los Angeles

405. *Bumper Section IV*. 1970 (10).
Acrylic on canvas, 46 x 36".
Private collection

406. *Bumper Section VI*. 1970 (12).
Acrylic on canvas, 48 x 66".
Private collection

407. *Bumper Section IX*. 1970 (15).
Acrylic on canvas, 48 x 66".
Galerie Thelan, Cologne

408. *Bumper Section X*. 1970 (16).
Acrylic on canvas, 66 x 48".
Private collection

409. *Bumper Section XII*. 1970 (18).
Acrylic on canvas, 48 x 66".
Private collection

410. *Bumper Section XIV*. 1970 (21).
Acrylic on canvas, 32 x 23".
Collection Galerie Isy Brachot, Brussels

411. *Bumper Section XV*. 1970 (22).
Acrylic on canvas, 48 x 34".
Collection Galerie Isy Brachot, Brussels

412. *Bumper Section XVI*. 1970 (23).
Acrylic on canvas, 34 x 48".
Private collection

413. *Bumper Section XVII*. 1970 (24).
Acrylic on canvas, 32 x 23".
Collection Norman Dubrow, New York

414. *Bumper Section XX*. 1970 (27).
Acrylic on canvas, 48 x 66".
Teheran Museum of Contemporary Art

415. *Bumper Section XXII*. 1970 (29).
Acrylic on canvas, 48 x 34".
Private collection, Calif.

416. *Bumper Section XXIII*. 1970 (30).
Acrylic on canvas, 48 x 34".
Private collection

417. *Chrome Wheel and Hubcap I*. 1970 (32).
Acrylic on canvas, 32 x 23".
Collection Myron Eddy, Los Angeles

418. *Bumper Section VII*. 1970 (13).
Acrylic on canvas, 48 x 66".
Private collection

419. *Bumper Section VIII*. 1970 (14).
Acrylic on canvas, 66 x 48".
Teheran Museum of Contemporary Art

420. *Detail of Bumper Section XII*. 1970 (19).
Acrylic on canvas, 34 x 48".
Private collection

421. *Bumper Section XIII*. 1970 (20).
Acrylic on canvas, 66 x 48".
Teheran Museum of Contemporary Art

422. *Bumper Section XVIII*. 1970 (25).
Acrylic on canvas, 23 x 32".
Private collection, Los Angeles

423. *Bumper Section XIX*. 1970 (26).
Acrylic on canvas, 32 x 23".
Private collection

424. *Chrome Wheel and Hubcap II*. 1970 (33).
Acrylic on canvas, 20 x 20".
Collection Galerie Isy Brachot, Brussels

425. *Ford–H & W*. 1970 (37).
Acrylic on canvas, 48 x 66".
Pioneer and Haggin Galleries, Calif.

199

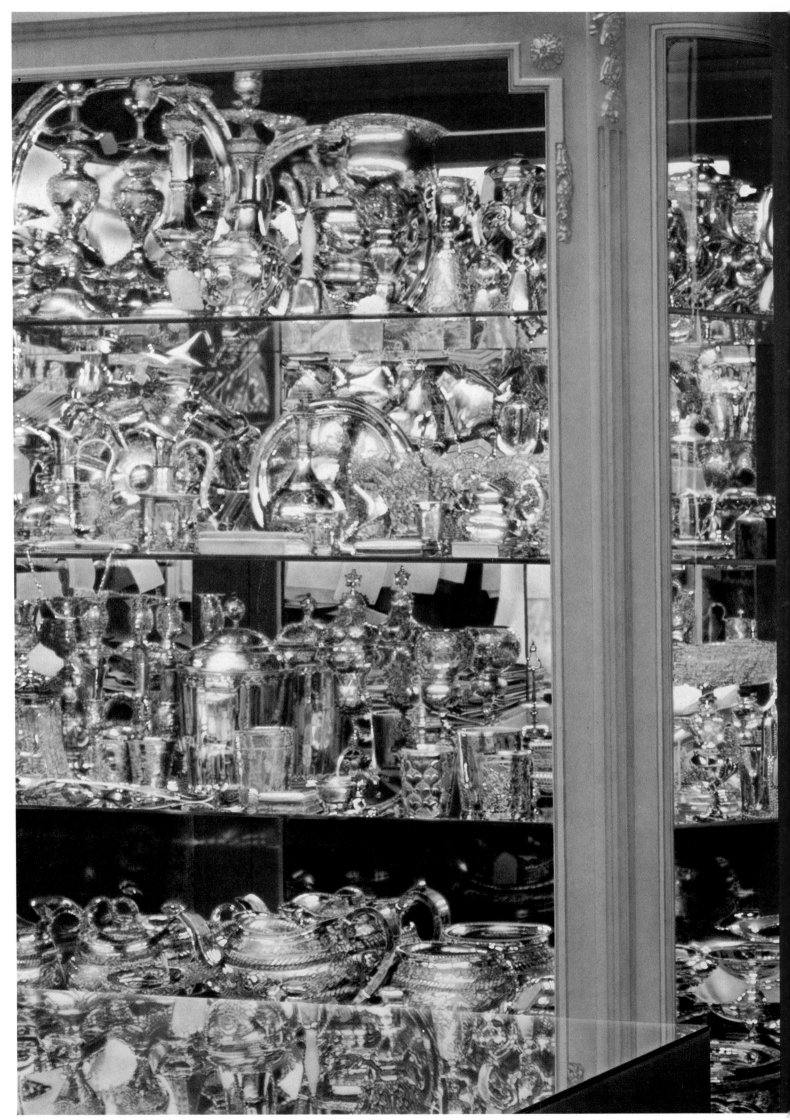

426. *Gorevic Silver I.* 1975–76 (99). Acrylic on canvas, 50 x 70". Private collection

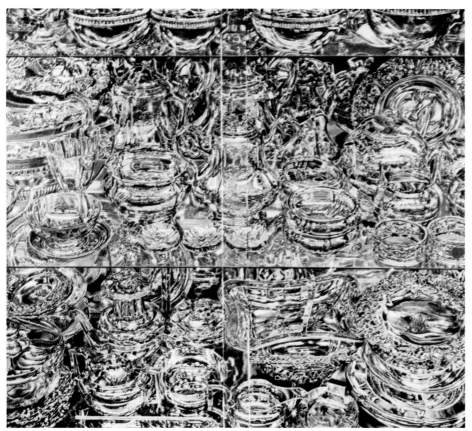

427. *Silverware V for S.* 1977 (104). Acrylic on canvas, 40 x 40". Private collection

428. *Silverware III.* 1976–77 (102). Acrylic on canvas, 24 x 25". Private collection

429. *Silverware IV.* 1977 (103). Acrylic on canvas, 24 x 30". Private collection

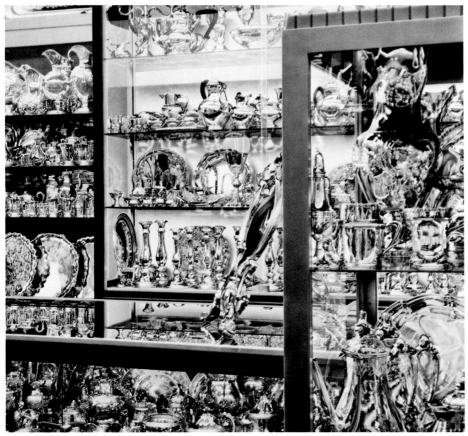

430. *Silverware for S.F.* 1975 (98). Acrylic on canvas, 48 x 48". Private collection

431. *Silverware I.* 1976 (100). Acrylic on canvas, 24¼ x 26". J. B. Speed Art Museum, Ky.

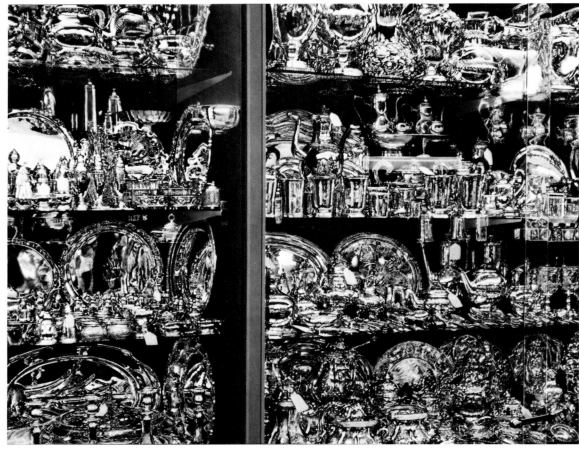

432. *Silverware II.* 1976 (101). Acrylic on canvas, 50 x 63½". Collection Galerie Isy Brachot, Brussels

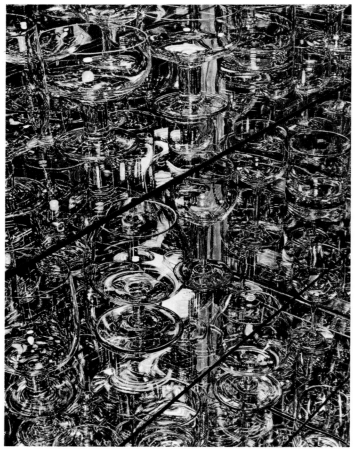

433. *G-I.* 1978 (105). Acrylic on canvas, 52½ x 40".
Private collection

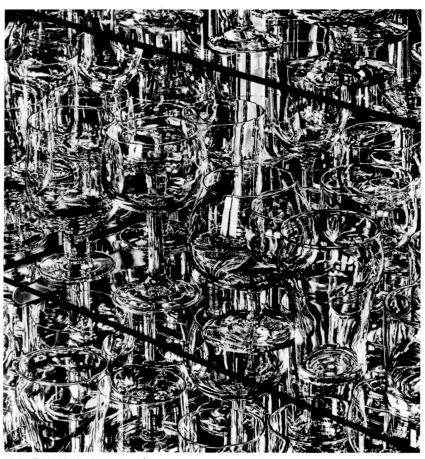

434. *G-II.* 1979 (106). Acrylic on canvas, 44 x 40".
Private collection

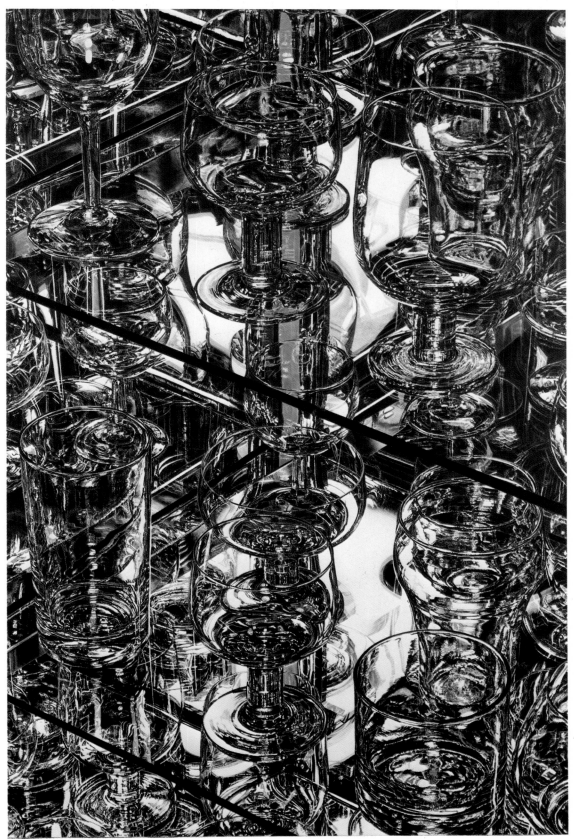

435. *G-III*. 1979 (107). Acrylic on canvas, 73 x 48". Private collection

BIOGRAPHY

1944 Born: Long Beach, Calif.

EDUCATION
1962–63 Fullerton Junior College, Calif.
 1967 B.F.A., University of Hawaii, Honolulu
 1969 M.F.A., University of Hawaii, Honolulu
1969–70 University of California, Santa Barbara

SOLO EXHIBITIONS
1968 Ewing Krainin Gallery, Honolulu
1970 Esther Bear Gallery, Santa Barbara, Calif.
 Galerie M.E. Thelen, Essen, West Germany
 Molly Barnes Gallery, Los Angeles
1971 French and Co., New York
 Molly Barnes Gallery, Los Angeles
1973 Galerie André François Petit, Paris
1974 Nancy Hoffman Gallery, New York
1975 Williams College Museum of Art, Williamstown, Mass.
1976 Art Gallery, Miami-Dade Community College, Miami, Fla.
 Nancy Hoffman Gallery, New York
1979 Nancy Hoffman Gallery, New York

SELECTED GROUP EXHIBITIONS
1970 "Beyond the Actual—Contemporary California Realist Painting,"
 Pioneer Museum and Haggin Galleries, Stockton, Calif.
 "Eighth Annual Southern California Exhibit," Long Beach Museum of
 Art, Calif.
 "West Coast '70," E. B. Crocker Art Gallery, Sacramento, Calif.
1971 "The Ala Story Collection of the Santa Barbara Museum," Santa Barbara
 Museum of Art, Calif.
 "Art Around the Automobile," Emily Lowe Gallery, Hofstra University,
 Hempstead, New York
 "Neue amerikanische Realisten," Galerie de Gestlo, Hamburg
 "New Painting," Santa Barbara Museum of Art, Calif.
 "New Realism," Brainerd Hall Art Gallery, State University College,
 Potsdam, N.Y.
 "Septième Biennale de Paris," Paris
 "Seventy-third Western Annual," Denver Art Museum, Colo.
 "The Shape of Realism," Deson-Zaks Gallery, Chicago
 "Spray," Santa Barbara Museum of Art, Calif.
 "Two Man Show," Aktionsgalerie, Bern
 "Verkehrskultur," Westfälischer Kunstverein, Münster
1972 "Art Around 1970," Neue Galerie der Stadt Aachen, West Germany
 "Documenta and No-Documenta Realists," Galerie de Gestlo,
 Hamburg
 "Documenta 5," Kassel, West Germany
 "L'Hyperréalistes américains," Galerie des Quatre Mouvements, Paris
 "Painting and Sculpture Today, 1972," Indianapolis Museum of Art
 "Phases of the New Realism," Lowe Art Museum, University of Miami,
 Coral Gables, Fla.
 "The Realist Revival," New York Cultural Center, New York
 "Sharp-Focus Realism," Sidney Janis Gallery, New York
 "Thirty-two Realists," Cleveland Institute of Art
1972–73 "Amerikanischer Fotorealismus," Württembergischer Kunstverein,
 Stuttgart; Frankfurter Kunstverein, Frankfurt; Kunst und
 Museumsverein, Wuppertal, West Germany
1973 "Albert Pilavin Collection of 20th Century Art," Museum of Art, Rhode
 Island School of Design, Providence
 "Art Acquisitions 1973," University Art Gallery, University of
 Massachusetts, Amherst
 "California Representation: Eight Painters in Documenta 5," Santa
 Barbara Museum of Art, Calif.
 "East Coast/West Coast/New Realism," San Jose State University, Calif.
 "The Emerging Real," Storm King Art Center, Mountainville, N.Y.
 Galleria Civica d'Arte Moderna, Turin
 "Grands maîtres hyperréalistes américains," Galerie des Quatre
 Mouvements, Paris
 "Hyperréalisme américain," organized by Services Américains
 d'Information et Relations Culturelles, Paris
 "Iperrealisti americani," Galleria La Medusa, Rome

"Mit Kamera, Pinsel und Spritzpistole," Ruhrfestspiele Recklinghausen,
 Städtische Kunsthalle, Recklinghausen, West Germany
"New American Graphic Art," Fogg Art Museum, Harvard University,
 Cambridge, Mass.
"New York Avant Garde," Saidye Bronfman Art Centre, Montreal
"Options 73/30," Contemporary Arts Center, Cincinnati
"Photo-Realism," Serpentine Gallery, London
"The Super-Realist Vision," DeCordova and Dana Museum, Lincoln,
 Mass.
"Young American Artists: Drawings and Graphics," exhibited in
 Denmark, Norway, Sweden, and Germany
1973–74 "Hyperréalisme," Galerie Isy Brachot, Brussels
 1974 "Amerikaans fotorealisme grafiek," Hedendaagse Kunst, Utrecht; Palais
 des Beaux-Arts, Brussels
 "Ars '74 Ateneum," Fine Arts Academy of Finland, Helsinki
 "Art 5 '74," Basel, Switzerland
 "Collector's Choice," Elvehjem Art Center, University of Wisconsin,
 Madison
 "Contemporary American Artists," Cleveland Museum of Art
 "Contemporary American Painting and Sculpture, 1974," Krannert Art
 Museum, University of Illinois, Champaign-Urbana
 "Hyperréalistes américains—réalistes européens," Centre National
 d'Art Contemporain, Paris
 "Kijken naar de werkelijkheid," Museum Boymans–van Beuningen,
 Rotterdam
 Moos Gallery, Montreal
 Moos Gallery, Toronto
 "New Editions," Claremont College, Claremont, Calif.
 "New Photo-Realism," Wadsworth Atheneum, Hartford, Conn.
 "New Realism Revisited," Brainerd Hall Art Gallery, State University
 College, Potsdam, N.Y.
 "Selections in Contemporary Realism," Akron Art Institute; The New
 Gallery, Cleveland
 "Tokyo Biennale, '74," Tokyo Metropolitan Museum of Art; Kyoto
 Municipal Museum; Aichi Prefectural Art Museum, Nagoya
 1975 "Image, Color and Form—Recent Paintings by Eleven Americans,"
 Toledo Museum of Art, Ohio
 "New Acquisitions," Cleveland Museum of Art
 "Photo-Realists," Louis K. Meisel Gallery, New York
 "Realismus und Realität," Kunsthalle, Darmstadt, West Germany
 "Realist Artists," William Paterson College, Wayne, N.J.
1975–76 "Photo-Realism, American Painting and Prints," New Zealand traveling
 exhibition: Barrington Gallery, Auckland; Robert McDougall Art
 Gallery, Christchurch; Academy of Fine Arts, National Art Gallery,
 Wellington; Dunedin Public Art Gallery, Dunedin; Govett-Brewster
 Art Gallery, New Plymouth; Waikato Art Museum, Hamilton
 "Super-Realism," Baltimore Museum of Art
 1976 "Art 7 '76," Basel, Switzerland
 "Aspects of Realism from the Nancy Hoffman Gallery," Art Gallery,
 University of Notre Dame, Ind.
 "Drawings," DM Gallery, London
 "Materials and Techniques of 20th Century Art," Cleveland
 Museum of Art
 "Panorama of American Art," Everson Museum, Syracuse, N.Y.
 "Troisième foire internationale d'art contemporain," Grand Palais,
 Paris
1976–77 "Photo-Realism in Painting," Art and Culture Center, Hollywood, Fla.;
 Museum of Fine Arts, St. Petersburg, Fla.
1976–78 "Aspects of Realism," traveling exhibition sponsored by Rothman's
 of Pall Mall Canada, Ltd.: Stratford, Ont.; Centennial Museum,
 Vancouver, B.C.; Glenbow-Alberta Institute, Calgary, Alta.;
 Mendel Art Gallery, Saskatoon, Sask.; Winnipeg Art Gallery, Man.;
 Edmonton Art Gallery, Alta.; Art Gallery, Memorial University of
 Newfoundland, St. John's; Confederation Art Gallery and Museum,
 Charlottetown, P.E.I.; Musée d'Art Contemporain, Montreal, Que.;
 Dalhousie University Museum and Gallery, Halifax, N.S.; Windsor
 Art Gallery, Ont.; London Public Library and Art Museum and
 McIntosh Memorial Art Gallery, University of Western Ontario; Art
 Gallery of Hamilton, Ont.
 1977 "Documenta 6," Kassel, West Germany

"New in the '70's," University Art Museum, Archer M. Huntington
Gallery, University of Texas, Austin
"New Realism," Jacksonville Art Museum, Fla.
"Painting 75–76–77," Art Gallery, Sarah Lawrence College, Bronxville,
N.Y.
"Photo-Images," Dayton Art Institute, Ohio
"Works on Paper II," Louis K. Meisel Gallery, New York
1977–78 "Illusion and Reality," Australian touring exhibition: Australian
National Gallery, Canberra; Western Australian Art Gallery, Perth;
Queensland Art Gallery, Brisbane; Art Gallery of New South Wales,
Sydney; Art Gallery of South Australia, Adelaide; National Gallery
of Victoria, Melbourne; Tasmanian Museum and Art Gallery, Hobart
1978 "Art and the Automobile," Flint Institute of Arts, Mich.
"Cityscape '78," Oklahoma Art Center, Oklahoma City
"Leading Realists and Current Abstract Art," Morris Gallery, Madison,
N.J.
Monmouth Museum, Lincroft, N.J.
"Photo-Realist Printmaking," Louis K. Meisel Gallery, New York

"Realist Painters," Museum of Fine Arts, St. Petersburg, Fla.; Herbert F.
Johnson Museum of Art, Cornell University, Ithaca, N.Y.
"Recent Works on Paper by Contemporary American Artists," Madison
Art Center, Wis.
"Things Seen: The Concept of Realism in the 20th Century," Sheldon
Memorial Art Gallery, Kansas City, Mo.
1979 "America in the 70s As Depicted by Artists in the Richard Brown
Baker Collection," Meadowbrook Art Gallery, Oakland
University, Rochester, Mich.
"Auto-Icons," Whitney Museum of American Art, Downtown
Branch, New York
Brookhaven National Laboratory, Upton, N.Y.
"Photo-Realism: Some Points of View," Jorgensen Gallery,
University of Connecticut, Storrs
"Selections of Photo-Realist Paintings from N.Y.C. Galleries,"
Southern Alleghenies Museum of Art, St. Francis College,
Loretto, Pa.

SELECTED BIBLIOGRAPHY

CATALOGUES
Shipley, James R., and Weller, Allen S. Introduction to *Contemporary
American Painting and Sculpture 1969.* Krannert Art Museum, University of
Illinois, Champaign-Urbana, Mar. 2–Apr. 6, 1969.
Brewer, Donald. Introduction to *Beyond the Actual—Contemporary California
Realist Painting.* Pioneer Museum and Haggin Galleries, Stockton, Calif.,
Nov. 6–Dec. 6, 1970.
West Coast 1970: Crocker Biennial. E. B. Crocker Gallery, Sacramento, Calif.,
1970.
Wong, James D. Introduction to *8th Annual Southern California Exhibit.* Long
Beach Museum of Art, Calif., Apr. 19–May 17, 1970.
Art Around the Automobile. Emily Lowe Gallery, Hofstra University, New
York, June–Aug., 1971.
Goldsmith, Benedict. *New Realism.* Brainerd Hall Art Gallery, State University
College, Potsdam, N.Y., Nov. 5–Dec. 12, 1971.
Internationale Kunst U. Informationsmesse. Belgisches Haus Volkshochschule,
Cologne, Oct. 5–10, 1971.
Mills, Paul C. Introduction to *The Ala Story Collection of the Santa Barbara
Museum of Art.* Santa Barbara Museum of Art, Calif., June 6–July 5, 1971.
———. Introduction to *Spray.* Santa Barbara Museum of Art, Calif.,
Apr. 24–May 30, 1971.
Septième Biennale de Paris, no. 7. Paris, 1971.
Story, Lewis W. *73d Western Annual.* Denver Art Museum, Colo., 1971.
Abadie, Daniel. Introduction to *Hyperréalistes américains.* Galerie des Quatre
Mouvements, Paris, Oct. 25–Nov. 25, 1972.
Amman, Jean Christophe. Introduction to *Documenta 5.* Neue Galerie and
Museum Fridericianum, Kassel, West Germany, June 30–Oct. 8, 1972.
Art Around 1970. Neue Galerie der Stadt Aachen, West Germany, 1972.
Baratte, John J., and Thompson, Paul E. *Phases of the New Realism.* Lowe Art
Museum, University of Miami, Coral Gables, Fla., Jan. 20–Feb. 20, 1972.
Janis, Sidney. Introduction to *Sharp Focus Realism.* Sidney Janis Gallery, New
York, Jan. 6–Feb. 4, 1972.
Warrum, Richard L. Introduction to *Painting and Sculpture Today, 1972.*
Indianapolis Museum of Art, Apr. 26–June 4, 1972.
Burton, Scott. *The Realist Revival.* New York Cultural Center, New York,
Dec. 6, 1972–Jan. 7, 1973.
Schneede, Uwe, and Hoffman, Heinz. Introduction to *Amerikanischer
Fotorealismus.* Württembergischer Kunstverein, Stuttgart, Nov. 16–Dec. 26,
1972; Frankfurter Kunstverein, Frankfurt, Jan. 6–Feb. 18, 1973; Kunst und
Museumsverein, Wuppertal, West Germany, Feb. 25–April 8, 1973.
Abadie, Daniel. *Don Eddy.* Foreword by John H. Neff. Galerie André François
Petit, Paris, Apr., 1973.
Albert Pilavin Collection of 20th Century Art. Museum of Art, Rhode Island
School of Design, Providence, Oct., 1973.
Alloway, Lawrence. Introduction to *Photo-Realism.* Serpentine Gallery,

London, Apr. 4–May 6, 1973.
Becker, Wolfgang. Introduction to *Mit Kamera, Pinsel und Spritzpistole.*
Ruhrfestspiele Recklinghausen, Städtische Kunsthalle, Recklinghausen,
West Germany, May 4–June 17, 1973.
Boulton, Jack. Introduction to *Options 73/30.* Contemporary Arts Center,
Cincinnati, Sept. 25–Nov. 11, 1973.
C. A. B. S. Introduction to *Realisti iperrealisti.* Galleria La Medusa, Rome,
Nov. 12, 1973.
Combattimento per un'immagine. Galleria Civica d'Arte Moderna, Turin,
Mar. 4, 1973.
Dali, Salvador. Introduction to *Grands mâitres hyperréalistes américains,*
Galerie des Quatre Mouvements, Paris, May 23–June 25, 1973.
Hogan, Carroll Edwards. Introduction to *Hyperréalistes américains.* Galerie
Arditti, Paris, Oct. 16–Nov. 30, 1973.
Iperrealisti americani. Galleria La Medusa, Rome, Jan. 2, 1973.
Lamagna, Carlo. Foreword to *The Super Realist Vision.* DeCordova and Dana
Museum, Lincoln, Mass., Oct. 7–Dec. 9, 1973.
Laursen, Steigrim. Introduction to *Young American Artists.* Radhus (City Hall),
Gentofte, Denmark, Jan.–Oct., 1973.
New American Graphic Art. Fogg Art Museum, Harvard University,
Cambridge, Mass., Sept.–Oct., 1973.
Radde, Bruce. Introduction to *East Coast/West Coast/New Realism.* University
Art Gallery, San Jose State University, Calif., Apr. 24–May 18, 1973.
Sims, Patterson. Introduction to *Realism Now.* Katonah Gallery, Katonah, N.Y.,
May 20–June 24, 1973.
Art Acquisitions 1973. University Art Gallery, University of Massachusetts,
Amherst, Jan. 31, 1973–Feb. 22, 1974.
Becker, Wolfgang. Introduction to *Kunst nach Wirklichkeit.* Kunstverein
Hannover, West Germany, Dec. 9, 1973–Jan. 27, 1974.
Hinson, Tom. Introduction to *Contemporary American Artists.* Cleveland
Museum of Art, Dec., 1973–Feb., 1974.
Hyperréalisme. Galerie Isy Brachot, Brussels, Dec. 14, 1973–Feb. 9, 1974.
Tucker, Marcia, and Dyens, Georges. Introduction to *New York Avant Garde
'74.* Saidye Bronfman Centre, Montreal, Nov. 27, 1973–Jan. 3, 1974.
Amerikaans fotorealisme grafiek. Hedendaagse Kunst, Utrecht, Aug., 1974;
Palais des Beaux-Arts, Brussels, Sept.–Oct., 1974.
Aspects of Realism. Gallery Moos Ltd., Toronto, Sept.–Oct., 1974.
Chase, Linda. "Photo-Realism." In *Tokyo Biennale 1974.* Tokyo Metropolitan
Museum of Art; Kyoto Municipal Museum; Aichi Prefectural Art Museum,
Nagoya, 1974.
Clair, Jean; Abadie, Daniel; Becker, Wolfgang; and Restany, Pierre.
Introductions to *Hyperréalistes américains—réalistes européens.* Centre
National d'Art Contemporain, Paris, Archives 11/12, Feb. 15–Mar. 31, 1974.
Cowart, Jack. *New Photo-Realism.* Wadsworth Atheneum, Hartford, Conn.,
Apr. 10–May 19, 1974.

Doty, Robert. Introduction to *Selections in Contemporary Realism*. Akron Art Institute, Sept. 20–Oct. 19, 1974; The New Gallery, Cleveland, Sept. 20–Oct. 19, 1974.

Goldsmith, Benedict. *New Realism Revisited*. Brainerd Hall Art Gallery, State University College, Potsdam, N.Y., 1974.

Kijken naar de werkelijkheid. Museum Boymans–van Beuningen, Rotterdam, June 1–Aug. 18, 1974.

Sarajas-Korte, Salme. Introduction to *Ars '74 Ateneum*. Fine Arts Academy of Finland, Helsinki, Feb. 15–Mar. 31, 1974.

Shipley, James R., and Weller, Allen S. Introduction to *Contemporary American Painting and Sculpture 1974*. Krannert Art Museum, University of Illinois, Champaign-Urbana, Mar. 10–Apr. 21, 1974.

Walthard, Dr. Frederic P. Foreword to *Art 5 '74*. Basel, Switzerland, June 19–24, 1974.

Warrum, Richard L. Introduction to *Painting and Sculpture Today, 1974*. Indianapolis Museum of Art, May 22–June 14, 1974; Taft Museum and Contemporary Arts Center, Cincinnati, Sept. 12–Oct. 26, 1974.

Krimmel, Bernd. Introduction to *Realismus und Realität*. Foreword by H. W. Sabais. Kunsthalle, Darmstadt, West Germany, May 24–July 6, 1975.

Meisel, Susan Pear. *Watercolors and Drawings—American Realists*. Louis K. Meisel Gallery, New York, Jan., 1975.

Phillips, Robert F. Introduction to *Image, Color and Form: Recent Paintings by Eleven Americans*. Toledo Museum of Art, Ohio, Jan. 12–Feb. 9, 1975.

Richardson, Brenda. Introduction to *Super Realism*. Baltimore Museum of Art, Nov. 18, 1975–Jan. 11, 1976.

Gervais, Daniel. Introduction to *Troisième foire internationale d'art contemporain*. Grand Palais, Paris, Oct. 16–24, 1976.

Walthard, Dr. Frederic P. Introduction to *Art 7 '76*. Basel, Switzerland, June 16–21, 1976.

Hicken, Russell Bradford. Introduction to *Photo-Realism in Painting*. Art and Culture Center, Hollywood, Fla., Dec. 3, 1976–Jan. 10, 1977; Museum of Fine Arts, St. Petersburg, Fla., Jan. 21–Feb. 25, 1977.

Chase, Linda. "U.S.A." In *Aspects of Realism*. Rothman's of Pall Mall Canada, Ltd., June, 1976–Jan., 1978.

Dempsey, Bruce. *New Realism*. Jacksonville Art Museum, Fla., 1977.

Documenta 6. Kassel, West Germany, 1977.

Seabolt, Fred. Introduction to *New in the '70s*. Foreword by Donald Goodall. University Art Museum, Archer M. Huntington Gallery, University of Texas, Austin, Aug. 21–Sept. 25, 1977.

Stringer, John. Introduction to *Illusion and Reality*. Australian Gallery Directors' Council, North Sydney, N.S.W., 1977–78.

Adams, Lowell. Foreword to *Cityscape '78*. Oklahoma Art Center, Oklahoma City, Oct. 27–Nov. 29, 1978.

Hodge, G. Stuart. Foreword to *Art and the Automobile*. Flint Institute of Arts, Mich., Jan. 12–Mar. 12, 1978.

Meisel, Susan Pear. Introduction to *The Complete Guide to Photo-Realist Printmaking*. Louis K. Meisel Gallery, New York, Dec., 1978.

Gerling, Steve. Introduction to *Photo-Realism: Some Points of View*. Jorgensen Gallery, University of Connecticut, Storrs, Mar. 19–Apr. 10, 1979.

Stokes, Charlotte. "As Artists See It: America in the 70s." In *America in the 70s As Depicted by Artists in the Richard Brown Baker Collection*. Meadowbrook Art Gallery, Oakland University, Rochester, Mich., Nov. 18–Dec. 16, 1979.

Streuber, Michael. Introduction to *Selections of Photo-Realist Paintings from N.Y.C. Galleries*. Southern Alleghenies Museum of Art, St. Francis College, Loretto, Pa., May 12–July 8, 1979.

ARTICLES

Alloway, Lawrence. "In the Museums: Paintings from the Photo," *Arts*, Dec. 1, 1970.

Frankenstein, Alfred. "Beyond the Actual Exhibition," *San Francisco Chronicle*, Nov. 30, 1970, p. 43.

Good, Jeanne. "Review," *Los Angeles Herald/Examiner*, Mar. 6, 1970.

"Review," *Artforum*, May, 1970.

"Review," *ARTNews*, May, 1970.

Seldis, Henry. "Review," *Los Angeles Times*, Feb. 20, 1970.

Kingsley, April. "Los Angeles," *Art Gallery Magazine*, June, 1971.

"Review," *Arts Magazine*, Sept.–Oct., 1971.

Sager, Peter. "Neue Formen des Realismus," *Magazin Kunst*, 4th Quarter, 1971, pp. 2512–16.

Amman, Jean Christophe. "Realismus," *Flash Art*, May–July, 1972, pp. 50–52.

"Auto Pop ou Pop Auto?," *Lui*, Dec., 1972.

Baker, Kenneth. "Don Eddy," *Artforum*, Mar., 1972, p. 88.

Chase, Linda; Foote, Nancy; and McBurnett, Ted. "The Photo-Realists: 12 Interviews," *Art in America*, vol. 60, no. 6 (Nov.–Dec., 1972), pp. 73–89.

"Die Documenta bestätigte sein Programm," *Hansestadt Hamburg die Welt* (Hamburg), no. 180 (Aug. 5, 1972).

Documenta 5 in Kassel, no. 148 (June 30, 1972).

"Documenta Issue," *Zeit Magazin*, no. 31/4 (Aug., 1972), pp. 4–15.

Grellis, Charles. "Art Around the Automobile," *Road and Track*, 1972.

Hickey, David. "Previews," *Art in America*, Jan.–Feb., 1972, pp. 37–38.

———. "Sharp Focus Realism," *Art in America*, Mar.–Apr., 1972, pp. 116–18.

"Les hommes et les oeuvres," *La Galerie*, no. 120 (Oct., 1972), pp. 16–17.

"Hyperréalisme arrive à Paris," *Argus de la Presse*, Nov., 1972.

"Hyperréalisme ou le retour aux origines," *Argus de la Presse*, Oct. 16, 1972.

"Hyperréalistes américains," *Argus de la Presse*, Nov. 16, 1972.

Karp, Ivan. "Rent Is the Only Reality, or the Hotel Instead of the Hymn," *Arts Magazine*, Dec., 1972, pp. 47–51.

"Die Kasseler Seh-Schule," *Stern Magazin*, no. 36 (Aug., 1972), pp. 20–23.

Kirkwood, Marie. "Art Institute's Exhibit Represents the Revolt Against Abstraction," *Ohio Sun Press*, Oct. 12, 1972.

Kramer, Hilton. "And Now, Pop Art: Phase II," *New York Times*, Jan. 16, 1972.

Kurtz, Bruce. "Documenta 5: A Critical Preview," *Arts Magazine*, Summer, 1972, pp. 34–41.

Lerman, Leo. "Sharp Focus Realism," *Mademoiselle*, Mar., 1972, pp. 170–73.

Levequi, J. J. "Les hommes et les oeuvres," *Argus de la Presse*, Oct., 1972.

Lista, Giovanni. "Iperrealisti americani," *NAC* (Milan), no. 12 (Dec., 1972), pp. 24–25.

"Les malheurs de l'Amérique," *Le Nouvel Observateur*, Nov. 6, 1972.

Marvel, Bill. "Saggy Nudes? Giant Heads? Make Way for 'Superrealism,' " *National Observer*, Jan. 29, 1972, p. 22.

"La nouvelle coqueluche: l'hyperréalisme," *L'Express*, Oct. 30, 1972.

"Novedades desde Paris," *El Dia*, Dec. 17, 1972.

Pozzi, Lucio. "Super Realisti U.S.A.," *Bolaffiarte*, no. 18 (Mar., 1972), pp. 54–63.

Ratcliff, Carter. "New York Letter," *Art International*, vol. XVI, no. 3 (Mar., 1972), pp. 28–29.

"Review," *ARTnews*, Jan., 1972.

Rosenberg, Harold. "The Art World," *The New Yorker*, Feb. 5, 1972, pp. 88–93.

Seitz, William C. "The Real and the Artificial: Painting of the New Environment," *Art in America*, Nov.–Dec., 1972, pp. 58–72.

Seldis, Henry J. "Documenta: Art Is Whatever Goes on in Artist's Head," *Los Angeles Times Calendar*, July 9, 1972.

Thornton, Gene. "These Must Have Been a Labor of Love," *New York Times*, Jan. 23, 1972.

Wasmuth, E. "La révolte des réalistes," *Connaissance des Arts*, June, 1972, pp. 118–23.

Wolmer, Denise. "In the Galleries," *Arts Magazine*, Mar., 1972, p. 57.

Apuleo, Vito. "Tra manifesto e illustrazione sino al rifiuto della scelta," *La Voce Repubblicana*, Feb. 24, 1973, p. 5.

"Arts: les expositions à New York," *Argus de la Presse*, Jan. 4, 1973.

Becker, Wolfgang. "NY? Realisme?," *Louisiana Revy*, vol. 13, no. 3 (Feb., 1973).

Borden, Lizzie. "Reviews," *Artforum*, Oct., 1973.

Bovi, Arturo di. "Arte/Più brutto del brutto," *Il Messaggiero*, Feb. 13, 1973, p. 3.

"Ceux qui peignent comme des photographs . . . ," *Paris Match*, Oct., 1973.

Chase, Linda. "Recycling Reality," *Art Gallery Magazine*, Oct., 1973, pp. 75–82.

Chase, Linda, and McBurnett, Ted. "Interviews with Robert Bechtle, Tom Blackwell, Chuck Close, Richard Estes and John Salt," *Opus International*, no. 44–45 (June, 1973), pp. 38–50.

"Don Eddy," *Art International*, Dec. 20, 1973.

E. D. G. "Arrivano gli iperrealisti," *Tribuna Letteraria*, Feb., 1973.

"European Galleries," *International Herald Tribune*, Feb. 17–18, 1973, p. 6.

Giannattasio, Sandra. "Riproduce la vita di ogni giorno la nuova pittura americano," *Avanti*, Feb. 8, 1973, p. 1.

Gilmour, Pat. "Photo-Realism," *Arts Review*, vol. 25 (Apr. 21, 1973), p. 249.

Gosling, Nigel. "The Photo Finish," *Observer Review* (London), Apr. 8, 1973.

Guercio, Antonio del. "Iperrealismo tra 'pop' e informale,' *Rinascita*, no. 8 (Feb. 23, 1973), p. 34.

Henry, Gerrit. "A Realist Twin Bill," *ARTnews*, Jan., 1973, pp. 26–28.

Hjort, Oysten. "Kunstmiljoeti Rhinlandet," *Louisiana Revy*, vol. 13, no. 3 (Feb., 1973).

"Late Night Window Shoppers," *Providence Journal*, Oct. 22, 1973.

"L'hyperréalisme américain," *Le Monde des Grandes Musiques*, no. 2 (Mar.–Apr., 1973), pp. 4, 56–57.

Maraini, Letizia. "Non fatevi sfuggire," *Il Globo*, Feb. 6, 1973, p. 8.

Marziano, Luciano. "Iperrealismo: La coagulazione dell'effimero," *Il Margutta* (Rome), no. 3–4 (Mar.–Apr., 1973).

Melville, Robert. "The Photograph as Subject," *Architectural Review*, vol. CLIII, no. 915 (May, 1973), pp. 329–33.

Micacchi, Dario. "La ricerca degli iperrealisti," *Unità*, Feb. 12, 1973.

Mizue (Tokyo), vol. 8, no. 821 (1973).

Moulin, Raoul-Jean. "Hyperréalistes américains," *L'Humanité*, Jan. 16, 1973.

"Noel Mahaffey," *Arts Magazine*, Feb., 1973.

Restany, Pierre. "Sharp Focus: La continuité réaliste d'une vision américaine," *Domus*, Aug., 1973.

Rubiu, Vittorio. "Il gusto controverso degli iperrealisti," *Corriere della Sera*, Feb. 25, 1973.

Seldis, Henry J. "New Realism: Crisp Focus on the American Scene," *Los Angeles Times*, Jan. 21, 1973, p. 54.

Swan, Bradford. "Pilavin Collection on Exhibit," *Providence Sunday Journal*, Oct. 21, 1973.

Trucchi, Lorenza di. "Iperrealisti americani alla Medusa," *Momento-sera*, Feb. 9–10, 1973, p. 8.

Chase, Linda. "The Connotation of Denotation," *Arts Magazine*, Feb., 1974, pp. 38–41.

Deroudille, René. "Réalistes et hyperréalistes," *Derrière Heure Lyonnaise*, Mar. 31, 1974.

"Don Eddy," *ARTnews*, Apr., 1974.

"Don Eddy," *Goya*, no. 119 (Mar.–Apr., 1974).

"Don Eddy," *Village Voice*, Feb. 29, 1974.

"Expositions," *Argus de la Presse*, Mar., 1974.

Frank, Peter. "Review," *Soho Weekly News*, Mar. 14, 1974.

Gibson, Michael. "Paris Show Asks a Question: What Is Reality?," *International Herald Tribune*, Feb. 23–24, 1974, p. 7.

Hughes, Robert. "An Omnivorous and Literal Dependence," *Arts Magazine*, June, 1974, pp. 25–29.

Kay, Jane Holtz. "There Was an Old Woman Who Lived in a Shoe," *Christian Science Monitor*, Feb. 7, 1974.

Lascault, Gilbert. "Autour de ce qui se nomme hyperréalisme," *Paris-Normandie*, Mar. 31, 1974.

Leogrande, Ernest. "Village Eye," *Our Town*, vol. 1, no. 43 (Feb. 22, 1974), p. 9.

Loring, John. "Photographic Illusionist Prints," *Arts Magazine*, Feb., 1974, pp. 42–43.

Lubell, Ellen. "Noel Mahaffey," *Arts Magazine*, June, 1974, p. 62.

McCue, George. "Reality and Dislocation in Big Illinois Show," *St. Louis Post-Dispatch*, Mar. 24, 1974.

Michael, Jacques. "La 'mondialisation' de l'hyperréalisme," *Le Monde*, Feb. 24, 1974.

Moulin, Raoul-Jean. "Les hyperréalistes américains et la neutralisation du réel," *L'Humanité*, Mar. 21, 1974.

"Natalie Bieser and Don Eddy," *Village Voice*, Feb. 28, 1974.

Progresso fotografico, Dec., 1974, pp. 61–62.

Spector, Stephen. "The Super Realists," *Architectural Digest*, Nov.–Dec., 1974, p. 85.

Teyssedre, Bernard. "Plus vrai que nature," *Le Nouvel Observateur*, Feb. 25–Mar. 3, 1974, p. 59.

Bruner, Louise. "Brash Paintings Stimulate Thinking Rather than Passive Thoughts," *Toledo Blade*, Jan. 12, 1975, p. 4.

"Don Eddy," *Nordjyllands Kunstmuseum*, no. 3 (Sept., 1975).

Hinson, T. E. "Eddy: New Shoes," *Cleveland Museum Bulletin*, Dec., 1975.

Lucie-Smith, Edward. "The Neutral Style," *Art and Artists*, vol. 10, no. 5 (Aug., 1975), pp. 6–15.

"New Shoes," *Santa Barbara News Press*, Sept. 27, 1975, p. C11.

"Photographic Realism," *Art-Rite*, no. 9 (Spring, 1975), p. 15.

Richard, Paul. "Whatever You Call It, Super Realism Comes On with a Flash," *Washington Post*, Nov. 25, 1975, p. B1.

Alloway, Lawrence. "Art," *The Nation*, vol. 222, no. 17 (May 1, 1976), pp. 539, 541.

Artner, Alan. "Mirroring the Merits of a Showing of Photo-Realism," *Chicago Tribune*, Oct. 24, 1976.

Borlase, Nancy. "Art," *Sydney Morning Herald*, Dec. 30, 1976.

Chase, Linda. "Photo-Realism: Post Modernist Illusionism," *Art International*, vol. XX, no. 3–4 (Mar.–Apr., 1976), pp. 14–27.

Cullinan, Helen. "Photo-Realist Dislikes Labels," *Cleveland Plain Dealer*, Feb. 1, 1976, sec. V, pp. 8, 10.

"Exhibition Displays Aspect of Realism," *New Westminster* (B.C.) *Columbian*, Oct. 9, 1976.

Forgey, Benjamin. "The New Realism, Paintings Worth 1,000 Words," *Washington Star*, Nov. 30, 1976, p. G24.

Fox, Mary. "Aspects of Realism," *Vancouver Sun*, Sept. 21, 1976.

Glasser, Penelope. "Aspects of Realism at Stratford," *Art Magazine* (Toronto), vol. 7, no. 28 (Summer, 1976), pp. 22–29.

Hartman, Rose. "Don Eddy," *Currànt*, vol. I (Feb.–Apr., 1976), pp. 40, 60.

Hoelterhoff, Manuela. "Strawberry Tarts Three Feet High," *Wall Street Journal*, Apr. 21, 1976.

K. M. "Realism," *New Art Examiner*, Nov., 1976.

Lubell, Ellen. "Don Eddy," *Arts Magazine*, May 1, 1976, p. 26.

Patton, Phil. "Books, Super-Realism: A Critical Anthology," *Artforum*, vol. XIV, no. 5 (Jan., 1976), pp. 52–54.

Perreault, John. "Getting Flack," *Soho Weekly News*, Apr. 22, 1976, p. 19.

Perry, Art. "So Much for Reality," *Province*, Sept. 30, 1976.

Borlase, Nancy. "In Selecting a Common Domestic Object," *Sydney Morning Herald*, July 30, 1977.

Carmalt, Susan. "Huntington Displays New Trends," *Austin Daily Texan*, Sept., 1977.

Edelson, Elihu. "New Realism at Museum Arouses Mixed Feelings," *Jacksonville* (Fla.) *Journal*, Feb., 1977.

Grishin, Sasha. "An Exciting Exhibition," *Canberra Times*, Feb. 16, 1977.

Groom, Gloria. "Modern Art Exhibit Gives a Nice Surprise," *The Citizen* (Austin, Tex.), Aug., 1977.

Hocking, Ian. "Something for All at Art Gallery," *News Adelaide*, Sept. 7, 1977.

Langer, Gertrude. "Realising Our Limitations in Grasping Reality," *Brisbane Courier Mail*, May 28, 1977.

Lynn, Elwyn. "The New Realism," *Quadrant*, Sept., 1977.

McGrath, Sandra. "I Am Almost a Camera," *The Australian* (Brisbane), July 27, 1977.

"Prints Exhibition for D'port," *The Examiner* (New Zealand), Sept. 7, 1977.

Schwartz, Estelle. "Art and the Passionate Collector," *Cue*, Dec. 9, 1977, pp. 7–11.

Shirey, David L. "Diverse and Lively," *New York Times*, Feb. 27, 1977.

Bongard, Willie. *Art Aktuell*, (Cologne), April, 1978.

Jensen, Dean. "Super Realism Proves a Super Bore," *Milwaukee Sentinel*, Dec. 1, 1978.

Mackie, Alwynne. "New Realism and the Photographic Look," *American Art Review*, Nov., 1978, pp. 72–79, 132–34.

Rodriguez, Joanne Milani. "Art Show Accents the Eccentricities of Camera's Vision," *Tampa Tribune-Times*, Feb. 5, 1978, pp. 1–2.

"The 12th Blossom Kent Art Program," *Dialogue*, Akron Art Institute, May–June, 1979, p. 25.

BOOKS

Kultermann, Udo. *New Realism*. New York: New York Graphic Society, 1972.

Brachot, Isy, ed. *Hyperréalisme*. Brussels: Imprimeries F. Van Buggenhoudt, 1973.

Sager, Peter. *Neue Formen des Realismus*. Cologne: Verlag M. DuMont Schauberg, 1973.

L'Iperrealismo italo Medusa. Rome: Romana Libri Alfabeto, 1974.

Battcock, Gregory, ed. *Super Realism, A Critical Anthology*. New York: E. P. Dutton, 1975.

Chase, Linda. *Hyperréalisme*. New York: Rizzoli, 1975.

Kultermann, Udo. *Neue Formen des Bildes*. Tübingen, West Germany: Verlag Ernst Wasmuth, 1975.

Rose, Barbara, ed. *Readings in American Art, 1900–1975*. New York: Praeger, 1975.

Honisch, Dieter, and Jensen, Jens Christian. *Amerikanische Kunst von 1945 bis Heute*. Cologne: DuMont Buchverlag, 1976.

Battcock, Gregory. *Why Art*. New York: E. P. Dutton, 1977.

Cummings, Paul. *Dictionary of Contemporary American Artists*. 3d ed. New York: St. Martin's Press, 1977.

Janson, H. W. *History of Art*. 2d ed. New York: Harry N. Abrams, 1977.

Lucie-Smith, Edward. *Super Realism*. Oxford: Phaidon, 1979.

Seeman, Helene Zucker, and Siegfried, Alanna. *SoHo*. New York: Neal-Schuman, 1979.

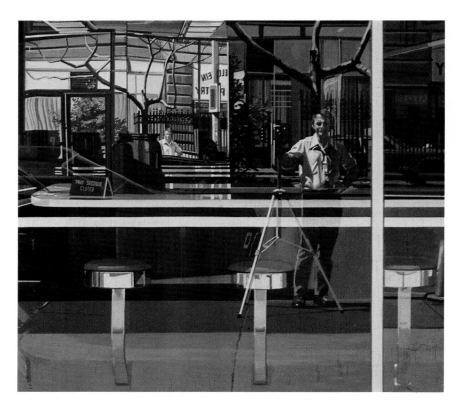

436. Richard Estes reflected in
Double Self-Portrait (plate 450)

RICHARD ESTES

That Richard Estes is the artist most frequently associated with the term Photo-Realism has nothing to do with media "hype," formalist criticism, or marketability. It is purely the result of response to Estes's work on the part of the viewing public, including those who are educated in art and those who are not. Although not generally considered innovative, his paintings have a quality and a presence that are almost universally respected.

Estes is the rare genius who simply ".knows" what is right—he feels and senses it. To Estes, a painting is either good or bad; he either likes it or he doesn't, without concern for anything other than visual aesthetics. This attitude permeates his work, and he wants us to consider it by these standards. His painting should not be intellectualized, because that is not what Estes is about.

Estes's work reflects the man: honest, clear, believable, and to the point. His answer to any question is short and simple, and at times suprisingly frank. For example, when asked why he uses photographs, Estes says, "It's silly to work from drawings when I can do better with photographs." To the question of why he paints the city, he responds, "I live in the city. If I lived somewhere else, that is what I would paint."

Estes is unabashed in proclaiming that he feels allied with all realist painters, and that he doesn't consider anyone a painter unless he is a realist. Because he totally dismisses abstract painting, I am inclined to call Estes a naive painter. Self-taught, he has developed every aspect of his art on his own, if not quite in a vacuum, then close to it. He has never conceded to me the influence of any other artist, although he has named some he "sort of" respects. Disdainful of art that lacks craftsmanship, Estes thinks that the Abstract Expressionists were so involved with emotion and personal expression, as well as with the idea of abolishing all established rules of painting, that

they abandoned all traces of craftsmanship. It is just this direct, uncomplicated attitude that has made Estes's paintings possible. Estes does not concern himself with many of the agonizing problems and decisions of the formalist painters. He shoots pictures at random and selects the ones he likes. Unrestricted by rigid ideas about scale, Estes can paint any given photograph large or small, in oils or watercolor, depending upon his feelings at the moment, with an uncanny way of making it all work.

In many ways, Estes's techniques and methods are unique among the Photo-Realist painters. Most of the others usually work from a single photographic image. Estes almost invariably uses two, three, or more photos. Several shots are taken at different lighting and focus settings; some are details of areas. Since neither the camera nor the eye sees exactly what Estes feels is "right," he combines photographs to make a painting. (I reiterate that for Estes the term "right" has nothing to do with academic or formalist concerns—it is the artist's intuitive understanding of what looks right.)

An interesting and immediately apparent aspect of Estes's painting is his brush-work. The strong, confident strokes, their edges rarely blended, remain visible in the

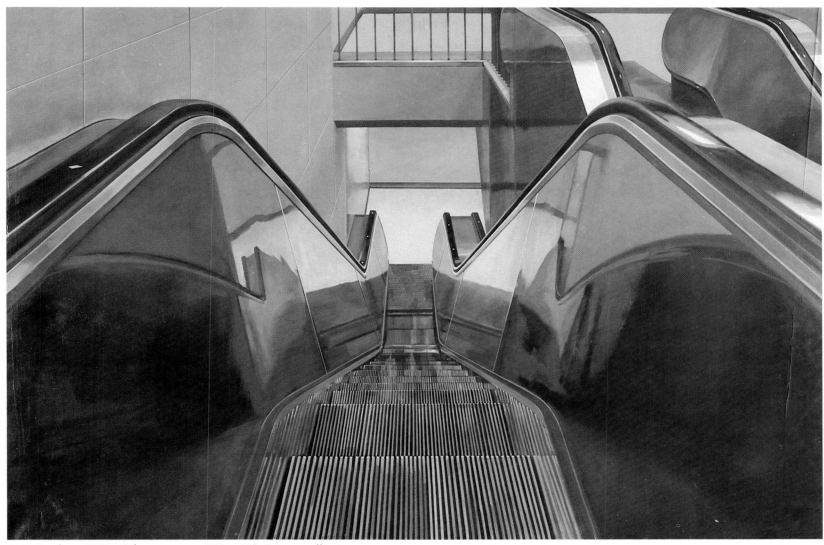

437. *Escalator.* 1970. Oil on canvas, 42½ x 62". Private collection

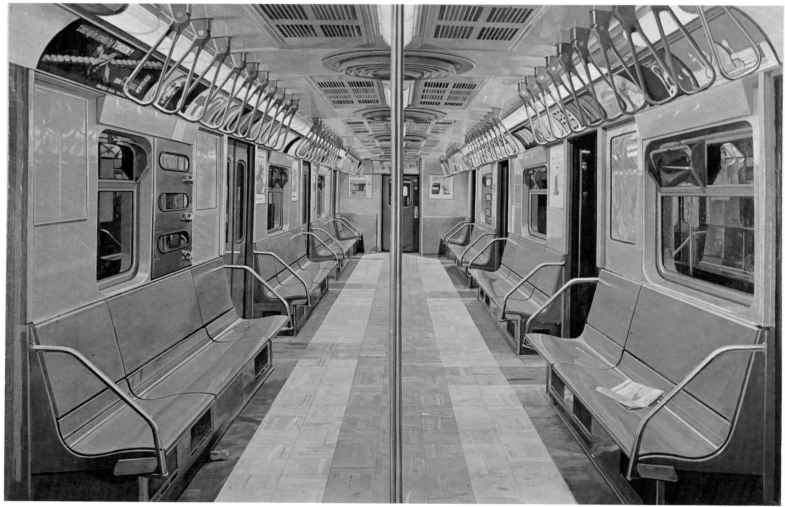

438. *Subway.* 1969. Oil on canvas, 42 x 60". Private collection

finished work. Color and tone gradation is attained by the placement of one solid color next to another. Estes can create an aluminum lamppost in several minutes with four to six vertical brushstrokes varying from very light gray on the lit side to very dark gray on the unlit side. From a viewing distance of two or three feet, the lamp appears smooth and rounded. McLean or Goings may spend an hour blending the edges of the strokes to achieve this appearance from two inches. Unlike other Photo-Realists who spend six months to a year on a painting, Estes paints very rapidly, executing a fully completed work in a month or two. In fact, a major work, when not closely inspected, will look almost finished in as little time as a week.

Estes has very little interest in what critics have to say about his work. A laudatory article does not excite him, and a venomous review does not upset him. In fact, when a former art critic for *New York Magazine* wrote a review of his show so vitriolic that it became an embarrassment both to her and to the magazine, Estes's only comment was that he was upset the magazine had taken the liberty of cropping his painting in the accompanying illustration after he had carefully composed it. Estes feels that the less a work of art has to be explained, the more successful that work is. He, therefore, feels that nothing need be said about his work. His paintings say it all.

Unlike the other Photo-Realists, Estes has done hundreds of sketches and small watercolors. Most are loose sketchpad studies done on location. No records of the subjects, sizes, dates, disposition, or numbers of these works have been kept. Records of Estes's work of the past ten years, including all paintings, are also extremely poor, with as much as seventy-five percent of the information missing.

We estimate that Estes has done between 100 and 125 acrylics, oils, and gouaches as a Photo-Realist. Of these, 86 are illustrated herein and seven are listed.

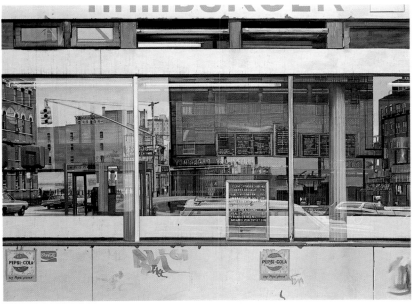

439. *A Hamburger Shop.* 1976. Oil on canvas, 40 x 50".
Neue Galerie der Stadt Aachen. Ludwig Collection

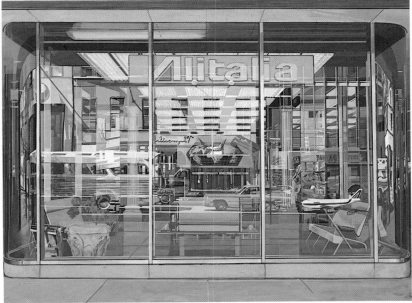

440. *Alitalia.* 1973. Oil on canvas, 30 x 40". Stuart M. Speiser Collection,
Smithsonian Institution, Washington, D.C.

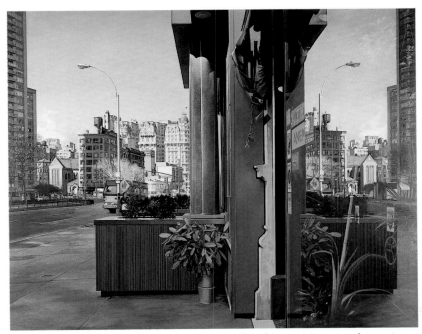

441. *Ansonia.* 1977. Oil on canvas, 48 x 60". Whitney Museum of American
Art, New York. Gift of Sydney and Frances Lewis Foundation

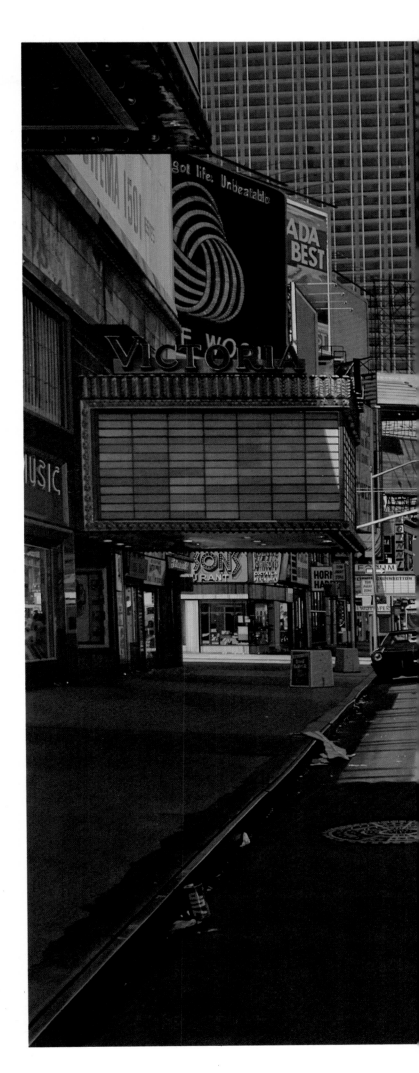

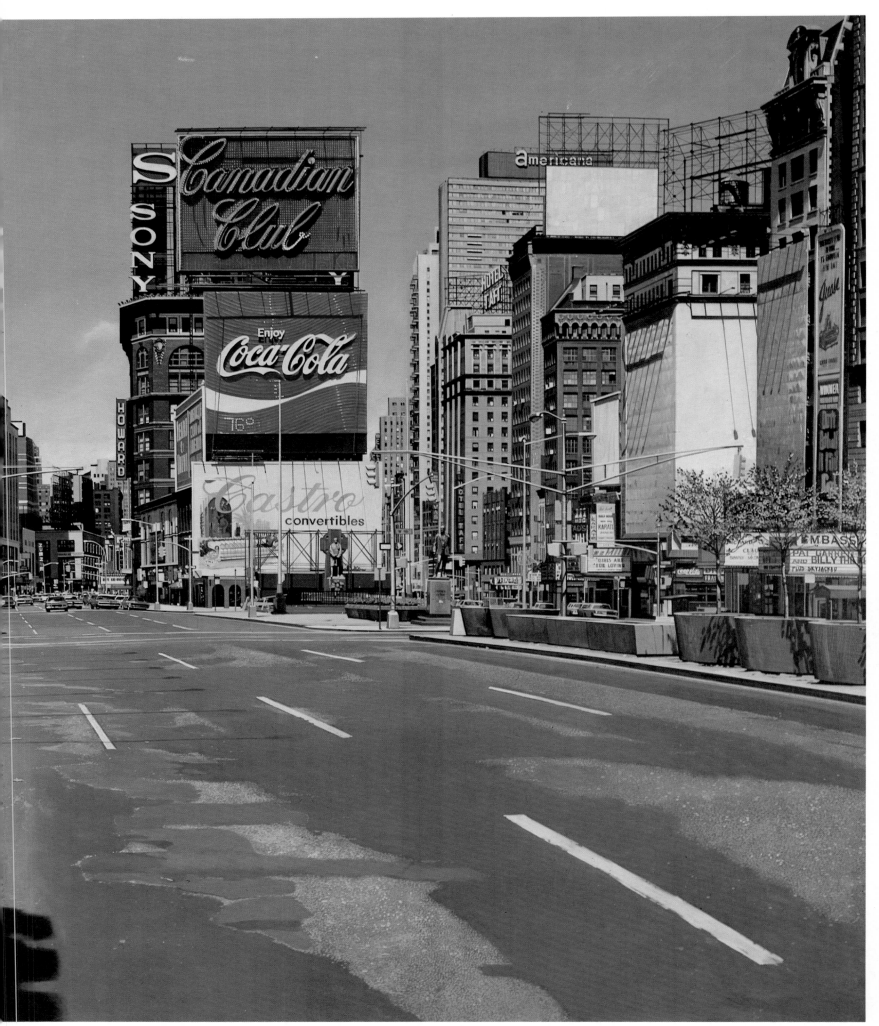

442. *Canadian Club*. 1974. Oil on Masonite, 48 x 60". Collection Mr. and Mrs. Morton G. Neumann, Ill.

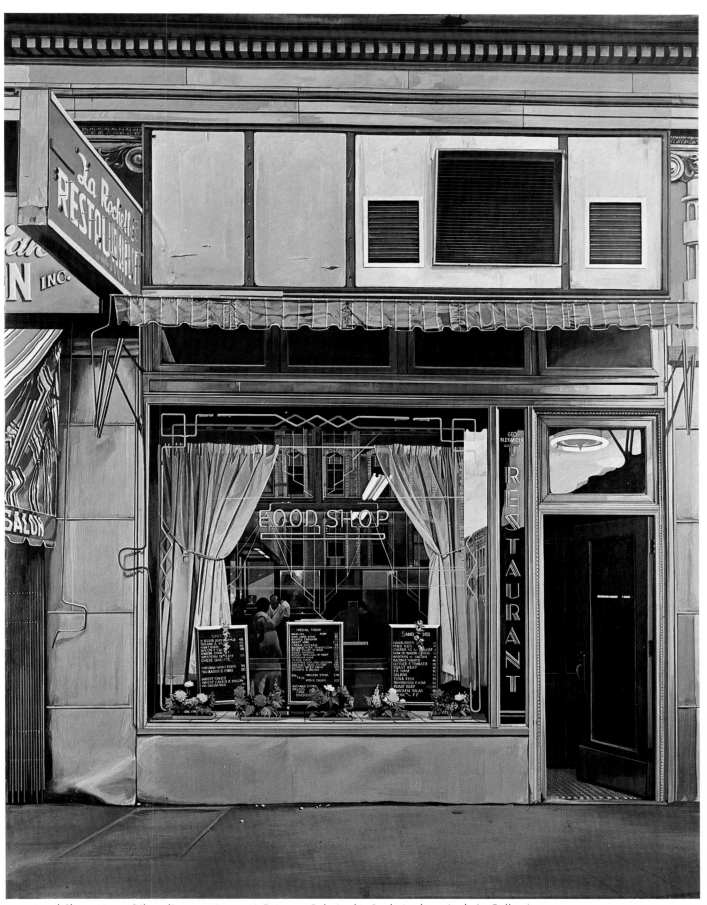

443. *Food Shop.* 1967. Oil on linen, 65⅜ x 48½". Neue Galerie der Stadt Aachen. Ludwig Collection

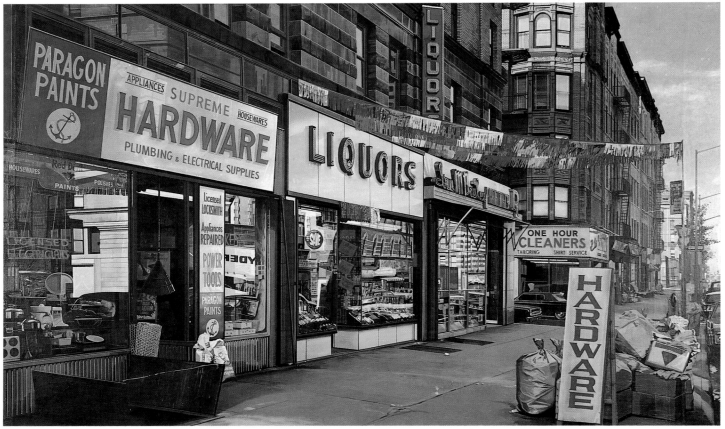

444. *Supreme Hardware*. 1974. Oil on canvas, 39 x 66". High Museum of Art, Atlanta, Ga.

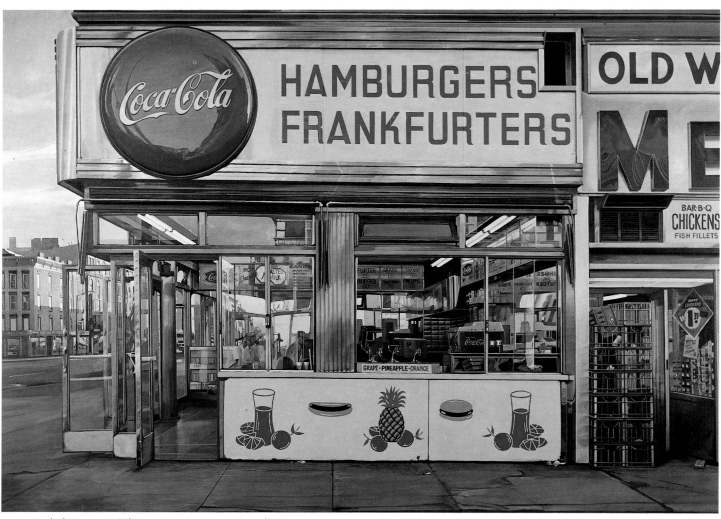

445. *Nedick's*. 1970. Oil on canvas, 48 x 66". Collection Mrs. Donald Pritzker

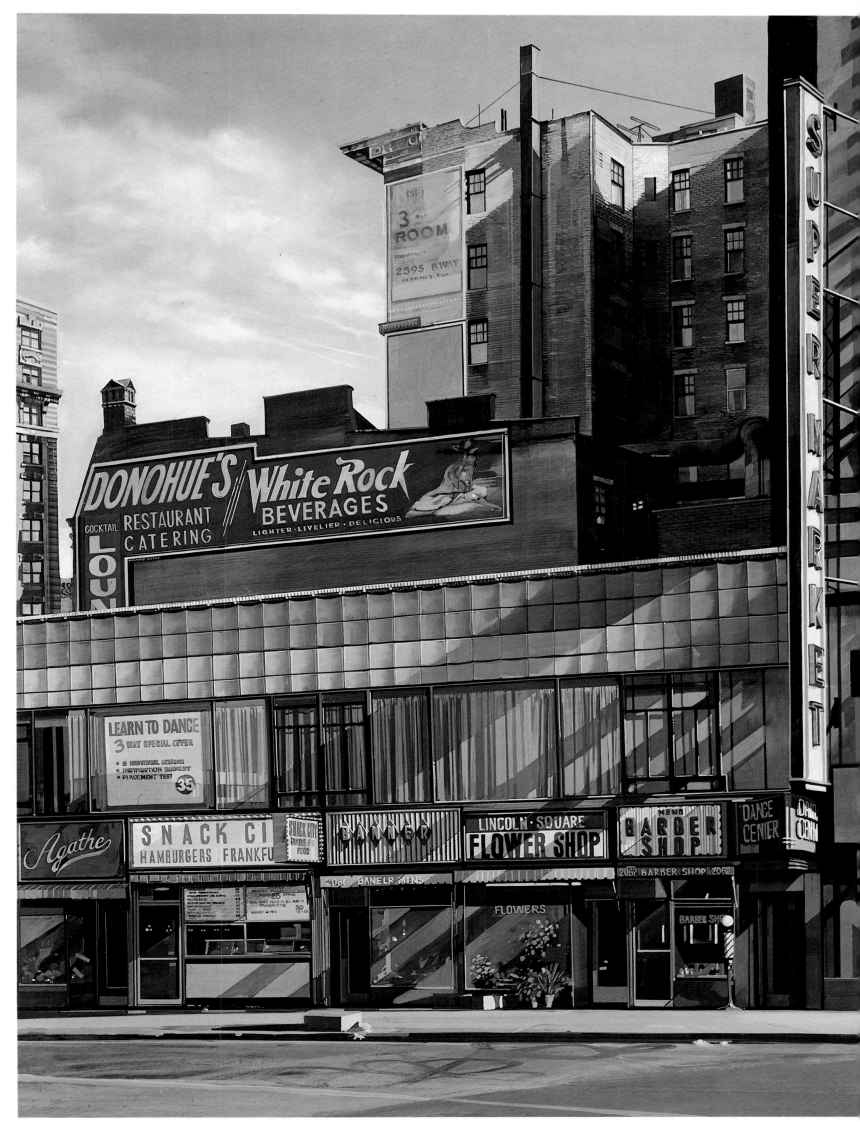

446. *Key Food.* 1970. Oil on canvas, 36 x 55". Collection Beatrice C. Mayer, Ill.

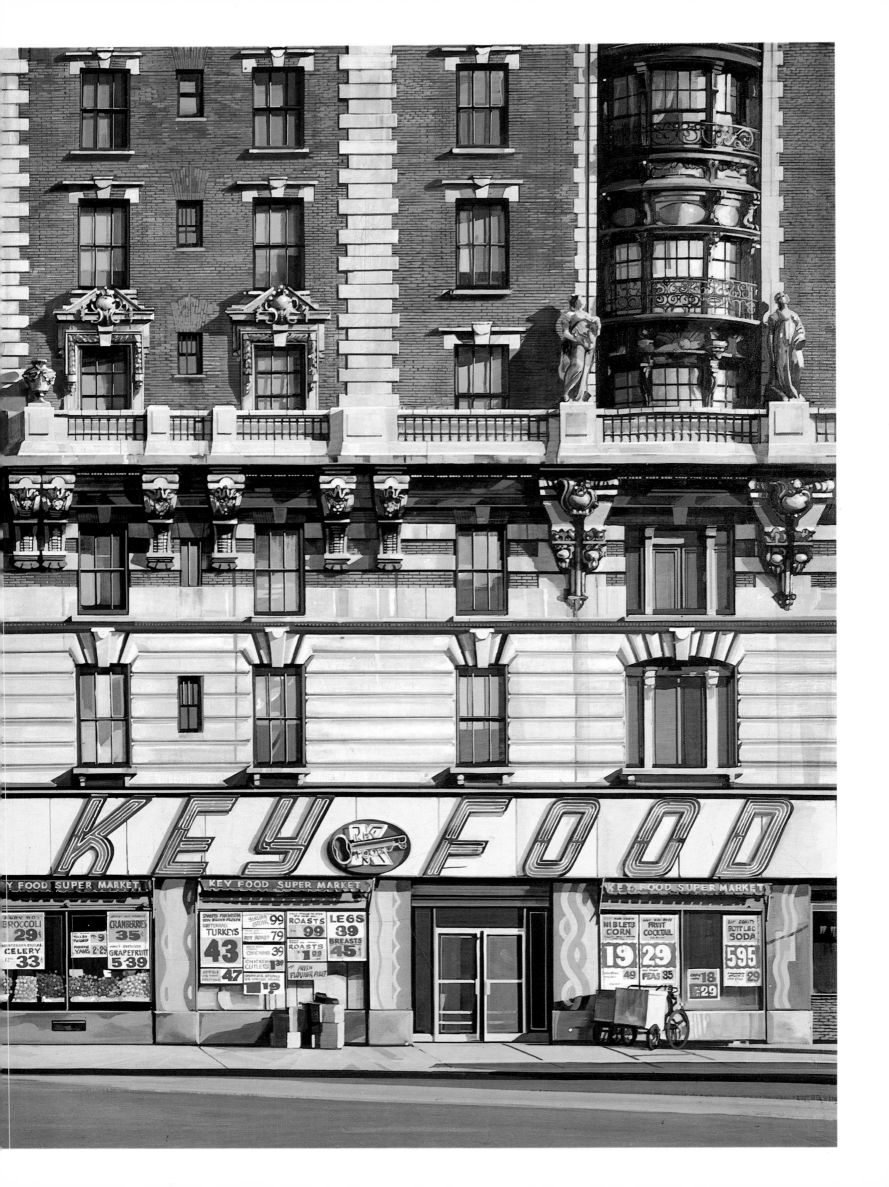

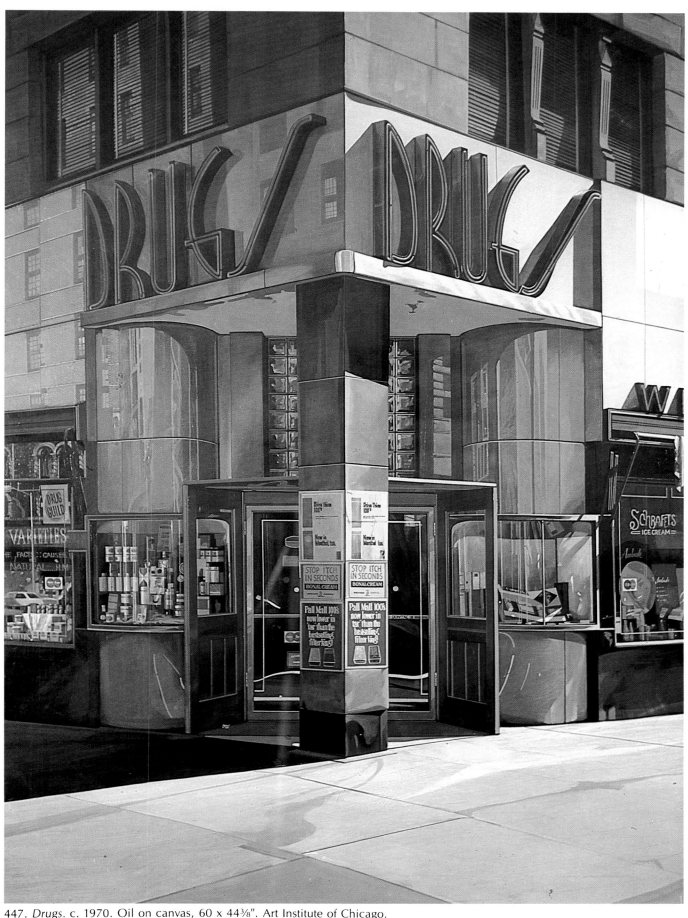

447. *Drugs.* c. 1970. Oil on canvas, 60 x 44⅜". Art Institute of Chicago.
Gift of Edgar Kaufmann and Twentieth Century Purchase Fund

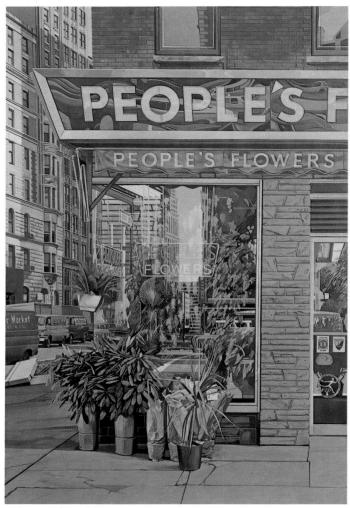

448. *People's Flowers*. 1971. Oil on canvas, 60 x 40".
H. H. Thyssen-Bornemisza Collection

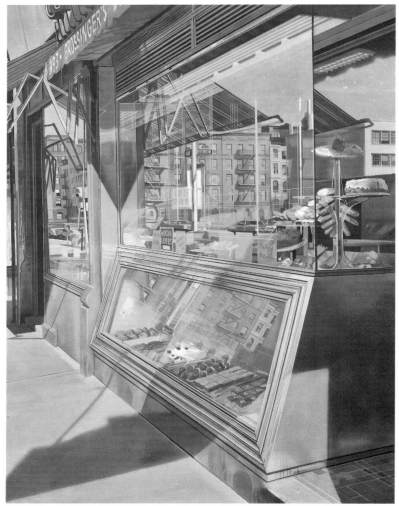

449. *Grossinger's*. c. 1970. Oil on canvas, c. 36 x 24".
Collection Mr. and Mrs. Robert Kogod, Md.

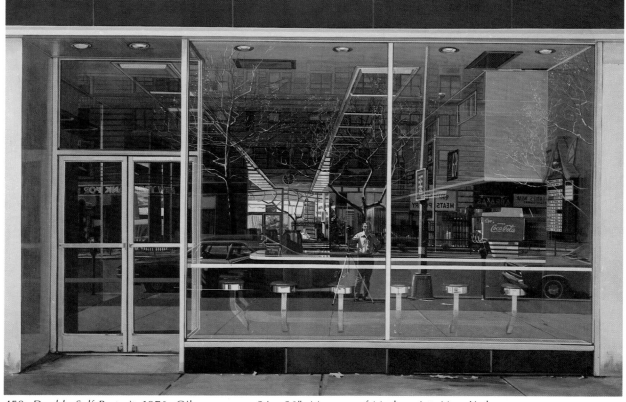

450. *Double Self-Portrait*. 1976. Oil on canvas, 24 x 36". Museum of Modern Art, New York.
Mr. and Mrs. Stuart M. Speiser Fund, 1976

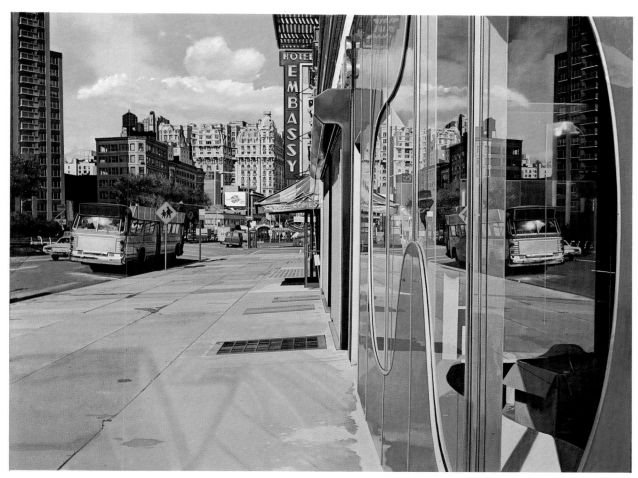

451. *Bus Reflections (Ansonia)*. 1972. Oil on canvas, 40 x 52". Private collection

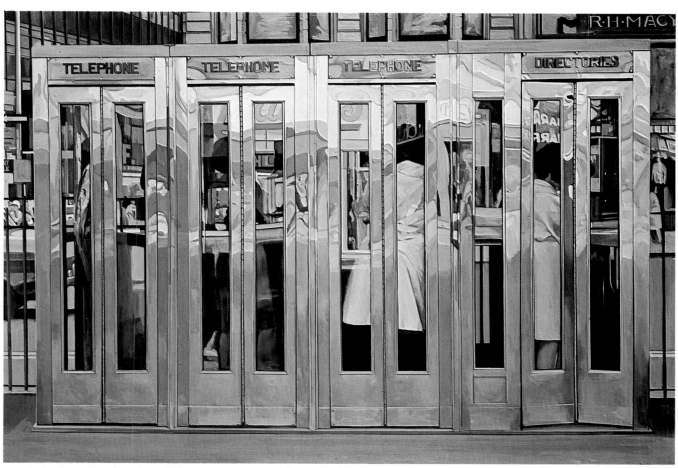

452. *Telephone Booths*. 1968. Oil on canvas, 48 x 69". H. H. Thyssen-Bornemisza Collection

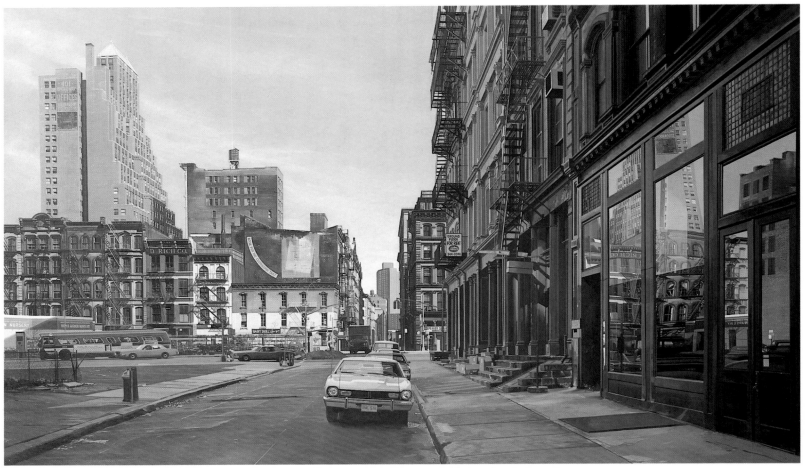

453. *Baby Doll Lounge*. 1978. Oil on canvas, 36 x 60". Collection Mr. and Mrs. H. Christopher J. Brumder

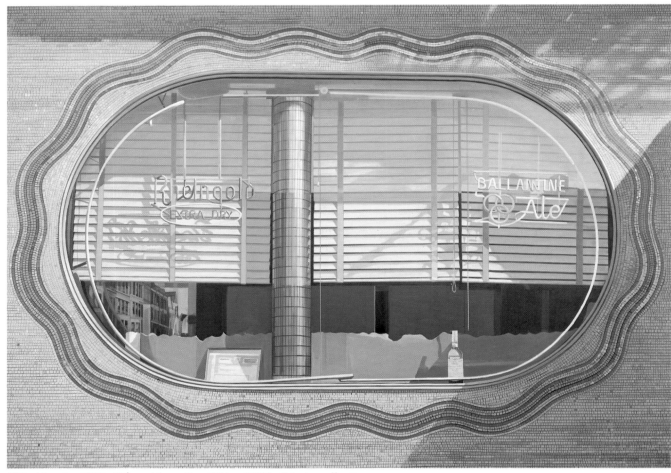

454. *Mosaic*. 1968. Oil on Masonite, 48½ x 66½". Private collection

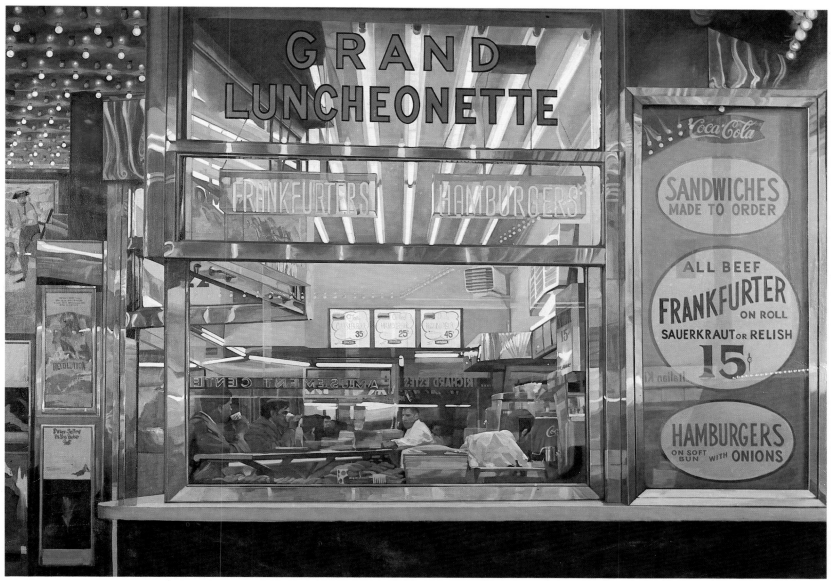

455. *Grand Luncheonette*. 1969. Oil on canvas, 51 x 69¼". Acquavella Gallery of Contemporary Art, New York

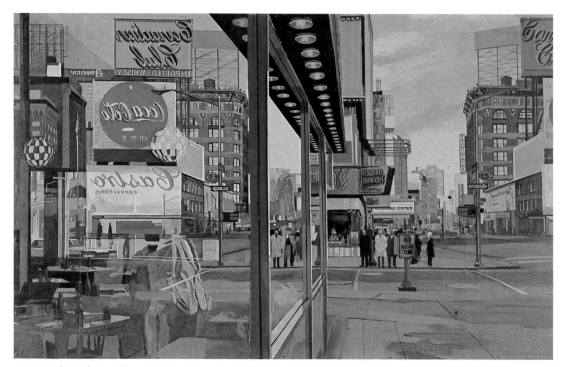

456. *46th and Broadway*. 1969. Oil on canvas, 16 x 24". Private collection

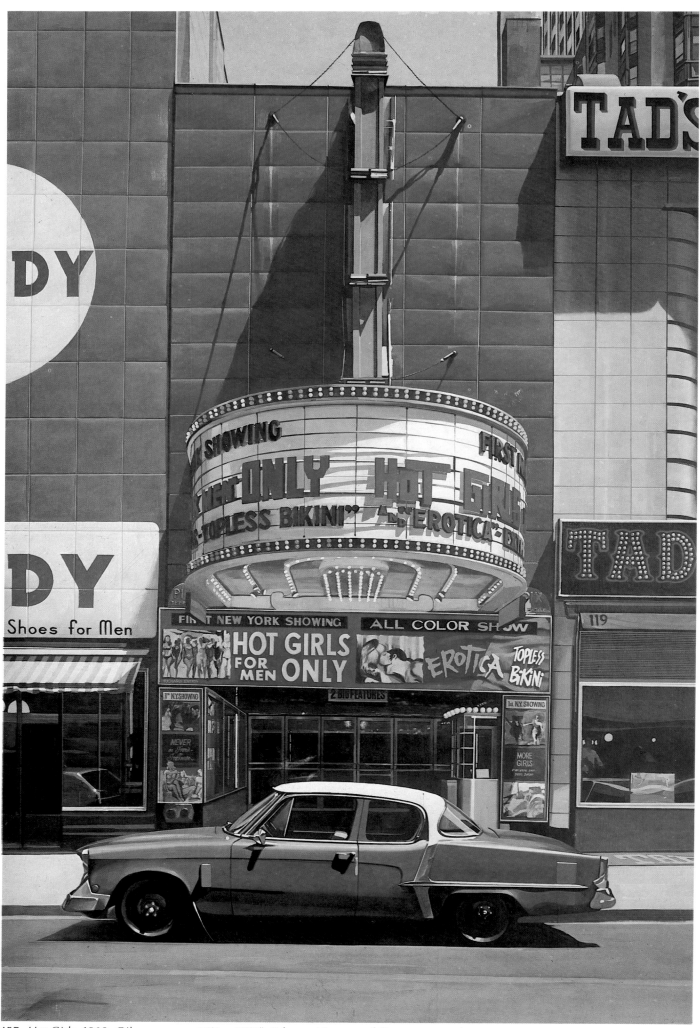

457. *Hot Girls*. 1968. Oil on canvas, 58¼ x 38⅝". Teheran Museum of Contemporary Art

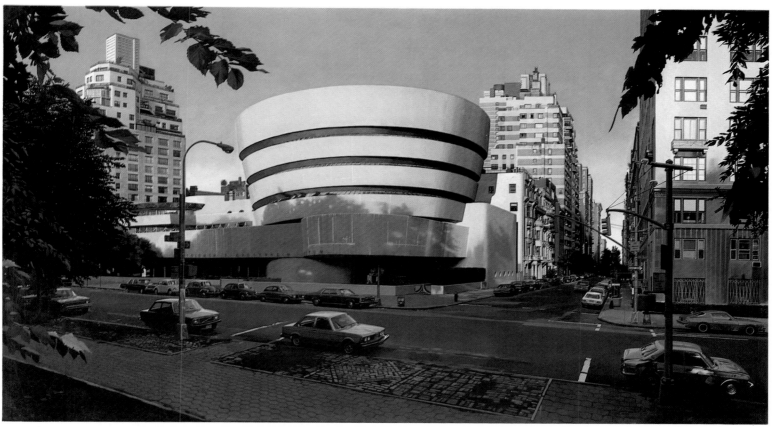

458. *The Solomon R. Guggenheim Museum*. 1979. Oil on canvas, 31⅛ x 55⅛".
Solomon R. Guggenheim Museum, New York

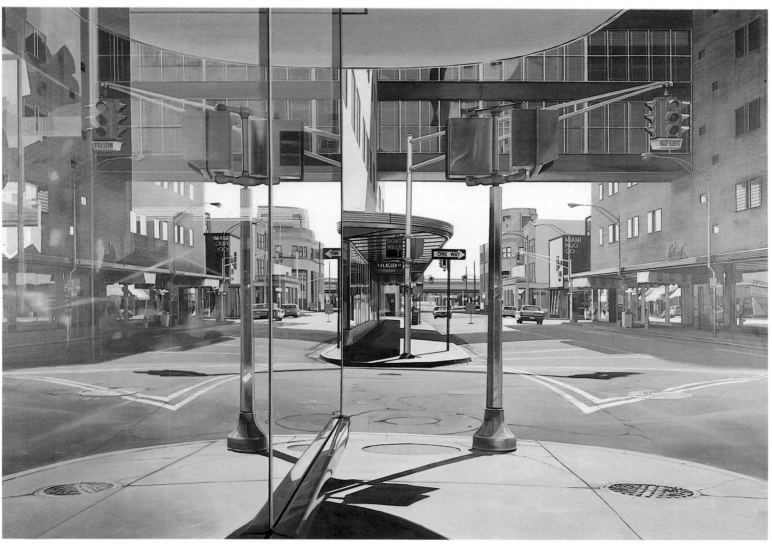

459. *Miami Rug Company*. 1974. Oil on canvas, 40 x 54". Private collection

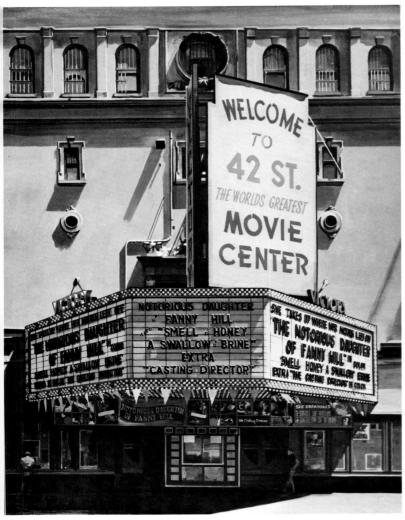

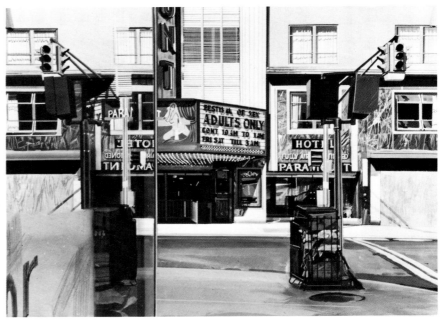

460. *Welcome to 42nd St. (Victory Theater).* 1968. Oil on Masonite, 32 x 24". Collection Mr. and Mrs. Stephen Paine, Mass.

461. *Hotel Paramount.* 1974. Gouache, 14¼ x 19½". Collection Paul Kantor, Calif.

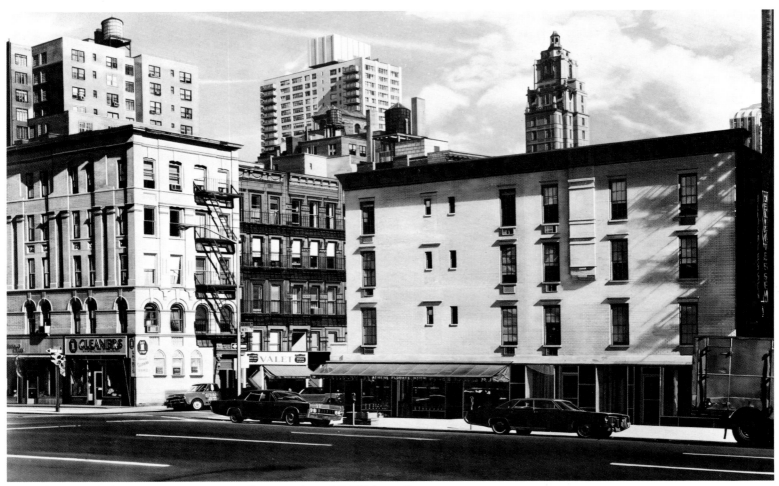

462. *Valet.* 1972. Oil on canvas, 44 x 68". Collection Edmund P. Pillsbury, Conn.

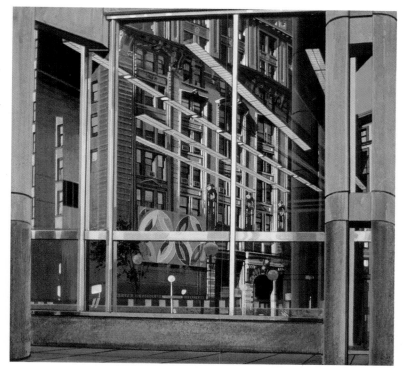

463. *Boston Bank Building*. 1974. Gouache, 12 x 18".
Private collection

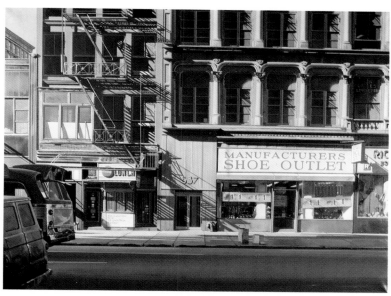

464. *Shoe Outlet*. 1973. Oil on canvas, 28 x 38".
Collection Belger Family, Mo.

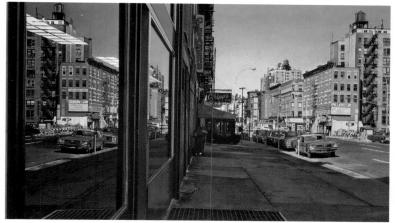

465. *Chipp's*. 1976. Oil on canvas, 27 x 44½".
Private collection

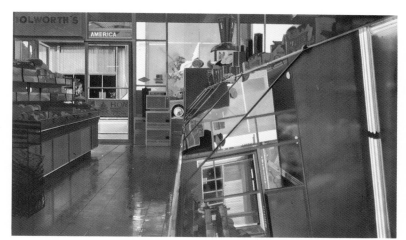

466. *Woolworth's*. 1973. Gouache, 14½ x 23¼".
Collection Edmund P. Pillsbury, Conn.

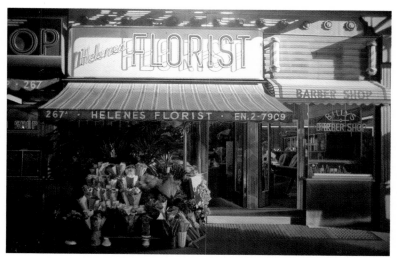

467. *Helene's Florist*. 1971. Oil on canvas, 48 x 72".
Toledo Museum of Art, Ohio. Gift of Edward Drummond Libbey

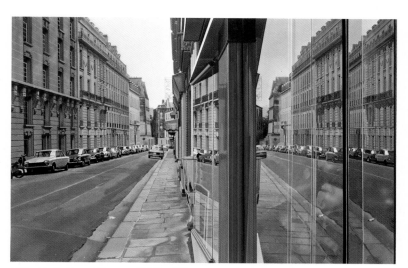

468. *Paris Street Scene*. 1972. Oil on canvas, 40 x 60".
Sydney and Frances Lewis Foundation, Va.

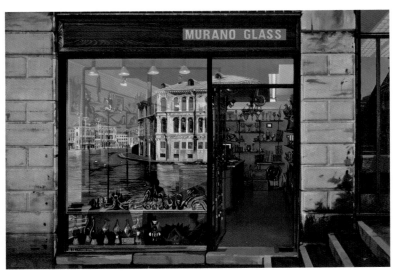

469. *Murano Glass*. 1976. Oil on canvas, 24 x 36".
Private collection, Ill.

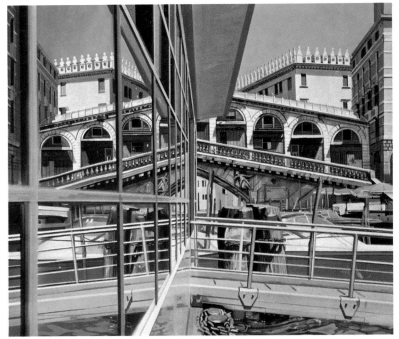

470. *Bridge*. 1974. Gouache, 16 x 17".
Private collection

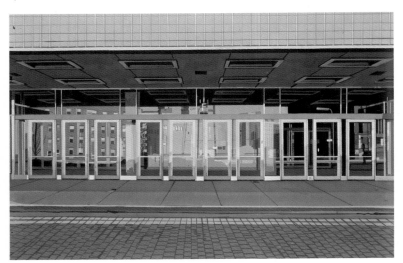

471. *Ten Doors*. 1972. Gouache, 14½ x 21".
Private collection

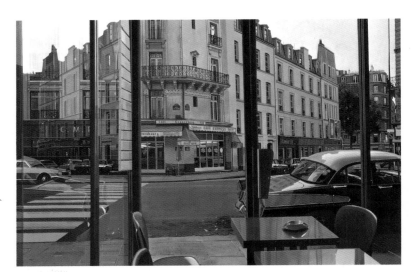

472. *Cafe Express*. 1975. Oil on canvas, 24 x 36".
Private collection

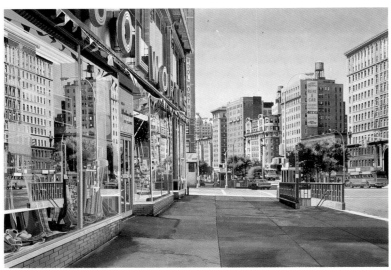

473. *Woolworth's*. 1974. Oil on canvas, 38 x 55".
Collection San Antonio Museum Association, San Antonio, Tex.

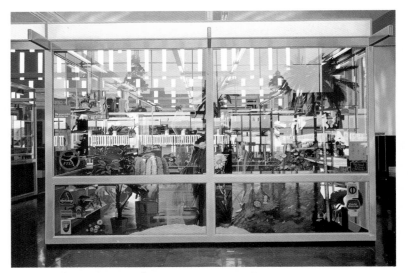

474. *Teleflorist*. 1974. Oil on canvas, 36 x 52".
Private collection

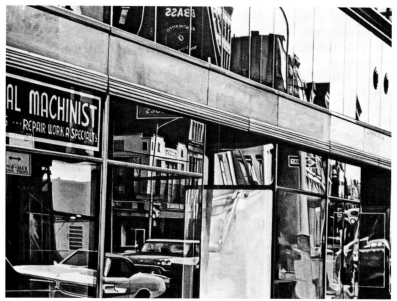

475. *General Machinist.* c. 1969. Oil on Masonite, c. 48 x 60".
Private collection

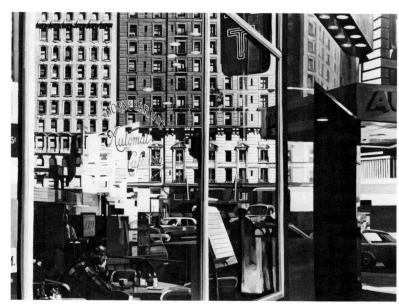

476. *Horn and Hardart Automat.* 1967. Oil on Masonite, 48 x 60".
Collection Mr. and Mrs. Stephen Paine, Mass.

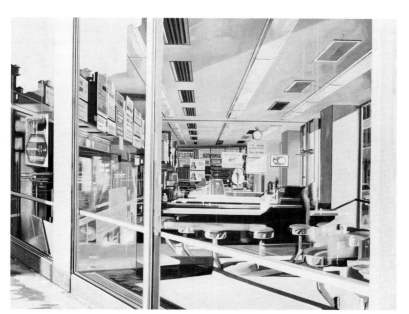

477. *Ice Cream.* 1976. Gouache, 19½ x 24½".
Collection the artist

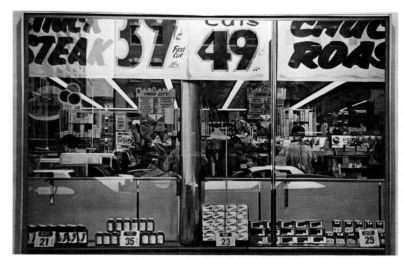

478. *Food City.* 1967. Oil on Masonite, 48 x 68".
Private collection

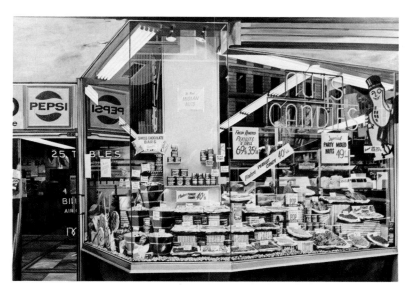

479. *The Candy Store.* 1969. Oil and synthetic polymer on canvas,
47¾ x 68¾". Whitney Museum of American Art, New York. Gift of
Friends of the Museum

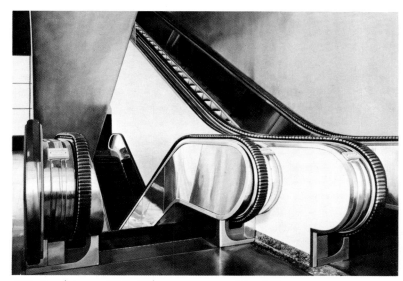

480. *Escalator.* c. 1971. Oil on canvas, c. 24 x 36".
Collection Mr. and Mrs. Morton G. Neumann, Ill.

228

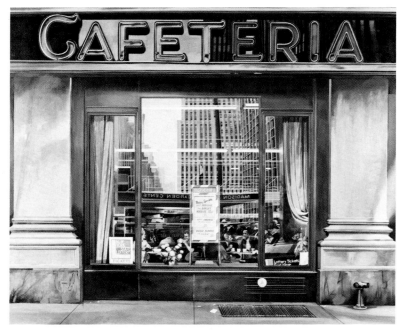

481. *Cafeteria.* 1970. Oil on canvas, 41½ x 49½".
Private collection, New York

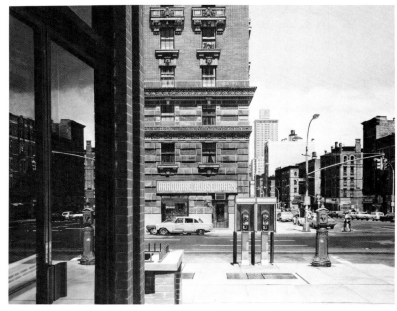

482. *Hotel Lucerne.* 1976. Oil on canvas, 48 x 60".
H. H. Thyssen-Bornemisza Collection

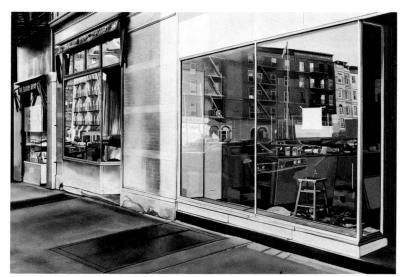

483. *Store Front.* 1971. Oil on canvas, 32⅛ x 44¼".
Sydney and Frances Lewis Foundation, Va.

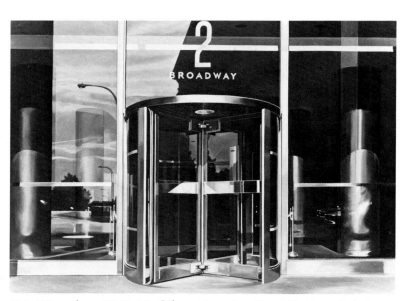

484. *2 Broadway.* 1968–69. Oil on Masonite, 48 x 66". Neue Galerie
der Stadt Aachen. Ludwig Collection

485. *D 106.* 1968. Oil on canvas, 22¼ x 30¼".
Collection Beatrice C. Mayer, Ill.

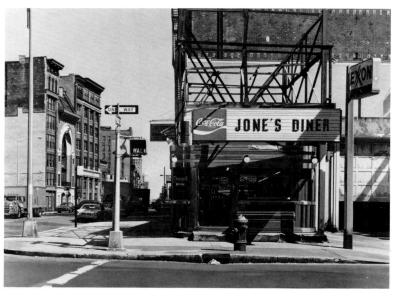

486. *Jone's Diner.* 1979. Oil on canvas, 36½ x 48".
Private collection

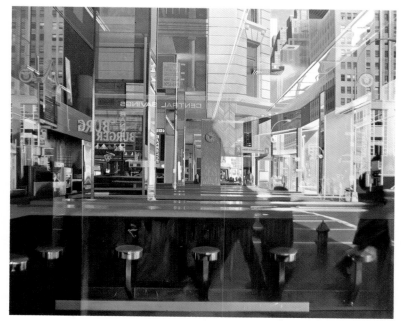

487. *Central Savings*. 1975. Oil on canvas, 36 x 48". Nelson Gallery, Atkins Museum, Mo. Friends of Arts Collection

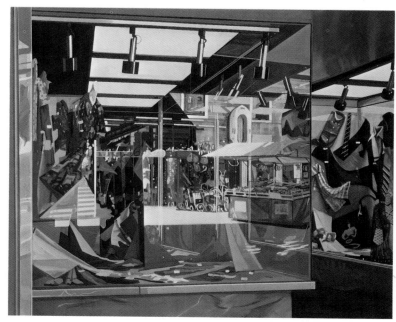

488. *Clothing Store*. 1976. Gouache and oil on illustration board, 20 x 22". Private collection

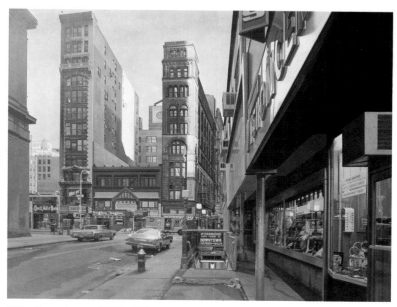

489. *Downtown*. 1978. Oil on canvas, 48 x 60". Neue Galerie der Stadt Aachen. Ludwig Collection

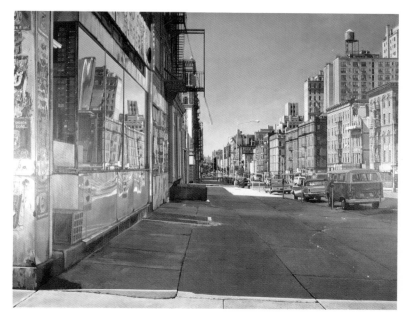

490. *Columbus Ave. at 90th St*. 1974. Oil on canvas, 48 x 60". Private collection

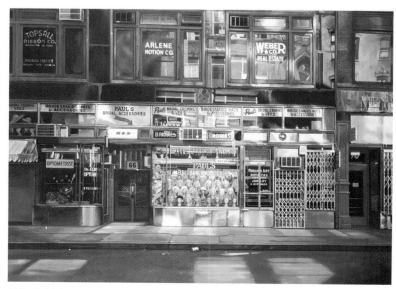

491. *Bridal Accessories*. 1975. Oil on canvas, 36 x 48". Collection Graham Gund, Mass.

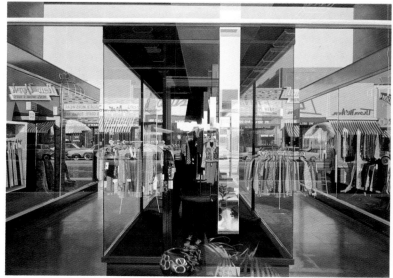

492. *Thom McAn*. c. 1974. Oil on canvas, c. 36 x 48". Collection Daniel Filipacchi, New York

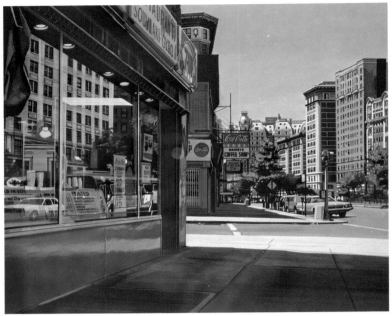

493. *Harvey's Coffee Shop.* 1976. Oil on board, 19½ x 25½".
Collection Michael Haber, New York

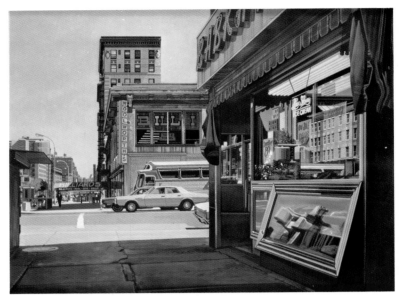

494. *Billiards.* 1976. Gouache on illustration board, 19⅝ x 25⅜".
Private collection

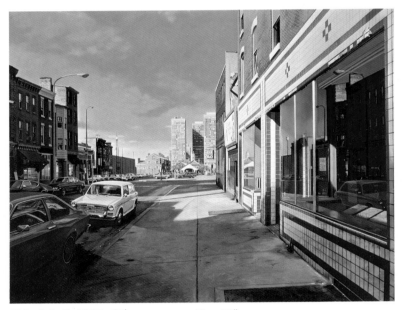

495. *B & O.* 1975. Oil on canvas, 48 x 60".
Collection the artist

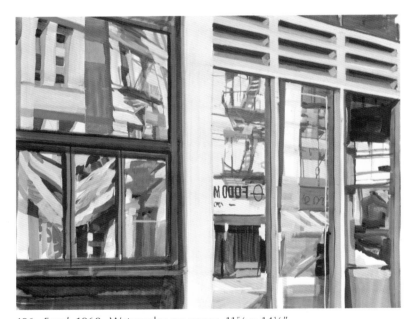

496. *Food.* 1968. Watercolor on paper, 11⅝ x 14¼".
Collection Dr. Jack Reddin, Kans.

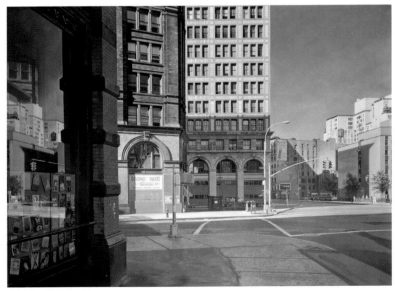

497. *Gourmet Treats.* 1977. Oil on canvas, 36 x 48".
Sydney and Frances Lewis Foundation, Va.

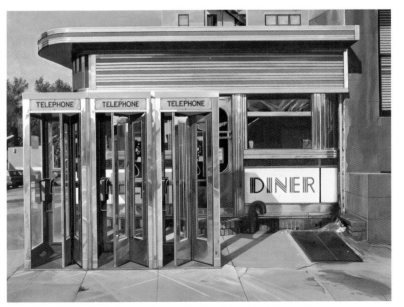

498. *Diner.* 1971. Oil on canvas, 40⅛ x 50". Hirshhorn Museum and
Sculpture Garden, Smithsonian Institution, Washington, D.C.

231

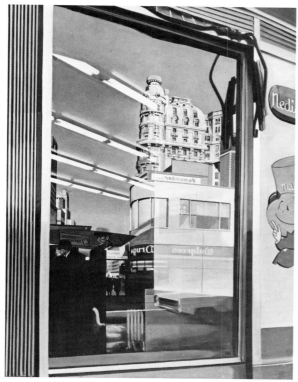

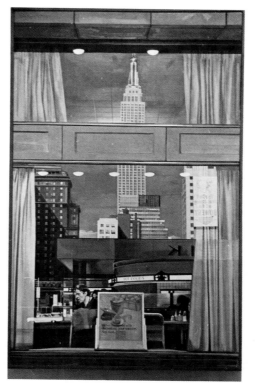

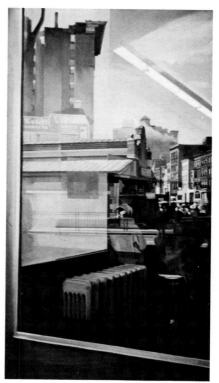

499. *Nedick's.* 1968–69.
Oil on canvas, 48 x 36".
Collection Mr. and Mrs. Malcolm Chace, Jr., R.I.

500. *Hot Foods.* 1967.
Oil on canvas, 48 x 30".
Private collection

501. *Donohue's.* 1967. Oil on canvas,
c. 45 x 28". Collection Mr. and Mrs.
Morton G. Neumann, Ill.

502. *Home of Chicago Blackhawks.* 1969. Oil on canvas, 30⅛ x 22¼".
Private collection

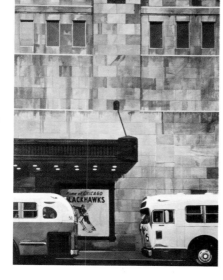

503. *Drugs.* 1970.
Acrylic on board,
19¾ x 14¼".
Private collection

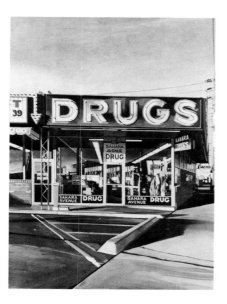

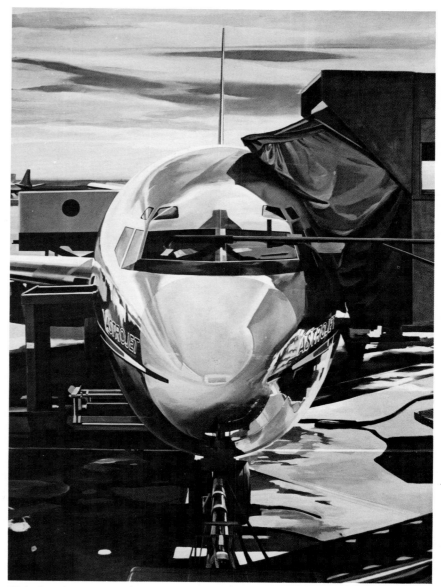

504. *Astrojet.* 1967. Oil on panel, 68 x 48". Des Moines Art Center.
Coffin Fine Arts Trust Fund

232

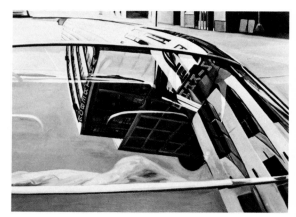

505. *Bus Window*. 1967 (repainted in 1973). Oil on hardboard, 48 x 36". Collection Mr. and Mrs. R. A. L. Ellis

506. *Bus Front*. 1967. Oil, 18 x 24". Private collection

507. *Robert Hall Reflections*. c. 1969. Oil on canvas, 36 x 48". Private collection

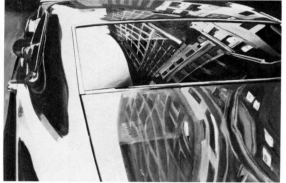

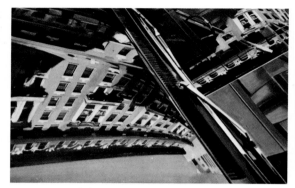

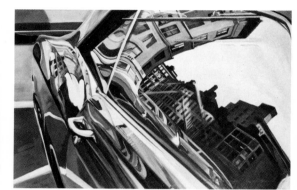

508. *Fastback*. 1967. Oil on board, 17¾ x 23⅝". Private collection

509. *Automobile Reflections*. 1969. Oil on canvas, 24 x 36". Collection Mr. and Mrs. Charles Herman, Mo.

510. *Untitled (Car Reflection)*. 1967. Oil on board, 23½ x 35⅜". Private collection

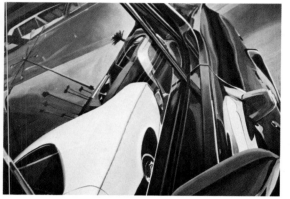

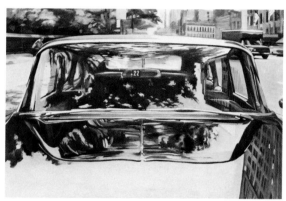

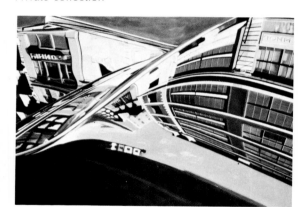

511. *Palm Tree Reflection*. Date unknown. Oil on canvas, 25½ x 35". Collection Roger Travis, New York

512. *Untitled*. 1967. Oil on board, 36 x 51½". Private collection

513. c. 1966. Other information, including whereabouts, unknown

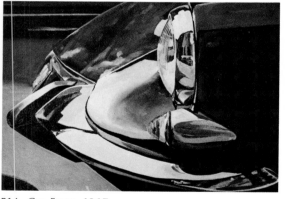

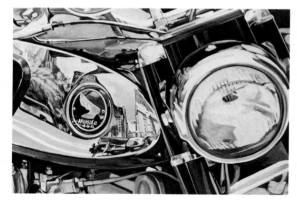

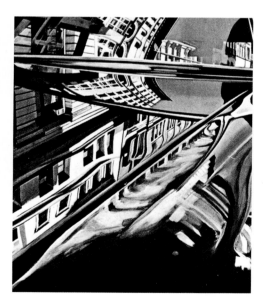

514. *Car Front*. 1967. Oil on panel, 18 x 24". Private collection

515. *Honda*. 1967. Oil on board, 23 x 35". Private collection

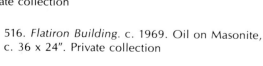

516. *Flatiron Building*. c. 1969. Oil on Masonite, c. 36 x 24". Private collection

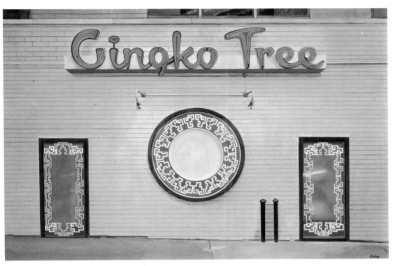

517. *Gingko Tree.* c. 1970. Oil on panel, 15 x 22".
James Goodman Gallery, New York

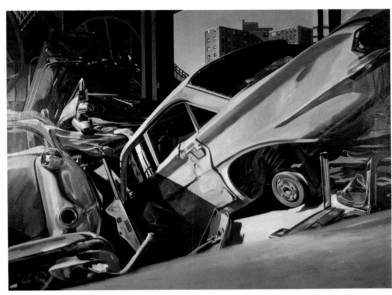

518. *Auto Graveyard.* 1968. Oil on canvas, 41 x 53".
Collection Galerie Isy Brachot, Brussels

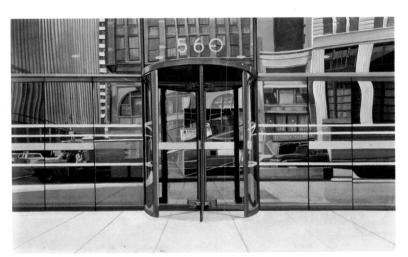

519. *560.* 1972. Gouache, 15 x 23". Collection Irene and
Marcus Kutter, Switzerland

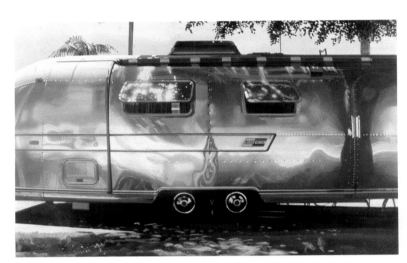

520. *Airstream.* 1974. Gouache on paper, 14 x 21".
Private collection

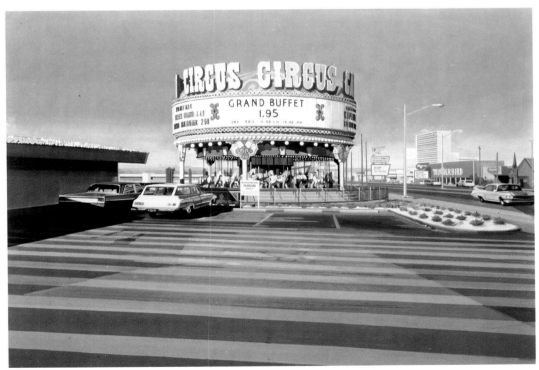

521. *Circus, Circus.* c. 1971. Oil on canvas, c. 18 x 30". Private collection

NOT ILLUSTRATED

Gordon's Gin. 1968.
Oil on panel, 24⅜ x 31⅞".
Collection Galerie Isy Brachot,
Brussels

570. 1974.
Gouache, 14½ x 20".
Morgan Gallery,
Shawnee Mission, Kans.

4½% Interest. 1978.
Oil on board, 26 x 18½".
Private collection

.40 Cash. 1978.
Oil on board, 28 x 20".
Private collection

Restaurant. 1978.
Oil on board, 24½ x 18".
Private collection

Big Diamonds. 1978.
Oil on board, 24½ x 17¾".
Private collection

Meat Dept. 1978.
Oil on board, 27 x 20".
Private collection

Al Todaro. 1979.
Oil on board, 20 x 15¼".
Private collection

C. Camilla e C. 1979.
Oil on board, 21 x 14½".
Private collection

BIOGRAPHY

1936 Born: Kewanee, Ill.

EDUCATION
1952–56 Chicago Art Institute

SOLO EXHIBITIONS
1968 Allan Stone Gallery, New York
 Hudson River Museum, Yonkers, N.Y.
1969 Allan Stone Gallery, New York
1970 Allan Stone Gallery, New York
1972 Allan Stone Gallery, New York
1974 Allan Stone Gallery, New York
 Museum of Contemporary Art, Chicago
1977 Allan Stone Gallery, New York
1978–79 "Richard Estes: The Urban Landscape," Museum of Fine Arts, Boston;
 Toledo Museum of Art, Ohio; Nelson Gallery, Atkins Museum,
 Kansas City, Mo.; Hirshhorn Museum and Sculpture Garden,
 Smithsonian Institution, Washington, D.C.

SELECTED GROUP EXHIBITIONS
1966 "Ninety-ninth Exhibition," American Watercolor Society, National
 Academy Galleries, New York
1967 "Biennial Exhibition of American Art," Krannert Art Museum,
 University of Illinois, Champaign-Urbana
1968 "Realism Now," Vassar College Art Gallery, Poughkeepsie, N.Y.
 "The Wellington-Ivest Collection," Museum of Fine Arts, Boston
1969 "American Report on the '60s," Denver Art Museum
 "Contemporary American Painting and Sculpture," Krannert Art
 Museum, University of Illinois, Champaign-Urbana
 "Directions 2: Aspects of a New Realism," Akron Art Institute, Ohio;
 Milwaukee Art Center; Contemporary Arts Museum, Houston
 "Painting and Sculpture Today, 1969," Indianapolis Museum of Art
 "Painting from the Photograph," Riverside Museum, New York
 "Thirty-fourth Annual Mid-Year Show," Butler Institute of American Art,
 Youngstown, Ohio
1970 "American Painting 1970," Virginia Museum of Fine Arts, Richmond
 "Centennial Exhibit," Indiana State University, Indianapolis
 "Cool Realism," Albright-Knox Art Gallery, Buffalo, N.Y.
 "Cool Realism," Everson Museum of Art, Syracuse, N.Y.
 "The Cool Realists," Jack Glenn Gallery, Corona del Mar, Calif.
 "Directly Seen—New Realism in California," Newport Harbor Art
 Museum, Balboa, Calif.
 "The Highway," Institute of Contemporary Art, University of
 Pennsylvania, Philadelphia; Institute for the Arts, Rice University,
 Houston; Akron Art Institute, Ohio
 "New Realism 1970," Headley Hall Gallery, St. Cloud State College,
 Minn.
 "Painting and Sculpture Today, 1970," Indianapolis Museum of Art
 "Twenty-two Realists," Whitney Museum of American Art, New York
1971 "Art Around the Automobile," Emily Lowe Gallery, Hofstra University,
 Hempstead, N.Y.
 "Art of the 1960s," Sammlung Ludwig, Wallraf-Richartz Museum,
 Cologne
 "Contemporary Selections 1971," Birmingham Museum of Art, Ala.
 National Academy of Design, New York
 "Neue amerikanische Realisten," Galerie de Gestlo, Hamburg
 "New Realism," State University College, Potsdam, N.Y.
 "New Realism, Old Realism," Bernard Danenberg Gallery, New York
 "Radical Realism," Museum of Contemporary Art, Chicago
 "Thirty-second Biennial Exhibition of Contemporary American
 Painting," Corcoran Gallery of Art, Washington, D.C.
 "Selected Painters," Mulvane Art Center of Topeka, Kans.
 "Whitney Annual," Whitney Museum of American Art, New York
1972 "Colossal Scale," Sidney Janis Gallery, New York
 "Documenta and No-Documenta Realists," Galerie de Gestlo,
 Hamburg
 "Documenta 5," Kassel, West Germany
 "L'Hyperréalistes américains," Galerie des Quatre Mouvements, Paris
 "Phases of the New Realism," Lowe Art Museum, University of Miami,
 Coral Gables, Fla.

"The Realist Revival," New York Cultural Center, New York
"Seventieth American Exhibition," Art Institute of Chicago
"Sharp-Focus Realism," Sidney Janis Gallery, New York
"Thirty-sixth International Biennial Exhibition," Venice
"Whitney Annual," Whitney Museum of American Art, New York
1972–73 "Amerikanischer Fotorealismus," Württembergischer Kunstverein,
 Stuttgart; Frankfurter Kunstverein, Frankfurt; Kunst und
 Museumsverein, Wuppertal, West Germany
1973 "American Art—Third Quarter Century," Seattle Art Museum
 "Amerikansk Realism," Galleri Ostergren, Malmö, Sweden
 "Art in Evolution," Xerox Square Exhibit Center, Xerox Corporation,
 Rochester, N.Y.
 "East Coast/West Coast/New Realism," University Art Gallery, San Jose
 State University, Calif.
 "The Emerging Real," Storm King Art Center, Mountainville, N.Y.
 Galleria Civica d'Arte Moderna, Turin
 "Grands maîtres hyperréalistes américains," Galerie des Quatre
 Mouvements, Paris
 "Hyperréalistes américains," Galerie Arditti, Paris
 "Iperrealisti americani," Galleria La Medusa, Rome
 "Mit Kamera, Pinsel und Spritzpistole," Ruhrfestspiele Recklinghausen,
 Städtische Kunsthalle, Recklinghausen, West Germany
 "Options 73/30," Contemporary Arts Center, Cincinnati
 "Photo-Realism," Serpentine Gallery, London
 "The Super-Realist Vision," DeCordova and Dana Museum, Lincoln,
 Mass.
 "Twenty-five Years of American Painting," Des Moines Art Center, Iowa
1973–74 "Hyperréalisme," Galerie Isy Brachot, Brussels
1973–78 "Photo-Realism 1973: The Stuart M. Speiser Collection," traveling
 exhibition: Louis K. Meisel Gallery, New York; Herbert F. Johnson
 Museum of Art, Ithaca, N.Y.; Memorial Art Gallery of the University
 of Rochester, N.Y.; Addison Gallery of American Art, Andover,
 Mass.; Allentown Art Museum, Pa.; University of Colorado
 Museum, Boulder; University Art Museum, University of Texas,
 Austin; Witte Memorial Museum, San Antonio, Tex.; Gibbes Art
 Gallery, Charleston, S.C.; Brooks Memorial Art Gallery, Memphis,
 Tenn.; Krannert Art Museum, University of Illinois, Champaign-
 Urbana; Helen Foresman Spencer Museum of Art, University of
 Kansas, Lawrence; Paine Art Center and Arboretum, Oshkosh, Wis.;
 Edwin A. Ulrich Museum, Wichita State University, Kans.; Tampa
 Bay Art Center, Tampa, Fla.; Rice University, Sewall Art Gallery,
 Houston; Tulane University Art Gallery, New Orleans; Smithsonian
 Institution, Washington, D.C.
1974 "Amerikaans fotorealisme grafiek," Hedendaagse Kunst, Utrecht; Palais
 des Beaux-Arts, Brussels
 "Ars '74 Ateneum," Fine Arts Academy of Finland, Helsinki
 "Art 5 '74," Basel, Switzerland
 "Contemporary American Paintings from the Lewis Collection,"
 Delaware Art Museum, Wilmington
 "Hyperréalistes américains—réalistes européens," Centre National
 d'Art Contemporain, Paris
 "Kijken naar de werkelijkheid," Museum Boymans–van Beuningen,
 Rotterdam
 "New Images: Figuration in American Painting," Queens Museum,
 Flushing, N.Y.
 "New Photo-Realism," Wadsworth Atheneum, Hartford, Conn.
 "Seventy-first American Exhibition," Art Institute of Chicago
 "Three Realists: Close, Estes, Raffael," Worcester Art Museum, Mass.
 "Tokyo Biennale, '74," Tokyo Metropolitan Museum of Art; Kyoto
 Municipal Museum; Aichi Prefectural Art Museum, Nagoya
 "Twelve American Painters," Virginia Museum of Fine Arts, Richmond
 "Twenty-five Years of Janis: Part II," Sidney Janis Gallery, New York
1975 "Photo-Realists," Louis K. Meisel Gallery, New York
 "Realismus und Realität," Kunsthalle, Darmstadt, West Germany
 "Trends in Contemporary American Realist Painting," Museum of Fine
 Arts, Boston
 "Watercolors and Drawings—American Realists," Louis K. Meisel
 Gallery, New York
1976 "Alumni Exhibition," School of the Art Institute, Chicago
 "America as Art," National Collection of Fine Arts, Smithsonian

Institution, Washington, D.C.

"American Master Drawings and Watercolors (Works on Paper from Colonial Times to the Present)," Whitney Museum of American Art, New York

"Art 7 '76," Basel, Switzerland

"A Selection of American Art, The Skowhegan School 1946–1976," Institute of Contemporary Art, Boston; Colby Museum of Art, Waterville, Maine

"Seventy-second American Exhibition," Chicago Art Institute

"Super Realism," Baltimore Museum of Art

"Three Decades of American Art," Seibu Museum of Art, Tokyo

"Urban Aesthetics," Queens Museum, Flushing, N.Y.

1976–77 "Photo-Realism in Painting," Art and Culture Center, Hollywood, Fla.; Museum of Fine Arts, St. Petersburg, Fla.

1976–78 "America 1976," Corcoran Gallery of Art, Washington, D.C.; Wadsworth Atheneum, Hartford, Conn.; Fogg Art Museum, Cambridge, and Institute of Contemporary Art, Boston, Mass.; Minneapolis Institute of Arts, Minn.; Milwaukee Art Center; Fort Worth Art Museum, Tex.; San Francisco Museum of Modern Art; High Museum of Art, Atlanta; Brooklyn Museum, New York

"Aspects of Realism," traveling exhibition sponsored by Rothman's of Pall Mall Canada, Ltd.: Stratford, Ont.; Centennial Museum, Vancouver, B.C.; Glenbow-Alberta Institute, Calgary, Alta.; Mendel Art Gallery, Saskatoon, Sask.; Winnipeg Art Gallery, Man.; Edmonton Art Gallery, Alta.; Art Gallery, Memorial University of Newfoundland, St. John's; Confederation Art Gallery and Museum, Charlottetown, P.E.I.; Musée d'Art Contemporain, Montreal, Que.; Dalhousie University Museum and Gallery, Halifax, N.S.; Windsor Art Gallery, Ont.; London Public Library and Art Museum and McIntosh Memorial Art Gallery, University of Western Ontario; Art Gallery of Hamilton, Ont.

1977 "New Acquisitions Exhibition," Museum of Modern Art, New York

"New Realism," Jacksonville Art Museum, Fla.

"New Realism: Modern Art Form," Boise Gallery of Art, Idaho

"Photo-Realists," Shore Gallery, Boston

"A View of a Decade," Museum of Contemporary Art, Chicago

"Washington International Art Fair," Washington, D.C.

"Whitney Biennial Exhibition," Whitney Museum of American Art, New York

"Works on Paper II," Louis K. Meisel Gallery, New York

1977–78 "Illusion and Reality," Australian touring exhibition: Australian National Gallery, Canberra; Western Australian Art Gallery, Perth; Queensland Art Gallery, Brisbane; Art Gallery of New South Wales, Sydney; Art Gallery of South Australia, Adelaide; National Gallery of Victoria, Melbourne; Tasmanian Museum and Art Gallery, Hobart

1978 "Art About Art," Whitney Museum of American Art, New York; North Carolina Museum of Art, Raleigh; Frederick S. Wight Art Gallery, University of California, Los Angeles; Portland Art Museum, Oreg.

"Art and the Automobile," Flint Institute of Arts, Mich.

Monmouth Museum, Lincroft, N.J.

"Photo-Realism and Abstract Illusionism," Arts and Crafts Center, Pittsburgh, Pa.

"Photo-Realist Printmaking," Louis K. Meisel Gallery, New York

Tolarno Galleries, Melbourne, Australia

"Works by Living Artists from the Collection of Mr. and Mrs. Leigh Block," Santa Barbara Museum of Art, Calif.

1979 "America in the 70s As Depicted by Artists in the Richard Brown Baker Collection," Meadowbrook Art Gallery, Oakland University, Rochester, Mich.

"The Opposite Sex: A Realistic Viewpoint," University of Missouri Art Gallery, Kansas City

"Selections of Photo-Realist Paintings from N.Y.C. Galleries," Southern Alleghenies Museum of Art, St. Francis College, Loretto, Pa.

Washington International Art Fair, Washington, D.C.

SELECTED BIBLIOGRAPHY

CATALOGUES

American Watercolor Society Ninety-ninth Annual Exhibition. National Academy Galleries, New York, Apr. 7–24, 1966.

Biennial Exhibition of American Art. Krannert Art Museum, University of Illinois, Champaign-Urbana, 1967.

Nochlin, Linda. "The New Realists," *Realism Now.* Vassar College Art Gallery, Poughkeepsie, N.Y., May 8–June 21, 1968.

Taylor, John Lloyd, and Atkinson, Tracy. Introduction to *Directions 2: Aspects of a New Realism.* Milwaukee Art Center, June 28–Aug. 10, 1969; Contemporary Arts Museum, Houston, Sept. 17–Oct. 19, 1969; Akron Art Institute, Ohio, Nov. 9–Dec. 14, 1969.

Thirty-fourth Annual Mid-Year Show. Butler Institute of American Art, Youngstown, Ohio, June 29–Sept. 1, 1969.

Warrum, Richard L. Introduction to *Painting and Sculpture Today, 1969.* Indianapolis Museum of Art, May, 1969.

Farb, Oriole. Introduction to *Paintings from the Photograph.* Riverside Museum, New York, Dec. 9, 1969–Feb. 15, 1970.

Brown, Denise Scott, and Venturi, Robert. Introduction to *The Highway.* Institute of Contemporary Art, University of Pennsylvania, Philadelphia, Jan. 14–Feb. 25, 1970; Institute for the Arts, Rice University, Houston, Mar. 12–May 18, 1970; Akron Art Institute, Ohio, June 5–July 16, 1970.

Directly Seen—New Realism in California. Newport Harbor Art Museum, Balboa, Calif., 1970.

Monte, James. Introduction to *Twenty-two Realists.* Whitney Museum of American Art, New York, Feb., 1970.

Selz, Peter. Introduction to *American Painting 1970.* Foreword by James M. Brown. Virginia Museum of Fine Arts, Richmond, May 4–June 7, 1970.

Wallin, Lee. Introduction to *New Realism, 1970.* St. Cloud State College, Minn., Feb. 13–Mar. 11, 1970.

Warrum, Richard L. Introduction to *Painting and Sculpture Today, 1970.* Foreword by Robert J. Rohn. Indianapolis Museum of Art, May, 1970.

Art Around the Automobile. Emily Lowe Gallery, Hofstra University, Hempstead, New York, June–Aug., 1971.

Baur, I. H. Foreword to *1971 Annual Exhibition.* Whitney Museum of American Art, New York, Feb., 1971.

Goldsmith, Benedict. *New Realism.* Brainerd Hall Art Gallery, State University College, Potsdam, N.Y., Nov. 5–Dec. 12, 1971.

Hopps, Walter. Introduction to *Thirty-second Biennial Exhibition of Contemporary American Painting.* Corcoran Gallery of Art, Washington, D.C., Feb. 28–Apr. 4, 1971.

Karp, Ivan C. Introduction to *Radical Realism.* Museum of Contemporary Art, Chicago, May 22–June 4, 1971.

Weiss, Evelyn. Introduction to *Art of the 1960s, Sammlung Ludwig.* Foreword by Peter Ludwig and Horst Keller. Wallraf-Richartz Museum, Cologne, 1971.

Abadie, Daniel. Introduction to *Hyperréalistes américains.* Galerie des Quatre Mouvements, Paris, Oct. 25–Nov. 25, 1972.

Amman, Jean Christophe. Introduction to *Documenta 5.* Neue Galerie and Museum Fridericianum, Kassel, West Germany, June 30–Oct. 8, 1972.

Baratte, John J., and Thompson, Paul E. *Phases of the New Realism.* Lowe Art Museum, University of Miami, Coral Gables, Fla., Jan. 20–Feb. 20, 1972.

Baur, I. H. Foreword to *1972 Annual Exhibition.* Whitney Museum of American Art, New York, Jan. 25–Mar. 19, 1972.

Colossal Scale. Sidney Janis Gallery, New York, Mar., 1972.

Janis, Sidney. Introduction to *Sharp Focus Realism.* Sidney Janis Gallery, New York, Jan. 6–Feb. 4, 1972.

Speyer, James A. Introduction to *Seventieth American Exhibition.* Art Institute of Chicago, June 24–Aug. 20, 1972.

Burton, Scott. *The Realist Revival.* New York Cultural Center, New York, Dec. 6, 1972–Jan. 7, 1973.

Schneede, Uwe, and Hoffman, Heinz. Introduction to *Amerikanischer Fotorealismus.* Württembergischer Kunstverein, Stuttgart, Nov. 16–Dec.

26, 1972; Frankfurter Kunstverein, Frankfurt, Jan. 6–Feb. 18, 1973; Kunst und Museumsverein, Wuppertal, West Germany, Feb. 25–Apr. 8, 1973.

Alloway, Lawrence. Introduction to *Amerikansk Realism*. Galleri Ostergren, Malmö, Sweden, Sept. 8–Oct. 14, 1973.

———. Introduction to *Photo-Realism*. Serpentine Gallery, London, Apr. 4 – May 6, 1973.

Becker, Wolfgang. Introduction to *Mit Kamera, Pinsel und Spritzpistole*. Ruhrfestspiele Recklinghausen, Städtische Kunsthalle, Recklinghausen, West Germany, May 4–June 17, 1973.

Boulton, Jack. Introduction to *Options 73/30*. Contemporary Arts Center, Cincinnati, Ohio, Sept. 25–Nov. 11, 1973.

C. A. B. S. Introduction to *Realisti iperrealisti*. Galleria La Medusa, Rome, Nov. 12, 1973.

Combattimento per un'immagine. Galleria Civica d'Arte Moderna, Turin, Mar. 4, 1973.

Dali, Salvador. Introduction to *Grands maîtres hyperréalistes américains*, Galerie des Quatre Mouvements, Paris, May 23–June 25, 1973.

Hogan, Carroll Edwards. Introduction to *Hyperréalistes américains*. Galerie Arditti, Paris, Oct. 16–Nov. 30, 1973.

Iperrealisti americani. Galleria La Medusa, Rome, Jan. 2, 1973.

Kozloff, Max. *Twenty-five Years of American Painting*. Des Moines Art Center, Iowa, Mar. 6–Apr. 22, 1973.

Lamagna, Carlo. Foreword to *The Super Realist Vision*. DeCordova and Dana Museum, Lincoln, Mass., Oct. 7–Dec. 9, 1973.

Meisel, Louis K. *Photo-Realism 1973: The Stuart M. Speiser Collection*. New York, 1973.

Radde, Bruce. Introduction to *East Coast/West Coast/New Realism*. University Art Gallery, San Jose State University, Calif., Apr. 24–May 18, 1973.

Sims, Patterson. Introduction to *Realism Now*. Katonah Gallery, Katonah, N.Y., May 20–June 24, 1973.

Sorce, Anthony John. Introduction to *Art in Evolution*. Xerox Corporation, Rochester, N.Y., May, 1973.

Van der Marck, Jan. *American Art: Third Quarter Century*. Foreword by Thomas N. Maytham and Robert B. Dootson. Seattle Art Museum, Aug. 22–Oct. 14, 1973.

Becker, Wolfgang. Introduction to *Kunst nach Wirklichkeit*. Kunstverein Hannover, West Germany, Dec. 9, 1973–Jan. 27, 1974.

Hyperréalisme. Galerie Isy Brachot, Brussels, Dec. 14, 1973–Feb. 9, 1974.

Amerikaans fotorealisme grafiek. Hedendaagse Kunst, Utrecht, Aug., 1974; Palais des Beaux-Arts, Brussels, Sept.–Oct., 1974

Chase, Linda. "Photo-Realism." In *Tokyo Biennale 1974*. Tokyo Metropolitan Museum of Art; Kyoto Municipal Museum; Aichi Prefectural Art Museum, Nagoya, 1974.

Clair, Jean; Abadie, Daniel; Becker, Wolfgang; and Restany, Pierre. Introductions to *Hyperréalistes américains—réalistes européens*. Centre National d'Art Contemporain, Paris, Archives 11/12, Feb. 15–Mar. 31, 1974.

Cowart, Jack. *New Photo-Realism*. Wadsworth Atheneum, Hartford, Conn., Apr. 10–May 19, 1974.

Gaines, William. Introduction to *Twelve American Painters*. Foreword by James M. Brown. Virginia Museum of Fine Arts, Richmond, Sept. 30–Oct. 27, 1974.

Kijken naar de Werkelijkheid. Museum Boymans–van Beuningen, Rotterdam, June 1–Aug. 18, 1974.

Sarajas-Korte, Salme. Introduction to *Ars '74 Ateneum*. Fine Arts Academy of Finland, Helsinki, Feb. 15–Mar. 31, 1974.

Shulman, Leon. *Three Realists: Close, Estes, Raffael*. Worcester Art Museum, Mass., Feb. 27–Apr. 7, 1974.

Speyer, James A. Introduction to *Seventy-first American Exhibition*. Art Institute of Chicago, June 15–Aug. 11, 1974.

Tatistcheff, Peter, and Schneider, Janet. Introduction to *New Images: Figuration in American Painting*. Queens Museum, Flushing, N.Y., Nov. 16–Dec. 29, 1974.

Twenty-five Years of Janis: Part II from Pollack to Pop, Op and Sharp Focus Realism. Sidney Janis Gallery, New York, Mar. 13–Apr. 13, 1974.

Walthard, Dr. Frederic P. Foreword to *Art 5 '74*. Basel, Switzerland, June 19–24, 1974.

Wyrick, Charles, Jr. Introduction to *Contemporary American Paintings from the Lewis Collection*. Delaware Art Museum, Wilmington, Sept. 13–Oct. 17, 1974.

Krimmel, Bernd. Introduction to *Realismus und Realität*. Foreword by H. W. Sabais. Kunsthalle, Darmstadt, West Germany, May 24–July 6, 1975.

Meisel, Susan Pear. *Watercolors and Drawings—American Realists*. Louis K. Meisel Gallery, New York, Jan., 1975.

Richardson, Brenda. Introduction to *Super Realism*. Baltimore Museum of Art,

Nov. 18, 1975–Jan. 11, 1976.

Armstrong, Thomas N., III. *Three Decades of American Art*. Seibu Museum of Art, Tokyo, June 18–July 20, 1976.

Schneider, Janet. *Urban Aesthetics*. Queens Museum, Flushing, N.Y., Jan. 17–Feb. 29, 1976.

Speyer, James A., and Rorimer, Ann. *Seventy-second American Exhibition*. Art Institute of Chicago, Mar. 13–May 9, 1976.

Taylor, Joshua C. Introduction to *America as Art*. National Collection of Fine Arts, Smithsonian Institution, Washington, D.C., 1976.

Walthard, Dr. Frederic P. Introduction to *Art 7 '76*. Basel, Switzerland, June 16–21, 1976.

Hicken, Russell Bradford. Introduction to *Photo-Realism in Painting*. Art and Culture Center, Hollywood, Fla., Dec. 3, 1976–Jan. 10, 1977; Museum of Fine Arts, St. Petersburg, Fla., Jan. 21–Feb. 25, 1977.

Chase, Linda. "U.S.A." In *Aspects of Realism*. Rothman's of Pall Mall Canada, Ltd., June, 1976–Jan., 1978.

Kleppe, Thomas S.; Rosenblum, Robert; and Welliver, Neil. *America 1976*. Corcoran Gallery of Art, Washington, D.C., Apr. 27–June 6, 1976; Wadsworth Atheneum, Hartford, Conn., July 4–Sept. 12, 1976; Fogg Art Museum, Cambridge, and Institute of Contemporary Art, Boston, Mass., Oct. 19–Dec. 7, 1976; Minneapolis Institute of Arts, Minn., Jan 16–Feb. 27, 1977; Milwaukee Art Center, Mar. 19–May 15, 1977; Fort Worth Art Museum, Tex., June 18–Aug. 14, 1977; San Francisco Museum of Modern Art, Sept. 10–Nov. 13, 1977; High Museum of Art, Atlanta, Dec. 10, 1977–Feb. 5, 1978; Brooklyn Museum, New York, Mar. 11–May 21, 1978.

Dempsey, Bruce. *New Realism*. Jacksonville Art Museum, Fla., 1977.

Felluss, Elias A. Foreword to *Washington International Art Fair*. Washington, D.C., 1977.

Friedman, Martin; Pincus-Witten, Robert; and Gay, Peter. *A View of a Decade*. Museum of Contemporary Art, Chicago, 1977.

Haskell, Barbara, and Tucker, Marcia. Introduction to *1977 Biennial Exhibition*. Whitney Museum of American Art, New York, Feb. 19–Apr. 3, 1977.

Karp, Ivan. Introduction to *New Realism: Modern Art Form*. Boise Gallery of Art, Idaho, Apr. 14–May 29, 1977.

Stringer, John. Introduction to *Illusion and Reality*. Australian Gallery Directors' Council, North Sydney, N.S.W., 1977-78.

Hodge, G. Stuart. Foreword to *Art and the Automobile*. Flint Institute of Arts, Mich., Jan. 12–Mar. 12, 1978.

Mead, Katherine Harper. Introduction to *Works by Living Artists from the Collection of Mr. and Mrs. Leigh Block*. Santa Barbara Museum of Art, Calif., Feb. 11–Apr. 9, 1978.

Meisel, Susan Pear. Introduction to *The Complete Guide to Photo-Realist Printmaking*. Louis K. Meisel Gallery, New York, Dec., 1978.

Canaday, John. Introduction to *Richard Estes: The Urban Landscape*. Foreword by John Arthur. Museum of Fine Arts, Boston, May 31–Aug. 6, 1978; Toledo Museum of Art, Ohio, Sept. 10–Oct. 22, 1978; Nelson Gallery–Atkins Museum, Kansas City, Mo., Nov. 9–Dec. 31, 1978; Hirshhorn Museum and Sculpture Garden, Smithsonian Institution, Washington, D.C., Jan. 25–Apr. 1, 1979.

Felluss, Elias A. Introduction to *Washington International Art Fair '79*, Washington, D.C., May, 1979.

Stokes, Charlotte. "As Artists See It: America in the 70s." In *America in the 70s As Depicted by Artists in the Richard Brown Baker Collection*. Meadowbrook Art Gallery, Oakland University, Rochester, Mich., Nov. 18–Dec. 16, 1979.

Streuber, Michael. Introduction to *Selections of Photo-Realist Paintings from N.Y.C. Galleries*. Southern Alleghenies Museum of Art, St. Francis College, Loretto, Pa., May 12–July 8, 1979.

ARTICLES

Constable, Rosalind. "Style of the Year: The Inhumanists," *New York Magazine*, vol. 1, no. 37 (Dec. 16, 1968), pp. 44–50, cover illustration.

Levin, Kim. "Reviews and Previews," *ARTnews*, vol. 67, no. 1 (Apr., 1968), p. 12.

Alloway, Lawrence. "Art," *The Nation*, Dec. 29, 1969, pp. 741–42.

Baumgold, Julie, ed. "Best Bets," *New York Magazine*, Dec. 8, 1969.

Benedict, Michael. "Reviews and Previews," *ARTnews*, vol. 68, no. 1 (Mar., 1969), p. 17.

Brumer, Miriam. "In the Galleries," *Arts Magazine*, vol. 43, no. 4 (Feb., 1969), p. 58.

Burton, Scott. "Generation of Light, 1945–1969," *ARTnews Annual 35* (Newsweek, Inc.), 1969, pp. 20–23.

Canaday, John. "Realism: Waxing or Waning?," *New York Times*, July 13,

1969, sec. 2, p. 27.

Gaynor, Frank. "Photographic Exhibit Depicts Today's U.S.," *Newark Sunday News,* Dec. 14, 1969, sec. 6, p. E18.

Schjeldahl, Peter. "The Flowering of the Super-Real," *New York Times,* Mar. 2, 1969, sec. 2, pp. D31, D33.

Shirey, David L. "The Gallery: It's Happening Out There," *Wall Street Journal,* Apr. 13, 1969, p. 14.

"Super Realism," *Life,* vol. 66, no. 25 (June 27, 1969), pp. 44–50A.

Tillim, Sidney. "A Variety of Realisms," *Artforum,* vol. 7, no. 10 (Summer, 1969), pp. 42–47.

Alloway, Lawrence. "In the Museums: Paintings from the Photo," *Arts Magazine,* Dec. 1, 1970.

Davis, Douglas. "Return of the Real: Twenty-two Realists on View at New York's Whitney," *Newsweek,* Feb. 23, 1970, p. 105.

Deschin, Jacob. "Photo into Painting," *New York Times,* Jan. 4, 1970.

Genauer, Emily. "On the Arts," *Newsday.* (Long Island, N.Y.), Feb. 21, 1970.

Gruen, John. "The Extended Vision," *New York Magazine,* Jan. 12, 1970.

———. "The Imported Dream, Richard Estes," *New York Magazine,* Apr. 20, 1970, p. 54.

Lichtblau, Charlotte. "Painters Use of Photographs Explored," *Philadelphia Enquirer,* Feb. 1, 1970.

Nemser, Cindy. "Presenting Charles Close," *Art in America,* Jan., 1970, pp. 98–101.

Nordstrom, Sherry C. "Reviews and Previews," *ARTnews,* vol. 69, no. 3 (May, 1970), p. 28.

Ratcliff, Carter. "Twenty-two Realists Exhibit at the Whitney," *Art International,* Apr., 1970, p. 105.

Stevens, Carol. "Message into Medium: Photography as an Artist's Tool," *Print,* vol. XXIV, no. III (May 6, 1970), pp. 54–59.

Stevens, Elizabeth. "The Camera's Eye on Canvas," *Wall Street Journal,* Jan. 6, 1970.

"Visual Arts," *Annual Report,* National Endowment of the Arts/National Council on the Arts, 1970.

Genauer, Emily. "Art '72: The Picture Is Brighter," *New York Post,* Dec. 31, 1971.

Marandel, J. Patrice. "The Deductive Image: Notes on Some Figurative Painters," *Art International,* Sept., 1971, pp. 58–61.

Sager, Peter. "Neue Formen des Realismus," *Magazin Kunst,* 4th Quarter, 1971, pp. 2512–16.

Amman, Jean Christophe. "Realismus," *Flash Art,* May–July, 1972, pp. 50–52.

Borden, Lizzie. "Cosmologies," *Artforum,* Oct., 1972, pp. 45–50.

Borsick, Helen. "Realism to the Fore," *Cleveland Plain Dealer,* Oct. 8, 1972.

Canaday, John. "A Critic's Valedictory: The Americanization of Modern Art and Other Upheavals," *New York Times,* Aug. 8, 1972, sec. 2, pp. 1, 23.

Chase, Linda; Foote, Nancy; and McBurnett, Ted. "The Photo-Realists: 12 Interviews," *Art in America,* vol. 60, no. 6 (Nov.–Dec., 1972), pp. 73–89.

"Cityscape," *Arts Magazine,* Mar., 1972, p. 57.

Davis, Douglas. "Art Is Unnecessary. Or Is It?," *Newsweek,* July 17, 1972, pp. 68–69.

———. "Nosing Out Reality," *Newsweek,* Aug. 14, 1972, p. 58.

"Documenta 5," *Frankfurter Allgemeine Zeitung,* no. 155 (July 8, 1972).

"Documenta Issue," *Zeit Magazin,* no. 31/4 (Aug., 1972), pp. 4–15.

Henry, Gerrit. "The Real Thing," *Art International,* vol. XVI, no. 6 (Summer, 1972), pp. 87–91, 194.

Hickey, David. "New York Reviews," *Art in America,* vol. 60, no. 2 (Mar.–Apr., 1972), pp. 116–18.

———. "Previews," *Art in America,* Jan.–Feb., 1972, pp. 37–38.

"Les hommes et les oeuvres," *La Galerie,* no. 120 (Oct., 1972), pp. 16–17.

Hughes, Robert. "The Realist as Corn God," *Time,* Jan. 31, 1972, pp. 50–55.

"Hyperréalisme arrive à Paris," *Argus de la Presse,* Nov., 1972.

"L'hyperréalisme ou le retour aux origines," *Argus de la Presse,* Oct. 16, 1972.

Karp, Ivan. "Rent Is the Only Reality, or the Hotel Instead of the Hymn," *Arts Magazine,* Dec., 1972, pp. 47–51.

Kramer, Hilton. "And Now, Pop Art: Phase II," *New York Times,* Jan. 16, 1972.

Kurtz, Bruce. "Documenta 5: A Critical Preview," *Arts Magazine,* Summer, 1972, pp. 34–41.

Lerman, Leo. "Sharp Focus Realism," *Mademoiselle,* Mar., 1972, pp. 170–73.

Levequi, J. J. "Les hommes et les oeuvres," *Argus de la Presse,* Oct., 1972.

Lista, Giovanni. "Iperrealisti americani," *NAC* (Milan), no. 12 (Dec., 1972), pp. 24–25.

Lubell, Ellen. "In the Galleries," *Arts Magazine,* vol. 46, no. 7 (May, 1972), pp. 67–68.

"Les malheurs de l'Amérique," *Le Nouvel Observateur,* Nov. 6, 1972.

Marvel, Bill. "Saggy Nudes? Giant Heads? Make Way for 'Superrealism,'" *National Observer,* Jan. 29, 1972, p. 22.

Naimer, Lucille. "The Whitney Annual," *Arts Magazine,* Mar., 1972, p. 54.

Nemser, Cindy. "New Realism," *Arts Magazine,* Nov., 1972, p. 85.

"La nouvelle coqueluche: l'hyperréalisme," *L'Express,* Oct. 30, 1972.

"Novedades desde Paris," *El Dia,* Dec. 17, 1972.

Perreault, John. "Reports, Forecasts, Surprises and Prizes," *Village Voice,* Jan. 6, 1972, pp. 21–24.

———. "The Hand Was Colossal But Small," *Village Voice,* Mar. 23, 1972, p. 72.

Pozzi, Lucio. "Super realisti U.S.A.," *Bolaffiarte,* no. 18 (Mar., 1972), pp. 54–63.

Rose, Barbara. "Real, Realer, Realist," *New York Magazine,* vol. 5, no. 5 (Jan. 31, 1972), p. 50.

Rosenberg, Harold. "The Art World," *The New Yorker,* Feb. 5, 1972, pp. 88–93.

Seitz, William C. "The Real and the Artificial: Painting of the New Environment," *Art in America,* Nov.–Dec., 1972, pp. 58–72.

Seldis, Henry J. "Documenta: Art Is Whatever Goes On in Artist's Head," *Los Angeles Times Calendar,* July 9, 1972.

Skowhegan (Maine) *School of Painting and Sculpture Bulletin,* 1972.

Thornton, Gene. "These Must Have Been a Labor of Love," *New York Times,* Jan. 23, 1972.

Wasmuth, E. "La révolte des réalistes," *Connaissance des Arts,* June, 1972, pp.118–23.

Wolmer, Denise. "In the Galleries," *Arts Magazine,* Mar., 1972, p. 57.

Allen, Barbara. "In and Around," *Interview Magazine,* Nov., 1973, p. 36.

Apuleo, Vito. "Tra manifesto e illustrazione sino al rifiuto della scelta," *La voce repubblicana,* Feb. 24, 1973, p. 5.

Art Now Gallery Guide, Sept., 1973, pp. 1–3.

Beardsall, Judy. "Stuart M. Speiser Photorealist Collection," *Art Gallery Magazine,* vol. XVII, no. 1 (Oct., 1973), pp. 5, 29–34.

Becker, Wolfgang. "NY? Realisme?," *Louisiana Revy,* vol. 13, no. 3 (Feb., 1973).

Bell, Jane. "Stuart M. Speiser Collection," *Arts Magazine,* Dec., 1973, p. 57.

Bovi, Arturo di. "Arte/Piú brutto del brutto," *Il Messaggiero,* Feb. 13, 1973, p. 3.

Chase, Linda, and McBurnett, Ted. "Interviews with Robert Bechtle, Tom Blackwell, Chuck Close, Richard Estes and John Salt," *Opus International,* no. 44–45 (June, 1973), pp. 38–50.

Chase, Linda. "Recycling Reality," *Art Gallery Magazine,* Oct., 1973, pp. 75–82.

"Don Eddy," *Art International,* Dec. 20, 1973.

E. D. G. "Arrivano gli iperrealisti," *Tribuna Letteraria,* Feb., 1973.

"European Galleries," *International Herald Tribune,* Feb. 17–18, 1973, p. 6.

"Gallerie," *L'Espresso* (Rome), no. 9 (Mar. 4, 1973).

Giannattasio, Sandra. "Riproduce la vita di ogni giorno la nuova pittura americano," *Avanti,* Feb. 8, 1973, p. 1.

Gilmour, Pat. "Photo-Realism," *Arts Review,* vol. 25 (Apr. 21, 1973), p. 249.

"Goings On About Town," *The New Yorker,* Oct. 1, 1973.

Gosling, Nigel. "The Photo Finish," *Observer Review* (London), Apr. 8, 1973.

Guercio, Antonio del. "Iperrealismo tra 'pop' e informale," *Rinascita,* no. 8 (Feb. 23, 1973), p. 34.

Hart, John. "A 'hyperrealist' U.S. tour at La Medusa," *Daily American* (Rome), Feb. 8, 1973.

Henry, Gerrit. "A Realist Twin Bill," *ARTnews,* Jan., 1973, pp. 26–28.

Hjort, Oysten. "Kunstmiljoeti Rhinlandet," *Louisiana Revy,* vol. 13, no. 3 (Feb., 1973).

"L'hyperréalisme américain," *Le Monde des Grandes Musiques,* no. 2 (Mar.–Apr., 1973), pp. 4, 56–57.

"Hyperréalistes américains," *Art Press,* Dec. 1, 1973, p. 2.

La Mesa, Rina G. "Nel vuoto di emozioni," *Sette Giorni,* Feb. 18, 1973, p. 31.

Levin, Kim. "The New Realism: A Synthetic Slice of Life," *Opus International,* no. 44–45 (June, 1973), pp. 28–37.

Lucie-Smith, Edward. "Super Realism from America," *Illustrated London News,* Mar., 1973.

Maraini, Letizia. "Non fatevi sfuggire," *Il Globo,* Feb. 6, 1973, p. 8.

Marziano, Luciano. "Iperrealismo: la coagulazione dell'effimero," *Il Margutta* (Rome), no. 3–4 (Mar.–Apr., 1973).

Melville, Robert. "The Photograph as Subject," *Architectural Review,* vol. CLIII, no. 915 (May, 1973), pp. 329–33.

Micacchi, Dario. "La ricerca degli iperrealisti," *Unità,* Feb. 12, 1973.

Michael, Jacques. "Le super-réalisme," *Le Monde,* Feb. 6, 1973, p. 23.

Moulin, Raoul-Jean. "Hyperréalistes américains," *L'Humanité,* Jan. 16, 1973.

Palazzoli, Daniel, and Mazzoletti, Raffaello. "Da Daguerre a Warhol," *Arte* (Milan), Mar., 1973, pp. 25–35, 93–94.

Perreault, John. "Airplane Art in a Head Wind," *Village Voice,* Oct. 4, 1973, p. 24.

Piradel, Jean-Louis. "Paris I: hyperréalistes américains," *Opus International,* no. 39 (1973), pp. 51–52.

"Realism Now," *Patent Trader,* May 26, 1973, p. 7A.

Restany, Pierre. "Sharp Focus: La continuité réaliste d'une vision américaine," *Domus,* Aug., 1973.

Rubiu, Vittorio. "Il gusto controverso degli iperrealisti," *Corriere della Sera,* Feb. 25, 1973.

Seldis, Henry J. "New Realism: Crisp Focus on the American Scene," *Los Angeles Times,* Jan. 21, 1973, p. 54.

Sherman, Jack. "Art Review: Photo-Realism, Johnson Museum," *Ithaca Journal,* Nov. 13, 1973.

"Specialize and Buy the Best," *Business Week,* Oct. 27, 1973, p. 107.

Trucchi, Lorenza di. "Iperrealisti americani alla Medusa," *Momento-sera,* Feb. 9–10, 1973, p. 8.

Alliata, Vicky. "American Essays on Super-Realism," *Domus,* no. 536 (July, 1974), pp. 52–54.

"ARS '74/Helsinki," *Art International,* May, 1974, pp. 38–39.

Berkman, Florence. "Three Realists: A Cold, Plastic World," *Hartford Times,* Mar. 10, 1974.

Butler, Joseph T. "America (Three Realists: Close, Estes, and Raffael)," *The Connoisseur,* vol. 186, no. 748 (June, 1974), pp. 142–43.

Campbell, Lawrence. "Reviews," *ARTnews,* vol. 73, no. 7 (Sept., 1974), p. 114.

Chase, Linda. "The Connotation of Denotation," *Arts Magazine,* Feb., 1974, pp. 38–41.

Clair, Jean. "Situation des réalismes," *Argus de la Presse,* Apr., 1974.

Coleman, A. D. "From Today Painting Is Dead," *Camera 35,* July, 1974, pp. 34, 36–37, 78.

"Collection of Aviation Paintings at Gallery," *Andover* (Mass.) *Townsman,* Feb. 28, 1974.

Cossitt, F. D. "Current Virginia Museum Show Is One of Best in Years," *Richmond Times Dispatch,* Oct. 6, 1974, sec. H.

Davis, Douglas. "Is Photography Really Art?," *Newsweek,* Oct. 21, 1974, p. 69.

———. "Summing Up the Season," *Newsweek,* July 1, 1974, p. 73.

Deroudille, René. "Réalistes et hyperréalistes," *Derrière Heure Lyonnaise,* Mar. 31, 1974.

"Expositions," *Argus de la Presse,* Mar., 1974.

"Flowers, Planes and Landscapes in New Art Exhibits," *Saturday Times-Union* (Rochester, N.Y.), Jan. 5, 1974.

Frank, Peter. "On Art," *Soho Weekly News,* Apr. 18, 1974, p. 14.

———. "On Art," *Soho Weekly News,* May 16, 1974, pp. 19, 22.

"Gallery Notes," *Memorial Art Gallery of the University of Rochester Bulletin,* vol. 39, no. 5 (Jan., 1974).

Gassiot-Talabor, Gerald. "Le choc des 'réalismes,' " *XXe Siècle,* no. 42 (June, 1974), pp. 25–32.

Gibson, Michael. "Paris Show Asks a Question: What Is Reality?," *International Herald Tribune,* Feb. 23–24, 1974, p. 7.

Hartman, Rose. "In and Around," *Soho Weekly News,* Apr. 18, 1974, p. 4.

Hemphill, Chris. "Estes," *Andy Warhol's Interview,* vol. IV, no. 11 (Oct., 1974), pp. 42–43.

Hughes, Robert. "An Omnivorous and Literal Dependence," *Arts Magazine,* June, 1974, pp. 25–29.

Kelley, Mary Lou. "Pop-Art Inspired Objective Realism," *Christian Science Monitor,* Mar. 1, 1974.

Lascault, Gilbert. "Autour de ce qui se nomme hyperréalisme," *Paris-Normandie,* Mar. 31, 1974.

Levin, Kim. "Audrey Flack at Meisel," *Art in America,* May–June, 1974, p. 106.

Loring, John. "Photographic Illusionist Prints," *Arts Magazine,* Feb., 1974, pp. 42–43.

Lubell, Ellen. "Noel Mahaffey," *Arts Magazine,* June, 1974, p. 62.

Michael, Jacques. "La 'mondialisation' de l'hyperréalisme," *Le Monde,* Feb. 24, 1974.

Moulin, Raoul-Jean. "Les hyperréalistes américains et la neutralisation du réel," *L'Humanité,* Mar. 21, 1974.

Nemser, Cindy. "The Close Up Vision," *Arts Magazine,* vol. 48, no. 5 (Feb., 1974).

Norman, Geraldine. "£21,000 Bright Spot in Sale," *The Times* (London), Dec. 5, 1974.

"The Objects of the Exercise," *Arts Guardian,* Apr. 29, 1974.

Olson, Robert J. M. "Arts Reviews," *Arts Magazine,* vol. 49, no. 1 (Sept., 1974), p. 62.

Perreault, John. "Critics Bogged and Mired," *Village Voice,* May 30, 1974, pp. 33–34.

Picard, Lil. "In...Out...und in Again," *Kunstforum International,* Jan. 2, 1974.

Progresso fotografico, Dec., 1974, pp. 61–62.

Raymond, Herbert. "The Real Estes," *Art and Artists,* vol. 9 (Aug., 1974), pp. 24–29.

Rose, Barbara. "Keeping Up with American Art," *Vogue,* June, 1974.

———. "Treacle and Trash," *New York Magazine,* vol. 7, no. 21 (May 27, 1974), pp. 80–81.

Russell, John. "An Unnatural Silence Pervades Estes Paintings," *New York Times,* May 25, 1974.

Shirey, David. "A New Realism Is on Display at Queens Museum," *New York Times,* Dec. 15, 1974, sec. BQLI, p. 18.

Spear, Marilyn W. "An Art Show That Is for Real," *Worcester* (Mass.) *Telegram,* Feb. 24, 1974, sec. E.

———. "Three Realists Showing at Museum," *Worcester* (Mass.) *Telegram,* Feb. 27, 1974, p. 12.

Spector, Stephen. "The Super Realists," *Architectural Digest,* Nov.–Dec., 1974, pp. 84–89.

Stubbs, Ann. "Audrey Flack," *Soho Weekly News,* Apr. 4, 1974.

Teyssedre, Bernard. "Plus vrai que nature," *Le Nouvel Observateur,* Feb. 25–Mar. 3, 1974, p. 59.

Virginia Museum of Fine Arts Bulletin, vol. XXXV, no. 1 (Sept., 1974).

Walsh, Sally. "Paintings That Look Like Photos," *Rochester Democrat and Chronicle,* Jan. 17, 1974.

"Worcester Art Museum Hosts Major Painting Exhibition," *Hudson-Sun/Enterprise-Sun* (Worcester, Mass.), Feb. 26, 1974.

Crossley, Mimi. "Best Collection Shows Certain Life Style," *Houston Post,* Sept. 14, 1975.

Hull, Roger. "Realism in Art Returns with Camera's Clarity," *Portland Oregonian,* Sept. 14, 1975.

Lucie-Smith, Edward. "The Neutral Style," *Art and Artists,* vol. 10, no. 5 (Aug., 1975), pp. 6–15.

"Photographic Realism," *Art-Rite,* no. 9 (Spring, 1975), p. 15.

"Photo-Realism Exhibit Is Opening at Paine Sunday," *Oshkosh Daily Northwestern,* Apr. 17, 1975.

"Photo-Realism Flies High at Paine," *Milwaukee Journal,* May, 1975.

"Photo-Realists at Paine," *View Magazine,* Apr. 27, 1975.

Preston, Malcolm. "The Artistic Eye Takes a New Look at the Cityscape," *Newsday* (Long Island, N.Y.), Feb. 19, 1975, p. 11.

Richard, Paul. "Whatever You Call It, Super Realism Comes On with a Flash," *Washington Post,* Nov. 25, 1975, p. B1.

Sutinen, Paul. "American Realism at Reed," *Willamette Week,* Sept. 12, 1975.

Wolfe, Tom. "The Painted Word," *Harper's,* Apr., 1975, pp. 91, 92.

Alloway, Lawrence. "Art," *The Nation,* vol. 222, no. 17 (May 1, 1976).

Artner, Alan. "Mirroring the Merits of a Showing of Photo-Realism," *Chicago Tribune,* Oct. 24, 1976.

Chase, Linda. "Photo-Realism: Post Modernist Illusionism," *Art International,* vol. XX, no. 3–4 (Mar.–Apr., 1976), pp. 14–27.

———. "Richard Estes: Radical Conservative," *New Lugano Review,* vol. 8–9 (1976), pp. 50, 62, 227–28.

Clay, Julien. "Réalité et fantasme de la ville," *XXe Siècle,* no. 45 (Dec., 1976), pp. 78–81.

"Face of the Land," *Time,* July 5, 1976, pp. 78–79.

Forgey, Benjamin. "The New Realism, Paintings Worth 1,000 Words," *Washington Star,* Nov. 30, 1976, p. G24.

Fox, Mary. "Aspects of Realism," *Vancouver Sun,* Sept. 21, 1976.

Fremont, Vincent. "C. J. Yao," *Interview Magazine,* Oct., 1976, p. 36.

Hoelterhoff, Manuela. "Strawberry Tarts Three Feet High," *Wall Street Journal,* Apr. 21, 1976.

K. M. "Realism," *New Art Examiner,* Nov., 1976.

Lucie-Smith, Edward. "Realism Rules: O.K.?," *Art and Artists,* vol. 11, no. 6 (Sept., 1976), pp. 8–15.

McDonald, Robert. "Richard McLean and Robert Cottingham," *Artweek,* Oct. 16, 1976, pp. 3–4.

Patton, Phil. "Books, Super-Realism: A Critical Anthology," *Artforum,* vol. XIV, no. 5 (Jan., 1976), pp. 52–54.

Perreault, John. "Getting Flack," *Soho Weekly News,* Apr. 22, 1976, p. 19.

———. "Photo-Shock," *Soho Weekly News,* Jan. 22, 1976, p. 16.

Perry, Art. "So Much for Reality," *Province,* Sept. 30, 1976.

Rosenblum, Robert. "Painting America First," *Art in America,* Jan.–Feb., 1976, pp. 82–85.

"Works on Paper," *International Herald Tribune,* Feb. 28, 1976.

Greenwood, Mark. "Toward a Definition of Realism: Reflections on the Rothman's Exhibition," *Arts/Canada,* vol. XXIV, no. 210–11 (Dec., 1976–Jan., 1977), pp. 6–23.

Borlase, Nancy. "In Selecting a Common Domestic Object," *Sydney Morning Herald,* July 30, 1977.

Brown, Gordon. "Arts Reviews," *Arts Magazine*, vol. 51, no. 10 (June, 1977), p. 48.

Crossley, Mimi. "Review: Photo-Realism," *Houston Post*, Dec. 9, 1977.

Edelson, Elihu. "New Realism at Museum Arouses Mixed Feelings," *Jacksonville* (Fla.) *Journal*, Feb., 1977.

"Fotorealista Richard Estes ofrece conferencia en bellas artes," *La República* (Rome), Apr. 5, 1977, p. 15.

Glueck, Grace. "The 20th Century Artists Most Admired by Other Artists," *ARTnews*, Nov., 1977.

Grishin, Sasha. "An Exciting Exhibition," *Canberra Times*, Feb. 16, 1977.

Hocking, Ian. "Something for All at Art Gallery," *News Adelaide*, Sept. 7, 1977.

"Illusion and Reality," *This Week in Brisbane*, June, 1977.

Lynn, Elwyn. "The New Realism," *Quadrant*, Sept., 1977.

Makin, Jeffrey. "Realism from the Squad," *Melbourne Sun*, Oct. 19, 1977, p. 43.

McGrath, Sandra. "I Am Almost a Camera," *The Australian* (Brisbane), July 27, 1977.

The Museum of Modern Art Members' Calendar, May, 1977.

Phillips, Ralph. "Just like the Real Thing," *Sunday Mail* (Brisbane), Sept. 11, 1977.

"Photo-Realism and Related Trends," *New York Times*, Feb. 4, 1977.

R. S. "The Museum of Modern Art," *Art in America*, Sept. 10, 1977, pp. 93–96.

"Richard Estes: Woolworth's America," *Artweek*, Apr. 2, 1977, cover.

Ashbery, John. "1976 and All That," *New York Magazine*, Apr. 3, 1978, pp. 63–64.

Bongard, Willie. *Art Aktuell* (Cologne), Apr., 1978.

"Finale," *Bostonia*, Autumn, 1978, p. 48.

Harnett, Lila. "Photo-Realist Prints: 1968–1978," *Cue*, Dec. 22, 1978, p. 23.

Harris, Helen. "Art and Antiques: The New Realists," *Town and Country*, Oct., 1978, pp. 242, 244, 246–47.

Jensen, Dean. "Super Realism Proves a Super Bore," *Milwaukee Sentinel*, Dec. 1, 1978.

Kramer, Hilton. "A Brave Attempt to Encapsulate a Decade," *New York Times*, Dec. 17, 1978, p. 39.

Mackie, Alwynne. "New Realism and the Photographic Look," *American Art Review*, Nov., 1978, pp. 72–79, 132–34.

Muchnic, Suzanne. "A Habit of Romantic Fantasy," *Los Angeles Times*, Mar. 24, 1978, p. 7.

Patton, Phil. "The Brush Is Quicker Than the Eye," *Horizon*, June, 1978, pp. 66–69.

Perreault, John. "Photo Realist Principles," *American Art Review*, Nov., 1978, pp. 108–11, 141.

"Photo Journalism and Photo Realism," *Milwaukee Journal*, Dec. 10, 1978.

Richard, Paul. "New Smithsonian Art: From 'The Sublime' to Photo Realism," *Washington Post*, Nov. 30, 1978, p. G21.

Rodriguez, Joanne Milani. "Art Show Accents the Eccentricities of Camera's Vision," *Tampa Tribune-Times*, Feb. 5, 1978, pp. 1–2.

Harshman, Barbara. "Photo-Realist Printmaking," *Arts*, Feb., 1979, p. 17.

Melcher, Victoria Kirsch. "Vigorous Currents in Realism Make Up Group Show at UMKC," *Kansas City* (Mo.) *Star*, Mar. 11, 1979, p. 3E.

BOOKS

Hunter, Sam. *American Art of the Twentieth Century*. New York: Harry N. Abrams, 1972.

Kultermann, Udo. *New Realism*. New York: New York Graphic Society, 1972.

Brachot, Isy, ed. *Hyperréalisme*. Brussels: Imprimeries F. Van Buggenhoudt, 1973.

Hentzen, Alfred. *Sonderdruck aus Intuition und Kunstwissenschaft*. Berlin: Gebruder Mann Verlag, 1973.

Sager, Peter. *Neue Formen des Realismus*. Cologne: Verlag M. DuMont Schauberg, 1973.

Wilmerding, John, ed. *The Genius of American Painting*. New York: William Morrow, 1973.

L'Iperrealismo italo Medusa. Rome: Romana Libri Alfabeto, 1974.

Battcock, Gregory, ed. *Super Realism, A Critical Anthology*. New York: E. P. Dutton, 1975.

Chase, Linda. *Hyperréalisme*. New York: Rizzoli, 1975.

Kultermann, Udo. *Neue Formen des Bildes*. Tübingen, West Germany: Verlag Ernst Wasmuth, 1975.

Lucie-Smith, Edward. *Late Modern—The Visual Arts Since 1945*. 2d ed. New York: Praeger, 1975.

Honisch, Dieter, and Jensen, Jens Christian. *Amerikanische Kunst von 1945 bis Heute*. Cologne: DuMont Buchverlag, 1976.

Lipman, Jean, and Franc, Helen M. *Bright Stars: American Painting and Sculpture Since 1776*. New York: E. P. Dutton, 1976.

Stebbins, Theodore E., Jr. *American Master Drawings and Watercolors*. New York: Harper & Row, 1976.

Who's Who in American Art. New York: R. R. Bowker, 1976.

Wilmerding, John. *American Art*. Harmondsworth, England: Penguin, 1976.

Arneson, H. H. *History of Modern Art*. New York: Harry N. Abrams, 1977.

Cummings, Paul. *Dictionary of Contemporary American Artists*. 3d ed. New York: St. Martin's Press, 1977.

Lucie-Smith, Edward. *Art Now: From Abstract Expressionism to Superrealism*. New York: William Morrow, 1977.

Rose, Barbara (with Jules D. Brown). *American Painting*. New York: Skira, Rizzoli, 1977.

Tighe, Mary Ann, and Lang, Elizabeth Ewing. *Art America*. New York: McGraw-Hill, 1977.

Adams, Hugh. *Art of the Sixties*. Oxford: Phaidon, 1978.

Lipman, Jean, and Marshall, Richard. *Art About Art*. New York: E. P. Dutton, 1978.

Lucie-Smith, Edward. *Super Realism*. Oxford: Phaidon, 1979.

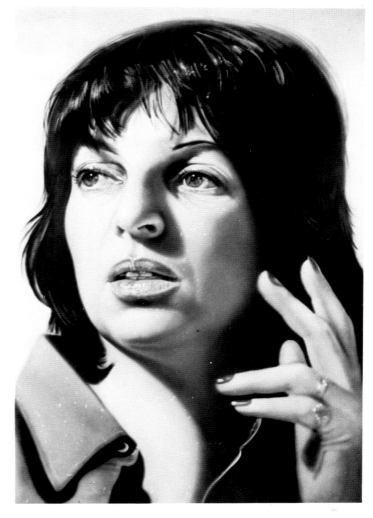

522. *Self-Portrait.* 1974 (31).
Acrylic on canvas, 80 x 64".
Collection Marcus and Irene
Kutter, Switzerland

AUDREY FLACK

Several important facts distinguish Audrey Flack from the other artists in the movement. First, she is the only woman among the dozen or so original Photo-Realists. Then, with the exception of Goings, she is the eldest member of the group. And she is by far the artist most experienced in the New York art scene, having shown her work in New York since 1948. Finally, her *Kennedy Motorcade*, painted in 1964, was the first true Photo-Realist work produced. These points are extremely important in analyzing Flack's work and her career in terms of her background and her objectives.

Flack studied art during the late forties and early fifties at Yale University, which was just introducing those art programs which were to produce some of the greatest artists of the sixties. By the mid-fifties, Flack was deeply involved with the small, elitist world of the Abstract Expressionists, whose influence on the young artists of the time was overwhelming. Amidst the pressure of abstract indoctrination, Flack decided to abandon abstraction and developed as a realist. She has since maintained a realist stance, having determined at that point in her career to make paintings which would attempt to reach all levels of humanity. It was her conviction that, for the purposes of communication, art requires a form of realism with recognizable subject matter and lucid statement. Although this attitude was not always fashionable in contemporary American painting, Flack has steadfastly pursued her goal for more than a quarter of a century. Although she benefited from all that surrounded her, Flack remained a lonely realist in the fifties.

Long before women's liberation and equal rights became major issues of the late sixties, Flack had begun to realize that the art world was a rough one dominated by men. Women simply were not accorded credit for their achievements or, even more distressing, it was assumed that there had never been any important female artists. Flack became aware at one point that she not only faced a struggle in her art, but that

she was also going to be involved in a political struggle, and that the two would become inextricably entwined. In the ensuing years, Flack has painted from a female point of view. It is hard to know if she is interpreting the world as a woman or intentionally politicizing. Suffice it to say that her vision is totally different from that of the other major Photo-Realists, all of whom are men.

Flack and her paintings are charismatic and highly emotional—qualities that at one point were thought to be antithetical to Photo-Realism and more characteristic of Pop Art. Unlike the taciturn Estes, Flack is extremely vocal, with a strong and forceful personality. She has taught, lectured, and set forth her new ideas for almost twenty years.

Spurred by the challenges of art, politics, and life, Flack has determinedly achieved most of her goals, and still has a long career ahead of her. The first Photo-Realist to have a work purchased by the Museum of Modern Art for its permanent collection, Flack is the only member of the group included in the collections of New York's four major art museums: the Metropolitan, the Museum of Modern Art, the Whitney, and the Guggenheim. One of the leading painters of the Photo-Realist movement, she is also regarded as one of the most accomplished still-life painters in contemporary art.

John Russell wrote of Flack's 1976 exhibition:

All students of still life painting are familiar with the "Vanitas": the collection of objects which symbolizes the vanity of terrestrial activities and suggests that we should think more of the next world and less of this one. Braque was the last great painter to make use of this ancient device and we may doubt it is due for renewal.

The case is quite different with greed. Greed in one form or another is the subject of a great many good paintings of our own day, and in Audrey Flack's photo-realist still lives it assumes new and startling dimensions.

These paintings have the particularity that they combine the classic materials of still life—a pear beaded with dew, for instance—with household objects from our own day: chainstore cosmetics, above all. Overcrowding reminiscent of the hey-day of Dutch still life is combined with enlargements of scale and dizzy feats of perspective until the sheer accumulation of visual material leaves us confused and sated. An unspoken cry of "More! Give me more!" could well be the motif of these paintings, which are clearly the work of an artist who is as cunning as she is determined. [From *New York Times*, Apr. 30, 1976. © 1976 by The New York Times Company. Reprinted by permission.]

Russell was astonishingly perceptive in his reference to the Vanitas, the term Flack had already decided to use for her forthcoming series, comprising three paintings to which she was to devote the next two years. It was in this series that the artist reached the epitome of statement and symbolism through still life. Lawrence Alloway's essay, "Audrey Flack—Vanitas," written for the Meisel exhibition catalogue in April, 1978, offers the following summary of the artist's career to date:

In the early sixties Flack belonged to a sketch club that met weekly to draw from the model: its members were Harold Bruder, Samuel Gelber, Philip Pearlstein, and Sidney Tillim. As Flack remembers it, her use of photographs as declared source

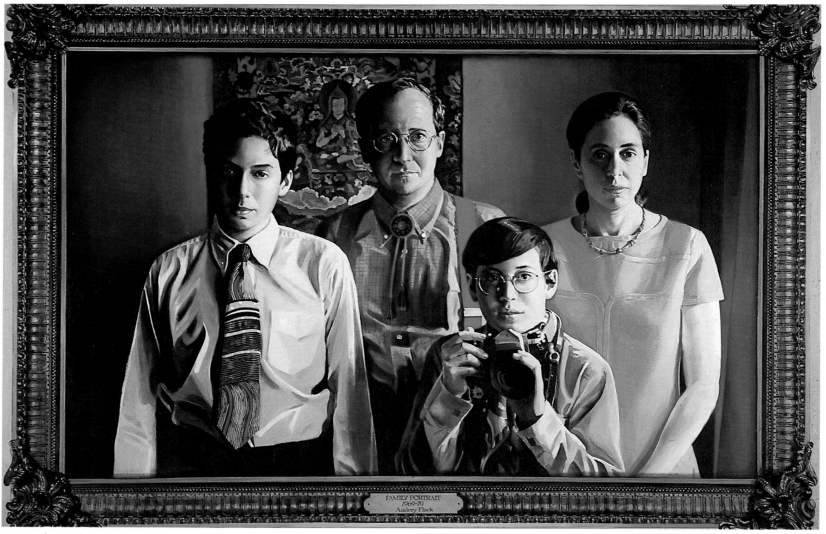

523. *Farb Family Portrait.* 1969–70 (3). Oil on canvas, 40 x 60". Rose Art Museum, Brandeis University, Mass.

material was divisive in the group. Flack painted Kennedy's Motorcade *(the last one),* The Teheran Conference, *and* Hitler. *These political subjects were followed by creamily romantic paintings of film stars, including Marilyn Monroe, the subject of one of the new paintings. In both these groups Flack was exploring the public imagery of events and people as they appear to the world. Her imagery drew upon our existing store of communications.*

In 1971 she made the crucial transition from human agents to artifacts. In this year she painted a group of architectural subjects, including the cathedrals of Amiens and Siena, the tower of Pisa, and Michelangelo's David in Florence. The subjects are still public, but they now have a strong cultural presence, identified with works of art. Flack's paintings of a sculpture by Luisa Roldan in 1972 show her dealing with a commanding humanist monument, one encrusted with beads and drapery. By rendering both the pathos of the figure and the details of her finery Flack was able to combine the resources of figure painting and still life, though indirectly.

In the early 60s Flack made several still lifes, small but premonitory. These include Royal Jello, *a collection of brand goods as on a kitchen counter, and*

243

Cosmetic Still Life, *a selection of the articles for make-up. The dimension of use of the objects is emphasized. The tendency of still life painters in the 20th century, and of their interpreters, has been to stress objects as geometric forms or accents of color, useful to the artist in providing a formal play of straight lines and curves, concavities and convexities, but of little interest in themselves. The decisive work in the personalization of still life objects in Flack's work is* Jolie Madame, 1972, *a large painting in which she combined the genre of still life with the humanist tradition of art as the vehicle of ambitious meaning. The work depicts a dressing table laden with objects that imply the taste of an unseen woman: they are possessions. In addition these ornaments and jewels have been shaped by various decorative traditions so that they are in sum a microcosm of the culture. (Ornamental forms have histories, like lions' paws on furniture legs or rosebuds on the silver.) The sequence from human figures—of a wide social range, to monuments and works of art as subject matter, and to the inventory of still life objects was rich in iconographical potential from the beginning.*

Gregory Battcock has the following comments on the Vanitas series:

Flack's new paintings begin a new chapter in modern art. She has bridged the gap between iconographical interpretation on the one hand, and objective formalism, on the other. Whereas the contributions of her predecessors remain isolated examples, serving to prove that subject matter in art is possible, despite numerous claims to the contrary, Flack may have pointed the direction for Super Realism and for art criticism as well.

Whether she will continue her daring approach and turn it into a new movement of protest and change in art, cannot be known at this time. She should be encouraged, for the advantages to art are considerable. She may have opened up a new kind of art, and a new kind of authority for the artist. [From New York Arts Journal, April–May, 1978.]

Flack spends weeks, and sometimes months, assembling still-life compositions and photographing them. From hundreds of slides she finally chooses the one from which to make her painting. She projects the slide onto a canvas, masking first one area, then another, and begins to paint over the projected image with an airbrush. Upon close inspection, the viewer will see many spits and oversprays and edges that do not quite meet or overlap. Like Estes, Flack is not so much concerned with technical perfection as she is with the overall work of art.

Audrey Flack had executed 51 paintings as a Photo-Realist as of December 31, 1979. Of these, 49 are illustrated herein. Two earlier paintings (pls. 569 and 570) are included for historical purposes, and two others, early views of sunsets, are listed.

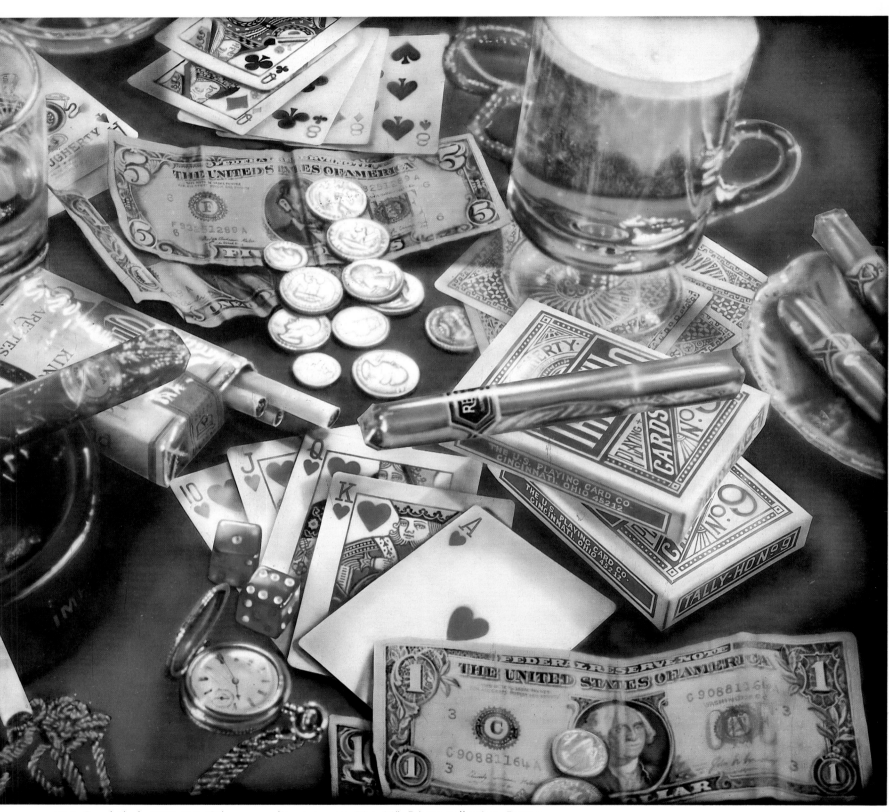

524. *Royal Flush*. 1973 (24). Oil over acrylic on canvas, 70 x 96". Private collection, France

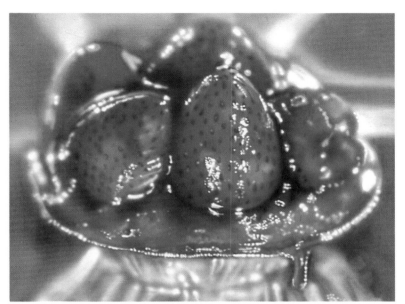

525. *Strawberry Tart*. 1974 (29).
Oil over acrylic on canvas, 24 x 30⅛".
Private collection

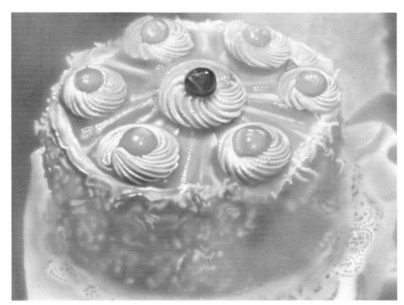

526. *Coconut Lemon Cake*. 1974 (30).
Oil over acrylic on canvas, 24 x 30".
Private collection, New York

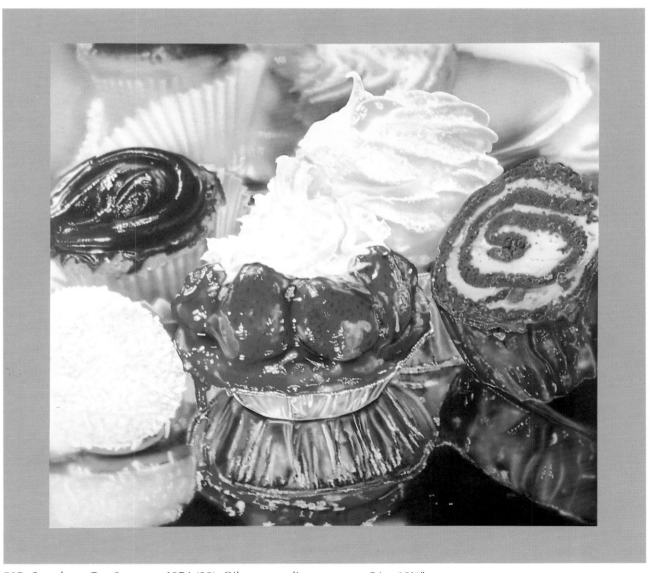

527. *Strawberry Tart Supreme*. 1974 (32). Oil over acrylic on canvas, 54 x 60¼".
Allen Memorial Art Museum, Oberlin College, Ohio

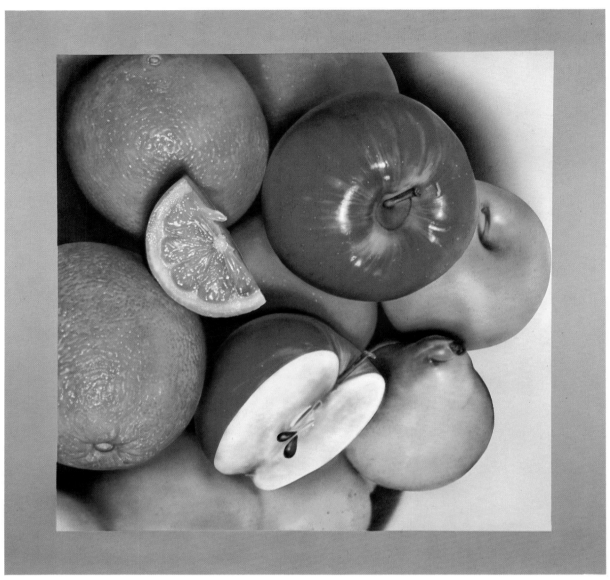

528. *Spaced Out Apple*. 1974 (33). Acrylic on canvas, 58 x 60".
Collection Mr. and Mrs. Jerome Westheimer, Okla.

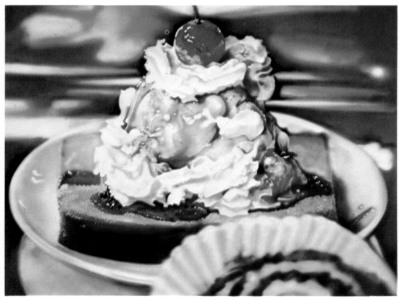

529. *Pound Cake Sundae*. 1974 (27). Oil over acrylic on canvas, 38 x 50¼". Private collection, Calif.

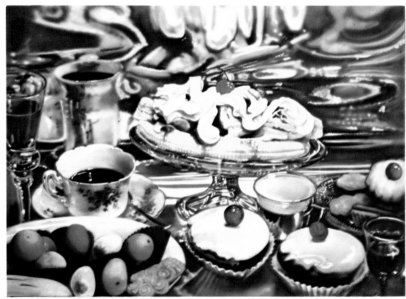

530. *Banana Split Sundae*. 1974 (28). Oil over acrylic on canvas, 38 x 50⅛". Private collection, New York

247

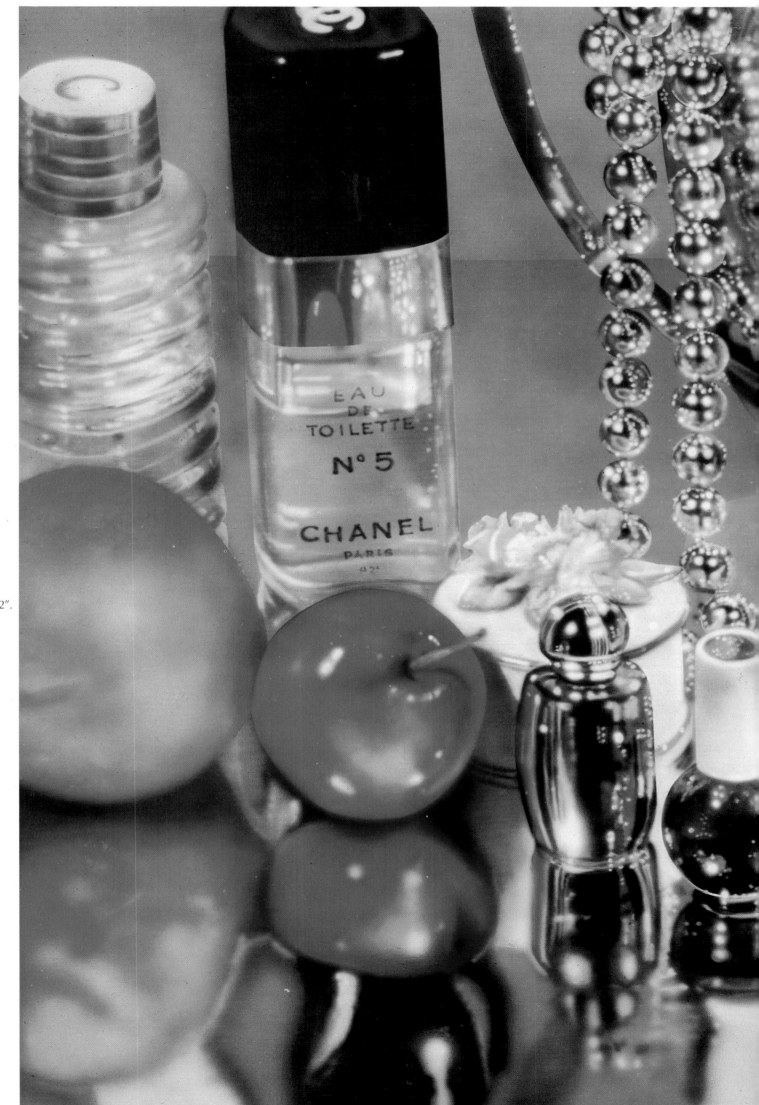

531. *Chanel*. 1974 (26).
Acrylic on canvas, 56 x 82".
Collection Mr. and Mrs.
Morton G. Neumann, Ill.

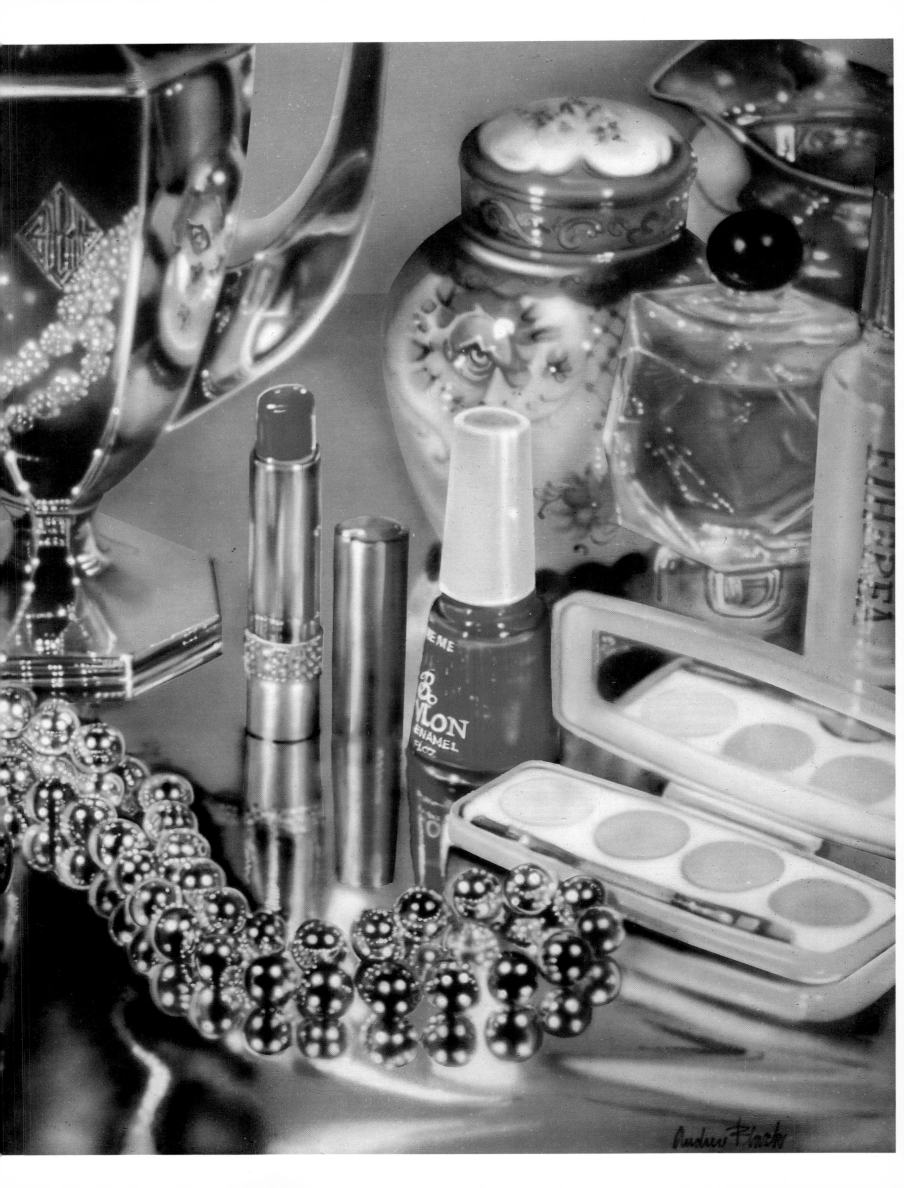

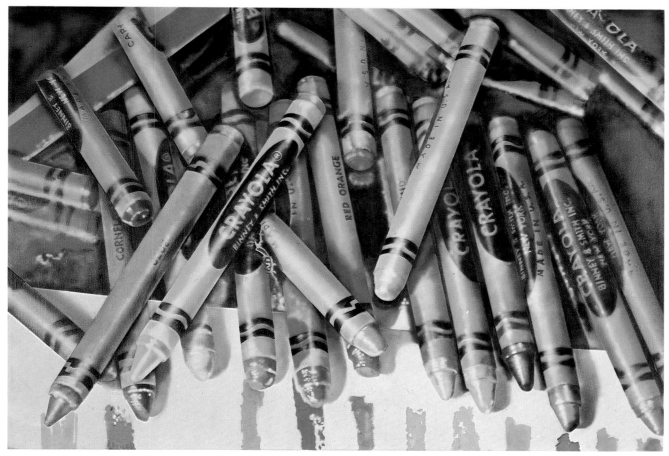

532. *Crayola*. 1972–73 (21). Oil over acrylic on canvas, 28 x 40". Collection M. Green, Chicago

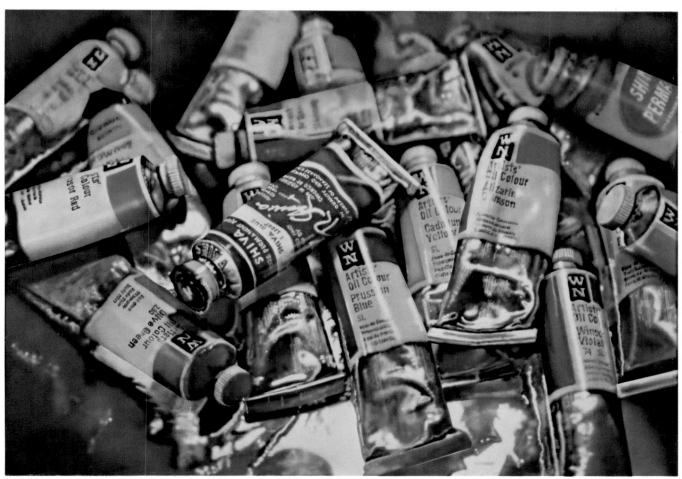

533. *Shiva Blue*. 1972–73 (22). Oil over acrylic on canvas, 36 x 50". Private collection

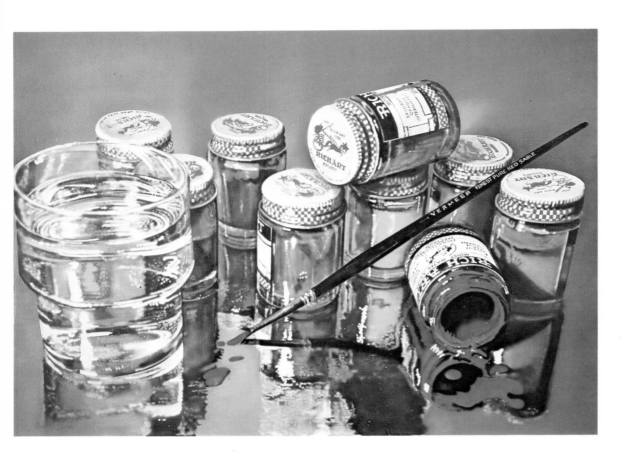

534. *Rich Art.* 1972–73 (20).
Oil over acrylic on canvas, 36 x 50".
Private collection

535. *Spitfire.* 1973 (23).
Oil over acrylic on canvas, 70 x 96".
Stuart M. Speiser Collection,
Smithsonian Institution, Washington, D.C.

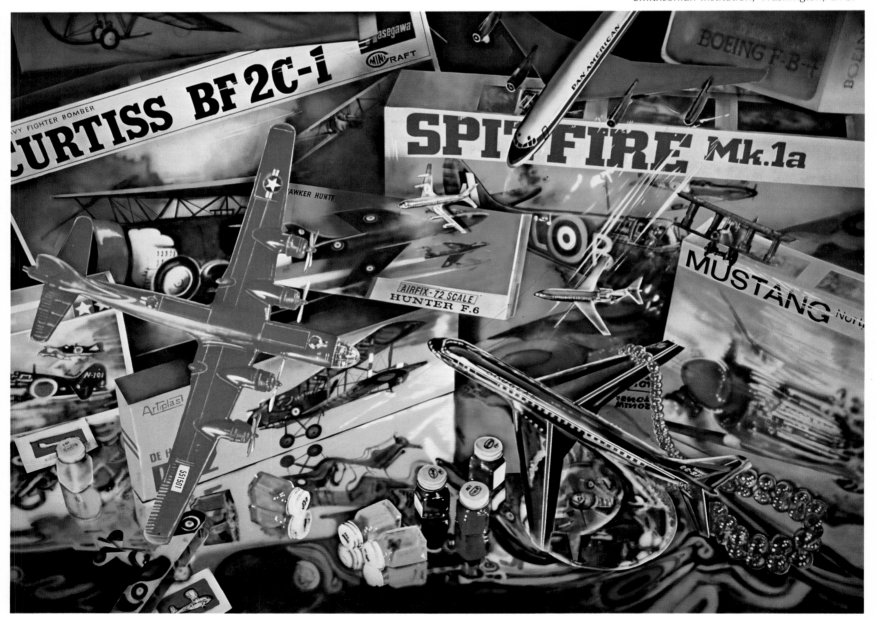

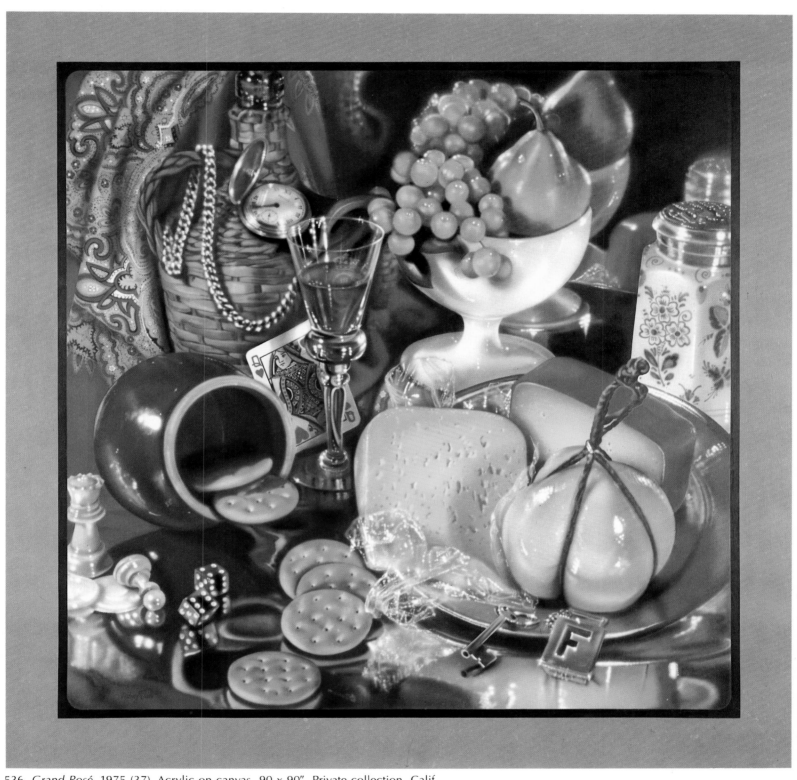

536. *Grand Rosé*. 1975 (37). Acrylic on canvas, 90 x 90". Private collection, Calif.

252

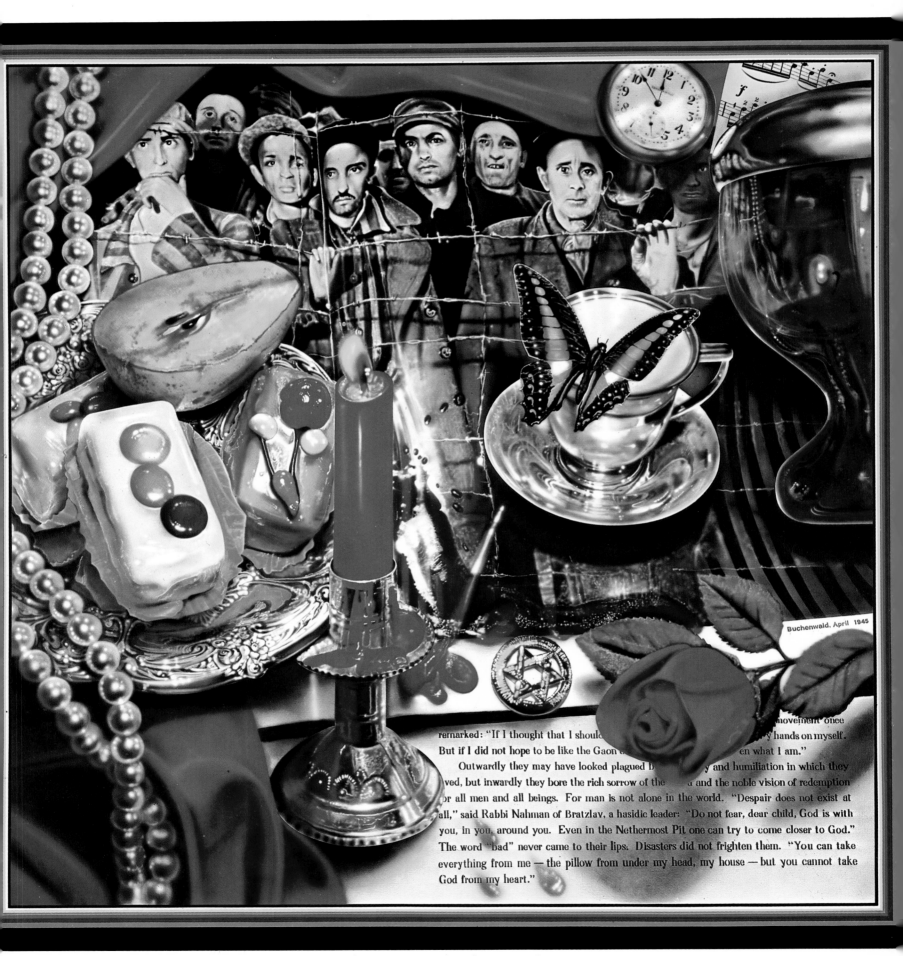

Buchenwald, April 1945

remarked: "If I thought that I should hands on myself. But if I did not hope to be like the Gaon en what I am."

Outwardly they may have looked plagued b... ... y and humiliation in which they ...ved, but inwardly they bore the rich sorrow of the and the noble vision of redemption ...or all men and all beings. For man is not alone in the world. "Despair does not exist at ...all," said Rabbi Nahman of Bratzlav, a hasidic leader: "Do not fear, dear child, God is with you, in you, around you. Even in the Nethermost Pit one can try to come closer to God." The word "bad" never came to their lips. Disasters did not frighten them. "You can take everything from me — the pillow from under my head, my house — but you cannot take God from my heart."

537. *World War II (Vanitas)*. 1976–77 (45). Oil over acrylic on canvas, 96 x 96". Private collection

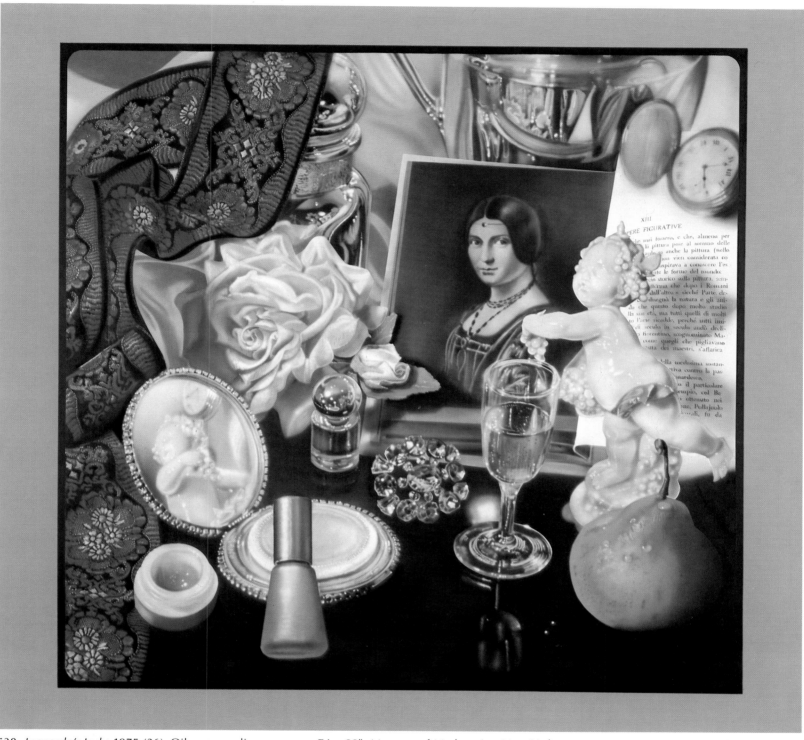

538. *Leonardo's Lady.* 1975 (36). Oil over acrylic on canvas, 74 x 80". Museum of Modern Art, New York.
Purchased with funds from the National Endowment for the Arts and an anonymous donor

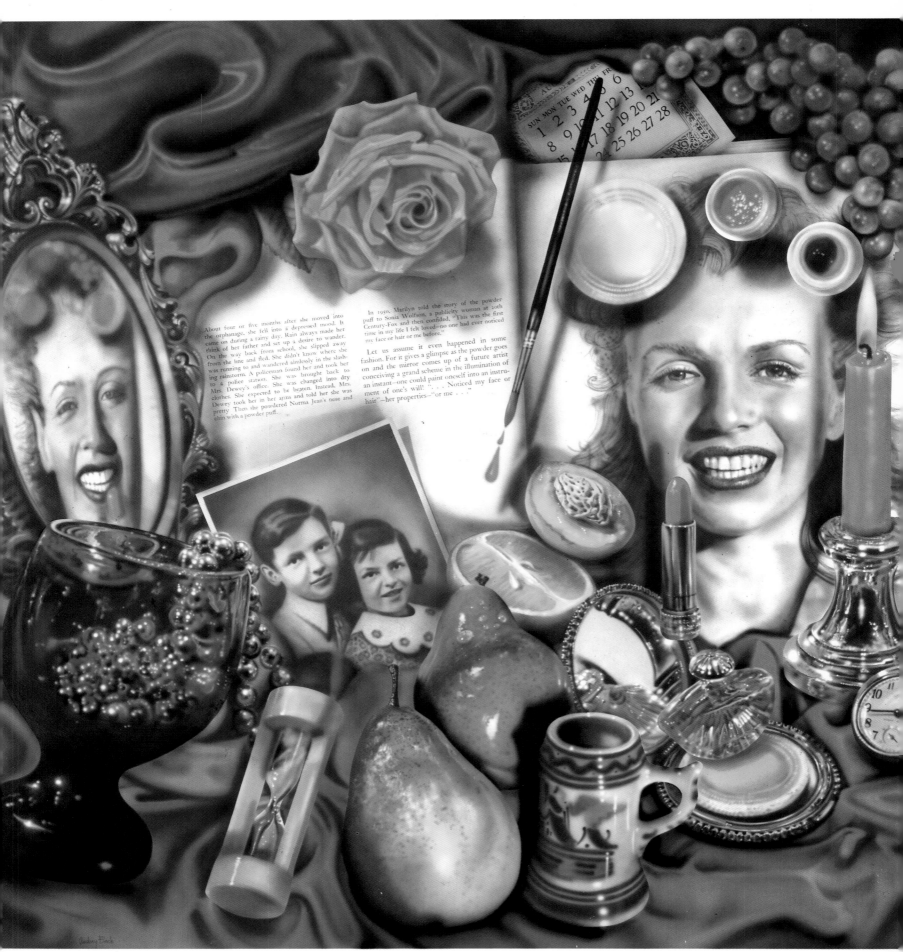

About four or five months after she moved into the orphanage, she fell into a depressed mood. It came on during a rainy day. Rain always made her think of her father and set up a desire to wander. On the way back from school, she slipped away from the line and fled. She didn't know where she was running to and wandered aimlessly in the slashing rainstorm. A policeman found her and took her to a police station. She was brought back to Mrs. Dewey's office. She expected to be beaten. Instead, Mrs. Dewey took her in her arms and told her she was pretty. Then she powdered Norma Jean's nose and chin with a powder puff.

In 1950, Marilyn told the story of the powder puff to Sonia Wolfson, a publicity woman at 20th Century-Fox and then confided, "This was the first time in my life I felt loved—no one had ever noticed my face or hair or me before."

Let us assume it even happened in some fashion. For it gives a glimpse as the powder goes on and the mirror comes up of a future artist conceiving a grand scheme in the illumination of an instant—one could paint oneself into an instrument of one's will! ". . . Noticed my face or hair"—her properties—"or me . . ."

539. *Marilyn* (Vanitas). 1977 (47). Oil over acrylic on canvas, 96 x 96". University of Arizona Museum of Art, Tucson

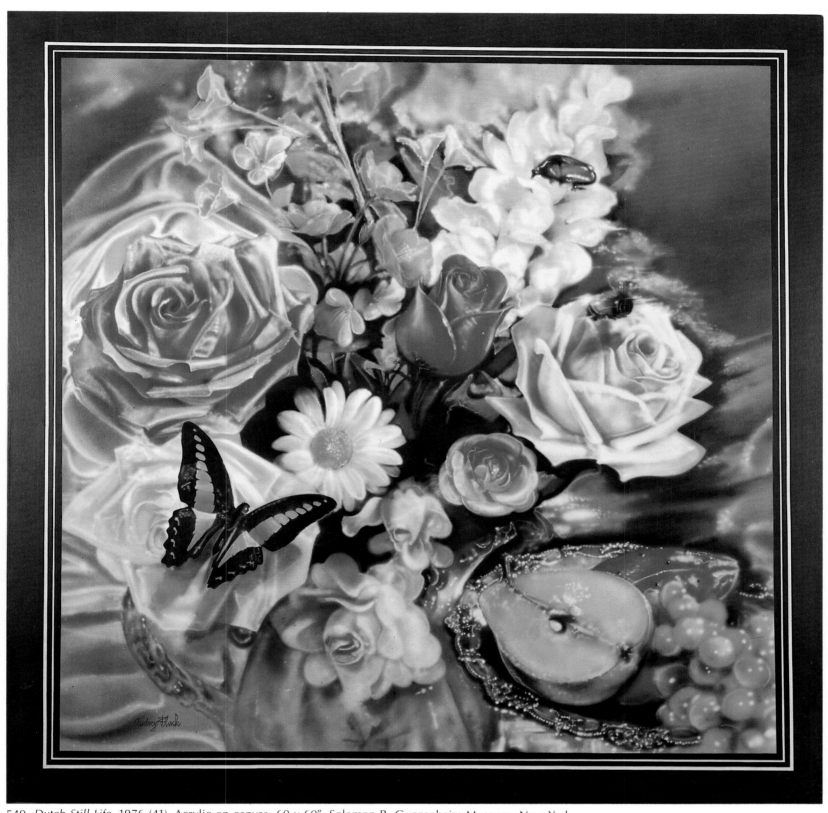

540. *Dutch Still Life.* 1976 (41). Acrylic on canvas, 60 x 60". Solomon R. Guggenheim Museum, New York

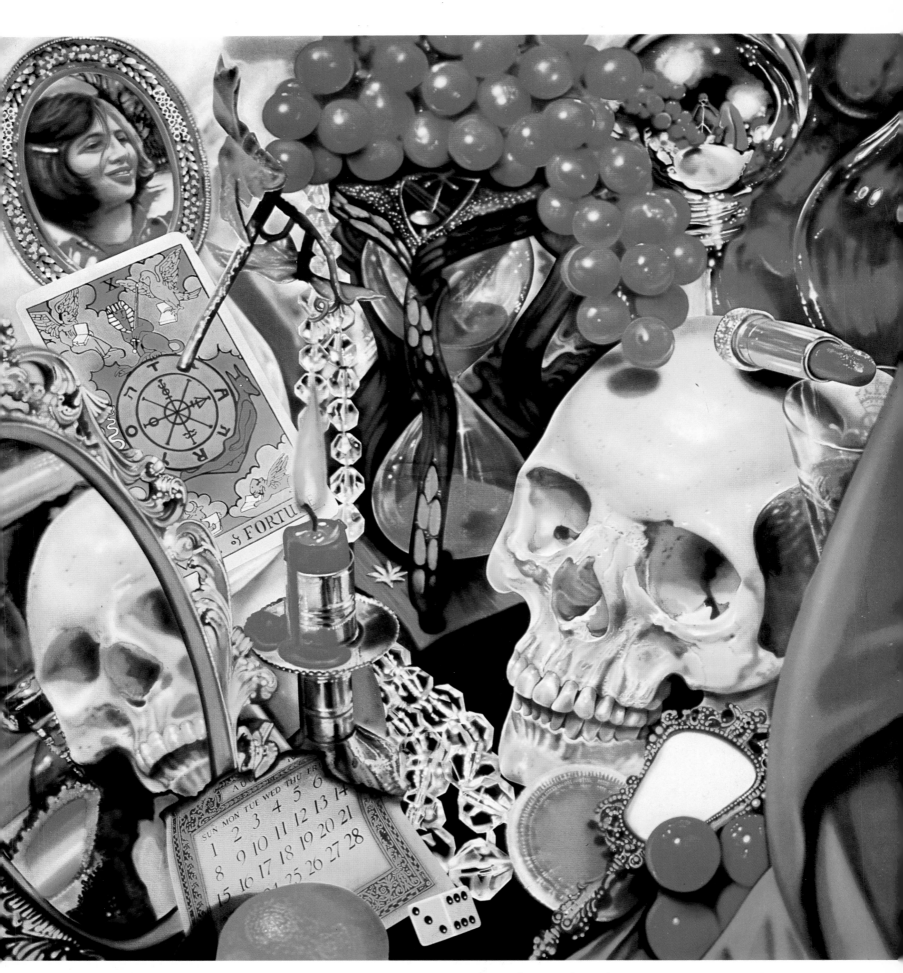

541. *Wheel of Fortune (Vanitas)*. 1977–78 (46). Oil over acrylic on canvas, 96 x 96". HHK Foundation for Contemporary Art, Inc., Wisc.

257

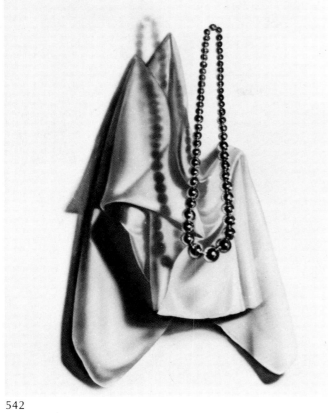

542

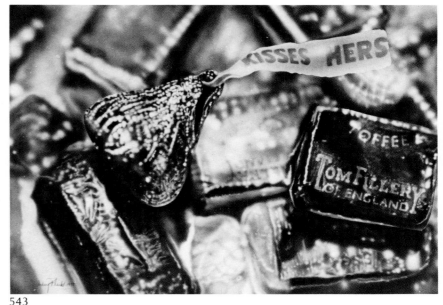

543

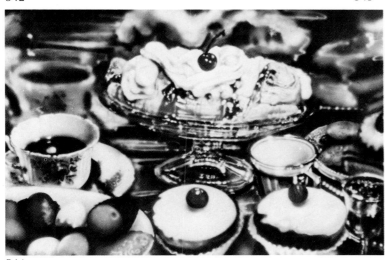

544

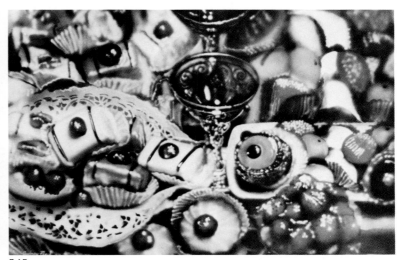

545

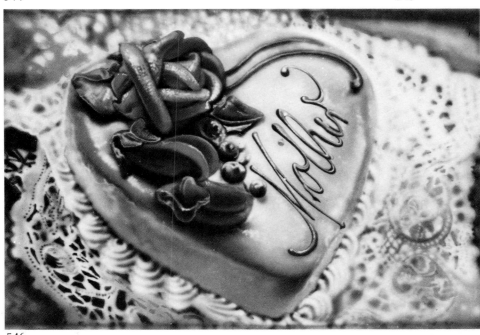

546

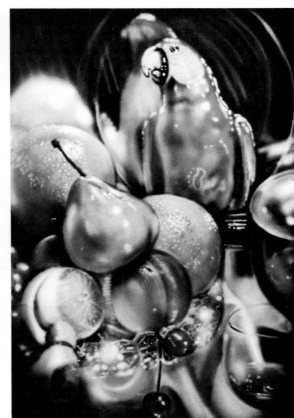

258

547

542. *Untitled (Drape and Beads).* 1975 (38).
Oil over acrylic on canvas, 36 x 30".
Collection the artist

543. *Hershey Kisses.* 1977 (48).
Acrylic on illustration board, 16 x 23".
Collection Louis and Susan Meisel, New York

544. *Golden Banana Split (Mellow Mouth).*
1976 (43). Acrylic on illustration board,
16 x 24". Collection Mr. and Mrs. W.
Jaeger, New York

545. *Petitfours.* 1976 (42).
Acrylic on illustration board, 16 x 24".
Collection Jean Siegel, New York

546. *Mother Cake.* 1976 (44).
Oil over acrylic on canvas, 22 x 30".
Collection R. Levenson, Pa.

547. *Parrot Still Life.* 1975 (34).
Acrylic on paper, 24 x 16".
Private collection, New York

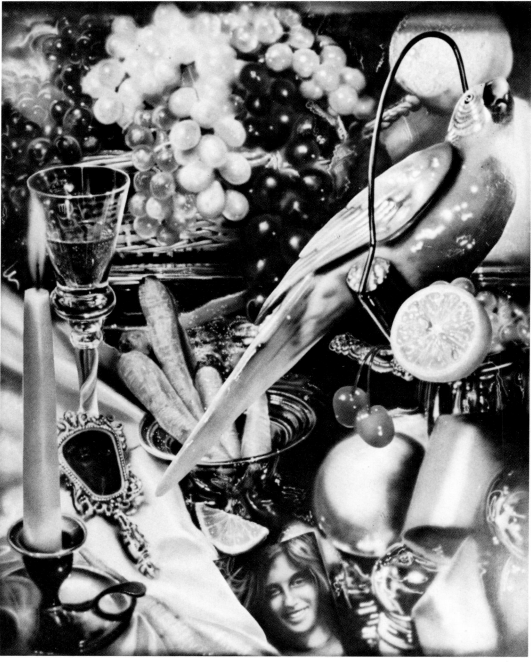

548. *Bounty.* 1978 (52).
Oil over acrylic on canvas,
80 x 67". Bellbranch Road
Foundation, N.C.

549. *Jolie Madame.* 1972 (19).
Oil on canvas, 71 x 96".
Australian National Gallery,
Canberra

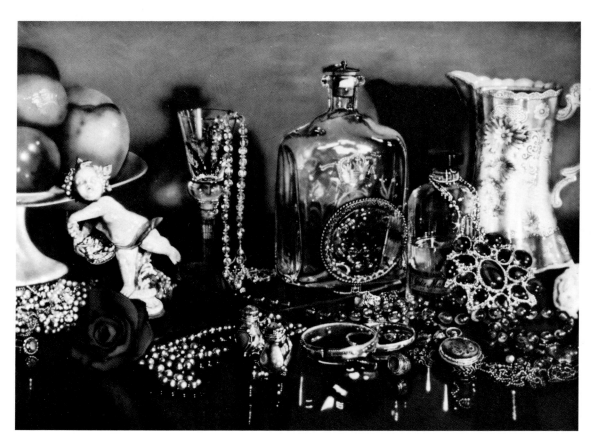

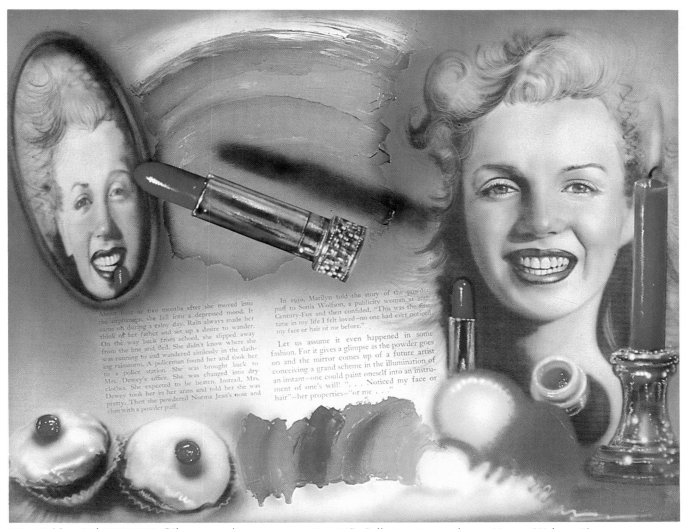

550. *Golden Girl.* 1978 (50). Oil over acrylic on canvas, 48 x 60". Collection Mr. and Mrs. Harvey Walner, Chicago

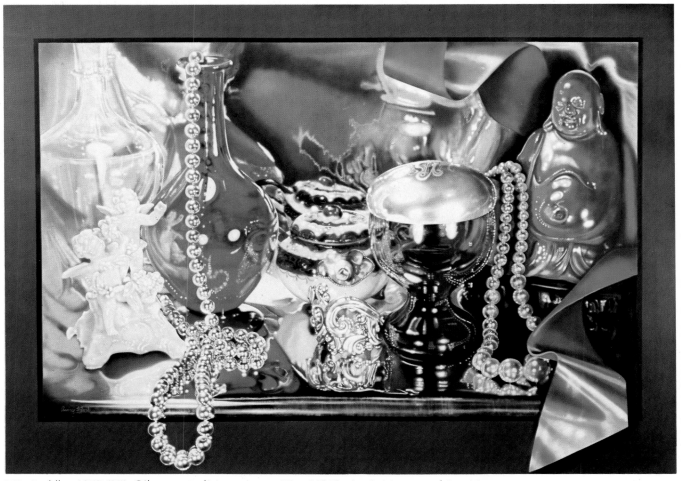

551. *Buddha.* 1975 (35). Oil over acrylic on canvas, 70 x 96". St. Louis Museum of Art, Mo.

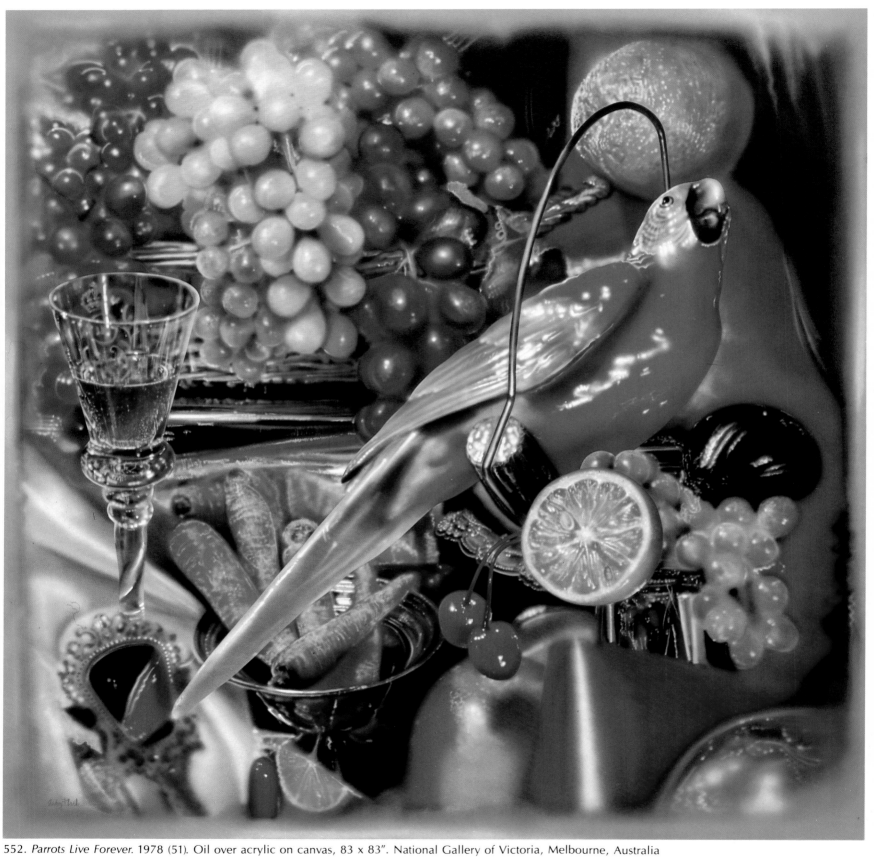

552. *Parrots Live Forever.* 1978 (51). Oil over acrylic on canvas, 83 x 83". National Gallery of Victoria, Melbourne, Australia

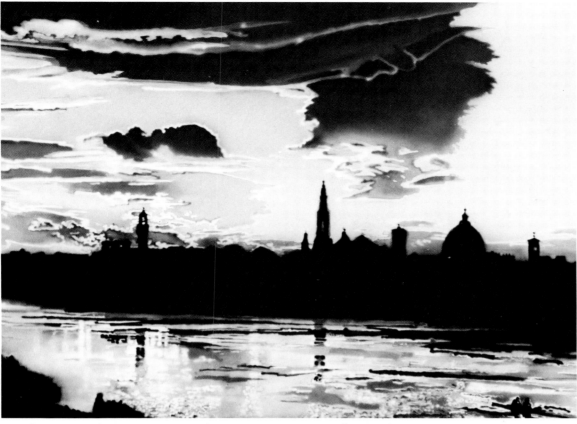

553. *Sunset over Florence.* 1971 (6). Oil on canvas, 46 x 66″. Collection the artist

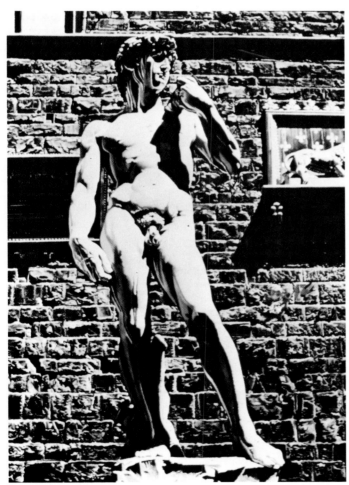

554. *Michelangelo's David.* 1971 (9). Oil on canvas, 66 x 46″.
Private collection

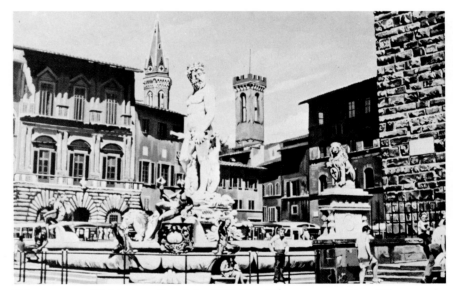

555. *Ammannati's Neptune Fountain.* 1971 (10). Oil on canvas, 26 x 40″
Capricorn Gallery, Md.

556. *Cordoba Angel.* 1972 (17).
Oil on paper, 30 x 20″.
Private collection

557. *San Gimignano Angel.* 1972
(18). Oil on paper, 30 x 20″.
Private collection

262

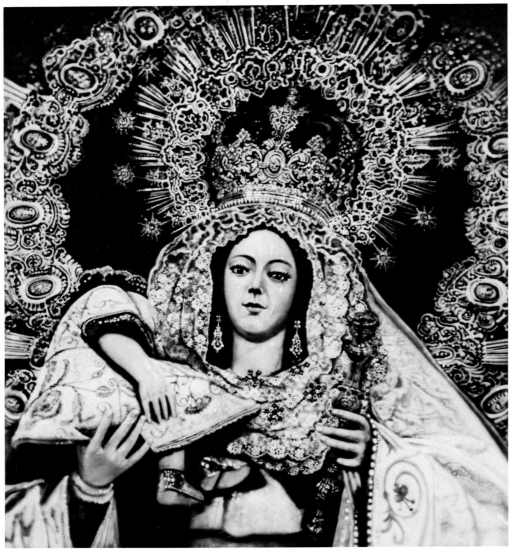

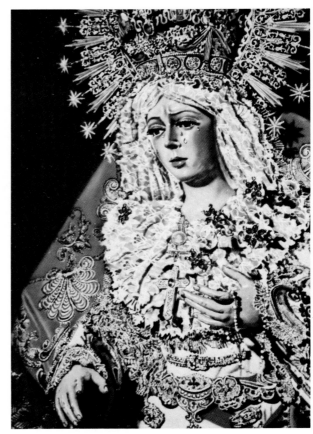

558. *Lady Madonna*. 1972 (16). Oil on canvas, 78 x 69". Whitney Museum of American Art, New York. Gift of Martin J. Zimet

559. *Macarena of Miracles*. 1971 (14). Oil on canvas, 66 x 46". Metropolitan Museum of Art, New York

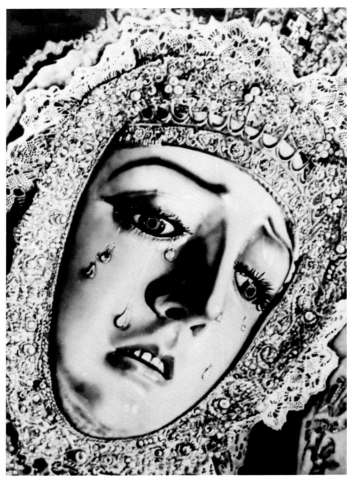

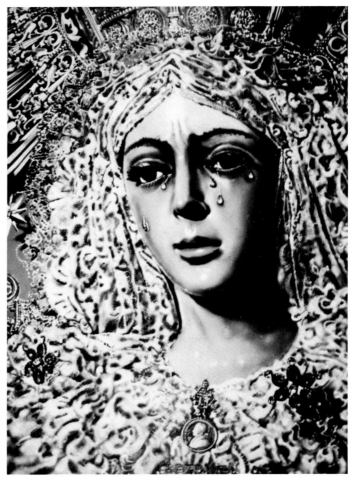

560. *Dolores of Cordoba*. 1971 (15). Oil on canvas, 70 x 50". Private collection

561. *Macarena Esperanza*. 1971 (13). Oil on canvas, 66 x 46". Collection Paul and Camille Hoffman, Ill.

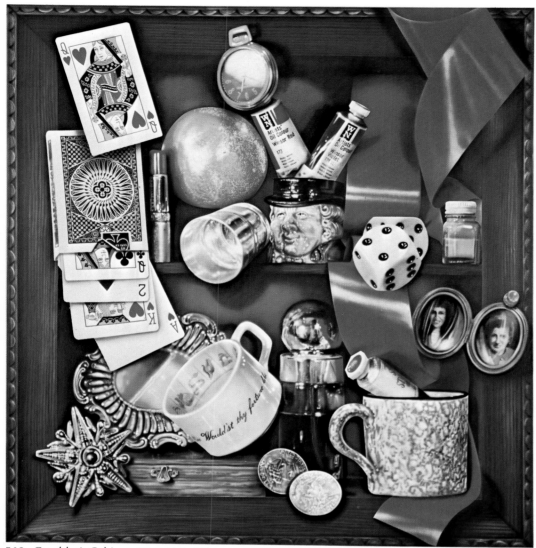

562. *Gambler's Cabinet*. 1976 (40). Oil over acrylic on canvas, 78 x 78".
Collection Louis and Susan Meisel, New York

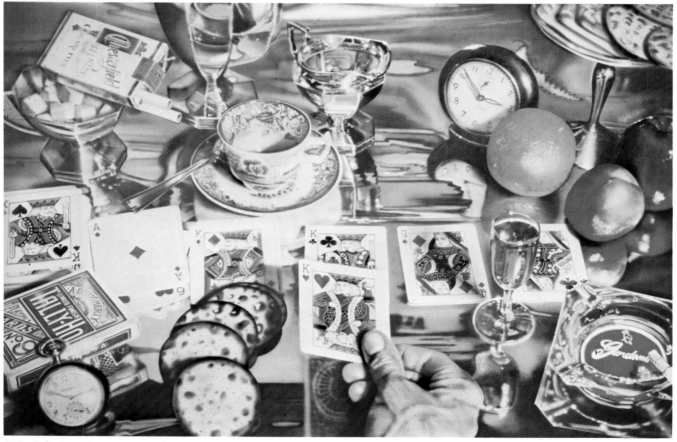

563. *Solitaire*. 1974 (25). Acrylic on canvas, 60 x 84". Collection Joan and Barrie Damson, Conn.

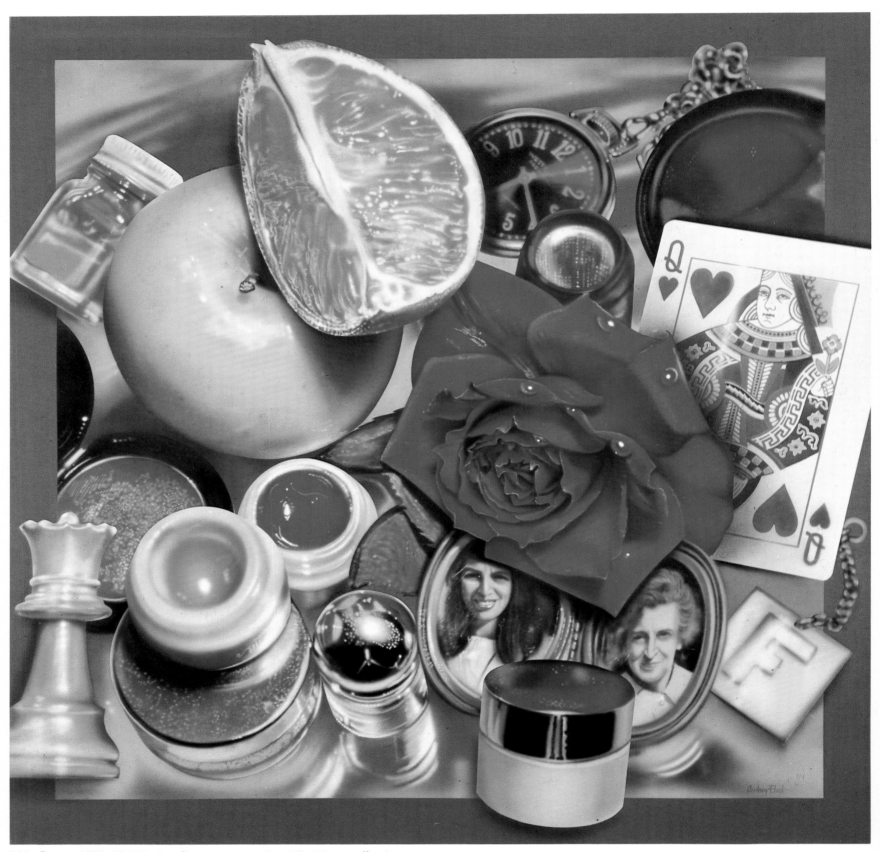

564. *Queen*. 1975–76 (39). Acrylic on canvas, 80 x 80". Private collection

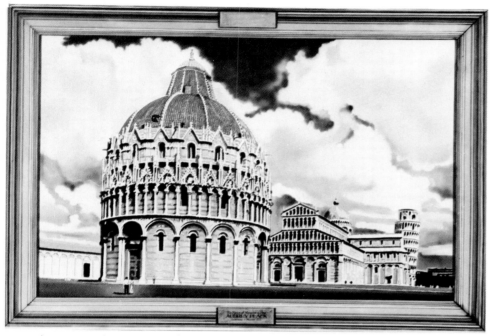

565. *The Piazza of Miracles in Pisa.* 1971 (11). Oil on canvas, 48 x 72".
Collection the artist

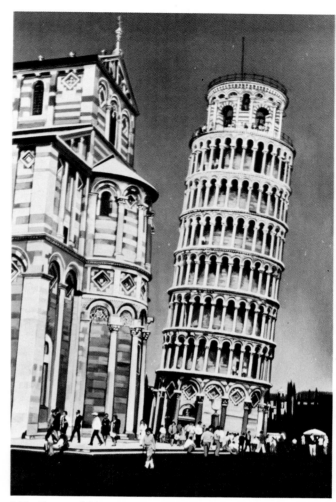

566. *Tower of Pisa.* 1971 (12). Oil on canvas, 72 x 48".
Capricorn Gallery, Md.

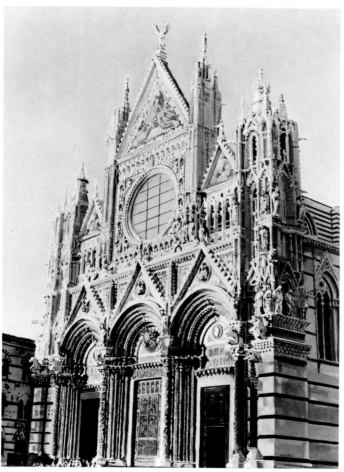

567. *Siena Cathedral.* 1971 (7). Oil on canvas, 66 x 46".
Collection Louis and Susan Meisel, New York

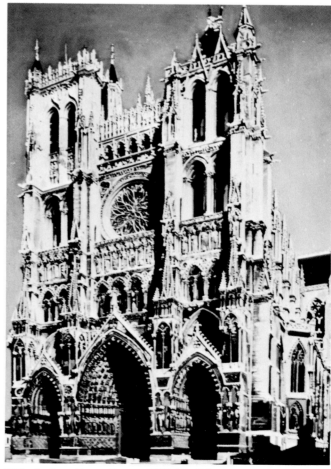

568. *Amiens Notre Dame.* 1971 (8). Oil on canvas, 66 x 46".
Private collection, Europe

266

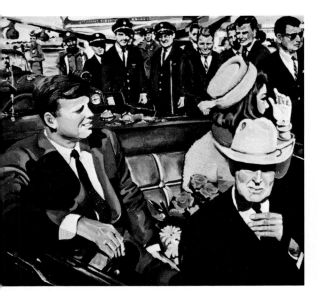

69. *Kennedy Motorcade*. 1964 (1).
Oil on canvas, 38 x 42".
Private collection

570. *War Protest March*. 1968 (2).
Oil on canvas, 20 x 30".
Private collection

571. *Sadat*. 1977–78 (49).
Acrylic on canvas, c. 40 x 32".
Collection Anwar al-Sadat, Egypt

NOT ILLUSTRATED

Sunset. 1971 (4).
Oil on canvas, c. 18 x 24".
Private collection

Transparent Sunset. 1971 (5).
Oil on canvas, c. 20 x 30".
Private collection

BIOGRAPHY

1931 Born: New York

EDUCATION
1951 Graduated from Cooper Union, New York
1952 B.F.A., Yale University, New Haven, Conn.
1953 New York University Institute of Fine Arts
1977 Cooper Union Honorary Doctorate

TEACHING
1960–68 Pratt Institute, New York
 New York University, New York
1966–67 Riverside Museum Master Institute, New York
1970–74 School of Visual Arts, New York
1975 Albert Dorne Professorship, University of Bridgeport, Conn.

SOLO EXHIBITIONS
1959 Roko Gallery, New York
1963 Roko Gallery, New York
1972 French and Co., New York
1974 Louis K. Meisel Gallery, New York
 Joseloff Gallery, University of Hartford, Conn.
1975 Carlson Gallery, Arnold Bernhard Arts Center, University of
 Bridgeport, Conn.
1976 Louis K. Meisel Gallery, New York
1978 Louis K. Meisel Gallery, New York

SELECTED GROUP EXHIBITIONS
1948 "Seventh Annual Exhibition," National Academy of Design, New York
1952 Yale University Art Gallery, New Haven, Conn.
1954–57 Tanager Gallery, New York
1956 Collectors Gallery, New York
1960 "Christmas Show," Karnig Gallery, New York

 Stable Gallery Annual, New York
1963 Boston University Gallery of Fine Arts
1963–64 "Nine Realist Painters," Robert Schoelkopf Gallery, New York
1964 "Ten West Side Artists," Riverside Museum, New York
1965 "Sixty-five Self-Portraits," School of Visual Arts, New York
 "Six Women," Fischbach Gallery, New York
1967 Goddard-Riverside Community Center, New York
1969 "Paintings from the Photograph," Riverside Museum, New York
1970 "New Realism, 1970," Headley Hall Gallery, St. Cloud State College,
 Minn.
 "Twenty-two Realists," Whitney Museum of American Art, New York
1972 "Annual Exhibit of Contemporary American Paintings," Whitney
 Museum of American Art, New York
 "Artists for CORE," Grippi and Waddell Gallery, New York
 Clark Polak Gallery, Los Angeles
 "L'Hyperréalistes américains," Galerie des Quatre Mouvements, Paris
 "New Accessions U.S.A.," Colorado Springs Fine Arts Center, Colo.
 "Painting and Sculpture Today, 1972," Indianapolis Museum of Art
 "Phases of the New Realism," Lowe Art Museum, University of Miami,
 Coral Gables, Fla.
 "Realism Now," New York Cultural Center, New York
 "Thirty-two Realists," Cleveland Institute of Art
 Warren Benedek Gallery, New York
 "Women in Art," Brainerd Hall Art Gallery, State University College,
 Potsdam, N.Y.
1973 "American Drawings 1963–1973," Whitney Museum of American Art,
 New York
 "Amerikansk realism," Galleri Ostergren, Malmö, Sweden
 "The Emerging Real," Storm King Art Center, Mountainville, N.Y.
 "Hyperréalistes américains," Galerie Arditti, Paris
 "Objects and Eight Women Realists," University of Massachusetts,
 Amherst

"Photo-Realism," Serpentine Gallery, London
"Realism Now," Katonah Gallery, Katonah, N.Y.
"The Super-Realist Vision," DeCordova and Dana Museum, Lincoln, Mass.
"Women Choose Women," New York Cultural Center, New York
1973–78 "Photo-Realism 1973: The Stuart M. Speiser Collection," traveling exhibition: Louis K. Meisel Gallery, New York; Herbert F. Johnson Museum of Art, Ithaca, N.Y.; Memorial Art Gallery of the University of Rochester, N.Y.; Addison Gallery of American Art, Andover, Mass.; Allentown Art Museum, Pa.; University of Colorado Museum, Boulder; University Art Museum, University of Texas, Austin; Witte Memorial Museum, San Antonio, Tex.; Gibbes Art Gallery, Charleston, S.C.; Brooks Memorial Art Gallery, Memphis, Tenn.; Krannert Art Museum, University of Illinois, Champaign-Urbana; Helen Foresman Spencer Museum of Art, University of Kansas, Lawrence; Paine Art Center and Arboretum, Oshkosh, Wis.; Edwin A. Ulrich Museum, Wichita State University, Kans.; Tampa Bay Art Center, Tampa, Fla.; Rice University, Sewall Art Gallery, Houston; Tulane University Art Gallery, New Orleans; Smithsonian Institution, Washington, D.C.
1974 "Amerikaans fotorealisme grafiek," Hedendaagse Kunst, Utrecht; Palais des Beaux-Arts, Brussels
"Ars '74 Ateneum," Fine Arts Academy of Finland, Helsinki
"Art 5 '74," Basel, Switzerland
"Contemporary American Painting and Sculpture, 1974," Krannert Art Museum, University of Illinois, Champaign-Urbana
"Contemporary Portraits by American Painters," Lowe Art Museum, University of Miami, Coral Gables, Fla.
"From Tea Pot Dome to Watergate," Everson Museum of Art, Syracuse, N.Y.
Moos Gallery, Montreal
Moos Gallery, Toronto
"New Image in Painting," Tokyo International Biennale
"New Photo-Realism," Wadsworth Atheneum, Hartford, Conn.
"New Realism Revisited," Brainerd Hall Art Gallery, State University College, Potsdam, N.Y.
"New York Eleven," C. W. Post Art Gallery, Greenvale, N.Y.
"Thirty-eighth Annual Midyear Show," Butler Institute of American Art, Youngstown, Ohio
"Tokyo Biennale, '74," Tokyo Metropolitan Museum of Art; Kyoto Municipal Museum; Aichi Prefectural Art Museum, Nagoya
"Women's Work: American Art 1974," Museum of the Philadelphia Civic Center
1975 "Art: A Woman's Sensibility," California Institute of the Arts, Valencia
"Image, Color and Form—Recent Paintings by Eleven Americans," Toledo Museum of Art, Ohio
Kent Bicentennial Portfolio: "Spirit of Independence," exhibited in 105 museums, 50 states
"The New Realism: Rip-Off or Reality?," Edwin A. Ulrich Museum, Wichita State University, Kans.
"Photo-Realists," Louis K. Meisel Gallery, New York
"Report from SoHo," New York University, Grey Art Gallery, New York
"Watercolors and Drawings—American Realists," Louis K. Meisel Gallery, New York
"The Year of the Woman," Bronx Museum of the Arts, New York
1975–76 "Photo-Realism, American Painting and Prints," New Zealand traveling exhibition: Barrington Gallery, Auckland; Robert McDougall Art Gallery, Christchurch; Academy of Fine Arts, National Art Gallery, Wellington; Dunedin Public Art Gallery, Dunedin; Govett-Brewster Art Gallery, New Plymouth; Waikato Art Museum, Hamilton
"Super Realism," Baltimore Museum of Art
1976 "American Artists '76: A Celebration," Marion Koogler McNay Art Institute, San Antonio, Tex.
"Artists and East Hampton," Guild Hall Art Gallery, East Hampton, N.Y.
"Art 7 '76," Basel, Switzerland
Lowe Art Museum, University of Miami, Coral Gables, Fla.
Roko Gallery, New York
"Troisième foire internationale d'art contemporain," Grand Palais, Paris
Young Hoffman Gallery, Chicago
1976–77 "The Aubrey Cartwright Foundation Exhibition of Contemporary Religious Art," Cathedral Church of St. John the Divine, New York
1976–78 "Aspects of Realism," traveling exhibition sponsored by Rothman's of Pall Mall Canada, Ltd.: Stratford, Ont.; Centennial Museum, Vancouver, B.C.; Glenbow-Alberta Institute, Calgary, Alta.;

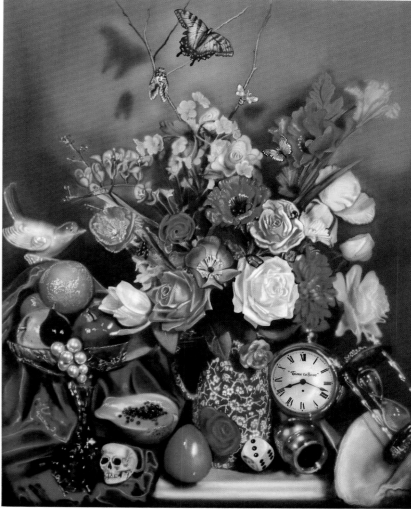

572. *Time to Save.* 1979 (53). Oil over acrylic on canvas, 80 x 64". Collection Mr. and Mrs. A. Jacobson, Tex.

Mendel Art Gallery, Saskatoon, Sask.; Winnipeg Art Gallery, Man.; Edmonton Art Gallery, Alta.; Art Gallery, Memorial University of Newfoundland, St. John's; Confederation Art Gallery and Museum, Charlottetown, P. E. I.; Musée d'Art Contemporain, Montreal, Que.; Dalhousie University Museum and Gallery, Halifax, N.S.; Windsor Art Gallery, Ont.; London Public Library and Museum and McIntosh Memorial Art Gallery, University of Western Ontario; Art Gallery of Hamilton, Ont.
1977 "Alumni Exhibition," Houghton Gallery, Cooper Union for the Advancement of Science and Art, New York
"Breaking the Picture Plane," Tomasulo Gallery, Union College, Cranford, N.J.
"The Chosen Object: European and American Still Life," Joslyn Art Museum, Omaha
"New in the '70s," University Art Museum, Archer M. Huntington Gallery, University of Texas, Austin
"New Realism," Jacksonville Art Museum, Fla.
"Photo-Realists," Shore Gallery, Boston
"Washington International Art Fair," Washington, D.C.
Woman's Caucus for Art, New York
"Works on Paper II," Louis K. Meisel Gallery, New York
1977–78 "Illusion and Reality," Australian touring exhibition: Australian National Gallery, Canberra; Western Australian Art Gallery, Perth; Queensland Art Gallery, Brisbane; Art Gallery of New South Wales, Sydney; Art Gallery of South Australia, Adelaide; National Gallery of Victoria, Melbourne; Tasmanian Museum and Art Gallery, Hobart
"June Blum, Audrey Flack, Alice Neel: Three Contemporary American Women Realists," Miami-Dade Community College, South Campus Art Gallery, Miami, Fla.
1978 "Art About Art," Whitney Museum of American Art, New York; North Carolina Museum of Art, Raleigh; Frederick S. Wight Art Gallery, University of California, Los Angeles; Portland Art Museum, Oreg.
"Artists Look at Art," Helen Foresman Spencer Museum of Art, University of Kansas, Lawrence
"Aspects of Realism," Guild Hall Art Gallery, East Hampton, N.Y.

Brookdale Community College, N.J.
"Drawing the Line," Montclair Art Museum, Montclair, N.J.
Monmouth Museum, Lincroft, N.J.
"Perspective '78: Works by Women," Freedman Art Gallery, Albright
College, Reading, Pa.
"Photo-Realism and Abstract Illusionism," Arts and Crafts Center of
Pittsburgh, Pa.
"Photo-Realist Printmaking," Louis K. Meisel Gallery, New York
Tolarno Galleries, Melbourne, Australia
"Washington International Art Fair," Washington, D.C.
Woman's Interart Center, New York
1978–80 "American Painting of the 70s," Albright-Knox Art Gallery, Buffalo;
Newport Harbor Art Museum, Balboa, Calif.; Oakland Museum,
Calif.; Cincinnati Art Museum; Art Museum of South Texas,
Corpus Christi; Krannert Art Museum, University of Illinois,
Champaign-Urbana
1979 "Narrative Realism," Art Association of Newport, R.I.

"The New American Still Life," Westmoreland County Museum of
Art, Greensburg, Pa.
"The Opposite Sex: A Realistic Viewpoint," University of Missouri
Art Gallery, Kansas City
"Photo-Realism: Some Points of View," Jorgensen Gallery,
University of Connecticut, Storrs
"Realist Space," C. W. Post Art Gallery, Long Island University,
Brookville, N.Y.
"Selections of Photo-Realist Paintings from N.Y.C. Galleries,"
Southern Alleghenies Museum of Art, St. Francis College,
Loretto, Pa.
Vision Gallery, Boston
Washington International Art Fair, Washington, D.C.
"Women Artists of Eastern Long Island," Guild Hall, East Hampton, N.Y.
1979–80 "Genesis of a Gallery, Part 2," Australian National Gallery,
Canberra, to travel throughout Australia.
The Vice President's House, Washington, D.C.

SELECTED BIBLIOGRAPHY

CATALOGUES

Nine Realist Painters. Robert Schoelkopf Gallery, New York, Dec. 19,
1963–Jan. 4, 1964.
Farb, Oriole. Introduction to Paintings from the Photograph. Riverside
Museum, New York, Dec. 9, 1969–Feb. 15, 1970.
Monte, James. Introduction to Twenty-two Realists. Whitney Museum of
American Art, New York, Feb. 1970.
Wallin, Lee. Introduction to New Realism, 1970. St. Cloud State College,
Minn., Feb. 13–Mar. 11, 1970.
Baratte, John J., and Thompson, Paul E. Phases of the New Realism. Lowe Art
Museum, University of Miami, Coral Gables, Fla., Jan. 20–Feb. 20, 1972.
Baur, John H. Foreword to 1972 Annual Exhibit of Contemporary American
Paintings. Whitney Museum of American Art, New York, Jan. 25–Mar. 19,
1972.
Goldsmith, Benedict. Introduction to Women in Art. Brainerd Hall Art Gallery,
State University College, Potsdam, N.Y., Mar. 3–28, 1972.
Naeve, Milo M. Introduction to New Accessions U.S.A. Colorado Springs Fine
Arts Center, Colo., Aug. 14–Oct. 1, 1972.
Warrum, Richard L. Introduction to Painting and Sculpture Today, 1972.
Indianapolis Museum of Art, Apr. 26–June 4, 1972.
Amaya, Mario. Introduction to Realism Now. New York Cultural Center, New
York, Dec. 6, 1972–Jan. 7, 1973.
Alloway, Lawrence. Introduction to Amerikansk Realism. Galleri Ostergren,
Malmö, Sweden, Sept. 8–Oct. 14, 1973.
———. Introduction to Photo-Realism. Serpentine Gallery, London, Apr. 4–
May 6, 1973.
Hogan, Carroll Edwards. Introduction to Hyperréalistes américains. Galerie
Arditti, Paris, Oct. 16–Nov. 30, 1973.
Lamagna, Carlo. Foreword to The Super-Realist Vision. DeCordova and Dana
Museum, Lincoln, Mass., Oct. 7–Dec. 9, 1973.
Lippard, Lucy. Introduction to Women Choose Women. Preface by Mario
Amaya. New York Cultural Center, New York, Jan. 12–Feb. 18, 1973.
Meisel, Louis K. Photo-Realism 1973: The Stuart M. Speiser Collection. New
York, 1973.
Mochon, Anne, and Levin, Miriam. Introduction to Objects and Eight Women
Realists. University of Massachusetts, Amherst, Nov. 18–Dec. 14, 1973.
Sims, Patterson. Introduction to Realism Now. Katonah Gallery, Katonah, New
York, May 20–June 24, 1973.
Solomon, Elke M. American Drawings 1963–1973. Whitney Museum of
American Art, New York, 1973.
Alloway, Lawrence. Introduction to New York Eleven. Foreword by Joan Vita
Miller. C. W. Post College, Greenvale, New York, Feb. 8–Mar. 11, 1974.
Amerikaans fotorealisme grafiek. Hedendaagse Kunst, Utrecht, Aug., 1974;
Palais des Beaux-Arts, Brussels, Sept.–Oct., 1974.
Aspects of Realism. Gallery Moos Ltd., Toronto, Sept.–Oct., 1974.
Campbell, Alan. Introduction to From Tea Pot Dome to Watergate. Everson

Museum of Art, Syracuse, N.Y., May 2–12, 1974.
Chase, Linda. "Photo-Realism." In Tokyo Biennale 1974. Tokyo Metropolitan
Museum of Art; Kyoto Municipal Museum; Aichi Prefectural Art Museum,
Nagoya, 1974.
Cowart, Jack. New Photo-Realism. Wadsworth Atheneum, Hartford, Conn.,
Apr. 10–May 19, 1974.
Goldsmith, Benedict. New Realism Revisited. Brainerd Hall Art Gallery, State
University College, Potsdam, N.Y., 1974.
Gruen, John. Introduction to Contemporary Portraits by American Painters.
Lowe Art Museum, University of Miami, Coral Gables, Fla., Oct. 3–Nov. 10,
1974.
Michiaki, Kawakita. Preface to New Image in Painting. Tokyo International
Biennale, June, 1974.
Perreault, John. "The Present Situation of American Art." In New Image in
Painting. Tokyo International Biennale, June, 1974.
Sarajas-Korte, Salme. Introduction to Ars '74 Ateneum. Fine Arts Academy of
Finland, Helsinki, Feb. 15–Mar. 31, 1974.
Thirty-eighth Annual Midyear Show. Butler Institute of American Art,
Youngstown, Ohio, June 30–Sept. 2, 1974.
Walthard, Dr. Frederic P. Foreword to Art 5 '74. Basel, Switzerland, June
19–24, 1974.
Woman's Work: American Art 1974. Museum of the Philadelphia Civic Center,
Pa., Apr. 27–May 26, 1974.
Baur, John H. Introduction to Kent Bicentennial Portfolio: Spirit of
Independence. Exhibited in 105 museums, 50 states, 1975.
Meisel, Susan Pear. Watercolors and Drawings—American Realists. Louis K.
Meisel Gallery, New York, Jan., 1975.
Metzger, Deena. Introduction to Art: A Woman's Sensibility. California
Institute of the Arts, Valencia, 1975.
Phillips, Robert F. Introduction to Image, Color and Form—Recent Paintings by
Eleven Americans. Toledo Museum of Art, Ohio, Jan. 12–Feb. 9, 1975.
Von Baron, Judith. Introduction to The Year of the Woman. Bronx Museum of
Arts, New York, Jan. 16–Feb. 20, 1975.
Richardson, Brenda. Introduction to Super Realism. Baltimore Museum of Art,
Nov. 18, 1975–Jan. 11, 1976.
Artists and East Hampton. Guild Hall, East Hampton, N.Y., Aug. 14–Oct. 3,
1976.
Felluss, Elias A. Foreword to Washington International Art Fair. Washington,
D.C., 1976.
Gervais, Daniel. Introduction to Troisième foire internationale d'art
contemporain. Grand Palais, Paris, Oct. 16–24, 1976.
Glaser, Bruce. Introduction to Audrey Flack: The Gray Border Series. Preface
by Louis K. Meisel. Louis K. Meisel Gallery, New York, Apr. 10–May 1, 1976.
Simkins, Alice C. Introduction to American Artists '76: A Celebration. Preface
by John Palmer Leeper. Marion Koogler McNay Art Institute, San Antonio,
Tex., 1976.

Walthard, Dr. Frederic P. Introduction to *Art 7 '76*. Basel, Switzerland, June 16–21, 1976.

Chase, Linda. "U.S.A." In *Aspects of Realism*. Rothman's of Pall Mall Canada, Ltd., June, 1976–Jan., 1978.

Ratcliff, Carter. Introduction to *The Aubrey Cartwright Foundation Exhibition of Contemporary Religious Art*. Cathedral Church of St. John the Divine, New York, Nov. 18, 1976–Jan. 2, 1977.

Cloudman, Ruth H. Introduction to *The Chosen Object: European and American Still Life*. Joslyn Art Museum, Omaha, Apr. 23–June 5, 1977.

Dempsey, Bruce. *New Realism*. Jacksonville Art Museum, Fla., 1977.

Felluss, Elias A. Foreword to *Washington International Art Fair*. Washington, D.C., 1977.

Seabolt, Fred. Introduction to *New in the '70s*. Foreword by Donald Goodall. University Art Museum, Archer M. Huntington Gallery, University of Texas, Austin, Aug. 21–Sept. 25, 1977.

June Blum, Audrey Flack, Alice Neel: Three Contemporary American Women Realists. Miami-Dade Community College, South Campus Art Gallery, Fla., Dec. 5–6, 1977, Jan. 4–19, 1978.

Stringer, John. Introduction to *Illusion and Reality*. Australian Gallery Directors' Council, North Sydney, N.S.W., 1977–78.

Alloway, Lawrence. Introduction to *Audrey Flack: Vanitas*. Louis K. Meisel Gallery, New York, Mar. 23–May 4, 1978.

Hennessey, William. *Artists Look at Art*. Foreword by Charles Eldredge. Helen Foresman Spencer Museum of Art, University of Kansas, Lawrence, Jan. 15–Mar. 12, 1978.

Koenig, Robert J. Introduction to *Drawing the Line*. Foreword by Kathryn E. Gamble. Montclair Art Museum, Montclair, N.J., Jan. 22–Mar. 19, 1978.

Meisel, Susan Pear. Introduction to *The Complete Guide to Photo-Realist Printmaking*, Louis K. Meisel Gallery, New York, Dec., 1978.

Schwartz, Therese. Introduction to *Perspective '78: Works by Women*. Freedman Gallery, Albright College, Reading, Pa., Oct. 8–Nov. 15, 1978.

Young, Mahonri Sharp. Foreword to *Aspects of Realism*. Guild Hall Art Gallery, East Hampton, N.Y., July 22–Aug. 13, 1978.

Cathcart, Linda L. *American Painting of the 70's*. Albright-Knox Art Gallery, Buffalo, Dec. 8, 1978–Jan. 14, 1979; Newport Harbor Art Museum, Balboa, Calif., Feb. 3–Mar. 18, 1979; Oakland Museum, Calif., Apr. 10–May 20, 1979; Cincinnati Art Museum, July 6–Aug. 26, 1979; Art Museum of South Texas, Corpus Christi, Sept. 9–Oct. 21, 1979; Krannert Art Museum, University of Illinois, Champaign-Urbana, Nov. 11, 1979–Jan. 2, 1980.

Chew, Paul A. Introduction to *The New American Still Life*. Westmoreland County Museum of Art, Greensburg, Pa., June 3–July 15, 1979.

Cooper, Marve H. Introduction to *Narrative Realism*. Art Association of Newport, R.I., Aug. 18–Sept. 16, 1979.

Felluss, Elias A. Introduction to *Washington International Art Fair '79*. May 2–7, 1979.

Gerling, Steve. Introduction to *Photo-Realism: Some Points of View*. Jorgensen Gallery, University of Connecticut, Storrs, Mar. 19–Apr. 10, 1979.

Miller, Wayne. Introduction to *Realist Space*. Foreword by Joan Vita Miller. C. W. Post Art Gallery, Long Island University, Brookville, N.Y., Oct. 19–Dec. 14, 1979.

Streuber, Michael. Introduction to *Selections of Photo-Realist Paintings from N.Y.C. Galleries*. Southern Alleghenies Museum of Art, St. Francis College, Loretto, Pa., May 12–July 8, 1979.

Mollison, James. Introduction to *Genesis of a Gallery, Part 2*. Australian National Gallery, Canberra, 1979–80.

ARTICLES

Mellow, James R. "Audrey Flack," *Arts Magazine*, Feb., 1959.

Sandler, Irving. "New Names This Month," *ARTnews*, Feb., 1959.

Raynor, Vivian. "Audrey Flack," *Arts Magazine*, Mar., 1963.

Adler, Robert. "West Side Artists: A New Awareness," *West Side News*, Oct. 1, 1964, p. 3.

"Art Tour: The Galleries—A Critical Choice," *New York Herald Tribune*, Mar. 19, 1966.

Alloway, Lawrence. "Art," *The Nation*, Dec. 29, 1969, pp. 741–42.

Baumgold, Julie, ed. "Best Bets," *New York Magazine*, Dec. 8, 1969.

Gaynor, Frank. "Photographic Exhibit Depicts Today's U.S.," *Newark Sunday News*, Dec. 14, 1969, sec. 6, p. E 18.

Perreault, John. "Get the Picture?," *Village Voice*, Dec. 18, 1969.

Nemser, Cindy. "Paintings from the Photograph," *Arts Magazine*, Dec.–Jan., 1969–1970.

Alloway, Lawrence. "In the Museums, Paintings from the Photo," *Arts*, Dec. 1, 1970.

Coleman, A. D. "Latent Image," *Village Voice*, Jan. 1, 1970.

Deschin, Jacob. "Photo into Painting," *New York Times*, Jan. 4, 1970.

Genauer, Emily. "On the Arts," *Newsday*, Feb. 21, 1970.

Lichtblau, Charlotte. "Painter's Use of Photographs Explored," *Philadelphia Enquirer*, Feb. 1, 1970.

Lord, Barry. "The 11 O'Clock News in Color," *Arts/Canada*, June, 1970, pp. 4, 21.

New York Times, Nov. 8, 1970, sec. II, pp. 6, 25.

Ratcliff, Carter. "Twenty-two Realists Exhibit at the Whitney," *Art International*, Apr., 1970, p. 105.

Stevens, Carol. "Message into Medium: Photography as an Artist's Tool," *Print*, vol. XXIV, no. III (May 6, 1970), pp. 54–59.

Stevens, Elizabeth. "The Camera's Eye on Canvas," *Wall Street Journal*, Jan. 6, 1970.

"Acquisitions by the Museum 1971–1972," *Whitney Review*, 1971–72.

Whitworth, Sarah. "Journeys in Art: Audrey Flack: Three Views," *The Ladder*, Dec., 1971–Jan., 1972, pp. 32–35, cover.

Benedict, Michael. "Audrey Flack," *ARTnews*, Apr., 1972.

Borsick, Helen. "Realism to the Fore," *Cleveland Plain Dealer*, Oct. 8, 1972.

Canaday, John. "Audrey Flack," *New York Times*, Mar. 4, 1972.

Henry, Gerrit. "The Real Thing," *Art International*, Summer, 1972, pp. 87–91.

Karp, Ivan. "Rent Is the Only Reality, or the Hotel Instead of the Hymn," *Arts Magazine*, Dec., 1972, pp. 47–51.

Kirkwood, Marie. "Art Institute's Exhibit Represents the Revolt Against Abstraction," *Sun Press* (Ohio), Oct. 12, 1972.

Naimer, Lucille. "The Whitney Annual," *Arts Magazine*, Mar., 1972, p. 54.

Nemser, Cindy. "Close-Up Vision: Representational Art," *Arts Magazine*, May, 1972, pp. 44–48.

———. "New Realism," *Arts Magazine*, Nov., 1972, p. 85.

Pozzi, Lucio. "Super realisti U.S.A.," *Bolaffiarte*, no. 18 (Mar., 1972), pp. 54–63.

Wasmuth, E. "La révolte des réalistes," *Connaissance des Arts*, June, 1972, pp. 118–23.

Wooten, Dick. "Something New? Real Pictures?," *Cleveland Press*, Oct. 17, 1972, p. 9.

Allen, Barbara. "In and Around," *Interview Magazine*, Nov., 1973, p. 36.

"Amiens Notre Dame," *Kunstforum International*, Mar. 4, 1973, p. 158.

Art Now Gallery Guide, Sept., 1973, pp. 1–3.

Azara, Nancy. "Artists in Their Own Image," *Ms.*, Jan., 1973, p. 57.

Beardsall, Judy. "Stuart M. Speiser Photorealist Collection," *Art Gallery Magazine*, vol. XVII, no. 1 (Oct., 1973), pp. 5, 29–34.

Bell, Jane. "Stuart M. Speiser Collection," *Arts Magazine*, Dec., 1973, p. 57.

Drexler, Rosalyn. "Audrey Flack," *New York Times*, Jan., 1973.

"Goings on About Town," *The New Yorker*, Oct. 1, 1973.

Gold, Barbara. "Sisterhood in New York," *Baltimore Sun*, Feb. 4, 1973.

Guercio, Antonio del. "Iperrealismo tra 'pop' e informale," *Rinascita*, no. 8 (Feb. 23, 1973), p. 34.

Henry, Gerrit. "A Realist Twin Bill," *ARTnews*, Jan., 1973, pp. 26–28.

"L'Hyperréalisme américain," *Le Monde des Grandes Musiques*, no. 2 (Mar.–Apr., 1973), pp. 4, 56–57.

Lubell, Ellen. "Women Choose Women," *Arts*, Mar.–Apr., 1973.

Mizue (Tokyo), vol. 8, no. 821 (1973).

"Neue Sachlichkeit—Neuer Realismus," *Kunstforum International*, Mar. 4, 1973, pp. 114–19.

Perreault, John. "Airplane Art in a Head Wind," *Village Voice*, Oct. 4, 1973, p. 24.

———. "Winning a Place in the Show," *Village Voice*, Jan. 25, 1973.

"Realism Now," *Patent Trader*, May 26, 1973, p. 7A.

"Reviews and Previews," *ARTnews*, Mar., 1973.

Sheridan, Lee. "'Women-Women' Contains Spirit," *Springfield Daily News*, Arts section, Feb. 9, 1973, p. 14.

B. M. "Reviews and Previews: Audrey Flack," *ARTnews*, vol. 71, no. 2 (Apr., 1974).

Coleman, A. D. "From Today Painting Is Dead," *Camera 35*, July, 1974, pp. 34, 36–37, 78.

"Collection of Aviation Paintings at Gallery," *Andover* (Mass.) *Townsman*, Feb. 28, 1974.

Forman, Nessa. "Goodbye to the Femme Fatale," *ARTnews*, Summer, 1974, pp. 65–66.

Frackman, Noel. "Audrey Flack," *Arts Magazine*, May, 1974, p. 70.

Frank, Peter. "Audrey Flack," *Soho Weekly News*, Apr. 11, 1974.

"Gallery Notes," *Memorial Art Gallery of the University of Rochester Bulletin*, vol. 39, no. 5 (Jan., 1974).

Goldenthal, Jolene. "Look at Art: Photo-Real Show at Atheneum," *Hartford Courant*, Apr. 14, 1974, p. 12F.

Goldenthal, June. "Look at Art: Audrey Flack, Photorealist," *Hartford Courant,* May 9, 1974.

Henry, Gerrit. "Reviews and Previews," *ARTnews,* May, 1974, pp. 91–92.

Hill, Richard. "The Technologies of Vision," *Art Magazine* (Toronto), vol. 6, no. 19 (Fall, 1974), p. 10.

Hughes, Robert. "An Omnivorous and Literal Dependence," *Arts Magazine,* (June, 1974), pp. 25–29.

Kozloff, Max. "Audrey Flack," *Artforum,* June, 1974, p. 65.

"Letter to the Editor," *Soho Weekly News,* Apr. 18, 1974.

Levin, Kim. "Audrey Flack at Meisel," *Art in America,* May–June, 1974, p. 106.

Nemser, Cindy. "Conversations with Audrey Flack," *Arts Magazine,* Feb., 1974, pp. 34–38.

———. "Letter to Audrey Flack Re: Kozloff on Audrey Flack," *Feminist Art Journal,* vol. 3, no. 3 (Fall, 1974).

"New York Eleven," *North Shore Commentary,* Feb. 14, 1974.

Perreault, John. "Glints of Glass, a Whiff of Poetry," *Village Voice,* Apr. 4, 1974.

———. "Reading a Monumental Still Life," *Village Voice,* May 2, 1974, p. 45.

Picard, Lil. "In . . . Out . . . und in Again," *Kunstforum International,* Jan. 2, 1974, pp. 215–17.

Progresso fotografico, Dec., 1974, pp. 61–62.

Saradoff, Lucia. "Outraged Women Artists . . .," *Soho Weekly News,* Jan. 16, 1974, pp. 2, 4, 5, 16.

School of Visual Arts Catalog, Spring, 1974, cover.

Spear, Richard. "Acquisitions 1973–1974," *Allen Memorial Art Museum Bulletin,* vol. XXXIII (Oberlin College), 1974–75, p. 17.

Stubbs, Ann. "Audrey Flack," *Soho Weekly News,* Apr. 4, 1974.

Vlack, Carol. "Photo Realist Audrey Flack Displays Works at MAG," *University of Rochester Campus Times,* Jan. 18, 1974, p. 9.

Walsh, Sally. "Paintings that Look Like Photos," *Rochester Democrat and Chronicle,* Jan. 17, 1974.

Zabel, Joe. "Realistic Works Predominate in 1974 Mid-Year," *The Jambar* (Youngstown State University, Ohio), July 11, 1974, p. 7.

"Audrey Flack Named Visiting Professor of Art," *Bridgeport Sunday Post,* Feb. 9, 1975.

Bruner, Louise. "Brash Paintings Stimulate Thinking Rather than Passive Thoughts," *Toledo Blade,* Jan. 12, 1975, p. 4.

The Children's Blood Foundation Souvenir Journal (New York), 1975.

Cowart, Jack. "Acquisitions: Three Contemporary American Paintings," *St. Louis Art Museum Bulletin,* Sept.–Oct., 1975, pp. 88–95.

DeMarino, Marg. "Art Makes Life More Liveable," *New Haven Register,* Mar. 21, 1975.

———. "Photo-Real Paintings Newest Art Style," *Hartford Times,* Mar. 21, 1975, p. 17.

Dubrow, Marsha. "Female Assertiveness, How a Pussycat Can Learn to Be a Panther," *New York Magazine,* July 28, 1975, p. 42.

"Growing Up," *Crawdaddy,* June, 1975, pp. 42–43.

Loercher, Diane. "Soho, the New World," *Christian Science Monitor,* Oct. 15, 1975, p. 30.

"Major Art Event Painting Sold to MOMA," *New Haven Register,* Apr. 11, 1975.

McNamara, T. J. "Photo-Realist Exhibition Makes Impact," *New Zealand Herald* (Auckland), July 23, 1975.

Mikotajuk, Andrea. "American Realists at Louis K. Meisel Gallery," *Arts Magazine,* Jan., 1975, pp. 19–20.

Nemser, Cindy. "Audrey Flack, Photorealist Rebel," *Feminist Art Journal,* vol. 4, no. 3 (Fall, 1975), pp. 5–12.

"1975–1976 Cultural Programs: Photo-Realist Audrey Flack to Appear at C.S.U." *Colorado State University Bulletin,* 1975, p. 22.

Normile, James. "Contemporary Portraiture," *Architectural Digest,* July–Aug., 1975.

"Photographic Realism," *Art-Rite,* no. 9 (Spring, 1975), p. 15.

Perreault, John. "Putting His Finger in Butter," *Soho Weekly News,* Oct. 16, 1975.

"Photo-Realism Exhibit Is Opening at Paine Sunday," *Oshkosh Daily Northwestern,* Apr. 17, 1975.

"Photo-Realism Flies High at Paine," *Milwaukee Journal,* May, 1975.

"Photo-Realists at Paine," *View Magazine,* Apr. 27, 1975.

Richard, Paul. "Whatever You Call It, Super-Realism Comes On with a Flash," *Washington Post,* Nov. 25, 1975, p. B1.

Toledo Museum Art Bulletin, Jan., 1975.

Weatherspoon Gallery Association Bulletin, University of North Carolina, Greensboro, 1975–76.

"The World Food Population Crisis," *Cross Talk,* vol. 4, part I (Dec.–Feb., 1975–76), p. 14.

Lanser, Fay. "Book Review—Art Talk: Conversations with 12 Women Artists," *Feminist Art Journal,* Winter, 1975–76, p. 40.

Alloway, Lawrence. "Alex Katz's Development," *Artforum,* Jan., 1976, p. 45.

———. "Art," *The Nation,* May 1, 1976, pp. 539, 541.

———. "Audrey Flack," *The Nation,* Apr., 1976.

———. "Close to Home," *The Nation,* Oct. 30, 1976, p. 446.

"At Meisel Gallery," *East Hampton* (N.Y.) *Star,* Apr. 29, 1976, sec. 11, p. 7.

Bourdon, David. "Photography Comes to Still Life," *Village Voice,* Apr. 26, 1976, p. 128.

———. "Why Photographers Like Artists," *Village Voice,* Feb. 23, 1976, p. 103.

The Bulletin Board (San Antonio), vol. 1, no. 1 (May, 1976).

Chase, Linda. "Photo-Realism: Post Modernist Illusionism," *Art International,* vol. XX, no. 3–4 (Mar.–Apr., 1976), pp. 14–27.

"Female Art Show," *San Antonio Express,* Feb. 5, 1976, p. 9F.

Forgey, Benjamin. "The New Realism, Paintings Worth 1,000 Words," *Washington Star,* Nov. 30, 1976, p. G24.

Glasser, Penelope. "Aspects of Realism at Stratford," *Art Magazine* (Toronto), vol. 7, no. 28 (Summer, 1976), pp. 22–29.

Grove, Nancy. "Audrey Flack," *Arts Magazine,* June, 1976, p. 24.

Henry, Gerrit. "Audrey Flack," *ARTnews,* Summer, 1976, p. 170.

Hoelterhoff, Manuela. "Strawberry Tarts Three Feet High," *Wall Street Journal,* Apr. 21, 1976.

Jones, Nancy Scott. "Celebrating Women in Art," *San Antonio Express News,* May 23, 1976, p. 3E.

Kramer, Hilton. "The Current Backlash in the Arts," *New York Times,* May 23, 1976.

Lion Art Magazine (Taipei), Jan., 1976, p. 47.

"McNay Planning Major Exhibition," *Northside* (Tex.) *Recorder,* Feb. 5, 1976, p. 5NE.

Moorman, Adelaide. "Women's Show," *Houston Breakthrough,* vol. 1, no. 6 (June–July, 1976), p. 13.

Nemser, Cindy. "More on the Arts Backlash," *New York Times,* Letter to the Editor, May 30, 1976.

"News from the Southwest," *Women's Caucus for Art Newsletter,* Apr., 1976, p. 8.

Pension World, July, 1976, cover.

Perreault, John. "Getting Flack," *Soho Weekly News,* Apr. 22, 1976, p. 19.

———. "Photo-Shock," *Soho Weekly News,* Jan. 22, 1976, p. 16.

Perry, Art. "So Much for Reality," *Province,* Sept. 30, 1976.

"Photography: Art and Process," *Visual Dialog,* vol. 1, no. 4 (June–Aug., 1976), p. 18.

"Planning Major Art Show," *San Antonio Light,* Feb. 5, 1976, p. 5D.

Rappaport, Jody. "Audrey Flack Art in Soho," *State University of New York at Stonybrook Journal,* June, 1976.

San Antonio Express, May 21, 1976, p. 14A.

Shirey, David. "A Mark of Independence," *New York Times,* July 25, 1976, p. 16.

———. "It Was a Very Good Hundred Years," *New York Times,* Sept. 19, 1976, p. 26.

Sieberling, Dorothy. "Real Big: An Escalation of Still Lifes," *New York Magazine,* Apr. 26, 1976, pp. 42–44.

Siegel, Jeanne. "Audrey Flack's Objects," *Arts Magazine,* June, 1976, pp. 103–5.

Tucker, William G. "Louis K. Meisel: Audrey Flack," *Artists Review Art,* vol. 1, no. 4 (Apr., 1976).

———. "Sugar on the Optic Nerve," *The Villager,* Apr. 15, 1976, p. 11.

"Weekly Guide to Culture: Happenings in San Antonio," *San Antonio Express News,* May 23, 1976.

Womanschool, vol. 2, no. 2 (Fall, 1976), p. 13.

Greenwood, Mark. "Toward a Definition of Realism: Reflections on the Rothman's Exhibition," *Arts/Canada,* vol. XXIV, no. 210–11 (Dec., 1976–Jan., 1977), pp. 6–23.

Battcock, Gregory. "Dinner for Eighty," *Soho Weekly News,* Nov. 10, 1977.

Borlase, Nancy. "In Selecting a Common Domestic Object," *Sydney Morning Herald,* July 30, 1977.

Carmalt, Susan. "Huntington Displays New Trends," *Austin Daily Texan,* Aug., 1977.

"Commencement 1977," *At Cooper Union,* vol. IX, no. 2 (Spring, 1977).

Edelson, Elihu. "New Realism at Museum Arouses Mixed Feelings," *Jacksonville* (Fla.) *Journal,* Feb., 1977.

———. "Photo Realism Shows Varying Degrees," *Jacksonville* (Fla.) *Journal,* Feb. 26, 1977, p. 18.

"For the Record," *Art Gallery Magazine,* Summer, 1977, p. 80.

Glueck, Grace. "The 20th Century Artists Most Admired by Other Artists,"

ARTnews, vol. 76, no. 9 (Nov., 1977), p. 84.

Graves, Jack. "The Star Talks to Audrey Flack, Super Realist," *East Hampton* (N.Y.) *Star,* Aug. 4, 1977, p. 11.

Grishin, Sasha. "An Exciting Exhibition," *Canberra Times,* Feb. 16, 1977.

"Illusion and Reality," *This Week in Brisbane,* June, 1977.

Langer, Gertrude. "Realising Our Limitations in Grasping Reality," *Brisbane Courier Mail,* May 28, 1977.

Lynn, Elwyn. "The New Realism," *Quadrant,* Sept., 1977.

Makin, Jeffrey. "Realism from the Squad," *Melbourne Sun,* Oct. 19, 1977, p. 43.

McGrath, Sandra. "I Am Almost a Camera," *The Australian* (Brisbane), July 27, 1977.

McIntyre, Mary. "70s Art Comes to Town," *Austin American-Statesman,* Aug. 28, 1977, pp. 7, 8.

Morrison, C. L. "Strong Works," *Artforum,* Dec., 1977.

Pequod, vol. 11, no. 3 (Summer, 1977), cover.

Perreault, John. *Soho Weekly News,* Jan., 1977.

"Photo-Realism and Related Trends," *New York Times,* Feb. 4, 1977.

"Prints Exhibition for D'port," *Examiner* (New Zealand), Sept. 7, 1977.

Russell, John. "Photo-Realism and Related Trends," *New York Times,* Feb. 4, 1977, p. C16.

R. S. "The Museum of Modern Art," *Art in America,* Sept. 10, 1977, pp. 93–96.

"Some Artists' Ideas on Eating Well," *New York Times,* Dec. 21, 1977, p. C5.

"Spotlight," *America Illustrated* (U.S. Information Agency, Washington, D.C.), no. 247 (1977), p. 56.

Thomas, Daniel. "The Way We See Now," *The Bulletin,* Sept. 10, 1977.

Tufts, Eleanor. "The Veristic Eye," *Arts Magazine,* Dec., 1977, p. 142.

Adams, Laurie. "Intimations of Mortality," *Ms.,* May, 1978, p. 24.

Art Now Gallery Guide, vol. 8, no. 8 (Apr., 1978), p. 17.

Battcock, Gregory. "Thinking Decently: Two Audacious Artists in New York," *New York Arts Journal,* Apr. 5, 1978, pp. 24–26.

Bell, Jane. "Art About Art About Art About…," *New York Arts Journal,* no. 11 (Sept.–Oct., 1978), p. 28.

Bongard, Willie. *Art Aktuell* (Cologne), Apr., 1978.

The Cooper Union Alumni Calendar (New York), 1978.

Devaney, Sally. "Kaleidoscope," *Art Gallery Magazine,* Oct.–Nov., 1978, p. 25.

Edwards, Ellen. "Eyes Have It in Portrait Show," *Miami Herald,* Jan. 8, 1978, p. 3L.

Englehardt, Nina. "Audrey Flack Portrays Man of the Year," *Women Artists News,* vol. 3, no. 8 (Feb., 1978).

Glueck, Grace. "Greater Soho—Spring Guide to Downtown Art World," *New York Times,* Mar. 31, 1978, p. C12.

———. "Soho in Springtime," *New York Times,* Mar. 31, 1978, p. C1.

Harnett, Lila. "Beyond Reality," *Cue,* Apr. 14, 1978, p. 21.

———. "Photo-Realist Prints: 1968–1978," *Cue,* Dec. 22, 1978, p. 23.

Harris, Helen. "Art and Antiques: The New Realists," *Town and Country,* Oct., 1978, pp. 242, 244, 246–47.

J. T. "Audrey Flack," *Art World,* Apr. 15–May 15, 1978, p. 13.

Jacobson, Carol. "Two Exhibits of Major Interest at Lincroft Sites," *Daily Register* (Lincroft, N.J.), Feb. 1, 1978.

Jordan, George. "Photo Realism Show at Tulane," *New Orleans Times–Picayune,* Feb. 23, 1978, sec. 1, p. 21.

Kramer, Hilton. "A Brave Attempt to Encapsulate a Decade," *New York Times,* Dec. 17, 1978, p. 39.

Lubell, Ellen. "Phototransformations," *Soho Weekly News,* Sept. 28, 1978, p. 80.

Mackie, Alwynne. "New Realism and the Photographic Look," *American Art Review,* Nov., 1978, pp. 72–79, 132–34.

"Man of the Year," *Time,* Jan. 1, 1978, cover.

The New Republic, June 24, 1978, cover.

O'Conor, Mary. "Eight Artists," *East Hampton* (N.Y.) *Star,* July 17, 1978, p. 14.

Perreault, John. "Audrey Flack, Odds Against the House," *Soho Weekly News,* vol. 5, no. 25 (Mar. 23–29, 1978), pp. 19–21, cover.

———. "A Painting that Is Difficult to Forget," *ARTnews,* Apr., 1978, pp. 150–51.

———. "Photo Realist Principles," *American Art Review,* Nov., 1978, pp. 108–11,141.

"Photo Journalism and Photo Realism," *Milwaukee Journal,* Dec. 10, 1978.

Raynor, Vivian. "Audrey Flack," *New York Times,* Apr. 14, 1978, p. C22.

Richard, Paul. "New Smithsonian Art: From 'The Sublime' to Photo Realism," *Washington Post,* Nov. 30, 1978, p. G21.

"Segunda Guerra Mundial," *Artes Visuales,* no. 18 (Summer, 1978).

Shirey, David. "Drawings: A Show with More than One Meaning," *New York Times,* Feb. 5, 1978, p. NJ-19.

———. "More Real Than Real," *New York Times,* Aug. 6, 1978, p. LI-14.

"Special from Broadway," *East Hampton* (N.Y.) *Star,* July 20, 1978, p. 13.

"Style Hampton-Style," *East Hampton* (N.Y.) *Summer Sun,* July 27, 1978, p. 11.

Thill, Mary. "Photorealist Flack Visits Brookdale," *The Stall* (Brookdale, N.J.), vol. 17, no. 2 (Feb. 17, 1978), p. 5.

Goodman, Vera. "Surprise Them with Art," *New Directions for Women* (Westwood, N.J.), vol. 7, no. 4 (Winter, 1978–79), pp. 13, 22.

"American Painting of the Seventies," *Bulletin,* Krannert Art Museum, University of Illinois, vol. 5, no. 1 (1979), pp. 2–3, 5.

Melcher, Victoria Kirsch. "Vigorous Currents in Realism Make Up Group Show at UMKC," *Kansas City Star* (Mo.), Mar. 11, 1979, p. 3E.

Perreault, John. "New Life for the Still Life," *Soho Weekly News,* Apr. 12, 1979, p. 54.

———. "New Museum? For Real? It Figures," *Soho Weekly News,* Sept. 20, 1979, p. 43.

Sozanski, Edward. "Narratives Boldly Stated Preface Untold Stories," *Providence Sunday Journal* (R.I.), Aug. 19, 1979, p. H1.

"Statues Don't Hit Back," *New York Times,* Feb. 16, 1979, p. C23.

Weintraub, Linda. "Perspective '78: Works by Women," *Arts Exchange* (Philadelphia), vol. 3, no. 1 (Jan.–Feb., 1979), p. 25.

"What's On in Washington," *Women Artists News,* Jan., 1979, p. 2.

BOOKS

Coke, Van Deren. *The Painter and the Photograph.* Albuquerque: University of New Mexico Press, 1972.

Kultermann, Udo. *New Realism.* New York: New York Graphic Society, 1972.

Kortlander, William. *Painting with Acrylics.* New York: Van Nostrand Reinhold, 1973.

Sager, Peter. *Neue Formen des Realismus.* Cologne: Verlag M. DuMont Schauberg, 1973.

Who's Who in American Art. New York: R. R. Bowker, 1973.

Kamarck, Edward, ed. *Arts in Society: Women and the Arts.* Madison, Wis.: University of Wisconsin Extension, 1974.

Art—A Woman's Sensibility: The Collected Works and Writings of Women Artists. Valencia, Calif.: California Institute of the Arts, 1975.

Battcock, Gregory, ed. *Super Realism, A Critical Anthology.* New York: E. P. Dutton, 1975.

Chase, Linda. *Hyperréalisme.* New York: Rizzoli, 1975.

Kultermann, Udo. *Neue Formen des Bildes.* Tübingen, West Germany: Verlag Ernst Wasmuth, 1975.

Nemser, Cindy. *Art Talk.* New York: Scribner's, 1975.

Pomeroy, Ralph. *The Ice Cream Connection.* London: Paddington Press, 1975.

Rose, Barbara, ed. *Readings in American Art, 1900–1975.* New York: Praeger, 1975.

Petersen, Karen, and Wilson, J. J. *Women Artists.* New York: Harper & Row, 1976.

Who's Who in American Art. New York: R. R. Bowker, 1976.

Melville, Keith. *Marriage and Family Today.* New York: Random House, 1977.

Rose, Barbara (with Jules D. Brown). *American Painting.* New York: Skira, Rizzoli, 1977.

Selleck, Jack. *Faces.* Worcester, Mass.: Davis Publications, 1977.

Lipman, Jean, and Marshall, Richard. *Art About Art.* New York: E. P. Dutton, 1978.

Saff, Donald, and Sacilotto, Deli. *Printmaking.* New York: Holt, Rinehart and Winston, 1978.

Walters, Margaret. *The Nude Male: A New Perspective.* New York: Paddington Press, 1978.

Lucie-Smith, Edward. *Super Realism.* Oxford: Phaidon, 1979.

Saff, Donald, and Sacilotto, Deli. *Screenprinting History and Process.* New York: Holt, Rinehart and Winston, 1979.

Seeman, Helene Zucker, and Siegfried, Alanna. *SoHo.* New York: Neal-Schuman, 1979.

573. Ralph Goings

RALPH GOINGS

Ralph Goings, the senior member of the Photo-Realist painters, is still quite young compared to other artists who have achieved international prominence. Goings's age is significant in that he graduated from school at the absolute high point in the reign of Abstract Expressionism, and so began his career as an abstract painter. As he tells it, it took him a number of years to find out that he was not essentially an abstract painter.

In 1962, Goings began working with realist images. At this point, Pop was beginning to appear on the American art scene, bringing with it a general acceptance of realism in high art. During the early and middle sixties, Goings's work—clearly influenced by Wayne Thiebaud and Mel Ramos—depicted the figure in a style related to Pop. Early in his career, Goings had used photos from magazines, like the Pop artists, who also derived their subject matter from the mass media. About 1967–68, he began using photos he had taken himself. The series of approximately ten paintings derived from these first photos, representing realistic figures against solid backgrounds, was called California Girls. Oddly enough, Arne Besser was doing very similar work in New York, but without the aid of a camera.

In 1969, Goings was invited to show in Sacramento in a group exhibition of paintings dealing with aspects of life in that city. One day as the deadline was drawing near, Goings went out with his camera, determined to photograph something he could paint for the show. At some point during that day, he realized how many pickup trucks there were in and around the city. Goings took many slides of trucks that day and began a series of paintings from them. He sent slides of these paintings to the O. K. Harris Gallery, which presented his first New York exhibition as a Photo-Realist in 1970.

With the notable exception of one of his most famous works, *Airstream* (pl. 575),

Goings's first true Photo-Realist paintings all depicted pickup trucks. Goings has never clearly stated why he chooses his particular subject matter, but it is fairly evident that, like Estes and many others, he paints familiar images from his environment. California is inundated with trucks and roadside fast-food stands, with metal, chrome, glass, gaudy colors, stainless steel—all producing a Pop feeling that Goings finds challenging to paint. Like Estes, he has stated a strong concern with craftsmanship and technical proficiency, and considers much of Pop Art to be sloppy painting.

Goings uses a word for his work which bears some investigation. The word is "render." In almost every interview and discussion, he says, "I render," or "My concern has always been with rendering." There is no dictionary definition of this word which adequately explains Goings's meaning. While "rendering" has traditionally been used in a derogatory sense to describe painters, and has been associated with illustration and architectural drawing, I believe that to Goings it means the craft of copying with exacting care. He says, "I like to copy—I do a lot of copying. I like tracing—I trace a lot. It's a useful tool for me." The word implies a degree of the impersonal and mechanical, in which the primary concern is technical craftsmanship brought as close to perfection as possible. Goings does, however, editorialize. By altering colors and removing some superfluous details, he changes the painting from the original photograph in ways that would be evident only if both were examined side by side.

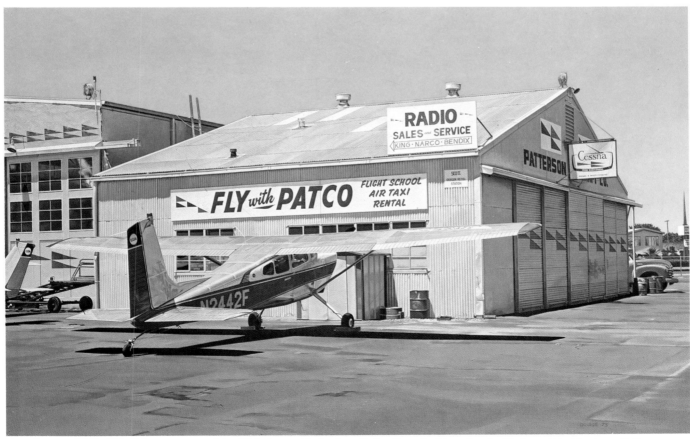

574. *Cessna*. 1973 (57). Oil on canvas, 36 x 52". Stuart M. Speiser Collection, Smithsonian Institution, Washington, D.C.

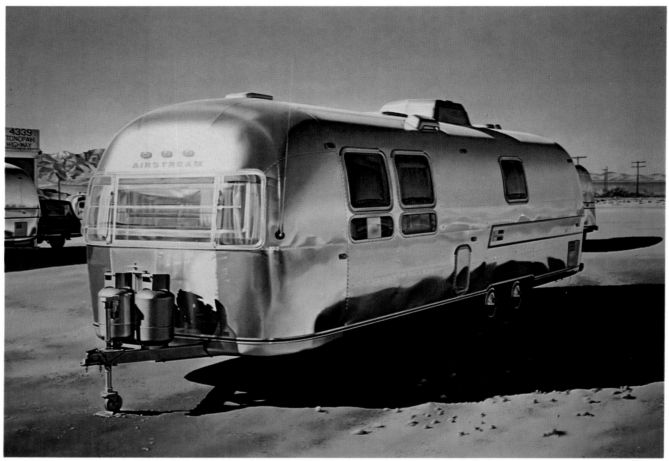

575. *Airstream*. 1970 (11). Oil on canvas, 60 x 84". Neue Galerie der Stadt Aachen. Ludwig Collection

Goings enjoys the physical act of painting. In rendering, he can spend eight to ten hours on three or four square inches of canvas. His blending is flawless and his brushstrokes virtually invisible. Goings is striving for a sterilizing effect, with almost no personal traces left; while he himself is conservative, this aspect of his work may make Goings one of the most radical opponents of the doctrines of abstract painting.

Goings says of his work:

Reality is possessed of a visual order and logic at once more dynamic and more subtle than any vista I can contrive. I try to perceive this splendor as objectively as possible and render it with believable authenticity. Realist painting provides an occasion to visually savor reality.

Ralph Goings
September 30, 1973

Ralph Goings had executed 141 Photo-Realist paintings and watercolors through 1979. Of these, 73 are illustrated herein and the rest are listed.

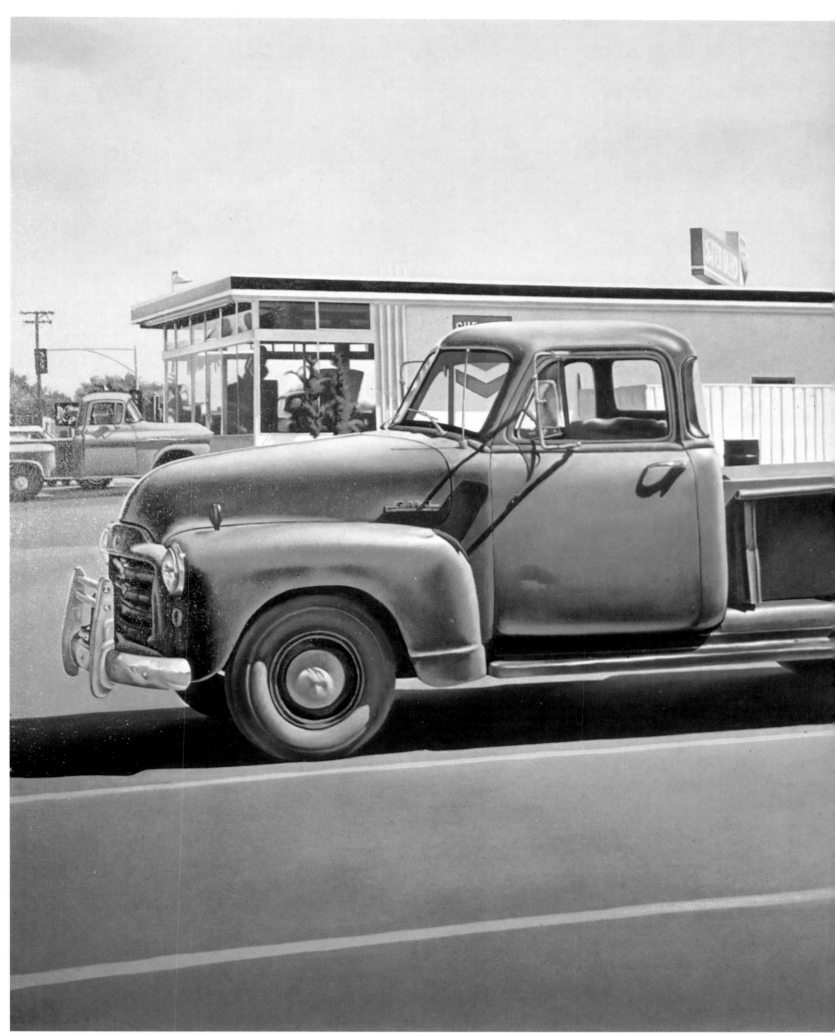

576. *Blue Chip Truck*. 1969 (2). Oil on canvas, 45 x 54". Private collection

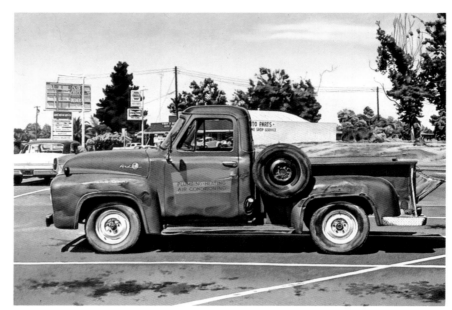

577. *Heating and Plumbing Truck.* 1969 (3). Oil on canvas, 45 x 63".
Private collection, Calif.

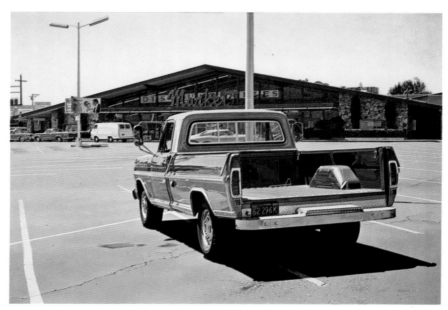

578. *Market Pick-up.* 1973 (59). Oil on canvas, 36 x 52".
Private collection

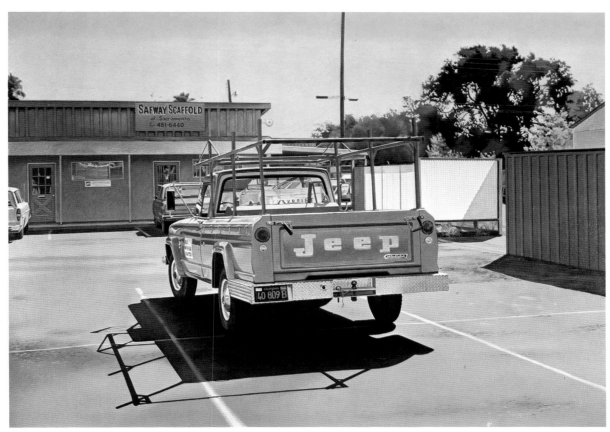

579. *Safeway Jeep*. 1969 (4). Oil on canvas, 45 x 63". Private collection

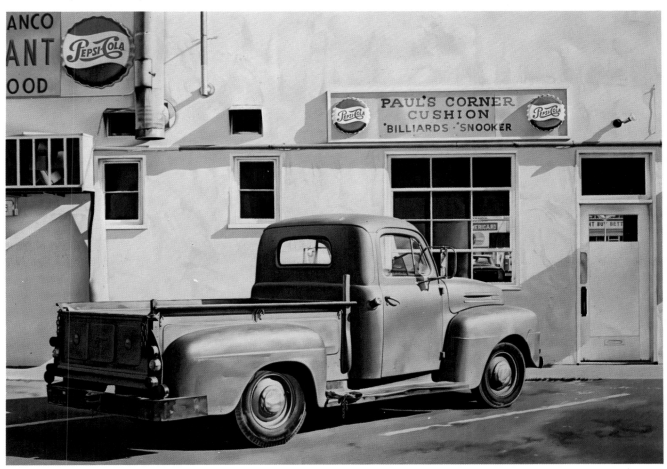

580. *Paul's Corner Cushion*. 1970 (8). Oil on canvas, 48 x 68". Private collection

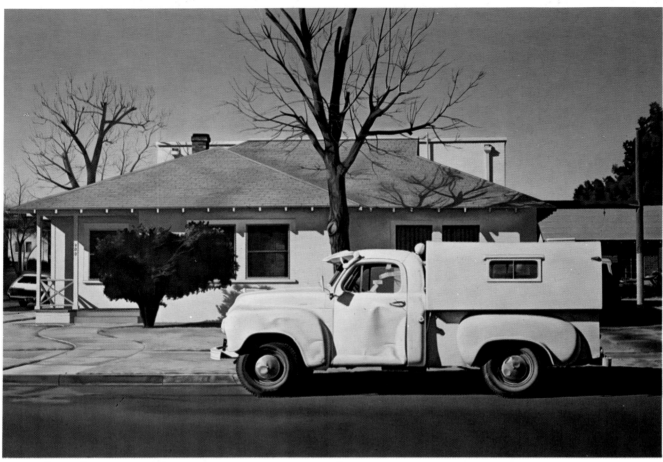

581. *Moby Dick*. 1971 (20). Oil on canvas, 48 x 68". Private collection

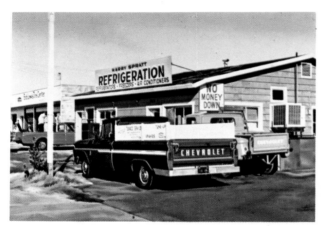

582. *Refrigeration Trucks*. 1970 (7). Oil on canvas,
45 x 63". Private collection

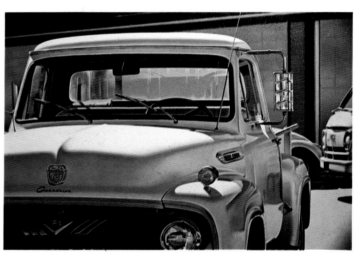

583. *White Ford Overdrive*. 1970 (9). Oil on canvas, 45 x 63".
Private collection, New York

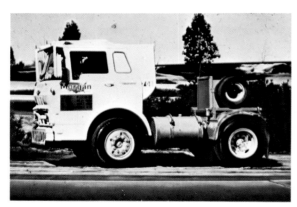

584. *Morgan Semi Rig*. 1970 (10). Oil on canvas,
48 x 68". Collection Beatrice C. Mayer, Ill.

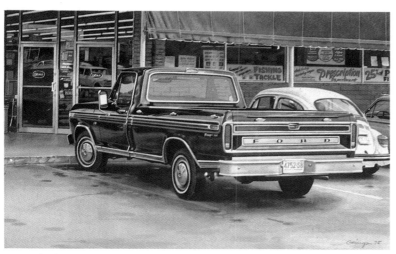

585. *Black Ford.* 1975 (82). Watercolor, 8 x 12⅜". Collection
Louis and Susan Meisel, New York

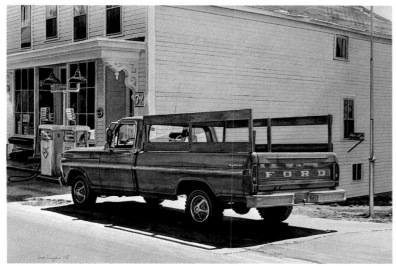

586. *General Store Ford.* 1975 (84). Watercolor, 10½ x 15".
Private collection, New York

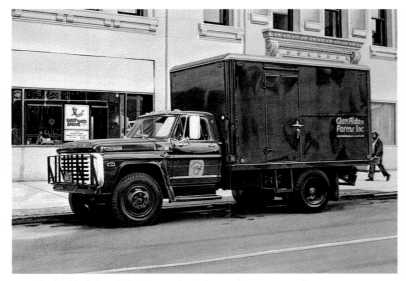

587. *Early Bird Special.* 1975 (83). Watercolor, 8½ x 12".
Morgan Gallery, Kans.

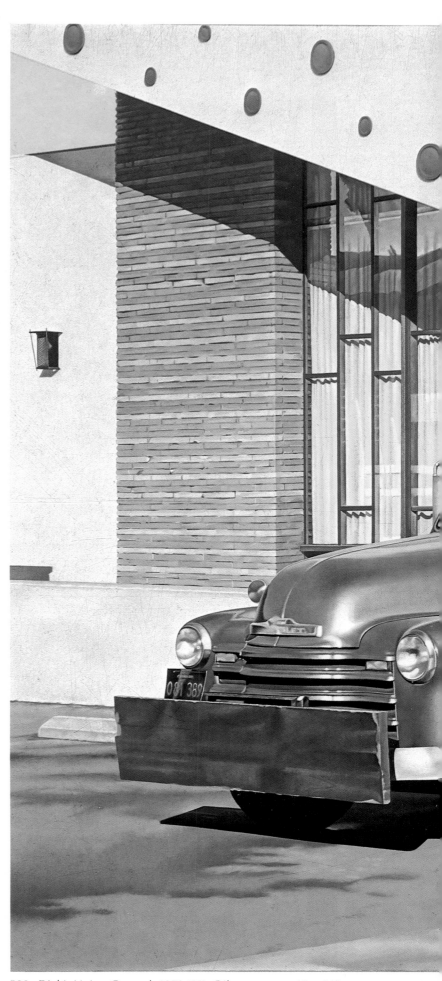

588. *Dick's Union General.* 1971 (21). Oil on canvas, 40 x 56".
Sydney and Frances Lewis Foundation, Va.

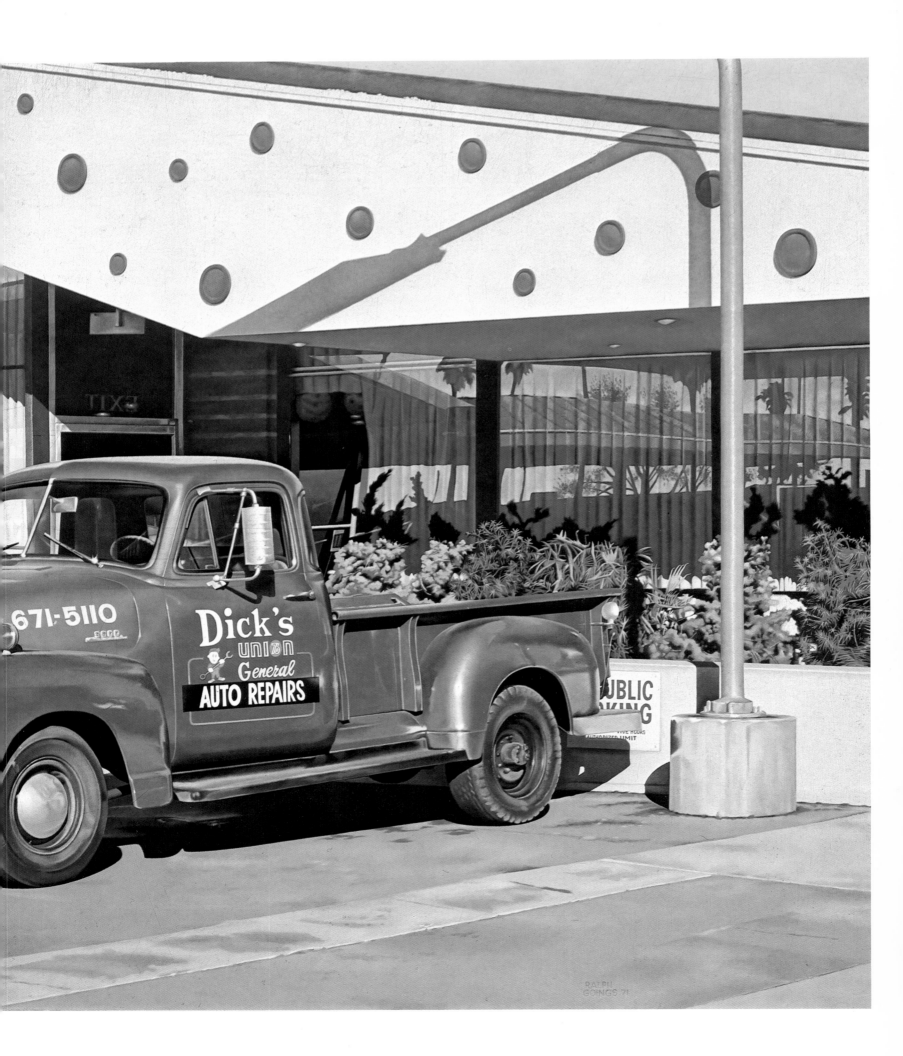

281

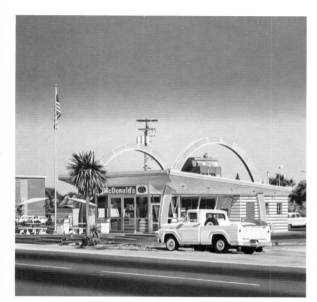

589. *McDonald's.* 1970 (14).
Oil on canvas, 41 x 41".
Private collection, New York

590. *Sizzle Kitchen.* 1971 (18).
Oil on canvas, 40 x 40".
Collection Mr. and Mrs. W. Jaeger, New York

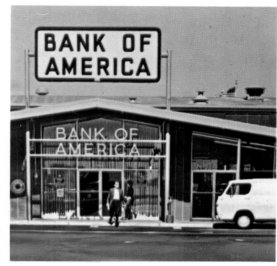

591. *Bank of America.* 1971 (19).
Oil on canvas, 41 x 41".
Collection Ethel Kraushar, New York

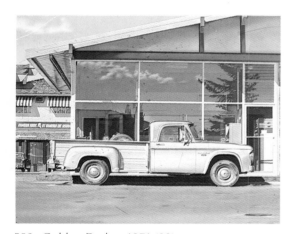

592. *Golden Dodge.* 1971 (23).
Oil on canvas, 60 x 72". Collection
Mr. and Mrs. Martin Schmukler, New York

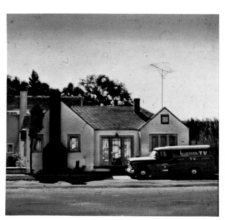

593. *Lawson's TV.* 1970 (16). Oil on
canvas, 41 x 41". Collection Lewis Clapp
Investment Science Associates, Mass.

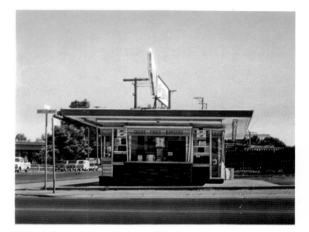

594. *8th and Broadway.* 1972 (28).
Oil on canvas, 40 x 50".
Private collection

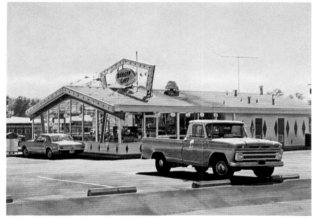

595. *Burger Chef.* 1970 (15).
Oil on canvas, 40 x 56".
Private collection

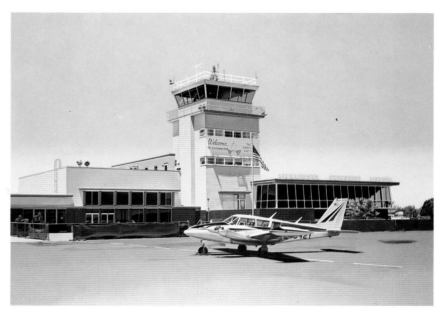

596. *Sacramento Airport.* 1970 (13). Oil on canvas, 60 x 84". Private collection

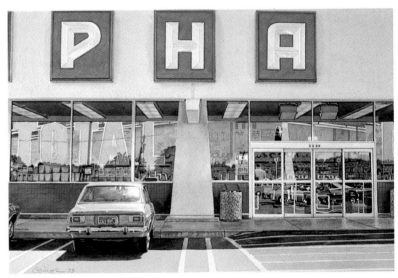

598. *Alpha.* 1973 (55). Watercolor, 9 x 12". Dillard Collection, Weatherspoon Art Gallery, N.C.

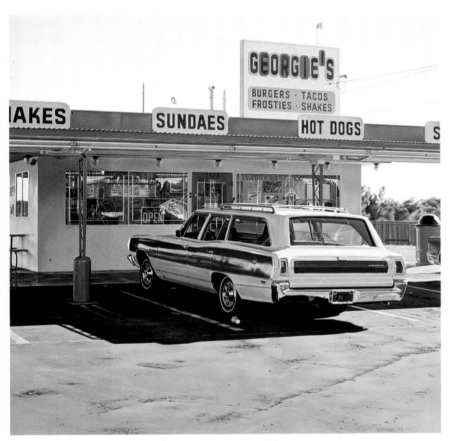

597. *Georgie's.* 1973 (46). Oil on canvas, 40 x 40". Private collection

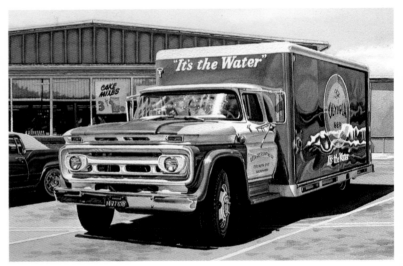

599. *Olympia Truck.* 1972 (35). Watercolor, 8 x 12". Richard Brown Baker Collection, New York

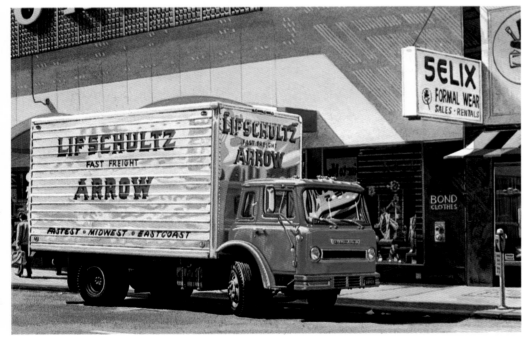

600. *Arrow Delivery Truck.* 1972 (36). Watercolor, 8 x 12". Private collection

601. *Sherwin-Williams Camper.* 1975 (88). Oil on canvas, 44 x 62". Museum of Modern Art, New York. Purchased with funds from N.E.A. and an anonymous donor, 1976

284

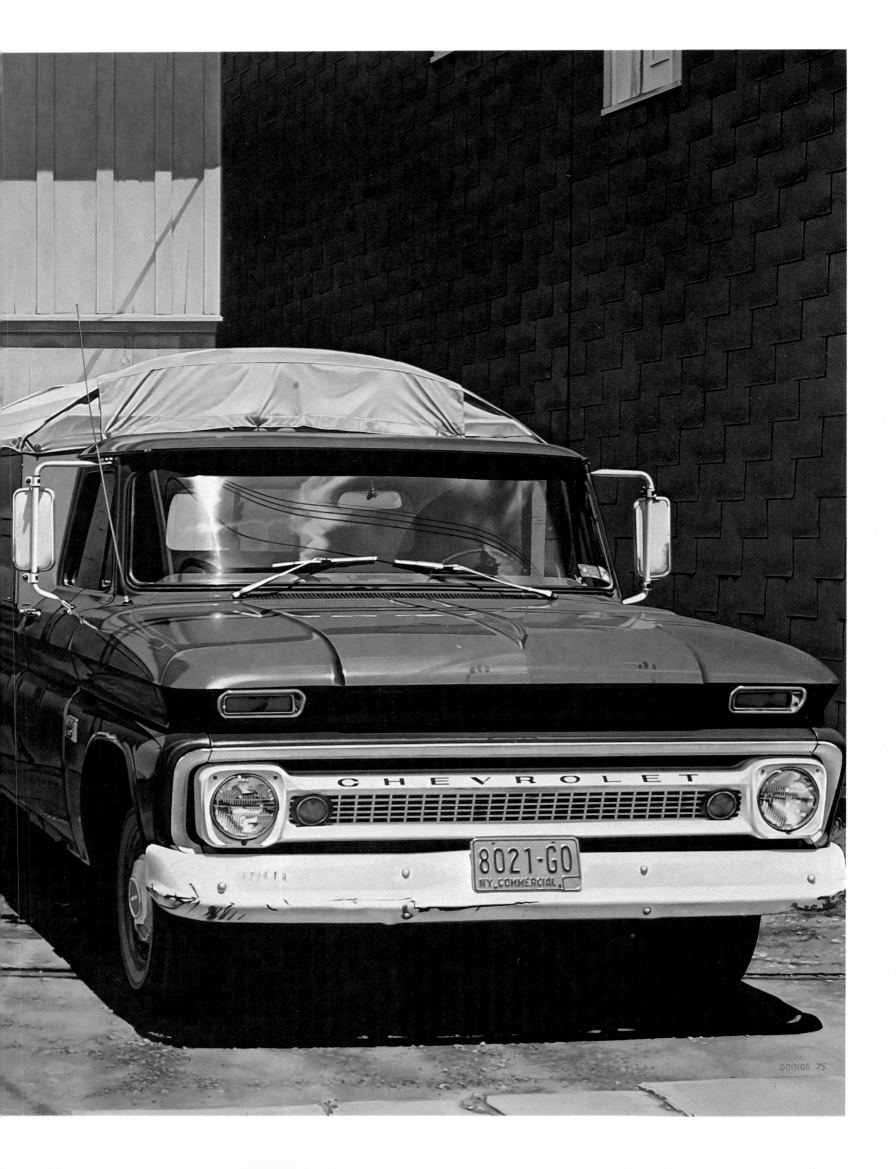

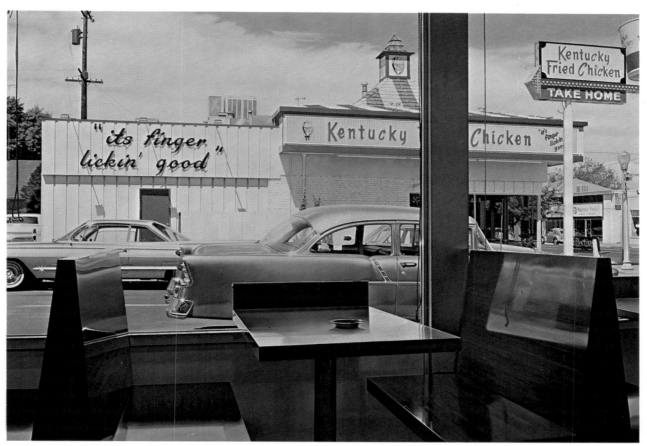

602. *Kentucky Fried Chicken.* 1973 (45). Oil on canvas, 48 x 68". Collection Paul and Camille Hoffman, Ill.

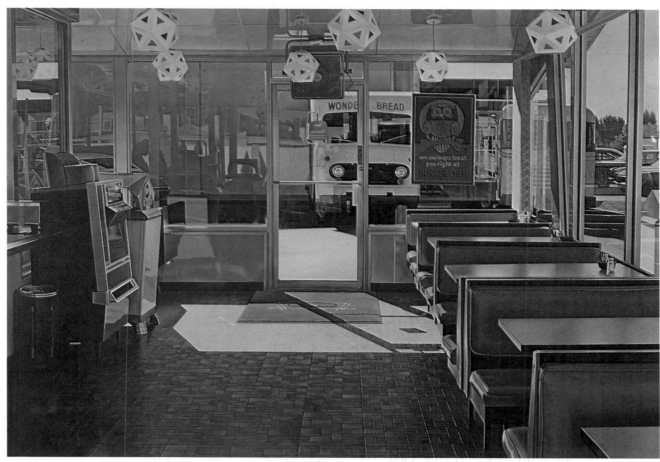

603. *Burger Chef Interior.* 1972 (38). Oil on canvas, 49 x 56½". Sydney and Frances Lewis Foundation, Va.

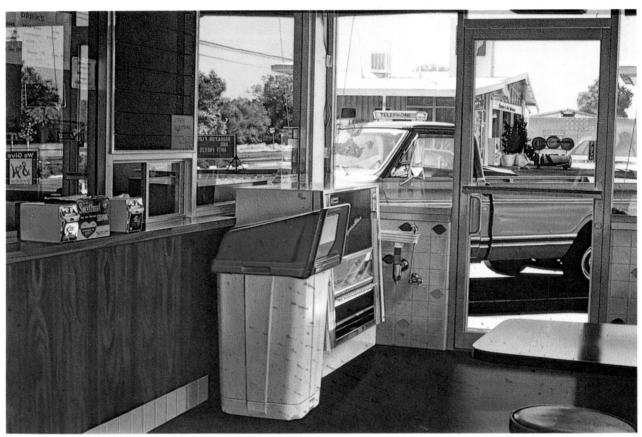

604. *Dairy Queen Interior.* 1972 (33). Oil on canvas, 36 x 50". Private collection

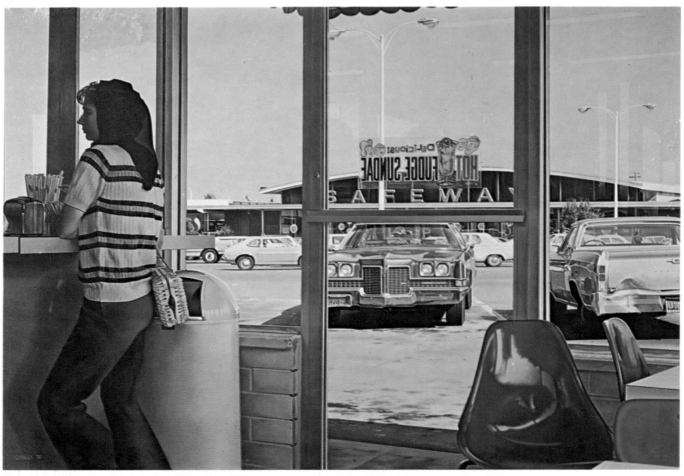

605. *Hot Fudge Sundae Interior.* 1972 (41). Oil on canvas, 40 x 56". Galleri Ostergren, Sweden

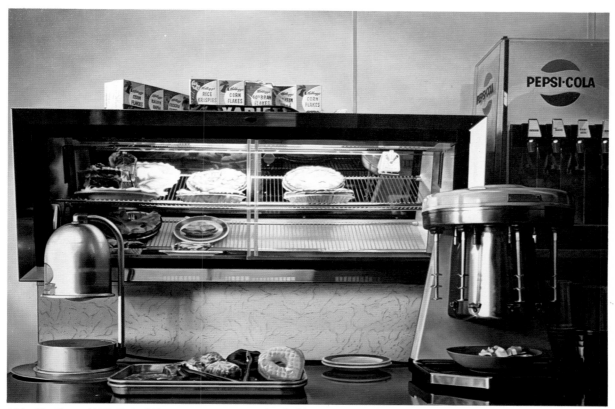

606. *Pie Case.* 1975 (75). Oil on canvas, 24 x 34". Sheldon Memorial Art Gallery, University of Nebraska, Lincoln

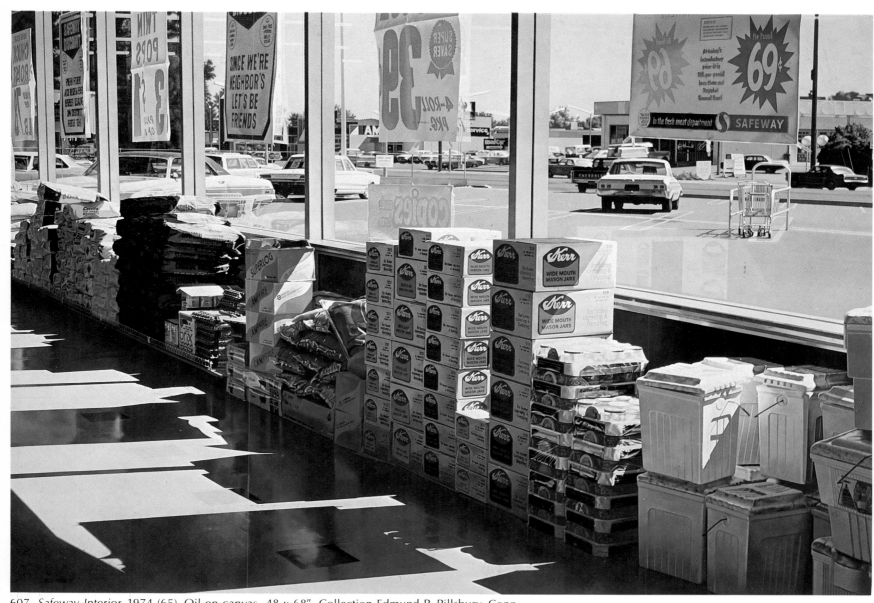

607. *Safeway Interior.* 1974 (65). Oil on canvas, 48 x 68". Collection Edmund P. Pillsbury, Conn.

608. *Dandee Donut Interior*. 1977 (105). Acrylic on paper, 12 x 17½". Collection Irving Luntz, Fla.

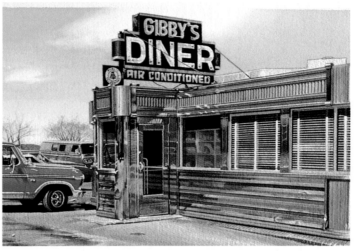

609. *Gibby's Diner*. 1978 (122). Watercolor, 10½ x 15½". Private collection

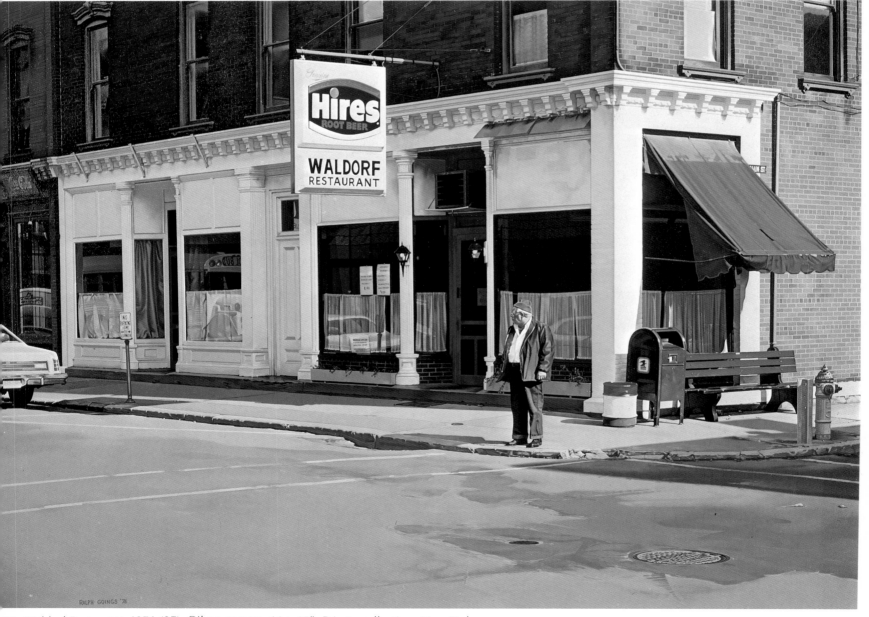

10. *Waldorf Restaurant*. 1976 (97). Oil on canvas, 44 x 60". Private collection, New York

611. *Lucky Pickup.* 1970–71 (17).
Oil on canvas, 48 x 35".
Private collection

612. *Lube.* 1974 (70).
Oil on canvas, 40 x 56".
Collection Daniel Filipacchi, Paris

613. *Blue GMC.* 1969 (5).
Oil on canvas, 45 x 63".
Collection Mr. and Mrs. Morton G. Neumann, Ill.

614. *Yellow Ford Camper.* 1969 (6).
Oil on canvas, 45 x 54".
Collection Ted Carey, New York

615. *Helen's Drive-In.* 1971 (25).
Oil on canvas, 34½ x 46½".
Collection Anita and Burton Reiner, Md.

616. *Country Chevrolets.* 1978 (123).
Oil on canvas, 26 x 36".
Richard Brown Baker Collection, New York

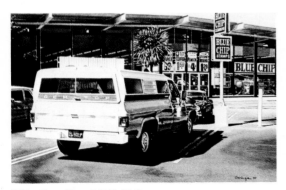

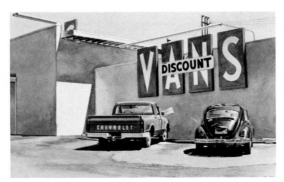

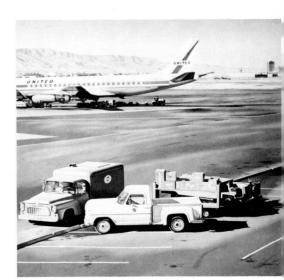

617. *Gem Top.* 1975 (74).
Watercolor on paper, 9 x 13⅜".
Collection Byron and Eileen Cohen, Kans.

618. *Van's Discount Chevrolet.* 1972 (42).
Watercolor on paper, 10 x 15".
Collection Susan and Louis Meisel, New York

619. *Las Vegas Airport.* 1970 (12).
Oil on canvas, 41 x 41".
Private collection

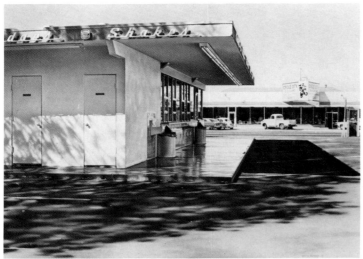

620. *Sundaes and Shakes*. 1972 (26). Oil on canvas, 35 x 48".
Collection Patterson Sims, New York

621. *Palevsky Pool*. 1973 (58). Oil on canvas, 40 x 54".
Private collection

622. *Rose Parade*. 1971 (24). Oil on canvas, 60 x 72". Private collection, Sweden

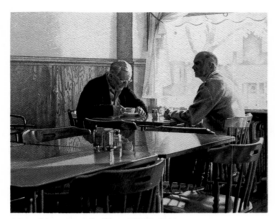

623. *Morning Coffee.* 1975 (89).
Watercolor, 10 x 12¾".
Collection Bruce and Barbara Berger, New York

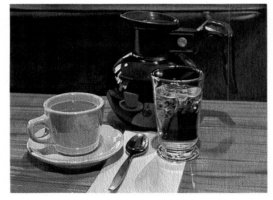

625. *Regular Coffee.* 1978 (121).
Watercolor, 9 x 12".
Collection Marc Anker, New York

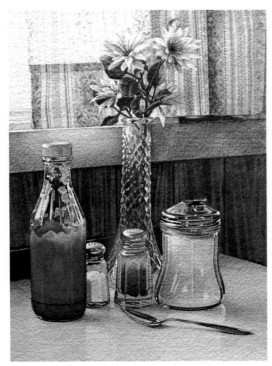

628. *Still Life with Flowers.* 1978 (120).
Watercolor, 12 x 8½".
Collection Mr. and Mrs. Jerry Joseph, New York

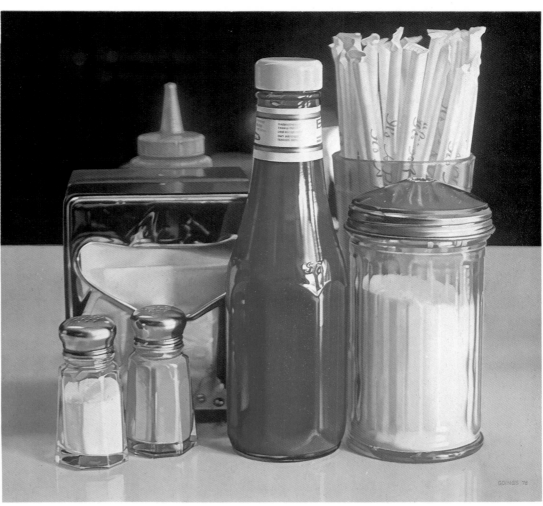

624. *Still Life—Untitled Ketchup.* 1978 (119). Oil on canvas, 30 x 28".
Collection A. Barry Hirschfeld, Colo.

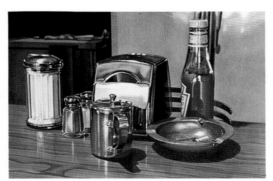

626. *Counter Top Still Life.* 1978 (118).
Watercolor, 10¼ x 15¼". Collection
Pollack, O'Connors & Jacobs, Mass.

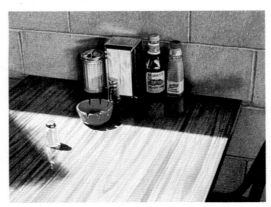

629. *Red Ashtray.* 1975 (85).
Watercolor, 9 x 12".
Private collection

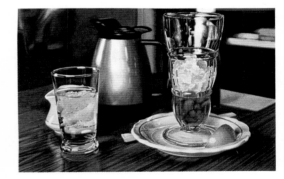

627. *Iced Tea.* 1976 (90).
Watercolor, 8⅜ x 12½".
Collection Dr. and Mrs. Barry J. Paley, New York

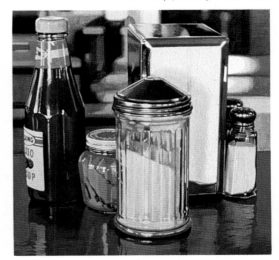

630. *Diner Still Life.* 1977 (106).
Watercolor, 11 x 11".
Collection Mr. and Mrs. Jim Jacobs, Mass.

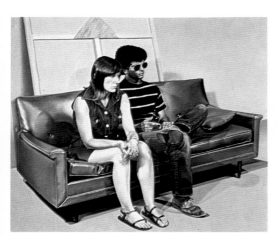

631. *Figures on a Couch*. 1969 (1).
Oil on canvas, 45½ x 52".
Neue Galerie der Stadt Aachen.
Ludwig Collection

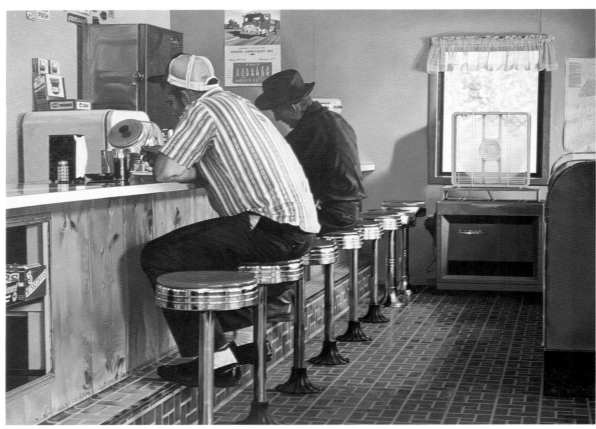

632. *Twin Springs Diner*. 1976 (100). Oil on canvas, 38 x 52".
Collection Marvin and Heidi Trachtenberg, New York

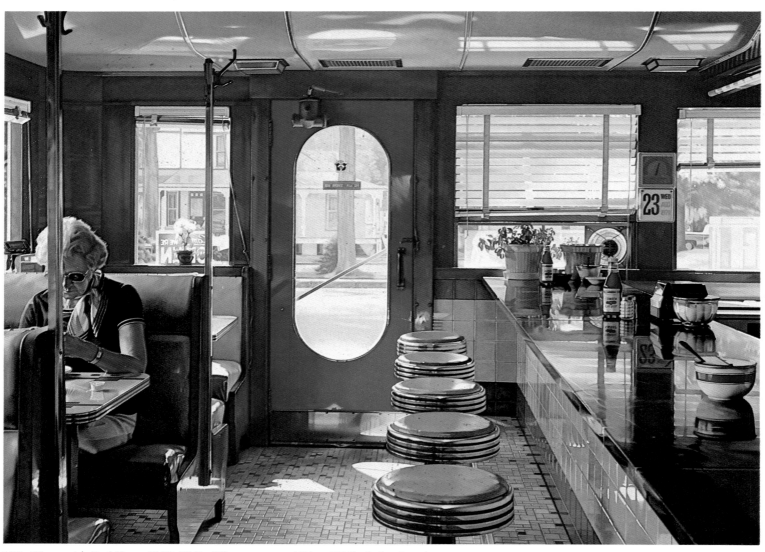

633. *Diner with Red Door*. 1979 (136). Oil on canvas, 44¼ x 60½". Collection the artist

634. *Meat Market Van.* 1974 (69). Watercolor on paper, 10¼ x 16". Collection Marvin and Heidi Trachtenberg, New York

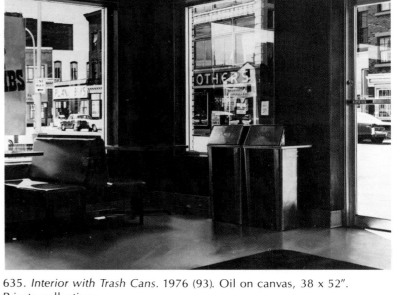

635. *Interior with Trash Cans.* 1976 (93). Oil on canvas, 38 x 52". Private collection

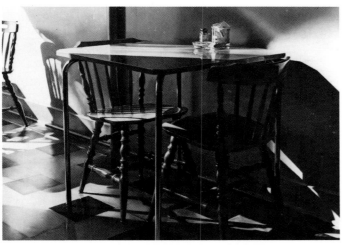

636. *Table and Chairs—Augustan Hotel.* 1976 (96). Oil on canvas, 24 x 34". Collection Sandra and Joe Rotman, Canada

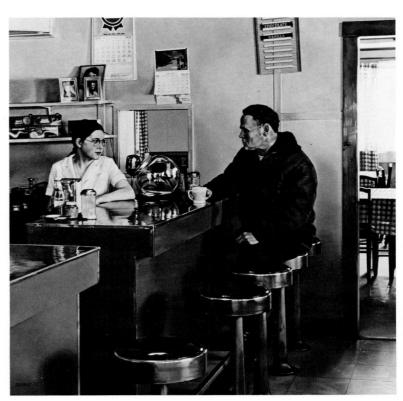

637. *Pee Wee's Diner.* 1977 (112). Oil on canvas, 48 x 48". Collection Ann H. Pollack, Md.

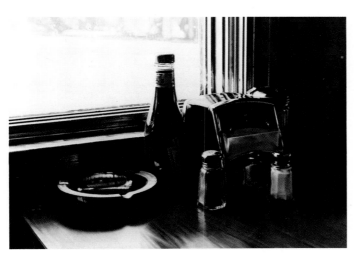

638. *Still Life by Window.* 1977 (114). Oil on canvas, 24 x 34". Collection Mr. and Mrs. Jim Jacobs, New York

294

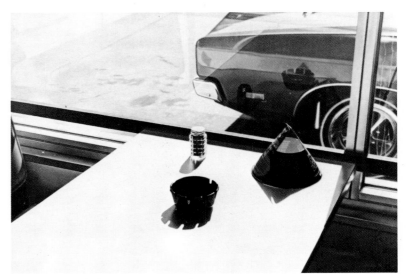

639. *Pepper Shaker.* 1973 (43). Oil on canvas, 36 x 52". Collection Shanna Goings, New York

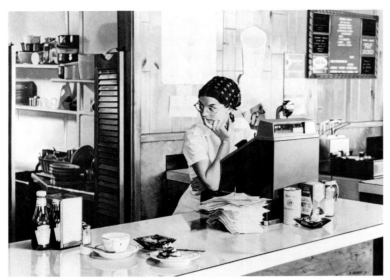

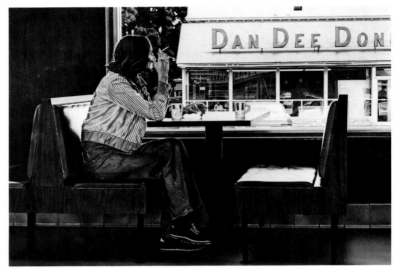

640. *One-Eleven Diner.* 1977 (103). Oil on canvas, 38 x 52".
Collection Monroe Meyerson, New York

641. *Dan Dee Donuts—Shanna.* 1975 (86). Oil on canvas, 35 x 50".
Collection William H. Hickock, Kans.

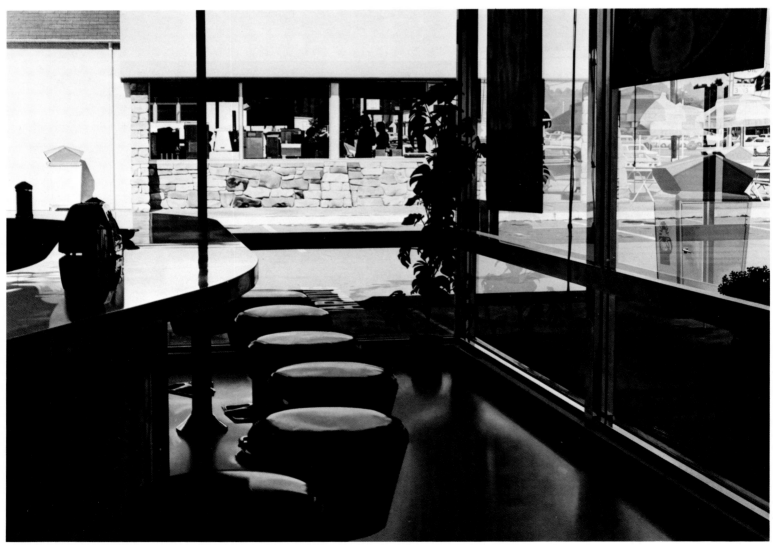

642. *Donut Shop.* 1975 (78). Oil on canvas, 44 x 62". Collection Sandra and Joe Rotman, Canada

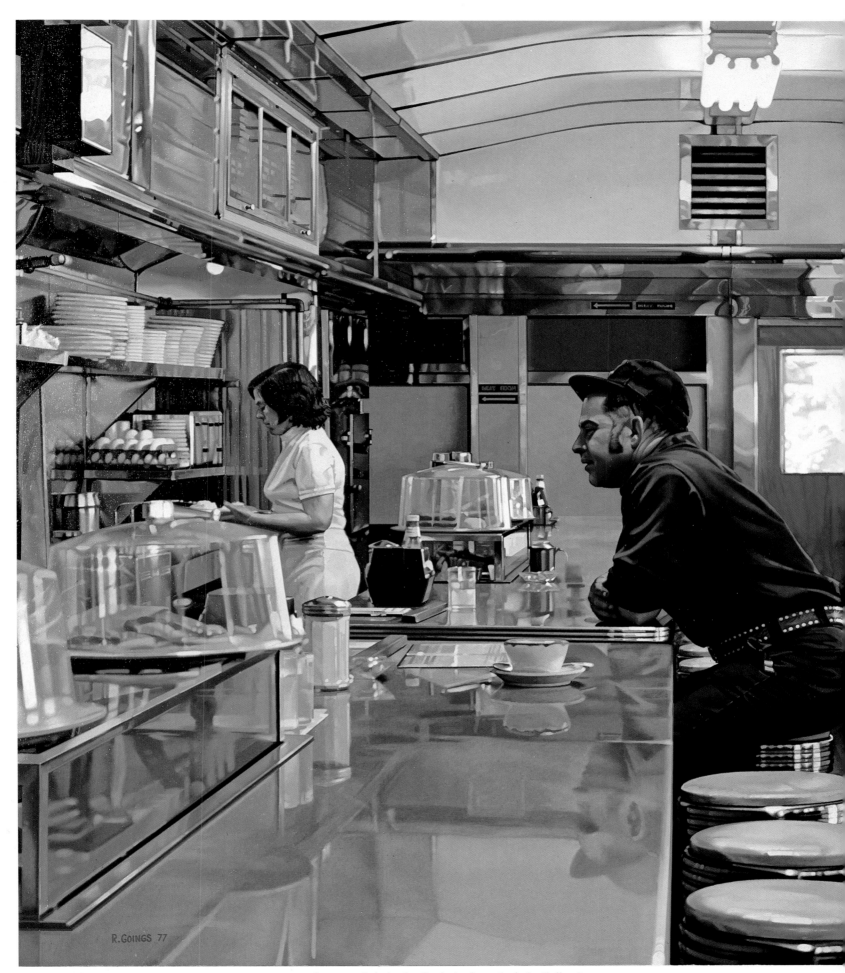

643. *Unadilla Diner.* 1977 (104). Oil on canvas, 48 x 68". Neue Galerie der Stadt Aachen. Ludwig Collection

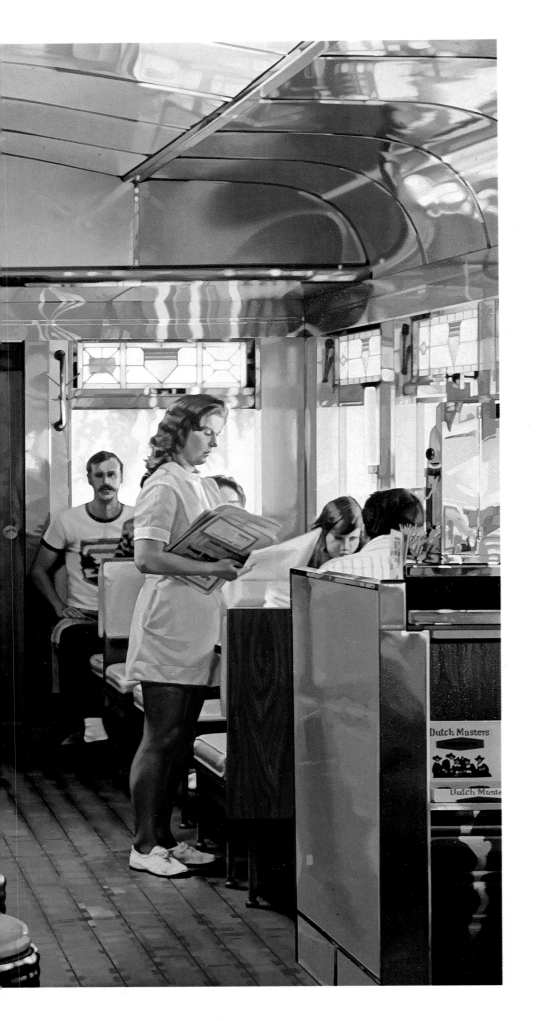

644. *Pee Wee's Diner Still Life*. 1977 (108).
Oil on canvas, 24 x 34".
Collection Dr. and Mrs. Barry J. Paley, New York

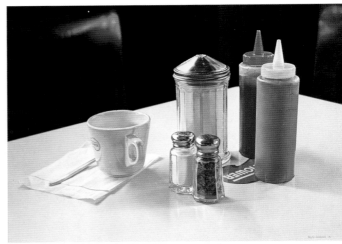

645. *White Tower*. 1976 (99).
Oil on canvas, 38 x 52".
Private collection

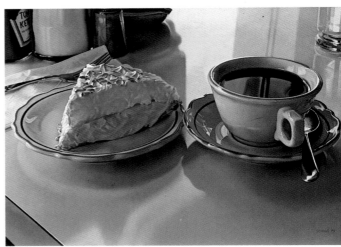

646. *Cream Pie*. 1979 (139).
Oil on canvas, 26 x 36".
Collection Daniel Filipacchi, New York

NOT ILLUSTRATED

Handy Andy Truck. 1971 (22).
Watercolor on paper, 9 x 12".
Collection Shanna Goings, New York

Coffee Express. 1972 (27).
Watercolor, 9 x 12".
Collection Shanna Goings, New York

Jimboy Taco Interior. 1972 (29).
Watercolor on paper, 9 x 12".
Galerie de Gestlo, Hamburg

Yellow Van—Norge. 1972 (30).
Watercolor on paper, 9 x 12".
Galleri Ostergren, Sweden

Gallen Kamp Ford. 1972 (31).
Watercolor on paper, 9 x 12".
Collection Louis and Susan Meisel, New York

Golden Tee Inn Motel. 1972 (32).
Watercolor on paper, 9 x 12".
Collection Bo Alvaryd, Sweden

Coffee Bar Still Life. 1972 (34).
Watercolor on paper, 9 x 12".
Collection M. T. Cohen/S. J. Gallé, New York

Art Lab Dodge. 1972 (37).
Watercolor on paper, 9 x 12".
Private collection, New York

Crystal Dairy Truck. 1972 (39).
Watercolor on paper, 9 x 12".
Private collection, New York

Lucky Yellow Pickup—Back View. 1972 (40).
Watercolor on paper, 9 x 12".
Private collection

Blue Chip Mail Truck. 1973 (44).
Acrylic on paper, 10 x 15".
Collection Patterson Sims, New York

Famous Brands. 1973 (47).
Watercolor on paper, 9 x 12¾".
Private collection

465 Ford. 1973 (48).
Watercolor on paper, 8½ x 11".
Private collection, New York

Wheel Chevrolet. 1973 (49).
Watercolor on paper, 8½ x 11".
Collection Bo Alvaryd, Sweden

Mister Donut. 1973 (50). Watercolor on
paper, 9 x 12". Neue Galerie der Stadt
Aachen. Ludwig Collection

Phone Here. 1973 (51).
Watercolor on paper, 10¼ x 15".
Collection Beatrice C. Mayer, Ill.

Seven-Up Truck. 1973 (52).
Watercolor on paper, 8½ x 11½".
Richard Brown Baker Collection, New York

Dari-Delight. 1973 (53).
Watercolor on paper, 8 x 11¼".
Private collection

Sweetheart Straws. 1973 (54).
Watercolor on paper, 9 x 12¾".
Collection Shanna Goings, New York

Two Fords. 1973 (56).
Watercolor on paper, 8½ x 12".
Collection Norman Dubrow, New York

Yellow and White Truck. 1973 (60).
Watercolor on paper, 10 x 14¼".
Private collection

Small Yellow Truck. 1973 (61).
Watercolor on paper, 1¼ x 2".
Collection Herbert Distel, Museum of Drawers

Still Life with Creamer. 1973 (62).
Watercolor on paper, 9 x 12¾".
Private collection

Thrifty. 1973 (63).
Watercolor on paper, 9 x 12¾".
Private collection

Firestone Complete. 1974 (64).
Watercolor on paper, 9 x 12¾".
Private collection

Smith's Ford Custom. 1974 (66).
Oil on canvas, 9½ x 13½".
Collection Edmund P. Pillsbury, Conn.

Whirley-Q Lunchette. 1974 (67).
Watercolor on paper, 9½ x 13".
Private collection

Cleaners. 1974 (68).
Watercolor on paper, 11 x 13½".
Private collection

Dunkin' Donut Coffee Shop. 1974 (71).
Watercolor on paper, 9¼ x 13⅞".
Private collection, Alaska

Laundry Interior. 1974 (72).
Watercolor on paper, 9⅜ x 14".
Private collection

Ice Water. 1974 (73).
Watercolor on paper, 9¼ x 12¼".
Collection Mr. and Mrs. Robert H. Mann, Kans.

Table Service (Coffee Mugs). 1975 (76).
Watercolor on paper, 9¼ x 12¼".
Collection Mr. and Mrs. Robert H. Mann, Kans.

Service Station Truck. 1975 (77).
Watercolor on paper, 8½ x 12". Collection
Mr. and Mrs. Martin Schmukler, New York

Entrance Blue Truck. 1975 (79).
Watercolor on paper, 11 x 16½".
Collection Richard Belger, Mo.

Chevron Truck. 1975 (80).
Watercolor on paper, 8¾ x 13".
Private collection

Untitled Coffee Cup. 1975 (81).
Watercolor on paper, 8 x 12⅛".
Collection Irving Luntz, Fla.

Stewart's Variety Chevy. 1975 (87).
Watercolor on paper, 10 x 12½".
Collection Mr. and Mrs. Sam Perkins, Kans.

Bread and Cake Truck. 1976 (91).
Watercolor on paper, 11½ x 17½".
Collection Benno Friedman, New York

Still Life with Pitcher. 1976 (92).
Watercolor on paper, 8 x 13½".
Collection Hannes von Gosseln, West Germany

Town of Cobleskill Truck. 1976 (94).
Watercolor on paper, 12 x 18¼".
Galerie de Gestlo, Hamburg

Coffee and Change. 1976 (95).
Watercolor on paper, 8½ x 12".
Private collection, New York

Tomato Ketchup. 1976 (98).
Watercolor on paper, 9 x 14".
Collection Larry Lupone, New York

River Valley Still Life. 1976 (101).
Oil on canvas, 24 x 34".
Collection Perce Young, Canada

Stereo Speakers. 1977 (102).
Watercolor on paper, 12 x 12".
Collection Myra and Jim Morgan, Kans.

Pancake House Still Life. 1977 (107).
Watercolor on paper, 10 x 10".
Private collection

Still Life with Relish. 1977 (109).
Watercolor on paper, 10 x 11".
Private collection

Blue Ashtray. 1977 (110).
Watercolor on paper, 9¼ x 13⅞".
Collection the artist

Sunlit Still Life. 1977 (111).
Watercolor on paper, 11 x 13¼".
Collection J. C. Pigozzi, London

Mellow Still Life. 1977 (113).
Gouache, 10 x 14".
Private collection

Red Top Pepper—Still Life. 1977 (115).
Gouache, 9½ x 9½".
Collection the artist

Best Pickup. 1977 (116).
Watercolor on paper, 9 x 13¼".
Sydney and Frances Lewis Foundation, Va.

Coors Truck. 1977 (117).
Gouache, 12 x 14".
Private collection

Country Chevrolets. 1978 (124).
Oil on canvas, 26 x 36".
Collection the artist

Blue Napkin Holder. 1978 (125).
Oil on canvas, 26 x 36".
Private collection

Counter Top Group. 1978 (126).
Watercolor on paper, 12½ x 10".
Collection Leonard Rosenberg, Pa.

Flowered Table Top. 1978 (127).
Watercolor on paper, 10 x 10".
Collection Armand Ornstein, Paris

Still Life with Menu. 1978 (128).
Watercolor on paper, 9 x 10½".
Private collection

Knife and Spoon. 1978 (129).
Watercolor on paper, 9 x 10".
Collection the artist

Still Life with Sugars. 1978 (130).
Oil on canvas, 28 x 30".
Collection Mr. and Mrs. Jerry Joseph, New York

Bulldozing International. 1978 (131).
Watercolor on paper, 10 x 15".
Collection Mr. and Mrs. W. Jaeger, New York

Coffee Shop Still Life. 1979 (132).
Watercolor on paper, 9 x 8¼".
Galerie de Gestlo, Cologne

Ford Still Life. 1979 (133).
Watercolor on paper, 10 x 15".
Private collection, New York

Walt's Restaurant. 1979 (134).
Oil on canvas, 44 x 60".
Richard Brown Baker Collection, New York

Tiled Lunch Counter. 1979 (135).
Oil on canvas, 48 x 64".
Private collection, New York

Fancy Catsup. 1979 (137).
Watercolor, 12 x 10".
Private collection, Calif.

Breakfast Menu. 1979 (138).
Watercolor on paper, 10 x 12".
Private collection, Calif.

*Annual Charlotteville Volunteer Fire Department
Bar B Q*. 1979 (140). Oil on canvas, 38 x 52".
Collection the artist

Gas Can. 1979 (141).
Watercolor on paper, 10 x 15". Collection
Marvin and Heidi Tractenberg, New York

BIOGRAPHY

1928 Born: Corning, Calif.

EDUCATION
1953 B.F.A., California College of Arts and Crafts, Oakland
1965 M.F.A., Sacramento State College, Calif.

SOLO EXHIBITIONS
1960 Artists Cooperative Gallery, Sacramento, Calif.
1962 Artists Cooperative Gallery, Sacramento, Calif.
1968 Artists Contemporary Gallery, Sacramento, Calif.
1970 O. K. Harris Gallery, New York
1973 O. K. Harris Gallery, New York
1977 O. K. Harris Gallery, New York

SELECTED GROUP EXHIBITIONS
1961 "Eightieth Annual Exhibition of the San Francisco Art Institute," San
 Francisco Museum of Modern Art
1963 Kingsley Annual, Sacramento, Calif.
1964 Sacramento State College, Calif.
1965 Crocker Art Association Invitational, Sacramento, Calif.
 Kingsley Annual, Sacramento, Calif.
 "Love Arena Show," Dwan Gallery, Los Angeles
1969 "Directions 2: Aspects of a New Realism," Akron Art Institute, Ohio;
 Milwaukee Art Center, Wis.; Contemporary Arts Museum, Houston
 Kingsley Annual, Sacramento, Calif.
 O. K. Harris Gallery, New York
 University of Nevada, Reno
1970 "Beyond the Actual—Contemporary California Realist Painting,"
 Pioneer Museum and Haggin Galleries, Stockton, Calif.
 "The Cool Realists," Jack Glenn Gallery, Corona del Mar, Calif.
 "Directly Seen—New Realism in California," Newport Harbor Art
 Museum, Balboa, Calif.
 "The Highway," Institute for Contemporary Art, University of
 Pennsylvania, Philadelphia; Institute for the Arts, Rice University,
 Houston; Akron Art Institute, Ohio
1971 "Directions 3: Eight Artists," Milwaukee Art Center
 FTD (Florist Transworld Delivery) Collection
 "New Realism," State University College, Potsdam, N.Y.
 "Radical Realism," Museum of Contemporary Art, Chicago
 "The Shape of Realism," Deson-Zaks Gallery, Chicago
 "USA West Coast," Kunstverein, Hamburg; Hanover; Cologne;
 Stuttgart
1972 "Art Around 1970," Neue Galerie der Stadt Aachen, West Germany
 "Documenta 5," Kassel, West Germany
 "L'Hyperréalistes américains," Galerie des Quatre Mouvements, Paris
 "Painting and Sculpture Today, 1972," Indianapolis Museum of Art
 "Phases of the New Realism," Lowe Art Museum, University of Miami,
 Coral Gables, Fla.
 "The Realist Revival," New York Cultural Center, New York
 "Sharp-Focus Realism," Sidney Janis Gallery, New York
 "The State of California Painting," Govett-Brewster Art Gallery, New
 Plymouth, New Zealand
1972–73 "Amerikanischer Fotorealismus," Württembergischer Kunstverein,
 Stuttgart; Frankfurter Kunstverein, Frankfurt; Kunst und
 Museumsverein, Wuppertal, West Germany
1973 "Amerikanske realister," Randers Kunstmuseum, Randers, Denmark;
 Lunds Konsthall, Lund, Sweden
 "East Coast/West Coast/New Realism," San Jose State University, Calif.
 Galleria Civica d'Arte Moderna, Turin
 "Grands maîtres hyperréalistes américains," Galerie des Quatre
 Mouvements, Paris
 "Hyperréalistes américains," Galerie Arditti, Paris
 "Image, Reality, and Superreality," Arts Council of Great Britain
 traveling exhibition
 "Iperrealisti americani," Galleria La Medusa, Rome
 "Mit Kamera, Pinsel und Spritzpistole," Ruhrfestspiele Recklinghausen,
 Städtische Kunsthalle, Recklinghausen, West Germany
 "Options 73/30," Contemporary Arts Center, Cincinnati
 "Photo-Realism," Serpentine Gallery, London
 "Realism Now," Katonah Gallery, Katonah, N.Y.

"Separate Realities," Los Angeles Municipal Art Center
"The Super-Realist Vision," DeCordova and Dana Museum, Lincoln,
 Mass.
1973–74 "Hyperréalisme," Galerie Isy Brachot, Brussels
1973–78 "Photo-Realism 1973: The Stuart M. Speiser Collection," traveling
 exhibition: Louis K. Meisel Gallery, New York; Herbert F. Johnson
 Museum of Art, Ithaca, N.Y.; Memorial Art Gallery of the University
 of Rochester, N.Y.; Addison Gallery of American Art, Andover,
 Mass.; Allentown Art Museum, Pa.; University of Colorado
 Museum, Boulder; University Art Museum, University of Texas,
 Austin; Witte Memorial Museum, San Antonio, Tex.; Gibbes Art
 Gallery, Charleston, S.C.; Brooks Memorial Museum, Memphis,
 Tenn.; Krannert Art Museum, University of Illinois, Champaign-
 Urbana; Helen Foresman Spencer Museum of Art, University of
 Kansas, Lawrence; Paine Art Center and Arboretum, Oshkosh, Wis.;
 Edwin A. Ulrich Museum, Wichita State University, Kans.; Tampa
 Bay Art Center, Tampa, Fla.; Rice University, Sewall Art Gallery,
 Houston; Tulane University Art Gallery, New Orleans; Smithsonian
 Institution, Washington, D.C.
1974 "Amerikaans fotorealisme grafiek," Hedendaagse Kunst, Utrecht; Palais
 des Beaux-Arts, Brussels
 "Ars '74 Ateneum," Fine Arts Academy of Finland, Helsinki
 "Art 5 '74," Basel, Switzerland
 "California Climate," Root Art Center, Hamilton College, Clinton, N.Y.
 "Contemporary American Paintings from the Lewis Collection,"
 Delaware Art Museum, Wilmington
 "Hyperréalistes américains—réalistes européens," Centre National
 d'Art Contemporain, Paris
 "Kijken naar de werkelijkheid," Museum Boymans–van Beuningen,
 Rotterdam
 "New Photo-Realism," Wadsworth Atheneum, Hartford, Conn.
 "Our Land, Our Sky, Our Water," International Exposition, Spokane,
 Wash.
 "Selections in Contemporary Realism," Akron Art Institute, New
 Gallery, Ohio
 "Tokyo Biennale, '74," Tokyo Metropolitan Museum; Kyoto Municipal
 Museum; Aichi Prefectural Art Museum, Nagoya
1975 "A Change of View," Aldrich Museum of Contemporary Art, Ridgefield,
 Conn.
 "American Realism," Reed College, Portland, Oreg.
 Fine Arts Center Gallery, State University College, Oneonta, N.Y.
 Lafayette Natural History Museum and Planetarium, Lafayette, La.
 "The New Realism: Rip-Off or Reality?," Edwin A. Ulrich Museum of
 Art, Wichita State University, Kans.
 O. K. Harris Gallery, New York
 "Realismus und Realität," Kunsthalle, Darmstadt, West Germany
 "Richard Brown Baker Collects," Yale University Art Gallery, New
 Haven, Conn.
 "Signs of Life: Symbols in the City," Renwick Gallery, Smithsonian
 Institution, Washington, D.C.
 "Super Realism," Baltimore Museum of Art
 "Watercolors and Drawings—American Realists," Louis K. Meisel
 Gallery, New York
1975–76 "Photo-Realism, American Painting and Prints," New Zealand traveling
 exhibition: Barrington Gallery, Auckland; Robert McDougall Art
 Gallery, Christchurch; Academy of Fine Arts, National Art Gallery,
 Wellington; Dunedin Public Art Gallery, Dunedin; Govett-Brewster
 Art Gallery, New Plymouth; Waikato Art Museum, Hamilton
1976 "America as Art," National Collection of Fine Arts, Smithsonian
 Institution, Washington, D.C.
 "American Master Drawings and Watercolors (Works on Paper from
 Colonial Times to the Present)," Whitney Museum of American Art,
 New York
 "American Paintings and Drawings," John Berggruen Gallery, San
 Francisco
 "Art on Paper," Weatherspoon Art Gallery, University of North
 Carolina, Greensboro
 "Art 7 '76," Basel, Switzerland
 "Contemporary Images in Watercolor," Akron Art Institute, Ohio;
 Indianapolis Museum of Art; Memorial Art Gallery of the University

of Rochester, N.Y.

"Perspective 1976," Freedman Art Gallery, Albright College, Reading, Pa.

"Photo-Realist Watercolors," Neuberger Museum, State University College, Purchase, N.Y.

"Sixth International Print Biennale," Cracow, Poland

"Today/Tomorrow," Lowe Art Museum, University of Miami, Coral Gables, Fla.

"Urban Aesthetics," Queens Museum, Flushing, New York

1976–78 "Aspects of Realism," traveling exhibition sponsored by Rothman's of Pall Mall Canada, Ltd.: Stratford, Ont.; Centennial Museum, Vancouver, B.C.; Glenbow-Alberta Institute, Calgary, Alta.; Mendel Art Gallery, Saskatoon, Sask.; Winnipeg Art Gallery, Man.; Edmonton Art Gallery, Alta.; Art Gallery, Memorial University of Newfoundland, St. John's; Confederation Art Gallery and Museum, Charlottetown, P.E.I.; Musée d'Art Contemporain, Montreal, Que.; Dalhousie University Museum and Gallery, Halifax, N.S.; Windsor Art Gallery, Ont.; London Public Library and Art Museum and McIntosh Memorial Art Gallery, University of Western Ontario; Art Gallery of Hamilton, Ont.

1977 "Art '77: A Selection of Works by Contemporary Artists from New York Galleries," Root Art Center, Hamilton College, Clinton, N.Y.

John Berggruen Gallery, San Francisco, Calif.

"New Realism," Jacksonville Art Museum, Fla.

"New Realism: Modern Art Form," Boise Gallery of Art, Idaho

"Photo-Realists," Shore Gallery, Boston

"A View of the Decade," Museum of Contemporary Art, Chicago

"Works on Paper II," Louis K. Meisel Gallery, New York

1977–78 "Illusion and Reality," Australian touring exhibition: Australian National Gallery, Canberra; Western Australian Art Gallery, Perth; Queensland Art Gallery, Brisbane; Art Gallery of New South Wales, Sydney; Art Gallery of South Australia, Adelaide; National Gallery of Victoria, Melbourne; Tasmanian Museum and Art Gallery, Hobart

"Representations of America," exhibition organized by the Metropolitan Museum of Art, New York: traveling to the Ministry of Culture, Moscow; the Hermitage, Leningrad; the Palace of Art, Minsk

1978 "Art and the Automobile," Flint Institute of Arts, Mich.

Monmouth Museum, Lincroft, N.J.

"Photo-Realist Printmaking," Louis K. Meisel Gallery, New York

1979 "America in the 70s As Depicted by Artists in the Richard Brown Baker Collection," Meadowbrook Art Gallery, Oakland University, Rochester, Mich.

SELECTED BIBLIOGRAPHY

CATALOGUES

Shipley, James R., and Weller, Allen S. Introduction to *Contemporary American Painting and Sculpture 1969*. Krannert Art Museum, University of Illinois, Champaign-Urbana, Mar. 2–Apr. 6, 1969.

Taylor, John Lloyd, and Atkinson, Tracy. Introduction to *Directions 2: Aspects of a New Realism*. Milwaukee Art Center, June 28–Aug. 10, 1969; Contemporary Arts Museum, Houston, Sept. 17–Oct. 19, 1969; Akron Art Center, Ohio, Nov. 9–Dec. 14, 1969.

Brewer, Donald. Introduction to *Beyond the Actual—Contemporary California Realist Painting*. Pioneer Museum and Haggin Galleries, Stockton, Calif., Nov. 6–Dec. 6, 1970.

Brown, Denise Scott, and Venturi, Robert. Introduction to *The Highway*. Institute of Contemporary Art, University of Pennsylvania, Philadelphia, Jan. 14–Feb. 25, 1970; Institute for the Arts, Rice University, Houston, Mar. 12–May 18, 1970; Akron Art Institute, Ohio, June 5–July 16, 1970.

Directly Seen—New Realism in California. Newport Harbor Art Museum, Balboa, Calif., 1970.

Goldsmith, Benedict. *New Realism*. Brainerd Hall Art Gallery, State University College, Potsdam, N.Y., Nov. 5–Dec. 12, 1971.

Karp, Ivan C. Introduction to *Radical Realism*. Museum of Contemporary Art, Chicago, May 22–June 4, 1971.

Taylor, John Lloyd. *Directions 3: Eight Artists*. Milwaukee Art Center, 1971.

Wright, Jesse G., and Michael, C. Preface to *FTD Collection*. Thorner Sidney Press, New York, 1971.

Abadie, Daniel. Introduction to *Hyperréalistes américains*. Galerie des Quatre Mouvements, Paris, Oct. 25–Nov. 25, 1972.

Amman, Jean Christophe. Introduction to *Documenta 5*. Neue Galerie and Museum Fridericianum, Kassel, West Germany, June 30–Oct. 8, 1972.

Art Around 1970. Neue Galerie der Stadt Aachen, West Germany, 1972.

Baratte, John J., and Thompson, Paul E. *Phases of the New Realism*. Lowe Art Museum, University of Miami, Coral Gables, Fla., Jan. 20–Feb. 20, 1972.

Janis, Sidney. Introduction to *Sharp Focus Realism*. Sidney Janis Gallery, New York, Jan. 6–Feb. 4, 1972.

Walls, Michael. *California Republic*. Foreword by Robert Ballard. Govett-Brewster Art Gallery, New Plymouth, New Zealand, 1972.

Warrum, Richard L. Introduction to *Painting and Sculpture Today, 1972*. Indianapolis Museum of Art, Apr. 26–June 4, 1972.

Burton, Scott. *The Realist Revival*. New York Cultural Center, New York, Dec. 6, 1972–Jan. 7, 1973.

Schneede, Uwe, and Hoffman, Heinz. Introduction to *Amerikanischer Fotorealismus*. Württembergischer Kunstverein, Stuttgart, Nov. 16–Dec. 26, 1972; Frankfurter Kunstverein, Frankfurt, Jan. 6–Feb. 18, 1973; Kunst und

Museumsverein, Wuppertal, West Germany, Feb. 25–Apr. 8, 1973.

Alloway, Lawrence. Introduction to *Photo-Realism*. Serpentine Gallery, London, Apr. 4–May 6, 1973.

Becker, Wolfgang. Introduction to *Mit Kamera, Pinsel und Spritzpistole*. Ruhrfestspiele Recklinghausen, Städtische Kunsthalle, Recklinghausen, West Germany, May 4–June 17, 1973.

Boulton, Jack. Introduction to *Options 73/30*. Contemporary Arts Center, Cincinnati, Sept. 25–Nov. 11, 1973.

C. A. B. S. Introduction to *Realisti iperrealisti*. Galleria La Medusa, Rome, Nov. 12, 1973.

Combattimento per un'immagine. Galleria Civica d'Arte Moderna, Turin, Mar. 4, 1973.

Dali, Salvador. Introduction to *Grands maîtres hyperréalistes américains*. Galerie des Quatre Mouvements, Paris, May 23–June 25, 1973.

Dreiband, Laurence. Notes to *Separate Realities*. Foreword by Curt Opliger. Los Angeles Municipal Art Gallery, Sept. 19–Oct. 21, 1973.

Hogan, Carroll Edwards. Introduction to *Hyperréalistes américains*. Galerie Arditti, Paris, Oct. 16–Nov. 30, 1973.

Iperrealisti americani. Galleria La Medusa, Rome, Jan. 2, 1973.

Lamanga, Carlo. Foreword to *The Super Realist Vision*. DeCordova and Dana Museum, Lincoln, Mass., Oct. 7–Dec. 9, 1973.

Lucie-Smith, Edward. Introduction to *Image, Reality, and Superreality*. Arts Council of Great Britain traveling exhibition, 1973.

Meisel, Louis K. *Photo-Realism 1973: The Stuart M. Speiser Collection*. New York, 1973.

Radde, Bruce. Introduction to *East Coast/West Coast/New Realism*. University Art Gallery, San Jose State University, Calif., Apr. 24–May 18, 1973.

Sims, Patterson. Introduction to *Realism Now*. Katonah Gallery, Katonah, N.Y., May 20–June 24, 1973.

Becker, Wolfgang. Introduction to *Kunst nach Wirklichkeit*. Kunstverein Hannover, West Germany, Dec. 9, 1973–Jan. 27, 1974.

Amerikaans fotorealisme grafiek. Hedendaagse Kunst, Utrecht, Aug., 1974; Palais des Beaux-Arts, Brussels, Sept.–Oct., 1974.

Chase, Linda. "Photo-Realism." In *Tokyo Biennale 1974*. Tokyo Metropolitan Museum of Art; Kyoto Municipal Museum; Aichi Prefectural Art Museum, Nagoya, 1974.

Clair, Jean; Abadie, Daniel; Becker, Wolfgang; and Restany, Pierre. Introductions to *Hyperréalistes américains—réalistes européens*. Centre National d'Art Contemporain, Paris, Archives 11/12, Feb. 15–Mar. 31, 1974.

Cowart, Jack. *New Photo-Realism*. Wadsworth Atheneum, Hartford, Conn., Apr. 10–May 19, 1974.

Doty, Robert. Introduction to *Selections in Contemporary Realism*. Akron Art

Institute, Ohio, Sept. 20–Oct. 19, 1974; New Gallery, Cleveland, Sept. 20–Oct. 19, 1974.

Hyperréalisme. Galerie Isy Brachot, Brussels, Dec. 14, 1973–Feb. 9, 1974.

Kijken naar de Werkelijkheid. Museum Boymans–van Beuningen, Rotterdam, June 1–Aug. 18, 1974.

Sarajas-Korte, Salme. Introduction to *Ars '74 Ateneum.* Fine Arts Academy of Finland, Helsinki, Feb. 15–Mar. 31, 1974.

Walthard, Dr. Frederic P. Foreword to *Art 5 '74.* Basel, Switzerland, June 19–24, 1974.

Wyrick, Charles, Jr. Introduction to *Contemporary American Paintings from the Lewis Collection.* Delaware Art Museum, Wilmington, Sept. 13–Oct. 17, 1974.

Dyer, Carlos. Introduction to *A Change of Views.* Foreword by Larry Aldrich. Aldrich Museum, Ridgefield, Conn., Fall, 1975.

Krimmel, Bernd. Introduction to *Realismus und Realität.* Foreword by H. W. Sabais. Kunsthalle, Darmstadt, West Germany, May 24–July 6, 1975.

Meisel, Susan Pear. *Watercolors and Drawings—American Realists.* Louis K. Meisel Gallery, New York, Jan., 1975.

Stebbins, Theodore E., Jr. Introduction to *Richard Brown Baker Collects.* Yale University Art Gallery, New Haven, Conn., Apr. 24–May 22, 1975.

Richardson, Brenda. Introduction to *Super Realism.* Baltimore Museum of Art, Nov. 18, 1975–Jan. 11, 1976.

Perspective 1976. Freedman Art Gallery, Albright College, Reading, Pa.

Carpenter, Gilbert. Introduction to *Art on Paper.* Weatherspoon Art Gallery, University of North Carolina, Greensboro, Nov. 14–Dec. 15, 1976.

Doty, Robert. *Contemporary Images in Watercolor.* Akron Art Institute, Ohio, Mar. 14–Apr. 25, 1976; Indianapolis Museum of Art, June 29–Aug. 8, 1976; Memorial Art Gallery of the University of Rochester, N.Y., Oct. 1–Nov. 11, 1976.

Schneider, Janet. *Urban Aesthetics.* Queens Museum, Flushing, New York, Jan. 17–Feb. 29, 1976.

Taylor, Joshua C. Introduction to *America as Art.* National Collection of Fine Arts, Washington, D.C., 1976.

Walthard, Dr. Frederic P. Introduction to *Art 7 '76.* Basel, Switzerland, June 16–21, 1976.

Weatherspoon Gallery Association Bulletin. University of North Carolina, Greensboro, 1976–77.

Chase, Linda. "U.S.A." In *Aspects of Realism.* Rothman's of Pall Mall Canada, Ltd., June, 1976–Jan., 1978.

Dempsey, Bruce. *New Realism.* Jacksonville Art Museum, Fla., 1977.

Friedman, Martin; Pincus-Witten, Robert; and Gay, Peter. *A View of a Decade.* Museum of Contemporary Art, Chicago, 1977.

Karp, Ivan. Introduction to *New Realism: Modern Art Form.* Boise Gallery of Art, Idaho, Apr. 14–May 29, 1977.

Stringer, John. Introduction to *Illusion and Reality.* Australian Gallery Directors' Council, North Sydney, N.S.W., 1977–78.

Hodge, G. Stuart. Foreword to *Art and the Automobile.* Flint Institute of Arts, Mich., Jan. 12–Mar. 12, 1978.

Meisel, Susan Pear. Introduction to *The Complete Guide to Photo-Realist Printmaking.* Louis K. Meisel Gallery, New York, Dec., 1978.

Stokes, Charlotte. "As Artists See It: America in the 70s." In *America in the 70s As Depicted by Artists in the Richard Brown Baker Collection.* Meadowbrook Art Gallery, Oakland University, Rochester, Mich., Nov. 18–Dec. 16, 1979.

ARTICLES

Tillim, Sidney. "A Variety of Realisms," *Artforum,* Summer, 1969, p. 43.

Bourgeois, Jean-Louis. "New York Reviews: Ralph Goings," *Artforum,* Nov., 1970, p. 87.

Glueck, Grace. "New York Gallery Notes," *Art in America,* Sept., 1970, p. 42.

Marandel, J. Patrice. "Lettre de New York," *Art International,* vol. XIV, no. 9 (Nov., 1970), p. 71.

Marvel, Bill. "The Art Picture: Photos, Trucks, Blood—These Are Galleries?," *National Observer,* Oct. 5, 1970.

Nordstrom, Sherry. "Reviews and Previews," *ARTnews,* vol. 69, no. 7 (Nov., 1970), p. 20.

Marandel, J. Patrice. "The Deductive Image: Notes on Some Figurative Painters," *Art International,* Sept., 1971, pp. 58–61.

Sager, Peter. "Neue Formen des Realismus," *Magazin Kunst,* 4th Quarter, 1971, pp. 2512–16.

Amman, Jean Christophe. "Realismus," *Flash Art* (May–July, 1972), pp. 50–52.

Borden, Lizzie. "Cosmologies," *Artforum,* Oct., 1972, pp. 45–50.

Chase, Linda; Foote, Nancy; and McBurnett, Ted. "The Photo-Realists: 12 Interviews," *Art in America,* vol. 60, no. 6 (Nov.–Dec., 1972), pp. 73–89.

Davis, Douglas. "Art Is Unnecessary. Or Is It?" *Newsweek,* July 17, 1972,

pp. 68–69.

"Documenta Issue," *Zeit Magazin,* no. 31/4 (Aug., 1972), pp. 4–15.

Henry, Gerrit. "The Real Thing," *Art International,* Summer, 1972, pp. 87–91.

Hickey, David. "Previews," *Art in America,* Jan.–Feb., 1972, pp. 37–38.

"L'Hyperréalisme ou le retour aux origines," *Argus de la Presse,* Oct. 16, 1972.

"Hyperréalistes américains," *Argus de la Presse,* Nov. 16, 1972.

Karp, Ivan. "Rent Is the Only Reality, or the Hotel Instead of the Hymn," *Arts Magazine,* Dec., 1972, pp. 47–51.

"Die Kasseler Seh-Schule," *Stern Magazin,* no. 36 (Aug., 1972), pp. 20–23.

Kramer, Hilton. "And Now, Pop Art: Phase II," *New York Times,* Jan. 16, 1972.

Kurtz, Bruce. "Documenta 5: A Critical Preview," *Arts Magazine,* Summer, 1972, pp. 34–41.

Lerman, Leo. "Sharp Focus Realism," *Mademoiselle,* Mar., 1972, pp. 170–73.

Lista, Giovanni. "Iperrealisti americani," *NAC* (Milan), no. 12 (Dec., 1972), pp. 24–25.

Marvel, Bill. "Saggy Nudes? Giant Heads? Make Way for 'Superrealism,'" *National Observer,* Jan. 29, 1972, p. 22.

Pozzi, Lucio. "Super Realisti U.S.A.," *Bolaffiarte,* no. 18 (Mar., 1972), pp. 54–63.

Ratcliff, Carter. "New York Letter," *Art International,* vol. XVI, no. 3 (Mar., 1972), pp. 28–29.

Rosenberg, Harold. "The Art World," *The New Yorker,* Feb. 5, 1972, pp. 88–93.

Seitz, William C. "The Real and the Artificial: Painting of the New Environment," *Art in America,* Nov.–Dec., 1972, pp. 58–72.

Thornton, Gene. "These Must Have Been a Labor of Love," *New York Times,* Jan. 23, 1972.

Wasmuth, E. "La révolte des réalistes," *Connaissance des Arts,* June, 1972, pp. 118–23.

"Wish You Were Here," *New York Magazine,* Sept. 25, 1972.

Wolmer, Denise. "In the Galleries," *Arts Magazine,* Mar., 1972, p. 57.

Apuleo, Vito. "Tra manifesto e illustrazione sino al rifiuto della scelta," *La Voce Repubblicana,* Feb. 24, 1973, p. 5.

Art Now Gallery Guide, Sept., 1973, pp. 1–3.

"Arts: les expositions à New York," *Argus de la Presse,* Jan. 4, 1973.

Battcock, Gregory. "New York," *Art and Artists,* Aug., 1973, p. 48.

Beardsall, Judy. "Stuart M. Speiser Photorealist Collection," *Art Gallery Magazine,* vol. XVII, no. 1 (Oct., 1973), pp. 5, 29–34.

Bell, Jane. "Stuart M. Speiser Collection," *Arts Magazine,* Dec., 1973, p. 57.

Borden, Lizzie. "Reviews," *Artforum,* Oct., 1973.

Bovi, Arturo di. "Arte /Piú brutto del brutto," *Il Messaggiero,* Feb. 13, 1973, p. 3.

Chase, Linda. "Recycling Reality," *Art Gallery Magazine,* Oct., 1973, pp. 75–82.

Chase, Linda, and McBurnett, Ted. "Interviews with Robert Bechtle, Tom Blackwell, Chuck Close, Richard Estes and John Salt," *Opus International,* no. 44–45 (June, 1973), pp. 38–50.

E. D. G. "Arrivano gli iperrealisti," *Tribuna Letteraria,* Feb., 1973.

"European Galleries," *International Herald Tribune,* Feb. 17–18, 1973, p. 6.

"Foto Realismus," *IZW Illustrierte Wochenzeitung,* no. 14 (June, 1973), pp. 8–10.

"Goings On About Town," *The New Yorker,* Oct. 1, 1973.

Frank, Peter. "Reviews and Previews," *ARTnews,* vol. 72, no. 6 (Summer, 1973).

Giannattasio, Sandra. "Riproduce la vita di ogni giorno la nuova pittura americano," *Avanti,* Feb. 8, 1973, p. 1.

Gilmour, Pat. "Photo-Realism," *Arts Review,* vol. 25 (Apr. 21, 1973), p. 249.

Guercio, Antonio del. "Iperrealismo tra 'pop' e informale," *Rinascita,* no. 8 (Feb. 23, 1973), p. 34.

Hart, John. "A 'hyperrealist' U.S. tour at La Medusa," *Daily American* (Rome), Feb. 8, 1973.

Henry, Gerrit. "A Realist Twin Bill," *ARTnews,* Jan., 1973, pp. 26–28.

Hjort, Oysten. "Kunstmiljoeti Rhinlandet," *Louisiana Revy,* vol. 13, no. 3 (Feb., 1973).

"L'Hyperréalisme américain," *Le Monde des Grandes Musiques,* no. 2 (Mar.–Apr., 1973), pp. 4, 56–57.

La Mesa, Rina G. "Nel vuoto di emozioni," *Sette Giorni,* Feb. 18, 1973, p. 31.

Levin, Kim. "The New Realism: A Synthetic Slice of Life," *Opus International,* no. 44–45 (June, 1973), pp. 28–37.

Lucie-Smith, Edward. "Super Realism from America," *Illustrated London News,* Mar., 1973.

Man, Felix H. "Rom-offene Stadt für die Kunste," *Die Welt,* Feb. 19, 1973.

Maraini, Letizia. "Non fatevi sfuggire," *Il Globo,* Feb. 6, 1973, p. 8.

Marziano, Luciano. "Iperrealismo: la coagulazione dell'effimero," *Il Margutta* (Rome), no. 3–4 (Mar.–Apr., 1973).

Melville, Robert. "The Photograph as Subject," *Architectural Review,* vol. CLIII, no. 915 (May, 1973), pp. 329–33.

Micacchi, Dario. "La ricerca degli iperrealisti," *Unità,* Feb. 12, 1973.

Michael, Jacques. "Le Super-réalisme," *Le Monde,* Feb. 6, 1973, p. 23.

Mizue (Tokyo), vol. 8, no. 821 (1973).

Moulin, Raoul-Jean. "Hyperréalistes américains," *L'Humanité,* Jan. 16, 1973.

Rubiu, Vittorio. "Il gusto controverso degli iperrealisti," *Corriere della Sera,* Feb. 25, 1973.

Schjeldahl, Peter. "New York Reviews," *Art in America,* Sept.–Oct., 1973, pp. 111–12.

Seldis, Henry J. "New Realism: Crisp Focus on the American Scene," *Los Angeles Times,* Jan. 21, 1973, p. 54.

Trucchi, Lorenza di. "Iperrealisti americani alla Medusa," *Momento-sera,* Feb. 9–10, 1973, p. 8.

"Ars '74/Helsinki," *Art International,* May, 1974, pp. 38–39.

Chase, Linda. "The Connotation of Denotation," *Arts Magazine,* Feb., 1974, pp. 38–41.

Clair, Jean. "Situation des réalismes," *Argus de la Presse,* Apr., 1974.

Coleman, A. D. "From Today Painting Is Dead," *Camera 35,* July, 1974, pp. 34, 36–37, 78.

Davis, Douglas. "Summing Up the Season," *Newsweek,* July 1, 1974, p. 73.

"Flowers, Planes and Landscapes in New Art Exhibits," *Saturday Times-Union* (Rochester, N.Y.), Jan. 5, 1974.

"Gallery Notes," *Memorial Art Gallery of the University of Rochester Bulletin,* vol. 39, no. 5 (Jan., 1974).

Gibson, Michael. "Paris Show Asks a Question: What Is Reality?," *International Herald Tribune,* Feb. 23–24, 1974, p. 7.

Hughes, Robert. "An Omnivorous and Literal Dependence," *Arts Magazine,* June, 1974, pp. 25–29.

Kelley, Mary Lou. "Pop Art Inspired Objective Realism," *Christian Science Monitor,* Mar. 1, 1974.

Loring, John. "Photographic Illusionist Prints," *Arts Magazine,* Feb., 1974, pp. 42–43.

Michael, Jacques. "La 'mondialisation' de l'hyperréalisme," *Le Monde,* Feb. 24, 1974.

Moulin, Raoul-Jean. "Les hyperréalistes américains et la neutralisation du réel," *L'Humanité,* Mar. 21, 1974.

Progresso fotografico, Dec., 1974, pp. 61–62.

Spector, Stephen. "The Super Realists," *Architectural Digest,* Nov.–Dec., 1974, p. 85.

Teyssedre, Bernard. "Plus vrai que nature," *Le Nouvel Observateur,* Feb. 25–Mar. 3, 1974, p. 59.

Walsh, Sally. "Paintings That Look Like Photos," *Rochester Democrat and Chronicle,* Jan. 17, 1974.

Albright, Thomas. "A Wide View of the New Realists," *San Francisco Chronicle,* Feb. 6, 1975, p. 38.

Hull, Roger. "Realism in Art Returns with Camera's Clarity," *Portland Oregonian,* Sept. 14, 1975.

Lucie-Smith, Edward. "The Neutral Style," *Art and Artists,* vol. 10, no. 5 (Aug., 1975), pp. 6–15.

Nordjyllands Kunst Museum, no. 3 (Sept., 1975).

"Photo-Realism Exhibit Is Opening at Paine Sunday," *Oshkosh Daily Northwestern,* Apr. 17, 1975.

"Photo-Realists at Paine," *View Magazine,* Apr. 27, 1975.

Preston, Malcolm. "The Artistic Eye Takes a New Look at the Cityscape," *Newsday* (Long Island, N.Y.), Feb. 19, 1975, p. 11.

Sutinen, Paul. "American Realism at Reed," *Willamette Week,* Sept. 12, 1975.

Borlase, Nancy. "Art," *Sydney Morning Herald,* Dec. 30, 1976.

Chase, Linda. "Photo-Realism: Post Modernist Illusionism," *Art International,* vol. XX, no. 3–4 (Mar.–Apr., 1976), pp. 14–27.

Forgey, Benjamin. "The New Realism, Paintings Worth 1,000 Words," *Washington Star,* Nov. 30, 1976, p. G24.

Fremont, Vincent. "C. J. Yao," *Interview Magazine,* Oct., 1976, p. 36.

Hoelterhoff, Manuela. "Strawberry Tarts Three Feet High," *Wall Street Journal,* Apr. 21, 1976.

K. M. "Realism," *New Art Examiner,* Nov., 1976.

Patton, Phil. "Books, Super-Realism: A Critical Anthology," *Artforum,* vol. XIV, no. 5 (Jan., 1976), pp. 52–54.

Perreault, John. "Getting Flack," *Soho Weekly News,* Apr. 22, 1976, p. 19.

Greenwood, Mark. "Toward a Definition of Realism: Reflections on the Rothman's Exhibition," *Arts/Canada,* vol. XXIV, no. 210–11 (Dec., 1976–Jan., 1977), pp. 6–23.

Borlase, Nancy. "In Selecting a Common Domestic Object," *Sydney Morning Herald,* July 30, 1977.

Crossley, Mimi. "Review: Photo-Realism," *Houston Post,* Dec. 9, 1977.

Edelson, Elihu. "New Realism at Museum Arouses Mixed Feelings," *Jacksonville* (Fla.) *Journal,* Feb., 1977.

Lynn, Elwyn. "The New Realism," *Quadrant,* Sept., 1977.

McGrath, Sandra. "I Am Almost a Camera," *The Australian* (Brisbane), July 27, 1977.

Phillips, Ralph. "Just Like the Real Thing," *Sunday Mail* (Brisbane), Sept. 11, 1977.

Schwartz, Estelle. "Art and the Passionate Collector," *Cue,* Dec., 1977, pp. 7–11.

Bongard, Willie. *Art Aktuell* (Cologne), Apr., 1978.

Harris, Helen. "Art and Antiques: The New Realists," *Town and Country,* Oct., 1978, pp. 242, 244, 246–47.

Jensen, Dean. "Super Realism Proves a Super Bore," *Milwaukee Sentinel,* Dec. 1, 1978.

Mackie, Alwynne. "New Realism and the Photographic Look," *American Art Review,* Nov., 1978, pp. 72–79, 132–34.

Richard, Paul. "New Smithsonian Art: From 'The Sublime' to Photo Realism," *Washington Post,* Nov. 30, 1978, p. G21.

Sanger, Elizabeth. "If Your Taste in Art Runs to the Bizarre, O.K. Harris Is O.K.," *Wall Street Journal,* Aug. 18, 1978, pp. 1, 29.

"Notes on People: 'Truck' at the Mondales Not Driving Them up a Wall," *New York Times,* Apr. 5, 1979.

Richard, Paul. "Art Show No. 3 at Vice President's House," *Washington Post,* Apr. 5, 1979, p. D8.

Cottingham, Jane. "Techniques of Three Photo-Realists," *American Artist,* Feb., 1980.

BOOKS

Art Now, New Age. Tokyo: Kodansha, 1972.

Kultermann, Udo. *New Realism.* New York: New York Graphic Society, 1972.

Brachot, Isy, ed. *Hyperréalisme.* Brussels: Imprimeries F. Van Buggenhoudt, 1973.

Sager, Peter. *Neue Formen des Realismus.* Cologne: Verlag M. DuMont Schauberg, 1973.

Who's Who in American Art. New York: R. R. Bowker, 1973.

L'Iperrealismo italo Medusa. Rome: Romana Libri Alfabeto, 1974.

Battcock, Gregory, ed. *Super Realism, A Critical Anthology.* New York: E. P. Dutton, 1975.

Chase, Linda. *Hyperréalisme.* New York: Rizzoli, 1975.

Hobbs, Jack. *Art in Context.* New York: Harcourt Brace Jovanovich, 1975.

Kultermann, Udo. *Neue Formen des Bildes.* Tübingen, West Germany: Verlag Ernst Wasmuth, 1975.

Lucie-Smith, Edward. *Late Modern—The Visual Arts Since 1945.* 2d ed. New York: Praeger, 1975.

Rose, Barbara, ed. *Readings in American Art, 1900–1975.* New York: Praeger, 1975.

Honisch, Dieter, and Jensen, Jens Christian. *Amerikanische Kunst von 1945 bis Heute.* Cologne: DuMont Buchverlag, 1976.

Stebbins, Theodore E., Jr. *American Master Drawings and Watercolors.* New York: Harper & Row, 1976.

Battcock, Gregory. *Why Art.* New York: E. P. Dutton, 1977.

Cummings, Paul. *Dictionary of Contemporary American Artists.* 3d ed. New York: St. Martin's Press, 1977.

Lucie-Smith, Edward. *Art Now: From Abstract Expressionism to Superrealism.* New York: William Morrow, 1977.

Tighe, Mary Ann, and Lang, Elizabeth Ewing. *Art America.* New York: McGraw-Hill, 1977.

Lucie-Smith, Edward. *Super Realism.* Oxford: Phaidon, 1979.

Seeman, Helene Zucker, and Siegfried, Alanna. *SoHo.* New York: Neal-Schuman, 1979.

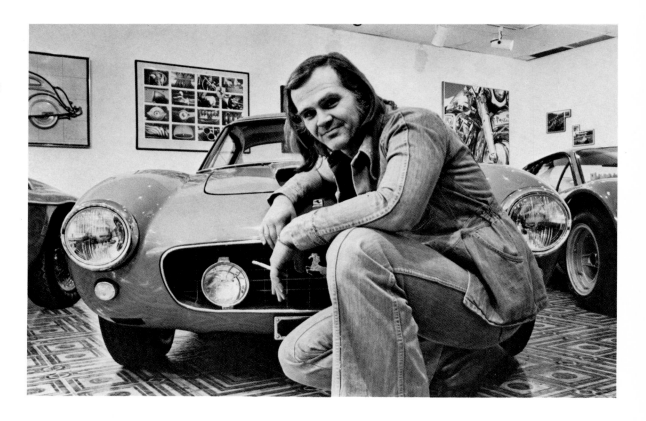

647. Ron Kleemann with Ferrari

RON KLEEMANN

Ron Kleemann began his professional career as an abstract sculptor in the early sixties. By 1967 he had turned to painting as his medium. His early works still related to the concerns of a sculptor, and involved shaped canvas and abstract sculptural forms. Because of his interest in sculptural forms and his attempt to create them in painting, his work was hard-edge in style and technique, rather than loose and expressionistic. From the beginning, there was a breaking of the picture plane, a rounding and shaping of elements, which was contrary to abstract doctrine. The work, if not yet realism, was at least a form of Surrealism.

By 1968 or 1969 Kleemann had begun to use photographs as aids in his work. By juxtaposing elements from several photographs, his paintings were surrealistic in very American and contemporary ways. One of the most well-known paintings of this period was *The Lex*. Other works from this time depict trucks, cars, or fire engines, with parts of the male or female anatomy superimposed. The Freudian sexual symbolism and meaning that can be discerned in most Surrealism is apparent also in almost all of Kleemann's work from the very beginning to the present. Kleemann's subject matter seems subconsciously induced and has been totally consistent even though the visual appearance of his work has changed drastically. The one word that could be used in connection with all of Kleemann's work over the past twenty years is "machismo." I think, though, that he was first consciously aware of this only when he turned to true Photo-Realism.

The first works that Kleemann painted as a pure Photo-Realist, and the works for which he has acquired an international reputation, all had racing cars as their subject. A racing machine—whether car, plane, motorcycle, boat—can usually be interpreted as a phallic symbol. Kleemann's real interest in the racing cars, however, was more subtle. He has stated many times in recent years that what really interests

648. *Xmas Tree Series: Red Light*. 1971 (10).
Pencil and collage on canvas, 48 x 48".
Private collection, New York
649. *Xmas Tree Series: Yellow Light No. 1*.
1971 (11). Acrylic and collage on canvas,
48 x 48". Private collection
650. *Xmas Tree Series: Yellow Light No. 2*.
1971 (12). Acrylic and collage on canvas,
48 x 48". Private collection
651. *Xmas Tree Series: Yellow Light No. 3*.
1971 (13). Acrylic on canvas,
48 x 48". Private collection, New York
652. *Xmas Tree Series: Green Light*. 1971 (14).
Acrylic on canvas, 48 x 48".
Private collection, New York

648

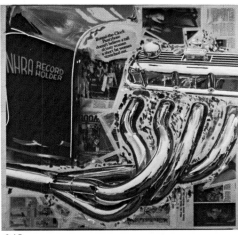

649

him is the mark, symbol, or, even, the spoor, that man places and leaves to indicate territorial imperative. He calls this "formal graffiti": names, decals, words, pinstripes, logos. Racing machines are covered with them. Kleemann's work makes us realize that everything everywhere carries a label or other mark that claims, "I made this. I sold this. I own this. THIS IS ME. Macho, ego." Even the license plate affixed to every vehicle is a mark of control by the state, and Kleemann's Poetic License series (plates 704 and 705) is devoted to just this one "mark." Like racing machines, trucks of all sorts convey the same sort of information, and trucks are the second most prevalent image in his work.

Kleemann always composes his paintings with the object in the foreground, almost breaking out of the picture plane at a rakish angle. The images, generally cropped, suggest that they are about to burst the borders of the canvas. While the vehicles are never portrayed in motion, they always appear on the verge of motion. These paintings grapple for the viewer's attention and demand emotional response.

If any Photo-Realist can be called painterly, it is Ron Kleemann. His technique is brushy and loose when viewed up close, but at a distance of about three feet it snaps into a sharp, clear photographic image. Most of the other Photo-Realists attempt to get the brushless photographic look from all distances.

Kleemann's work has an important dimension related to Conceptual Art, although this aspect is not generally recognized. He became a licensed taxi driver before painting the Sculls Angels work (pl. 679). He traded a serigraph of *SoHo Saint 33 and 4 Score* (pl. 684) for a helmet, boots, and coat to become an honorary fireman, as part of his Fire Engine series. He created Team Kleemann—Conceptual Art Racing Team for the 1977 Indianapolis 500, complete with vans, sponsors, decal jackets, and publicity, but no car.

Prototype for Draggin' Sculls is the basis of a proposal Kleemann made in 1974. Knowing that people accept that a Photo-Realist painting is done from a photograph of reality, he decided to make a painting of a reality that did not exist and create a reality at the suggestion of a painting. His proposal was to paint a Scull's Angels taxicab with racing tires smoking and with eight chrome exhaust pipes protruding. He hoped that Scull would give a used cab to race-car mechanics to make the Draggin' Sculls Racing Team a reality.

Kleemann says, "While I am spending six months on a painting, I am creating, changing, and disposing of hundreds of other artworks in my mind. A few of them eventually become reality in future works."

Much of his time is spent in titling his paintings. Unlike the other Photo-Realists, he

650

651

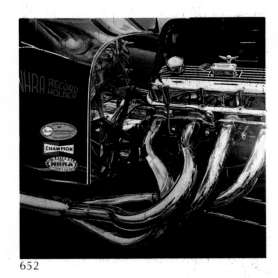
652

is very concerned with titles, all of which have cryptic meanings and are very much a part of his work. Often they include humor and double entendre. SoHo used to be known as "Hell's Hundred Acres" because of its susceptibility to fire. The SoHo Saint was always there as the savior. "Prototype for Draggin' Sculls" has already been explained.

In 1971 Kleemann did the Xmas Tree series of five works (pls. 648 to 652). In drag-racing terminology the Xmas tree is the system of five lights used to start each race. The lights come on in the following order: red, yellow 1, yellow 2, yellow 3, and green. The five paintings are named for the lights. All five started with exactly the same drawing: the second, third, fourth, and fifth were continued to the next step in Kleemann's process. Then the third, fourth, and fifth were taken another step, the fourth and fifth advanced further, and only the fifth was completed. They stand as a documentation of Kleemann's work-in-progress, clearly showing how he creates his paintings.

The Cartwheel series comprises the most recent Indianapolis 500 paintings and prints. CART stands for Conceptual Art Racing Team.

Kleemann's latest project is named "Marollerons." He claims that this painting of the Bay City Rollers was psychically induced by the fact that the Rollers, from Britain, chose their name by arbitrarily sticking a pin into a spinning globe and hitting Bay City, Michigan, Ron's birthplace. (The painting will not be completed in time for inclusion in this book.)

Kleemann has supplied the following statement, which he entitles *Voice of the Icon:*

Before my involvement in what is now called Photo-Realism, I was doing large, shield-shaped, emblematic machine-form paintings. Because these insignia paintings were so esoteric, I searched for a more generalized subject matter to imply the same sort of visual representation of a literal idea. I found the race car, which is a clear object of worship, both to the fans and those participating in the sport itself.

I have always painted icons—recording the phenomena of twentieth-century religious objects. The race car represents the most obvious cross-cultural icon, but not the only one. From race cars I've gone on to other subject matter, with increasingly subcultural images. They are still, however, objects of worship.

The subject matter of my paintings is not subtle: it says what it is. The only subtleties exist in the microcosms of the painting itself. My paintings are a fist tattooed with the word "HERE!" across the knuckles. I want to capsulize a concentrated

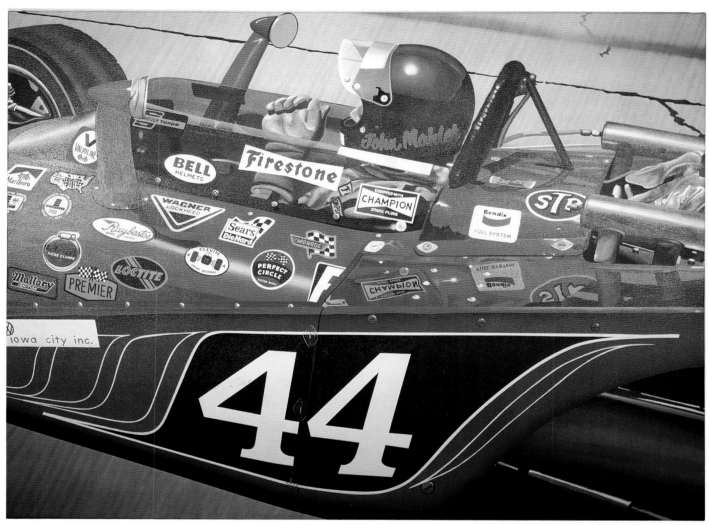

653. *The Way It's Spozed to Be: 11:30 A.M.* 1972 (22). Acrylic on canvas, 36 x 48". Private collection, N.J.

moment on canvas. I can compare myself to a filmmaker without a movie camera, continually observing and making visual situations in my head, but with only one frame per movie (the resulting painting).

We reflect our personalities by the objects we surround ourselves with—a narcissistic reflection of our own importance in accordance with our individual choices. In painting these objects, I am trying to chronicle the visual icons of our time and to record the phenomena of their social importance.

It isn't the reflective quality of chrome as a painting problem that interests me—it's the evidence that people need a certain amount of "chrome" in their lives, in a figurative sense, in order to see themselves. Perhaps to remind them that they do, in fact, exist. Recently, I have been suffixing the titles of my paintings with the word "cross," as a literal symbol for the specifically depicted icon in the painting (*Big Foot Cross; Marion County Doublecross; Mustang Sally, the Third Cross*). Despite this, I don't consider myself a social painter—I want to show, not tell. I find object-worship curious, so I paint about it.

As you might suspect, I paint religiously every day.

Ron Kleemann
1978

Ron Kleemann had executed 63 Photo-Realist works through December 31, 1979. We have illustrated 60 of these herein and have listed the remaining three.

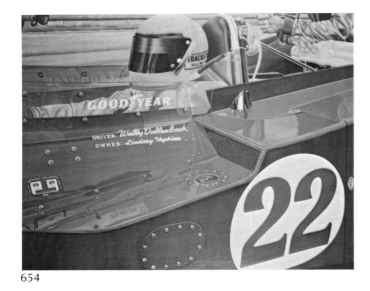

654

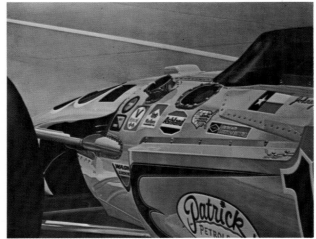

655

654. *Sprit Spit*. 1972 (26).
Acrylic on canvas, 47½ x 59½".
Collection Daniel Filipacchi, New York

655. *Johnny Lonestar*. 1972 (18).
Acrylic on canvas, 36 x 60".
Private collection, France

656. *Sir Cale*. 1971 (15).
Acrylic on canvas, 48 x 48".
Private collection, Iowa

657. *It's a Natural*. 1972 (17).
Acrylic on canvas, 53½ x 39¼".
Collection Daniel Filipacchi, New York

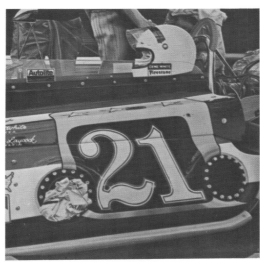

656

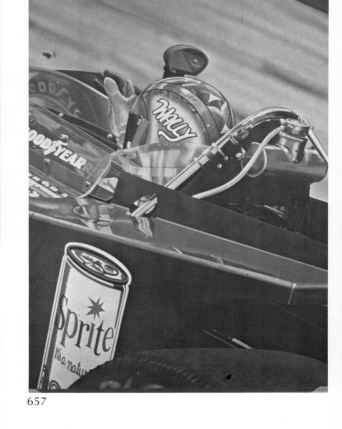

657

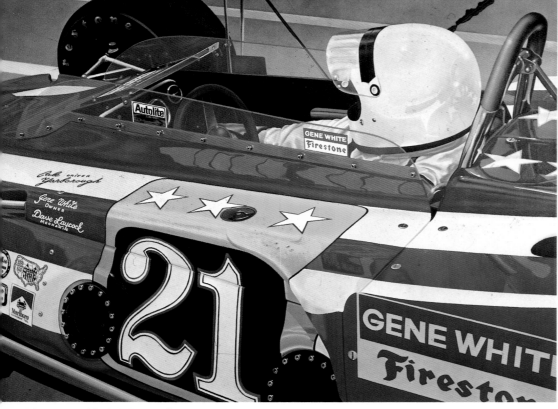

58. *Mongoose*. 1972 (16). Acrylic on canvas, 36 x 48".
Collection Daniel Filipacchi, New York

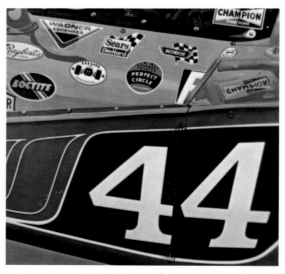

659. *No. 44*. 1972 (23). Acrylic on canvas, 48 x 48".
Aldrich Museum of Contemporary Art,
Ridgefield, Conn.

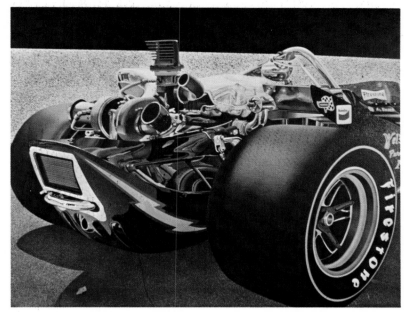

660. *Lightning Strikes Twice.* 1971 (19). Acrylic on canvas, c. 30 x 36".
Private collection, Mich.

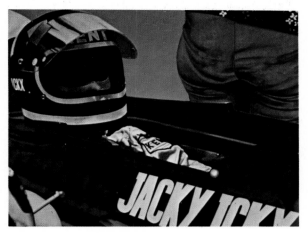

661. *Ickx Up.* 1972 (28). Acrylic on canvas, 28 x 36".
Private collection, Europe

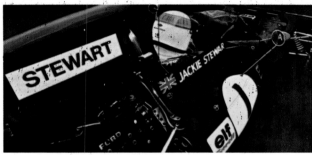

662. *Flying Scot One and Flying Scot Too.* 1972 (24).
Acrylic on canvas, 24 x 48".
Private collection, Europe

663. *Donohue's Ride.* 1972 (27).
Acrylic on canvas, 36 x 48".
Collection Daniel Filipacchi, New York

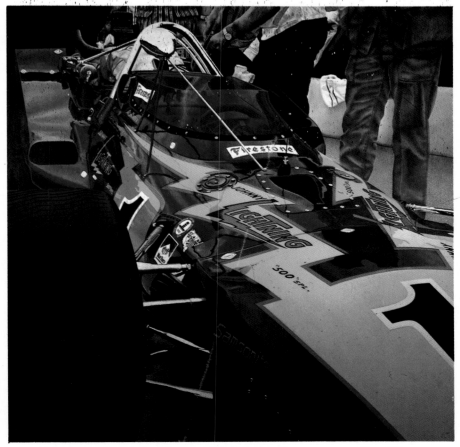

664. *Lightning Strikes Twice, Twice.* 1971 (20). Acrylic on canvas, 70 x 70".
Private collection, France

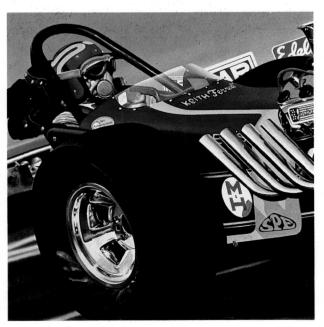

665. *Slingshot.* 1972 (21). Acrylic on canvas, 38 x 38".
Private collection, Washington, D.C.

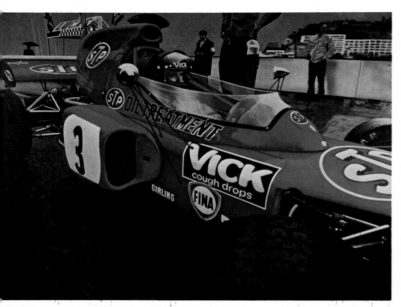

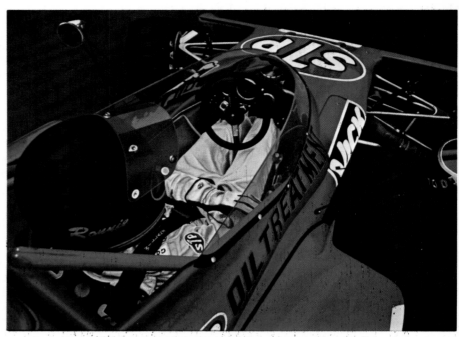

66. *Monaco March in May.* 1972 (29). Acrylic on canvas, 70 x 90".
Collection Michelle Rosenfeld, N.J.

667. *Ronnie's Massage Parlor.* 1972 (25). Acrylic on canvas, 36 x 48".
Collection Daniel Filipacchi, New York

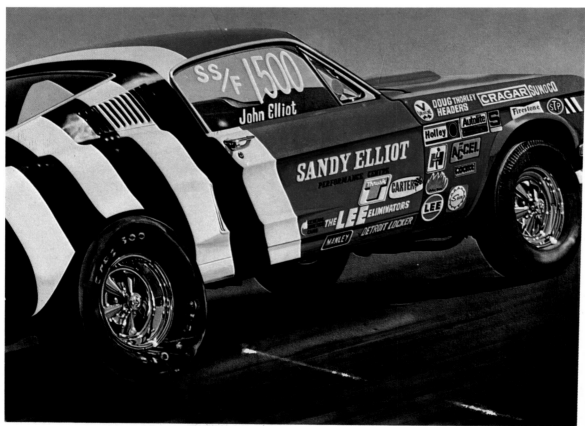

668. *Superstocker.* 1973 (30). Acrylic on canvas, 36 x 48". Tamayo Museum, Mexico City

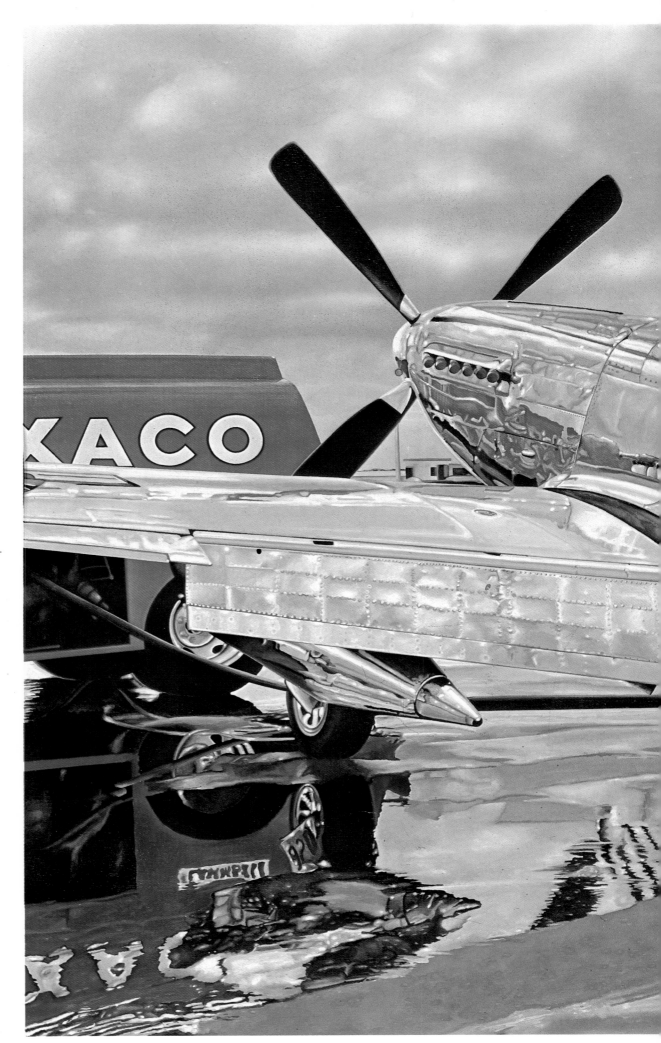

669. *Mustang Sally Forth*. 1973 (35).
Acrylic on canvas, 50 x 72".
Stuart M. Speiser Collection,
Smithsonian Institution, Washington, D.C.

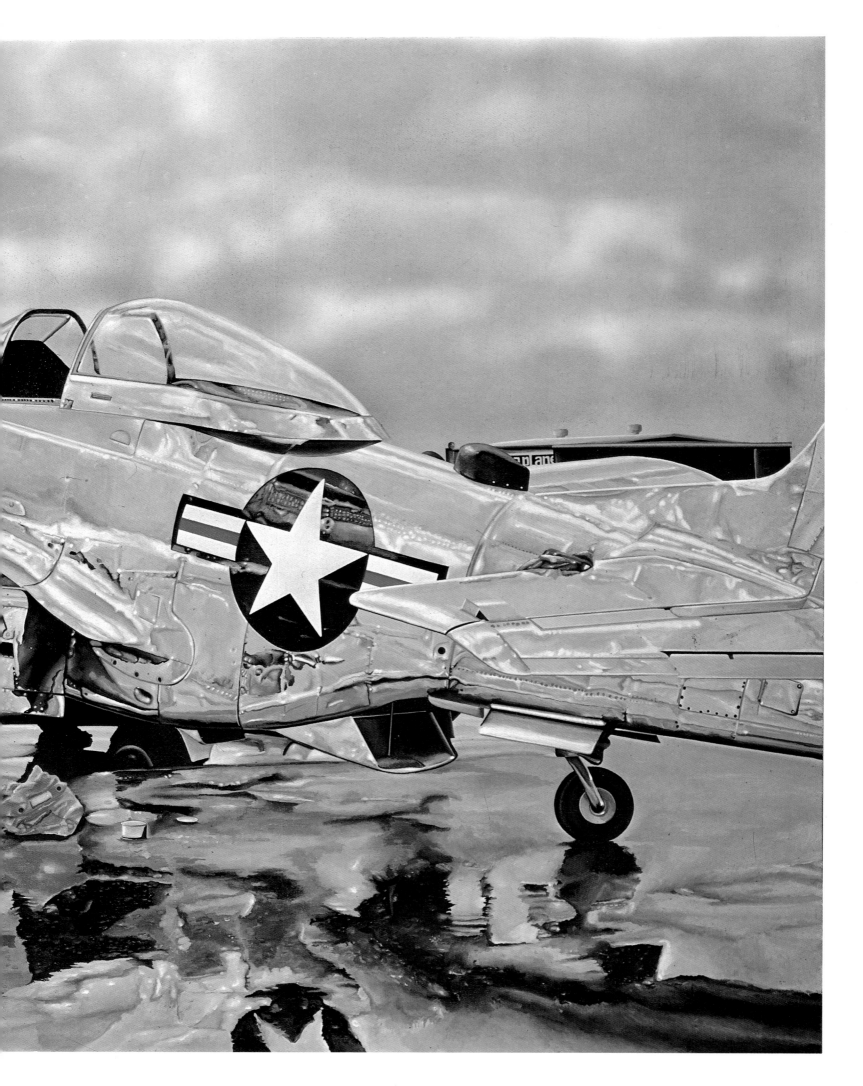

670. *W. W. II Amputee, Bearcat (with Jugs by George).* 1973 (32). Acrylic on canvas, 48 x 36". Collection Mr. and Mrs. Morton G. Neumann, Ill.

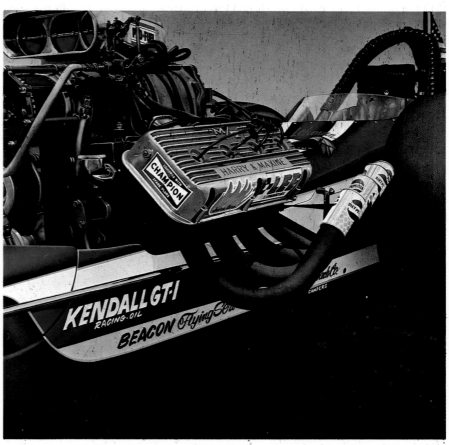

671. *Harry Loves Maxine the American Way.* 1973 (31). Acrylic on canvas, 48 x 48". Private collection, Europe

672. *23 Skidoo.* 1973 (37). Acrylic on canvas, 36 x 46". Collection Daniel Filipacchi, New York

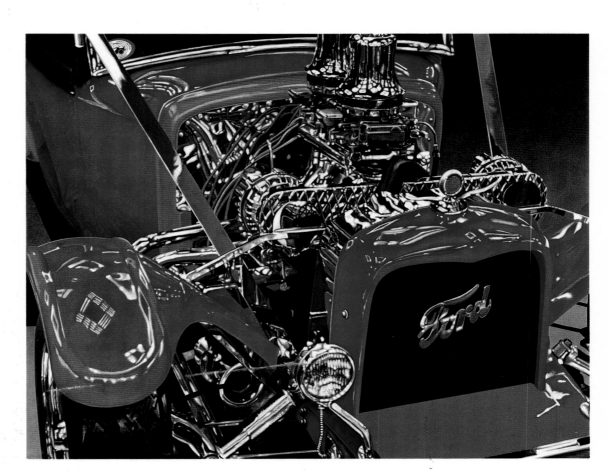

673. *Under the Wing of Johncock's Power Stilt*. 1974 (38). Acrylic on canvas, 36 x 48". Collection Daniel Filipacchi, New York

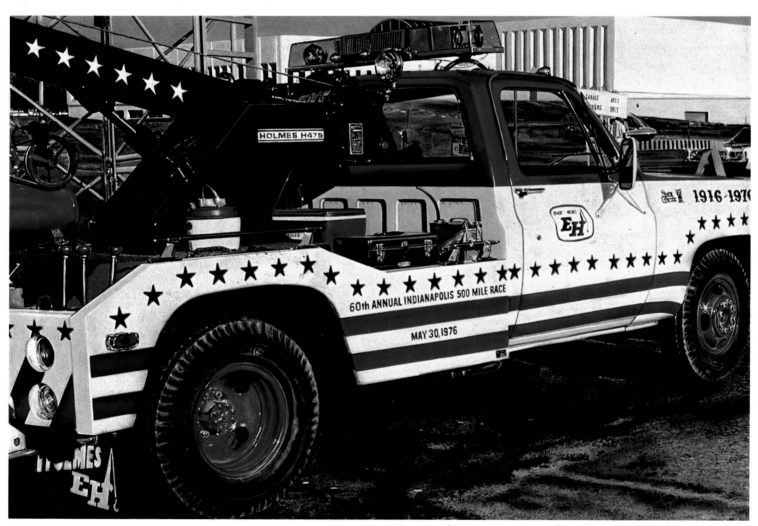

674. *Stars and Stripes Forever*. 1977 (55). Acrylic on canvas, 32 x 44". University of Virginia Museum of Art, Charlottesville

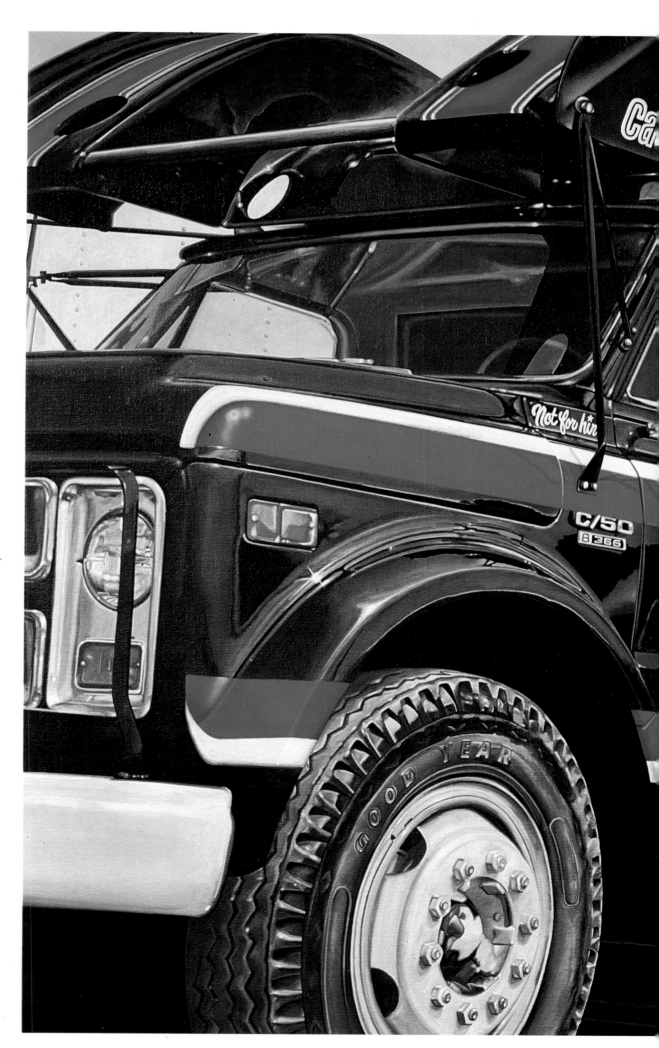

675. *Hobbs No. 2 Tub*. 1974 (39).
Acrylic on canvas, 42 x 60".
Museum of Modern Art, New York.
Stuart M. Speiser Fund, 1976

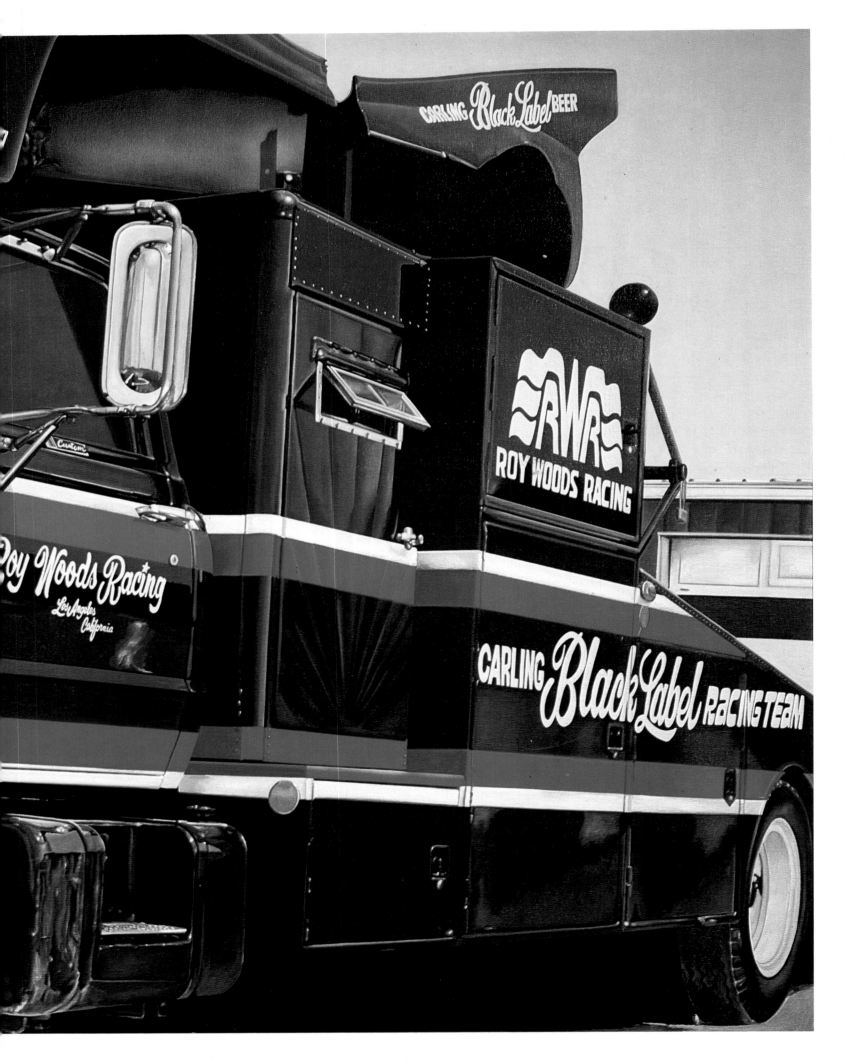

315

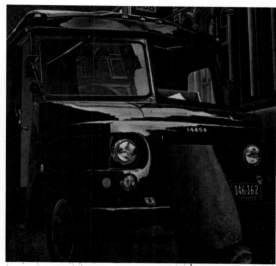

676. *Leo's Revenge.* 1971 (6).
Acrylic on canvas, 48 x 48".
Collection Mrs. Robert B. Mayer, Ill.

677. *Broadway No. 6 to South Ferry.* 1971 (4).
Acrylic on canvas, 70 x 91".
Collection Mrs. Robert B. Mayer, Ill.

678. *U.P.S. Parcel Series No. 1.* 1971 (7).
Acrylic on canvas, 36 x 36".
Collection Mr. William J. Poplack, Mich.

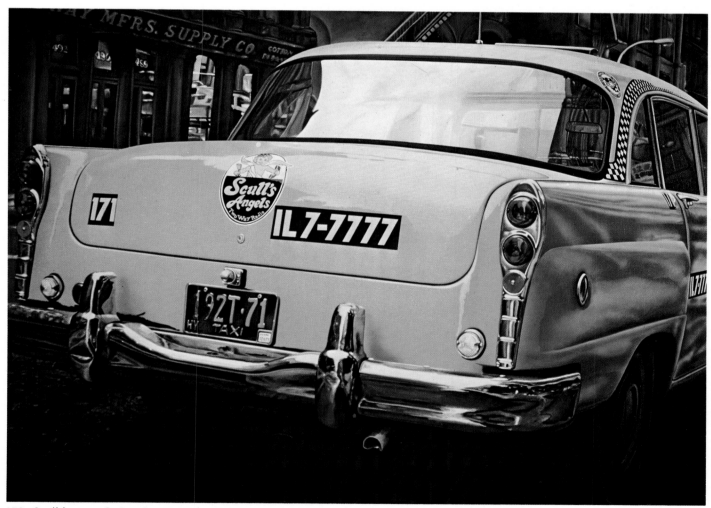

679. *Scullduggery Series: Prototype for Draggin' Sculls.* 1973 (36). Acrylic on canvas, 50 x 68".
Private collection

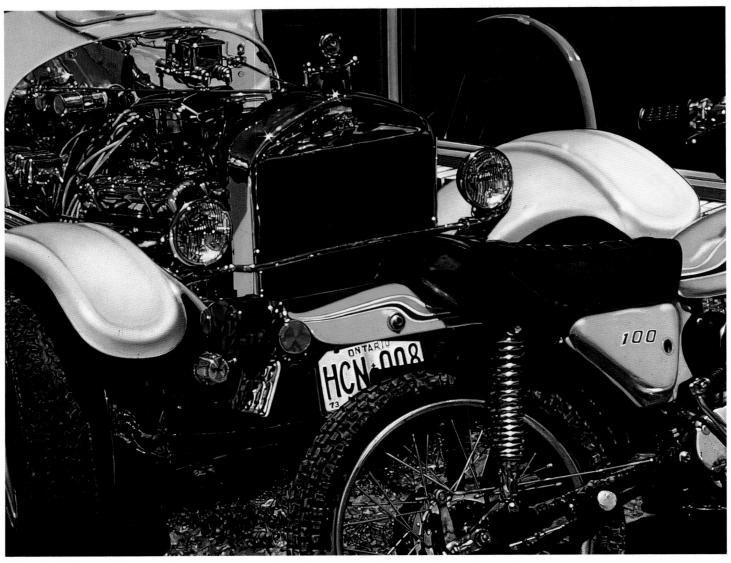

680. *Farthest/Close*. 1975 (48). Acrylic on canvas, 30 x 38". Collection Louis and Susan Meisel, New York

681. *Far/Closest Me/250 Hrs*. 1975 (46). Acrylic on canvas, 30 x 38". Private collection, Switzerland

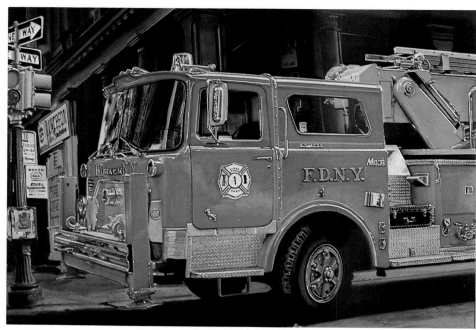

682. *Unsplit Mack.* 1975 (50). Acrylic on paper, 19 x 27".
Collection Elliott Meisel, New York

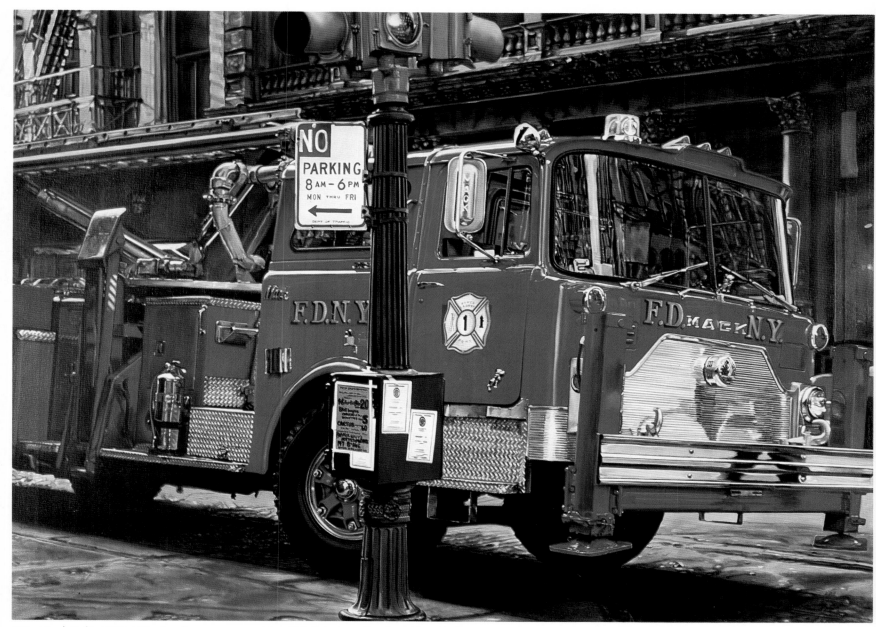

683. *Mack Split.* 1975 (49). Acrylic on canvas, 44 x 60". Private collection, New York

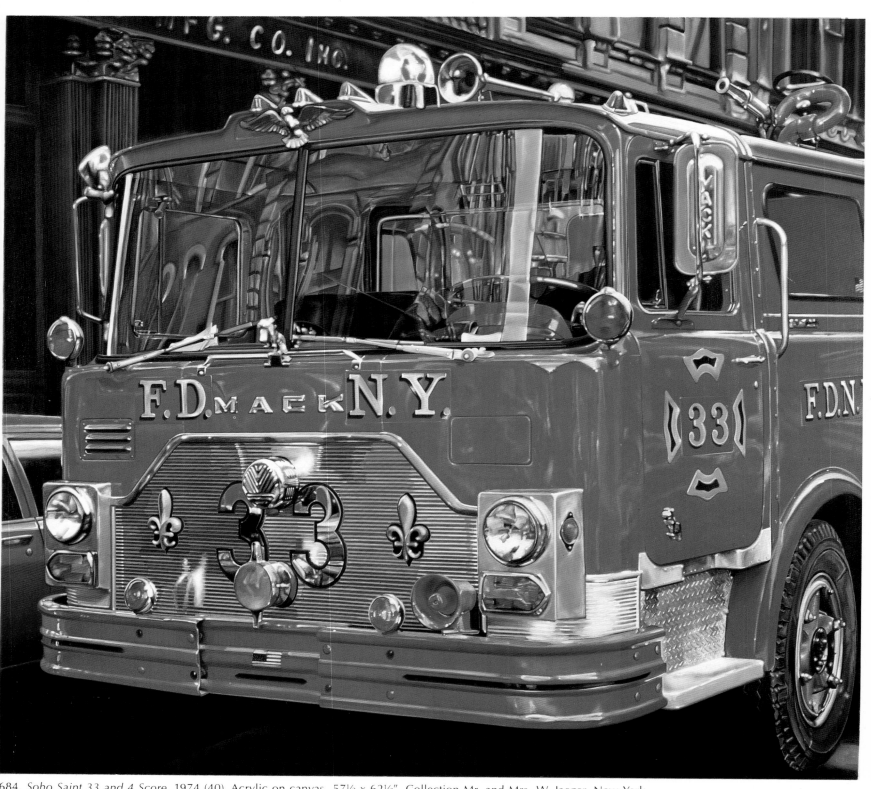

684. *Soho Saint 33 and 4 Score*. 1974 (40). Acrylic on canvas, 57½ x 62½". Collection Mr. and Mrs. W. Jaeger, New York

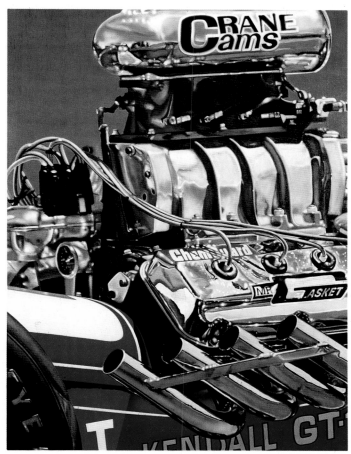

685. *Mr. Gasket.* 1974 (43). Acrylic on canvas, 48 x 36".
Collection Louis and Susan Meisel, New York

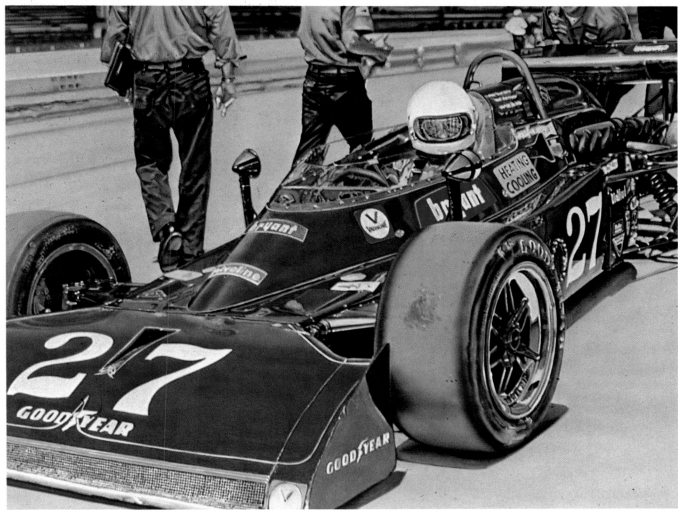

686. *Cartwheel Series: Guthrie.* 1977 (58). Acrylic on canvas, 41¾ x 53¼".
Collection Mr. and Mrs. Gerald Paul, Ind.

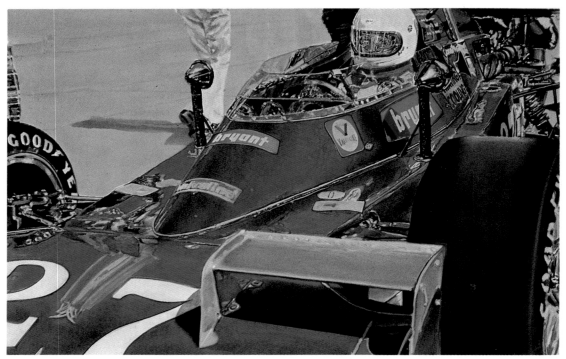

687. *Cartwheel Series: Janet Guthrie.* 1977 (60). Acrylic on paper, 18¾ x 27½".
Collection Dr. and Mrs. Barry J. Paley, New York

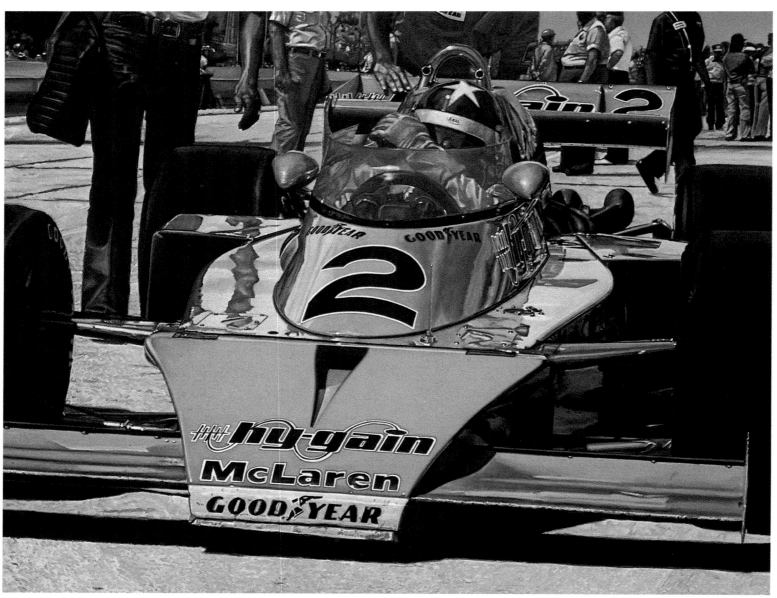

688. *Cartwheel Series: Johnny Rutherford.* 1977 (59). Acrylic on canvas, 44½ x 55". Indianapolis Museum of Art.
Gift of Paul Harris Stores, Inc.

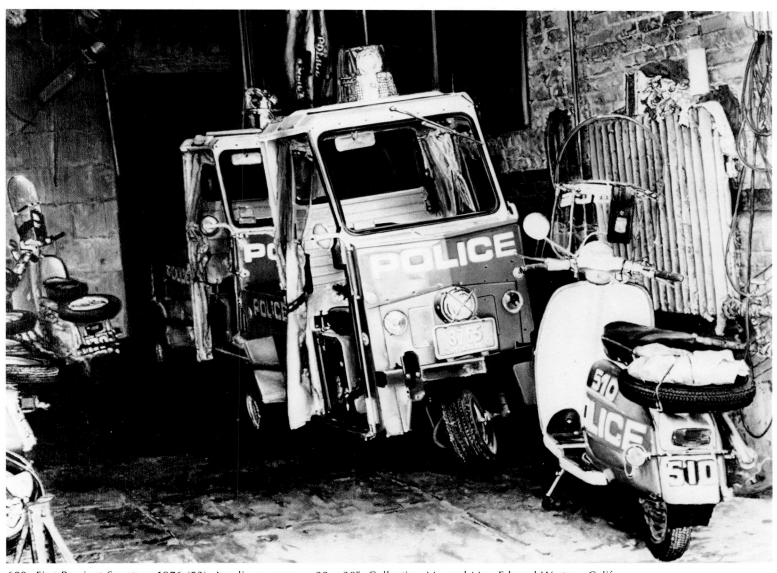

689. *First Precinct Scooters.* 1976 (53). Acrylic on canvas, 28 x 38". Collection Mr. and Mrs. Edward Weston, Calif.

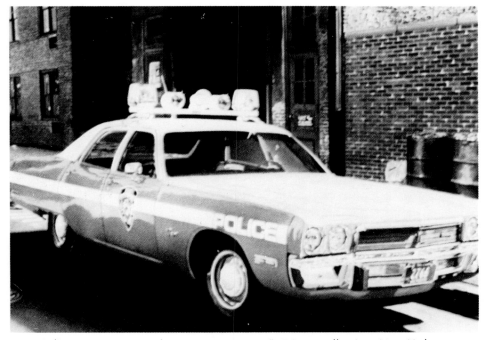

690. *Police.* 1976 (54). Acrylic on paper, 19 x 26". Private collection, New York

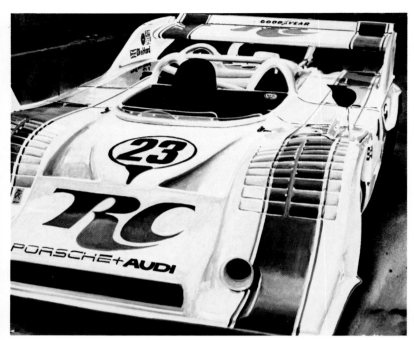

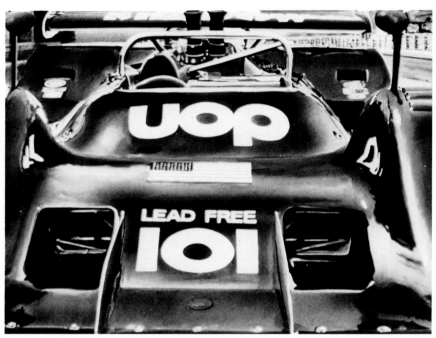

691. *R.C.* 1974 (41). Acrylic on paper, 12½ x 12½".
Collection Martin I. Harman, New York

692. *Lead Free 101*. 1974 (42). Acrylic on paper, 11¾ x 15".
Private collection

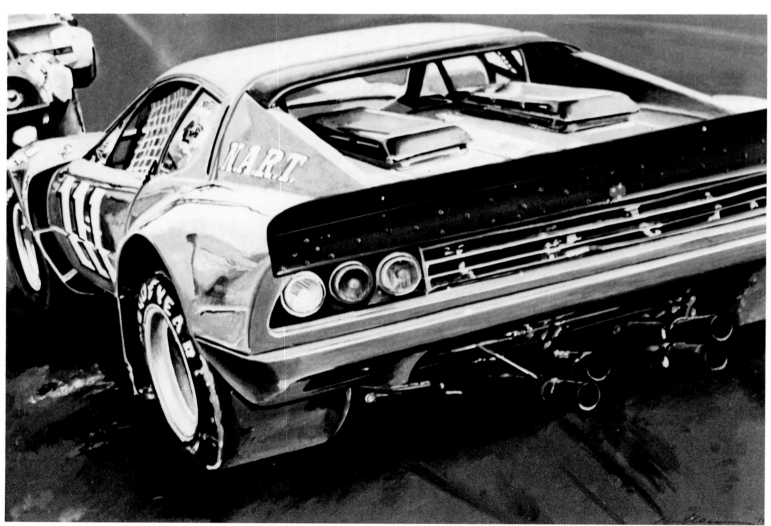

693. *N.A.R.T.* 1975 (47). Acrylic on paper, 10½ x 15". Private collection

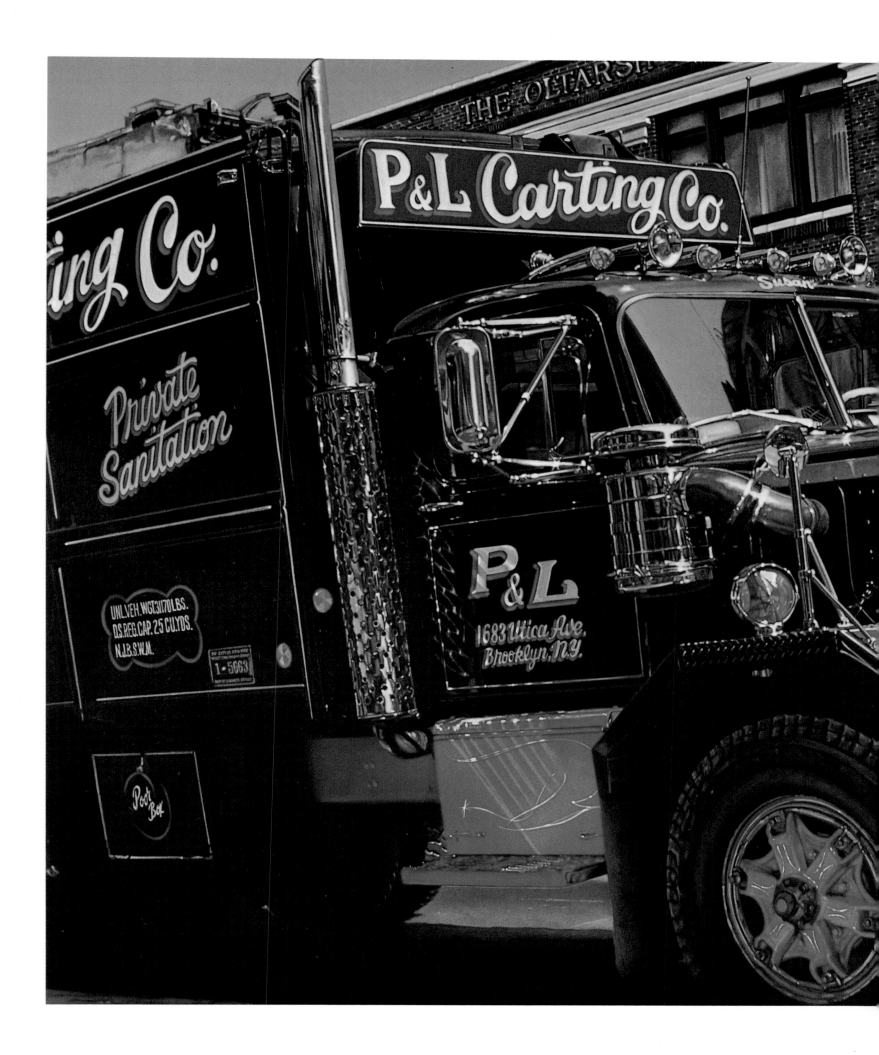

324

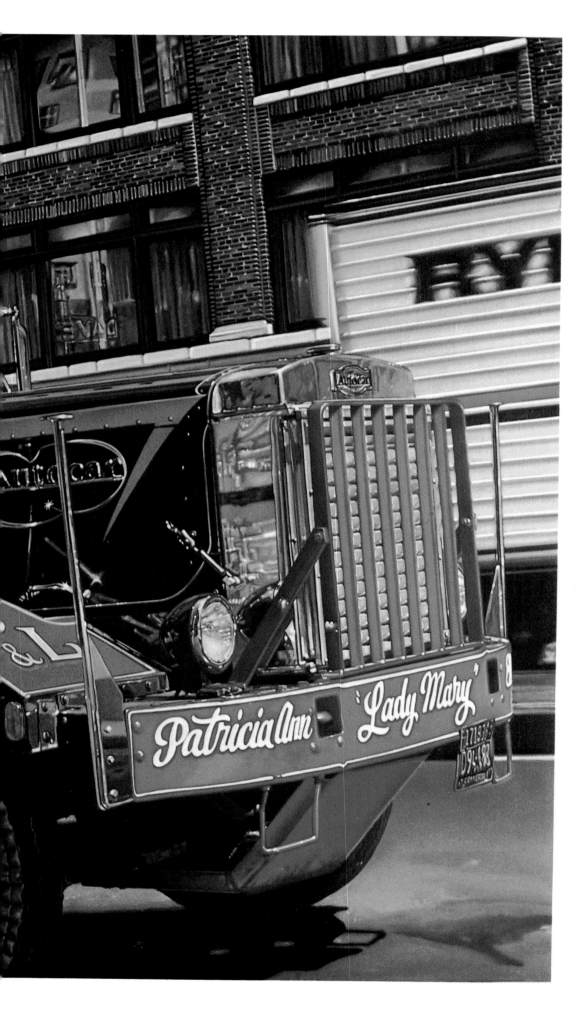

694. *Private Sanitation*. 1976 (51).
Acrylic on canvas, 44 x 66".
Collection Stanton Rosenberg, M.D., Kans.

695. *Keep On Truckin'*. 1971 (5). Acrylic on canvas, 48 x 48".
Private collection, New York

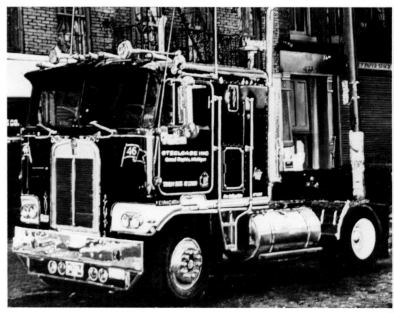

696. *Ten Four, Good Buddy*. 1977 (56). Acrylic on paper, 18½ x 22".
Collection Louis and Susan Meisel, New York

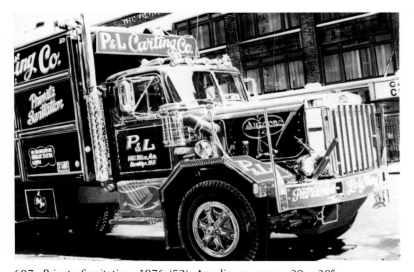

697. *Private Sanitation*. 1976 (52). Acrylic on paper, 20 x 30".
Collection Mr. and Mrs. W. Jaeger, New York

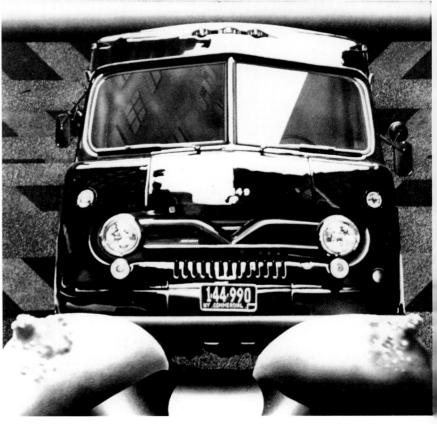

698. *U.P.S. Parcel Series No. 2: Lift and Separate*. 1971 (8). Acrylic on canvas,
36 x 36". Private collection, France

699. *AA Competition Eliminator (Fueler)*. 1971 (9). Acrylic on canvas, 48 x 48".
Private collection, France

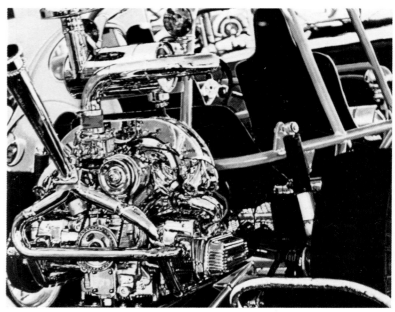

700. *Buggie*. 1977 (57). Acrylic on paper, 17 x 21".
Collection Louis and Susan Meisel, New York

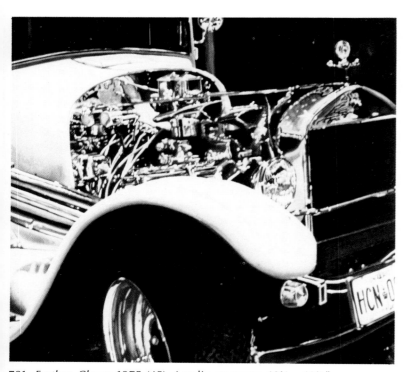

701. *Further, Closer*. 1975 (45). Acrylic on paper, 12¼ x 12½".
Private collection, Spain

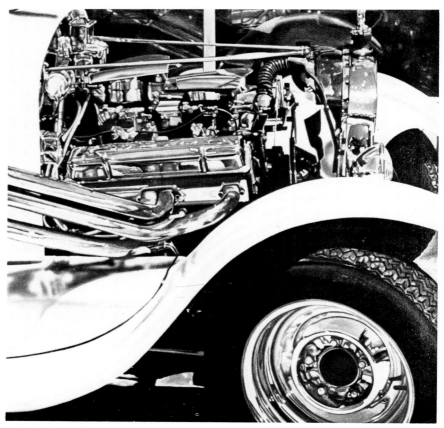

702. *Further, Closer*. 1974 (44). Acrylic on canvas, 30 x 30".
Private collection, Conn.

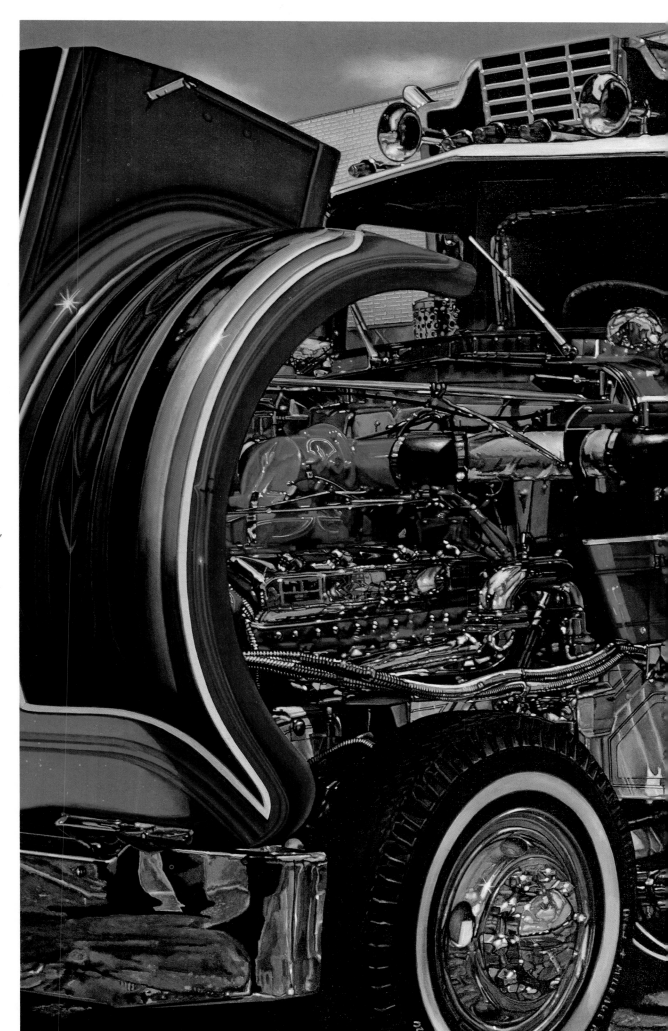

703. *Big Foot Cross*. 1978 (61).
Acrylic on canvas, 54¼ x 78".
Solomon R. Guggenheim Museum,
New York

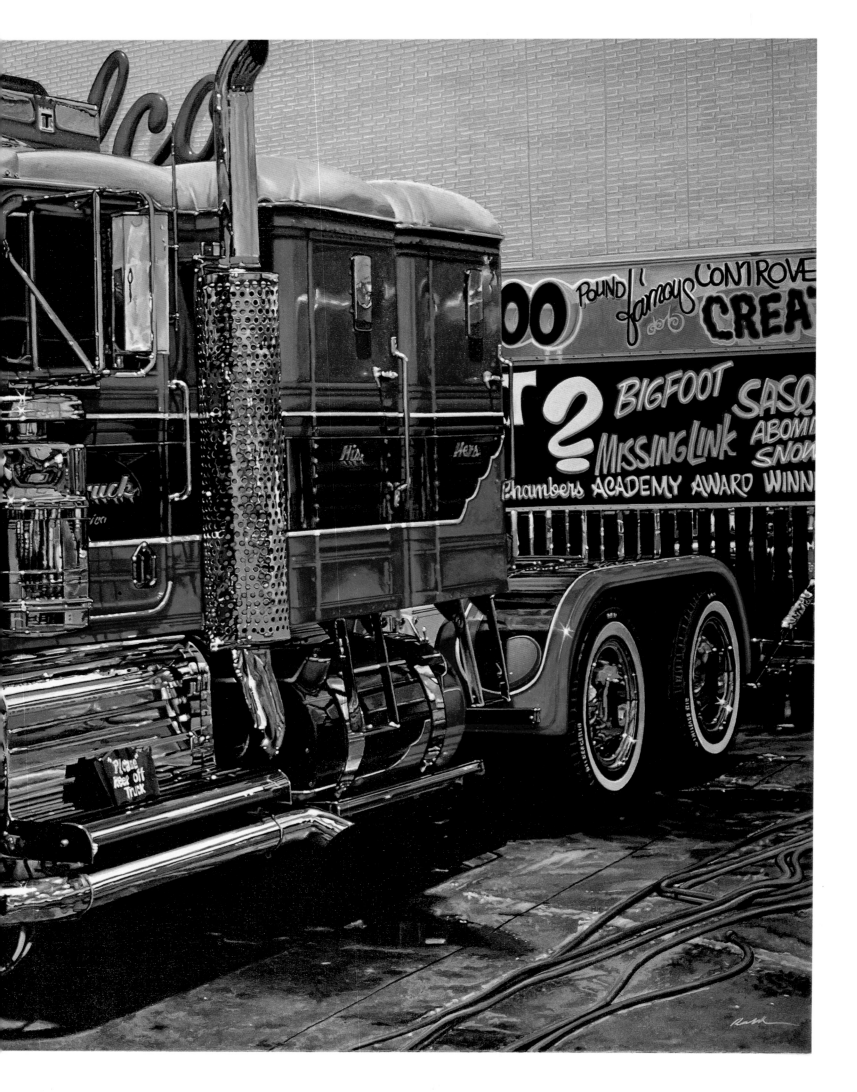

704. *Poetic License Series: New York*. 1973 (33). Acrylic on canvas, 44 x 60".
Private collection, Calif.

NOT ILLUSTRATED
The Lex. 1970 (1).
Acrylic on canvas, 78¾ x 90½".
Private collection, France
Yellow Backhoe. 1970 (2).
Acrylic on canvas, 66 x 96".
Museum of Contemporary Art,
Chicago
International Harvest...er.
1971 (3).
Acrylic on canvas, 48 x 48".
Private collection

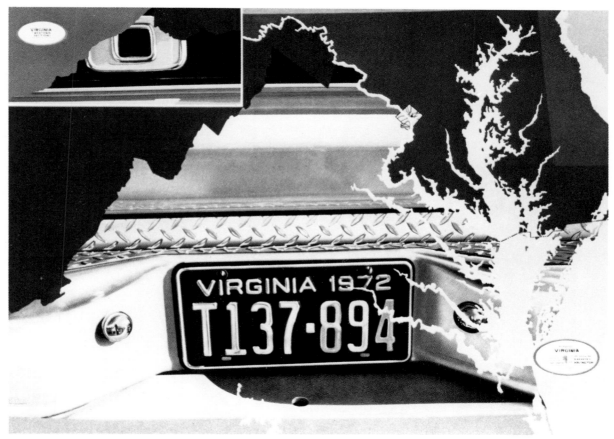

705. *Poetic License Series: Virginia*. 1973 (34). Acrylic on canvas, 44 x 60".
Collection the artist

BIOGRAPHY

1937 Born: Bay City, Mich.

EDUCATION
1961 B.S. in Design, University of Michigan, College of Architecture and
 Design

SOLO EXHIBITIONS
1971 French and Co., New York
1974 Louis K. Meisel Gallery, New York
1976 Louis K. Meisel Gallery, New York
 Reed College, Portland, Oreg.
1977 Indianapolis Museum of Art
1979 Louis K. Meisel Gallery, New York

SELECTED GROUP EXHIBITIONS
1961 "San Francisco Art Annual," San Francisco Museum of Modern Art
1970 Galerie 99, Bay Harbor Island, Fla.
1971 "Art Around the Automobile," Emily Lowe Gallery, Hofstra University,
 Hempstead, N.Y.
 French and Co., New York
 "New Realism," Brainerd Hall Art Gallery, State University College,
 Potsdam, N.Y.
 "Radical Realism," Museum of Contemporary Art, Chicago
 Rider College, Trenton, N.J.
 "The Shape of Realism," Deson-Zaks Gallery, Chicago
1972 Aldrich Museum, Ridgefield, Conn.
 L'Hyperréalistes américains," Galerie des Quatre Mouvements, Paris
 "Painting and Sculpture Today, 1972," Indianapolis Museum of Art
 "Phases of the New Realism," Lowe Art Museum, University of Miami,
 Coral Gables, Fla.
 "Realism Now," New York Cultural Center, New York
 "Sharp-Focus Realism," Sidney Janis Gallery, New York
 University of Massachusetts, Amherst
 Warren Benedek Gallery, New York
1973 "Grands maîtres hyperréalistes américains," Galerie des Quatre
 Mouvements, Paris
 "Realism Now," Katonah Gallery, Katonah, N.Y.
 Shorewood Graphics Gallery, New York
 "The Super-Realist Vision," DeCordova and Dana Museum, Lincoln,
 Mass.
1973–74 "Hyperréalisme," Galerie Isy Brachot, Brussels
1973–78 "Photo-Realism 1973: The Stuart M. Speiser Collection," traveling
 exhibition: Louis K. Meisel Gallery, New York; Herbert F. Johnson
 Museum of Art, Ithaca, N.Y.; Memorial Art Gallery of the University
 of Rochester, N.Y.; Addison Gallery of American Art, Andover,
 Mass.; Allentown Art Museum, Pa.; University of Colorado
 Museum, Boulder; University Art Museum, University of Texas,
 Austin; Witte Memorial Museum, San Antonio, Tex.; Gibbes
 Art Gallery, Charleston, S.C.; Brooks Memorial Art Gallery,
 Memphis, Tenn.; Krannert Art Museum, University of Illinois,
 Champaign-Urbana; Helen Foresman Spencer Museum of Art,
 University of Kansas, Lawrence; Paine Art Center and Arboretum,
 Oshkosh, Wis.; Edwin A. Ulrich Museum, Wichita State University,
 Kans.; Tampa Bay Art Center, Tampa, Fla.; Rice University, Sewall
 Art Gallery, Houston; Tulane University Art Gallery, New Orleans;
 Smithsonian Institution, Washington, D.C.
1974 "Amerikaans fotorealisme grafiek," Hedendaagse Kunst, Utrecht; Palais
 des Beaux-Arts, Brussels
 "Art 5 '74," Basel, Switzerland
 Galerie André François Petit, Paris
 Moos Gallery, Montreal
 Moos Gallery, Toronto
 "New Photo-Realism," Wadsworth Atheneum, Hartford, Conn.
 "New Realism Revisited," Brainerd Hall Art Gallery, State University
 College, Potsdam, N.Y.
 "Painting and Sculpture Today, 1974," Indianapolis Museum of Art;
 Taft Museum and Contemporary Arts Center, Cincinnati
 Randolph-Macon College, Lynchburg, Pa.

Taft Museum and Contemporary Art Center, Cincinnati
 "Thirty-eighth Annual Midyear Show," Butler Institute of American Art,
 Youngstown, Ohio
 "Tokyo Biennale, '74," Tokyo Metropolitan Museum of Art; Kyoto
 Municipal Museum; Aichi Prefectural Art Museum, Nagoya
 "Twenty-five Years of Janis: Part II," Sidney Janis Gallery, New York
1975 Morgan Gallery, Shawnee Mission, Kans.
 "The New Realism: Rip-Off or Reality?," Edwin A. Ulrich Museum of
 Art, Wichita State University, Kans.
 New York Cultural Center, New York
 "Photo-Realists," Louis K. Meisel Gallery, New York
 "Watercolors and Drawings—American Realists," Louis K. Meisel
 Gallery, New York
1975–76 "Photo-Realism, American Painting and Prints," New Zealand traveling
 exhibition: Barrington Gallery, Auckland; Robert McDougall Art
 Gallery, Christchurch; Academy of Fine Arts, National Art Gallery,
 Wellington; Dunedin Public Art Gallery, Dunedin; Govett-Brewster
 Art Gallery, New Plymouth; Waikato Art Museum, Hamilton
1976 "Realism (Paintings and Drawings)," Young Hoffman Gallery, Chicago
 "Troisième foire internationale d'art contemporain," Grand Palais,
 Paris
 "Washington International Art Fair," Washington, D.C.
1976–78 "Aspects of Realism," traveling exhibition sponsored by Rothman's of
 Pall Mall Canada, Ltd.: Stratford, Ont.; Centennial Museum,
 Vancouver, B.C.; Glenbow-Alberta Institute, Calgary, Alta.; Mendel
 Art Gallery, Saskatoon, Sask.; Winnipeg Art Gallery, Man.;
 Edmonton Art Gallery, Alta.; Art Gallery, Memorial University of
 Newfoundland, St. John's, Newf.; Confederation Art Gallery and
 Museum, Charlottetown, P.E.I.; Musée d'Art Contemporain,
 Montreal, Que.; Dalhousie University Museum and Gallery,
 Halifax, N.S.; Windsor Art Gallery, Ont.; London Public Library and
 Art Museum and McIntosh Memorial Art Gallery, University of
 Western Ontario; Art Gallery of Hamilton, Ont.
1977 "Breaking the Picture Plane," Tomasulo Gallery, Union College,
 Cranford, N.J.
 Chinetti Gallery, New York
 Galerie le Portrail, Heidelberg
 Hanson-Cowles Gallery, Minneapolis
 Montclair State College, Upper Montclair, N.J.
 Morgan Gallery, Shawnee Mission, Kans.
 "New in the '70s," University of Texas, Austin
 "New Realism," Jacksonville Art Museum, Fla.
 "Photo-Realists," Shore Gallery, Boston
 "Washington International Art Fair," Washington, D.C.
 "Works on Paper II," Louis K. Meisel Gallery, New York
1977–78 "Illusion and Reality," Australian touring exhibition: Australian
 National Gallery, Canberra; Western Australian Art Gallery, Perth;
 Queensland Art Gallery, Brisbane; Art Gallery of New South Wales,
 Sydney; Art Gallery of South Australia, Adelaide; National Gallery
 of Victoria, Melbourne; Tasmanian Museum and Art Gallery, Hobart
1978 "Art and the Automobile," Flint Institute of Arts, Mich.
 "Cityscape '78," Oklahoma Art Center, Oklahoma City
 Gallery 700, Milwaukee, Wis.
 Monmouth Museum, Lincroft, N.J.
 Palm Springs Art Fair, Calif.
 "Photo-Realism and Abstract Illusionism," Arts and Crafts Center of
 Pittsburgh
 "Photo-Realist Printmaking," Louis K. Meisel Gallery, New York
 Thomas Segal Gallery, Boston
 University of Nebraska, Lincoln, Nebr.
 "Washington International Art Fair," Washington, D.C.
 "With a Little Help from Our Friends," Mississippi Museum of Art,
 Jackson
1979 "Selections of Photo-Realist Paintings from N.Y.C. Galleries,"
 Southern Alleghenies Museum of Art, St. Francis College,
 Loretto, Pa.
 Washington International Art Fair, Washington, D.C.

706. *Marion County: Double Cross.* 1978 (63). Acrylic on paper, 19¼ x 31¼".
Collection Mr. and Mrs. Robert M. Beningson, New York

707. *Manhattan on the Hudson.* 1979 (62). Acrylic on canvas, 47 x 59½". Private collection

332

SELECTED BIBLIOGRAPHY

CATALOGUES

Art Around the Automobile. Emily Lowe Gallery, Hofstra University, Hempstead, N.Y., June–Aug., 1971.

Goldsmith, Benedict. *New Realism.* Brainerd Hall Art Gallery, State University College, Potsdam, N.Y., Nov. 5–Dec. 12, 1971.

Karp, Ivan C. Introduction to *Radical Realism.* Museum of Contemporary Art, Chicago, May 22–June 4, 1971.

Abadie, Daniel. Introduction to *Hyperréalistes américains.* Galerie des Quatre Mouvements, Paris, Oct. 25–Nov. 25, 1972.

Baratte, John J., and Thompson, Paul E. *Phases of the New Realism.* Lowe Art Museum, University of Miami, Coral Gables, Fla., Jan. 20–Feb. 20, 1972.

Janis, Sidney, Introduction to *Sharp Focus Realism.* Sidney Janis Gallery, New York, Jan. 6–Feb. 4, 1972.

Warrum, Richard L. Introduction to *Painting and Sculpture Today, 1972.* Indianapolis Museum of Art, Apr. 26–June 4, 1972.

Amaya, Mario. Introduction to *Realism Now.* New York Cultural Center, New York, Dec. 6, 1972–Jan. 7, 1973.

Dali, Salvador. Introduction to *Grands maîtres hyperréalistes américains.* Galerie des Quatre Mouvements, Paris, May 23–June 25, 1973.

Lamagna, Carlo. Foreword to *The Super Realist Vision.* DeCordova and Dana Museum, Lincoln, Mass., Oct. 7–Dec. 9, 1973.

Meisel, Louis K. *Photo-Realism 1973: The Stuart M. Speiser Collection.* New York, 1973.

Sims, Patterson. Introduction to *Realism Now.* Katonah Gallery, Katonah, N.Y., May 20–June 24, 1973.

Hyperréalisme. Galerie Isy Brachot, Brussels, Dec. 14, 1973–Feb. 9, 1974.

Amerikaans fotorealisme grafiek. Hedendaagse Kunst, Utrecht, Aug., 1974; Palais des Beaux-Arts, Brussels, Sept.–Oct., 1974.

Aspects of Realism. Moos Gallery, Toronto, Sept.–Oct., 1974.

Chase, Linda. "Photo-Realism." In *Tokyo Biennale 1974.* Tokyo Metropolitan Museum of Art; Kyoto Municipal Museum; Aichi Prefectural Art Museum, Nagoya, 1974.

Cowart, Jack. *New Photo-Realism.* Wadsworth Atheneum, Hartford, Conn., Apr. 10–May 19, 1974.

Goldsmith, Benedict. *New Realism Revisited.* Brainerd Hall Art Gallery, State University College, Potsdam, N.Y., 1974.

Shipley, James R., and Weller, Allen S. Introduction to *Contemporary American Paintings and Sculpture 1974.* Krannert Art Museum, University of Illinois, Champaign-Urbana, Mar. 10–Apr. 21, 1974.

Thirty-eighth Annual Midyear Show. Butler Institute of American Art, Youngstown, Ohio, June 30–Sept. 2, 1974.

Twenty-five Years of Janis: Part II from Pollack to Pop, Op and Sharp Focus Realism. Sidney Janis Gallery, New York, Mar. 13–Apr. 13, 1974.

Walthard, Dr. Frederic P. Foreword to *Art 5 '74.* Basel, Switzerland, June 19–24, 1974.

Warrum, Richard L. Introduction to *Painting and Sculpture Today, 1974.* Indianapolis Museum of Art, May 22–June 14, 1974; Taft Museum and Contemporary Arts Center, Cincinnati, Sept. 12–Oct. 26, 1974.

Meisel, Susan Pear. *Watercolors and Drawings—American Realists.* Louis K. Meisel Gallery, New York, Jan., 1975.

Felluss, Elias A. Foreword to *Washington International Art Fair.* Washington, D.C., 1976.

Gervais, Daniel. Introduction to *Troisième foire internationale d'art contemporain.* Paris, Oct. 16–24, 1976.

Chase, Linda. "U.S.A." In *Aspects of Realism.* Rothman's of Pall Mall Canada, Ltd., June, 1976–Jan., 1978.

Dempsey, Bruce. *New Realism.* Jacksonville Art Museum, Fla., 1977.

Felluss, Elias. Foreword to *Washington International Art Fair.* Washington, D.C., 1977.

Seabolt, Fred. Introduction to *New in the '70s.* Foreword by Donald Goodall. University Art Museum, Archer M. Huntington Gallery, University of Texas, Austin, Aug. 21–Sept. 25, 1977.

Stringer, John. Introduction to *Illusion and Reality.* Australian Gallery Directors' Council, North Sydney, N.S.W., 1977–78.

Adams, Lowell. Foreword to *Cityscape '78.* Oklahoma Art Center, Oklahoma City, Oct. 27–Nov. 29, 1978.

Henry, J. B., III. Introduction to *With a Little Help from Our Friends.*

Foreword by M. J. Czarniecki III. Mississippi Museum of Art, Jackson, Apr. 22–July 16, 1978.

Hodge, G. Stuart. Foreword to *Art and the Automobile.* Flint Institute of Arts, Mich., Jan. 12–Mar. 12, 1978.

Meisel, Susan Pear. Introduction to *The Complete Guide to Photo-Realist Printmaking.* Louis K. Meisel Gallery, New York, Dec., 1978.

Felluss, Elias A. Introduction to *Washington International Art Fair '79.* May 2–7, 1979.

Meisel, Louis K. Introduction to *Ron Kleemann.* Louis K. Meisel Gallery, New York, Apr. 28–May 26, 1979.

Streuber, Michael. Introduction to *Selections of Photo-Realist Paintings from N.Y.C. Galleries.* Southern Alleghenies Museum of Art, St. Francis College, Loretto, Pa., May 12–July 8, 1979.

ARTICLES

Karp, Ivan. "Rent Is the Only Reality, or the Hotel Instead of the Hymn," *Arts Magazine,* Dec., 1972, pp. 47–51.

Kramer, Hilton. "And Now, Pop Art: Phase II," *New York Times,* Jan. 16, 1972.

Lerman, Leo. "Sharp Focus Realism," *Mademoiselle,* Mar., 1972, pp. 170–73.

Lista, Giovanni. "Iperrealisti americani," *NAC* (Milan), no. 12 (Dec., 1972), pp. 24–25.

Pozzi, Lucio. "Super realisti U.S.A.," *Bolaffiarte,* no. 18 (Mar., 1972), pp. 54–63.

Ratcliff, Carter. "New York Letter," *Art International,* vol. XVI, no. 3 (Mar., 1972), pp. 28–29.

Rosenberg, Harold. "The Art World," *The New Yorker,* Feb. 5, 1972, pp. 88–93.

Wolmer, Denise. "In the Galleries," *Arts Magazine,* Mar., 1972, p. 57.

Art Now Gallery Guide, Sept., 1973, pp. 1–3.

Arts Magazine, Dec., 1973, p. 75.

Beardsall, Judy. "Stuart M. Speiser Photorealist Collection," *Art Gallery Magazine,* vol. XVII, no. 1 (Oct., 1973), pp. 5, 29–34.

Bell, Jane. "Stuart M. Speiser Collection," *Arts Magazine,* Dec., 1973, p. 57.

"L' Hyperréalisme américain," *Le Monde des Grandes Musiques,* no. 2 (Mar.–Apr., 1973), pp. 4, 56–57.

"Lettre de Suisse," *Art International/Lugano Review,* vol. XVII, no. 10 (Dec. 20, 1973), p. 46.

"Realism Now," *Patent Trader,* May 26, 1973, p. 7A.

Chase, Linda. "The Connotation of Denotation," *Arts Magazine,* Feb., 1974, pp. 38–41.

"Flowers, Planes and Landscapes in New Art Exhibits," *Saturday Times-Union* (Rochester, N.Y.), Jan. 5, 1974.

"Gallery Notes," *Memorial Art Gallery of the University of Rochester Bulletin,* vol. 39, no. 5 (Jan., 1974).

Hartman, Rose. "In and Around," *Soho Weekly News,* Apr. 4, 1974, p. 4.
———. "In and Around," *Soho Weekly News,* Apr. 18, 1974, p. 4.

"May 1974 Events," *Allentown* (Pa.) *Art Museum Bulletin,* May, 1974.

Ries, Martin. "Ron Kleemann," *Arts Magazine,* June, 1974, p. 65.

Walsh, Sally. "Paintings That Look Like Photos," *Rochester Democrat and Chronicle,* Jan. 17, 1974.

Zabel, Joe. "Realistic Works Predominate in 1974 Mid-Year," *Jambar* (Youngstown State University, Ohio), July 11, 1974, p. 7.

Mikotajuk, Andrea. "American Realists at Louis K. Meisel," *Arts Magazine,* Jan., 1975, pp. 19–20.

"Photo-Realism Exhibit Is Opening at Paine Sunday," *Oshkosh Daily Northwestern,* Apr. 17, 1975.

"Photo-Realism Flies High at Paine," *Milwaukee Journal,* May, 1975.

"Photo-Realists at Paine," *View Magazine,* Apr. 27, 1975.

Belden, Dorothy. "Realism Exaggerated in Ulrich Art Exhibition," *Wichita Eagle,* Mar., 1976, Life-style page.

Chase, Linda. "Photo-Realism: Post Modernist Illusionism," *Art International,* vol. XX, no. 3–4 (Mar.–Apr., 1976), pp. 14–27.

Glasser, Penelope. "Aspects of Realism at Stratford," *Art Magazine* (Toronto), vol. 7, no. 28 (Summer, 1976), pp. 22–29.

K. M. "Realism," *New Art Examiner,* Nov., 1976.

Reed College Bulletin, Jan., 1976.

"Soho," *British Broadcasting Company,* Fall, 1976.

Clay, Nancy. "Native Artist Has Big Plans for Bay City Rollers Painting," *Bay City (Mich.) Times,* Aug. 24, 1977, p. 9A.

Edelson, Elihu. "New Realism at Museum Arouses Mixed Feelings," *Jacksonville (Fla.) Journal,* Feb., 1977.

Garmel, Marion Simon. "More Real Than a Photo, Artist Says," *Indianapolis News,* May 14, 1977, p. 4.

———. "Sport Art—The Coming Thing," *Indianapolis News,* Apr. 30, 1977, p. 4.

Groom, Gloria. "Modern Art Exhibit Gives a Nice Surprise," *The Citizen (Austin, Tex.),* Aug., 1977.

Hughes, Jonathan. "World's Most Exclusive Club," *Indianapolis 500 Official 1977 Program,* May, 1977, pp. 21, 23–24.

"Kleemann Exhibit Opens at IMA Downtown Gallery," *Indianapolis Sunday Star,* May 1, 1977, p. 13.

Mannweiler, David. "Doesn't Look Like Indy," *Indianapolis News,* May 6, 1977, p. 25.

Markus, Robert. "Sport Art Enters Chicago Scene," *Chicago Tribune,* Oct. 20, 1977.

"Official 500 Artist Will Bring Exhibit to Downtown Gallery," *American Fletcherline,* vol. 6, no. 8 (Apr. 29, 1977), p. 1.

Oppenheimer, Dan. "Soho Portraits: the Indy 500," *Soho Weekly News,* vol. 4, no. 36 (June 9–15, 1977), p. 10.

"Prints Exhibition for D'port," *The Examiner (Australia),* Sept. 7, 1977.

"Ron Kleemann: Indy Artist," *Indianapolis 500 Official 1977 Program,* May, 1977, p. 39.

R. S. "The Museum of Modern Art," *Art in America,* Sept. 10, 1977, pp. 93–96.

Van Dyck, Dave. "Sports Art, the New Wave?," *Chicago Sun-Times,* Oct. 20, 1977.

"A. J. Foyt's Fourth Win—A Trackside Chronicle," *Indianapolis 500 Official 1978 Program,* May, 1978.

"Acquisitions," *1978 Annual Report,* The Solomon R. Guggenheim Museum, New York.

Bongard, Willie. *Art Aktuell* (Cologne), Apr., 1978.

Harris, Helen. "Art and Antiques: The New Realists," *Town and Country,* Oct., 1978, pp. 242, 244, 246–47.

Indianapolis 500 Official 1978 Program, May, 1978, cover illustration, pp. 28, 29, 55.

Jensen, Dean. "Super Realism Proves a Super Bore," *Milwaukee Sentinel,* Dec. 1, 1978.

"Photo Journalism and Photo Realism," *Milwaukee Journal,* Dec. 10, 1978.

"Ron Kleemann, Official 500 Artist," *Indianapolis 500 Official 1978 Program,* May, 1978, p. 72.

"SA Crowds See Fine Arts Exhibition," *Indianapolis News,* Jan. 9, 1978.

"Ron Kleemann Official 500 Artist," *Indianapolis 500 Official 1979 Program,* May, 1979, pp. 11, 119, cover.

BOOKS

Brachot, Isy, ed. *Hyperréalisme.* Brussels: Imprimeries F. Van Buggenhoudt, 1973.

Sager, Peter. *Neue Formen des Realismus.* Cologne: Verlag M. DuMont Schauberg, 1973.

Battcock, Gregory, ed. *Super Realism, A Critical Anthology.* New York: E. P. Dutton, 1975.

Chase, Linda. *Hyperréalisme.* New York: Rizzoli, 1975.

Kultermann, Udo. *Neue Formen des Bildes.* Tübingen, West Germany: Verlag Ernst Wasmuth, 1975.

Seeman, Helene Zucker, and Siegfried, Alanna. *SoHo.* New York: Neal-Schuman, 1979.

708. Richard McLean in his studio

RICHARD McLEAN

Richard McLean, known for his paintings of horses, is unique among the Photo-Realists in his choice of rural subject matter. Actually, the horses—like the more familiar pickup trucks, cars, motorcycles, and toys in the work of other artists—serve merely as the central image in the photographic composition, which is ultimately the subject of all Photo-Realist painting.

Growing up in the ranch country of the American Northwest, McLean spent much of his youth with the animals of his environment, in activities ranging from milking cows to participating in rodeos. In the late sixties, when McLean began using photographs in his work, he looked for a subject that interested him, not in his current urban surroundings, but back to the time of his youth. After having painted *IHLE Country* (pl.709) from a snapshot he had taken of a friend on a horse, McLean thought about the paucity of animal subjects in recent American art, and he staked out this specific subject matter as his artistic territory. McLean is still painting the horses he began with, but over the years he has also painted cows, donkeys, and, often, people.

After *IHLE,* McLean worked for a number of years from black-and-white photographs in horse magazines. The paintings executed from these photographs show standard images of people and horses posed with trophies and ribbons. They bear a close relationship to the commercial imagery of Pop Art—people in the "look-at-the-camera" pose, horses usually in full side shot and always in perfect show position.

Since 1973, when he was commissioned by Stuart M. Speiser to paint *Sacramento Glider* (pl. 734), McLean has been taking his own photographs. Despite occasional attempts to achieve shots like those in the magazines, most of his work since 1973 is more relaxed and personal, moving away from the obligatory images found in magazines for the horsey set. Recently, he has done a number of still-life watercolors of horse paraphernalia.

McLean's works are technical masterpieces that reveal no brushstrokes. His blending is probably the most accomplished among the Photo-Realist brush painters and

709. *IHLE Country.* 1967 (1).
Oil on canvas, 61 x 61".
Private collection

almost defies belief that he never uses the airbrush. His ability to paint light reflected from the coats of horses is brilliant, and his attention to detail superb. Compositionally, McLean is a classicist, utilizing a dominant central image in a total picture, with neither cropping nor off-center weighting.

Richard McLean has made the following statement about his work:

Although the present subject matter of my images is people and animals, I consider myself essentially a still-life painter inasmuch as the actual form-building process centers on an almost fetishistic concern for and a pleasure in the mechanics of resolving, among sets of objects (figurations), their "plastic relationships." Resolving those relationships is a nuts-and-bolts matter and, therefore, its problems and satisfactions are, by definition, the private experience of the guy holding the wrench. Every painter knows this, of course, as do builders of model ships. But in spite of its obviousness, the "crafting" of the image provides for me the consummate satisfaction of the whole enterprise...the very prospect of engaging it in each successive painting is essential to why I paint.

But the making of a painting is also preceded by a notion of how I want that image (the photograph) to operate as a painting—it determines the character and direction of the crafting process. How I want the image to act hasn't changed much in the last few years; I've only become more convinced of its personal necessity. It has to do with minimizing the photographic and associative references in the event depicted so as to allow it to assume a new "authenticity"—one that stands apart from both the photograph and "real life."

Of course, to some extent, the painting is fated, by the conditions of its inception, to recall photography and the life that is photographed. My aim is to bring about an image that transcends, in a sense, those two realities (while still maintaining their physiognomy) and establishes a uniquely separate, primary existence peculiar to and dependent upon the painting of it.

Richard McLean
September 29, 1973
Oakland, California

Richard McLean had executed 74 works in oil or watercolor through 1979. Of these, 68 are illustrated herein and the rest are listed.

336

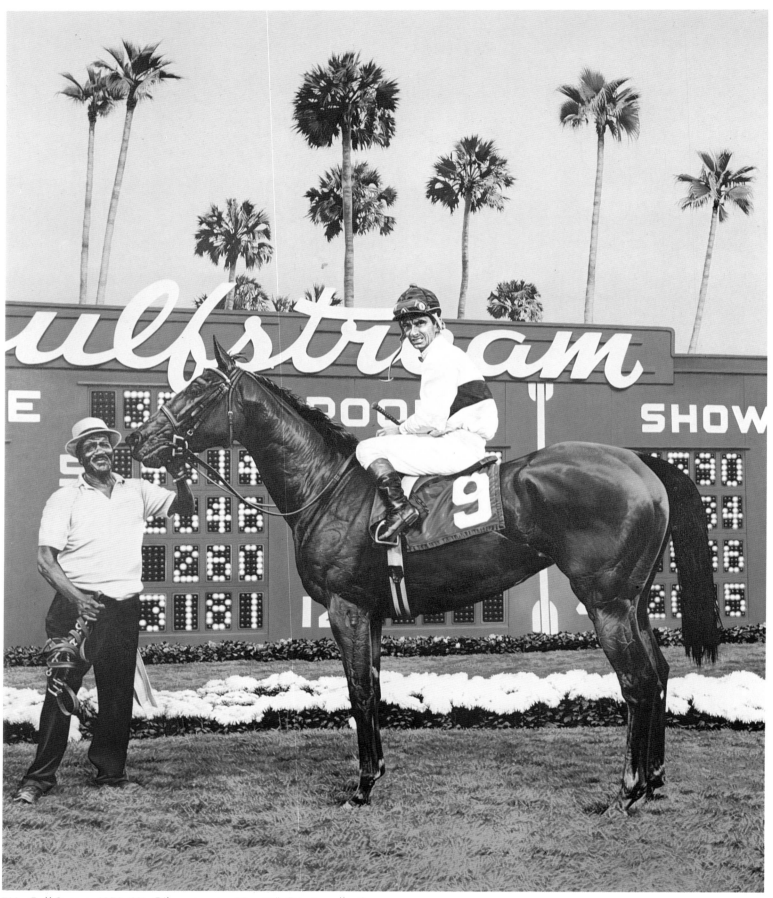

710. *Gulf Stream*. 1970 (13). Oil on canvas, 72 x 60". Private collection

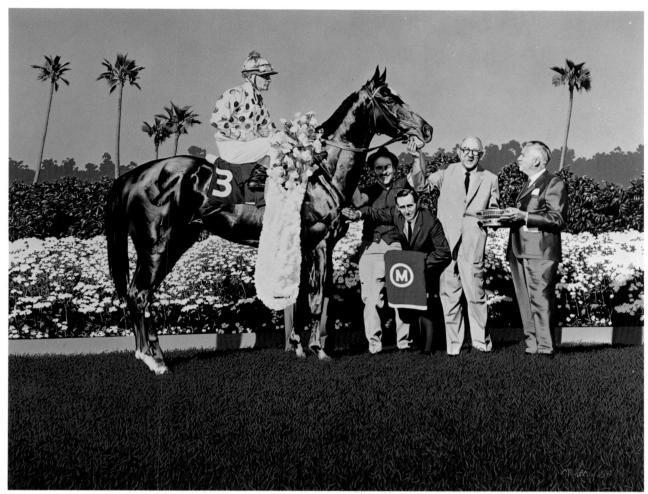

711. *Native Diver at Hollywood Park*. 1968 (6). Oil on canvas, 60 x 72". Collection Monroe Meyerson, New York

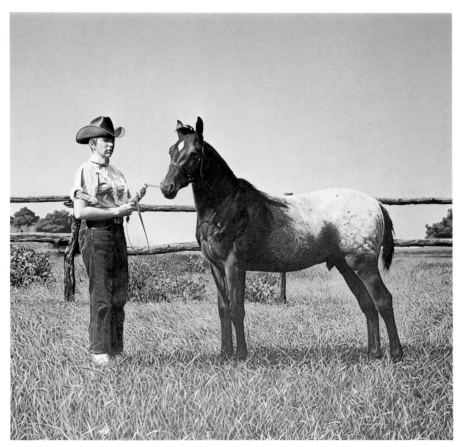

712. *Joker's Huckleberry*. 1970 (10). Oil on canvas, 60 x 60".
Private collection, Europe

713. *Synbad's Mt. Rainier.* 1968 (5).
Oil on canvas, 60 x 60".
Collection Beatrice C. Mayer, Ill.

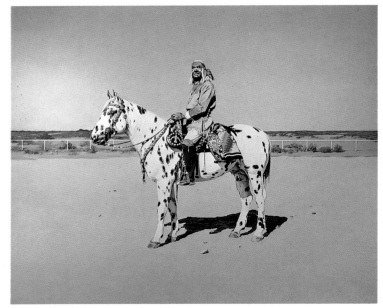

714. *Chubs Powderface.* 1969 (7).
Oil on canvas, 56 x 67½".
Private collection, New York

715. *Roy Huffaker and Jose Uno Win First Place.* 1970 (11).
Oil on canvas, 64 x 82".
Collection Richard Belger, Mo.

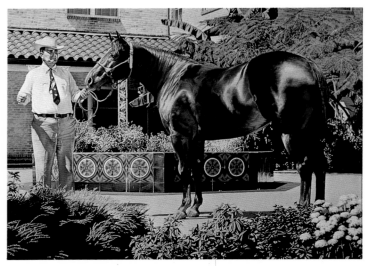

716. *Mackey Marie.* 1971 (14).
Oil on canvas, 56 x 71".
Collection Doris and Charles Saatchi, London

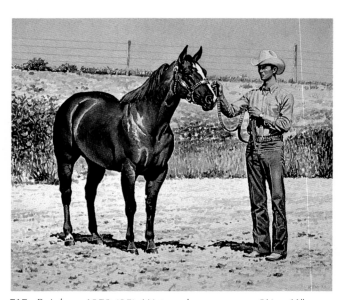

717. *Rainbug.* 1973 (25). Watercolor on paper, 9½ x 11".
Collection Louis and Susan Meisel, New York

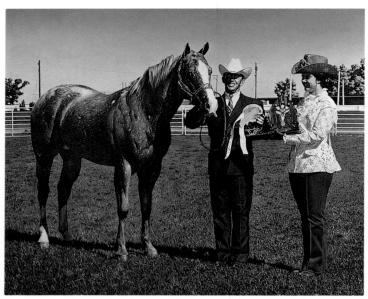

718. *Johnny Snowcap.* 1971 (17). Oil on canvas, 60¾ x 72¾".
Virginia Museum of Fine Arts, Richmond

719. *Rustler Charger.* 1971 (16). Oil on canvas, 66¾ x 66¼". Neue Galerie der Stadt Aachen. Ludwig Collection

720. *Albuquerque*. 1972 (21). Oil on canvas, 50 x 60". Private collection

721. *Mr. Fairsocks*. 1973 (22).
Watercolor, 10 x 10".
Private collection, Europe

722. *Mr. Fairsocks*. 1973 (30). Oil on canvas, 63 x 63".
Collection Paul and Camille Hoffman, Ill.

723. *Wishing Well Bridge*. 1972 (20).
Oil on canvas, 60 x 63".
Sydney and Frances Lewis Foundation, Va.

724. *Dewy Dude*. 1973 (23).
Oil on canvas, 8¼ x 10".
Oakland Museum, Calif.

725. *Dumas*. 1973 (24).
Watercolor on paper, 8¼ x 10".
Richard Brown Baker Collection, New York

726. *Persimmon Hill*. 1972 (19).
Oil on canvas, 60 x 60".
Collection Daniel Filipacchi, New York

727. *Lexington Winter*. 1970 (12).
Oil on canvas, 60 x 60".
Private collection, New York

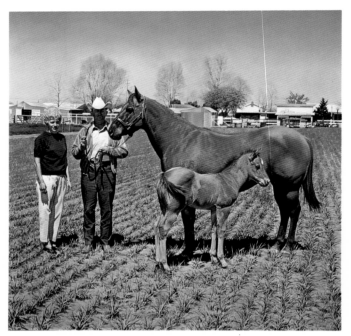

728. *Miss Paulo's 45.* 1972 (18). Oil on canvas, 60 x 60".
Collection Robert B. Hodes, New York

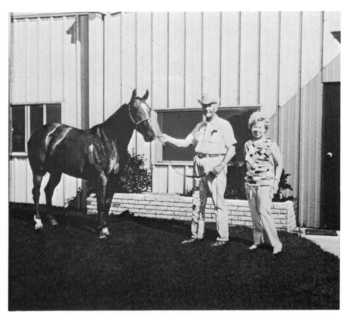

729. *Dializ.* 1971 (15). Oil on canvas, 60 x 60".
Collection Mr. and Mrs. Morton G. Neumann, Ill.

730. *Nearctic.* 1973 (26).
Watercolor on paper, 8½ x 11½".
Private collection, Europe

731. *Chapparosa.* 1973 (28).
Watercolor on paper, 10" tondo.
Collection the artist

732. *Foxy Mac.* 1973 (29).
Oil on canvas, 72 x 63".
Collection Carlo Bilotti, London

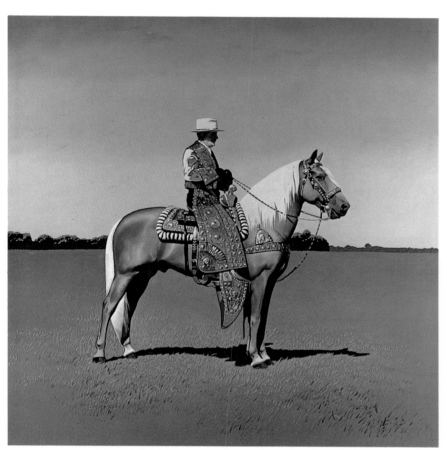

733. *Pasadena Fancy.* 1967 (2). Oil on canvas, 61 x 61". Private collection

734. *Sacramento Glider.* 1973 (31).
Oil on canvas, 54 x 66".
Stuart M. Speiser Collection,
Smithsonian Institution, Washington, D.C.

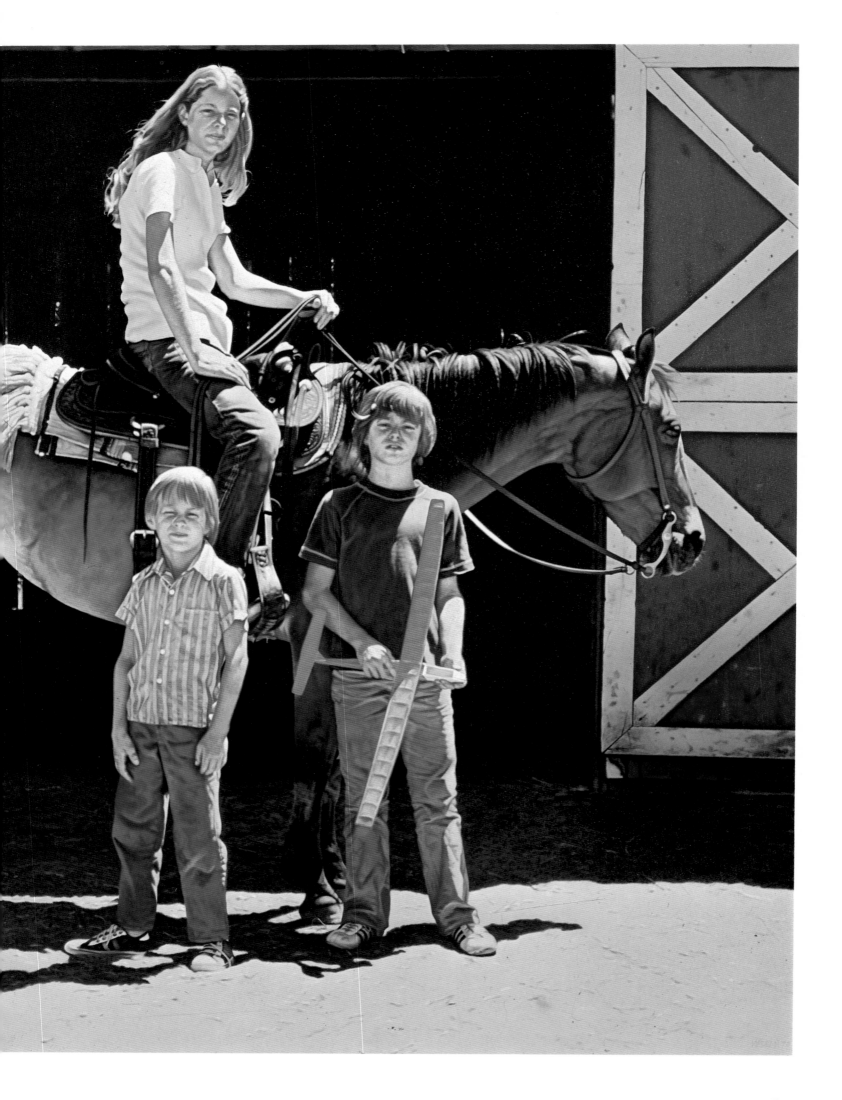

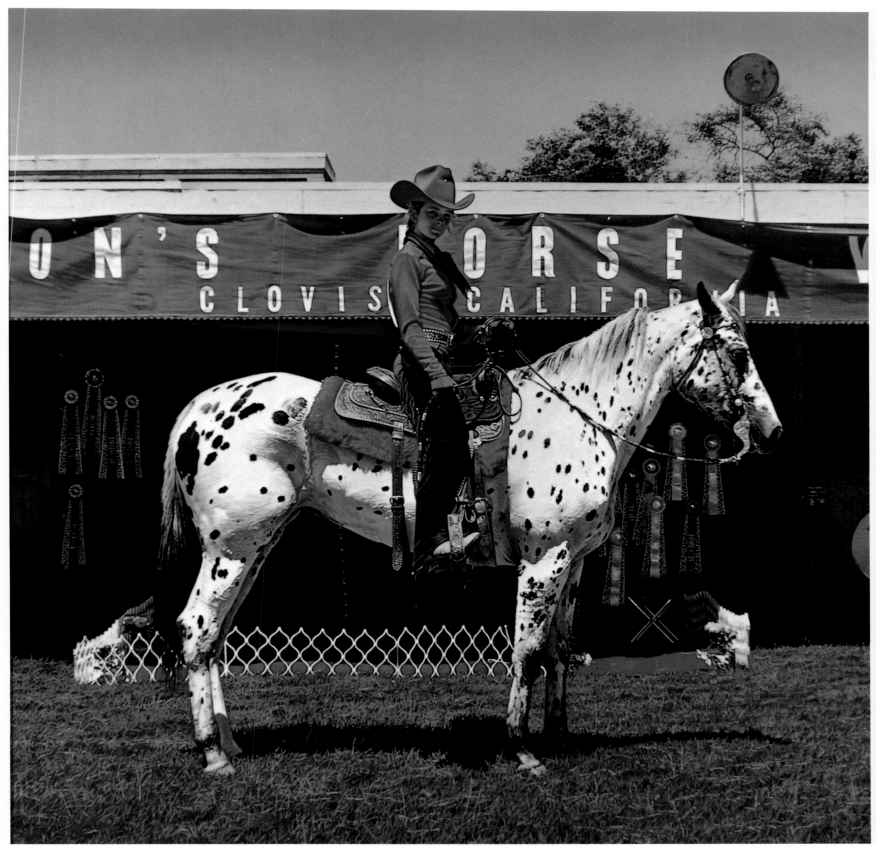

735. *Spring Doe*. 1975 (42). Oil on canvas, 60 x 60". Private collection, Calif.

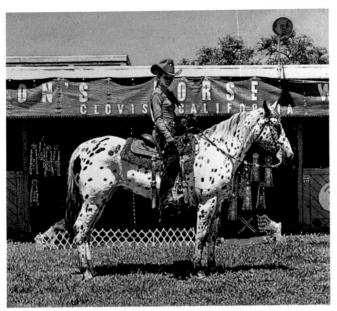

736. *Spring Doe*. 1974 (40). Watercolor, 9 x 9½".
Private collection, New York

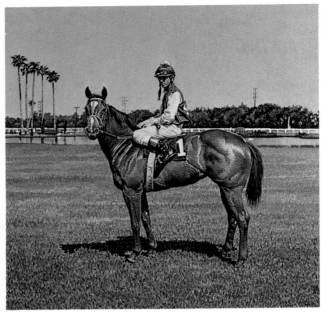

737. *Blue and White Start*. 1974 (39). Watercolor, 10 x 10".
Private collection, New York

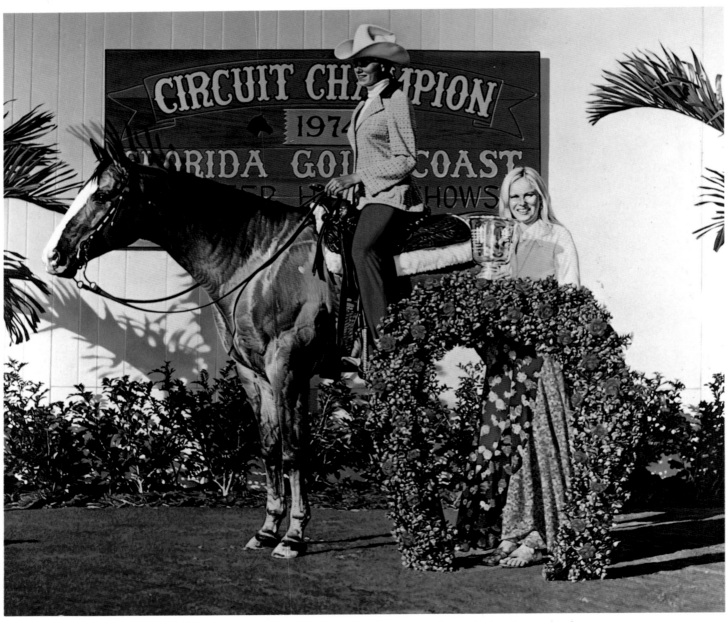

738. *Peppy Command*. 1975 (49). Oil on canvas, 52 x 60". Collection Irene and Marcus Kutter, Switzerland

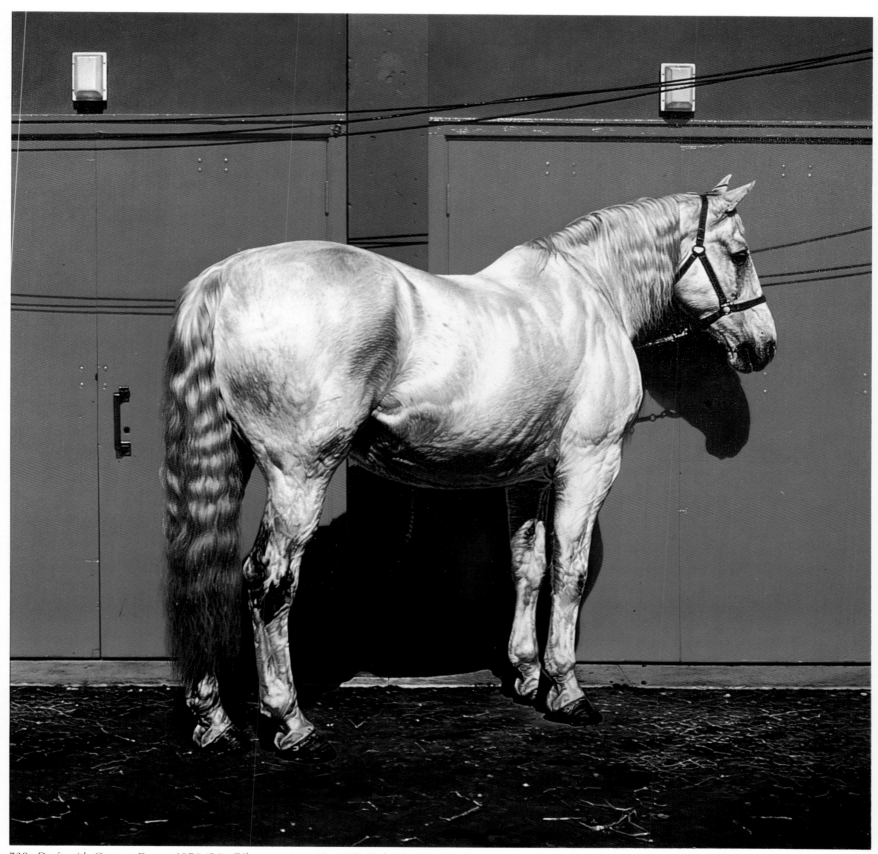

739. *Draft with Orange Doors.* 1976 (54). Oil on canvas, 48 x 48". Richard Brown Baker Collection, New York

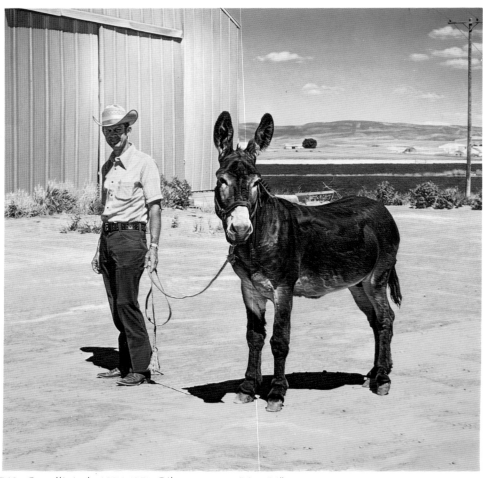

740. *Carroll's Jack.* 1974 (35). Oil on canvas, 54 x 54".
Museum Boymans—van Beuningen, Rotterdam

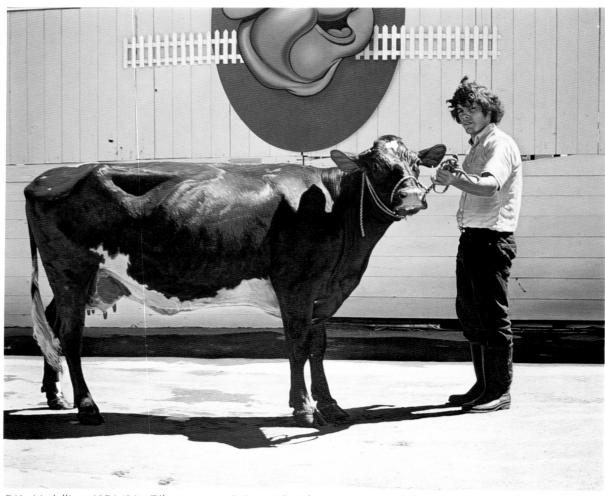

741. *Medallion.* 1974 (36). Oil on canvas, 54¼ x 66". Solomon R. Guggenheim Museum, New York.
Purchased with funds contributed by Mr. and Mrs. Barrie M. Damson

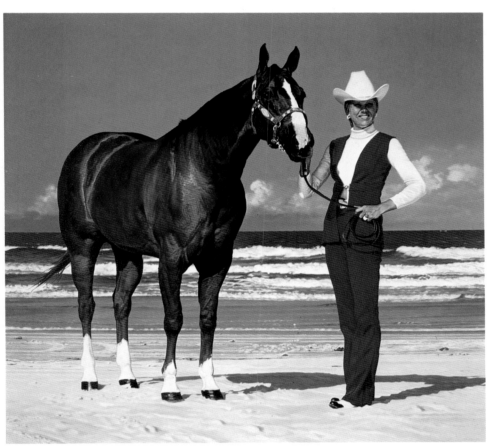

742. *Dixie Coast.* 1974 (41). Oil on canvas, 54 x 58".
Collection Mr. and Mrs. W. Jaeger, New York

743. *Diamond Tinker and Jet Chex.* 1976–77 (61).
Oil on canvas, 56 x 63".
Sydney and Frances Lewis Foundation, Va.

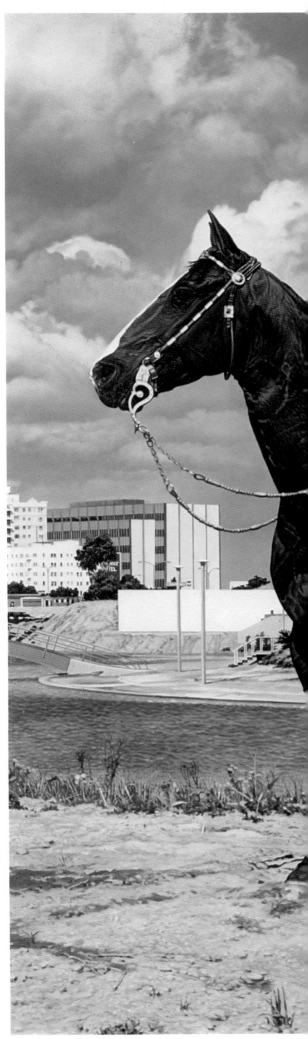

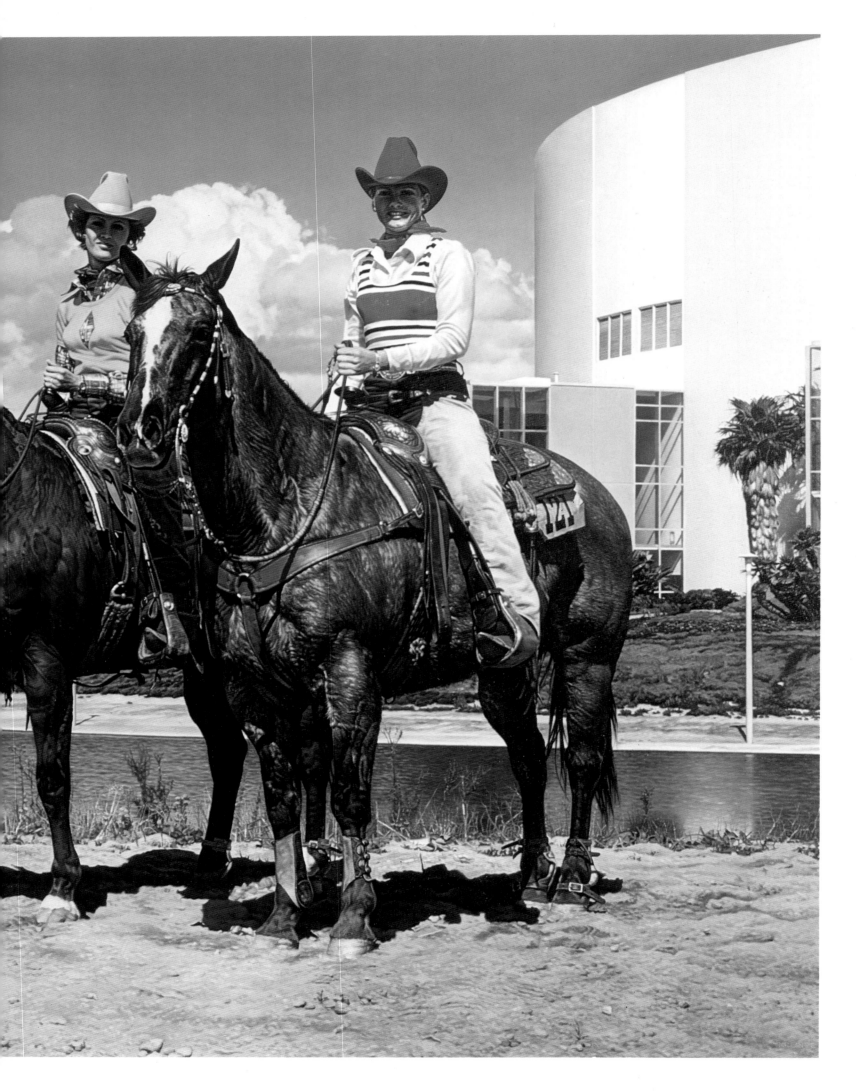

744. *Angus with Blue Butler.* 1974 (37). Watercolor, 8½ x 12¼".
Collection M. T. Cohen/S. J. Gallé, New York

745. *Opie's Raquel.* 1977 (65). Watercolor, 9½ x 11¾".
Collection Daniel Filipacchi, New York

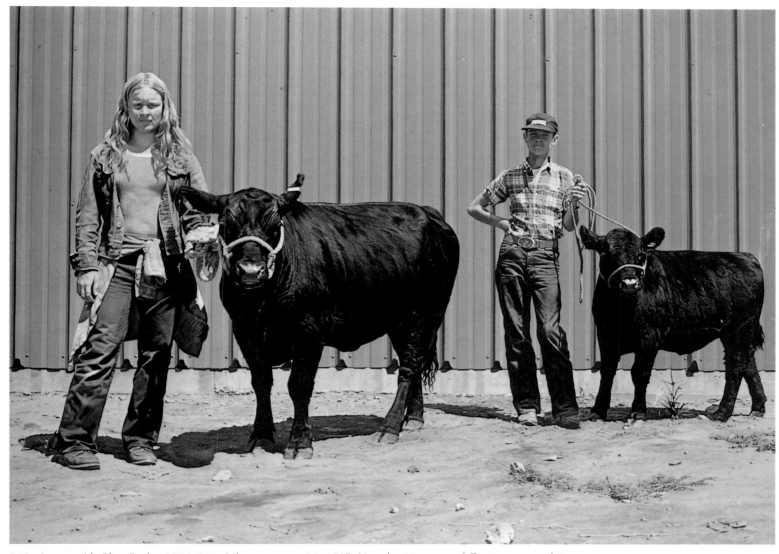

746. *Angus with Blue Butler.* 1974 (38). Oil on canvas, 54 x 78". Utrecht Museum of Contemporary Art

747. *Prim Style.* 1978 (66). Oil on canvas, 44 x 56". Private collection

748. *The Boilermaker.* 1977 (62). Oil on canvas, 56½ x 69". Private collection

749. *The Boilermaker*. 1976 (60). Watercolor, 10 x 12¼".
Collection Byron Meyer, Calif.

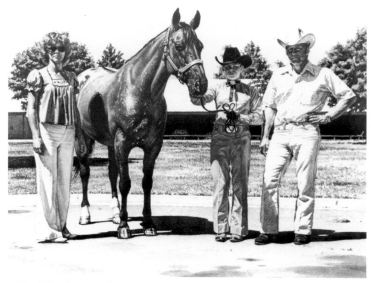

750. *Miss Comanche*. 1976 (55). Watercolor, 10 x 12½".
Collection Jean Paul Loup, Ill.

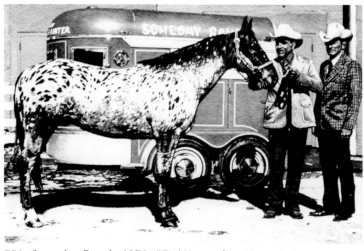

751. *Someday Ranch*. 1976 (57). Watercolor, 10 x 14½".
Collection Dr. and Mrs. Barry J. Paley, New York

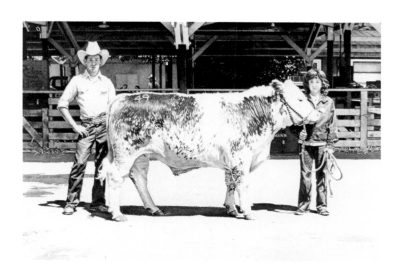

752. *Jim and Tina's 49*. 1973–74 (34). Watercolor, 8¼ x 12".
Collection the artist

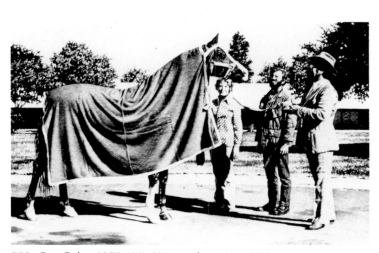

753. *Ben-Raba*. 1975 (46). Watercolor, 8¼ x 13½".
Collection Mr. and Mrs. W. Jaeger, New York

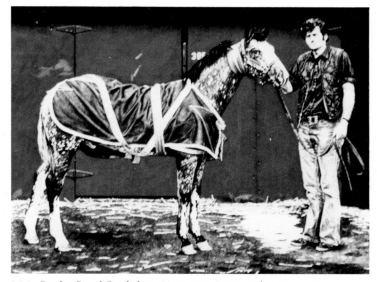

754. *Rocky Road Buckshot*. 1976 (52). Watercolor, 10 x 13".
Private collection, Europe

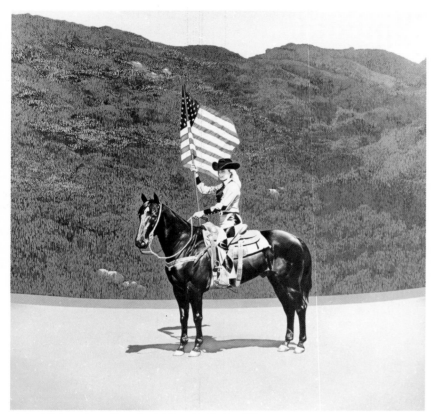

755. *All-American Standard Miss*. 1968 (3). Oil on canvas, 60 x 60".
Private collection, Calif.

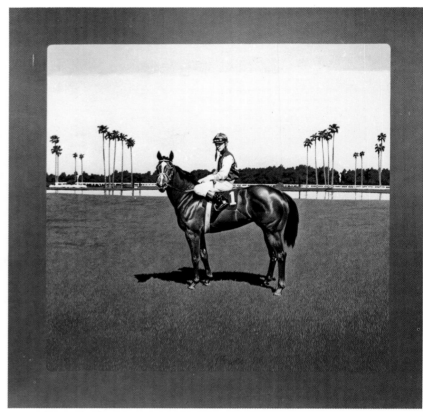

756. *Blue and White Start*. 1968 (4). Oil on canvas, 60 x 60".
Collection the artist

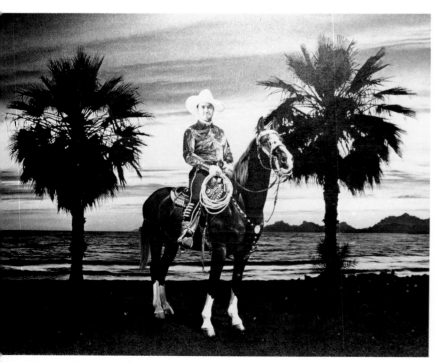

757. *Mexican Sunset with Straightshooter*. 1969 (9). Oil on canvas, 54½ x 68".
Collection Lewis Clapp, Mass.

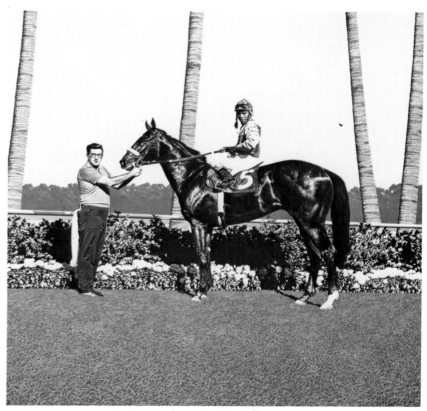

758. *Still Life with Black Jockey*. 1969 (8). Oil on canvas, 60 x 60".
Whitney Museum of American Art, New York

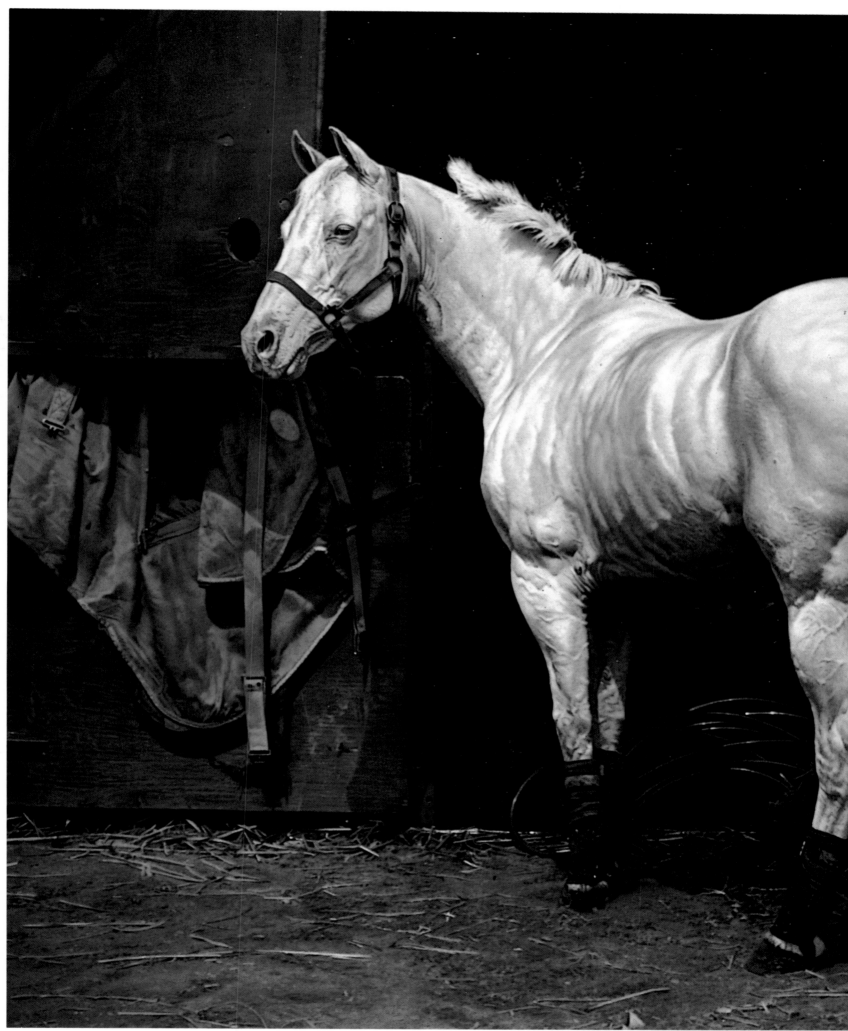

759. *Sheba*. 1978 (67). Oil on canvas, 50 x 61". Collection Mr. and Mrs. W. Jaeger, New York

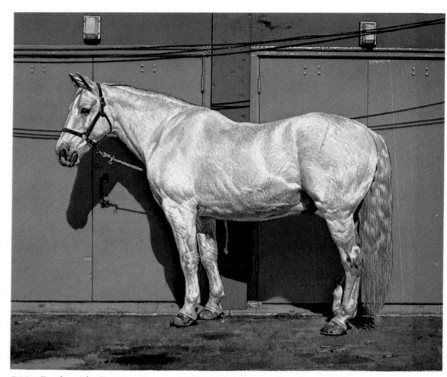

760. *Draft with Orange Doors.* 1975 (43). Watercolor, 9 x 10½".
Private collection, Denmark

761. *Powder River Green*. 1973–74 (33). Oil on canvas, 54 x 54". Private collection

762. *Mark's Poker Chip*. 1976 (51). Watercolor, 10½ x 11".
Private collection, Europe

763. *Washoe's Crown Prince*. 1975 (45). Watercolor, 10½ x 12".
Private collection, Colo.

764. *Davis Clinic*. 1973 (32). Watercolor, 9 x 11½".
Private collection, France

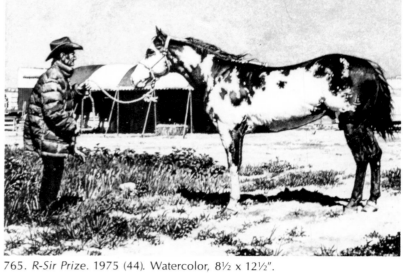

765. *R-Sir Prize*. 1975 (44). Watercolor, 8½ x 12½".
Collection Mr. and Mrs. Martin Schmukler, New York

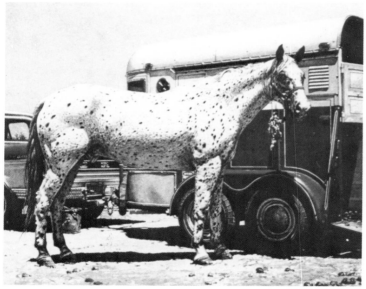

766. *Frosty Bar*. 1975 (50). Watercolor, 9½ x 11¾".
Private collection, Europe

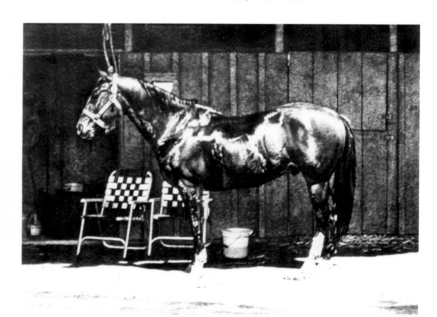

767. *Buzz Ballou*. 1976 (58). Watercolor, 10 x 14½".
Collection Frank Burgel, Iran

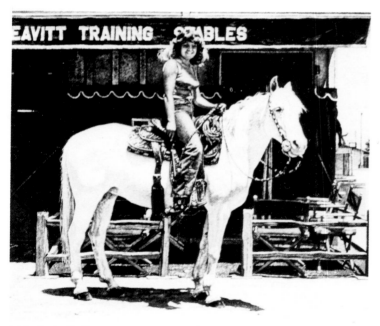

768. *Satin Doll*. 1975 (48). Watercolor, 9¾ x 11".
Private collection, New York

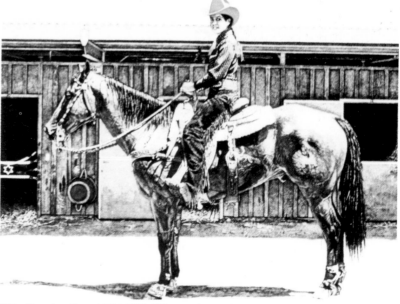

769. *Poncho Bert*. 1976 (53). Watercolor, 10¾ x 13".
Private collection, Europe

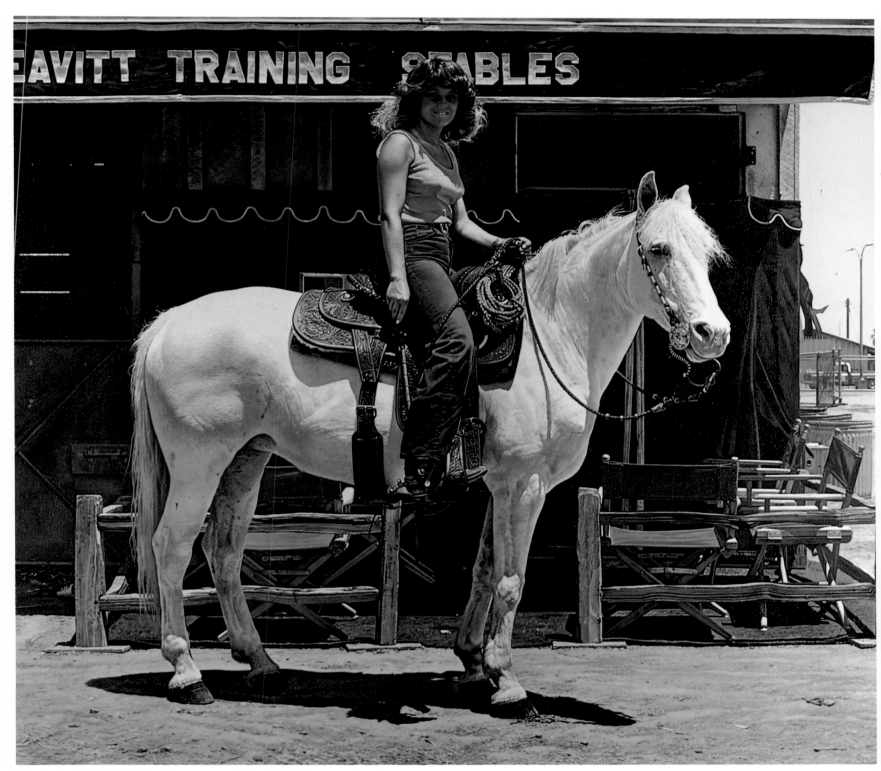

770. *Satin Doll*. 1978 (70). Oil on canvas, 54 x 60". Collection the artist

771. *Kahlua Lark.* 1979 (71). Oil on canvas, 44 x 54". Collection John and Lissa DeAndrea, Colo.

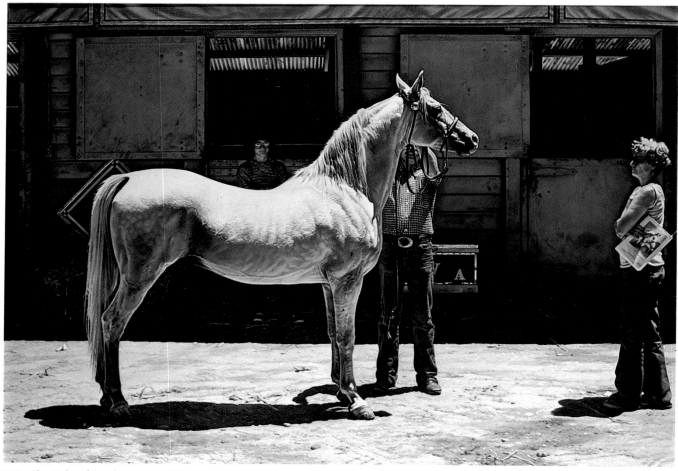

772. *The Sale of Werbor.* 1979 (72). Oil on canvas, 36 x 50". Collection R-L Canadien Fuel, Toronto

773. *Still Life with Prize Ribbons*. 1975 (47). Watercolor, 9 x 11". San Francisco Museum of Modern Art. William L. Gerstle Fund Purchase

774. *Still Life with Paradise*. 1976 (59). Watercolor, 11¼ x 9¼". Collection the artist

775. *Still Life with Pairs*. 1977 (63). Watercolor, 12 x 9⅜". Collection the artist

776. *Still Life with Prize Ribbons—Windward Stud*. 1976 (56). Watercolor, 11 x 11". Collection the artist

NOT ILLUSTRATED

Miss Paulo's 45. 1973 (27).
Watercolor, 9¼ x 10¼".
Private collection, New York

Sheba. 1977 (64).
Watercolor on paper, 10⅞ x 12⅛".
Collection Myra and Jim Morgan, Kans.

Rancho Del Mar. 1978 (68).
Watercolor on paper, 12½ x 9".
Private collection, New York

Mac. 1978 (69).
Watercolor on paper, 9¾ x 14".
Private collection, Belgium

Negam. 1979 (73).
Watercolor on paper, 12¼ x 14½".
Collection Mr. and Mrs. Jim Jacobs, New York

Spotted Gelding with Blue Trailer. 1979 (74).
Watercolor on paper, 12 x 15".
Capricorn Gallery, Md.

362

BIOGRAPHY

1934 Born: Hoquiam, Wash.

EDUCATION
1958 B.F.A., California College of Arts and Crafts, Oakland
1962 M.F.A., Mills College, Oakland, Calif.

TEACHING
1963 California State University, San Francisco
1963–65 California College of Arts and Crafts, Oakland

SOLO EXHIBITIONS
1957 Lucien Labaudt Gallery, San Francisco
1963 Richmond Art Center, Richmond, Calif.
1964 Berkeley Gallery, Berkeley, Calif.
1965 Valparaiso University, Valparaiso, Ind.
1966 Berkeley Gallery, San Francisco
1967 University of Omaha, Nebr.
1968 Berkeley Gallery, San Francisco
1971 O. K. Harris Gallery, New York
1973 O. K. Harris Gallery, New York
1975 O. K. Harris Gallery, New York
1976 Galerie de Gestlo, Hamburg
 John Berggruen Gallery, San Francisco
1978 O. K. Harris Gallery, New York

SELECTED GROUP EXHIBITIONS
1957 "California Sculptors Annual," Oakland Art Museum, Calif.
 "Northern California Painters Annual," Oakland Art Museum, Calif.
 San Francisco Art Festival
1960 "Watercolor/Graphics Annual," Richmond Art Center, Richmond, Calif.
1961 "San Francisco Art Annual," San Francisco Museum of Modern Art
1962 California State University, San Francisco
 Denver Museum of Art
 "San Francisco Art Annual," San Francisco Museum of Modern Art
1963 Berkeley Gallery, Berkeley, Calif.
 "Twelfth Annual Painting and Sculpture Exhibition," Richmond Art Center, Richmond, Calif.
1964 "Max 24," Purdue University, Lafayette, Ind.
 "Thirteenth Annual Painting and Sculpture Exhibition," Richmond Art Center, Richmond, Calif.
 "Winter Invitational," California Palace of the Legion of Honor, San Francisco
1965 Mills College, Oakland, Calif.
1966 "Kingsley Annual," Crocker Art Gallery, Sacramento, Calif.
1966–68 "East Bay Realists," San Francisco Art Institute, traveling exhibition
1967 "Eighty Contemporaries in the West," University of Arizona, Phoenix
 "Four Painters," California State University, Hayward
 "Thirtieth Anniversary Exhibition," Richmond Art Center, Richmond, Calif.
1969 Berkeley Gallery, Berkeley, Calif.
 "California Painters," Northern University of Illinois, De Kalb
 "A Decade of Accomplishment: American Drawings and Prints of the 1960s," Bell Telephone Company, Chicago
 Phyllis Kind Gallery, Chicago
 University of Nevada, Reno
 "Views of Sacramento," Artist's Contemporary Gallery, Sacramento, Calif.
1970 "Beyond the Actual—Contemporary California Realist Painting," Pioneer Museum and Haggin Galleries, Stockton, Calif.
 "The Cool Realists," Jack Glenn Gallery, Corona del Mar, Calif.
 "Directly Seen—New Realism in California," Newport Harbor Art Museum, Balboa, Calif.
 "Expo '70," Osaka, Japan
 "The Highway," Institute of Contemporary Art, University of Pennsylvania, Philadelphia; Institute for the Arts, Rice University, Houston; Akron Art Institute, Ohio
 "People Painters," University of California, Davis
 "Twenty-two Realists," Whitney Museum of American Art, New York
 "West Coast '70," E. B. Crocker Art Gallery, Sacramento, Calif.

1971 "Neue amerikanische Realisten," Galerie de Gestlo, Hamburg
 "New Realism," State University College, Potsdam, N.Y.
 "Prospect '71," Düsseldorf, West Germany
 "Radical Realism," Museum of Contemporary Art, Chicago
1972 "Art Around 1970," Neue Galerie der Stadt Aachen, West Germany
 "California Painting," Albright-Knox Art Gallery, Buffalo, N.Y.
 "California Representation: Eight Painters in Documenta 5," Santa Barbara Museum of Art, Calif.
 "Documenta and No-Documenta Realists," Galerie de Gestlo, Hamburg
 "Documenta 5," Kassel, West Germany
 "L'Hyperréalistes américains," Galerie des Quatre Mouvements, Paris
 "Phases of the New Realism," Lowe Art Museum, University of Miami, Coral Gables, Fla.
 "Realism Now," New York Cultural Center, New York
 "Sharp-Focus Realism," Sidney Janis Gallery, New York
 "The State of California Painting," Govett-Brewster Art Gallery, New Plymouth, New Zealand
 "Thirty-two Realists," Cleveland Institute of Art
1972–73 "Amerikanischer Fotorealismus," Württembergischer Kunstverein, Stuttgart; Frankfurter Kunstverein, Frankfurt; Kunst und Museumsverein, Wuppertal, West Germany
1973 "Amerikansk realism," Galleri Ostergren, Malmö, Sweden
 "Amerikanske realister," Randers Kunstmuseum, Randers, Denmark; Lunds Konsthall, Lund, Sweden
 "East Coast/West Coast/New Realism," California State University, San Jose
 "Ekstrem realisme," Louisiana Museum of Modern Art, Humlebaek, Denmark
 "The Emerging Real," Storm King Art Center, Mountainville, N.Y.
 "Hyperréalistes américains," Galerie Arditti, Paris
 "Image, Reality, and Superreality," Arts Council of Great Britain, traveling exhibition
 "Iperrealisti americani," Galleria La Medusa, Rome
 "Mit Kamera, Pinsel und Spritzpistole," Ruhrfestspiele Recklinghausen, Städtische Kunsthalle, Recklinghausen, West Germany
 "Options 73/30," Contemporary Arts Center, Cincinnati
 "Photo-Realism," Serpentine Gallery, London
 "Realism Now," Katonah Gallery, Katonah, N.Y.
 "Separate Realities," Los Angeles Municipal Art Center
 "The Super-Realist Vision," DeCordova and Dana Museum, Lincoln, Mass.
1973–74 "Hyperréalisme," Galerie Isy Brachot, Brussels
 "Kunst nach Wirklichkeit," Kunstverein Hannover, West Germany
1973–78 "Photo-Realism 1973: The Stuart M. Speiser Collection," traveling exhibition: Louis K. Meisel Gallery, New York; Herbert F. Johnson Museum of Art, Ithaca, N.Y.; Memorial Art Gallery of the University of Rochester, N.Y.; Addison Gallery of American Art, Andover, Mass.; Allentown Art Museum, Pa.; University of Colorado Museum, Boulder; University Art Museum, University of Texas, Austin; Witte Memorial Museum, San Antonio, Tex.; Gibbes Art Gallery, Charleston, S.C.; Brooks Memorial Art Gallery, Memphis, Tenn.; Krannert Art Museum, University of Illinois, Champaign-Urbana; Helen Foresman Spencer Museum of Art, University of Kansas, Lawrence; Paine Art Center and Arboretum, Oshkosh, Wis.; Edwin A. Ulrich Museum, Wichita State University, Kans.; Tampa Bay Art Center, Tampa, Fla.; Rice University, Sewall Art Gallery, Houston; Tulane University Art Gallery, New Orleans; Smithsonian Institution, Washington, D.C.
1974 "Amerikaans fotorealisme grafiek," Hedendaagse Kunst, Utrecht; Palais des Beaux-Arts, Brussels
 "Ars '74 Ateneum," Fine Arts Academy of Finland, Helsinki
 "Art 5 '74," Basel, Switzerland
 "Aspects of the Figure," Cleveland Museum of Art
 "California Climate," Root Art Center, Hamilton College, Clinton, N.Y.
 "Contemporary American Paintings from the Lewis Collection," Delaware Art Museum, Wilmington
 "The Horse in Art," Santa Barbara Museum of Art, Calif.
 "Hyperréalistes américains—réalistes européens," Centre National d'Art Contemporain, Paris

"Kijken naar de werkelijkheid," Museum Boymans–van Beuningen, Rotterdam
"Living American Artists and the Figure," Pennsylvania State University, University Park
"New Photo-Realism," Wadsworth Atheneum, Hartford, Conn.
"Projekt '74" Wallraf-Richartz Museum, Cologne
"Tokyo Biennale, '74," Tokyo Metropolitan Museum of Art; Kyoto Municipal Museum; Aichi Prefectural Art Museum, Nagoya
1975 "American Realism," Reed College, Portland, Oreg.
"The New Realism: Rip-Off or Reality?," Edwin A. Ulrich Museum of Art, Wichita State University, Kans.
O. K. Harris Gallery, New York
"Realismus und Realität," Kuntshalle, Darmstadt, West Germany
"Realist Painting in California," John Berggruen Gallery, San Francisco
"Super Realism," Baltimore Museum of Art
"Watercolors and Drawings—American Realists," Louis K. Meisel Gallery, New York
1975–76 "Photo-Realism, American Painting and Prints," New Zealand traveling exhibition: Barrington Gallery, Auckland; Robert McDougall Art Gallery, Christchurch; Academy of Fine Arts, National Art Gallery, Wellington; Dunedin Public Art Gallery, Dunedin; Govett-Brewster Art Gallery, New Plymouth; Waikato Art Museum, Hamilton
1976 "Amerikanske realister," Galerie Arnesen, Copenhagen
"Art 7 '76," Basel, Switzerland
"Contemporary Images in Watercolor," Akron Art Institute, Ohio; Indianapolis Museum of Art; Memorial Art Gallery of the University of Rochester, N.Y.
"Painting and Sculpture in California: The Modern Era," San Francisco Museum of Modern Art; Smithsonian Institution, Washington, D.C.
"Photo-Realist Watercolors," Neuberger Museum, State University College, Purchase, N.Y.
"Troisième foire internationale d'art contemporain," Grand Palais, Paris
"Works on Paper," Galerie de Gestlo, Hamburg
1976–78 "Aspects of Realism," traveling exhibition sponsored by Rothman's of Pall Mall Canada, Ltd.: Stratford, Ont.; Centennial Museum, Vancouver, B.C.; Glenbow-Alberta Institute, Calgary, Alta.; Mendel Art Gallery, Saskatoon, Sask.; Winnipeg Art Gallery, Man.; Edmonton Art Gallery, Alta.; Art Gallery, Memorial University of Newfoundland, St. John's; Confederation Art Gallery and Museum, Charlottetown, P.E.I.; Musée d'Art Contemporain, Montreal, Que.; Dalhousie University Museum and Gallery, Halifax, N.S.; Windsor Art Gallery, Ont.; London Public Library and Art Museum and McIntosh Memorial Art Gallery, University of Western Ontario; Art Gallery of Hamilton, Ont.

1977 "American Drawings 1927–1977," Minnesota Museum of Art, St. Paul
"American Paintings and Drawings," John Berggruen Gallery, San Francisco
"A Comparative Study of Nineteenth Century California Paintings and Contemporary California Realism," California State University, Chico
"Masters of Watercolor," O. K. Harris Gallery, New York
"New Realism: Modern Art Form," Boise Gallery of Art, Idaho
"Thirty Years of American Art, 1945–1975, Selections from the Permanent Collection," Whitney Museum of American Art, New York
"Works on Paper II," Louis K. Meisel Gallery, New York
1977–78 "Illusion and Reality," Australian touring exhibition: Australian National Gallery, Canberra; Western Australian Art Gallery, Perth; Queensland Art Gallery, Brisbane; Art Gallery of New South Wales, Sydney; Art Gallery of South Australia, Adelaide; National Gallery of Victoria, Melbourne; Tasmanian Museum and Art Gallery, Hobart
1978 Albert Contreras Gallery, Los Angeles
"Berggruen at Art Center," Art Center, College of Design, Pasadena, Calif.
Monmouth Museum, Lincroft, N.J.
"Photo-Realist Printmaking," Louis K. Meisel Gallery. New York
Tolarno Galleries, Melbourne, Australia
1978–79 "American Drawing," Minnesota Museum of Art, St. Paul
1979 "America in the 70s As Depicted by Artists in the Richard Brown Baker Collection," Meadowbrook Art Gallery, Oakland University, Rochester, Mich.
1979–80 "Reflections of Realism," Museum of Albuquerque

SELECTED BIBLIOGRAPHY

CATALOGUES

Shipley, James R., and Weller, Allen S. Introduction to *Contemporary American Painting and Sculpture 1969*. Krannert Art Museum, University of Illinois, Champaign-Urbana, Mar. 2–Apr. 6, 1969.

Brewer, Donald. Introduction to *Beyond the Actual—Contemporary California Realist Painting*. Pioneer Museum and Haggin Galleries, Stockton, Calif., Nov. 6–Dec. 6, 1970.

Directly Seen—New Realism in California. Newport Harbor Art Museum, Balboa, Calif., 1970.

Monte, James. Introduction to *Twenty-two Realists*. Whitney Museum of American Art, New York, Feb. 1970.

West Coast 1970: Crocker Biennial. E. B. Crocker Gallery, Sacramento, Calif., 1970.

Brown, Denise Scott, and Venturi, Robert. Introduction to *The Highway*. Institute of Contemporary Art, University of Pennsylvania, Philadelphia, Jan. 14–Feb. 25, 1970; Institute for the Arts, Rice University, Houston, Mar. 12–May 18, 1970; Akron Art Institute, Ohio, June 5–July 16, 1970.

Fischer, Konrad; Harten, Jurgen; and Strelow, Hans. "Projection." In *Prospect '71*. Städtische Kunsthalle, Düsseldorf, West Germany, 1971.

Goldsmith, Benedict. *New Realism*. Brainerd Hall Art Gallery, State University College, Potsdam, N.Y., Nov. 5–Dec. 12, 1971.

Internationale Kunst U. Informationsmesse. Belgisches Haus Volkshochschule, Cologne, Oct. 5–10, 1971.

Karp, Ivan C. Introduction to *Radical Realism*. Museum of Contemporary Art, Chicago, May 22–June 4, 1971.

Abadie, Daniel. Introduction to *Hyperréalistes américains*. Galerie des Quatre Mouvements, Paris, Oct. 25–Nov. 25, 1972.

Amman, Jean Christophe. Introduction to *Documenta 5*. Neue Galerie and Museum Fridericianum, Kassel, West Germany, June 30–Oct. 8, 1972.

Art Around 1970. Neue Galerie der Stadt Aachen, West Germany, 1972.

Baratte, John J., and Thompson, Paul E. *Phases of the New Realism*. Lowe Art Museum, University of Miami, Coral Gables, Fla., Jan. 20–Feb. 20, 1972.

Janis, Sidney. Introduction to *Sharp-Focus Realism*. Sidney Janis Gallery, New York, Jan. 6–Feb. 4, 1972.

Walls, Michael. *California Republic*. Foreword by Robert Ballard. Govett-Brewster Art Gallery, New Plymouth, New Zealand, 1972.

Amaya, Mario. Introduction to *Realism Now*. New York Cultural Center, New York, Dec. 6, 1972–Jan. 7, 1973.

Schneede, Uwe, and Hoffman, Heinz. Introduction to *Amerikanischer Fotorealismus*. Württembergischer Kunstverein, Stuttgart, Nov. 16–Dec. 26, 1972; Frankfurter Kunstverein, Frankfurt, Jan. 6–Feb. 18, 1973; Kunst und Museumsverein, Wuppertal, West Germany, Feb. 25–Apr. 8, 1973.

Alloway, Lawrence. Introduction to *Amerikansk realism*. Galleri Ostergren, Malmö, Sweden, Sept. 8–Oct. 14, 1973.

———. Introduction to *Photo-Realism*. Serpentine Gallery, London, Apr. 4–May 6, 1973.

Becker, Wolfgang. Introduction to *Mit Kamera, Pinsel und Spritzpistole*. Ruhrfestspiele Recklinghausen, Städtische Kunsthalle, Recklinghausen, West Germany, May 4–June 17, 1973.

Boulton, Jack. Introduction to *Options 73/30*. Contemporary Arts Center, Cincinnati, Sept. 25–Nov. 11, 1973.

C. A. B. S. Introduction to *Realisti iperrealisti*. Galleria La Medusa, Rome,

364

Nov. 12, 1973.

Dali, Salvador. Introduction to *Grands maîtres hyperréalistes américains.* Galerie des Quatre Mouvements, Paris, May 23–June 25, 1973.

Dreiband, Laurence. Notes to *Separate Realities.* Foreword by Curt Opliger. Los Angeles Municipal Art Gallery, Sept. 19–Oct. 21, 1973.

Ekstrem realisme. Louisiana Museum of Modern Art, Humlebaek, Denmark, 1973.

Hogan, Carroll Edwards. Introduction to *Hyperréalistes américains.* Galerie Arditti. Paris. Oct. 16–Nov. 30, 1973.

Iperrealisti americani. Galleria La Medusa, Rome, Jan. 2, 1973.

Lamagna, Carlo. Foreword to *The Super-Realist Vision.* DeCordova and Dana Museum, Lincoln, Mass., Oct. 7–Dec. 9, 1973.

Lucie-Smith, Edward. Introduction to *Image, Reality, and Superreality.* Arts Council of Great Britain, traveling exhibition, 1973.

Meisel, Louis K. *Photo-Realism 1973: The Stuart M. Speiser Collection.* New York, 1973.

Radde, Bruce. Introduction to *East Coast/West Coast/New Realism.* University Art Gallery, California State University, San Jose, Apr. 24–May 18, 1973.

Sims, Patterson. Introduction to *Realism Now.* Katonah Gallery, Katonah, N.Y., May 20–June 24, 1973.

Becker, Wolfgang. Introduction to *Kunst nach Wirklichkeit.* Kunstverein Hannover, West Germany, Dec. 9, 1973–Jan. 27, 1974.

Hyperréalisme. Galerie Isy Brachot, Brussels, Dec. 14, 1973–Feb. 9, 1974.

Amerikaans fotorealisme grafiek. Hedendaagse Kunst, Utrecht, Aug., 1974; Palais des Beaux-Arts, Brussels, Sept.–Oct., 1974.

Chase, Linda. "Photo-Realism." In *Tokyo Biennale 1974.* Tokyo Metropolitan Museum of Art; Kyoto Municipal Museum; Aichi Prefectural Art Museum, Nagoya, 1974.

Clair, Jean; Abadie, Daniel; Becker, Wolfgang; and Restany, Pierre. Introductions to *Hyperréalistes américains—réalistes européens.* Centre National d'Art Contemporain, Paris, Archives 11/12, Feb. 15–Mar. 31, 1974.

Cowart, Jack. *New Photo-Realism.* Wadsworth Atheneum, Hartford, Conn., Apr. 10–May 19, 1974.

Davis, William. *Living American Artists and the Figure.* Foreword by William Hull. Pennsylvania State University, University Park, Nov. 2–Dec. 22, 1974.

Henning, Edward B. Introduction to *Aspects of the Figure.* Cleveland Museum of Art, July 10–Sept. 1, 1974.

Kijken naar de werkelijkheid. Museum Boymans–van Beuningen, Rotterdam, June 1–Aug. 18, 1974.

Ronte, Dieter. Introduction to *Kunst bleibt Kunst.* Projekt '74, Wallraf-Richartz Museum, Cologne, 1974.

Sarajas-Korte, Salme. Introduction to *Ars '74 Ateneum.* Fine Arts Academy of Finland, Helsinki, Feb. 15–Mar. 31, 1974.

Walthard, Dr. Frederic P. Foreword to *Art 5 '74.* Basel, Switzerland, June 19–24, 1974.

Wyrick, Charles, Jr. Introduction to *Contemporary American Paintings from the Lewis Collection.* Delaware Art Museum, Wilmington, Sept. 13–Oct. 17, 1974.

Krimmel, Bernd. *Introduction to Realismus und Realität.* Foreword by H. W. Sabais. Kunsthalle, Darmstadt, West Germany, May 24–July 6, 1975.

Meisel, Susan Pear. *Watercolors and Drawings—American Realists.* Louis K. Meisel Gallery, New York, Jan., 1975.

Richardson, Brenda. Introduction to *Super Realism.* Baltimore Museum of Art, Nov. 18, 1975–Jan. 11, 1976.

Doty, Robert. *Contemporary Images in Watercolor.* Akron Art Institute, Ohio, Mar. 14–Apr. 25, 1976; Indianapolis Museum of Art, June 29–Aug. 8, 1976; Memorial Art Gallery of the University of Rochester, N.Y., Oct. 1–Nov. 11, 1976.

Gervais, Daniel. Introduction to *Troisième foire internationale d'art contemporain.* Paris, Oct. 16–24, 1976.

Walthard, Dr. Frederic P. Introduction to *Art 7 '76.* Basel, Switzerland, June 16–21, 1976.

Chase, Linda. "U.S.A." In *Aspects of Realism.* Rothman's of Pall Mall Canada, Ltd., June, 1976–Jan., 1978.

Cummings, Paul. Introduction to *American Drawings, 1927–1977.* Minnesota Museum of Art, St. Paul, Sept. 6–Oct. 29, 1977.

Karp, Ivan. Introduction to *New Realism: Modern Art Form.* Boise Gallery of Art, Idaho, Apr. 14–May 29, 1977.

Stringer, John. Introduction to *Illusion and Reality.* Australian Gallery Directors' Council, North Sydney, N.S.W., 1977–78.

Meisel, Susan Pear. Introduction to *The Complete Guide to Photo-Realist Printmaking.* Louis K. Meisel Gallery, New York, Dec., 1978.

Stokes, Charlotte. "As Artists See It: America in the 70s." In *America in the 70s As Depicted by Artists in the Richard Brown Baker Collection,*

Meadowbrook Art Gallery, Oakland University, Rochester, Mich., Nov. 18–Dec. 16, 1979.

Landis, Ellen. Introduction to *Reflections of Realism.* Museum of Albuquerque, Sept. 1, 1979–Jan. 30, 1980.

ARTICLES

Breckenridge, Betty. "Reviews: San Francisco," *Artforum,* Feb., 1963, p. 45.

Magloff, Joanna. "Art News from San Francisco," *ARTnews,* Apr., 1964, p. 20.

Ventura, Anita. "Pop, Photo and Paint," *Arts Magazine,* Apr., 1964, pp. 50–54.

D. H. "College Exhibit: Persistent Image," *Fresno Bee,* July 27, 1969.

Nilson, Karl Gustav. "Realism U.S.A.," *Konstrevy* (Stockholm), no. 2 (Nov. 2, 1969), pp. 68–71.

Davis, Douglas. "Return of the Real: Twenty-two Realists on View at New York's Whitney," *Newsweek,* Feb. 23, 1970, p. 105.

Lord, Barry. "The Eleven O'Clock News in Color," *Arts/Canada,* June, 1970.

Ratcliff, Carter. "Twenty-two Realists Exhibit at the Whitney," *Art International,* Apr., 1970, p. 105.

Battcock, Gregory. "Reviews," *Art and Artists,* Sept., 1971, p. 63.

Domingo, Willis. "Reviews," *Arts Magazine,* May, 1971, p. 55.

Genauer, Emily. "Art '72: The Picture Is Brighter," *New York Post,* Dec. 31, 1971.

Marandel, J. Patrice. "The Deductive Image: Notes on Some Figurative Painters," *Art International,* Sept., 1971, pp. 58–61.

Sager, Peter. "Neue Formen des Realismus," *Magazin Kunst,* 4th Quarter, 1971, pp. 2512–16.

Borden, Lizzie. "Cosmologies," *Artforum,* Oct., 1972, pp. 45–50.

Borsick, Helen. "Realism to the Fore," *Cleveland Plain Dealer,* Oct. 8, 1972.

Chase, Linda; Foote, Nancy; and McBurnett, Ted. "The Photo-Realists: 12 Interviews," *Art in America,* vol. 60, no. 6 (Nov.–Dec., 1972), pp. 73–89.

Hickey, David. "Sharp Focus Realism," *Art in America,* Mar.–Apr., 1972, pp. 116–18.

Hughes, Robert. "The Realist as Corn God," *Time,* Jan. 31, 1972, pp. 50–55.

"L'Hyperréalisme ou le retour aux origines," *Argus de la Presse,* Oct. 16, 1972.

"Hyperréalistes américains," *Argus de la Presse,* Nov. 16, 1972.

Karp, Ivan. "Rent Is the Only Reality, or the Hotel Instead of the Hymn," *Arts Magazine,* Dec., 1972, pp. 47–51.

Kirkwood, Marie. "Art Institute's Exhibit Represents the Revolt Against Abstraction," *Ohio Sun Press,* Oct. 12, 1972.

Kramer, Hilton. "And Now, Pop Art: Phase II," *New York Times,* Jan. 16, 1972.

Kurtz, Bruce. "Documenta 5: A Critical Preview," *Arts Magazine,* Summer, 1972, pp. 34–41.

Lerman, Leo. "Sharp-Focus Realism," *Mademoiselle,* Mar., 1972, pp. 170–73.

Lista, Giovanni. "Iperrealisti americani," *NAC* (Milan), no. 12 (Dec., 1972), pp. 24–25.

Muller, W. K. "Prints and Multiples," *Arts Magazine,* Apr., 1972, p. 28.

Nemser, Cindy. "New Realism," *Arts Magazine,* Nov., 1972, p. 85.

"La nouvelle coqueluche: L'hyperréalisme," *L'Express,* Oct. 30, 1972.

Pozzi, Lucio. "Super realisti U.S.A.," *Bolaffiarte,* no. 18 (Mar., 1972), pp. 54–63.

Rosenberg, Harold. "The Art World," *The New Yorker,* Feb. 5, 1972, pp. 88–93.

Seitz, William C. "The Real and the Artificial: Painting of the New Environment," *Art in America,* Nov.–Dec., 1972, pp. 58–72.

Wolmer, Denise. "In the Galleries," *Arts Magazine,* Mar., 1972, p. 57.

Allen, Barbara. "In and Around," *Interview Magazine,* Nov., 1973, p. 36.

Apuleo, Vito. "Tra manifesto e illustrazione sino al rifiuto della scelta," *La Voce Repubblicana,* Feb. 24, 1973, p. 5.

Art Now Gallery Guide, Sept., 1973, pp. 1–3.

Becker, Wolfgang. "NY? Realisme?," *Louisiana Revy,* vol. 13, no. 3 (Feb., 1973).

Bell, Jane. "Stuart M. Speiser Collection," *Arts Magazine,* Dec., 1973, p. 57.

Bovi, Arturo di. "Arte/Più brutto del brutto," *Il Messaggiero,* Feb. 13, 1973, p. 3.

Chase, Linda, and McBurnett, Ted. "Interviews with Robert Bechtle, Tom Blackwell, Chuck Close, Richard Estes, and John Salt," *Opus International,* no. 44–45 (June, 1973), pp. 38–50.

Chase, Linda. "Recycling Reality," *Art Gallery Magazine,* Oct., 1973, pp. 75–82.

"Don Eddy," *Art International,* Dec. 20, 1973.

E. D. G. "Arrivano gli iperrealisti," *Tribuna Letteraria,* Feb., 1973.

"European Galleries," *International Herald Tribune,* Feb. 17–18, 1973, p. 6.

Giannattasio, Sandra. "Riproduce la vita di ogni giorno la nuova pittura americano," *Avanti,* Feb. 8, 1973, p. 1.

"Goings On About Town," *The New Yorker,* Oct. 1, 1973.

Guercio, Antonio del. "Iperrealismo tra 'pop' e informale," *Rinascita,* no. 8

(Feb. 23, 1973), p. 34.

Hart, John. "A 'hyperrealist' U.S. tour at La Medusa," *Daily American* (Rome), Feb. 8, 1973.

Hjort, Oysten. "Kunstmiljoeti Rhinlandet," *Louisiana Revy,* vol. 13, no. 3 (Feb., 1973).

"L'hyperréalisme américain," *Le Monde des Grandes Musiques,* no. 2 (Mar.–Apr., 1973), pp. 4, 56–57.

La Mesa, Rina G. "Nel vuoto di emozioni," *Sette Giorni,* Feb. 18, 1973, p. 31.

Levin, Kim. "The New Realism: A Synthetic Slice of Life," *Opus International,* no. 44–45 (June, 1973), pp. 28–37.

Maraini, Letizia. "Non fatevi sfuggire," *Il Globo,* Feb. 6, 1973, p. 8.

Marziano, Luciano. "Iperrealismo: La coagulazione dell'effimero," *Il Margutta* (Rome), no. 3–4 (Mar.–Apr., 1973).

Melville, Robert. "The Photograph as Subject," *Architectural Review,* vol. CLIII, no. 915 (May, 1973), pp. 329–33.

Michael, Jacques. "Le super-réalisme," *Le Monde,* Feb. 6, 1973, p. 23.

Mizue (Tokyo), vol. 8, no. 821 (1973).

Moulin, Raoul-Jean. "Hyperréalistes américains," *L'Humanité,* Jan. 16, 1973.

Perreault, John. "Airplane Art in a Head Wind," *Village Voice,* Oct. 4, 1973.

"Realism Now," *Patent Trader,* May 26, 1973, p. 7A.

Rubiu, Vittorio. "Il gusto controverso degli iperrealisti," *Corriere della Sera,* Feb. 25, 1973.

"Stuart Speiser Collection," *Art International,* Nov., 1973.

Trucchi, Lorenza di. "Iperrealisti americani alla Medusa," *Momento-sera,* Feb. 9–10, 1973, p. 8.

Chase, Linda. "The Connotation of Denotation," *Arts Magazine,* Feb., 1974, pp. 38–41.

Coleman, A. D. "From Today Painting Is Dead," *Camera 35,* July, 1974, pp. 34, 36–37, 78.

"Collection of Aviation Paintings at Gallery," *Andover* (Mass.) *Townsman,* Feb. 28, 1974.

Davis, Douglas. "Summing Up the Season," *Newsweek,* July 1, 1974, p. 73.

Deroudille, René. "Réalistes et hyperréalistes," *Derrière Heure Lyonnaise,* Mar. 31, 1974.

"Flowers, Planes and Landscapes in New Art Exhibits," *Saturday Times-Union* (Rochester, N.Y.), Jan. 5, 1974.

"Gallery Notes," *Memorial Art Gallery of the University of Rochester Bulletin,* vol. 39, no. 5 (Jan., 1974).

Hughes, Robert. "An Omnivorous and Literal Dependence," *Arts Magazine,* June, 1974, pp. 25–29.

Kelley, Mary Lou. "Pop Art Inspired Objective Realism," *Christian Science Monitor,* Mar. 1, 1974.

Loring, John. "Photographic Illusionist Prints," *Arts Magazine,* Feb., 1974, pp. 42–43.

Michael, Jacques. "La 'mondialisation' de l'hyperréalisme," *Le Monde,* Feb. 21, 1974.

Moulin, Raoul-Jean. "Les hyperréalistes américains et la neutralisation du réel," *L'Humanité,* Mar. 21, 1974.

Progresso fotografico, Dec., 1974, pp. 61–62.

Spector, Stephen. "The Super Realists," *Architectural Digest,* Nov.–Dec., 1974, p. 85.

Teyssedre, Bernard. "Plus vrai que nature," *Le Nouvel Observateur,* Feb. 25–Mar. 3, 1974, p. 59.

Tooker, Dan. "Interview: Richard McLean," *Art International,* vol. 28 (Sept., 1974), pp. 27, 40–41.

Albright, Thomas. "A Wide View of the New Realists," *San Francisco Chronicle,* Feb. 6, 1975, p. 38.

Hull, Roger. "Realism in Art Returns with Camera's Clarity," *Portland Oregonian,* Sept. 14, 1975.

Lucie-Smith, Edward. "The Neutral Style," *Art and Artists,* vol. 10, no. 5 (Aug., 1975), pp. 6–15.

Nordjyllands Kunst Museum, no. 3 (Sept., 1975).

"Photo-Realism Exhibit Is Opening at Paine Sunday," *Oshkosh Daily Northwestern,* Apr. 17, 1975.

"Photo-Realists at Paine," *View Magazine,* Apr. 27, 1975.

Ray, Steve. "Photo/Art: Real or Reel," *Oshkosh Advance-Titan,* May 1, 1975.

Richard, Paul. "Whatever You Call It, Super Realism Comes On with a Flash," *Washington Post,* Nov. 25, 1975, p. B1.

Sutinen, Paul. "American Realism at Reed," *Willamette Week,* Sept. 12, 1975.

Albright, Thomas. "Wanted: A Figurative Study," *San Francisco Chronicle,* Oct. 5, 1976.

Belden, Dorothy. "Realism Exaggerated in Ulrich Art Exhibition," *Wichita Eagle,* Mar., 1976, Lifestyle page.

Chase, Linda. "Photo-Realism: Post Modernist Illusionism," *Art International,* vol. XX, no. 3–4 (Mar.–Apr., 1976), pp. 14–27.

Fox, Mary. "Aspects of Realism," *Vancouver Sun,* Sept. 21, 1976.

Fried, Alexander. "Three Artists Trying to Be Different," *San Francisco Examiner,* Oct. 1, 1976, p. 32.

Glasser, Penelope. "Aspects of Realism at Stratford," *Art Magazine* (Toronto) vol. 7, no. 28 (Summer, 1976), pp. 22–29.

Marlowe, John. "Richard McLean—An Interview," *Current Magazine,* Sept.–Oct., 1976, p. 39.

McDonald, Robert. "Richard McLean and Robert Cottingham," *Artweek,* Oct. 16, 1976, pp. 3–4.

Patton, Phil. "Books, Super-Realism: A Critical Anthology," *Artforum,* vol. XIV, no. 5 (Jan., 1976), pp. 52–54.

Perry, Art. "So Much for Reality," *Province,* Sept. 30, 1976.

Borlase, Nancy. "In Selecting a Common Domestic Object," *Sydney Morning Herald,* July 30, 1977.

Crossley, Mimi. "Review: Photo-Realism," *Houston Post,* Dec. 9, 1977.

Hocking, Ian. "Something for All at Art Gallery," *News Adelaide,* Sept. 7, 1977.

Lynn, Elwyn. "The New Realism," *Quadrant,* Sept., 1977.

Makin, Jeffrey. "Realism from the Squad," *Melbourne Sun,* Oct. 19, 1977, p. 43.

McCracken, Peg. "The Illusion and Reality Show," *6 A.M. Arts Melbourne and Art Almanac,* Dec., 1977.

McGrath, Sandra. "I Am Almost a Camera," *The Australian* (Brisbane), July 27, 1977.

Bongard, Willie. *Art Aktuell* (Cologne), Apr., 1978.

Mackie, Alwynne. "New Realism and the Photographic Look," *American Art Review,* Nov., 1978, pp. 72–79, 132–34.

BOOKS

Kultermann, Udo. *New Realism.* New York: New York Graphic Society, 1972.

Brachot, Isy, ed. *Hyperréalisme.* Brussels: Imprimeries F. Van Buggenhoudt, 1973.

Sager, Peter. *Neue Formen des Realismus.* Cologne: Verlag M. DuMont Schauberg, 1973.

Who's Who in American Art. New York: R. R. Bowker, 1973.

L'Iperrealismo italo Medusa. Rome: Romana Libri Alfabeto, 1974.

Abadie, Daniel. *L'hyperréalisme américain.* Petite Encyclopédie de l'Art, vol. 113. Paris: Gernand Hazan, 1975.

Battcock, Gregory, ed. *Super Realism, A Critical Anthology.* New York: E. P. Dutton, 1975.

Chase, Linda. *Hyperréalisme.* New York: Rizzoli, 1975.

Kultermann, Udo. *Neue Formen des Bildes.* Tübingen, West Germany: Verlag Ernst Wasmuth, 1975.

Lucie-Smith, Edward. *Late Modern—The Visual Arts Since 1945.* 2d ed. New York: Praeger, 1975.

Rose, Barbara, ed. *Readings in American Art, 1900–1975.* New York: Praeger, 1975.

Honisch, Dieter, and Jensen, Jens Christian. *Amerikanische Kunst von 1945 bis Heute.* Cologne: DuMont Buchverlag, 1976.

Who's Who in American Art. New York: R. R. Bowker, 1976

Wilmerding, John. *American Art.* Harmondsworth, England: Penguin, 1976.

Battcock, Gregory. *Why Art.* New York: E. P. Dutton, 1977.

Cummings, Paul. *Dictionary of Contemporary American Artists.* 3d ed. New York: St. Martin's Press, 1977.

Lucie-Smith, Edward. *Art Now: From Abstract Expressionism to Superrealism.* New York: William Morrow, 1977.

———. *Super Realism.* Oxford: Phaidon, 1979.

Seeman, Helene Zucker, and Siegfried, Alanna. *SoHo.* New York: Neal-Schuman, 1979.

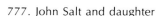
777. John Salt and daughter

JOHN SALT

John Salt, the only major Photo-Realist painter who is not American, was born in Birmingham, England, where he lived until 1970. In that year, he moved to New York, where his development as a Photo-Realist began.

In England, Salt, thinking that he wanted to be an abstract painter, had begun painting semi-abstract paintings of machines. He was unhappy painting this way, however, and shortly after arriving in New York he completed the first series of close-up interiors of old cars. The paintings were somewhat blurry and bland in color—these were the years when he was learning airbrush technique. While other airbrush painters used masks, tape, or nothing at all to create edges, Salt used stencils, and now his work is extremely sharp and clear.

Salt's seven-year stay in New York (he returned to England in 1978) was most important to the development of his art. It was in New York that he found subject matter and ideas, as well as methods and techniques, that he would never have been exposed to elsewhere. The work for which he has become known is totally American in appearance and philosophy.

When asked about his choice of subject matter, Salt answered tellingly, ''The automobile seemed like such obvious subject matter to me. It is so large and ugly in America. It is not so important to us in England, and I wouldn't have even thought of painting it at home. There's no real message or importance to the cars in my painting, though. I just like them. It's interesting that the cars are painted in factories with a spray gun and that is also the method I use to paint pictures of them. I use an airbrush.''

Almost all of Salt's cars are derelict, wrecked, rusted, and abandoned. Although he maintains that he is not making a statement, I think that he is, at least subconsciously. Of course it is probably more interesting to paint these wrecks and derelicts because

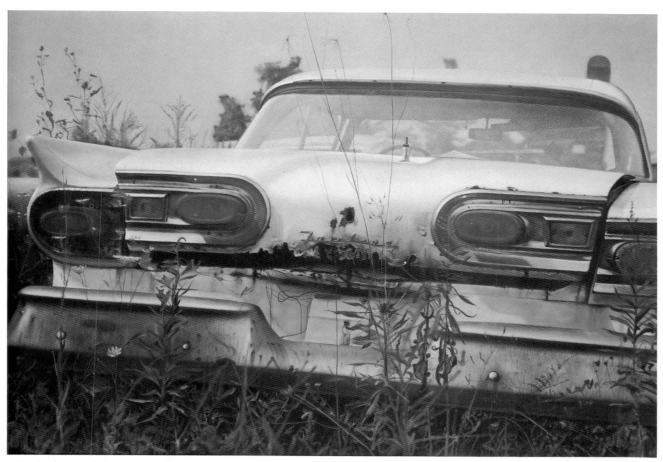

778. *Fairlane in Weeds*. 1971 (37). Oil on canvas, 49 x 69". Collection Mr. and Mrs. Robert Snower, Kans.

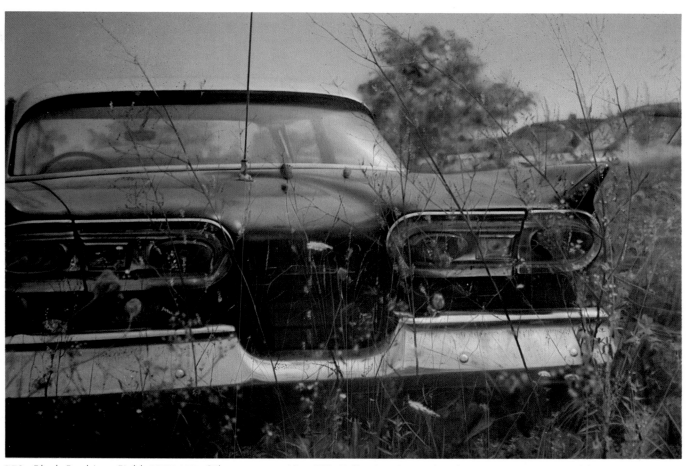

779. *Black Ford in a Field*. 1972 (41). Oil on canvas, 48 x 72". Collection Bernard and Marion Orenstein, Calif.

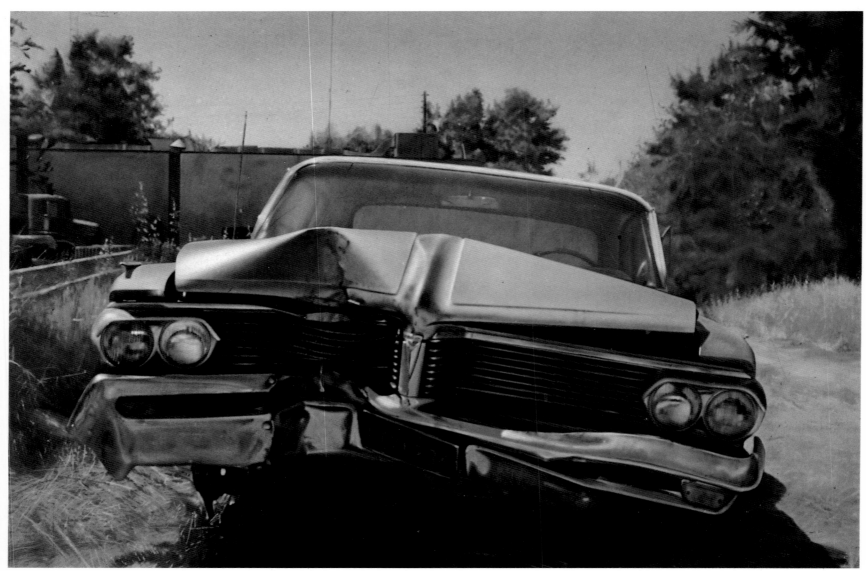

780. *Pontiac in a Deserted Lot.* 1971 (38). Oil on canvas, 49 x 72½". Virginia Museum of Fine Arts, Richmond

of the greater variation of detail and texture. There is also a touch of nostalgia involved with the older vehicles. Recently, Salt has begun to notice and paint mobile homes. In a way, it seems that he is equating the trailers and their transient occupants with the earlier derelict cars.

Salt, like the other Photo-Realists, recognizes the role of the camera and slides as aids to his work, but he is the only one who has mentioned the importance the photograph has for him in making the transition from a three-dimensional object to a two-dimensional image.

When photographing material for his paintings, Salt generally likes just to point the camera, hand-held, at the object and take a lot of pictures. He does not attempt a precise or finished composition. He says he likes what he gets this way—if something is cropped in a strange way, then it is purely by chance that it becomes a good painting. He does, of course, look through hundreds of slides to find the ones that will work as paintings and it is in this editing that many of his decisions are made.

Salt, whose watercolors are among the best from this group of painters, is a quiet, unassuming artist who is very private about his studio and methods.

John Salt had painted 95 works as of December 31, 1979. We have illustrated 89 of these and listed the remainder herein.

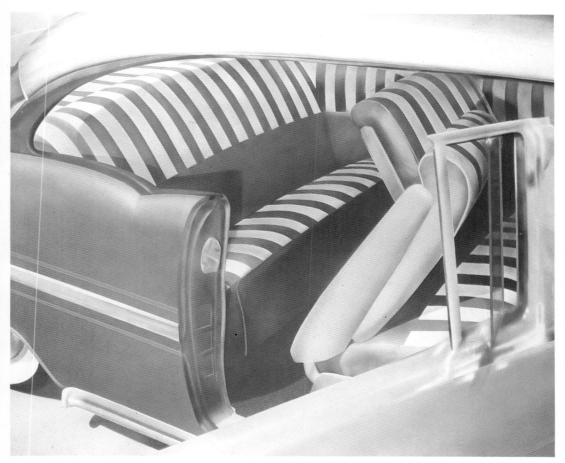

781. *Custom.* 1969 (10). Oil on canvas, 54 x 66". Private collection, Paris

782. *Vehicle in a Shopping Area.* 1970 (22).
Oil on canvas, 37 x 52".
Private collection, New York

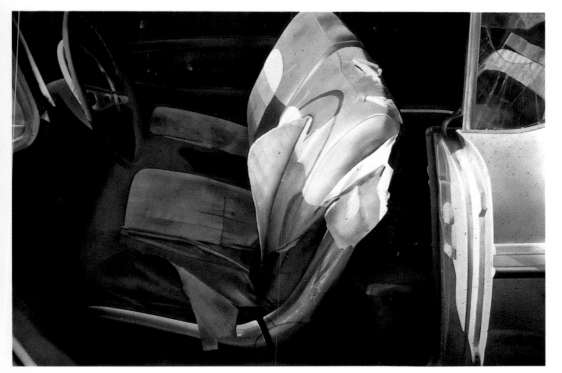

783. *Arrested Vehicle (Yellow Foam Interior).* 1970 (21). Oil on canvas, 53 x 78".
Private collection

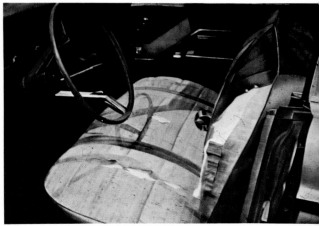

784. *Arrested Vehicle (Fat Seats).* 1970 (19).
Oil on canvas, 53 x 78".
Collection Hubert Peeters, M.D., Belgium

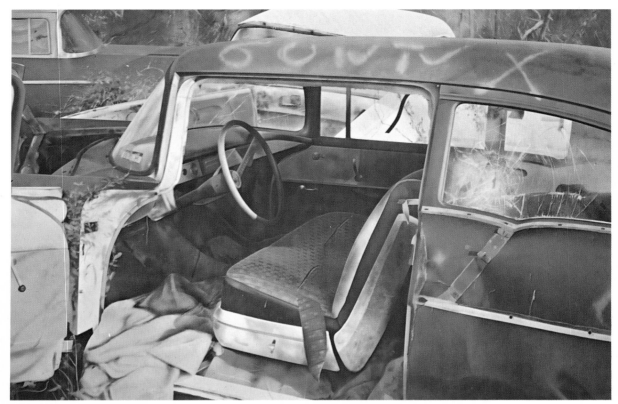

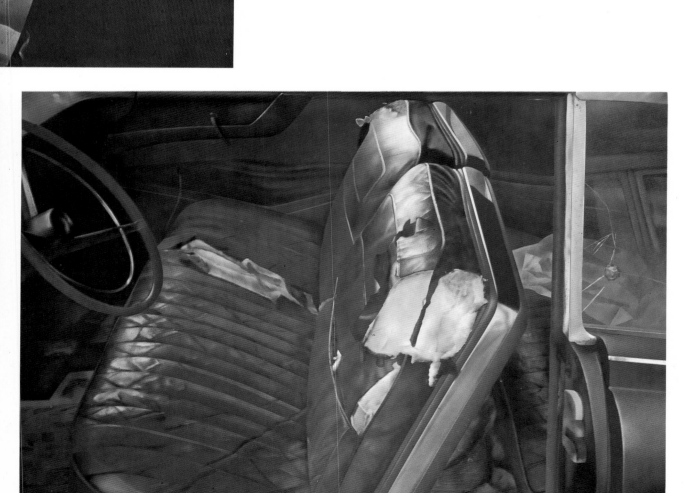

785. *Arrested Vehicle (Writing on Roof)*. 1970 (18). Oil on canvas, 53 x 78".
Collection Ethel Kraushar, New York

786. *Arrested Vehicle with Burgundy Seats*. 1970 (17). Oil on canvas, 52½ x 78". Collection Sandra and Joe Rotman, Canada

371

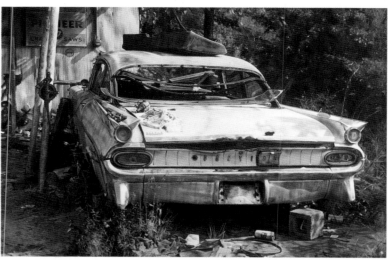

787. *Pioneer Pontiac.* 1972–73 (51).
Oil on canvas, 49 x 72".
Collection Bruce and Barbara Berger, New York

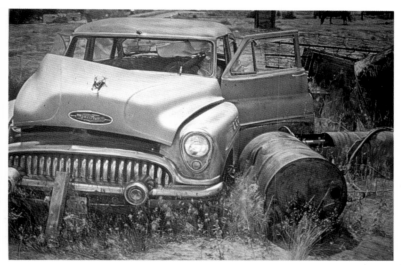

788. *Albuquerque Wreck.* 1972 (43).
Oil on canvas, 49 x 72".
Collection Richard Belger, Mo.

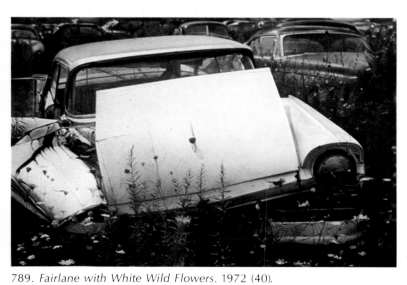

789. *Fairlane with White Wild Flowers.* 1972 (40).
Oil on canvas, 48 x 72".
Sydney and Frances Lewis Foundation, Va.

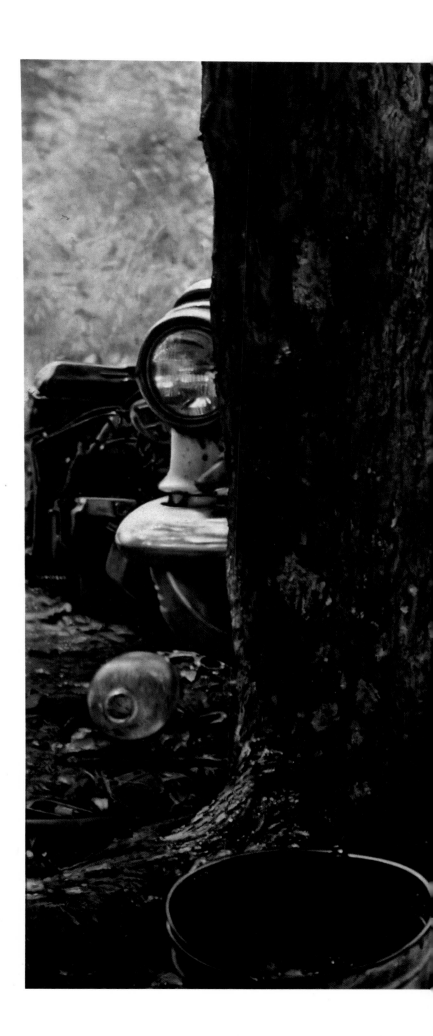

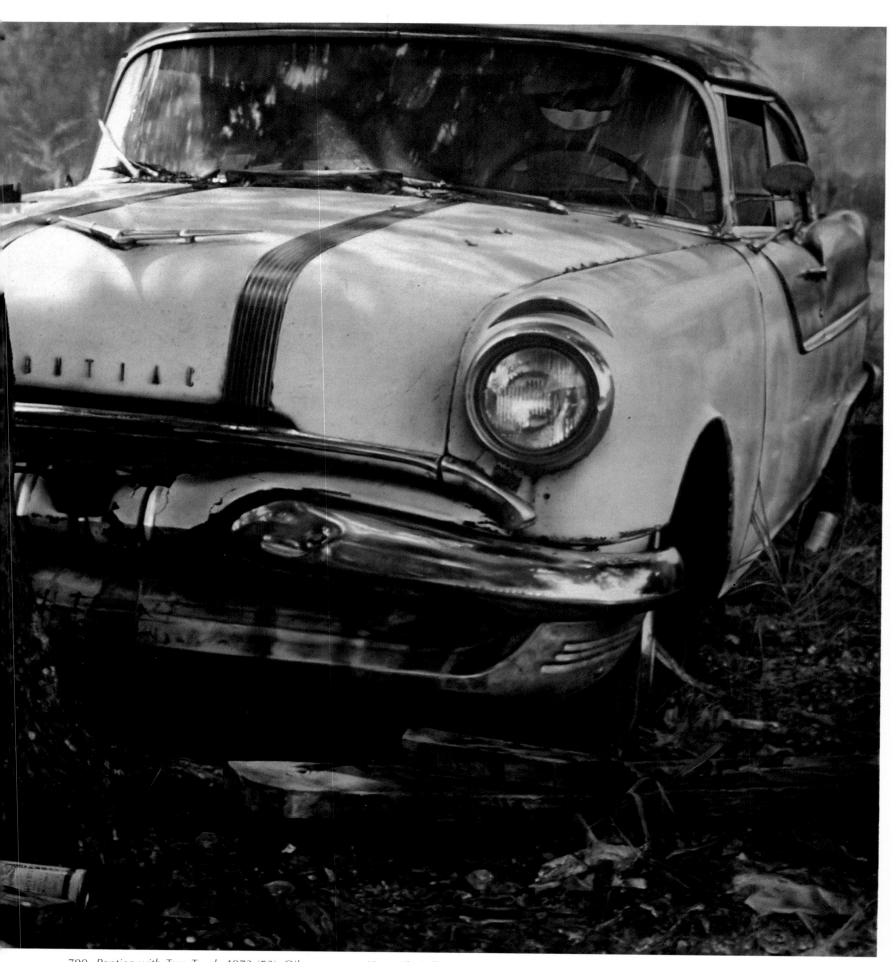

790. *Pontiac with Tree Trunk*. 1973 (53). Oil on canvas, 42 x 60". Collection Mr. and Mrs. W. Jaeger, New York

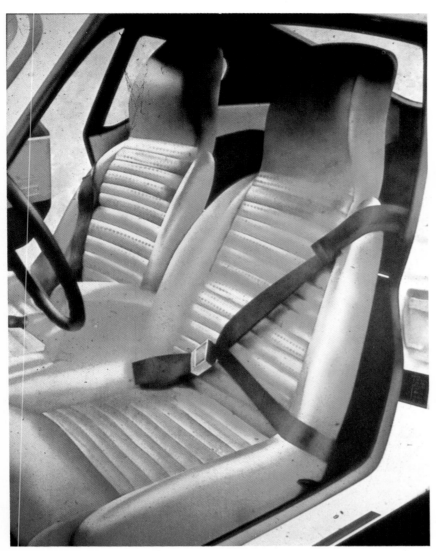

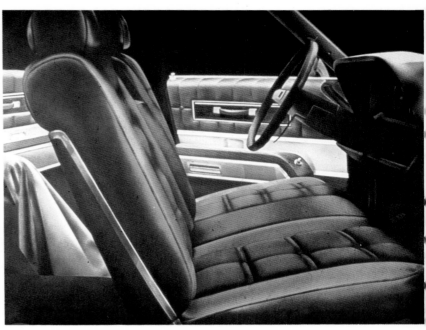

792. *Bride*. 1969 (8). Oil on canvas, 53½ x 69".
Collection Murray Wilson, M.D., Canada

791. *Red Seats*. 1969 (6). Oil on canvas, 82 x 62".
Indianapolis Museum of Art

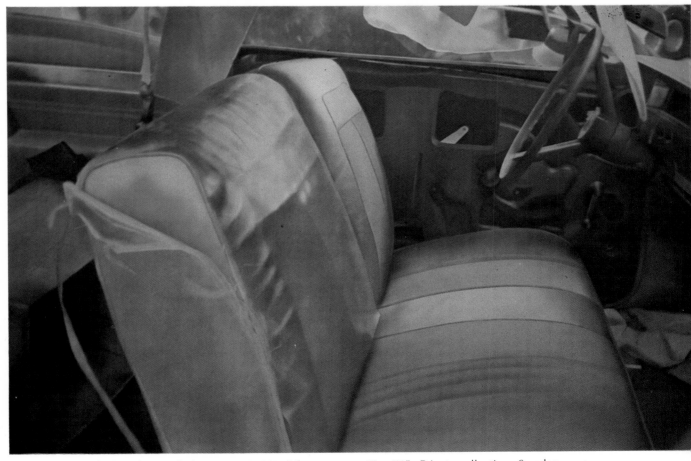

793. *Arrested Vehicle (Silver Upholstery)*. 1970 (20). Oil on canvas, 53 x 78". Private collection, Sweden

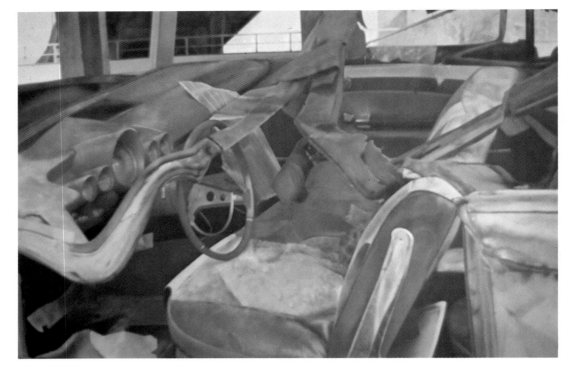

794. *Demolished Vehicle.* 1970 (27).
Oil on canvas, 51 x 72".
Housatonic Museum of Art, Conn.

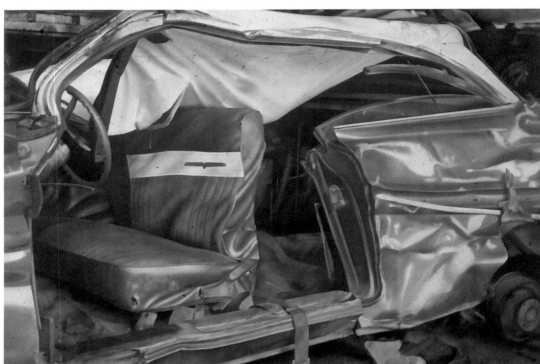

795. *Arrested Vehicle with Crushed Roof.*
1971 (29). Oil on canvas, 46½ x 70½".
J. B. Speed Art Museum, Louisville, Ky.

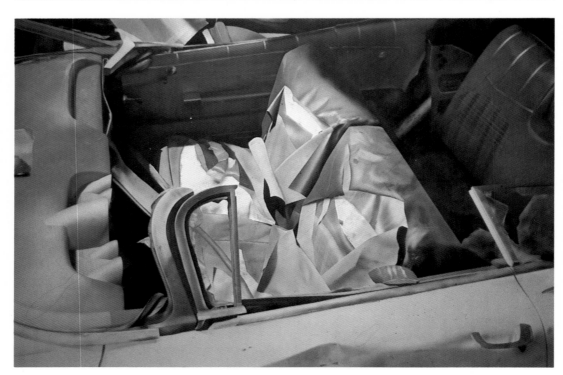

796. *Arrested Vehicle (Overview).* 1970 (16).
Oil on canvas, 53 x 78".
Collection Galerie Isy Brachot, Brussels

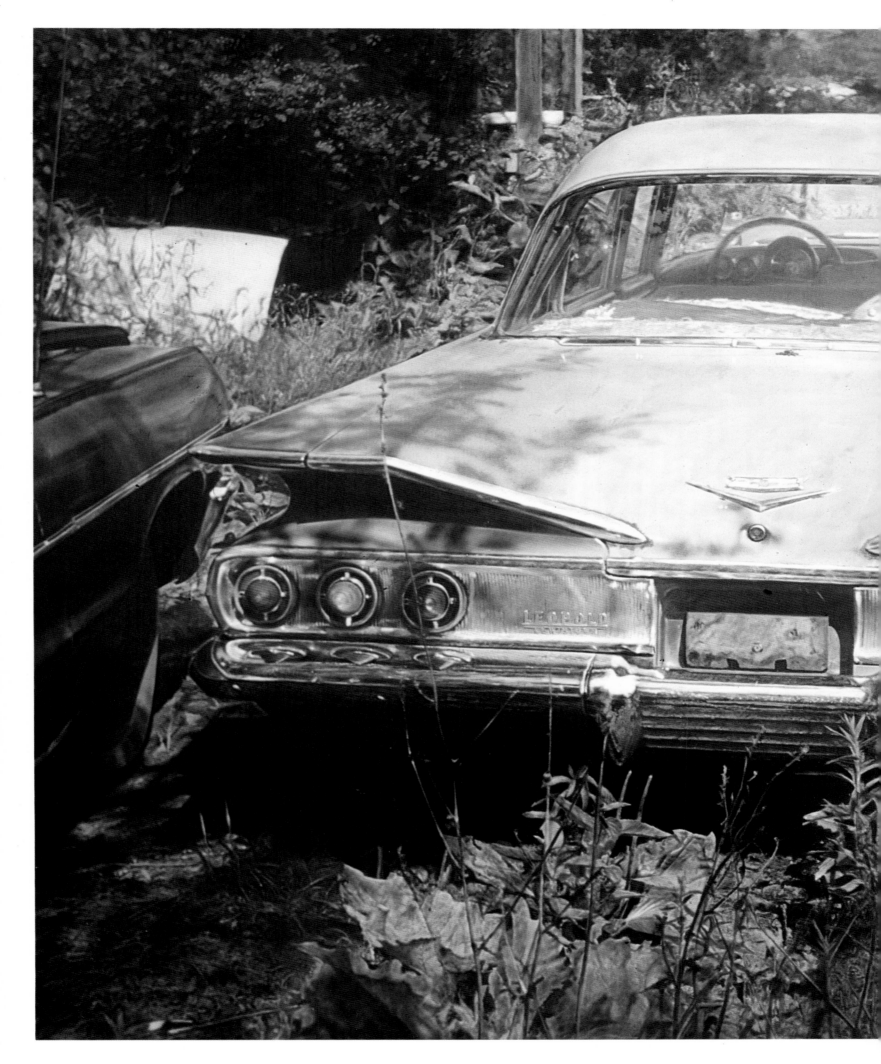

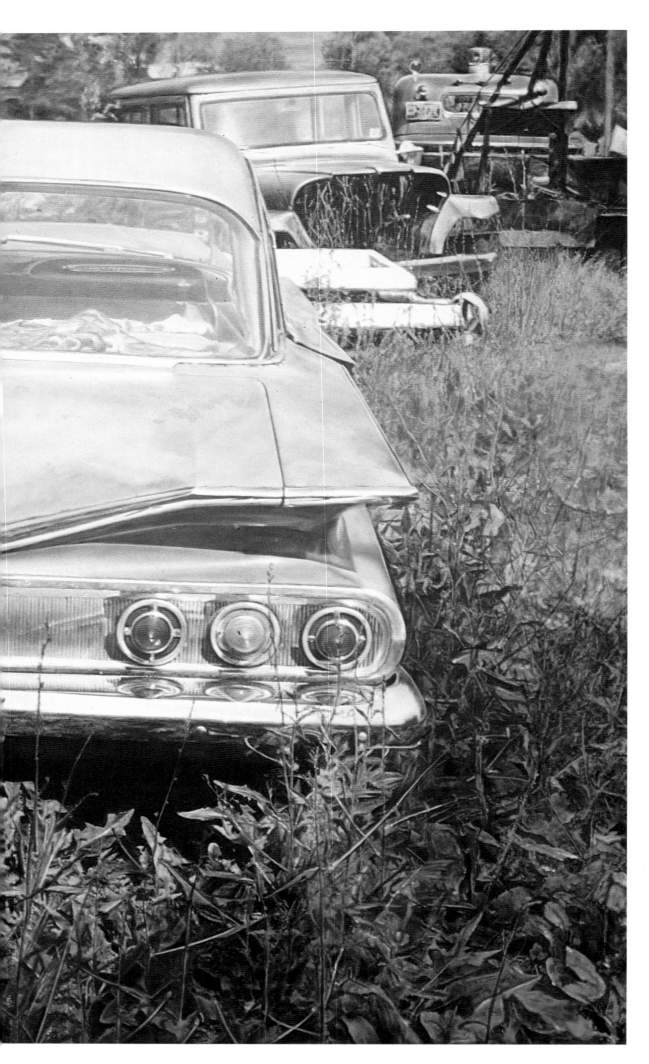

797. *Chevy in Green Fields.* 1973 (59).
Oil on canvas, 49 x 72".
Private collection

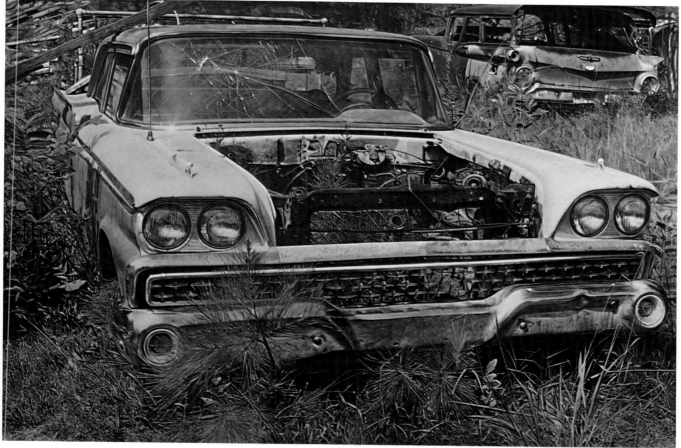

798. *'58 White Ford Without Hood.* 1973 (58). Oil on canvas, 49 x 72".
Collection Mr. and Mrs. Morton G. Neumann, Ill.

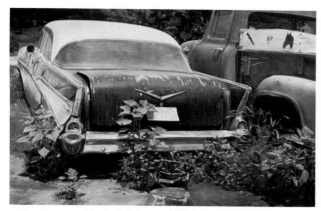

799. *Chevy with Red Primered Pickup.* 1972 (39).
Oil on canvas, 47 x 70".
Collection Paul and Camille Hoffman, Ill.

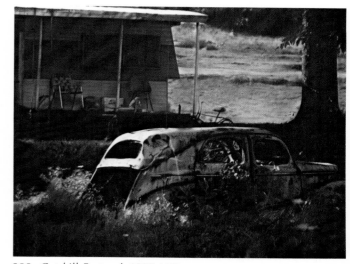

800. *Catskill Pastoral.* 1972 (42).
Oil on canvas, 46 x 58".
Collection Mr. and Mrs. J. Piegel, Colo.

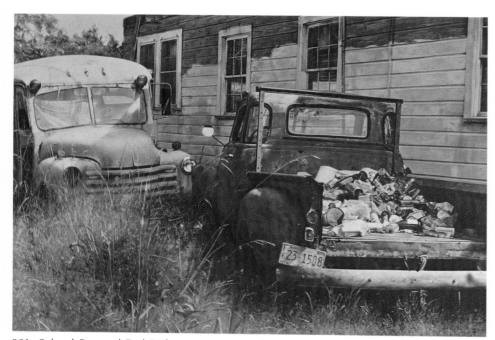

801. *School Bus and Red Pickup.* 1973 (54). Oil on canvas, 49 x 72". Private collection

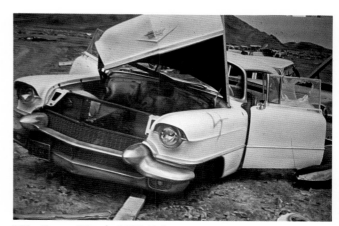

802. *Desert Wreck.* 1972 (46).
Oil on canvas, c. 48 x 72".
Galerie de Gestlo, Hamburg

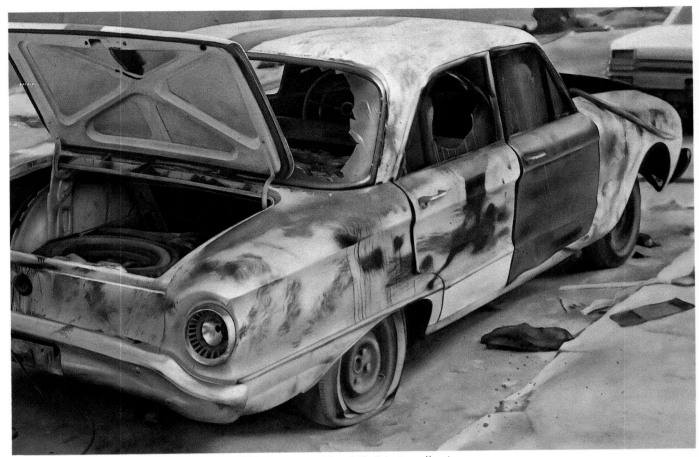

803. *Falcon (Patchwork Surface)*. 1971 (36). Oil on canvas, 46 x 64". Private collection

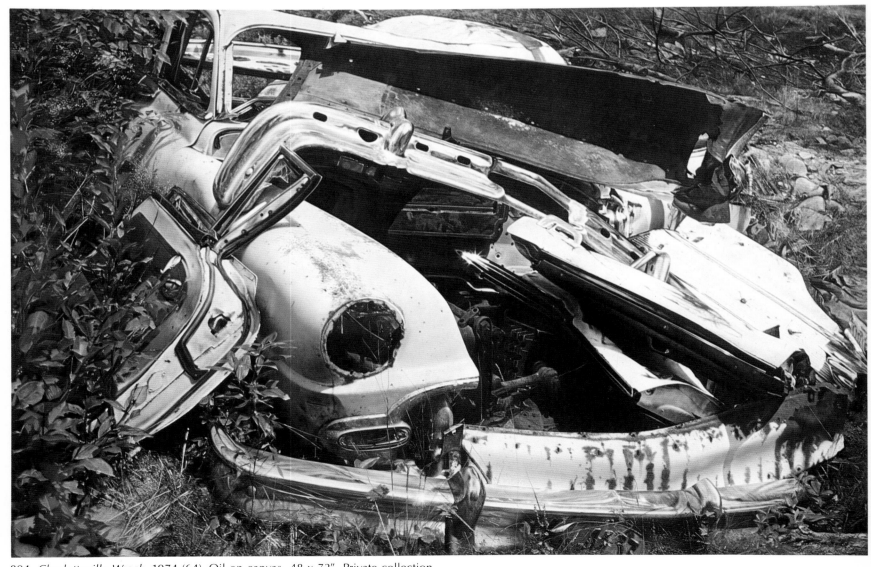

804. *Charlotteville Wreck*. 1974 (64). Oil on canvas, 48 x 72". Private collection

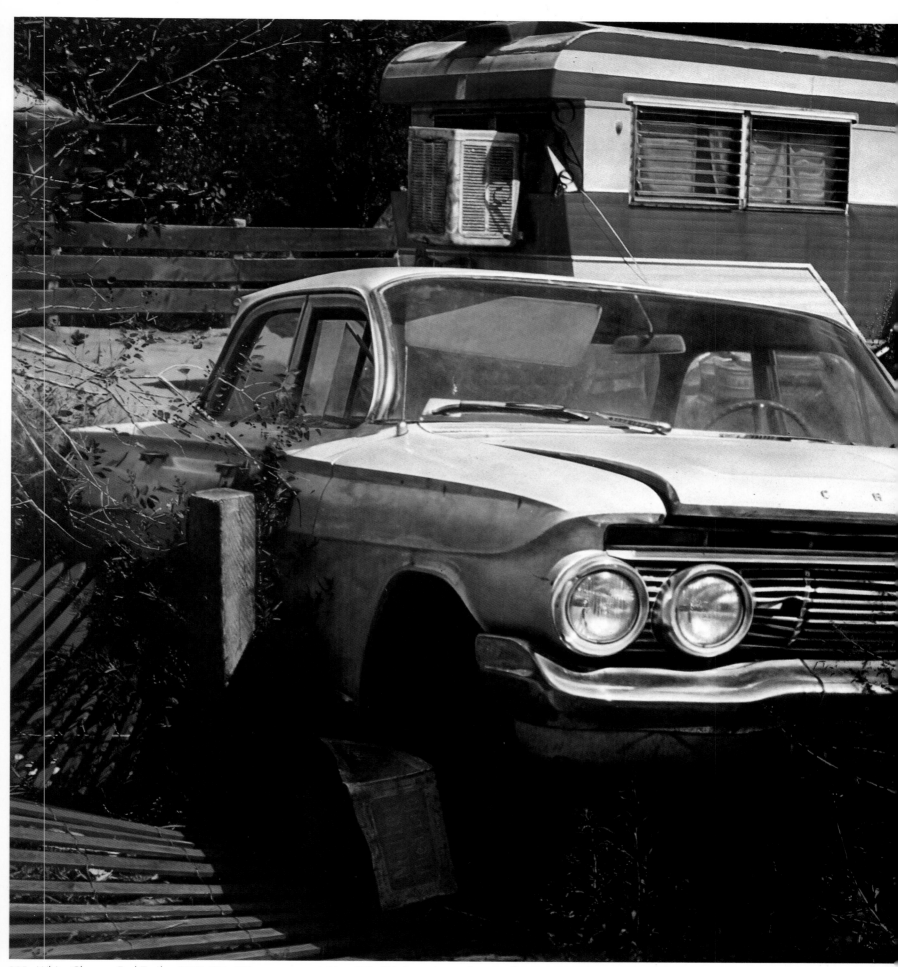

805. *White Chevy—Red Trailer.* 1975 (74). Oil on canvas, 44½ x 67". City Museum and Art Gallery, Birmingham, England

380

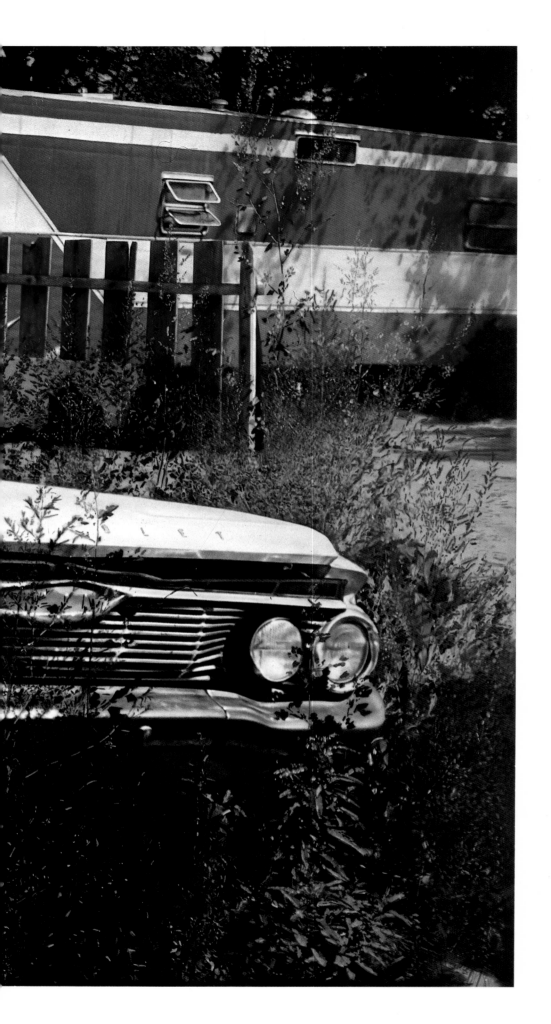

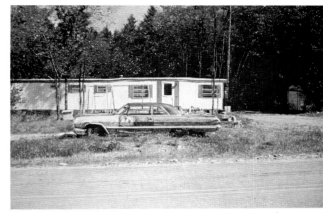

806. *Purple Impala*. 1976 (86).
Watercolor on paper, 11⅞ x 17⅜".
Collection Louis and Susan Meisel, New York

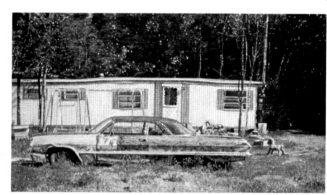

807. *Purple Impala*. 1976 (78).
Watercolor on paper, 6½ x 11".
Collection Grant and Sims, New York

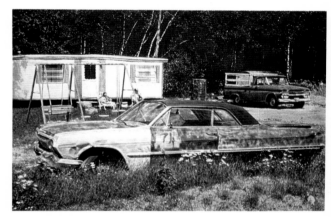

808. *Purple Impala with Swing*. 1975 (70).
Watercolor on paper, 11 x 16½".
Luntz Gallery, Fla.

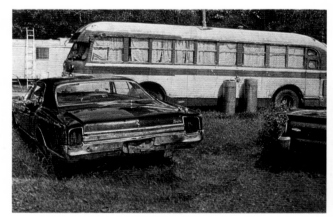

809. *Blue Oldsmobile*. 1977 (87).
Watercolor on paper, 11 x 16¼".
Private collection, New York

381

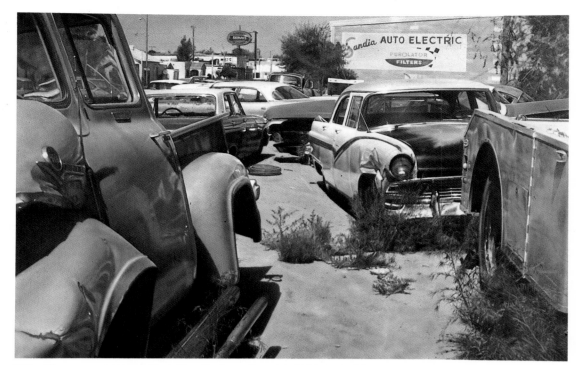

810. *Albuquerque Wreck Yard (Sandia Auto Electric)*. 1972 (44). Oil on canvas, 48 x 72".
Collection Carlo Bilotti, London

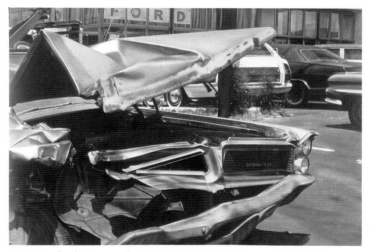

811. *Crushed Bonneville*. 1971 (34). Oil on canvas, 49 x 69".
Galerie de Gestlo, Hamburg

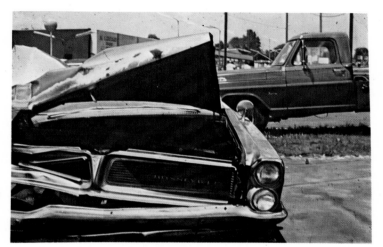

812. *Crushed Bonneville with Blue Pickup*. 1971 (35). Oil on canvas, 49 x 73". Private collection, Sweden

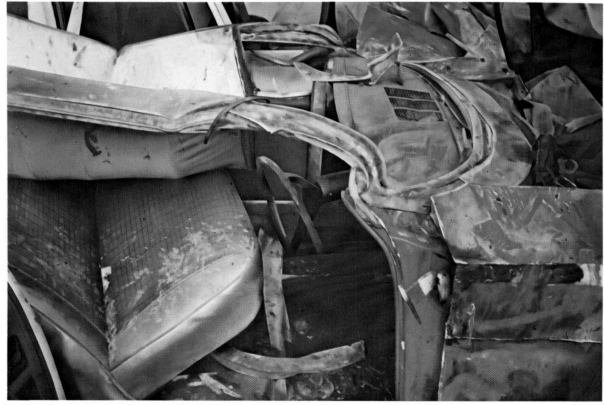

813. *Demolished Arrested Auto*. 1970 (26). Oil on canvas, 53 x 78". Private collection

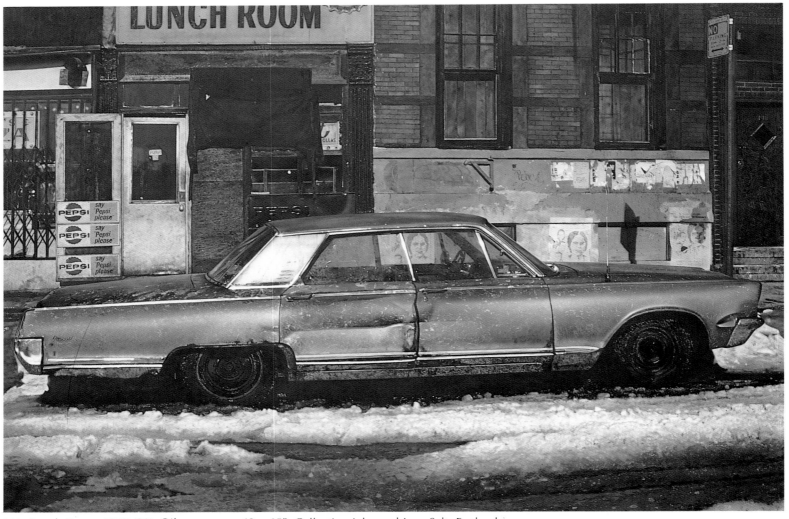

814. *Lunch Room*. 1977 (90). Oil on canvas, 43 x 65". Collection John and Jean Salt, England

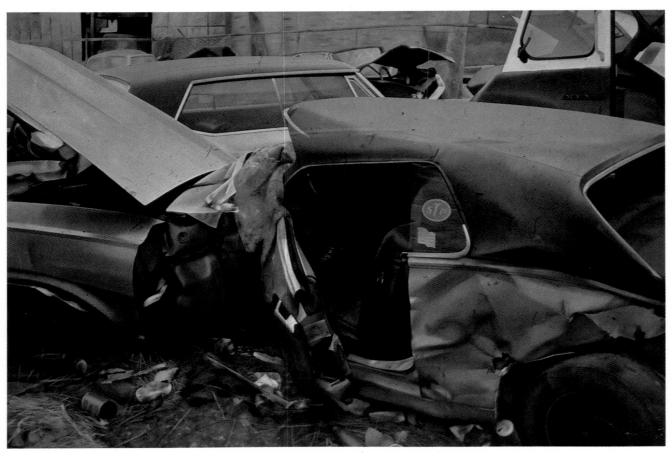

815. *Demolished Vehicle (S.T.P. with Trash)*. 1971 (28). Oil on canvas, 51½ x 73½".
Galleri Ostergren, Sweden

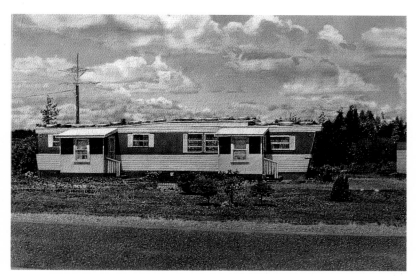

816. *Mobile Home with Porches.* 1977 (88). Watercolor on paper, 12 x 17¾". Private collection

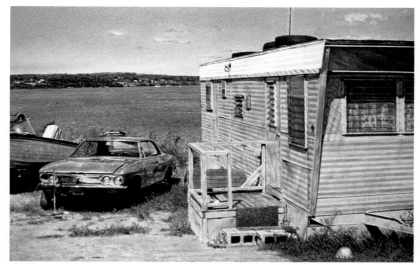

817. *Trailer and Ocean.* 1975 (72). Watercolor on paper, 11 x 17". Collection Gilbert Shapiro, New York

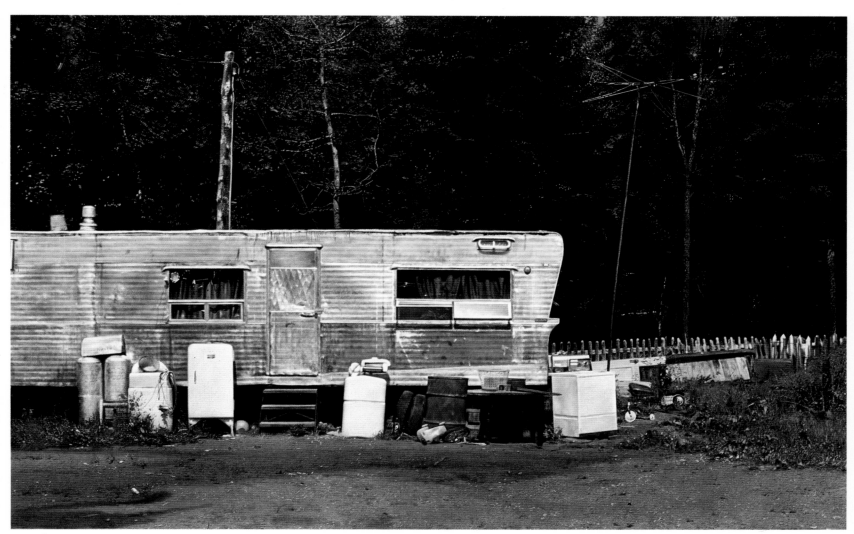

818. *Three-toned Trailer.* 1975 (71). Oil on canvas, 27½ x 41½". Collection the artist

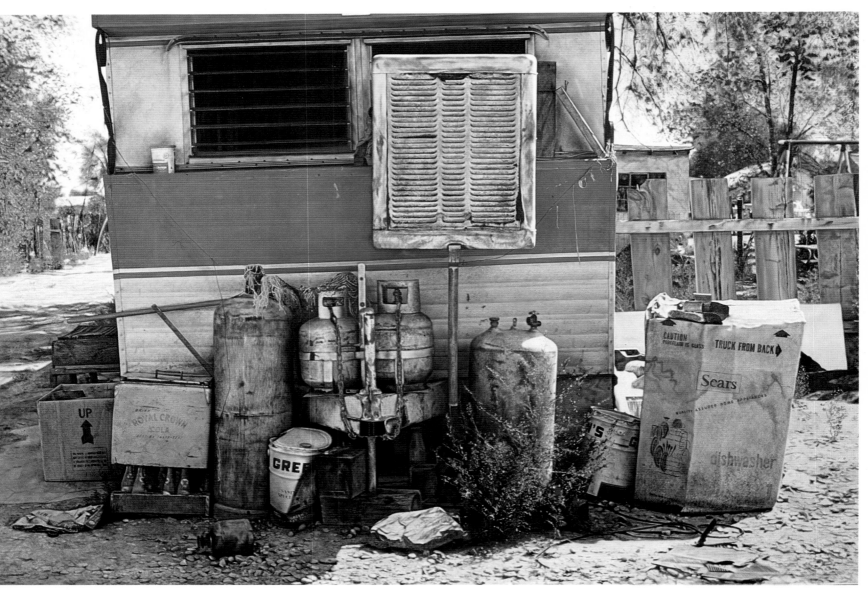

319. *Red and White Trailer*. 1973 (63). Oil on canvas, 49 x 72". Galerie de Gestlo, Hamburg

820. *Red Trailer*. 1973 (61).
Watercolor on paper, 13 x 17".
Private collection, New York

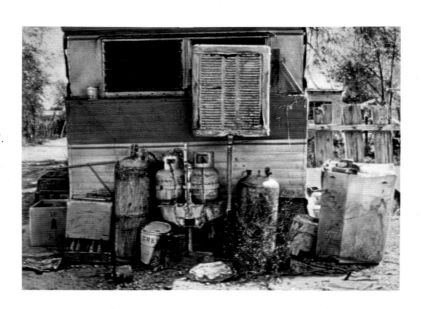

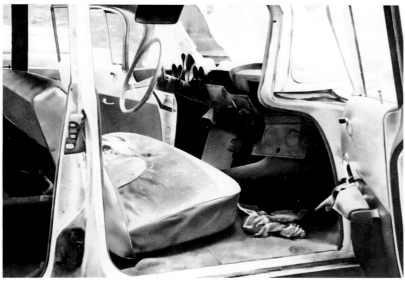

821. *Arrested Vehicle with Broken Windows.* 1970 (15). Oil on canvas, 53 x 78". Power Gallery of Contemporary Art, University of Sydney, Australia

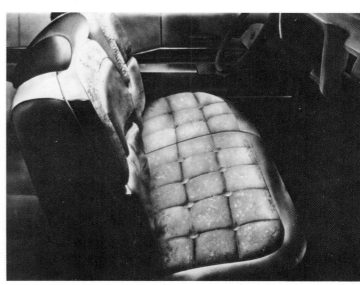

822. *Electra I.* 1969 (1). Oil on canvas, 53½ x 69". Private collection, Switzerland

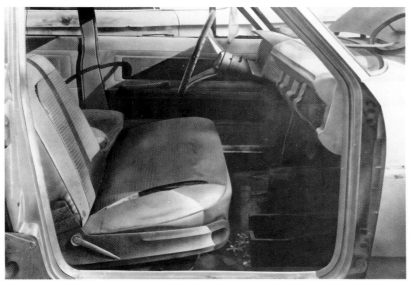

823. *Arrested Auto with Blue Seats.* 1970 (12). Oil on canvas, 53 x 76½". Private collection, Mass.

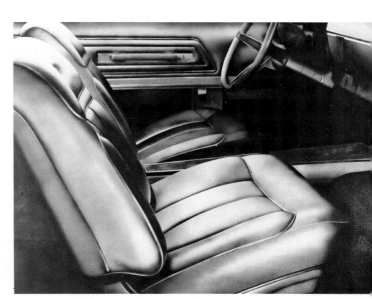

824. *Riviera I.* 1969 (3). Oil on canvas, 53½ x 69". Collection Mr. and Mrs. Selig Altschul, New York

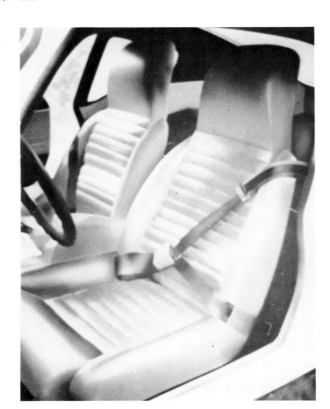

826. *Blue Interior.* 1970 (14). Oil on canvas, 45½ x 57". Galerie Thelen, West Germany

825. *Red Seats in Grisaille.* 1969 (7). Oil on canvas, 36 x 27". Private collection, New York

827. *Electra II.* 1969 (2). Oil on canvas, 53½ x 69".
Collection Daniel Filipacchi, New York

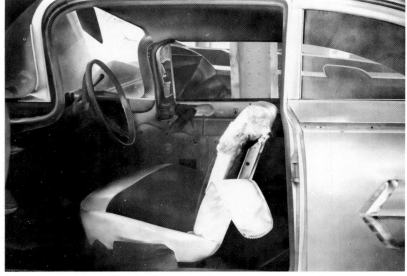

828. *Arrested Auto No. 1.* 1969 (9). Oil on canvas, 53 x 72".
Sydney and Frances Lewis Foundation, Va.

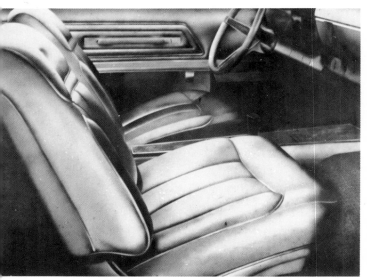

829. *Riviera II.* 1969 (4). Oil on canvas, 53½ x 69".
Syracuse University Museum of Art, N.Y.

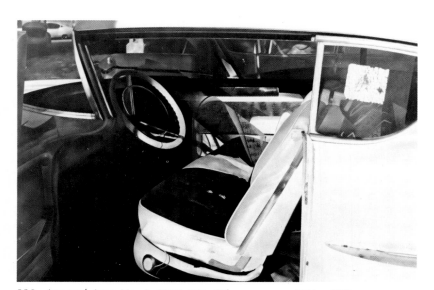

830. *Arrested Auto No. 2.* 1970 (13). Oil on canvas, 52½ x 77".
Collection Monroe Meyerson, New York

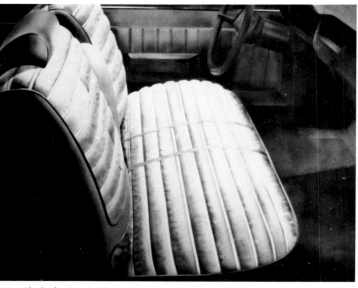

831. *Skylark.* 1969 (5). Oil on canvas, 53 x 69".
Port of New York Authority Collection

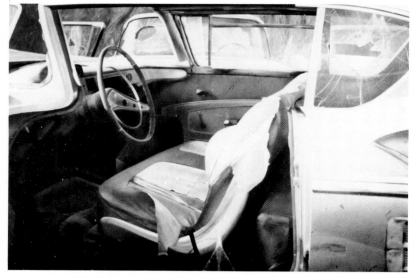

832. *Arrested Vehicle (Graveyard).* 1970 (25). Oil on canvas, 53 x 78".
Collection Mr. and Mrs. Jerry Berger, Kans.

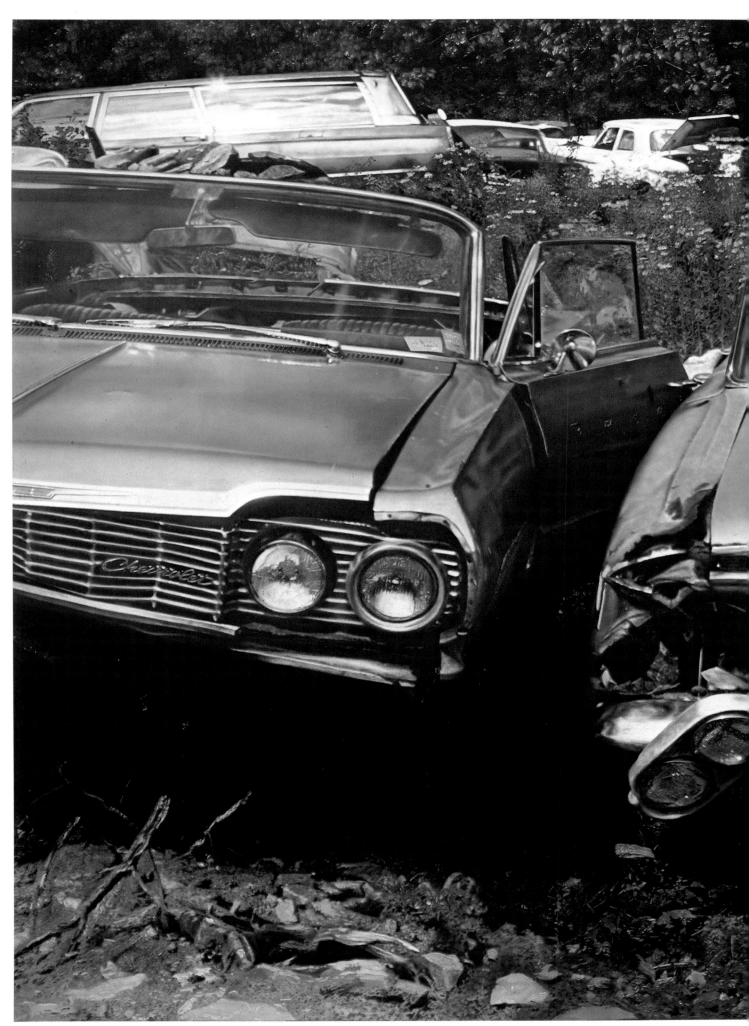

833. *Two Chevies in Wreck Yard.* 1976 (79). Oil on canvas, 38 x 57". Collection Nanelle Abrams, Calif.

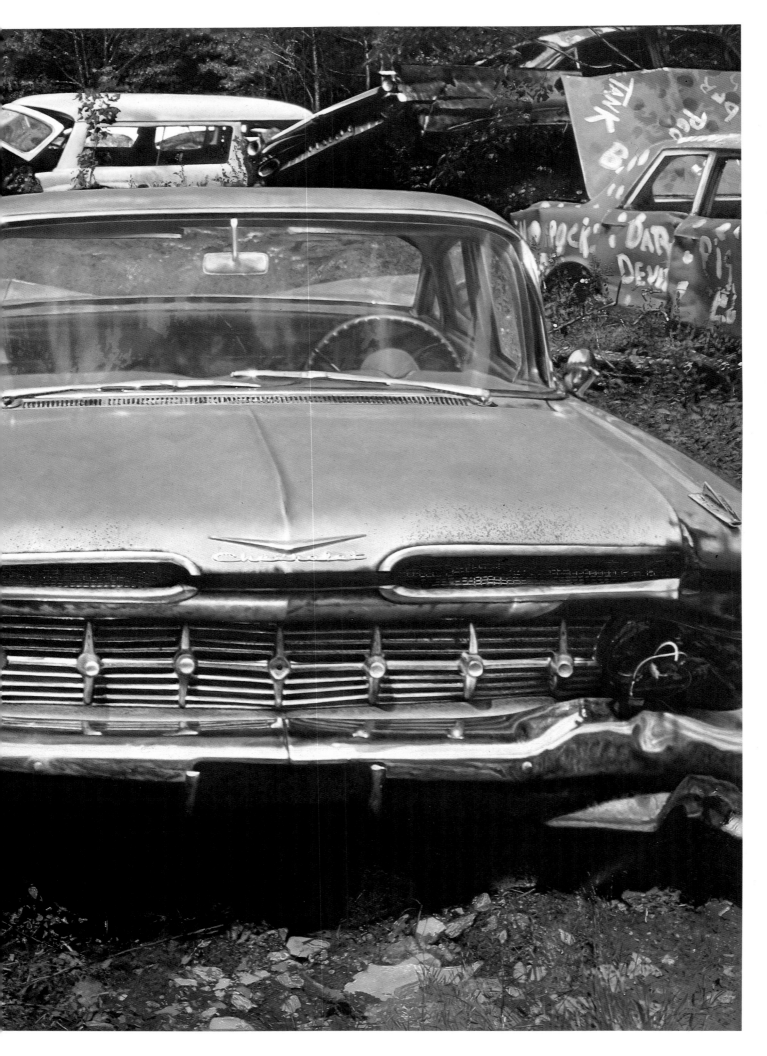

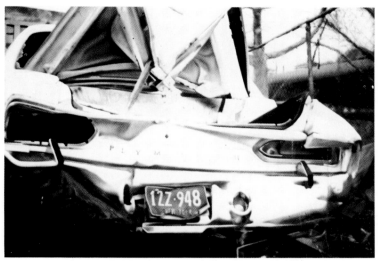

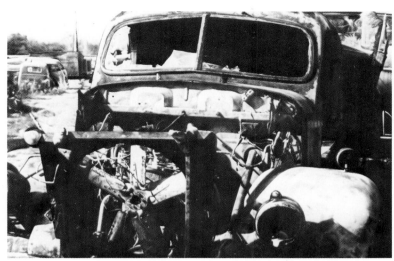

834. *Demolished Plymouth in Landscape.* 1971 (30). Oil on canvas, 49½ x 71". Private collection

835. *Truck in Wrecking Yard.* 1972 (45). Oil on canvas, 62 x 92". Collection Bernard and Marion Orenstein, Calif.

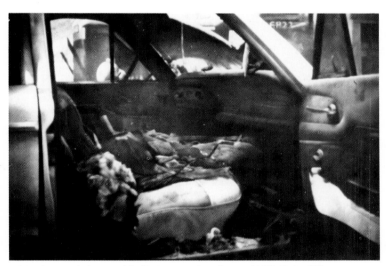

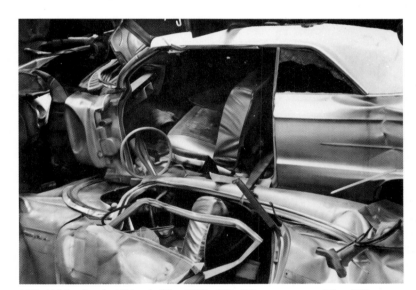

836. *Arrested Auto with Decomposing Seats.* 1970 (24). Oil on canvas, 53 x 78½". Private collection, Germany

837. *White Roofed Wreck Pile.* 1971 (33). Oil on canvas, 65 x 92". Collection Anita and Burton Reiner, Md.

838. *Wrecking Yard (Skeleton Car).* 1971 (32). Oil on canvas, 65 x 92". Museum Boymans–van Beuningen, Rotterdam

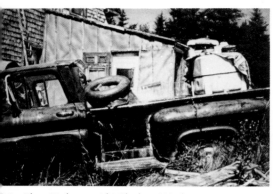

839. *Blue Pickup with Clothes Washer.* 1974 (68).
Watercolor on paper, 12 x 17⅝".
Collection Mr. and Mrs. W. Jaeger, New York

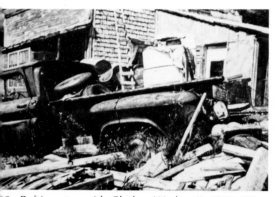

840. *Refrigerator with Clothes Washer II.* 1975 (77).
Watercolor on paper, 12 x 17".
Collection Dr. and Mrs. Barry J. Paley, New York

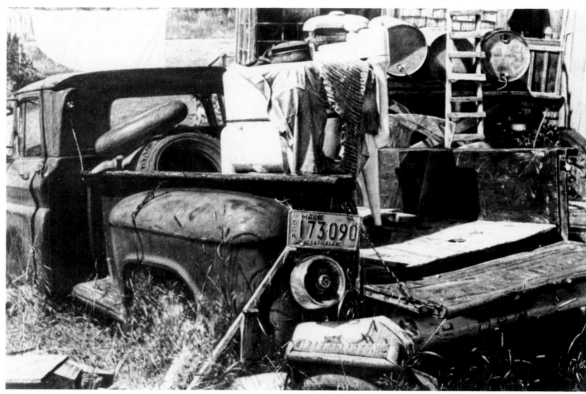

841. *Maine Pickup.* 1974 (67). Watercolor on paper, 23 x 30". Private collection, New York

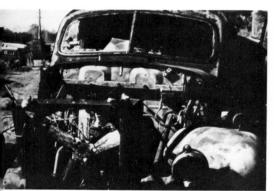

842. *Truck in Wrecking Yard.* 1972 (47).
Watercolor on paper, 14 x 20".
Sidney and Frances Lewis Foundation, Va.

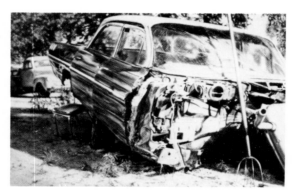

843. *Wreck with Pitchfork.* 1972 (49).
Watercolor on paper, 12½ x 19".
Richard Brown Baker Collection, New York

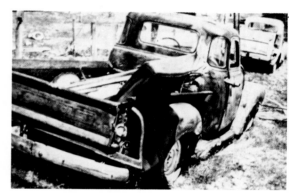

844. *Two Pickups.* 1972 (50).
Watercolor on paper, 12¾ x 19".
Private collection

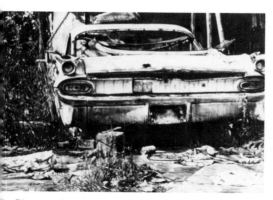

845. *Pioneer Pontiac.* 1973 (52).
Watercolor on paper, 22½ x 30".
Collection Bo Alvaryd, Sweden

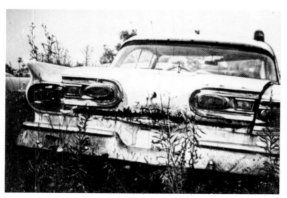

846. *Fairlane in Weeds.* 1974 (62).
Watercolor on paper, 11⅞ x 17⅝".
Private collection, New York

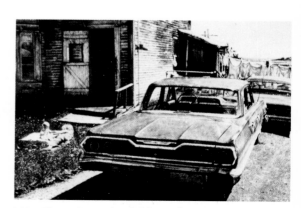

847. *Chevrolet with Children Playing.* 1976 (82).
Watercolor on paper, 11½ x 17½".
Galerie de Gestlo, Hamburg

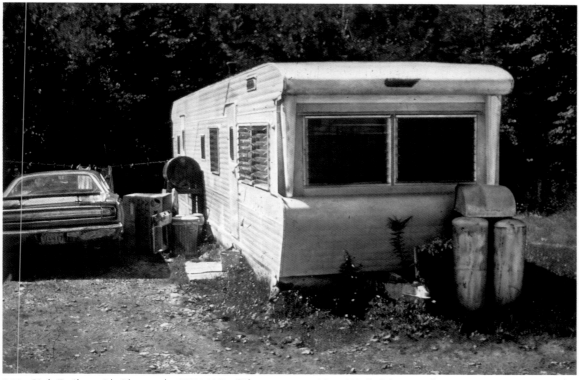

848. *Pink Trailer with Plymouth.* 1974 (65). Oil on canvas, 43 x 63½". Private collection

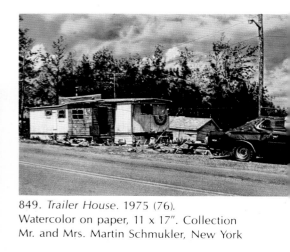

849. *Trailer House.* 1975 (76). Watercolor on paper, 11 x 17". Collection Mr. and Mrs. Martin Schmukler, New York

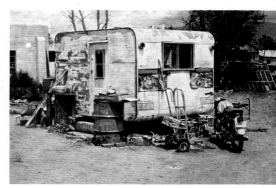

850. *White Trailer House.* 1976 (81). Watercolor on paper, 16⅛ x 19¾". Collection the artist

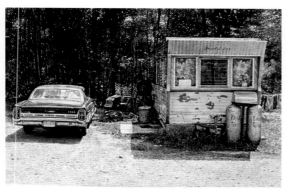

851. *Ford with Great Lakes Trailer.* 1975 (75). Watercolor on paper, 12 x 17". Private collection, New York

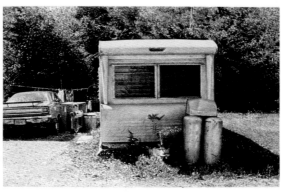

852. *Pink Trailer with Gas Tanks.* 1976 (85). Watercolor on paper, 10¾ x 16". Collection John C. Davis, Ky.

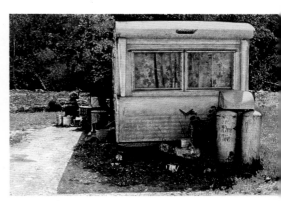

853. *Pink Trailer in Sunlight.* 1976 (83). Watercolor on paper, 11½ x 17". Morgan Gallery, Kans.

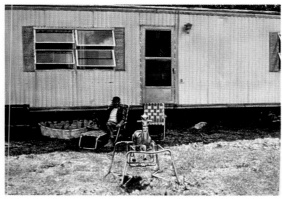

854. *Trailer with Rocking Horse.* 1974–75 (69). Watercolor on paper, 22½ x 29½". Collection Mr. and Mrs. Robert H. Mann, Kans.

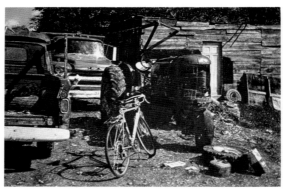

855. *Tractor and Bicycle.* 1977–78 (91). Watercolor on paper, 11 x 16½". Private collection, Switzerland

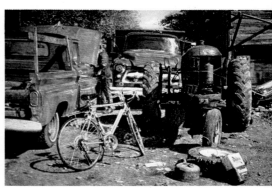

856. *Yellow Bicycle.* 1976 (80). Watercolor on paper, 12 x 17½". Private collection, New York

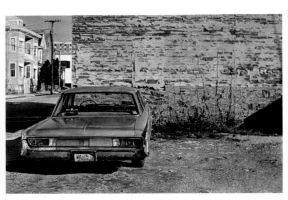

857. *Blue Chrysler with Brick Wall.* 1978 (92).
Watercolor on paper, 12 x 17¼".
Collection the artist

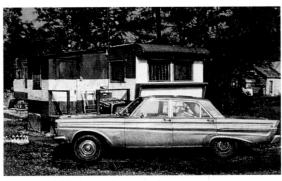

858. *Red Trailer with Porch.* 1977 (89).
Watercolor on paper, 15½ x 24½".
Collection Mr. and Mrs. Nathan Gelfman, New York

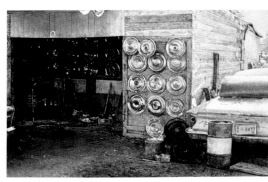

859. *Garage with Hubcaps.* 1976 (84).
Watercolor on paper, 10 x 15".
Morgan Gallery, Kans.

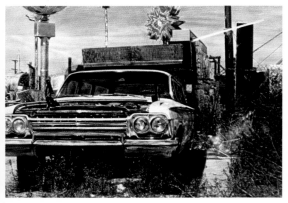

860. *Orange Sunburst Wreck.* 1973 (56).
Watercolor on paper, 22½ x 30".
Galerie de Gestlo, Hamburg

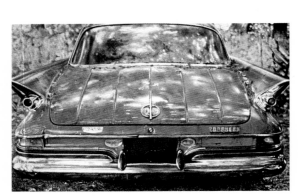

861. *Red Chrysler, Rear View.* 1975 (73).
Watercolor on paper, 12 x 17".
Private collection

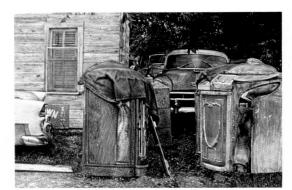

862. *Jukeboxes.* 1973 (55).
Watercolor on paper, 22½ x 30".
Collection M. T. Cohen/S. J. Gallé, New York

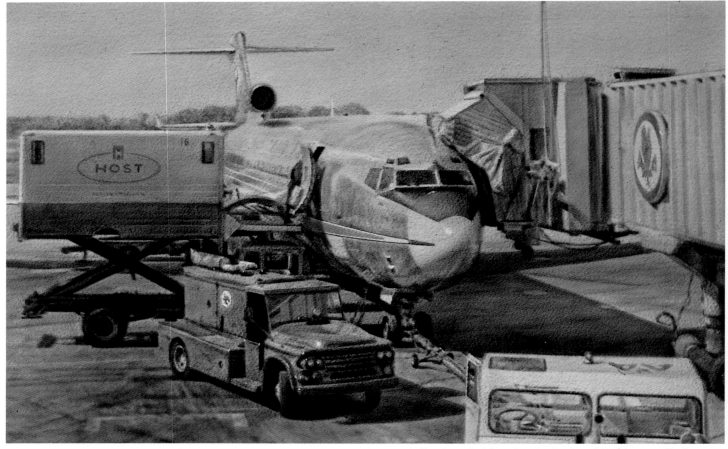

863. *Airport.* 1973 (57). Watercolor on paper, 22½ x 30". Stuart M. Speiser Collection, Smithsonian Institution, Washington, D.C.

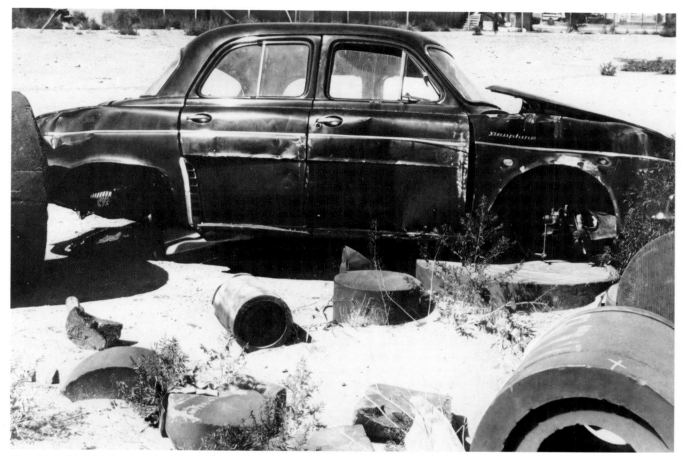

864. *Dauphine in Desert.* 1974 (66). Oil on canvas, 45 x 67". Private collection, Calif.

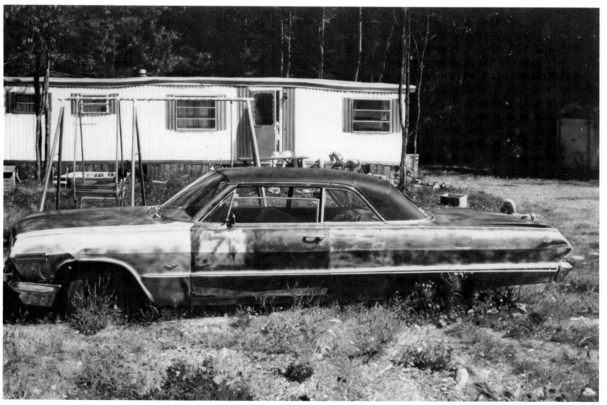

865. *Purple Impala.* 1973 (60). Oil on canvas, 43½ x 64". Private collection, New York

BIOGRAPHY

1937 Born: Birmingham, England

EDUCATION
 Birmingham College of Art, England
 Slade School of Fine Arts, London

DEGREES AND AWARDS
1960 Diploma in Fine Arts, London
1967 National Diploma in Design
 Fellowship, Maryland Institute College
1967–68 Postgraduate Scholarship, Birmingham
1968 Michigan University, Purchase Award
1969 M.F.A., Maryland Institute College

SOLO EXHIBITIONS
1965 Ikon Gallery, Birmingham, England
1966 Lion Gallery, Stourbridge, England
 Birmingham University, England
1967 Ikon Gallery, Birmingham, England
1969 Zabriskie Gallery, New York
1970 Gertrude Kasle Gallery, Detroit
 O. K. Harris Gallery, New York
1972 Galerie de Gestlo, Hamburg
1973 O. K. Harris Gallery, New York
1974 Galerie de Gestlo, Hamburg
1975 Ikon Gallery, Birmingham, England

SELECTED GROUP EXHIBITIONS
1966 A. I. A. Gallery, London
 Arts Council, Belfast and Dublin
 Drian Gallery, London
 John Moore Gallery, Liverpool
1968 Academy of the Arts, Easton, Md.
 Baltimore Museum of Art
 Western Michigan University, Kalamazoo
1969 Dallas Museum of Fine Arts
 Delaware Art Museum, Wilmington
 Lowe Art Museum, University of Miami, Coral Gables, Fla.
 Rhode Island School of Design, Providence, R.I.
 Visual Arts Gallery, New York
1970 "American Painting 1970," Virginia Museum of Fine Arts, Richmond
 "Cool Realism," Albright-Knox Art Gallery, Buffalo, N.Y.
 "Cool Realism," Everson Museum of Art, Syracuse, N.Y.
 "The Cool Realists," Jack Glenn Gallery, Corona del Mar, Calif.
 "The Highway," Institute of Contemporary Art, University of
 Pennsylvania, Philadelphia; Institute for the Arts, Rice University,
 Houston; Akron Art Institute, Ohio
 Jerrold Morris Gallery, Toronto
 "Painting and Sculpture Today, 1970," Indianapolis Museum of Art
1971 "Arts Festival, 1971," Dowling College, Oakdale, N.Y.
 "Aspects of Current Painting," University of Rochester, N.Y.
 "Die Metamorphose des Dinges," Palais des Beaux-Arts, Brussels
 "Neue amerikanische Realisten," Galerie de Gestlo, Hamburg
 "New Realism," Brainerd Hall Art Gallery, State University College,
 Potsdam, N.Y.
 Purdue University, Lafayette, Ind.
 "Radical Realism," Museum of Contemporary Art, Chicago
 "Septième Biennale de Paris," Paris
 "The Shape of Realism," Deson-Zaks Gallery, Chicago
 "Spray," Santa Barbara Museum of Art
1972 "Documenta 5," Kassel, West Germany
 "L'Hyperréalistes américains," Galerie des Quatre Mouvements, Paris
 "Neue Realisten," Westfalischer KV, Münster
 "Phases of the New Realism," Lowe Art Museum, University of Miami,
 Coral Gables, Fla.
 "The Realist Revival," New York Cultural Center, New York
 "Relativizing Realism," Stedelijk van Abbemuseum, Eindhoven,
 Netherlands
 "Sharp-Focus Realism," Sidney Janis Gallery, New York
 "Thirty-two Realists," Cleveland Institute of Art

1972–73 "Amerikanischer Fotorealismus," Württembergischer Kunstverein,
 Stuttgart; Frankfurter Kunstverein, Frankfurt; Kunst und
 Museumsverein, Wuppertal, West Germany
1973 "Amerikanske realister," Randers Kunstmuseum, Randers, Denmark;
 Lunds Konsthall, Lund, Sweden
 "The Emerging Real," Storm King Art Center, Mountainville, N.Y.
 "Grands maîtres hyperréalistes américains," Galerie des Quatre
 Mouvements, Paris
 "Hyperréalistes américains," Galerie Arditti, Paris
 "Image, Reality, and Superreality," Arts Council of Great Britain
 traveling exhibition
 "Iperrealisti americani," Galleria La Medusa, Rome
 "Mit Kamera, Pinsel und Spritzpistole," Ruhrfestspiele Recklinghausen,
 Städtische Kunsthalle, Recklinghausen, West Germany
 "Options 73/30," Contemporary Arts Center, Cincinnati
 "Photo-Realism," Serpentine Gallery, London
 "Realism Now," Katonah Gallery, Katonah, N.Y.
 "The Super-Realist Vision," DeCordova and Dana Museum, Lincoln,
 Mass.
1973–74 "Hyperréalisme," Galerie Isy Brachot, Brussels
 "Kunst nach Wirklichkeit," Kunstverein Hannover, West Germany
1973–78 "Photo-Realism 1973: The Stuart M. Speiser Collection," traveling
 exhibition: Louis K. Meisel Gallery, New York; Herbert F. Johnson
 Museum of Art, Ithaca, N.Y.; Memorial Art Gallery of the University
 of Rochester, N.Y.; Addison Gallery of American Art, Andover,
 Mass.; Allentown Art Museum, Pa.; University of Colorado
 Museum, Boulder; University Art Museum, University of Texas,
 Austin; Witte Memorial Museum, San Antonio, Tex.; Gibbes Art
 Gallery, Charleston, S.C.; Brooks Memorial Art Gallery, Memphis,
 Tenn.; Krannert Art Museum, University of Illinois, Champaign-
 Urbana; Helen Foresman Spencer Museum of Art, University of
 Kansas, Lawrence; Paine Art Center and Arboretum, Oshkosh, Wis.;
 Edwin A. Ulrich Museum, Wichita State University, Kans.; Tampa
 Bay Art Center, Tampa, Fla.; Rice University, Sewall Art Gallery,
 Houston; Tulane University Art Gallery, New Orleans; Smithsonian
 Institution, Washington, D.C.
1974 "Amerikaans fotorealisme grafiek," Hedendaagse Kunst, Utrecht; Palais
 des Beaux-Arts, Brussels
 "Ars '74 Ateneum," Fine Arts Academy of Finland, Helsinki
 "Art 5 '74," Basel, Switzerland
 "Choice Dealers/Dealers' Choice," New York Cultural Center, New
 York
 "Contemporary American Paintings from the Lewis Collection,"
 Delaware Art Museum, Wilmington
 "Hyperréalistes américains—réalistes européens," Centre National
 d'Art Contemporain, Paris
 "Kijken naar de werkelijkheid," Museum Boymans–van Beuningen,
 Rotterdam
 "New Photo-Realism," Wadsworth Atheneum, Hartford, Conn.
 "Tokyo Biennale, '74," Tokyo Metropolitan Museum of Art; Kyoto
 Municipal Museum; Aichi Prefectural Art Museum, Nagoya
 "Works on Paper," Virginia Museum of Fine Arts, Richmond
1975 O. K. Harris Gallery, New York
 "Realismus und Realität," Kunsthalle, Darmstadt, West Germany
 "Richard Brown Baker Collects," Yale University Art Gallery, New
 Haven, Conn.
 "Watercolors and Drawings—American Realists," Louis K. Meisel
 Gallery, New York
 "Wreck—A Tragic Romantic Theme," C. W. Post Art Gallery, Long
 Island University, Greenvale, N.Y.
1975–76 "Painting, Drawing and Sculpture of the 60s and 70s from the Dorothy
 and Herbert Vogel Collection," Institute of Contemporary Art,
 University of Pennsylvania, Philadelphia; Contemporary Arts
 Center, Cincinnati
 "Photo-Realism, American Painting and Prints," New Zealand traveling
 exhibition: Barrington Gallery, Auckland; Robert McDougall Art
 Gallery, Christchurch; Academy of Fine Arts, National Art Gallery,
 Wellington; Dunedin Public Art Gallery, Dunedin; Govett-Brewster
 Art Gallery, New Plymouth; Waikato Art Museum, Hamilton
 "Super Realism," Baltimore Museum of Art

1976 "American Master Drawings and Watercolors (Works on Paper from Colonial Times to the Present)," Whitney Museum of American Art, New York

"Art 7 '76," Basel, Switzerland

"Contemporary Images in Watercolor," Akron Art Institute, Ohio; Indianapolis Museum of Art; Memorial Art Gallery of the University of Rochester, N.Y.

"Works on Paper," Galerie de Gestlo, Hamburg

1976–78 "Aspects of Realism," traveling exhibition sponsored by Rothman's of Pall Mall Canada, Ltd.: Stratford, Ont.; Centennial Museum, Vancouver, B.C.; Glenbow-Alberta Institute, Calgary, Alta.; Mendel Art Gallery, Saskatoon, Sask.; Winnipeg Art Gallery, Man.; Edmonton Art Gallery, Alta.; Art Gallery, Memorial University of Newfoundland, St. John's; Confederation Art Gallery and Museum, Charlottetown, P.E.I.; Musée d'Art Contemporain, Montreal; Dalhousie University Museum and Gallery, Halifax, N.S.; Windsor Art Gallery, Ont.; London Public Library and Art Museum and McIntosh Memorial Art Gallery, University of Western Ontario; Art Gallery of Hamilton, Ont.

1977 "New Realism," Jacksonville Art Museum, Fla.

"Works on Paper II," Louis K. Meisel Gallery, New York

1978 "Art and the Automobile," Flint Institute of Arts, Mich. Monmouth Museum, Lincroft, N.J.

"Photo-Realist Printmaking," Louis K. Meisel Gallery, New York

1979 "America in the 70s As Depicted by Artists in the Richard Brown Baker Collection," Meadowbrook Art Gallery, Oakland University, Rochester, Mich.

"Auto-Icons," Whitney Museum of American Art, Downtown Branch, New York

"Selections from the Collection of Richard Brown Baker," Squibb Gallery, Princeton, N.J.

"Selections of Photo-Realist Paintings from N.Y.C. Galleries," Southern Alleghenies Museum of Art, St. Francis College, Loretto, Pa.

SELECTED BIBLIOGRAPHY

CATALOGUES

Brown, Denise Scott, and Venturi, Robert. Introduction to *The Highway.* Institute of Contemporary Art, University of Pennsylvania, Philadelphia, Jan. 14–Feb. 25, 1970; Institute for the Arts, Rice University, Houston, Mar. 12–May 18, 1970; Akron Art Institute, Ohio, June 5–July 16, 1970.

Selz, Peter. Introduction to *American Painting 1970.* Foreword by James M. Brown. Virginia Museum of Fine Arts, Richmond, May 4–June 7, 1970.

Warrum, Richard L. Introduction to *Painting and Sculpture Today, 1970.* Foreword by Robert J. Rohn. Indianapolis Museum of Art, May, 1970.

Goldsmith, Benedict. *New Realism.* Brainerd Hall Art Gallery, State University College, Potsdam, N.Y., Nov. 5–Dec. 12, 1971.

Internationale Kunst U. Informationsmesse. Belgisches Haus Volkshochschule, Cologne, Oct. 5–10, 1971.

Karp, Ivan C. Introduction to *Radical Realism.* Museum of Contemporary Art, Chicago, May 22–June 4, 1971.

Mills, Paul C. Introduction to *Spray.* Santa Barbara Museum of Art, Apr. 24–May 30, 1971.

Septième Biennale de Paris. No. 7, Paris, 1971.

Abadie, Daniel. Introduction to *Hyperréalistes américains.* Galerie des Quatre Mouvements, Paris, Oct. 25–Nov. 25, 1972.

Amman, Jean Christophe. Introduction to *Documenta 5.* Neue Galerie and Museum Fridericianum, Kassel, West Germany, June 30–Oct. 8, 1972.

Baratte, John J., and Thompson, Paul E. *Phases of the New Realism.* Lowe Art Museum, University of Miami, Coral Gables, Fla., Jan. 20–Feb. 20, 1972.

Janis, Sidney. Introduction to *Sharp-Focus Realism.* Sidney Janis Gallery, New York, Jan. 6–Feb. 4, 1972.

Burton, Scott. *The Realist Revival.* New York Cultural Center, New York, Dec. 6, 1972–Jan. 7, 1973.

Schneede, Uwe, and Hoffman, Heinz. Introduction to *Amerikanischer Fotorealismus.* Württembergischer Kunstverein, Stuttgart, Nov. 16–Dec. 26, 1972; Frankfurter Kunstverein, Frankfurt, Jan. 6–Feb. 18, 1973; Kunst und Museumsverein, Wuppertal, West Germany, Feb. 25–Apr. 8, 1973.

Alloway, Lawrence. Introduction to *Photo-Realism.* Serpentine Gallery, London, Apr. 4–May 6, 1973.

Becker, Wolfgang. Introduction to *Mit Kamera, Pinsel und Spritzpistole.* Ruhrfestspiele Recklinghausen, Städtische Kunsthalle, Recklinghausen, West Germany, May 4–June 17, 1973.

Boulton, Jack. Introduction to *Options 73/30.* Contemporary Arts Center, Cincinnati, Sept. 25–Nov. 11, 1973.

C. A. B. S. Introduction to *Realisti iperrealisti.* Galleria La Medusa, Rome, Nov. 12, 1973.

Dali, Salvador. Introduction to *Grands maîtres hyperréalistes américains.* Galerie des Quatre Mouvements, Paris, May 23–June 25, 1973.

Hogan, Carroll Edwards. Introduction to *Hyperréalistes américains.* Galerie Arditti, Paris, Oct. 16–Nov. 30, 1973.

Iperrealisti americani. Galleria La Medusa, Rome, Jan. 2, 1973.

Lamagna, Carlo. Foreword to *The Super-Realist Vision.* DeCordova and Dana Museum, Lincoln, Mass., Oct. 7–Dec. 9, 1973.

Lucie-Smith, Edward. Introduction to *Image, Reality and Superreality.* Arts Council of Great Britain traveling exhibition, 1973.

Meisel, Louis K. *Photo-Realism 1973: The Stuart M. Speiser Collection.* New York, 1973.

Sims, Patterson. Introduction to *Realism Now.* Katonah Gallery, Katonah, N.Y., May 20–June 24, 1973.

Becker, Wolfgang. Introduction to *Kunst nach Wirklichkeit.* Kunstverein Hannover, West Germany, Dec. 9, 1973–Jan. 27, 1974.

Hyperréalisme. Galerie Isy Brachot, Brussels, Dec. 14, 1973–Feb. 9, 1974.

Amerikaans fotorealisme grafiek. Hedendaagse Kunst, Utrecht, Aug., 1974; Palais des Beaux-Arts, Brussels, Sept.–Oct., 1974.

Chase, Linda. "Photo-Realism." In *Tokyo Biennale 1974.* Tokyo Metropolitan Museum of Art; Kyoto Municipal Museum; Aichi Prefectural Art Museum, Nagoya, 1974.

Clair, Jean; Abadie, Daniel; Becker, Wolfgang; and Restany, Pierre. Introductions to *Hyperréalistes américains—réalistes européens.* Centre National d'Art Contemporain, Paris, Archives 11/12, Feb. 15–Mar. 31, 1974.

Cowart, Jack. *New Photo-Realism.* Wadsworth Atheneum, Hartford, Conn., Apr. 10–May 19, 1974.

Kijken naar de werkelijkheid. Museum Boymans–van Beuningen, Rotterdam, June 1–Aug. 18, 1974.

Sarajas-Korte, Salme. Introduction to *Ars '74 Ateneum.* Fine Arts Academy of Finland, Helsinki, Feb. 15–Mar. 31, 1974.

Walthard, Dr. Frederic P. Foreword to *Art 5 '74.* Basel, Switzerland, June 19–24, 1974.

Wyrick, Charles, Jr. Introduction to *Contemporary American Paintings from the Lewis Collection.* Delaware Art Museum, Wilmington, Sept. 13–Oct. 17, 1974.

Krimmel, Bernd. Introduction to *Realismus und Realität.* Foreword by H. W. Sabais. Kunsthalle, Darmstadt, West Germany, May 24–July 6, 1975.

Meisel, Susan Pear. *Watercolors and Drawings—American Realists.* Louis K. Meisel Gallery, New York, Jan., 1975.

Stebbins, Theodore E., Jr. Introduction to *Richard Brown Baker Collects.* Yale University Art Gallery, New Haven, Conn., Apr. 24–May 22, 1975.

Delahunty, Suzanne. Foreword to *Painting, Drawing and Sculpture of the 60s and 70s from the Dorothy and Herbert Vogel Collection.* Institute of Contemporary Art, University of Pennsylvania, Philadelphia, Oct. 7–Nov. 18, 1975; Contemporary Arts Center, Cincinnati, Dec. 17, 1975–Feb. 15, 1976.

Richardson, Brenda. Introduction to *Super Realism.* Baltimore Museum of Art, Nov. 18, 1975–Jan. 11, 1976.

Doty, Robert. *Contemporary Images in Watercolor.* Akron Art Institute, Ohio, Mar. 14–Apr. 25, 1976; Indianapolis Museum of Art, June 29–Aug. 8, 1976; Memorial Art Gallery of the University of Rochester, N.Y., Oct. 1–Nov. 11,

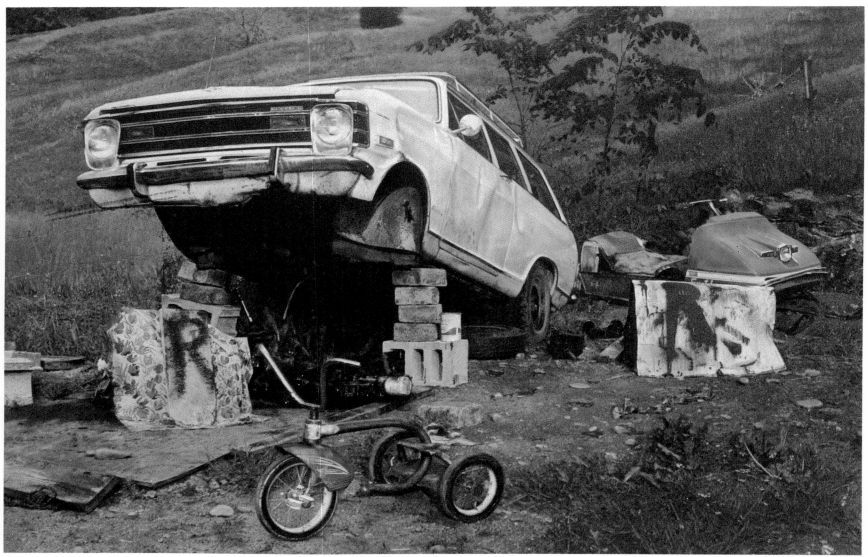

866. *Car on Cinder Blocks.* 1978 (93). Oil on canvas, 24 x 35¼". Collection the artist

1976.

Walthard, Dr. Frederic P. Introduction to *Art 7 '76.* Basel, Switzerland, June 16–21, 1976.

Chase, Linda. "U.S.A." In *Aspects of Realism.* Rothman's of Pall Mall Canada, Ltd., June, 1976–Jan., 1978.

Dempsey, Bruce. *New Realism.* Jacksonville Art Museum, Fla., 1977.

Hodge, G. Stuart. Foreword to *Art and the Automobile.* Flint Institute of Arts, Mich., Jan. 12–Mar. 12, 1978.

Meisel, Susan Pear. Introduction to *The Complete Guide to Photo-Realist Printmaking.* Louis K. Meisel Gallery, New York, Dec., 1978.

Baker, Richard Brown. Introduction to *Selections from the Collection of Richard Brown Baker.* Squibb Gallery, Princeton, N.J., Oct. 4–Nov. 4, 1979.

Stokes, Charlotte. "As Artists See It: America in the 70s." In *America in the 70s As Depicted by Artists in the Richard Brown Baker Collection,* Meadowbrook Art Gallery, Oakland University, Rochester, Mich., Nov. 18–Dec. 16, 1979.

ARTICLES

Canaday, John. "John Salt," *New York Times,* Oct. 3, 1969.

"Exhibition at Zabriskie Gallery," *ARTnews,* vol. 68, no. 87 (Nov., 1969).

"John Salt," *Arts Magazine,* vol. 44, no. 65 (Nov., 1969).

"John Salt," *Time,* Oct. 17, 1969.

Perreault, John. "Exhibition at Zabriskie Gallery," *Village Voice,* Oct. 2, 1969.

Glueck, Grace. "New York Gallery Notes," *Art in America,* vol. 58, no. 6 (Nov.–Dec., 1970).

Gruen, John. "John Salt," *New York Magazine,* Dec., 1970, p. 67.

Hackanson, Joy. "Exhibition, Gertrude Kasle Gallery," *Detroit Sunday News,* Oct. 18, 1970.

Perreault, John. "Art & . . . ," *Village Voice,* Nov. 26, 1970.

Ashton, Dore. "New York Commentary: Downtown, Uptown, All Around the Town," *Studio International,* vol. 181, no. 929 (Jan., 1971).

Battcock, Gregory. *Art and Artists,* vol. 5, no. 11 (Feb., 1971).

G. H. "Exhibition at O. K. Harris Gallery," *ARTnews,* vol. 69, no. 9 (Jan., 1971).

Marandel, J. Patrice. "Lettre de New York," *Art International,* vol. XV, no. 1 (Jan., 1971).

———. "The Deductive Image: Notes on Some Figurative Painters," *Art International,* Sept., 1971, pp. 58–61.

Pincus-Witten, Robert. "John Salt," *Artforum,* vol. IX, no. 5 (Jan., 1971), pp. 80–81.

Ratcliff, Carter. "New York Letter," *Art International,* vol. XV, no. 1 (Jan., 1971).

Sager, Peter. "Neue Formen des Realismus," *Magazin Kunst,* 4th Quarter, 1971, pp. 2512–16.

Borsick, Helen. "Realism to the Fore," *Cleveland Plain Dealer,* Oct. 8, 1972.

Chase, Linda; Foote, Nancy; and McBurnett, Ted. "The Photo-Realists: 12 Interviews," *Art in America,* vol. 60, no. 6 (Nov.–Dec., 1972), pp. 73–89.

"Die Documenta bestätigte sein Programm," *Die Welt* (Hamburg), no. 180 (Aug. 5, 1972).

"Exhibition at Galerie de Gestlo, Hamburg," *Die Welt* (Hamburg), Jan. 14, 1972.

"Les hommes et les oeuvres," *La Galerie,* no. 120 (Oct., 1972), pp. 16–17.

"L'Hyperréalisme ou le retour aux origines," *Argus de la Presse,* Oct. 16, 1972.

"Hyperréalistes américains," *Argus de la Presse,* Nov. 16, 1972.

Karp, Ivan. "Rent Is the Only Reality, or the Hotel Instead of the Hymn," *Arts Magazine,* Dec., 1972, pp. 47–51.

Kirkwood, Marie. "Art Institute's Exhibit Represents the Revolt Against Abstraction," *Ohio Sun Press,* Oct. 12, 1972.

Kurtz, Bruce. "Documenta 5: A Critical Preview," *Arts Magazine,* Summer, 1972, pp. 34–41.

Lerman, Leo. "Sharp-Focus Realism," *Mademoiselle,* Mar., 1972, pp. 170–73.

Levequi, J. J. "Les Hommes et les oeuvres," *Argus de la Presse,* Oct., 1972.

Lista, Giovanni. "Iperrealisti americani," *NAC* (Milan), no. 12 (Dec., 1972), pp. 24–25.

Marmori, Giancarlo di. "Piú vero del vero," *L'Espresso,* no. 29 (July 16, 1972), pp. 4–15.

Nemser, Cindy. "New Realism," *Arts Magazine,* Nov., 1972, p. 85.

"Novedades desde Paris," *El Dia,* Dec. 17, 1972.

Pozzi, Lucio. "Super realisti U.S.A.," *Bolaffiarte,* no. 18 (Mar., 1972), pp. 54–63.

Ratcliff, Carter. "New York Letter," *Art International,* vol. XVI, no. 3 (Mar., 1972), pp. 28–29.

Rosenberg, Harold. "The Art World," *The New Yorker,* Feb. 5, 1972, pp. 88–93.

Seitz, William C. "The Real and the Artificial: Painting of the New Environment," *Art in America,* vol. 60, no. 6 (Nov.–Dec., 1972), pp. 58–72.

Apuleo, Vito. "Tra manifesto e illustrazione sino al rifiuto della scelta," *La Voce Repubblicana,* Feb. 24, 1973, p. 5.

"Arts: les expositions à New York," *Argus de la Presse,* Jan. 4, 1973.

Becker, Wolfgang. "NY? Realisme?," *Louisiana Revy,* vol. 13, no. 3 (Feb., 1973).

Borden, Lizzie. "Reviews," *Artforum,* Oct., 1973.

Bovi, Arturo di. "Arte/Piú brutto del brutto," *Il Messaggiero,* Feb. 13, 1973, p. 3.

Chase, Linda. "Recycling Reality," *Art Gallery Magazine,* Oct., 1973, pp. 75–82.

Chase, Linda, and McBurnett, Ted. "Interviews with Robert Bechtle, Tom Blackwell, Chuck Close, Richard Estes and John Salt," *Opus International,* no. 44–45 (June, 1973), pp. 38–50.

E. D. G. "Arrivano gli iperrealisti," *Tribuna Letteraria,* Feb., 1973.

"European Galleries," *International Herald Tribune,* Feb. 17–18, 1973, p. 6.

"Foto Realismus," *IZW Illustrierte Wochenzeitung,* no. 14 (June, 1973). pp. 8–10.

Giannattasio, Sandra. "Riproduce la vita di ogni giorno la nuova pittura americano," *Avanti,* Feb. 8, 1973, p. 1.

Guercio, Antonio del. "Iperrealismo tra 'pop' e informale," *Rinascita,* no. 8 (Feb. 23, 1973), p. 34.

Hart, John. "A 'Hyperrealist' U.S. Tour at La Medusa," *Daily American* (Rome), Feb. 8, 1973.

"L'Hyperréalisme américain," *Le Monde des Grandes Musiques,* no. 2 (Mar.–Apr., 1973), pp. 4, 56–57.

Levin, Kim. "The New Realism: A Synthetic Slice of Life," *Opus International,* no. 44–45 (June, 1973), pp. 28–37.

Lucie-Smith, Edward. "Super Realism From America," *Illustrated London News,* Mar., 1973.

Maraini, Letizia. "Non fatevi sfuggire," *Il Globo,* Feb. 6, 1973, p. 8.

Marziano, Luciano. "Iperrealismo: la coagulazione dell'effimero," *Il Margutta* (Rome), no. 3–4 (Mar.–Apr., 1973).

Melikian, Souren. "Gauging the Prices of Contemporary Art," *International Herald Tribune,* Apr. 14–15, 1973.

Micacchi, Dario. "La ricerca degli iperrealisti," *Unità,* Feb. 12, 1973.

Mizue (Tokyo), vol. 8, no. 821 (1973).

Moulin, Raoul-Jean. "Hyperréalistes américains," *L'Humanité,* Jan. 16, 1973.

Perreault, John. "Art & . . . ," *Village Voice,* Mar. 15, 1973.

Rubiu, Vittorio. "Il gusto controverso degli iperrealisti," *Corriere della Sera,* Feb. 25, 1973.

Schjeldahl, Peter. "Exhibition at O. K. Harris 1973," *New York Times,* Mar. 18, 1973.

"Specialize and Buy the Best," *Business Week,* Oct. 27, 1973, p. 107.

Trucchi, Lorenza di. "Iperrealisti americani alla Medusa," *Momento-sera,* Feb. 9–10, 1973, p. 8.

Deroudille, René. "Réalistes et hyperréalistes," *Derrière Heure Lyonnaise,* Mar. 31, 1974.

"Expositions," *Argus de la Presse,* Mar., 1974.

Loring, John. "Photographic Illusionist Prints," *Arts Magazine,* Feb., 1974, pp. 42–43.

Moulin, Raoul-Jean. "Les Hyperréalistes américains et la neutralisation du réel," *L'Humanité,* Mar. 21, 1974.

Progresso fotografico, Dec., 1974, pp. 61–62.

Slipek, Edwin J., Jr. "Multi-Dimensional Works on Paper," *Richmond Mercury,* Oct. 23, 1974, p. 19.

Teyssedre, Bernard. "Plus vrai que nature," *Le Nouvel Observateur,* Feb. 25–Mar. 3, 1974, p. 59.

Virginia Museum of Fine Arts Bulletin, vol. XXXV, no. 1 (Sept., 1974).

Lucie-Smith, Edward. "The Neutral Style," *Art and Artists,* vol. 10, no. 5 (Aug., 1975), pp. 6–15.

"Photo-Realism Exhibit Is Opening at Paine Sunday," *Oshkosh Daily Northwestern,* Apr. 17, 1975.

"Photo-Realism Flies High at Paine," *Milwaukee Journal,* May, 1975.

"Photo-Realists at Paine," *View Magazine,* Apr. 27, 1975.

Rowan, Eric. "Artists Come to Terms with Landscape," *The Times* (London), Oct. 11, 1975.

Schjeldahl, Peter. "How to Explain the Flood of Realist Art," *New York Times,* Mar. 18, 1975.

Sutinen, Paul. "American Realism at Reed," *Willamette Week,* Sept. 12, 1975.

Chase, Linda. "Photo-Realism: Post Modernist Illusionism," *Art International,* vol. XX, no. 3–4 (Mar.–Apr., 1976), pp. 14–27.

K. M. "Realism," *New Art Examiner,* Nov., 1976.

Perreault, John. "Getting Flack," *Soho Weekly News,* Apr. 22, 1976, p. 19.

Greenwood, Mark. "Toward a Definition of Realism: Reflections on the Rothman's Exhibition," *Arts/Canada,* vol. XXIV, no. 210–11 (Dec., 1976–Jan., 1977), pp. 6–23.

Edelson, Elihu. "New Realism at Museum Arouses Mixed Feelings," *Jacksonville* (Fla.) *Journal,* Feb., 1977.

Bongard, Willie. *Art Aktuell* (Cologne), Apr., 1978.

Harris, Helen. "Art and Antiques: The New Realists," *Town and Country,* Oct., 1978, pp. 242, 244, 246–47.

"Photo Journalism and Photo-Realism," *Milwaukee Journal,* Dec. 10, 1978.

BOOKS

Hunter, Sam. *American Art of the Twentieth Century.* New York: Harry N. Abrams, 1972.

Kultermann, Udo. *New Realism.* New York: New York Graphic Society, 1972.

Brachot, Isy, ed. *Hyperréalisme.* Brussels: Imprimeries F. Van Buggenhoudt, 1973.

Sager, Peter. *Neue Formen des Realismus.* Cologne: Verlag M. DuMont Schauberg, 1973.

L'Iperrealismo italo Medusa. Rome: Romana Libri Alfabeto, 1974.

Calamandrei, Mauro, and Gorgoni, Gianfranco. *Art USA.* Milan: Fratelli Fabbri Editori, 1974.

Battcock, Gregory, ed. *Super Realism, A Critical Anthology.* New York: E. P. Dutton, 1975.

Chase, Linda. *Hyperréalisme.* New York: Rizzoli, 1975.

Kultermann, Udo. *Neue Formen des Bildes.* Tübingen, West Germany: Verlag Ernst Wasmuth, 1975.

Lucie-Smith, Edward. *Late Modern—The Visual Arts Since 1945.* 2d ed. New York: Praeger, 1975.

Honisch, Dieter, and Jensen, Jens Christian. *Amerikanische Kunst von 1945 bis Heute.* Cologne: DuMont Buchverlag, 1976.

Stebbins, Theodore E., Jr. *American Master Drawings and Watercolors.* New York: Harper & Row, 1976.

Billeter, Erika. *Malerei und Photographie im Dialog.* Zurich: Benteli, Verlag & Kunsthaus, 1977.

Lucie-Smith, Edward. *Art Now: From Abstract Expressionism to Superrealism.* New York: William Morrow, 1977.

———. *Super Realism.* Oxford: Phaidon, 1979.

Seeman, Helene Zucker, and Siegfried, Alanna. *SoHo.* New York: Neal-Schuman, 1979.

867. Ben Schonzeit at work

BEN SCHONZEIT

Among the youngest of the major Photo-Realists, Schonzeit is by far the most prolific, having painted well over two hundred works in the last eight years. He was one of the leaders in pioneering the use of the airbrush and is now one of its most proficient technicians. Most important, perhaps, is Schonzeit's artistic philosophy. More than for any other Photo-Realist, the camera and the photograph constitute an integral part of his work. He is probably the best photographer of the group and, in some respects, his photographs can and do stand on their own as works of art. While the others use the photograph as a tool, for Schonzeit the photo virtually shares an equality with the painting for which it is a study.

Schonzeit is unique in his composition and choice of subject matter. While most other Photo-Realists are clearly influenced by, and to some extent aligned with, Pop Art, Schonzeit seems to be more involved with Abstract Expressionist and color-field concerns. Some of his earlier works even reveal a touch of surrealist influence in their unusual juxtapositions. Although his work depicts prearranged still-life objects, it is difficult to term Schonzeit a still-life painter. His extreme enlargement and tight cropping of images remove the paintings from the realm of any still lifes we have ever seen and greatly enhance the abstract qualities of his work. In fact, Schonzeit chooses objects for their size, shape, and color and composes them before photo- graphing and painting in much the same manner that a color-field painter will select colors and forms for a painting.

The major difference between Schonzeit's work and true abstract painting does not lie in the realism of the forms but in the illusion of space and depth created by Schonzeit's strong interest in focus. Contrary to abstract doctrine, his works do not

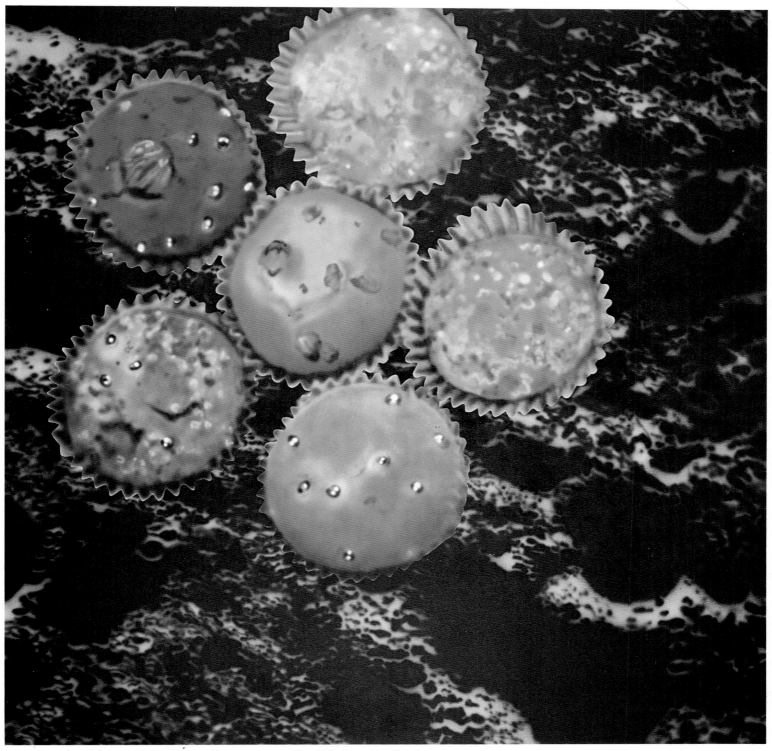

868. *Cupcakes (Moon)*. 1970 (26). Acrylic on canvas, 72 x 72". Private collection

appear flat on the surface, nor does he adhere to the theory of flat surfaces professed by such realists as Alex Katz and Jack Beal. His works are rounded, sculptured, and dimensional, breaking the picture plane. His mastery of masking in combination with the airbrush at times gives his work an appearance of collage, which adds to the illusion of a third dimension.

Ben Schonzeit had executed approximately 300 works by the end of 1979. We have illustrated 83 of these and have listed 104 more, accounting for about 90 percent of his true Photo-Realist paintings.

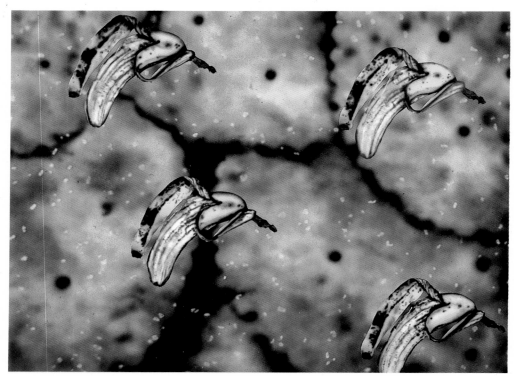

869. *Bananas (Ritz Crackers).* 1970 (16). Acrylic on canvas, 72 x 96". Private collection

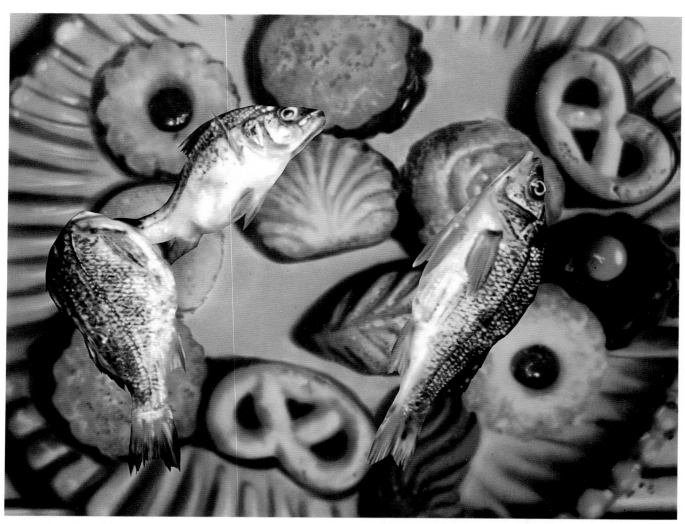

870. *Fish and Cookies.* 1970 (31). Acrylic on canvas, 42 x 54". Private collection

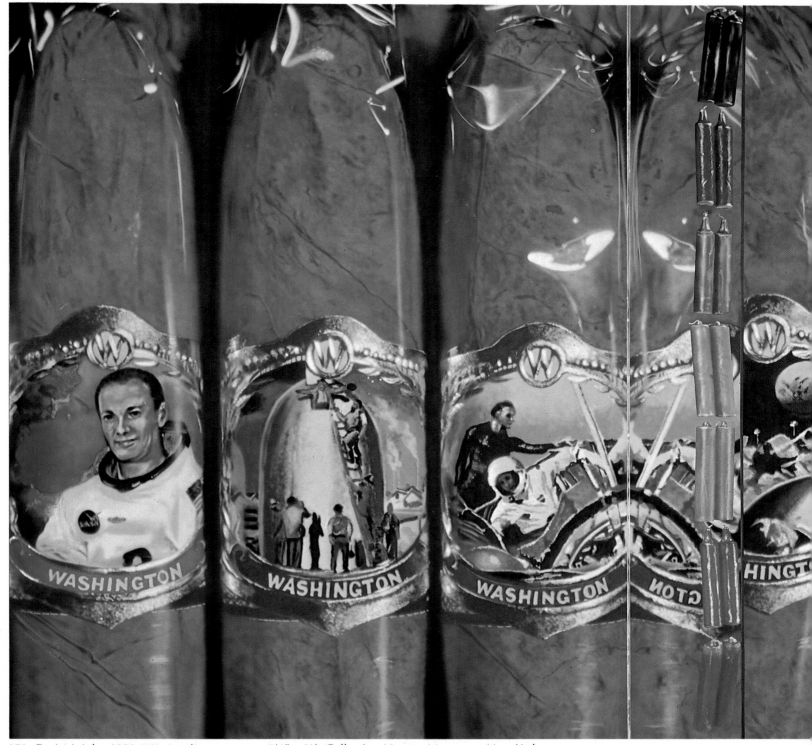

871. *Dr. Joe's Joke.* 1971 (68). Acrylic on canvas, 7'6" x 11'. Collection Monroe Meyerson, New York

872. *Large Cokes.* 1969 (6). Acrylic on canvas, 30 x 36".
Private collection

873. *Forty Coupons.* 1970 (32). Acrylic on canvas,
72 x 72". Private collection

874. *Lollipops and Gladioli*. 1970 (42). Acrylic on canvas, 60 x 84".
Private collection

875. *Two Men and a Lady*. 1970 (53). Acrylic on canvas, 72 x 96".
Galerie des Quatre Mouvements, Paris

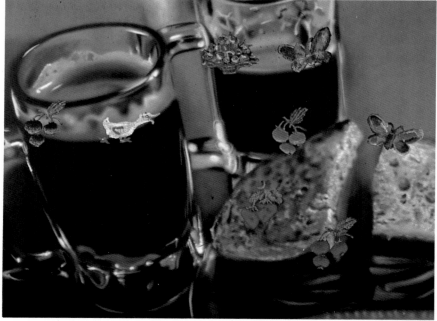

876. *Appliqués and Two Porters*. 1971 (59). Acrylic on canvas, 42 x 54".
Private collection

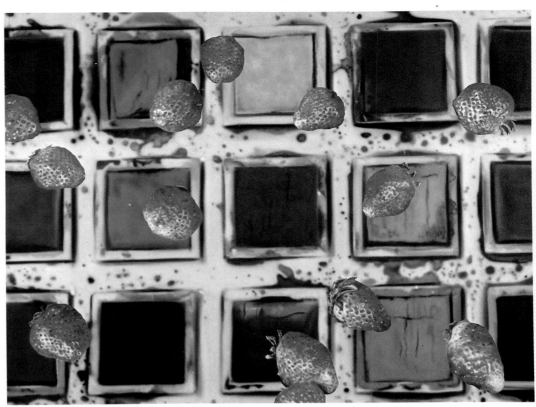

877. *Strawberries (Watercolors) II*. 1970 (51). Acrylic on canvas, 60 x 84". Private collection

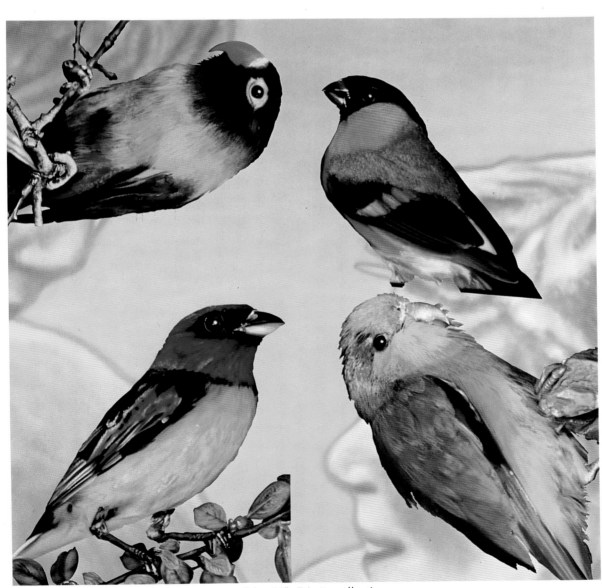

878. *Birdaid*. 1971 (60). Acrylic on canvas, 84 x 84". Private collection

879. *Fruit of the Month (F.O.T.M.).* 1972 (83).
Acrylic on canvas, 96 x 96".
Private collection

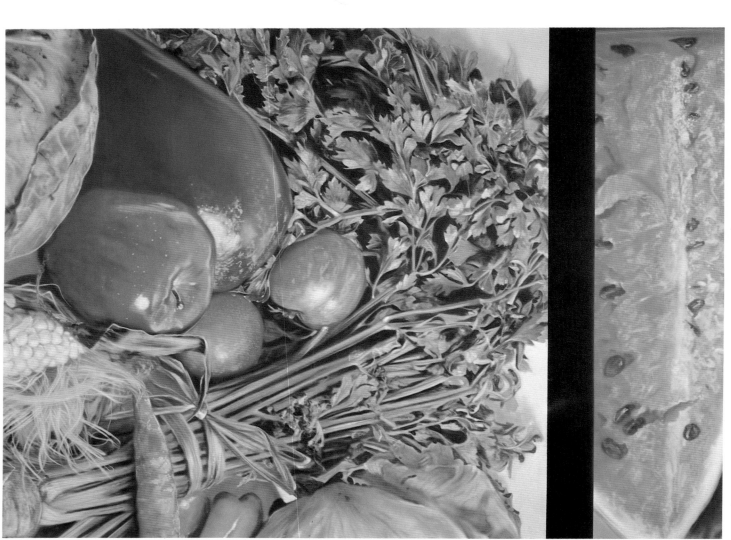

881. *Herb's Frames.* 1972 (85). Acrylic on canvas, 72 x 96". Private collection

Private collection

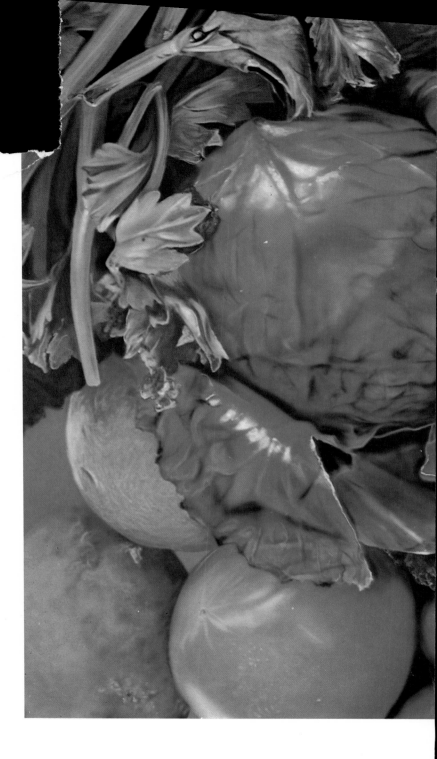

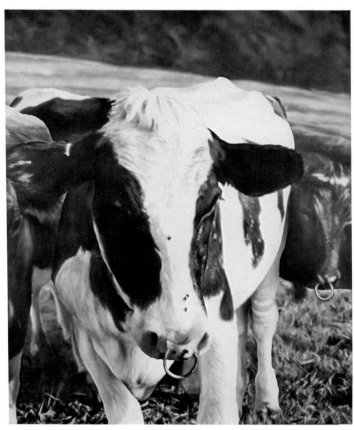

883. *Dairy Bull*. 1972 (81). Acrylic on canvas, 60 x 48".
Private collection

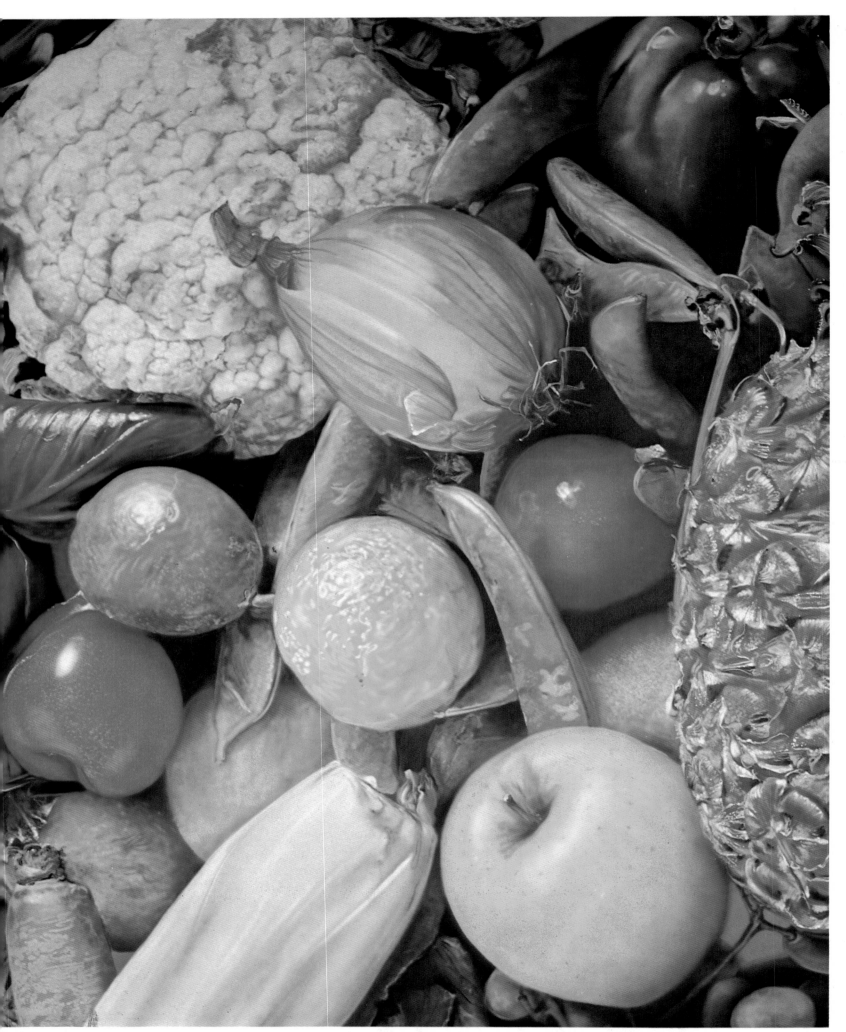

884. *Produce*. 1972 (87). Acrylic on canvas, 8' x 10'. Kunstmuseum, Basel. Gift of Dr. Marcus Kutter

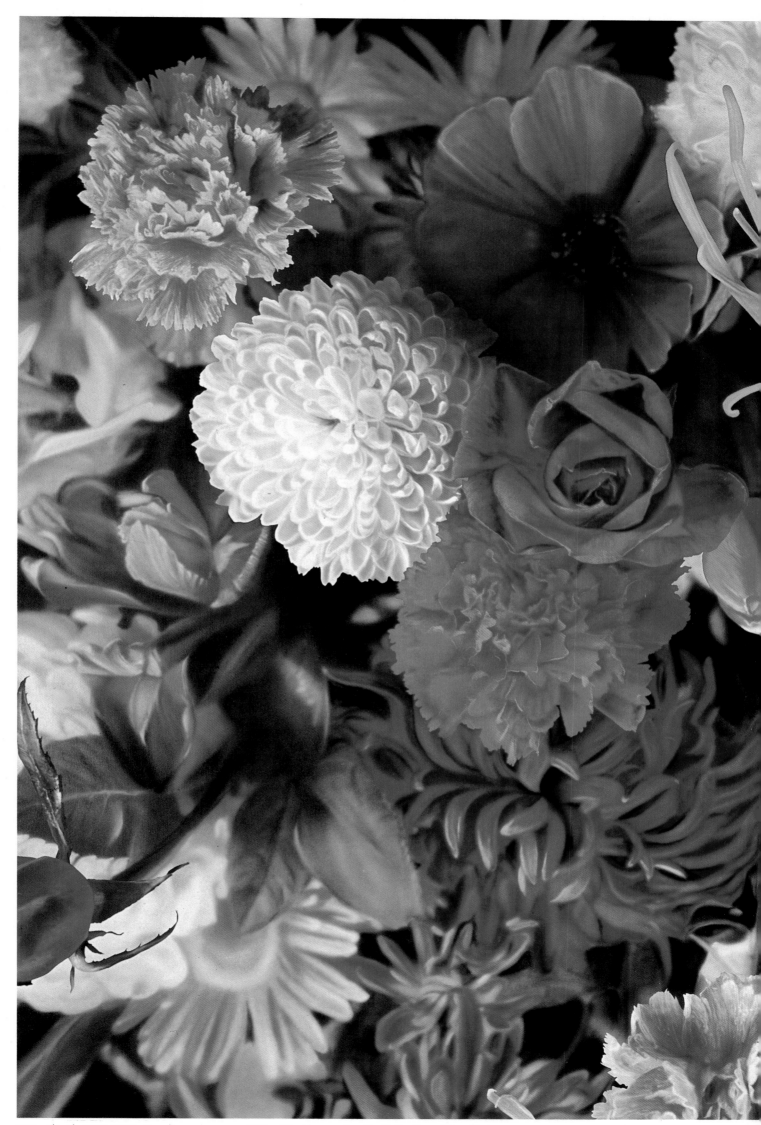

885. *Floral*. 1973 (102). Acrylic on canvas, 6'8" x 9'. Abrams Family Collection, New York

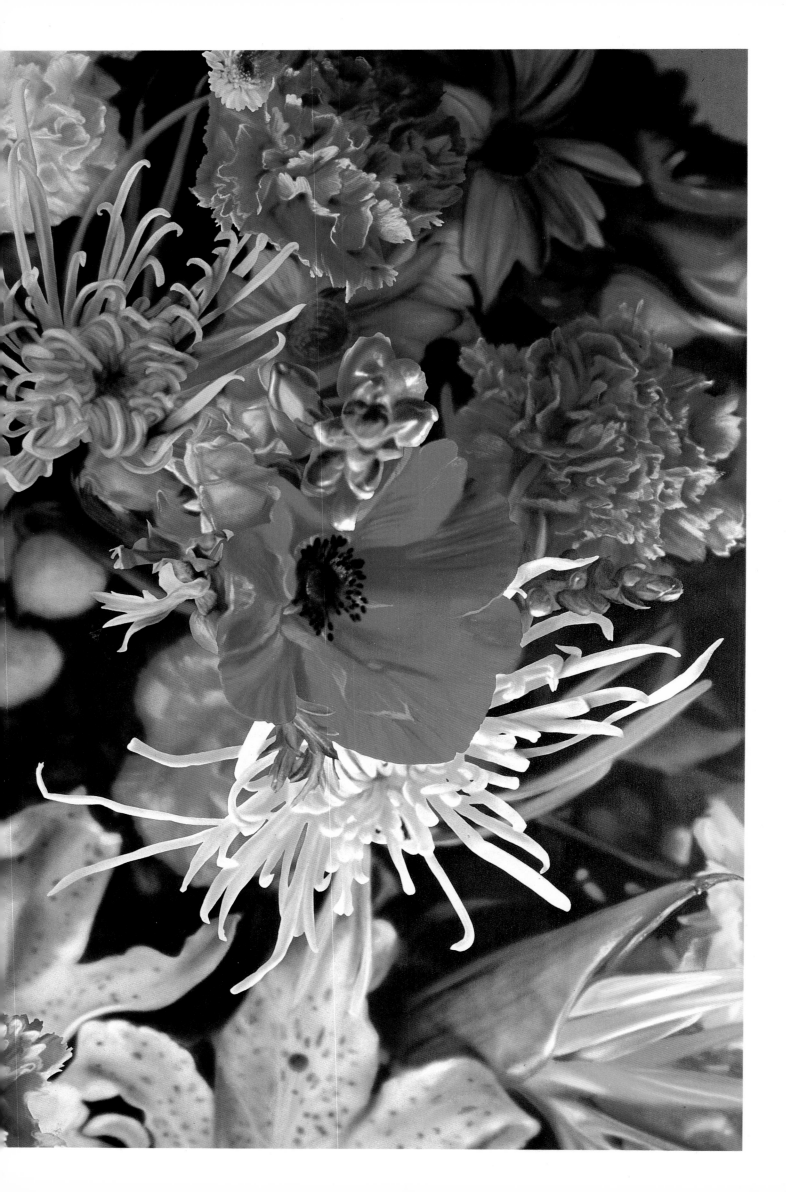

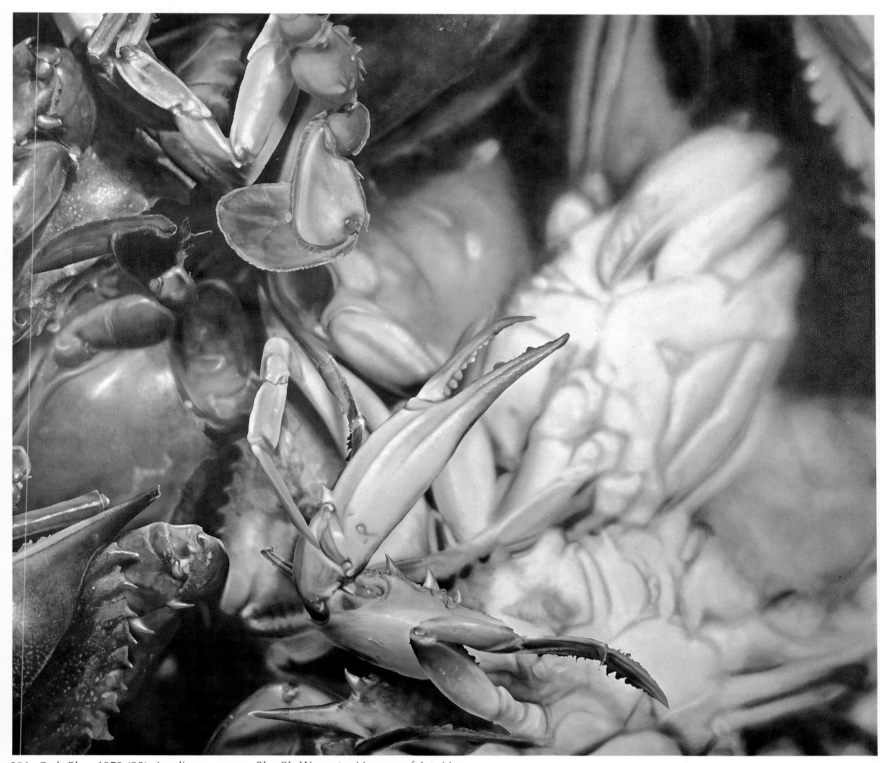

886. *Crab Blue*. 1973 (98). Acrylic on canvas, 8' x 9'. Worcester Museum of Art, Mass.

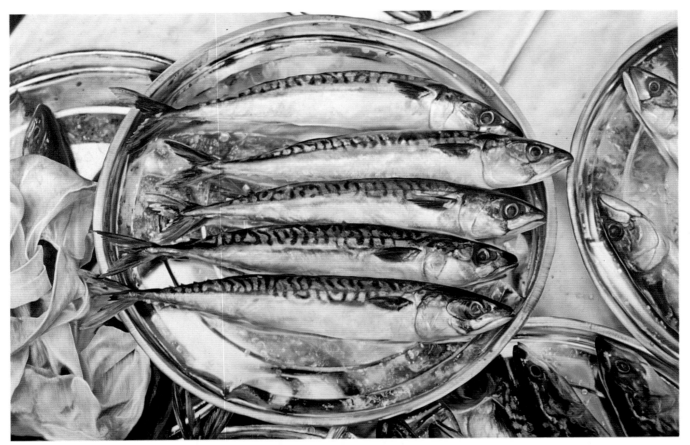

887. *Mackerel.* 1973 (110). Acrylic on canvas, 48 x 72". Art Appreciation Association, New York

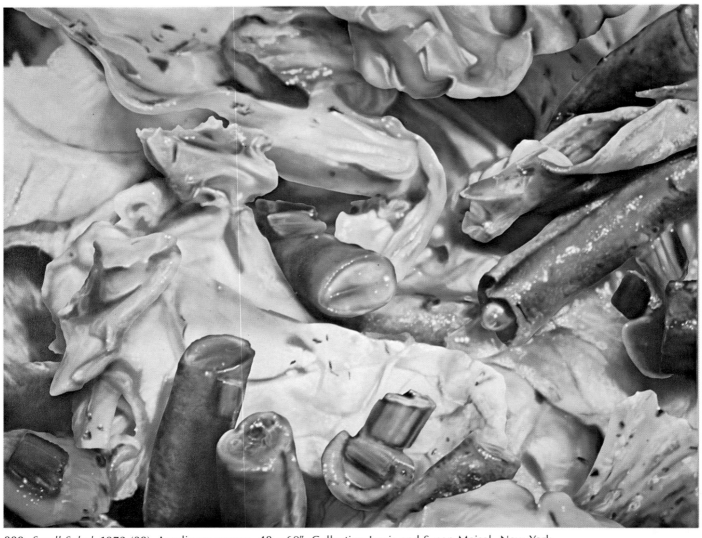

888. *Small Salad.* 1972 (88). Acrylic on canvas, 48 x 60". Collection Louis and Susan Meisel, New York

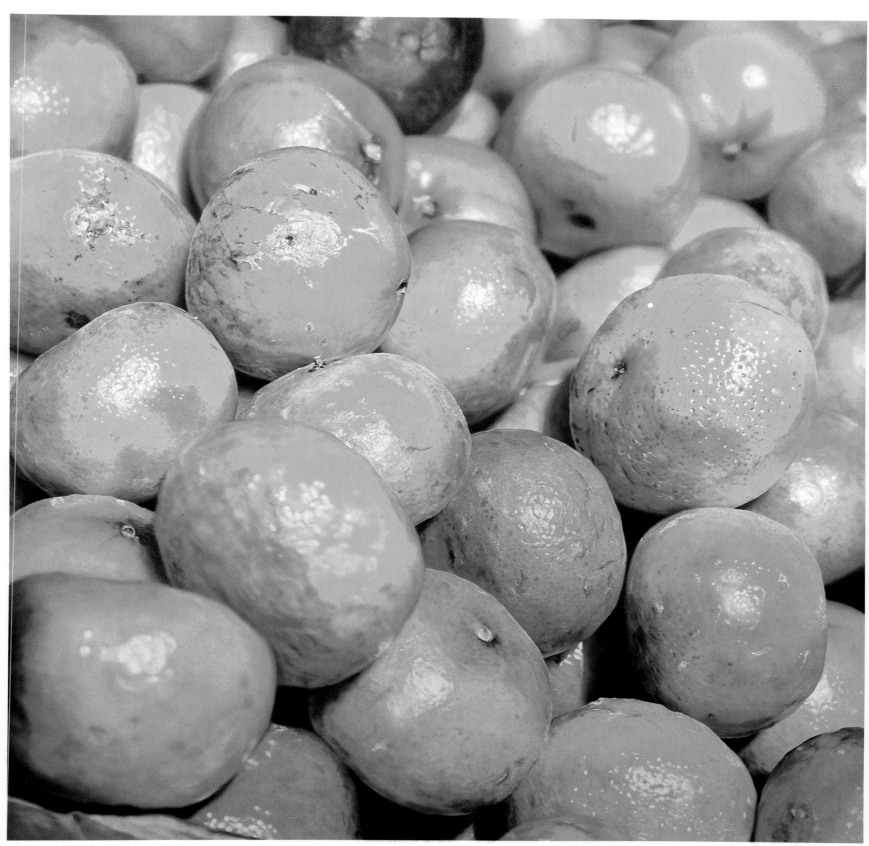

889. *Honey Tangerines*. 1974 (129). Acrylic on canvas, 72 x 72". Private collection, New York

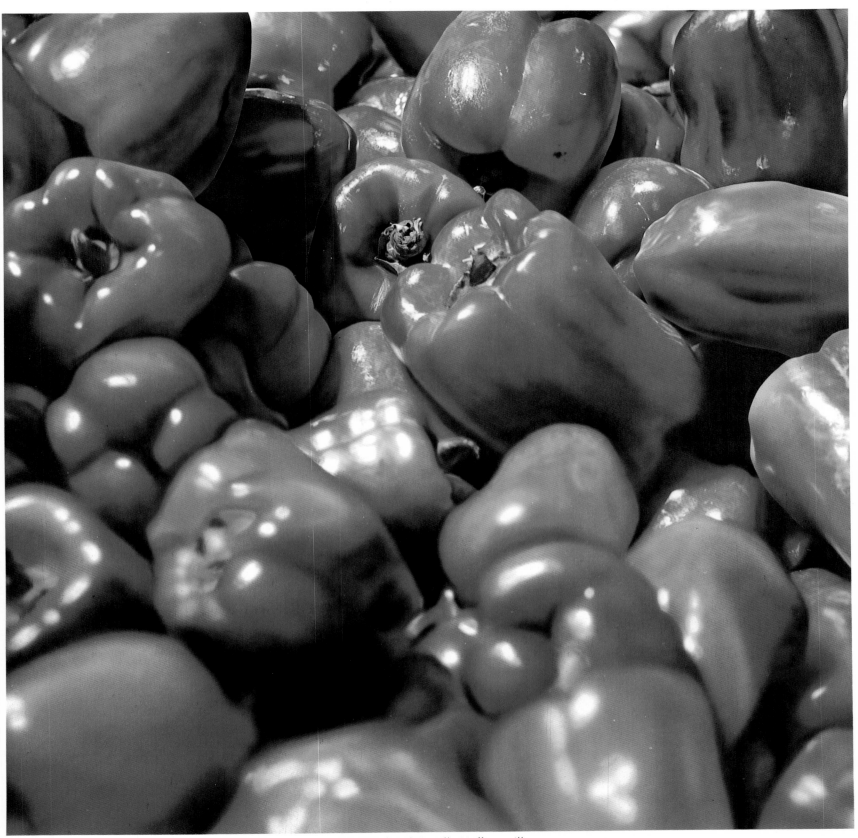

890. *Peppered.* 1974 (137). Acrylic on canvas, 72 x 72". Collection Paul and Camille Hoffman, Ill.

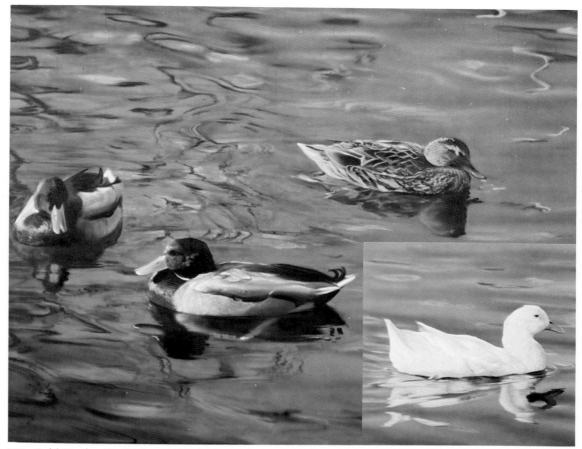

891. *Cold Duck—Duck View*. 1973 (97). Acrylic on canvas, 48 x 60". Galerie Mikro, West Berlin

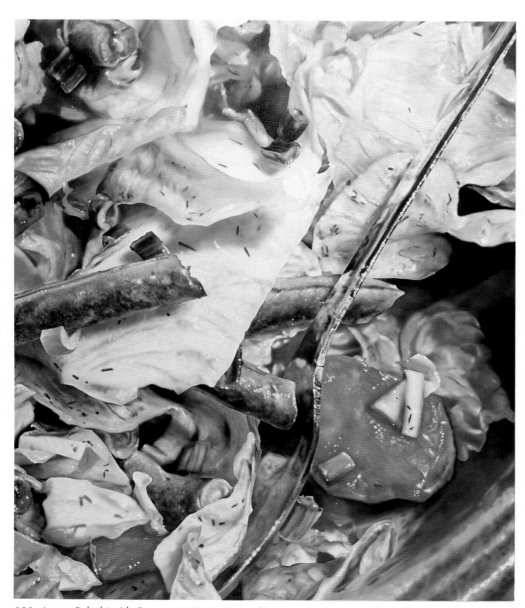

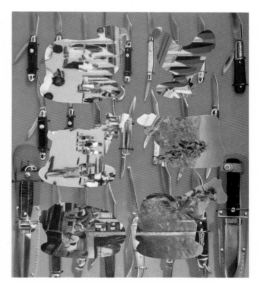

893. *Catalina Cutouts*. 1971 (65).
Acrylic on canvas, 84 x 72".
Galerie de Gestlo, Hamburg

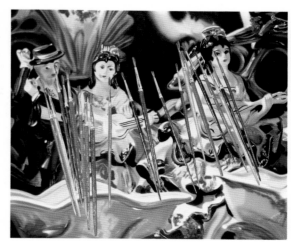

892. *Large Salad (with Spoon)*. 1972 (86). Acrylic on canvas, 72 x 60". Collection the artist

894. *Olé*. 1971 (73). Acrylic on canvas, 72 x 84".
Galerie Mikro, West Berlin

895. *Cauliflower.* 1975 (141). Acrylic on canvas, 84 x 84". Private collection, Conn.

896. *Tools (Drawing Tools)*. 1974 (138). Acrylic on canvas, 60 x 48". Private collection

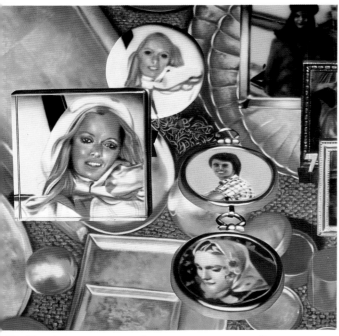

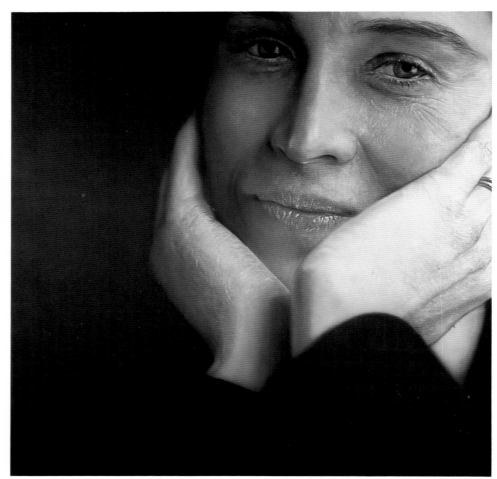

897. *Blond*. 1971 (61). Acrylic on canvas, 72 x 72".
Collection Daniel Filipacchi, New York

898. *Dione*. 1974 (126). Acrylic on canvas, 72 x 72". Private collection

900. *Charlie Parker, The Bird*. 1977 (178). Acrylic on canvas, 48 x 48". Collection Mr. and Mrs. Robert Krasnow, Calif.

899. *Joseph Giummo*. 1977 (180). Oil on canvas, 72 x 72". Collection the artist

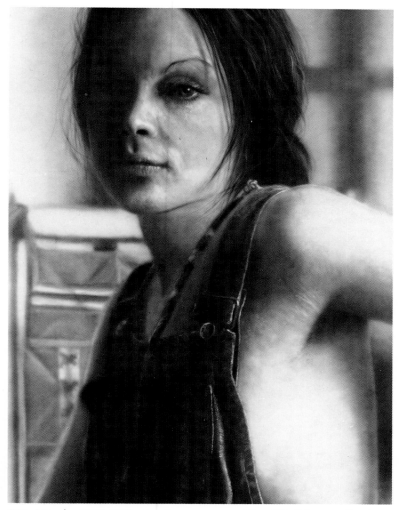

901. *Wanda.* 1973 (120). Acrylic on canvas, 80 x 60". Private collection

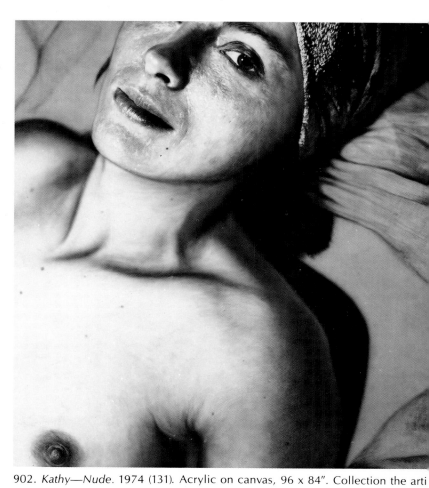

902. *Kathy—Nude.* 1974 (131). Acrylic on canvas, 96 x 84". Collection the arti

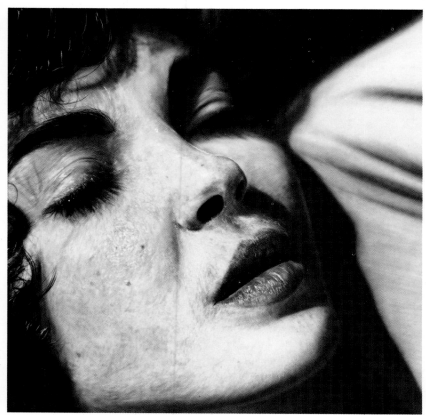

903. *Linda.* 1974 (134). Acrylic on canvas, 72 x 72". Collection the artist

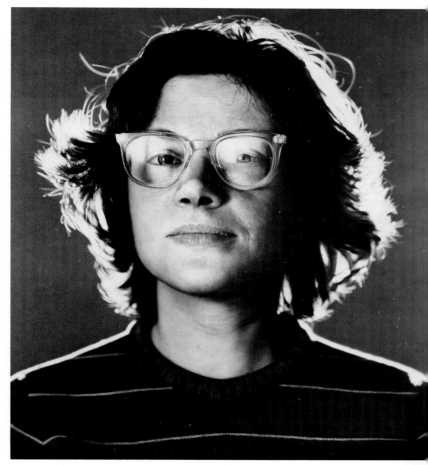

904. *Marcia.* 1975 (147). Acrylic on canvas, 84 x 96".
Winnipeg Art Gallery, Canada

418

905. *Daniel (Profile)*. 1976 (157).
Acrylic on canvas, 60 x 48".
Collection Daniel Filipacchi, New York

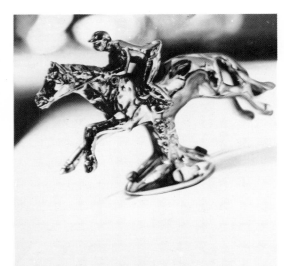

906. *Horse and Rider*. 1974 (130).
Acrylic on canvas, 72 x 72".
Galerie de Gestlo, Hamburg

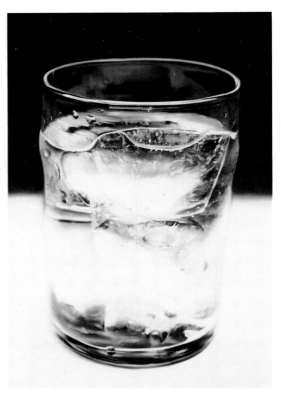

907. *Ice Water Glass*. 1973 (108).
Acrylic on canvas, 72 x 48".
Sydney and Frances Lewis Foundation, Va.

908. *Keys Study*. 1974 (133).
Acrylic on canvas, 72 x 72".
Collection the artist

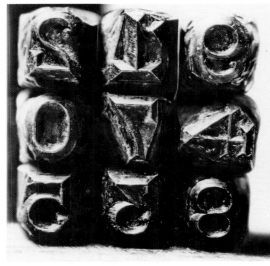

909. *Figure Painting*. 1975 (150).
Acrylic on canvas, 72 x 72".
Galerie de Gestlo, Hamburg

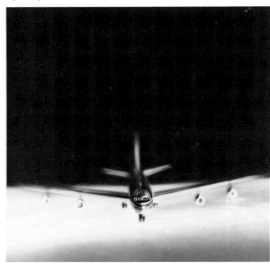

910. *Aviation Painting*. 1973 (93). Acrylic on
canvas, 72 x 72". Stuart M. Speiser Collection,
Smithsonian Institution, Washington, D.C.

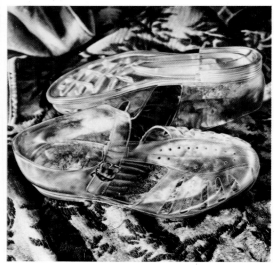

911. *Clear Jellies*. 1976 (155).
Acrylic on canvas, 84 x 84".
Kunstmuseum, Basel. Gift of Dr. Marcus Kutter

912. *Bergano's Table*. 1977 (175).
Acrylic on canvas, 36 x 36".
Collection Louis and Susan Meisel, New York

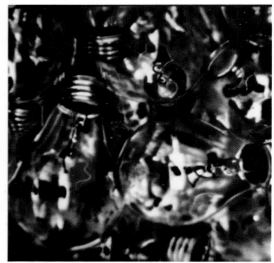

913. *Lightbulbs*. 1969 (9).
Acrylic on canvas, 36 x 36".
Private collection

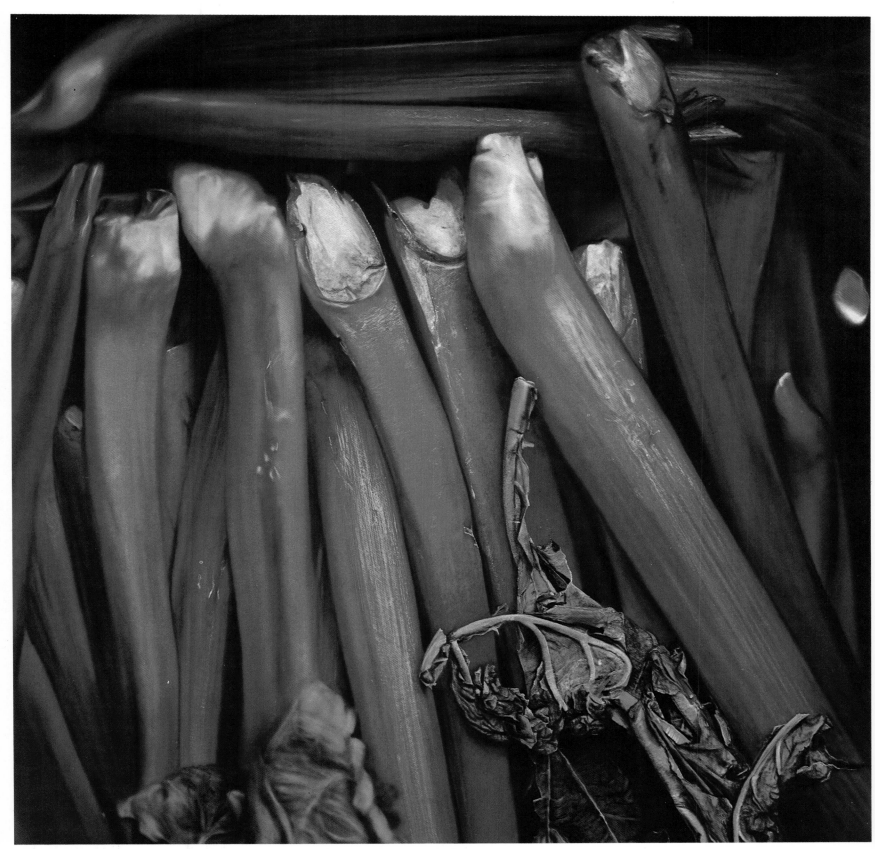

914. *Rhubarb*. 1975 (152). Acrylic on canvas, 60 x 60". Delaware Art Museum, Wilmington

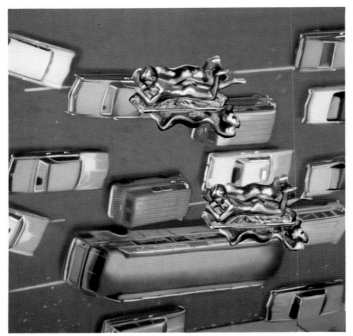

915. *Ashtrays (Third Ave.)*. 1970 (15). Acrylic on canvas,
60 x 60". Collection Monroe Meyerson, New York

916. *Diana (Geometric Figures with Rabbit)*. 1970 (34). Acrylic
on canvas, 60 x 84". Private collection

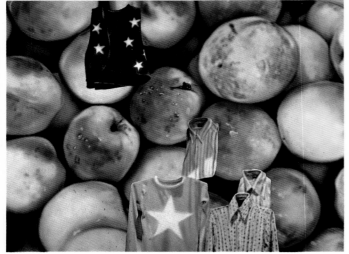

917. *Peaches and Shirts*. 1970 (46). Acrylic on canvas, 42 x 54".
Collection the artist

918. *Sugar*. 1972 (89). Acrylic on canvas, 8' x 10'.
Galerie de Gestlo, Hamburg

919. *Golden Delish*. 1971 (71). Acrylic on canvas, 60 x 72".
Galerie Mikro, West Berlin

920. *After the Hurricane*. 1971 (57). Acrylic on canvas, 84 x 84".
Galerie de Gestlo, Hamburg

921. *Donuts.* 1973 (100).
Acrylic on canvas, 60 x 72".
Private collection

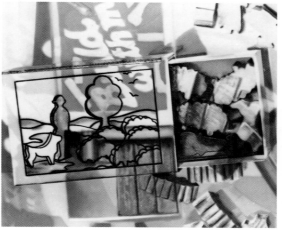

922. *Build with Me.* 1971 (64).
Acrylic on canvas, 60 x 72".
Private collection

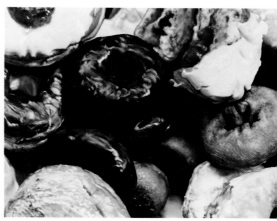

923. *Small Donuts.* 1973 (115).
Acrylic on canvas, 42 x 54".
Collection Martin I. Harman, New York

924. *Tools II (Screwdrivers).* 1974 (139).
Acrylic on canvas, 48 x 60".
Private collection

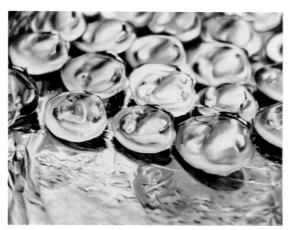

925. *Clams (on the Half Shell).* 1974 (125).
Acrylic on canvas, 48 x 60".
Galerie de Gestlo, Hamburg

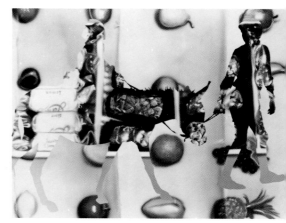

926. *Taffy Donkey Walk.* 1971 (74).
Acrylic on canvas, 42 x 54".
Galerie Mikro, West Berlin

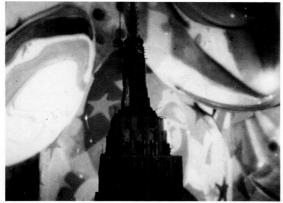

927. *Empire State.* 1970 (28).
Acrylic on canvas, 72 x 96".
Private collection

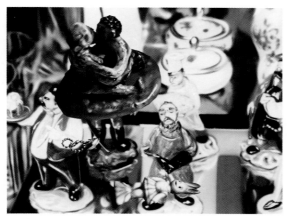

928. *Figurines.* 1970 (30).
Acrylic on canvas, 42 x 54".
Collection the artist

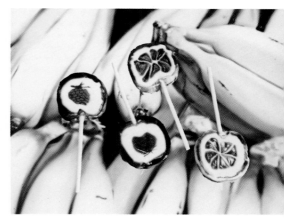

929. *Fruit Pops (Bananas).* 1970 (33).
Acrylic on canvas, 42 x 54".
Private collection

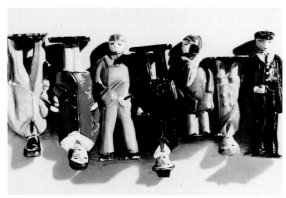

930. *The Train Family.* 1976 (173).
Acrylic on canvas, 6'7½" x 9'10½".
Collection Mobil Oil Corporation, New York

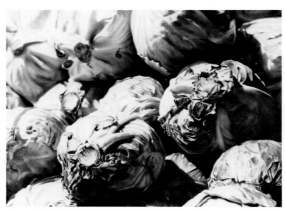

931. *Cabbage.* 1973 (94).
Acrylic on canvas, 6'8" x 9'.
Collection Mr. and Mrs. Morton G. Neumann, Ill.

932. *Greenery.* 1976 (161).
Diptych, acrylic on canvas, 6' x 9'.
Nationalgalerie, West Berlin

133. *Deerfield Sunset.* 1976 (158). Acrylic on canvas, 6' x 10'. DM Gallery, London

4. *The Continental Divide.* 1975 (143). Acrylic on canvas, 7' x 14'. Collection the artist

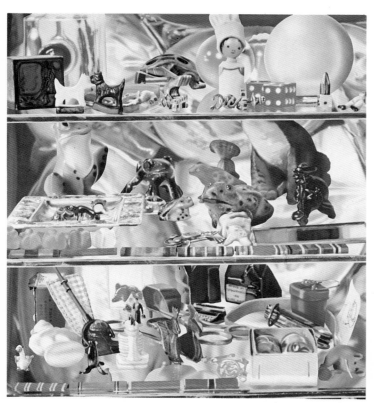

935. *Frog Box.* 1971 (70). Acrylic on canvas, 60 x 48".
Private collection

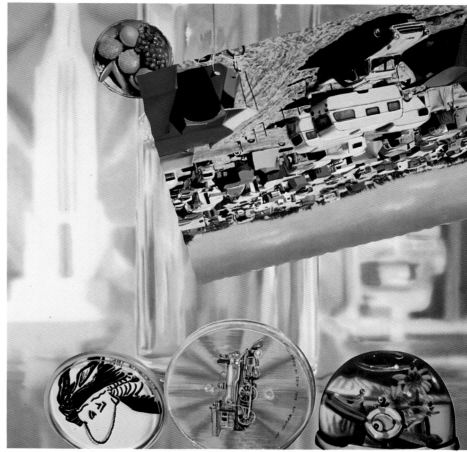

936. *East Meets West.* 1972 (82). Acrylic on canvas, 80 x 80".
Collection Daniel Filipacchi, New York

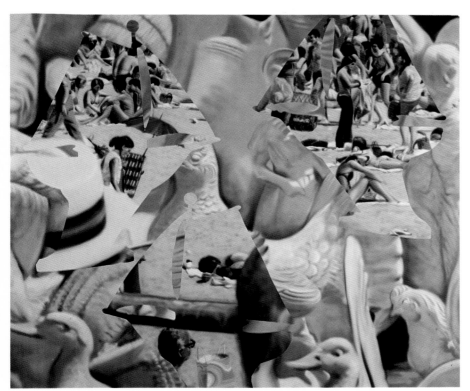

937. *Brighton Boats Blueboy.* 1971 (63). Acrylic on canvas, 72 x 84".
Galerie Mikro, West Berlin

938. *Come with Me QE.* 1972 (80). Acrylic on canvas, 60 x 72".
Galerie Mikro, West Berlin

939. *Eggplant*. 1976 (159). Acrylic on canvas, 60 x 60". Private collection, Mass.

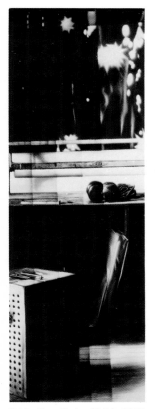

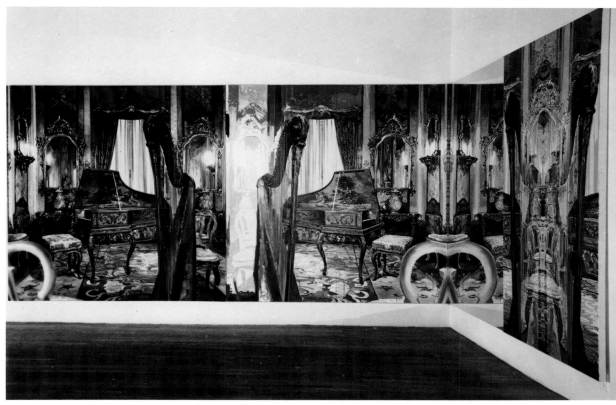

940. *Test Strip.* 1976 (172).
Acrylic on canvas, 9' x 3'.
Private collection

941. *The Music Room.* 1977–78 (187). Diptych, acrylic on canvas, with mirror, 8' x 16'. Collection the artist

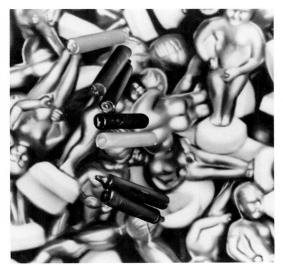

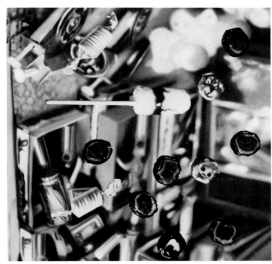

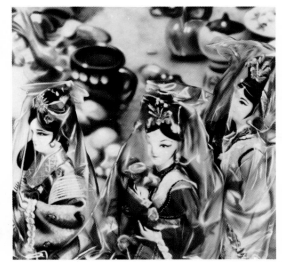

942. *Candles and Humorous Sculptures.* 1970 (21).
Acrylic on canvas, 30 x 30".
Galerie Mikro, West Berlin

943. *Watermelon Candies.* 1970 (55).
Acrylic on canvas, 72 x 72".
Private collection

944. *Three Chinese Dolls.* 1971 (75). Acrylic on canvas, 72 x 72". Neue Galerie der Stadt Aachen. Ludwig Collection

945. *Ground Cover.* 1977 (185).
Acrylic on canvas, 84 x 84".
Private collection

946. *Shiners II.* 1976 (169).
Acrylic on canvas, 24 x 24".
Private collection

947. *Gold Mine.* 1975 (145).
Acrylic on canvas, 72 x 72".
Collection the artist

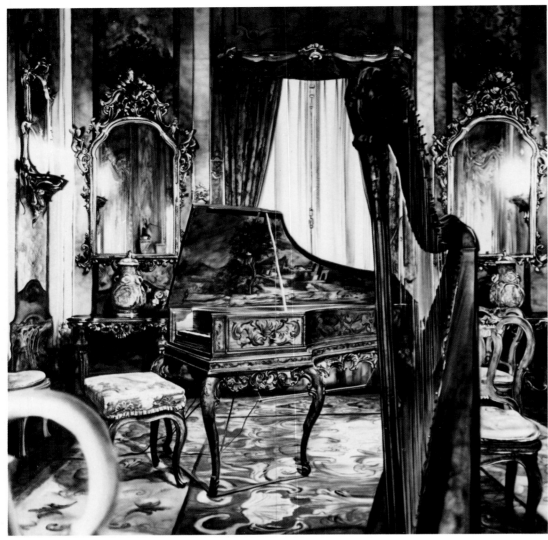

948. Detail of plate 941

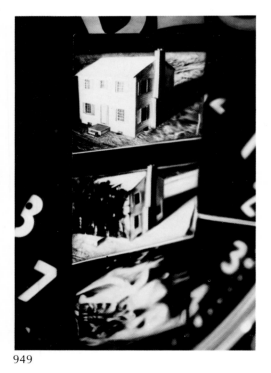

949

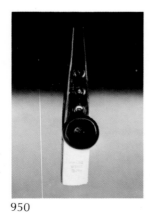

950

951

949. *House.* 1975 (146). Acrylic on canvas, 96 x 65".
Private collection

950. *One Kazoo.* 1975 (151). Acrylic on canvas, 54 x 36".
Private collection

951. *Men's Clothing.* 1977 (182). Acrylic on canvas, 72 x 27".
Private collection

Rhubarb and Hats. 1970 (39).
Acrylic on canvas, 42 x 54".
Private collection

Jujubes. 1970 (40).
Acrylic on canvas, 30 x 30".
State University of New York, Alfred

Lemons and Marbles. 1970 (41).
Acrylic on canvas, 30 x 30".
Private collection

Lollipops (Waves). 1970 (43).
Acrylic on canvas, 42 x 54".
Private collection

Marina del Rey. 1970 (44).
Acrylic on canvas, 72 x 96".
Collection the artist

Nectarines (Slippers). 1970 (45).
Acrylic on canvas, 42 x 54".
Collection Dr. and Mrs. Martin Yasuna, Calif.

Pears. 1970 (47).
Watercolor and pencil on paper, 15 x 20".
University of Massachusetts, Amherst

Plums and Shirts. 1970 (48).
Acrylic on canvas, 72 x 48".
Private collection

Slipper Toe (White). 1970 (49).
Acrylic on canvas, 16 x 15".
Private collection

Small Slipper (Black). 1970 (50).
Acrylic on canvas, 14 x 14".
Collection the artist

Taxis. 1970 (52).
Acrylic on canvas, 18 x 16".
Private collection

Warrior. 1970 (54).
Acrylic on canvas, 48 x 72".
Collection the artist

Whistles (Oranges). 1970 (56).
Acrylic on canvas, 42 x 54".
Private collection

Animals (Iron Miniatures). 1971 (58).
Acrylic on canvas, 56 x 78".
Collection the artist

Bootlamp Sacto. 1971 (62).
Acrylic on canvas, 48 x 60".
Galerie Mikro, West Berlin

Catalina Cutouts/Banana Pie. 1971 (66).
Acrylic on canvas, 30 x 30".
Private collection

Cosmetics. 1971 (67).
Acrylic on canvas, 48 x 60".
Collection Daniel Filipacchi, New York

Englishtown Jewels. 1971 (69).
Acrylic on canvas, 60 x 72".
Collection Best Products Co., Inc., Va.

Graduates. 1971 (72).
Acrylic on canvas, 30 x 30".
Collection the artist

Two Dark Beers and Pastries. 1971 (76).
Acrylic on canvas, 48 x 60".
Private collection

Vegetables. 1971 (77).
Acrylic on canvas, 60 x 72".
Galerie Mikro, West Berlin

Walnut and Tangerines. 1971 (78).
Oil on canvas over board, c. 4¼ x 6⅝".
Collection Jane Malton, New York

Bomb. 1972 (79).
Acrylic on canvas, 6'8" x 9'.
Galerie Mikro, West Berlin

Tree Frog. 1972 (90).
Acrylic on canvas, 54 x 42".
Galerie Mikro, West Berlin

Anada Dry Ice. 1972 (91).
Acrylic on canvas, 84 x 84".
Private collection

Zucchinis. 1972 (92).
Acrylic on canvas, 48½ x 34½".
Collection Best Products Co., Inc., Va.

"C" Animals. 1973 (95).
Acrylic on canvas, 22 x 30".
Museum of Contemporary Art, Chicago

Cold Duck. 1973 (96).
Acrylic on paper, 14½ x 22".
Collection Martin I. Harman, New York

DeSantis Meat. 1973 (99).
Acrylic on canvas, 72 x 72".
Collection the artist

Eight Peppers. 1973 (101).
Acrylic on canvas, 60 x 72".
Galerie Mikro, West Berlin

Flower Painting. 1973 (103).
Acrylic on canvas, 84 x 84".
Private collection

Frog Box Top. 1973 (104).
Acrylic on canvas, 72 x 72".
Galerie Mikro, West Berlin

From the Last Life. 1973 (105).
Acrylic on canvas, 48 x 60".
Galerie Mikro, West Berlin

Greenport (Sunset). 1973 (106).
Acrylic on canvas, 90 x 96".
Galerie de Gestlo, Hamburg

(Moonrise) Greenport. 1973 (107).
Acrylic on canvas, 90 x 90".
Collection the artist

Jane's Toy. 1973 (109).
Acrylic on canvas, 60 x 72".
Galerie Mikro, West Berlin

Marcia and Sam. 1973 (111).
Acrylic on paper, 22 x 30".
Collection Martin I. Harman, New York

Marcia in a Pool. 1973 (112).
Acrylic on canvas, 60 x 84".
Collection the artist

Marcia and Sam. 1973 (113).
Acrylic on canvas, 48 x 60".
Collection the artist

Salad Plate. 1973 (114).
Acrylic on paper, 22 x 30".
Collection the artist

Television Painting. 1973 (117).
Acrylic on canvas, 72 x 72".
Collection the artist

Tomato. 1973 (118).
Acrylic on canvas, 60 x 72".
Private collection

Tomatoes, Stage I. 1973 (119).
Acrylic on paper, 22½ x 30".
Private collection

Wanda Bimson. 1973 (121).
Acrylic on paper, 30 x 40".
Collection the artist

Aviation Fragment (Eye). 1974 (122).
Acrylic on canvas, c. 8 x 10".
Collection the artist

Bamboo Century Village. 1974 (123).
Acrylic on paper, 60 x 72".
Private collection

Buttons. 1974 (124).
Acrylic on canvas, 72 x 72".
Collection Nancy Hoffman, New York

Grapes I. 1974 (127).
Acrylic on paper, 15 x 11".
Collection Carolyn Martin, New York

Grapes II. 1974 (128).
Acrylic on canvas, 15 x 11".
Private collection, New York

Keys North. 1974 (132).
Acrylic on canvas, 72 x 72".
Galerie de Gestlo, Hamburg

My Father in Florida (My Father's Moustache).
1974 (135). Acrylic on paper, 40 x 30".
The Art Gallery, Ball State University, Ind.

Orchid. 1974 (136).
Acrylic on paper, 24 x 20".
DM Gallery, London

Tulips. 1974 (140).
Acrylic on canvas, 72 x 72".
Collection Dr. and Mrs. Gerard Seltzer, Ohio

Cheesecakes. 1975 (142).
Acrylic on paper, 22¼ x 29¼".
Private collection

French Cream. 1975 (144).
Acrylic on paper, 22½ x 29¼".
Private collection

Mushrooms. 1975 (148).
Acrylic on canvas, 24 x 24".
Private collection

My Left-handed Shears. 1975 (149).
Acrylic on paper, 22¼ x 29¼".
Collection Monroe Meyerson, New York

Still Water. 1975 (153).
Acrylic on canvas, 72 x 72".
Galerie de Gestlo, Hamburg

Tug off New Jersey. 1975 (154).
Watercolor on paper, 13 x 17".
Private collection, New York

Daniel (Front). 1976 (156).
Acrylic on canvas, 48 x 60".
Collection Daniel Filipacchi, New York

Ground Cover. 1976 (160).
Acrylic on canvas, 84 x 84". Collection
Dorothea and Norman Brickell, New York

Maple Syrup. 1976 (162).
Acrylic on paper, c. 17 x 14".
Galerie de Gestlo, Hamburg

Milk and Egg. 1976 (163).
Acrylic on paper, c. 17 x 14".
Galerie de Gestlo, Hamburg

One Cake. 1976 (164).
Acrylic on canvas, 13 x 13½".
Collection Philip Werber, New York

Parrot Tulip. 1976 (165).
Acrylic on canvas, 60 x 72".
Chase Manhattan Bank, New York

A Remarkable Strawberry Shortcake. . . .
1976 (166). Acrylic on paper, 20 x 17".
Private collection

A Remarkable Pie. . . . 1976 (167).
Acrylic on paper, 20 x 17".
Private collection

Shiners I. 1976 (168).
Acrylic on canvas, 24 x 24".
Collection John C. Davis, Ky.

Small Cakes. 1976 (170).
Acrylic on paper, 26¼ x 22⅛".
Private collection

Stopwatch. 1976 (171).
Acrylic on paper, size unknown.
Galerie de Gestlo, Hamburg

Unfinished Stopwatch with Impossible Detail.
1976 (174). Acrylic on paper, 13½ x 11½".
Collection Nancy Hoffman, New York

A Boston Table. 1977 (176).
Acrylic on paper, 23 x 18¾".
Private collection

A Boston Floor. 1977 (177).
Watercolor on paper, 17½ x 24".
Private collection

Durango Wildflowers. 1977 (179).
Acrylic on canvas, 60 x 60".
Abrams Family Collection, New York

Men's Clothing. 1977 (181).
Watercolor on paper, 27 x 72".
Private collection

Shaggy Palm. 1977 (183).
Watercolor on paper, 26 x 16".
Private collection

Shaggy Palm. 1977 (184).
Oil on canvas, 48 x 84".
Collection the artist

Three Children. 1977 (186).
Acrylic on canvas, 60 x 72".
Private collection

BIOGRAPHY

1942 Born: Brooklyn, N.Y.

EDUCATION
1964 B.F.A., Cooper Union, New York

SOLO EXHIBITIONS
1970 French and Co., New York
1971 Galerie de Gestlo, Hamburg
 Galerie Mikro, West Berlin
1972 French and Co., New York
 Galerie Mikro, West Berlin
 Neue Galerie der Stadt Aachen, West Germany
1973 Galerie Mikro, West Berlin
 Nancy Hoffman Gallery, New York
 Carl Solway Gallery, Cincinnati
1975 Galerie de Gestlo, Hamburg
 Nancy Hoffman Gallery, New York
1976 Galerie de Gestlo, Hamburg
 Nancy Hoffman Gallery, New York
1978 Galerie de Gestlo, Hamburg
 "The Music Room," Villa Vizcaya Museum and Gardens, Miami, Fla.
 Nancy Hoffman Gallery, New York
1979 Galerie de Gestlo, Cologne
 Michael Berger Gallery, Pittsburgh
 "Modern Dancers," Nancy Hoffman Gallery, New York
 "Portraits of the Artist," Tomasulo Gallery, Union College,
 Cranford, N.J.
1980 Nancy Hoffman Gallery, New York

SELECTED GROUP EXHIBITIONS
1965 Eye Gallery, Washington, D.C.
1970 "Cool Realism," Albright-Knox Art Gallery, Buffalo, N.Y.
 Mulvane Art Center, Topeka, Kans.
 Protetch-Rivkin Gallery, Washington, D.C.
 Purdue University, Lafayette, Ind.
1971 "The American Art Attack," Glauber-Poons Gallery, Amsterdam
 FTD (Florist Transworld Delivery) Collection
 "New Realism," State University College, Potsdam, N.Y.
 "The Shape of Realism," Deson-Zaks Gallery, Chicago
 "Spray," Santa Barbara Museum of Art, Calif.
1972 "Documenta 5," Kassel, West Germany
 "L'Hyperréalistes américains," Galerie des Quatre Mouvements, Paris
 "Phases of the New Realism," Lowe Art Museum, University of Miami,
 Coral Gables, Fla.
 "Realism Now," New York Cultural Center, New York
1972–73 "Amerikanischer Fotorealismus," Württembergischer Kunstverein,
 Stuttgart; Frankfurter Kunstverein, Frankfurt; Kunst und
 Museumsverein, Wuppertal, West Germany
1973 "Art on Paper 1973," Weatherspoon Gallery, University of North
 Carolina, Greensboro
 "Contemporary Painting," Brainerd Hall Art Gallery, State University
 College, Potsdam, N.Y.
 "East Coast/West Coast/New Realism," San Jose State University, Calif.
 "The Emerging Real," Storm King Art Center, Mountainville, N.Y.
 "Grands maîtres hyperréalistes américains," Galerie des Quatre
 Mouvements, Paris
 "The Joan and Rufus Foshee Collection," Block Hall Gallery, University
 of Montevallo, Ala.
 "Mit Kamera, Pinsel und Spritzpistole," Ruhrfestspiele Recklinghausen,
 Städtische Kunsthalle, Recklinghausen, West Germany
 "New York Avant Garde," Saidye Bronfman Art Centre, Montreal
 "Options 73/30," Contemporary Arts Center, Cincinnati
 "Prospect 1973," Kunsthalle, Düsseldorf
 "Realism Now," Katonah Gallery, Katonah, N.Y.
 "Say It with Flowers," Hofstra University, Hempstead, N.Y.
 "The Super-Realist Vision," DeCordova and Dana Museum, Lincoln,
 Mass.
1973–74 "Hyperréalisme," Galerie Isy Brachot, Brussels
1973–78 "Photo-Realism 1973: The Stuart M. Speiser Collection," traveling
 exhibition: Louis K. Meisel Gallery, New York; Herbert F. Johnson

952. *Portrait of the Artist No. 2.* 1979 (188). Oil on canvas,
33 x 33". Collection the artist

Museum of Art, Ithaca, N.Y.; Memorial Art Gallery of the University
of Rochester, N.Y.; Addison Gallery of American Art, Andover,
Mass.; Allentown Art Museum, Pa.; University of Colorado
Museum, Boulder; University Art Museum, University of Texas,
Austin; Witte Memorial Museum, San Antonio, Tex.; Gibbes Art
Gallery, Charleston, S.C.; Brooks Memorial Art Gallery, Memphis,
Tenn.; Krannert Art Museum, University of Illinois, Champaign-
Urbana; Helen Foresman Spencer Museum of Art, University of
Kansas, Lawrence; Paine Art Center and Arboretum, Oshkosh, Wis.;
Edwin A. Ulrich Museum, Wichita State University, Kans.; Tampa
Bay Art Center, Tampa, Fla.; Rice University, Sewall Art Gallery,
Houston; Tulane University Art Gallery, New Orleans; Smithsonian
Institution, Washington, D.C.
1974 "Amerikaans fotorealisme grafiek," Hedendaagse Kunst, Utrecht; Palais
 des Beaux-Arts, Brussels
 "Art Acquisitions 1973," University Art Gallery, University of
 Massachusetts, Amherst
 "Art 5 '74," Basel, Switzerland
 "Aspects of the Figure," Cleveland Museum of Art
 "Choice Dealers/Dealers' Choice," New York Cultural Center,
 New York
 "Contemporary American Painting and Sculpture, 1974," Krannert Art
 Museum, University of Illinois, Champaign-Urbana
 "Contemporary Portraits by American Painters," Lowe Art Museum,
 University of Miami, Coral Gables, Fla.
 "Kijken naar de werkelijkheid," Museum Boymans–van Beuningen,
 Rotterdam
 Moos Gallery, Montreal
 Moos Gallery, Toronto
 "New Photo-Realism," Wadsworth Atheneum, Hartford, Conn.
 "New Realism Revisited," Brainerd Hall Art Gallery, State University
 College, Potsdam, N.Y.
 "Painting and Sculpture Today, 1974," Indianapolis Museum of Art;
 Taft Museum and Contemporary Arts Center, Cincinnati
 "Selections in Contemporary Realism," Akron Art Institute; New
 Gallery, Cleveland
 "Seventy-first American Exhibition," Art Institute of Chicago
 "Tokyo Biennale, '74," Tokyo Metropolitan Museum of Art; Kyoto
 Municipal Museum; Aichi Prefectural Art Museum, Nagoya
1975 "Art on Paper, 1975," Weatherspoon Art Gallery, University of North
 Carolina, Greensboro
 "Image, Color and Form—Recent Paintings by Eleven Americans,"
 Toledo Museum of Art, Ohio
 "The Long Island Art Collectors' Exhibition," C. W. Post Art Gallery,
 Long Island University, Greenvale, N.Y.
 "Realismus und Realität," Kunsthalle, Darmstadt, West Germany
 "Realist Artists," William Patterson College, Wayne, N.J.
 "SoHo in Buffalo," Albright-Knox Art Gallery, Buffalo, N.Y.

"Super Realism," Baltimore Museum of Art

"Twenty-five Stills," Whitney Museum Downtown, New York

"Watercolors and Drawings—American Realists," Louis K. Meisel Gallery, New York

1975–76 "Photo-Realism, American Painting and Prints," New Zealand traveling exhibition: Barrington Gallery, Auckland; Robert McDougall Art Gallery, Christchurch; Academy of Fine Arts, National Art Gallery, Wellington; Dunedin Public Art Gallery, Dunedin; Govett-Brewster Art Gallery, New Plymouth; Waikato Art Museum, Hamilton

1976 "Art for Your Collection XIII," Museum of Art, Rhode Island School of Design, Providence

"Art 7 '76," Basel, Switzerland

"Aspects of Realism from the Nancy Hoffman Gallery," Art Gallery, University of Notre Dame, Ind.

"Biennial Exhibition," Lehigh Art Galleries, Lehigh University, Bethlehem, Pa.

"Close to Home," Genesis Gallery, New York

"Drawings," DM Gallery, London

"1976 Mid Year Show," Butler Institute of American Art, Youngstown, Ohio

"Painting and Sculpture Today, 1976," Indianapolis Museum of Art

"Perspective 1976," Freedman Art Gallery, Albright College, Reading, Pa.

"The Presence and the Absence in Realism," Brainerd Hall Art Gallery, State University College, Potsdam, N.Y.

"Realism," Young-Hoffman Gallery, Chicago

"Troisième foire internationale d'art contemporain," Grand Palais, Paris

1976–77 "Photo-Realism in Painting," Art and Culture Center, Hollywood, Fla.; Museum of Fine Arts, St. Petersburg, Fla.

1976–78 "America 1976," Corcoran Gallery of Art, Washington, D.C.; Wadsworth Atheneum, Hartford, Conn.; Fogg Art Museum, Cambridge, Mass.; Institute of Contemporary Art, Boston; Minneapolis Institute of Arts; Milwaukee Art Center; Fort Worth Art Museum, Tex.; San Francisco Museum of Modern Art; High Museum of Art, Atlanta; Brooklyn Museum, New York

"Aspects of Realism," traveling exhibition sponsored by Rothman's of Pall Mall Canada, Ltd.: Stratford, Ont.; Centennial Museum, Vancouver, B.C.; Glenbow-Alberta Institute, Calgary, Alta.; Mendel Art Gallery, Saskatoon, Sask.; Winnipeg Art Gallery, Man.; Edmonton Art Gallery, Alta.; Art Gallery, Memorial University of Newfoundland, St. John's; Confederation Art Gallery and Museum, Charlottetown, P.E.I.; Musée d'Art Contemporain, Montreal, Que.; Dalhousie University Museum and Gallery, Halifax, N.S.; Windsor Art Gallery, Ont.; London Public Library and Art Museum and McIntosh Memorial Art Gallery, University of Western Ontario; Art Gallery of Hamilton, Ont.

1977 "America '76," Heath Gallery, Atlanta; Simone Stern Gallery, New Orleans

"The Chosen Object: European and American Still Life," Joslyn Art Museum, Omaha, Nebr.

"Fall 1977 Contemporary Collectors," Aldrich Museum of Contemporary Art, Ridgefield, Conn.

"Group Art Show," Nancy Hoffman Gallery, New York; Hiestand Hall Art Gallery, Miami University, Oxford, Ohio

Internationaler Kunstmarkt, Cologne

"Master Prints and Drawings," New Gallery, Cleveland

"New in the '70s," University of Texas, Austin

"New Realism," Jacksonville Art Museum, Fla.

"Off the Beaten Path," Brainerd Hall Art Gallery, State University College, Potsdam, N.Y.

"Still Life," Boston University Art Gallery, Boston

"Works on Paper II," Louis K. Meisel Gallery, New York

1977–78 "Illusion and Reality," Australian touring exhibition: Australian National Gallery, Canberra; Western Australian Art Gallery, Perth; Queensland Art Gallery, Brisbane; Art Gallery of New South Wales, Sydney; Art Gallery of South Australia, Adelaide; National Gallery of Victoria, Melbourne; Tasmanian Museum and Art Gallery, Hobart

"Photo-Realism," Art and Culture Center, Hollywood, Fla.; Museum of Fine Arts, St. Petersburg, Fla.

1978 "Drawings Since 1960," University Art Gallery, Creighton University, Omaha, Nebr.

"Landscape/Cityscape," Brainerd Hall Art Gallery, State University College, Potsdam, N.Y.

Monmouth Museum, Lincroft, N.J.

"Photo-Realist Printmaking," Louis K. Meisel Gallery, New York

"The Work Show," M. H. de Young Memorial Museum, Downtown Center, San Francisco

1978–79 "Things Seen: The Concept of Realism in the 20th Century," Sheldon Memorial Art Gallery, University of Nebraska, Lincoln, traveling exhibition

1979 Brookhaven National Laboratory, Upton, N.Y.

"Photo-Realism: Some Points of View," Jorgensen Gallery, University of Connecticut, Storrs

"Realist Space," C. W. Post Art Gallery, Long Island University, Brookville, N.Y.

"Selections from the Collection of Richard Brown Baker," Squibb Gallery, Princeton, N.J.

"Selections of Photo-Realist Paintings from N.Y.C. Galleries," Southern Alleghenies Museum of Art, St. Francis College, Loretto, Pa.

SELECTED BIBLIOGRAPHY

CATALOGUES

Goldsmith, Benedict. New Realism. Brainerd Hall Art Gallery, State University College, Potsdam, N.Y., Nov. 5–Dec. 12, 1971.

Internationale Kunst U. Informationsmesse. Belgisches Haus Volkshochschule, Cologne, Oct. 5–10, 1971.

Mills, Paul C. Introduction to Spray. Santa Barbara Museum of Art, Calif., Apr. 24–May 30, 1971.

Schmeidel, R. V. "Scharfen und Untiefen." In Ben Schonzeit. Galerie Mikro, West Berlin, 1971.

Wright, Jesse G., and Michael, C. Preface to FTD Collection. Thorner Sidney Press, New York, 1971.

Abadie, Daniel. Introduction to Hyperréalistes américains. Galerie des Quatre Mouvements, Paris, Oct. 25–Nov. 25, 1972.

Amman, Jean Christophe. Introduction to Documenta 5. Neue Galerie and Museum Fridericianum, Kassel, West Germany, June 30–Oct. 8, 1972.

Baratte, John J., and Thompson, Paul E. Phases of the New Realism. Lowe Art Museum, University of Miami, Coral Gables, Fla., Jan. 20–Feb. 20, 1972.

Becker, Wolfgang. Introduction to Ben Schonzeit. Neue Galerie der Stadt Aachen, West Germany, June 10–July 30, 1972.

Amaya, Mario. Introduction to Realism Now. New York Cultural Center, New York, Dec. 6, 1972–Jan. 7, 1973.

Schneede, Uwe, and Hoffman, Heinz. Introduction to Amerikanischer Fotorealismus. Württembergischer Kunstverein, Stuttgart, Nov. 16–Dec. 26, 1972; Frankfurter Kunstverein, Frankfurt, Jan. 6–Feb. 18, 1973; Kunst und Museumsverein, Wuppertal, West Germany, Feb. 25–Apr. 8, 1973.

Becker, Wolfgang. Introduction to Mit Kamera, Pinsel und Spritzpistole. Ruhrfestspiele Recklinghausen, Städtische Kunsthalle, Recklinghausen, West Germany, May 4–June 17, 1973.

Carpenter, Gilbert F. Introduction to Art on Paper 1973. Weatherspoon Gallery, University of North Carolina, Greensboro, Nov. 18–Dec. 16, 1973.

Dali, Salvador. Introduction to Grands maîtres hyperréalistes américains. Galerie des Quatre Mouvements, Paris, May 23–June 25, 1973.

Goldsmith, Benedict. Introduction to Contemporary Painting. Brainerd Hall Art Gallery, State University College, Potsdam, N.Y., Sept. 7–28, 1973.

The Joan and Rufus Foshee Collection. Block Hall Gallery, University of
Montevallo, Ala., Mar. 27–Apr. 17, 1973.

Lamagna, Carlo. Foreword to *The Super-Realist Vision.* DeCordova and Dana
Museum, Lincoln, Mass., Oct. 7–Dec. 9, 1973.

Meisel, Louis K. *Photo-Realism 1973: The Stuart M. Speiser Collection.* New
York, 1973.

Radde, Bruce. Introduction to *East Coast/West Coast/New Realism.* University
Art Gallery, San Jose State University, Calif., Apr. 24–May 18, 1973.

Sims, Patterson. Introduction to *Realism Now.* Katonah Gallery, Katonah, N.Y.,
May 20–June 24, 1973.

Strelow, Hans. Introduction to *Prospect '73.* Kunsthalle, Düsseldorf, Sept. 28–
Oct. 7, 1973.

Hyperréalisme. Galerie Isy Brachot, Brussels, Dec. 14, 1973–Feb. 9, 1974.

Tucker, Marcia, and Dyens, Georges. Introduction to *New York Avant Garde
'74.* Saidye Bronfman Centre, Montreal, Nov. 27, 1973–Jan. 3, 1974.

Amerikaans fotorealisme grafiek. Hedendaagse Kunst, Utrecht, Aug., 1974;
Palais des Beaux-Arts, Brussels, Sept.–Oct., 1974.

Art Acquisitions 1973. University Art Gallery, University of Massachusetts,
Amherst, Jan. 31–Feb. 22, 1974.

Aspects of Realism. Moos Gallery Ltd., Toronto, Sept.–Oct., 1974.

Doty, Robert. Introduction to *Selections in Contemporary Realism.* Akron Art
Institute, Sept. 20–Oct. 19, 1974; New Gallery, Cleveland, Sept. 20–Oct.
19, 1974.

Goldsmith, Benedict. *New Realism Revisited.* Brainerd Hall Art Gallery, State
University College, Potsdam, N.Y., 1974.

Gruen, John. Introduction to *Contemporary Portraits by American Painters.*
Lowe Art Museum, University of Miami, Coral Gables, Fla., Oct. 3–Nov. 10,
1974.

Henning, Edward B. Introduction to *Aspects of the Figure.* Cleveland Museum
of Art, July 10–Sept. 1, 1974.

Kijken naar de werkelijkheid. Museum Boymans–van Beuningen, Rotterdam,
June 1–Aug. 18, 1974.

Shipley, James R., and Weller, Allen S. Introduction to *Contemporary
American Painting and Sculpture, 1974.* Krannert Art Museum, University of
Illinois, Champaign-Urbana, Mar. 10–Apr. 21, 1974.

Speyer, James A. Introduction to *Seventy-first American Exhibition.* Art Institute
of Chicago, June 15–Aug. 11, 1974.

Warrum, Richard L. Introduction to *Painting and Sculpture Today, 1974.*
Indianapolis Museum of Art, May 22–June 14, 1974; Taft Museum and
Contemporary Arts Center, Cincinnati, Sept. 12–Oct. 26, 1974.

Krimmel, Bernd. Introduction to *Realismus und Realität.* Foreword by H. W.
Sabais. Kunsthalle, Darmstadt, West Germany, May 24–July 6, 1975.

Meisel, Susan Pear. *Watercolors and Drawings—American Realists.* Louis
K. Meisel Gallery, New York, Jan., 1975.

Miller, Joan Vita. Foreword to *The Long Island Art Collectors' Exhibition.* C. W.
Post College, Greenvale, N.Y., Oct. 24–Nov. 23, 1975.

Phillips, Robert F. Introduction to *Image, Color and Form: Recent Paintings by
Eleven Americans.* Toledo Museum of Art, Ohio, Jan. 12–Feb. 9, 1975.

SoHo in Buffalo. Albright-Knox Gallery, Buffalo, N.Y., 1975.

Tucker, James E. Foreword to *Art on Paper.* Weatherspoon Art Gallery,
University of North Carolina, Greensboro, Nov. 16–Dec. 14, 1975.

Twenty-five Stills. Whitney Museum Downtown, New York, 1975.

Richardson, Brenda. Introduction to *Super-Realism.* Baltimore Museum of Art,
Nov. 18, 1975–Jan. 11, 1976.

Gervais, Daniel. Introduction to *Troisième foire internationale d'art
contemporain.* Grand Palais, Paris, Oct. 16–24, 1976.

Goldsmith, Benedict. Introduction to *The Presence and the Absence in
Realism.* Brainerd Hall Art Gallery, State University College, Potsdam, N.Y.,
Mar. 26–Apr. 30, 1976.

Greenleaf, Anne M. Introduction to *Painting and Sculpture Today, 1976.*
Foreword by Norbert Neuss. Indianapolis Museum of Art, June 9–July 18,
1976.

Perspective 1976. Freedman Art Gallery, Albright College, Reading, Pa.

Singer, Clyde. Introduction to *1976 Mid Year Show.* Butler Institute of
American Art, Youngstown, Ohio, 1976.

Warrum, Richard L. Introduction to *Painting and Sculpture Today, 1976.*
Indianapolis Museum of Art, May, 1976.

Walthard, Dr. Frederic P. Introduction to *Art 7 '76.* Basel, Switzerland,
June 16–21, 1976.

Hicken, Russell Bradford. Introduction to *Photo-Realism in Painting.* Art and
Culture Center, Hollywood, Fla., Dec. 3, 1976–Jan. 10, 1977; Museum of
Fine Arts, St. Petersburg, Fla., Jan. 21–Feb. 25, 1977.

Chase, Linda. "U.S.A." In *Aspects of Realism.* Rothman's of Pall Mall Canada,
Ltd., June, 1976–Jan., 1978.

Kleppe, Thomas S.; Rosenblum, Robert; and Welliver, Neil. *America 1976.*

Corcoran Gallery of Art, Washington , D.C., Apr. 27–June 6, 1976;
Wadsworth Atheneum, Hartford, Conn., July 4–Sept. 12, 1976; Fogg Art
Museum, Cambridge, Mass., and Institute of Contemporary Art, Boston,
Oct. 19–Dec. 7, 1976; Minneapolis Institute of Arts, Jan. 16–Feb. 27, 1977;
Milwaukee Art Center, Mar. 19–May 15, 1977; Fort Worth Art Museum,
Tex., June 18–Aug. 14, 1977; San Francisco Museum of Modern Art,
Sept. 10–Nov. 13, 1977; High Museum of Art, Atlanta, Dec. 10, 1977–
Feb. 5, 1978; Brooklyn Museum, New York, Mar. 11–May 21, 1978.

Cloudman, Ruth. Introduction to *The Chosen Object: European and American
Still Life.* Joslyn Art Museum, Omaha, Nebr., Apr. 23–June 5, 1977.

Dempsey, Bruce. *New Realism.* Jacksonville Art Museum, Fla., 1977.

Dyer, Carlos. Introduction to *Fall 1977: Contemporary Collectors.* Aldrich
Museum of Contemporary Art, Ridgefield, Conn., Sept. 25–Dec. 18, 1977.

Goldsmith, Benedict. Introduction to *Off the Beaten Path.* Brainerd Hall Art
Gallery, State University College, Potsdam, N.Y., Nov. 11–Dec. 16, 1977.

Internationaler kunstmarkt Köln 1977. Cologne, Oct. 26–31, 1977.

Seabolt, Fred. Introduction to *New in the '70s.* Foreword by Donald Goodall.
University Art Museum, Archer M. Huntington Gallery, University of Texas,
Austin, Aug. 21–Sept. 25, 1977.

Stringer, John. Introduction to *Illusion and Reality.* Australian Gallery
Directors' Council, North Sydney, N.S.W., 1977–78.

Garfield, Alan. Introduction to *Drawings Since 1960.* University Art Gallery,
Creighton University, Omaha, Nebr., Sept. 30–Oct. 28, 1978.

Meisel, Louis K. Introduction to *Landscape/Cityscape.* Brainerd Hall Art
Gallery, State University College, Potsdam, N.Y., Sept. 22–Oct. 22, 1978.

Meisel, Susan Pear. Introduction to *The Complete Guide to Photo-Realist
Printmaking.* Louis K. Meisel Gallery, New York, Dec., 1978.

Baker, Richard Brown. Introduction to *Selections from the Collection of
Richard Brown Baker.* Squibb Gallery, Princeton, N.J., Oct. 4–Nov. 4,
1979.

Gerling, Steve. Introduction to *Photo-Realism: Some Points of View.*
Jorgensen Gallery, University of Connecticut, Storrs, Mar. 19–Apr. 10,
1979.

Miller, Wayne. Introduction to *Realist Space.* Foreword by Joan Vita Miller.
C. W. Post Art Gallery, Long Island University, Brookville, N.Y., Oct. 19–
Dec. 14, 1979.

Streuber, Michael. Introduction to *Selections of Photo-Realist Paintings from
N.Y.C. Galleries.* Southern Alleghenies Museum of Art, St. Francis
College, Loretto, Pa., May 12–July 8, 1979.

ARTICLES

Chamberlain, Betty. "In the Galleries," *New York Philharmonic Hall Playbill,*
Dec., 1970, p. 30.

"December Exhibitions," *Art Gallery Magazine,* Dec., 1970, p. 47.

Atirnomis. "Ben Schonzeit," *Arts Magazine,* Dec.–Jan., 1971, pp. 63, 65.

"Berliner Notizen," *Spandauer Volksblatt* (Berlin), Oct. 20, 1971.

"Galerie Lichter," *Berliner Leben,* vol. 7 (Nov., 1971), p. 11.

Glozer, Laszlo. "Als wäre das Zeug Allerlei Antiquität," *Süddeutsche Zeitung*
(Munich), no. 245 (Oct. 13, 1971).

Gruen, John. "Angels in Treetops," *New York Magazine,* Jan. 4, 1971, p. 50.

"Kunst Kalender," *Feuilleton Die Zeit,* Dec. 3, 1971.

Meenan, Monica. "Living with Style—The Boissiers," *Town and Country,* July,
1971, p. 48.

"New York Artist Speaks," *Falcon News* (Colorado Springs, Colo.), Apr. 16,
1971, p. 6.

Ohff, Heinz. "Der doppelte Realismus," *Der Tagesspiegel* (Berlin), no. 7920
(Oct. 2, 1971), p. 4.

"Review," *Arts Magazine,* Dec.–Jan., 1971.

"Review," *New York Magazine,* Jan., 1971.

Rhode, Werner. "Wandaktien," *Süddeutsche Zeitung* (Munich), no. 264
(Nov. 4, 1971).

Sager, Peter. "Neue Formen des Realismus," *Magazin Kunst,* 4th Quarter,
1971, pp. 2512–16.

Schauer, Lucie. "Kunst für kitschliebhaber," *Die Welt,* no. 251 (Oct. 28, 1971).

Trappschuh, Elke. "Grober Markt für kleine Sammler," *Handelsblatt,* no. 196
(Oct. 12, 1971).

Vitt, Walter von. "Köln ist zu wichtig geworden," *General Auzeiger Bonn
Feuilleton,* Oct. 12, 1971.

Amman, Jean Christophe. "Realismus," *Flash Art,* May–July, 1972, pp. 50–52.

Borsick, Helen. "Realism to the Fore," *Cleveland Plain Dealer,* Oct. 8, 1972.

Delegates World Bulletin (United Nations), 1972, p. 286.

"Die Documenta bestätigte sein Programm," *Hansestadt Hamburg die Welt,*
no. 180 (Aug. 5, 1972).

"Documenta 5," *Frankfurter Allgemeine Zeitung,* no. 155 (July 8, 1972).

Documenta 5 in Kassel, no. 148 (June 30, 1972).

"Goings On About Town," *The New Yorker,* Apr. 8, 1972, p. 11.

Henry, Gerrit. "The Real Thing," *Art International,* Summer, 1972, pp. 87–91.

Kirkwood, Marie. "Art Institute's Exhibit Represents the Revolt Against Abstraction," *Ohio Sun Press,* Oct. 12, 1972.

Kurtz, Bruce. "Documenta 5: A Critical Preview," *Arts Magazine,* Summer, 1972, pp. 34–41.

Lubell, Ellen. "Ben Schonzeit," *Arts Magazine,* May, 1972, p. 67.

Marmori, Giancarlo di. "Piú vero del vero," *L'Espresso,* no. 29 (July 16, 1972), pp. 4–15.

M. B. "Ben Schonzeit," *ARTnews,* Apr., 1972, p. 59.

Nemser, Cindy. "Close-Up Vision: Representational Art," *Arts Magazine,* May, 1972, pp. 44–48.

Pozzi, Lucio. "Super realisti U.S.A.," *Bolaffiarte,* no. 18 (Mar., 1972), pp. 54–63.

Sello, Gottfried. *Die Zeit* (Hamburg), Jan., 1972.

Shirey, David. "A Close Examination of Feininger Prints," *New York Times,* Mar. 25, 1972, p. 27.

Wooten, Dick. "Something New? Real Pictures?," *Cleveland Press,* Oct. 17, 1972, p. 9.

Beardsall, Judy. "Stuart M. Speiser Photorealist Collection," *Art Gallery Magazine,* vol. XVII, no. 1 (Oct., 1973), pp. 5, 29–34.

Becker, Wolfgang. "Ben Schonzeit," *Kunstforum International,* no. 1 (Mar.–Apr., 1973).

Borden, Lizzie. "Reviews," *Artforum,* Oct., 1973.

"L'hyperréalisme américain," *Le Monde des Grandes Musiques,* no. 2 (Mar.–Apr., 1973), pp. 4, 56–57.

Jurgen-Fischer, K. "Om formale grunde til naturalismen," *Louisiana Revy,* vol. 13, no. 3 (Feb., 1973).

"Lockere Hand," *Der Speigel,* no. 40 (Oct. 1, 1973).

Mellow, James R. "Here's a Garden Worth Cultivating," *New York Times,* Aug. 19, 1973, p. D19.

Mizue (Tokyo), vol. 8, no. 821 (1973).

Nemser, Cindy. "Fotografiet som sandhed," *Louisiana Revy,* vol. 13, no. 3 (Feb., 1973).

"Neue sachlichkeit–neuer realismus," *Kunstforum International,* Mar. 4, 1973, pp. 114–19.

Perreault, John. "Cracking Up and the Intergalactic," *Village Voice,* Dec. 27, 1973.

Preston, Malcolm. "Art: Flowery Delights," *Newsday* (Long Island, N.Y.), July, 1973.

"Prospect '73," *Art International,* Dec., 1973.

"Stuart Speiser Collection," *Art International,* Nov., 1973.

Tucker, James E. "Yearly Acquisitions," *Weatherspoon Gallery Association Bulletin,* University of North Carolina, Greensboro, 1973–74.

"Ben Schonzeit," *Arts Magazine,* Feb., 1974, p. 68.

"Ben Schonzeit," *Goya,* no. 119 (Mar.–Apr., 1974).

"The Fine Art of Food," *Claremont* (Calif.) *Collegian,* Nov. 13, 1974.

"Hot Stuff at the Chicago Art Institute," *Chicago Tribune,* June 9, 1974, cover, p. 3.

Rose, Barbara. "Keeping Up with American Art," *Vogue,* June, 1974.

Spector, Stephen. "The Super Realists," *Architectural Digest,* Nov.–Dec., 1974, p. 85.

Walsh, Sally. "Paintings That Look Like Photos," *Rochester Democrat and Chronicle,* Jan. 17, 1974.

"Ben Schonzeit," *Nordjyllands Kunstmuseum,* no. 3 (Sept., 1975).

Bruner, Louise. "Brash Paintings Stimulate Thinking Rather than Passive Thoughts," *Toledo Blade,* Jan. 12, 1975, p. 4.

"Photo-Realism Exhibit Is Opening at Paine Sunday," *Oshkosh Daily Northwestern,* Apr. 17, 1975.

"Photo-Realists at Paine," *View Magazine,* Apr. 27, 1975.

Richard, Paul. "Whatever You Call It, Super Realism Comes On with a Flash," *Washington Post,* Nov. 25, 1975, p. B1.

Adrian, Dennis. "Art Imitating Life in a Great Big Way," *Chicago Daily News,* Oct. 16–17, 1976.

Artner, Alan. "Mirroring the Merits of a Showing of Photo-Realism," *Chicago Tribune,* Oct. 24, 1976.

Belden, Dorothy. "Realism Exaggerated in Ulrich Art Exhibition," *Wichita Eagle,* Mar., 1976, Lifestyle page.

Chase, Linda. "Photo-Realism: Post Modernist Illusionism," *Art International,* vol. XX, no. 3–4 (Mar.–Apr., 1976), pp. 14–27.

Forgey, Benjamin. "The New Realism, Paintings Worth 1,000 Words," *Washington Star,* Nov. 30, 1976, p. G24.

Fox, Mary. "Aspects of Realism," *Vancouver Sun,* Sept. 21, 1976.

Hoelterhoff, Manuela. "Strawberry Tarts Three Feet High," *Wall Street Journal,* Apr. 21, 1976.

Kramer, Hilton. "Back to the Land with a Paintbrush," *New York Times,* May 30, 1976, p. D23.

Lubell, Ellen. "Review," *Arts Magazine,* Mar., 1976.

Mosch, Inge. "Ein Meister des Fotorealismus," *Hamburger Abendblatt,* vol. 13, no. 264 (Nov. 11, 1976).

Perreault, John. "Getting Flack," *Soho Weekly News,* Apr. 22, 1976, p. 19.

Rosenblum, Robert. "Painting America First," *Art in America,* Jan.–Feb., 1976, pp. 82–85.

"Schonzeit on Schonzeit," *Art and Artists,* Jan., 1976, pp. 10–13.

"Szene," *Der Spiegel,* no. 46 (1976), p. 198.

Greenwood, Mark. "Toward a Definition of Realism: Reflections on the Rothman's Exhibition," *Arts/Canada,* vol. XXIV, no. 210–11 (Dec., 1976–Jan., 1977), pp. 6–23.

Edelson, Elihu. "New Realism at Museum Arouses Mixed Feelings," *Jacksonville* (Fla.) *Journal,* Feb., 1977.

"Illusion and Reality," *This Week in Brisbane,* June, 1977.

Groom, Gloria. "Modern Art Exhibit Gives a Nice Surprise," *The Citizen* (Austin, Tex.), Aug., 1977.

Lynn, Elwyn. "The New Realism," *Quadrant,* Sept., 1977.

McGrath, Sandra. "I Am Almost a Camera," *The Australian* (Brisbane), July 27, 1977.

Pidgeon, W. E. "In Search of Reality," *New South Wales Sunday Telegraph,* July 31, 1977.

Thomas, Daniel. "The Way We See Now," *The Bulletin,* Sept. 10, 1977.

Alvarez, Tina. "Airbrushing Photo-Realist a Pioneer in Art World," *Encore,* June 29, 1978, p. 6.

Anderson, Alexander. "Ben Schonzeit," *Village Voice,* Apr. 3, 1978, p. 51.

"Art," *Soho Weekly News,* Mar. 16, 1978, centerfold.

"Ben Schonzeit," *East Side Express,* Mar.–Apr., 1978, p. 12.

Bongard, Willie. *Art Aktuell* (Cologne), Apr., 1978.

The Brooklyn Museum Bulletin, Mar., 1978.

"College Art Parley Draws 6,000," *New York Times,* Jan. 27, 1978, p. C15.

Edwards, Ellen. "An Artist Draws on Vizcaya," *Miami Herald,* June 4, 1978, sec. L, pp. 1, 2.

Glueck, Grace. "Greater Soho—Spring Guide to Downtown Art World," *New York Times,* Mar. 31, 1978.

Mackie, Alwynne. "New Realism and the Photographic Look," *American Art Review,* Nov., 1978, pp. 72–79, 132–34.

Rodriguez, Joanne Milani. "Art Show Accents the Eccentricities of Camera's Vision," *Tampa Tribune-Times,* Feb. 5, 1978, pp. 1–2.

Russell, John. "Art: Over 50 Years of Prints in Brooklyn," *New York Times,* Mar. 17, 1978, p. C23.

Cottingham, Jane. "Techniques of Three Photo-Realists," *American Artist,* Feb., 1980.

BOOKS

Brachot, Isy, ed. *Hyperréalisme.* Brussels: Imprimeries F. Van Buggenhoudt, 1973.

Sager, Peter. *Neue Formen des Realismus.* Cologne: Verlag M. DuMont Schauberg, 1973.

L'Iperrealismo italo Medusa. Rome: Romana Libri Alfabeto, 1974.

Battcock, Gregory, ed. *Super Realism, A Critical Anthology.* New York: E. P. Dutton, 1975.

Chase, Linda. *Hyperréalisme.* New York: Rizzoli, 1975.

Kultermann, Udo. *Neue Formen des Bildes.* Tübingen, West Germany: Verlag Ernst Wasmuth, 1975.

Schinneller, James A. *Art/Search and Self-Discovery.* 3d ed. Worcester, Mass.: Davis Publications, 1975.

Honisch, Dieter, and Jensen, Jens Christian. *Amerikanische Kunst von 1945 bis Heute.* Cologne: DuMont Buchverlag, 1976.

Billeter, Erika. *Malerei und Photographie im Dialog.* Zurich: Benteli, Verlag & Kunsthaus, 1977.

Lucie-Smith, Edward. *Super Realism.* Oxford: Phaidon, 1979.

Seeman, Helene Zucker, and Siegfried, Alanna. *SoHo.* New York: Neal-Schuman, 1979.

SELECTED PHOTO-REALIST EXHIBITIONS AND BIBLIOGRAPHY

This section contains a list of selected major group exhibitions, catalogues, articles, and books relating to the Photo-Realist movement during the years from 1967 to 1977, as well as some partial updates through Fall, 1979. Materials that have Photo-Realism as their main theme and that cite more than one Photo-Realist artist have been chosen for inclusion here. For a more thorough bibliographical treatment of any individual artist, the reader may refer to the bibliographical section of the chapter on that artist.

For all the bibliographical sections of this volume, I have researched both public and private libraries and, where possible, the personal libraries and files of individual artists, in order to make the entries as complete as I could. In a few cases, pertaining mostly to foreign periodicals, I have decided to include some incomplete entries, with the expectation that they will be helpful as a starting point to those particularly interested in foreign coverage of the movement. The updated material, for the years 1978 and 1979, is less exhaustive than that for the other years.

It is my hope that this bibliography of Photo-Realism will prove an important aid to scholars interested in the historical significance of Photo-Realism in the past decade.

Helene Zucker Seeman

SELECTED GROUP EXHIBITIONS

1969 "Directions 2: Aspects of a New Realism," Akron Art
Institute, Ohio; Milwaukee Art Center; Contemporary
Arts Museum, Houston

1969–70 "Painting from the Photograph," Riverside Museum, New
York

1970 "Beyond the Actual—Contemporary California Realist
Painting," Pioneer Museum and Haggin Galleries,
Stockton, Calif.

"Cool Realism," Albright-Knox Art Gallery, Buffalo, N.Y.

"Cool Realism," Everson Museum of Art, Syracuse, N.Y.

"The Cool Realists," Jack Glenn Gallery, Corona del Mar,
Calif.

"Directly Seen—New Realism in California," Newport
Harbor Art Museum, Balboa, Calif.

"The Highway," Institute of Contemporary Art, University
of Pennsylvania, Philadelphia; Institute for the Arts,
Rice University, Houston; Akron Art Institute, Ohio

"New Realism 1970," Headley Hall Gallery, St. Cloud
State College, Minn.

"Twenty-two Realists," Whitney Museum of American
Art, New York

1971 "Art Around the Automobile," Emily Lowe Gallery,
Hofstra University, Hempstead, N.Y.

"Neue amerikanische Realisten," Galerie de Gestlo,
Hamburg

"New Realism," Brainerd Hall Art Gallery, State
University College, Potsdam, N.Y.

"Radical Realism," Museum of Contemporary Art,
Chicago

"The Shape of Realism," Deson-Zaks Gallery, Chicago

1972 "Art Around 1970," Neue Galerie der Stadt Aachen, West
Germany

"Documenta and No-Documenta Realists," Galerie de
Gestlo, Hamburg

"Documenta 5," Kassel, West Germany

"L'Hyperréalistes américains," Galerie des Quatre
Mouvements, Paris

"Painting and Sculpture Today, 1972," Indianapolis
Museum of Art

"Phases of the New Realism," Lowe Art Museum,
University of Miami, Coral Gables, Fla.

"Realism Now," New York Cultural Center, New York

"The Realist Revival," New York Cultural Center, New
York

"Sharp-Focus Realism," Sidney Janis Gallery, New York

"Thirty-two Realists," Cleveland Institute of Art

1972–73 "Amerikanischer Fotorealismus," Württembergischer
Kunstverein, Stuttgart; Frankfurter Kunstverein,
Frankfurt; Kunst und Museumsverein, Wuppertal, West
Germany

1973 "Amerikansk realism," Galleri Ostergren, Malmö, Sweden

"Amerikanske realister," Randers Kunstmuseum, Randers,
Denmark; Lunds Konsthall, Lund, Sweden

"California Representation: Eight Painters in Documenta
5," Santa Barbara Museum of Art, Calif.

"East Coast/West Coast/New Realism," San Jose State
University, Calif.

"The Emerging Real," Storm King Art Center,
Mountainville, N.Y.

"Grands maîtres hyperréalistes américains," Galerie des
Quatre Mouvements, Paris

"Hyperréalistes américains," Galerie Arditti, Paris

"Iperrealisti americani," Galleria La Medusa, Rome

"Mit Kamera, Pinsel und Spritzpistole," Ruhrfestspiele
Recklinghausen, Städtische Kunsthalle,
Recklinghausen, West Germany

"Options 73/30," Contemporary Arts Center, Cincinnati

"Photo-Realism," Serpentine Gallery, London

"Realism Now," Katonah Gallery, Katonah, N.Y.

"Separate Realities," Los Angeles Municipal Art Center

"The Super-Realist Vision," DeCordova and Dana
Museum, Lincoln, Mass.

1973–74 "Hyperréalisme," Galerie Isy Brachot, Brussels

"Kunst nach Wirklichkeit," Kunstverein Hannover, West
Germany

1973–78 "Photo-Realism 1973: The Stuart M. Speiser Collection,"
traveling exhibition: Louis K. Meisel Gallery, New
York; Herbert F. Johnson Museum of Art, Ithaca, N.Y.;
Memorial Art Gallery of the University of Rochester,
N.Y.; Addison Gallery of American Art, Andover,
Mass.; Allentown Art Museum, Pa.; University of
Colorado Museum, Boulder; University Art Museum,
University of Texas, Austin; Witte Memorial Museum,
San Antonio, Tex.; Gibbes Art Gallery, Charleston, S.C.;
Brooks Memorial Art Gallery, Memphis, Tenn.;
Krannert Art Museum, University of Illinois,
Champaign-Urbana; Helen Foresman Spencer
Museum of Art, University of Kansas, Lawrence; Paine
Art Center and Arboretum, Oshkosh, Wis.; Edwin A.
Ulrich Museum, Wichita State University, Kans.;
Tampa Bay Art Center, Tampa, Fla.; Rice University,
Sewall Art Gallery, Houston; Tulane University Art
Gallery, New Orleans; Smithsonian Institution,
Washington, D.C.

1974 "Amerikaans fotorealisme grafiek," Hedendaagse Kunst,
Utrecht; Palais des Beaux-Arts, Brussels

"Ars '74 Ateneum," Fine Arts Academy of Finland, Helsinki

"Contemporary American Paintings from the Lewis
Collection," Delaware Art Museum, Wilmington

"Hyperréalistes américains—réalistes européens," Centre
National d'Art Contemporain, Paris

"Kijken naar de werkelijkheid," Museum Boymans–van
Beuningen, Rotterdam

"Living American Artists and the Figure," Pennsylvania State
University, University Park

Moos Gallery, Montreal

Moos Gallery, Toronto

"New Photo-Realism," Wadsworth Atheneum, Hartford,
Conn.

"New Realism Revisited," Brainerd Hall Art Gallery, State
University College, Potsdam, N.Y.

"Selections in Contemporary Realism," Akron Art Institute,
Ohio; New Gallery, Cleveland

"Three Realists: Close, Estes, Raffael," Worcester Art
Museum, Mass.

"Tokyo Biennale, '74," Tokyo Metropolitan Museum of Art;
Kyoto Municipal Museum; Aichi Prefectural Art Museum,
Nagoya

1975 "American Realism," Reed College, Portland, Oreg.

"Image, Color and Form—Recent Paintings by Eleven
Americans," Toledo Museum of Art, Ohio

"The New Realism: Rip-Off or Reality?," Edwin A. Ulrich
Museum, Wichita State University, Kans.

"Photo-Realists," Louis K. Meisel Gallery, New York

"Realismus und Realität," Kunsthalle, Darmstadt, West
Germany
"Realist Painting in California," John Berggruen Gallery, San
Francisco
"Richard Brown Baker Collects," Yale University Art Gallery,
New Haven, Conn.
"Watercolors and Drawings—American Realists," Louis K.
Meisel Gallery, New York
1975–76 "Photo-Realism, American Painting and Prints," New
Zealand traveling exhibition: Barrington Gallery, Aukland;
Robert McDougall Art Gallery, Christchurch; Academy of
Fine Arts, National Art Gallery, Wellington; Dunedin
Public Art Gallery, Dunedin; Govett-Brewster Art Gallery,
New Plymouth; Waikato Art Museum, Hamilton
"Super Realism," Baltimore Museum of Art
1976 "America as Art," National Collection of Fine Arts,
Smithsonian Institution, Washington, D.C.
"Photo-Realist Watercolors," Neuberger Museum, State
University College, Purchase, N.Y.
"Realism (Paintings and Drawings)," Young Hoffman
Gallery, Chicago
"Works on Paper," Galerie de Gestlo, Hamburg
1976–77 "Photo-Realism in Painting," Art and Culture Center,
Hollywood, Fla.; Museum of Fine Arts, St. Petersburg, Fla.
1976–78 "Aspects of Realism," traveling exhibition sponsored by
Rothman's of Pall Mall Canada, Ltd.: Stratford, Ont.;
Centennial Museum, Vancouver, B.C.; Glenbow-Alberta
Institute, Calgary, Alta.; Mendel Art Gallery, Saskatoon,
Sask.; Winnipeg Art Gallery, Man.; Edmonton Art Gallery,
Alta.; Art Gallery, Memorial University of Newfoundland,
St. John's; Confederation Art Gallery and Museum,
Charlottetown, P.E.I.; Musée d'Art Contemporain,
Montreal; Dalhousie University Museum and Gallery,
Halifax, N.S.; Windsor Art Gallery, Ont.; London Public
Library and Art Museum, and McIntosh Memorial Art
Gallery, University of Western Ontario; Art Gallery of
Hamilton, Ont.
1977 "Breaking the Picture Plane," Tomasulo Gallery, Union
College, Cranford, N.J.
"New in the '70s," University Art Museum, Archer M.
Huntington Gallery, University of Texas, Austin
"New Realism," Jacksonville Art Museum, Fla.
"New Realism: Modern Art Form," Boise Gallery of Art,
Idaho
"Photo-Realists," Shore Gallery, Boston
"A View of a Decade," Museum of Contemporary Art,
Chicago
"Works on Paper II," Louis K. Meisel Gallery, New York
1977–78 "Illusion and Reality," Australian touring exhibition:
Australian National Gallery, Canberra; Western Australian
Art Gallery, Perth; Queensland Art Gallery, Brisbane; Art
Gallery of New South Wales, Sydney; Art Gallery of South
Australia, Adelaide; National Gallery of Victoria,
Melbourne; Tasmanian Museum and Art Gallery, Hobart
"Representations of America," exhibition organized by the
Metropolitan Museum of Art, New York: traveling to the
Ministry of Culture, Moscow; the Hermitage, Leningrad;
the Palace of Art, Minsk
1978 "Art About Art," Whitney Museum of American Art, New
York
"Art and the Automobile," Flint Institute of Arts, Mich.
"Aspects of Realism," Guild Hall Art Gallery, East Hampton,
N.Y.
"Cityscape '78," Oklahoma Art Center, Oklahoma City
"Drawings Since 1960," University Art Gallery, Creighton
University, Omaha, Nebr.
"Landscape/Cityscape," Brainerd Hall Art Gallery, State
University College, Potsdam, N.Y.
Monmouth Museum, Lincroft, N.J.
"Photo-Realism and Abstract Illusionism," Arts and Crafts
Center, Pittsburgh, Pa.
"Photo-Realist Printmaking," Louis K. Meisel Gallery, New
York
Tolarno Galleries, Melbourne, Australia
1979 "Late Twentieth Century Art from the Sidney and Frances
Lewis Foundation," Institute of Contemporary Art,
University of Pennsylvania, Philadelphia
"The Opposite Sex: A Realistic Viewpoint," University of
Missouri Art Gallery, Kansas City
"Photo-Realism: Some Points of View," Jorgensen Gallery,
University of Connecticut, Storrs
"Realist Space," C. W. Post Art Gallery, Long Island
University, Brookville, N.Y.
"Selections of Photo-Realist Paintings from N.Y.C.
Galleries," Southern Alleghenies Museum of Art,
St. Francis College, Loretto, Pa.
1979–80 "Late Twentieth Century Art from the Sidney and Frances
Lewis Foundation," Institute of Contemporary Art of the
University of Pennsylvania, Philadelphia; Dayton Art
Institute, Ohio; Brooks Memorial Art Gallery, Memphis;
Dupont Gallery, Washington and Lee University,
Lexington, Va.

SELECTED BIBLIOGRAPHY

CATALOGUES
Nochlin, Linda. "The New Realists." In Realism Now. Vassar College
Art Gallery, Poughkeepsie, N.Y., May 8–June 21, 1968.
Taylor, John Lloyd, and Atkinson, Tracy. Introduction to Directions 2:
Aspects of a New Realism. Milwaukee Art Center, June 28–Aug. 10,
1969; Contemporary Arts Museum, Houston, Sept. 17–Oct. 19,
1969; Akron Art Center, Ohio, Nov. 9–Dec. 14, 1969.
Farb, Oriole. Introduction to Painting from the Photograph. Riverside
Museum, New York, Dec. 9, 1969–Feb. 15, 1970.
Brewer, Donald. Introduction to Beyond the Actual—Contemporary
California Realist Painting. Pioneer Museum and Haggin Galleries,
Stockton, Calif., Nov. 6–Dec. 6, 1970.
Brown, Denise Scott, and Venturi, Robert. Introduction to The
Highway. Institute of Contemporary Art, University of Pennsyl-
vania, Philadelphia, Jan. 14–Feb. 25, 1970; Institute for the Arts,
Rice University, Houston, Mar. 12–May 18, 1970; Akron Art
Institute, Ohio, June 5–July 16, 1970.
Monte, James. Introduction to Twenty-two Realists. Whitney Museum
of American Art, New York, Feb., 1970.
Wallin, Lee. Introduction to New Realism, 1970. St. Cloud State
College, Minn., Feb. 13–Mar. 11, 1970.
Art Around the Automobile. Emily Lowe Gallery, Hofstra University,

Hempstead, N.Y., June–Aug., 1971.

Goldsmith, Benedict. *New Realism*. Brainerd Hall Art Gallery, State University College, Potsdam, N.Y., Nov. 5–Dec. 12, 1971.

Karp, Ivan C. Introduction to *Radical Realism*. Museum of Contemporary Art, Chicago, May 22–June 4, 1971.

Abadie, Daniel. Introduction to *Hyperréalistes américains*. Galerie des Quatre Mouvements, Paris, Oct. 25–Nov. 25, 1972.

Amman, Jean Christophe. Introduction to *Documenta 5*. Neue Galerie and Museum Fridericianum, Kassel, West Germany, June 30–Oct. 8, 1972.

Baratte, John J., and Thompson, Paul E. *Phases of the New Realism*. Lowe Art Museum, University of Miami, Coral Gables, Fla., Jan. 20- Feb. 20, 1972.

Baur, I. H. Foreword to *1972 Annual Exhibition*. Whitney Museum of American Art, New York, Jan. 25–Mar. 19, 1972.

Janis, Sidney. Introduction to *Sharp-Focus Realism*. Sidney Janis Gallery, New York, Jan. 6–Feb. 4, 1972.

Warrum, Richard L. Introduction to *Painting and Sculpture Today, 1972*. Indianapolis Museum of Art, Apr. 26–June 4, 1972.

Amaya, Mario. Introduction to *Realism Now*. New York Cultural Center, New York, Dec. 6, 1972–Jan. 7, 1973.

Burton, Scott. *The Realist Revival*. New York Cultural Center, New York, Dec. 6, 1972–Jan. 7, 1973.

Schneede, Uwe, and Hoffman, Heinz. Introduction to *Amerikanischer Fotorealismus*. Württembergischer Kunstverein, Stuttgart, Nov. 16–Dec. 26, 1972; Frankfurter Kunstverein, Frankfurt, Jan. 6–Feb. 18, 1973; Kunst und Museumsverein, Wuppertal, West Germany, Feb. 25–Apr. 8, 1973.

Alloway, Lawrence. Introduction to *Amerikansk realism*. Galleri Ostergren, Malmö, Sweden, Sept. 8–Oct. 14, 1973.

———. Introduction to *Photo-Realism*. Serpentine Gallery, London, Apr. 4–May 6, 1973.

Becker, Wolfgang. Introduction to *Mit Kamera, Pinsel und Spritzpistole*. Ruhrfestspiele Recklinghausen, Städtische Kunsthalle, Recklinghausen, West Germany, May 4–June 17, 1973.

Boulton, Jack. Introduction to *Options 73/30*. Contemporary Arts Center, Cincinnati, Sept. 25–Nov. 11, 1973.

C. A. B. S. Introduction to *Realisti iperrealisti*. Galleria La Medusa, Rome, Nov. 12, 1973.

Dali, Salvador. Introduction to *Grands maîtres hyperréalistes américains*. Galerie des Quatre Mouvements, Paris, May 23–June 25, 1973.

Dreiband, Laurence. Notes to *Separate Realities*. Foreword by Curt Opliger. Los Angeles Municipal Art Gallery, Sept. 19–Oct. 21, 1973.

Hogan, Carroll Edwards. Introduction to *Hyperréalistes américains*. Galerie Arditti, Paris, Oct. 16–Nov. 30, 1973.

Iperrealisti americani. Galleria La Medusa, Rome, Jan. 2, 1973.

Lamagna, Carlo. Foreword to *The Super-Realist Vision*. DeCordova and Dana Museum, Lincoln, Mass., Oct. 7–Dec. 9, 1973.

Meisel, Louis K. *Photo-Realism 1973: The Stuart M. Speiser Collection*. New York, 1973.

Radde, Bruce. Introduction to *East Coast/West Coast/New Realism*. University Art Gallery, San Jose State University, Calif., Apr. 24–May 18, 1973.

Sims, Patterson. Introduction to *Realism Now*. Katonah Gallery, Katonah, N.Y., May 20–June 24, 1973.

Van der Marck, Jan. Text to *American Art: Third Quarter Century*. Foreword by Thomas N. Maytham and Robert B. Dootson. Seattle Art Museum, Wash., Aug. 22–Oct. 14, 1973.

Becker, Wolfgang. Introduction to *Kunst nach Wirklichkeit*. Kunstverein Hannover, West Germany, Dec. 9, 1973–Jan. 27, 1974.

Hyperréalisme. Galerie Isy Brachot, Brussels, Dec. 14, 1973–Feb. 9, 1974.

Amerikaans fotorealisme grafiek. Hedendaagse Kunst, Utrecht, Aug., 1974; Palais des Beaux-Arts, Brussels, Sept.–Oct., 1974.

Aspects of Realism. Moos Gallery, Toronto, Sept.–Oct., 1974.

Chase, Linda. "Photo-Realism." In *Tokyo Biennale 1974*. Tokyo Metropolitan Museum of Art; Kyoto Municipal Museum; Aichi Prefectural Art Museum, Nagoya.

Clair, Jean; Abadie, Daniel; Becker, Wolfgang; and Restany, Pierre. Introductions to *Hyperréalistes américains—réalistes européens*. Centre National d'Art Contemporain, Paris, Archives 11/12, Feb. 15–Mar. 31, 1974.

Cowart, Jack. *New Photo-Realism*. Wadsworth Atheneum, Hartford, Conn., Apr. 10–May 19, 1974.

Doty, Robert. Introduction to *Selections in Contemporary Realism*. Akron Art Institute, Ohio, Sept. 20–Oct. 19, 1974; New Gallery, Cleveland, Sept. 20–Oct. 19, 1974.

Goldsmith, Benedict. *New Realism Revisited*. Brainerd Hall Art Gallery, State University College, Potsdam, N.Y., 1974.

Gruen, John. Introduction to *Contemporary Portraits by American Painters*. Lowe Art Museum, University of Miami, Coral Gables, Fla., Oct. 3–Nov. 10, 1974.

Kijken naar de werkelijkheid. Museum Boymans–van Beuningen, Rotterdam, June 1–Aug. 18, 1974.

Ronte, Dieter. Introduction to *Kunst bleibt Kunst*. Projekt '74, Wallraf-Richartz Museum, Cologne, 1974.

Sarajas-Korte, Salme. Introduction to *Ars '74 Ateneum*. Fine Arts Academy of Finland, Helsinki, Feb. 15–Mar. 31, 1974.

Shulman, Leon. *Three Realists: Close, Estes, Raffael*. Worcester Art Museum, Mass., Feb. 27–Apr. 7, 1974.

Twenty-five Years of Janis: Part II from Pollock to Pop, Op and Sharp Focus Realism. Sidney Janis Gallery, New York, Mar. 13–Apr. 13, 1974.

Wyrick, Charles, Jr. Introduction to *Contemporary American Paintings from the Lewis Collection*. Delaware Art Museum, Wilmington, Sept. 13–Oct. 17, 1974.

Krimmel, Bernd. Introduction to *Realismus und Realität*. Foreword by H. W. Sabais. Kunsthalle, Darmstadt, West Germany, May 24–July 6, 1975.

Meisel, Susan Pear. *Watercolors and Drawings—American Realists*. Louis K. Meisel Gallery, New York, Jan., 1975.

Miller, Joan Vita. Foreword to *The Long Island Art Collectors' Exhibition*. C. W. Post College, Greenvale, N.Y., Oct. 24–Nov. 23, 1975.

Phillips, Robert F. Introduction to *Image, Color and Form: Recent Paintings by Eleven Americans*. Toledo Museum of Art, Ohio, Jan. 12–Feb. 9, 1975.

Richardson, Brenda. Introduction to *Super Realism*. Baltimore Museum of Art, Nov. 18, 1975–Jan. 11, 1976.

Doty, Robert. *Contemporary Images in Watercolor*. Akron Art Institute, Ohio, Mar. 14–Apr. 25, 1976; Indianapolis Museum of Art, June 29–Aug. 8, 1976; Memorial Art Gallery of the University of Rochester, N.Y., Oct. 1–Nov. 11, 1976.

Gervais, Daniel. Introduction to *Troisième foire internationale d'art contemporain*. Paris, Oct. 16–24, 1976.

Goldsmith, Benedict. *The Presence and the Absence in Realism*. Brainerd Hall Art Gallery, State University College, Potsdam, N.Y., Mar. 26–Apr. 30, 1976.

Hicken, Russell Bradford. Introduction to *Photo-Realism in Painting*. Art and Culture Center, Hollywood, Fla., Dec. 3, 1976–Jan. 10, 1977; Museum of Fine Arts, St. Petersburg, Fla., Jan. 21–Feb. 25, 1977.

Chase, Linda. "U.S.A." In *Aspects of Realism*. Rothman's of Pall Mall Canada, Ltd., June, 1976–Jan., 1978.

Dempsey, Bruce. *New Realism*. Jacksonville Art Museum, Fla., 1977.

Karp, Ivan. Introduction to *New Realism: Modern Art Form*. Boise Gallery of Art, Idaho, Apr. 14–May 29, 1977.

Seabolt, Fred. Introduction to *New in the '70s*. Foreword by Donald Goodall. University Art Museum, Archer M. Huntington Gallery, University of Texas, Austin, Aug. 21–Sept. 25, 1977.

Stringer, John. Introduction to *Illusion and Reality*. Australian Gallery Directors' Council, North Sydney, N.S.W., 1977–78.

Adams, Lowell. Foreword to *Cityscape '78*. Oklahoma Art Center,

Oklahoma City, Oct. 27–Nov. 29, 1978.

Garfield, Alan. Introduction to *Drawings Since 1960.* University Art Gallery, Creighton University, Omaha, Nebr., Sept. 30–Oct. 28, 1978

Hodge, G. Stuart. Foreword to *Art and the Automobile.* Flint Institute of Arts, Mich., Jan. 12–Mar. 12, 1978.

Meisel, Louis K. Introduction to *Landscape/Cityscape.* Brainerd Hall Art Gallery, State University College, Potsdam, N.Y., Sept. 22–Oct. 22, 1978.

Meisel, Susan Pear. Introduction to *The Complete Guide to Photo-Realist Printmaking.* Louis K. Meisel Gallery, New York, Dec., 1978.

Young, Mahonri Sharp. Foreword to *Aspects of Realism.* Guild Hall, East Hampton, N.Y., July 22–Aug.13, 1978.

Butler, Susan L. Introduction to *Late Twentieth Century Art from the Sydney and Frances Lewis Foundation.* Institute of Contemporary Art, University of Pennsylvania, Philadelphia, Mar. 22–May 2, 1979.

Gerling, Steve. Introduction to *Photo-Realism: Some Points of View.* Jorgensen Gallery, University of Connecticut, Storrs, Mar. 19–Apr. 10, 1979.

Miller, Wayne. Introduction to *Realist Space.* Foreword by Joan Vita Miller. C. W. Post Art Gallery, Long Island University, Brookville, N.Y., Oct. 19–Dec. 14, 1979.

Streuber, Michael. Introduction to *Selections of Photo-Realist Paintings from N.Y.C. Galleries.* Southern Alleghenies Museum of Art, St. Francis College, Loretto, Pa., May 12–July 8, 1979.

Butler, Susan L. Introduction to *Late Twentieth Century Art from the Sydney and Frances Lewis Foundation.* Institute of Contemporary Art of the University of Pennsylvania, Philadelphia, Mar. 22–May 2, 1979; Dayton Art Institute, Ohio, Sept. 13–Nov. 4, 1979; Brooks Memorial Art Gallery, Memphis, Dec. 2, 1979–Jan. 27, 1980; Dupont Gallery, Washington and Lee University, Lexington, Va., Feb. 18–Mar. 21, 1980.

ARTICLES

Gaynor, Frank. "Photographic Exhibit Depicts Today's U.S.," *Newark Sunday News,* Dec. 14, 1969, sec. 6, p. E18.

Nilson, Karl Gustav. "Realism U.S.A.," *Konstrevy* (Stockholm), Nov. 2, 1969, pp. 68–71.

Perreault, John. "Get the Picture?," *Village Voice,* Dec. 18, 1969.

Davis, Douglas. "Return of the Real: Twenty-two Realists on View at New York's Whitney," *Newsweek,* Feb. 23, 1970, p. 105.

Deschin, Jacob. "Photo into Painting," *New York Times,* Jan. 4, 1970.

Lichtblau, Charlotte. "Painters' Use of Photographs Explored," *Philadelphia Enquirer,* Feb. 1, 1970.

Nemser, Cindy. "Presenting Charles Close," *Art in America,* Jan., 1970, pp. 98–101.

Ratcliff, Carter. "Twenty-two Realists Exhibit at the Whitney," *Art International,* Apr., 1970, p. 105.

Stevens, Elizabeth. "The Camera's Eye on Canvas," *Wall Street Journal,* Jan. 6, 1970.

Genauer, Emily. "Art '72: The Picture Is Brighter," *New York Post,* Dec. 31, 1971.

Marandel, J. Patrice. "The Deductive Image: Notes on Some Figurative Painters," *Art International,* Sept., 1971, pp. 58–61.

Sager, Peter. "Neue Formen des Realismus," *Magazin Kunst,* 4th Quarter, 1971, pp. 2512–16.

Amman, Jean Christophe. "Realismus," *Flash Art,* May–July, 1972, pp. 50–52.

Borden, Lizzie. "Cosmologies," *Artforum,* Oct., 1972, pp. 45–50.

Borsick, Helen. "Realism to the Fore," *Cleveland Plain Dealer,* Oct. 8, 1972.

Chase, Linda; Foote, Nancy; and McBurnett, Ted. "The Photo-Realists: Twelve Interviews," *Art in America,* vol. 60, no. 6 (Nov.–Dec., 1972), pp. 73–89.

Davis, Douglas. "Nosing Out Reality," *Newsweek,* Aug. 14, 1972, p. 58.

"Die Documenta bestätigte sein Programm," *Die Welt* (Hamburg), no. 180 (Aug. 5, 1972).

"Documenta 5," *Frankfurter Allgemeine Zeitung,* no. 155 (July 8, 1972).

"Documenta Issue," *Zeit Magazin,* no. 31/4 (Aug., 1972), pp. 4–15.

Henry, Gerrit. "The Real Thing," *Art International,* Summer, 1972, pp. 87–91.

Hickey, David. "Sharp Focus Realism," *Art in America,* Mar.–April, 1972, pp. 116–18.

"Les hommes et les oeuvres," *La Galerie,* no. 120 (Oct., 1972), pp. 16–17.

Hughes, Robert. "The Realist as Corn God," *Time,* Jan. 31, 1972, pp. 50–55.

"Hyperréalisme arrive à Paris," *Argus de la Presse,* Nov., 1972.

"L'Hyperréalisme ou le retour aux origines," *Argus de la Presse,* Oct. 16, 1972.

"Hyperréalistes américains," *Argus de la Presse,* Nov. 16, 1972.

Karp, Ivan. "Rent Is the Only Reality, or the Hotel Instead of the Hymn," *Arts Magazine,* Dec., 1972, pp. 47–51.

"Die Kasseler Seh-Schule," *Stern Magazin,* no. 36 (Aug., 1972), pp. 20–23.

Kirkwood, Marie. "Art Institute's Exhibit Represents the Revolt Against Abstraction," *Ohio Sun Press,* Oct. 12, 1972.

Kramer, Hilton. "And Now, Pop Art: Phase II," *New York Times,* Jan. 16, 1972.

Kurtz, Bruce. "Documenta 5: A Critical Preview," *Arts Magazine,* Summer, 1972, pp. 34–41.

Lerman, Leo. "Sharp Focus Realism," *Mademoiselle,* Mar., 1972, pp. 170–73.

Levequi, J. J. "Les hommes et les oeuvres," *Argus de la Presse,* Oct., 1972.

Lista, Giovanni. "Iperrealisti americani," *NAC* (Milan), no. 12 (Dec., 1972), pp. 24–25.

"Les malheurs de l'Amérique," *Nouvel Observateur,* Nov. 6, 1972.

Marmori, Giancarlo di. "Piú vero del vero," *L'Espresso,* no. 29 (July 16, 1972), pp. 4–15.

Marvel, Bill. "Saggy Nudes? Giant Heads? Make Way for 'Superrealism,'" *National Observer,* Jan. 29, 1972, p. 22.

Nemser, Cindy. "Close-Up Vision: Representational Art," *Arts Magazine,* May, 1972, pp. 44–48.

———. "New Realism," *Arts Magazine,* Nov., 1972, p. 85.

"La nouvelle coqueluche: l'hyperréalisme," *L'Express,* Oct. 30, 1972.

Perreault, John. "Realistically Speaking," *Village Voice,* Dec. 14, 1972, pp. 36–38.

Pozzi, Lucio. "Super Realisti U.S.A.," *Bolaffiarte,* no. 18 (Mar., 1972), pp. 54–63.

Rose, Barbara. "Real, Realer, Realist," *New York Magazine,* vol. 5, no. 5 (Jan. 31, 1972), p. 50.

Rosenberg, Harold. "The Art World," *The New Yorker,* Feb. 5, 1972, pp. 88–93.

Schulze, Franz. "It's Big, and It's Superreal," *Chicago Daily News,* Feb. 12–13, 1972, p. 6.

Seitz, William C. "The Real and The Artificial: Painting of the New Environment," *Art in America,* vol. 6, no. 6 (Nov.–Dec., 1972), pp. 58–72.

Seldis, Henry J. "Documenta: Art Is Whatever Goes on in Artist's Head," *Los Angeles Times Calendar,* July 9, 1972.

Thornton, Gene. "These Must Have Been a Labor of Love," *New York Times,* Jan. 23, 1972.

Wasmuth, Ernest. "La révolte des réalistes," *Connaissance des Arts,* June, 1972, pp. 118–23.

Wooten, Dick. "Something New? Real Pictures?," *Cleveland Press,* Oct. 17, 1972, p. 9.

Apuleo, Vito. "Tra manifesto e illustrazione sino al rifiuto della scelta," *La Voce Repubblicana,* Feb. 24, 1973, p. 5.

Beardsall, Judy. "Stuart M. Speiser Photorealist Collection," *Art Gallery Magazine,* vol. XVII, no. 1 (Oct., 1973), pp. 5, 29–34.

Becker, Wolfgang. "NY? Realisme?," *Louisiana Revy*, vol. 13, no. 3 (Feb., 1973).

Bell, Jane. "Stuart M. Speiser Collection," *Arts Magazine*, Dec., 1973, p. 57.

Bovi, Arturo di. "Arte/Piú brutto del brutto," *Il Messaggiero*, Feb. 13, 1973, p. 3.

Chase, Linda. "Recycling Reality," *Art Gallery Magazine*, Oct., 1973, pp. 75–82.

Chase, Linda, and McBurnett, Ted. "Interviews with Robert Bechtle, Tom Blackwell, Chuck Close, Richard Estes, and John Salt," *Opus International*, no. 44–45 (June, 1973), pp. 38–50.

E. D. G. "Arrivano gli iperrealisti," *Tribuna Letteraria*, Feb., 1973.

"Foto Realismus," *IZW Illustrierte Wochenzeitung*, no. 14 (June, 1973), pp. 8–10.

Giannattasio, Sandra. "Riproduce la vita di ogni giorno la nuova pittura americana," *Avanti*, Feb. 8, 1973, p. 1.

Gilmour, Pat. "Photo-Realism," *Arts Review*, vol. 25 (Apr. 21, 1973), p. 249.

Gosling, Nigel. "The Photo Finish," *Observer Review* (London), April 8, 1973.

Guercio, Antonio del. "Iperrealismo tra 'pop' e informale," *Rinascita*, no. 8 (Feb. 23, 1973), p. 34.

Hart, John. "A 'Hyperrealist' U.S. Tour at La Medusa," *Daily American* (Rome), Feb. 8, 1973.

Henry, Gerrit. "A Realist Twin Bill," *ARTnews*, Jan., 1973, pp. 26–28.

Hjort, Oysten. "Kunstmiljoeti Rhinlandet," *Louisiana Revy*, vol. 13, no. 3 (Feb., 1973).

"L'Hyperréalisme américain," *Le Monde des Grandes Musiques*, no. 2 (Mar.–Apr., 1973), pp. 4, 56–57.

Levin, Kim. "The New Realism: A Synthetic Slice of Life," *Opus International*, no. 44–45 (June, 1973), pp. 28–37.

Lucie-Smith, Edward. "Super Realism from America," *Illustrated London News*, Mar., 1973.

Maraini, Letizia. "Non fatevi sfuggire," *Il Globo*, Feb. 6, 1973, p. 8.

Marziano, Luciano. "Iperrealismo: la coagulazione dell'effimero," *Il Margutta* (Rome), no. 3–4 (Mar.–Apr., 1973).

Melville, Robert. "The Photograph as Subject," *Architectural Review*, vol. CLIII, no. 915 (May, 1973), pp. 329–33.

Micacchi, Dario. "La ricerca degli iperrealisti," *Unità*, Feb. 12, 1973.

Michael, Jacques. "Le Super-realisme," *Le Monde*, Feb. 6, 1973, p. 23.

Mizue (Tokyo), vol. 8, no. 821 (1973).

Moulin, Raoul-Jean. "Hyperréalistes américains," *L'Humanité*, Jan. 16, 1973.

Perreault, John. "Airplane Art in a Head Wind," *Village Voice*, Oct. 4, 1973, p. 24.

Piradel, Jean-Louis. "Paris: Hyperréalistes américains," *Opus International*, no. 39 (1973), pp. 51–52.

Restany, Pierre. "Sharp Focus: La continuité réaliste d'une vision américaine," *Domus*, Aug., 1973.

Rubiu, Vittorio. "Il gusto controverso degli iperrealisti," *Corriere della Sera*, Feb. 25, 1973.

Seldis, Henry J. "New Realism: Crisp Focus on the American Scene," *Los Angeles Times*, Jan. 21, 1973, p. 54.

Sherman, Jack. "Art Review: Photo-Realism, Johnson Museum," *Ithaca Journal*, Nov. 13, 1973.

"Stuart Speiser Collection," *Art International*, Nov., 1973.

Trucchi, Lorenza di. "Iperrealisti americani alla Medusa," *Momento-sera*, Feb. 9–10, 1973, p. 8.

Berkman, Florence. "Three Realists: A Cold, Plastic World," *Hartford Times*, Mar. 10, 1974.

Chase, Linda. "The Connotation of Denotation," *Arts Magazine*, Feb., 1974, pp. 38–41.

Clair, Jean. "Situation des réalismes," *Argus de la Presse*, Apr., 1974.

Coleman, A. D. "From Today Painting Is Dead," *Camera 35*, July, 1974, pp. 34, 36–37, 78.

"Collection of Aviation Paintings at Gallery," *Andover* (Mass.) *Townsman*, Feb. 28, 1974.

Davis, Douglas. "Summing Up the Season," *Newsweek*, July 1, 1974, p. 73.

Deroudille, René. "Réalistes et hyperréalistes," *Derrière Heure Lyonnaise*, Mar. 31, 1974.

Gassiot-Talabor, Gerald. "Le choc des 'Réalismes,' " *XXe Siècle*, no. 42 (June, 1974), pp. 25–32.

Gibson, Michael. "Paris Show Asks a Question: What Is Reality?," *International Herald Tribune*, Feb. 23–24, 1974, p. 7.

Hill, Richard. "The Technologies of Vision," *Art Magazine* (Toronto), vol. 6, no. 19 (Fall, 1974), p. 10.

Hughes, Robert. "An Omnivorous and Literal Dependence," *Arts Magazine*, June, 1974, pp. 25–29.

Kelley, Mary Lou. "Pop Art Inspired Objective Realism," *Christian Science Monitor*, Mar. 1, 1974.

Lascault, Gilbert. "Autour de ce qui se nomme hyperréalisme," *Paris-Normandie*, Mar. 31, 1974.

Levin, Kim. "Audrey Flack at Meisel," *Art in America*, May–June, 1974, p. 106.

Loring, John. "Photographic Illusionist Prints," *Arts Magazine*, Feb., 1974, pp. 42–43.

Michael, Jacques. "La 'mondialisation' de l'hyperréalisme," *Le Monde*, Feb. 24, 1974.

Moulin, Raoul-Jean. "Les hyperréalistes américains et la neutralisation du réel," *L'Humanité*, Mar. 21, 1974.

Progresso fotografico, Dec., 1974, pp. 61–62.

Schjeldahl, Peter. "Too Easy To Be Art?," *New York Times*, May 12, 1974, p. 23.

Spear, Marilyn W. "An Art Show That Is for Real," *Worcester* (Mass.) *Sunday Telegram*, Feb. 24, 1974, sec. E, pp. 1, 4.

———. "Three Realists Showing at Museum," *Worcester* (Mass.) *Telegram*, Feb. 27, 1974, p. 12.

Spector, Stephen. "The Super Realists," *Architectural Digest*, Nov.–Dec., 1974, pp. 84–89.

Stubbs, Ann. "Audrey Flack," *Soho Weekly News*, Apr. 4, 1974.

Teyssedre, Bernard. "Plus vrai que nature," *Le Nouvel Observateur*, Feb. 25–Mar. 3, 1974, p. 59.

Walsh, Sally. "Paintings That Look Like Photos," *Rochester Democrat and Chronicle*, Jan. 17, 1974.

"Worcester Art Museum Hosts Major Painting Exhibition," *Hudson-Sun/Enterprise-Sun* (Worcester, Mass.), Feb. 26, 1974.

Zabel, Joe. "Realistic Works Predominate in 1974 Mid-Year," *The Jambar* (Youngstown State University), July 11, 1974, p. 7.

Albright, Thomas. "A Wide View of the New Realists," *San Francisco Chronicle*, Feb. 6, 1975, p. 38.

Bruner, Louise. "Brash Paintings Stimulate Thinking Rather Than Passive Thoughts," *Toledo Blade*, Jan. 12, 1975, p. 4.

Hull, Roger. "Realism in Art Returns with Camera's Clarity," *Portland Oregonian*, Sept. 14, 1975.

Lucie-Smith, Edward. "The Neutral Style," *Art and Artists*, vol. 10, no. 5 (Aug., 1975), pp. 6–15.

McNamara, T. J. "Photo-Realist Exhibition Makes Impact," *New Zealand Herald* (Auckland), July 23, 1975.

Nordjyllands Kunst Museum, no. 3, Sept., 1975.

"Photographic Realism," *Art-Rite*, no. 9 (Spring, 1975), p. 15.

"Photo-Realism Exhibit Is Opening at Paine Sunday," *Oshkosh Daily Northwestern*, Apr. 17, 1975.

"Photo-Realism Flies High at Paine," *Milwaukee Journal*, May, 1975.

"Photo-Realists at Paine," *View Magazine*, Apr. 27, 1975.

Ray, Steve. "Photo/Art: Real or Reel," *Oshkosh Advance-Titan*, May 1, 1975.

Richard, Paul. "Whatever You Call It, Super Realism Comes On with a Flash," *Washington Post*, Nov. 25, 1975, p. B1.

Sutinen, Paul. "American Realism at Reed," *Willamette Week*, Sept. 12, 1975.

Albright, Thomas. "Wanted: A Figurative Study," *San Francisco Chronicle*, Oct. 5, 1976.

Alloway, Lawrence. "Art," *The Nation*, vol. 222, no. 17 (May 1, 1976).

Artner, Alan. "Mirroring the Merits of a Showing of Photo-Realism," *Chicago Tribune,* Oct. 24, 1976.

Chase, Linda. "Photo-Realism: Post Modernist Illusionism," *Art International,* vol. XX, no. 3–4 (Mar.–Apr., 1976), pp. 14–27.

"Exhibition Displays Aspect of Realism," *New Westminster* (B.C.) *Columbian,* Oct. 9, 1976.

Forgey, Benjamin. "The New Realism, Paintings Worth 1,000 Words," *Washington Star,* Nov. 30, 1976, p. G24.

Fox, Mary. "Aspects of Realism," *Vancouver Sun,* Sept. 21, 1976.

Glasser, Penelope. "Aspects of Realism at Stratford," *Art Magazine* (Toronto), vol. 7, no. 28 (Summer, 1976), pp. 22–29.

Hoelterhoff, Manuela. "Strawberry Tarts Three Feet High," *Wall Street Journal,* Apr. 21, 1976.

K. M. "Realism," *New Art Examiner,* Nov., 1976.

McDonald, Robert. "Richard McLean and Robert Cottingham," *Artweek,* Oct. 16, 1976, pp. 3–4.

Patton, Phil. "Books, Super-Realism: A Critical Anthology," *Artforum,* vol. XIV, no. 5 (Jan., 1976), pp. 52–54.

Perreault, John. "Getting Flack," *Soho Weekly News,* Apr. 22, 1976, p. 19.

———. "Photo-Shock," *Soho Weekly News,* Jan. 22, 1976, p. 16.

Perry, Art. "So Much for Reality," *Province,* Sept. 30, 1976.

Greenwood, Mark. "Toward a Definition of Realism: Reflections on the Rothmans Exhibition," *Arts/Canada,* vol. XXIV, no. 210–11 (Dec., 1976–Jan., 1977), pp. 6–23.

Borlase, Nancy. "In Selecting a Common Domestic Object," *Sydney Morning Herald,* July 30, 1977.

Crossley, Mimi. "Review: Photo-Realism," *Houston Post,* Dec. 9, 1977.

Edelson, Elihu. "New Realism at Museum Arouses Mixed Feelings," *Jacksonville Journal,* Feb., 1977.

Grishin, Sasha. "An Exciting Exhibition," *Canberra Times,* Feb. 16, 1977.

Groom, Gloria. "Modern Art Exhibit Gives a Nice Surprise," *The Citizen* (Austin, Tex.), Aug., 1977.

Hocking, Ian. "Something for All at Art Gallery," *News Adelaide,* Sept. 7, 1977.

"Illusion and Reality," *This Week in Brisbane,* June, 1977.

Langer, Gertrude. "Realising Our Limitations in Grasping Reality," *Brisbane Courier Mail,* May 28, 1977.

Lynn, Elwyn. "The New Realism," *Quadrant,* Sept., 1977.

Makin, Jeffrey. "Realism from the Squad," *Melbourne Sun,* Oct. 19, 1977, p. 43.

McCracken, Peg. "The Illusion and Reality Show," *6 A.M. Arts Melbourne and Art Almanac,* Dec., 1977.

McGrath, Sandra. "I Am Almost a Camera," *The Australian* (Brisbane), July 27, 1977.

Phillips, Ralph. "Just Like the Real Thing," *Sunday Mail* (Brisbane), Sept. 11, 1977.

"Photo-Realism and Related Trends," *New York Times,* Feb. 4, 1977.

Pidgeon, W. E. "In Search of Reality," *Sunday Telegraph* (New South Wales), July 31, 1977.

Thomas, Daniel. "The Way We See Now," *The Bulletin,* Sept. 10, 1977.

Bongard, Willie. *Art Aktuell* (Cologne), Apr., 1978.

Harnett, Lila. "Photo-Realist Prints: 1968–1978," *Cue,* Dec. 22, 1978, p. 23.

Harris, Helen. "Art and Antiques: The New Realists," *Town and Country,* Oct., 1978, pp. 242, 244, 246–47.

Jensen, Dean. "Super Realism Proves a Super Bore," *Milwaukee Sentinel,* Dec. 1, 1978.

Kramer, Hilton. "A Brave Attempt to Encapsulate a Decade," *New York Times,* Dec. 17, 1978, p. 39.

Mackie, Alwynne. "New Realism and the Photographic Look," *American Art Review,* Nov., 1978, pp. 72–79, 132–34.

O'Conor, Mary. "Eight Artists," *East Hampton Star* (N.Y.), July 17, 1978, p. 14.

Perreault, John. "Art Picks: Photo-Realist Prints," *Soho Weekly News,* Dec. 14, 1978, p. 54.

———. "Photo Realist Principles," *American Art Review,* Nov., 1978, pp. 108–11, 141.

"Photo Journalism and Photo Realism," *Milwaukee Journal,* Dec. 10, 1978.

Richard, Paul. "New Smithsonian Art: From 'The Sublime' to Photo Realism," *Washington Post,* Nov. 30, 1978, p. G21.

Rodriguez, Joanne Milani. "Art Show Accents the Eccentricities of Camera's Vision," *Tampa Tribune-Times,* Feb. 5, 1978, pp. 1–2.

Sanger, Elizabeth. "If Your Taste in Art Runs to the Bizarre, O.K. Harris Is O.K.," *Wall Street Journal,* Aug. 18, 1978, pp. 1, 29.

"Special from Broadway," *East Hampton Star* (N.Y.), July 20, 1978, p. 13.

"Style Hampton-Style," *East Hampton Summer Sun* (N.Y.), July 27, 1978, p. 11.

Harshman, Barbara. "Photo-Realist Printmaking," *Arts,* Feb., 1979, p. 17.

Melcher, Victoria Kirsch. "Vigorous Currents in Realism Make Up Group Show at UMKC," *Kansas City Star,* Mar. 11, 1979, p. 3E.

BOOKS

Hunter, Sam. *American Art of the Twentieth Century.* New York: Harry N. Abrams, 1972.

Kultermann, Udo. *New Realism.* New York: New York Graphic Society, 1972.

Brachot, Isy, ed. *Hyperréalisme.* Brussels: Imprimeries F. Van Buggenhoudt, 1973.

Sager, Peter. *Neue Formen des Realismus.* Cologne: Verlag M. DuMont Schauberg, 1973.

Wilmerding, John, ed. *The Genius of American Painting.* New York: William Morrow, 1973.

Calamandrei, Mauro, and Gorgoni, Gianfranco. *Art USA.* Milan: Fratelli Fabbri Editori, 1974.

L'Iperrealismo italo Medusa. Rome: Romana Libri Alfabeto, 1974.

Battcock, Gregory, ed. *Super Realism, A Critical Anthology.* New York: E. P. Dutton, 1975.

Chase, Linda. *Hyperréalisme.* New York: Rizzoli, 1975.

Kultermann, Udo. *Neue Formen des Bildes.* Tübingen, West Germany: Verlag Ernst Wasmuth, 1975.

Lucie-Smith, Edward. *Late Modern—The Visual Arts Since 1945.* 2d ed. New York: Praeger, 1975.

Rose, Barbara, ed. *Readings in American Art, 1900–1975.* New York: Praeger, 1975.

Walker, John A. *Art Since Pop.* London: Thames and Hudson, 1975.

Honisch, Dieter, and Jensen, Jens Christian. *Amerikanische Kunst von 1945 bis Heute.* Cologne: DuMont Buchverlag, 1976.

Lipman, Jean, and Franc, Helen M. *Bright Stars: American Painting and Sculpture Since 1776.* New York: E. P. Dutton, 1976.

Stebbins, Theodore E., Jr. *American Master Drawings and Watercolors.* New York: Harper & Row, 1976.

Wilmerding, John. *American Art.* Harmondsworth, England: Penguin, 1976.

Battcock, Gregory. *Why Art.* New York: E. P. Dutton, 1977.

Billeter, Erika. *Malerei und Photographie im Dialog.* Zurich: Benteli, 1977.

Lucie-Smith, Edward. *Art Now: From Abstract Expressionism to Superrealism.* New York: William Morrow, 1977.

Rose, Barbara (with Jules D. Brown). *American Painting.* New York: Skira, Rizzoli, 1977.

Lipman, Jean, and Marshall, Richard. *Art About Art.* New York: E. P. Dutton, 1978.

Lucie-Smith, Edward. *Super Realism.* Oxford: Phaidon, 1979.

INDEX

F

G

H

I

J

K

ACKNOWLEDGMENTS

Without the support of the following people, this book would not have been possible:

Helene Zucker Seeman, research librarian
The artists, their families, and their assistants
Carol Ann Klonarides, Jean Diao, and Carlo Lamagna, O. K. Harris Gallery
Milly Glimcher, Pace Gallery
The staff of Nancy Hoffman Gallery
Carol Androccio
Joan Wolff, Allan Stone Gallery
The staff of Louis K. Meisel Gallery
Grace Meisel
Margaret Donovan, Margaret Kaplan, and Dirk Luykx of Harry N. Abrams, Inc.
All the collectors and museums listed herein.

And—for ten years of withstanding everything—Susan Pear Meisel, to whom this book is dedicated.

PHOTOGRAPH CREDITS

The author and the publisher wish to thank the following individuals and organizations, who have taken the photographs for this book: Robert Bechtle; Eric Pollitzer; Bruce C. Jones; D. James Dee; Wayne Miller; Gerard Murrell; Bevan Davies; Schopplein Studios; Robert E. Mates and Paul Katz; Neil Winokur; Jeanne Hamilton; O. E. Nelson; Frank J. Thomas; eeva–inkeri; Geoffrey Clements; Nathan Rabin; Albert L. Mozell.